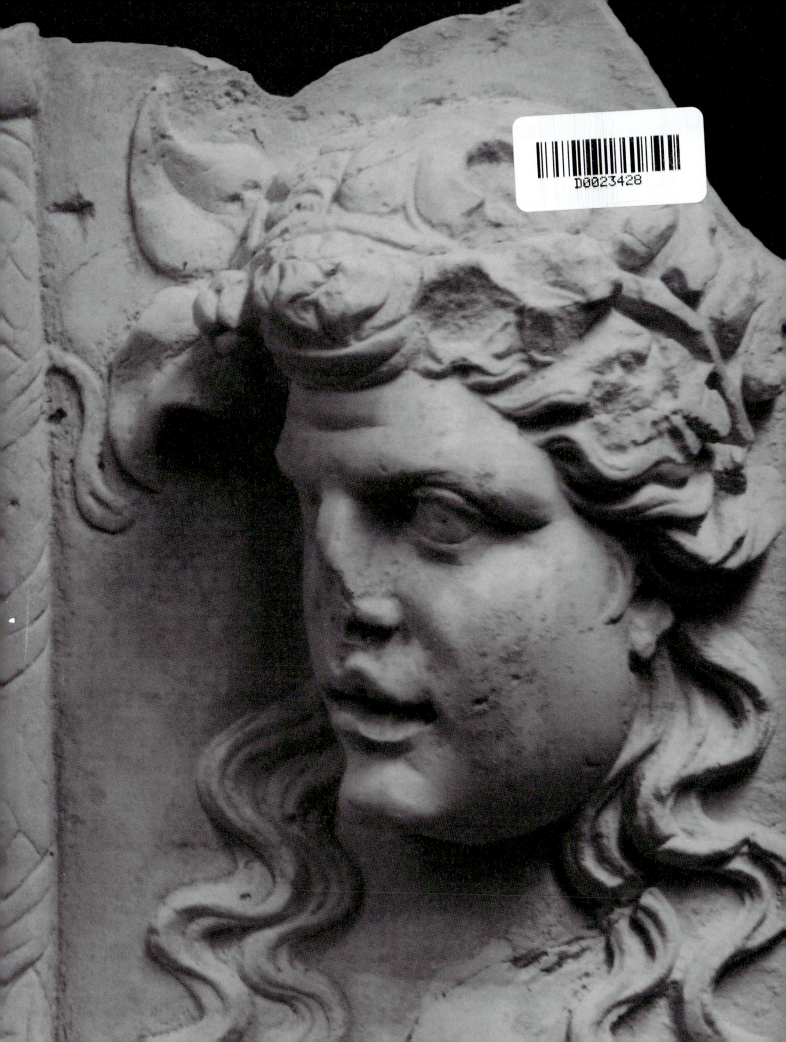

Classical Sculpture

Frontispiece. *Portrait of a middle-aged woman (102).*

MUSEUM MONOGRAPH NO. 125

Classical Sculpture ❧

Catalogue of the Cypriot, Greek, and Roman Stone Sculpture

in the University of Pennsylvania Museum
of Archaeology and Anthropology

IRENE BALD ROMANO

University of Pennsylvania Museum of Archaeology and Anthropology
Philadelphia

For Katy, Sarah, Lizzie, and David

LIBRARY OF CONGRESS CATALOGING-IN-PUBLICATION DATA

University of Pennsylvania. Museum of Archaeology and Anthropology.
 Classical sculpture : catalogue of the Cypriot, Greek, and Roman stone sculpture in the University of Pennsylvania Museum of Archaeology and Anthropology / Irene Bald Romano.— 1st ed.
 p. cm.
 Includes bibliographical references and index.
 ISBN-13: 978-1-931707-84-8 (hardcover : alk. paper)
 ISBN-10: 1-931707-84-7 (hardcover : alk. paper)
 1. Sculpture, Classical—Catalogs. 2. Sculpture, Cypriote—Catalogs. 3. Sculpture—Pennsylvania—Philadelphia—Catalogs.
4. University of Pennsylvania. Museum of Archaeology and Anthropology—Catalogs. I. Romano, Irene Bald. II. Title.
 NB87.P45U555 2006
 733.3074—dc22
 2006001040

 Publication of this book has been aided by a grant from the von Bothmer Publication Fund of the Archaeological Institute of America.

Financial support was also provided by The Samuel H. Kress Foundation and the American Hellenic Institute Foundation.

Printed in the UK by Butler & Tanner, Frome

Table of Contents

Illustrations

Illustrations on CD

Preface

This is the first complete published catalogue of the Classical sculpture collection in the University of Pennsylvania Museum of Archaeology and Anthropology (UPM). In 1921, S. B. Luce published a *Catalogue of the Mediterranean Section, The University Museum* with brief descriptions, but no illustrations, of the key pieces in the existing collection, including the sculpture, pottery, and bronzes. Luce did not include the Classical sculptures under the domain of the other curatorial divisions of the Museum, such as the Near Eastern and Egyptian Sections. Since Luce's catalogue, many of the individual stone sculptures in the collection have been published in various formats and in scattered sources, though many have never been published.

The goal of this volume is to present a comprehensive catalogue of all of the Cypriot, Greek, and Roman stone sculptures in the Museum, including relevant pieces in the Near Eastern and Egyptian Sections, and to provide for each piece a complete description with measurements and report of condition, a list of the previously published sources, and a commentary reflecting the most recent scholarship, along with ample photographic documentation. The goal is also to present a useful work for various audiences. The writing of this catalogue has been a precarious balance of providing information that the general reader will find informative and interesting, that will stimulate students to engage in further study on some of the topics raised by individual pieces or groups of sculptures, and that will satisfy a need in the scholarly community to finally have in their hands a work that provides an up-to-date and comprehensive look at a significant Classical sculpture collection in one of the world's great archaeology museums.

The impetus for writing this catalogue of the Classical sculpture in the UPM came from the preparation for the renovation and reinstallation of the Museum's permanent Classical galleries, "Worlds Intertwined: Etruscans, Greeks, and Romans," that opened to the public in March 2003 (CD Figs. 1–4). Almost half (approximately 70) of the stone sculptures included in this catalogue are on display in these new Classical galleries. Six of the ten Etruscan stone sculptures in the UPM's collection are also exhibited in the Etruscan World gallery but are not included in this corpus because they have been thoroughly treated in the *Catalogue of the Etruscan Gallery of the University of Pennsylvania Museum of Archaeology and Anthropology* by Jean MacIntosh Turfa (2005: Cat. no. 228: head of sphinx, from Narce; Cat. no. 302: female bust, from Tuscania; Cat. no. 230: relief cippus fragment, from Chiusi; Cat. no. 295: inscribed cinerary chest and lid of Arnth Remzna; Cat. no. 229: winged lion, possibly from Vulci; and Cat. no. 293: sarcophagus, from Cività Musarna).

With the exception of a female head from Kourion in the Roman World gallery (**8**) (CD Fig. 6) and a male statuette from Kourion (**11**) in the Greek World gallery, the Cypriot sculpture remains in storage awaiting a future gallery devoted to Cyprus and the Aegean worlds. Likewise, only two of the Palmyrene or Graeco-Parthian sculptures are currently on display in the Roman World gallery (**132** and **142**), and only one of the sculptures from Nysa Scythopolis (Beth Shean/Beisan) (**93**) is exhibited in the Greek World gallery.

Catalogue Organization

This catalogue is mainly organized into groupings by provenience, so that the excavated collections from Kourion, Nemi, Minturnae, Teanum Sidicinum, Nysa Scythopolis, and Palmyra have been treated together, each with an introduction. The Cypriot collection also comprises a coherent corpus, and since it includes the earliest material in this catalogue, it is presented first, though the Cypriot pieces range in date from the late 7th c. BC to the Roman period. Within this category the sculptures collected by Max Ohnefalsch-Richter (**1–7**) have been grouped together with an introduction, followed by those excavated at Kourion (**8–11**), with pieces with no known provenience at the end of the Cypriot category. Throughout the catalogue in general, within each smaller grouping, the entries are arranged with representations of females first and in chronological order, followed by males in chronological order, then pieces of questionable gender and animal figures.

In the broad category of Greek sculpture, Attic grave monuments (**17–23**), including one of the Roman period (**23**), and East Greek grave stelai (**24–26**) are grouped together and presented in more or less chronological order. Divine and idealized images of the Hellenistic period form a separate category (**27–34**), followed by a group of female heads which can be dated by style to either the Late Hellenistic or the Imperial Roman periods (**35–41**). Lastly,

under the broad category of Greek sculpture, but listed separately, are two sculptures that are Roman copies or adaptations of well-known Greek works (**42–43**).

The sculptures from the Sanctuary of Diana Nemorensis at Lake Nemi are presented next, as most of these belong to the Late Hellenistic/Republican period, though several can be dated to the Early Imperial period (**44–82**). Likewise, the sculptures from Colonia Minturnae are treated as a distinct group with pieces ranging from the second half of the 1st c. BC to the 2nd or 3rd c. AD (**83–90**). The pieces from Teanum Sidicinum (**91–92**) and a group of nine sculptures in marble and limestone from the Museum's excavations in the 1920s at Nysa Scythopolis (Beth Shean/Beisan) in ancient Palestine (**93–101**) follow. The remaining Roman sculptures are organized under the broad heading of "Other Roman Sculpture" (**102–124**) and are divided into "Portraits"; "Divine and Idealized Images"; and "Reliefs." Again, where appropriate, female images are presented first and in chronological order, followed by male. A small category of "Uncertain Works or Forgeries" includes pieces that are suspected of being forgeries (**125** and **126**), as well as pieces that are difficult to place because of their fragmentary or crude nature (**127–129**). As discrete groupings from the fringes of the Classical world, Palmyrene relief sculpture and Graeco-Parthian sculpture form the final categories in this catalogue (**130–154**).

For each catalogue entry, the heading includes the following information in this order: catalogue number; short title; UPM accession number (see concordance of accession numbers and catalogue numbers on p. 325); provenience, if known; assigned date; material (with stable isotopic results for those pieces for which we were able to conduct this analysis; see below pp. 80–81 for discussion of the technique and references); and measurements using the metric system. Next is a discussion of the acquisition of the piece, to the extent this is known, followed by all previous bibliographic citations, including both brief mentions and fuller publications. Under the heading of condition is a discussion of the present state of the piece of sculpture, while the description is a fuller clinical analysis. The extent of the commentary and its nature vary, as each piece presents unique issues. A discussion of chronology is included in most of the entries, while questions of identification, provenience, function, technique, meaning, and iconography are addressed as warranted.

Introduction to the Classical Sculpture Collection

This corpus of Classical sculpture from the UPM includes 154 works from Italy, Greece, Cyprus, Asia Minor, North Africa, Roman Syria and Palestine, Egypt, and Babylonia, ranging in date from late 7th c. BC to 4th c. AD. The majority of the sculptures are made of marble or limestone, though there are a handful of pieces in alabaster (**150–152**), basalt (**107**), and red granite (**110**). As is the case for many parts of the UPM's extraordinary collections, what sets this corpus of Classical sculpture apart from many in the United States is not its size but the large number of pieces which were excavated, for which provenience is known, or for which the Museum has archival records. Excavated sculptures from Kourion (**8–11**), the Sanctuary of Diana at Lake Nemi (**44–82**), Colonia Minturnae (**83–90**), Teanum Sidicinum (**91–92**), Nysa Scythopolis (**93–101**), and Koptos (**110**) are important in this regard, though these pieces or groups represent only a portion of the excavated *corpora* from these sites.

In addition, provenience (at least the site) can be established for approximately 30 other sculptures in this corpus, including 7 Cypriot works in the Ohnefalsch-Richter collection (**1–7**), around 18 from Syrian Palmyra (**130–147**), and other important individual pieces such as the block with the erased inscription and relief from Puteoli (**123**), the Menander head from Montecelio (**43**), and the portraits from Caesarea Cappadociae (**108**), Batna (El Bab) (**112**), and Hierapolis (Membidj) (**104**). Nevertheless, throughout the research process, I was mindful of the difficulties of examining individual pieces or groups of sculptures in isolation, with or without provenience, and of trying to place them in the context of their chronological, geographical, or cultural sphere. For the larger groups of sculptures, like those from Nemi, Minturnae, Kourion, Nysa Scythopolis, and Palmyra, I have provided some introductory remarks in an attempt to paint a broader contextual picture. A number of individual sculptures in this collection were purchased from dealers or accepted as gifts for which there is little or no information regarding provenience.

The UPM acquired the majority of the sculptures in this corpus between the 1880s and 1890s—when some of the Palmyrene and Graeco-Parthian material, the Ohnefalsch-Richter Cypriot collection, and the Nemi material were purchased—and the 1930s. There were few major acquisitions after that time, with the exception of the Kourion material which was excavated by the Museum and accessioned in 1954, the head of the Roman legionary purchased in 1954 (**122**), the gift of an Attic grave monument in 1963 (**23**), and the "Benghazi Venus" acquired as a gift in 1969 (**29**).

It was mainly with funds provided by Lucy Wharton Drexel (Mrs. Joseph H. Drexel; 1838–1912) (Fig. 1), a prominent Philadelphia philanthropist and advisory member of the Museum's Board of Managers from 1897 to 1912, that many of the earliest purchases of Classical sculpture were made, from the 1890s to around 1911. Purchases were made from various collectors and dealers, some in Italy though contacts

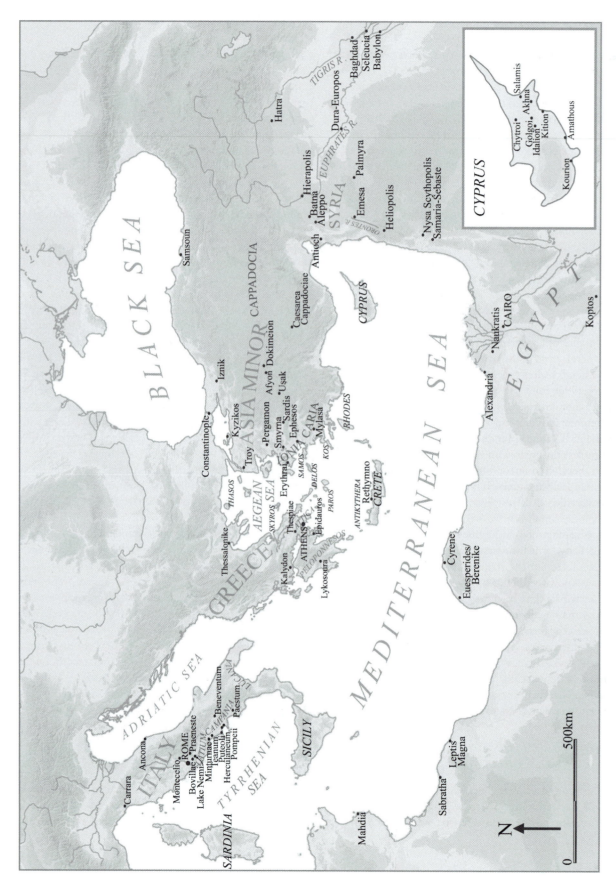

Map of Mediterranean and Near Eastern world with key sites referred to in this volume. Adapted by David Pacifico, Corinth Computer Project, 2005, with permission from Elliott 2004.

established by Arthur L. Frothingham, as was the case with the Nemi collection (see below pp. 75–78; Guldager Bilde and Moltesen 2002:7–10). Edward Perry Warren (1860–1928), a well-known American collector of ancient art who lived at Lewes House in East Sussex, England, and whose name is closely associated with the acquisition of many ancient works of art for the Museum of Fine Arts in Boston (for a recent biography see Sox 1991; also Calder 1996b), acted as an intermediary or directly sold seven important pieces of sculpture to the Museum, mostly in 1901 (**28**: head of Athena purchased in Cairo in 1901; **30**: statuette of Aphrodite purchased in 1901; **43**: head of Menander acquired in Rome by E. P. Warren in 1897 and bought from him by the Museum in 1901; **93**: portrait of a middle-aged woman purchased through Warren in 1913; **105**: portrait head of a boy purchased in 1901; **114**: goddess in flight purchased in 1901; and **118**: table support of Dionysos/Bacchus in 1901). Four pieces of sculpture, comprising two Attic funerary monuments (**20, 21**), a Hellenistic head of Herakles (**31**), and a probable forgery of female head (**126**), were purchased in 1904 in Munich from Paul Arndt (1865–1937), a German collector, dealer of Greek sculpture, and respected scholar (see Calder 1996a for biographical sketch of Arndt). Two Attic grave monuments were also purchased from dealer Joseph Brummer in Paris in 1926 (**17** and **18**). Hermann Hilprecht (1859–1925), Professor of Assyriology at the University of Pennsylvania and Curator of the Museum's Babylonian Section from 1888 to 1910, was responsible for collecting five sculptures from Turkey (**103, 108, 109, 113, 120**), one of which (**120**) is part of an exchange loan with the Philadelphia Museum of Art in the 1930s; several other minor pieces of sculpture were included in this loan (**36**) and in a similar long-term loan from the Academy of Natural Sciences in Philadelphia which was converted to a gift in 1997 (**38, 127**). Two important works, both from sites in Syria, have been on long-term loan from the family of the Baron Max von Oppenheim since the 1930s (**104** and **112**).

There are so many remarkable and important pieces in this sculptural corpus that it is difficult to pinpoint just a few highlights. The excavated collections, especially those from the Italian sites of the Sanctuary of Diana at Lake Nemi and Colonia Minturnae, stand out as unique in the United States. Although the Cypriot stone sculpture collection is small (**1–16**), there are extremely interesting examples from a variety of sites, especially from Kourion (**8–11**), that document the island's varying sculptural traditions from the Cypro-Archaic to the Roman periods.

The six 4th c. BC Attic grave monuments (**17–22**) are important as representatives of the high quality of Athenian stone carving of the Classical period and as cultural documents of Athenian society. A strength of the

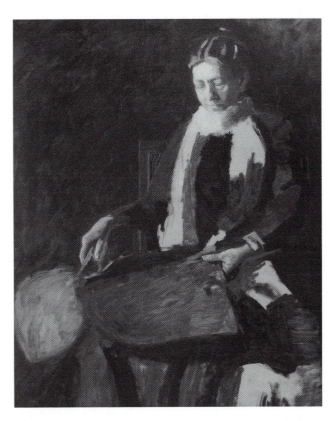

Fig. 1. Mrs Joseph H. Drexel, *1900, oil on canvas, Thomas Eakins. Photograph: Courtesy of Hirshhorn Museum and Sculpture Garden, Smithsonian Institution. Gift of Joseph H. Hirshhorn, 1966. Photograph by Lee Stalsworth.*

UPM corpus is sculptural works of the Hellenistic period, especially from Nemi (see discussion of chronology on p. 78–79), but also from other sites in Italy (**27, 28, 30**), North Africa (**29**), and East Greece (**24–26**).

This corpus is also rich in sculptural material from the Roman east, from Asia Minor (**103, 108, 109, 113**), from Roman Syria and Palestine (**93–101, 104, 112, 130–149, 153–154**), and Babylonia (**150–152**). The Palmyrene and Graeco-Parthian works in limestone and alabaster (**130–154**) are testimony to unique regional sculptural expressions that blend Graeco-Roman and eastern styles, iconography, materials, and workmanship.

Perhaps the most important individual piece in the collection from an historical viewpoint is the marble block from Puteoli (**123**) with an inscription honoring Domitian, a rare surviving document of the Roman institution of *damnatio memoriae*, reused on the *verso* as a relief from a major but enigmatic Trajanic monument. It has, thus, been given the fullest treatment in this catalogue and has also

been assigned "pride of place" in the center of the Museum's Roman World gallery (see CD Fig. 3).

Among the Roman sculptures are a large number of portraits of various types ranging in date from the Julio-Claudian period through the 4th c. AD, including images of members of the imperial family (e.g., **85, 103, 109, 110, 112**) and of private individuals, used both as grave monuments and honorific portraits (e.g., **83, 84, 104, 108, 111**). Two sculp-tures in the Roman collection that have not been adequately studied until now have proven to be of great interest. It has been possible, for example, to delve more deeply into the post-ancient history of the seated statue of Dionysos/Bacchus with the lion (**117**) and suggest the name of a possible early 17th c. restorer of the statue in Rome. And, the head of a legionary (**122**) may be associated with the well-known Hartwig-Kelsey fragments and part of a major Flavian monument in Rome.

Acknowledgments

In the writing of this catalogue with a broad scope of material from the 7th c. BC to the 4th c. AD and from all ends of the Mediterranean world and into the fringes of the Near Eastern world, I have been only too aware of my own limitations. As a result, I have leaned heavily on the collegial support of many other scholars who have generously provided their guidance and expertise. First and foremost, I appreciate the advice and assistance of all of my colleagues in the Mediterranean Section of the Museum, but especially Donald White who gave permission for and enthusiastically encouraged this study; Lynn Makowsky who cheerfully and efficiently oversaw the movement and photography of the collection; and David Gilman Romano who contributed to my research in so many ways. I am also grateful to my colleagues in the Egyptian Section for their assistance, David Silverman, Jennifer Wegner, and Joseph Wegner; and to those in the Near Eastern Section, Richard Zettler, Shannon White, Nancy Perschbacher, and Maude de Schauensee.

In addition, I would like to recognize the generous scholarly assistance of Frederick Albertson, Martin Bentz, Pia Guldager Bilde, Clotilde D'Amato, G. Roger Edwards, Moshe Fischer, Harriet Flower, Elaine Gazda, Hans Goette, Erika Harnett, Antoine Hermary, Norman Herz, Elfriede Knauer, Alexander Kruglov, Mette Moltesen, Olga Palagia, François Queyrel, Olga Raggio, Brunilde S. Ridgway, Brian Rose, Andreas Scholl, and David Soren. As always, I assume full responsibility if I have gone astray with any of the information they have so generously provided.

All of the photographs in this catalogue belong to the University of Pennsylvania Museum of Archaeology and Anthropology, except those noted in the list of figures and those of **33** which were taken by Karl A. Dimler and provided courtesy of Bryn Mawr College. The cleaning and conservation of the stone sculpture collection was expertly carried out by Tamsen Fuller with the cooperation and support of the staff of the Conservation Department of the Museum, including Virginia Greene, Lynn Grant, Julie Lawson, and Mark Abbe. I am also grateful for the assistance of the Archives of the UPM, especially to Alex Pezzati, Charles Kline, Sharon Misdea, Aryon Hoselton, and Colin Helb, and to Francine Sarin and Jennifer Chiappardi in the Museum's Photography Department who undertook the new photography for the catalogue and scanning of the images. I am grateful to Jack Murray and Scott Thom in the Exhibits Department who cheerfully removed pieces from display for me to study. I would also like to gratefully acknowledge the volunteer assistance of Elizabeth Romano and Sarah Romano during the summer of 2004, and to Suzanne McDevitt and Katherine Romano for their design advice. I would especially like to express my thanks to the Publications Department, in particular Walda Metcalf and Jennifer Quick, for shepherding this volume through the publication process, and to Matt Manieri, especially for assisting with the creation of the CD.

I owe a huge dept of gratitude to the Department of Classical and Near Eastern Archaeology at Bryn Mawr College for extending to me the courtesy of an appointment as Research Associate, and to Eileen Markson and Jeremy Blatchley at the Rhys Carpenter Library for their hospitality and assistance.

For their financial support of this endeavor I would like to acknowledge the generosity of the University of Pennsylvania Museum of Archaeology and Anthropology and the former Williams Director, Dr. Jeremy Sabloff, for the Rodney S. Young Post-doctoral Fellowships in 1998–99 and 2003–4; the Mellon 1984 Foundation; The Samuel H. Kress Foundation; the Institute of Museum and Library Services for a grant to clean and conserve the sculpture collection; the American Hellenic Institute Foundation; and the von Bothmer Publication Fund of the Archaeological Institute of America.

JANUARY 29, 2005
MERION, PENNSYLVANIA

CATALOGUE

Cypriot Sculpture (1–16)

Ohnefalsch-Richter Collection (1–7)

In the early 1890s the UPM purchased 204 Cypriot artifacts from the German antiquarian, Max Ohne-falsch-Richter (1850–1917). Ohnefalsch-Richter began his career in Cyprus as a journalist, but quickly became entranced with the rich archaeological world of the island and stayed for 12 years (1878 to 1890), conducting explorations at sites such as Salamis, Soloi, Idalion, Tamassos, Kourion, Ayia Paraskevi, Amathus, and Marion (described in Ohnefalsch-Richter 1893:1–28). Although these were legal and careful excavations within the limited control of archaeological sites of those days, they were by no means scientific by today's standards. By agreement with the excavation sponsors, Ohnefalsch-Richter was permitted to keep a portion of the antiquities found during his excavations, and he also made purchases of artifacts discovered from local clandestine explo-

rations, which he sold to museums in Europe and in the United States. It is probably from the latter category that many of the UPM's pieces from Ohnefalsch come. These were among the very first artifacts in the collections of the Mediterranean Section of the newly founded Museum and include seven Cypriot stone sculptures (**1–7**).

Ohnefalsch-Richter published some of his findings, most notably in his major work *Kypros, the Bible and Homer* (1893). For specific documentation of most of the Ohnefalsch-Richter objects in the UPM collection there is only an unpublished listing of the finds in the Museum's archives, cited here as the "Ohnefalsch-Richter Collection Catalogue." For more about the collecting activities of Max Ohnefalsch-Richter see Karageorghis and Brennan 1999:1–5; Buchholz 1989:3–27, cahier 11–12.

1

FEMALE HEAD

MS 149
Temenos of Artemis-Kybele, Akhna, Cyprus
Cypro-Archaic period, 6th c. BC
Soft limestone
P. H. 0.062; W. at base 0.05; Max. Th. 0.04 m.
ACQUISITION: *Collected in Cyprus, 1882, by Max*
 Ohnefalsch-Richter. Ohnefalsch-Richter Collection
 Catalogue #249: from the Temenos of Artemis Kybele
 at Achna, in the east of the island. See Ohnefalsch-

 Richter 1893:1–2, site no. 1.
PUBLICATIONS: *Unpublished.*

CONDITION: Single fragment broken off at the neck. Much worn.

DESCRIPTION: Small frontal figure wearing a hairdo with bangs over the forehead, ending in thickened curls, falling behind the ears in a triangular section. Elongated oval

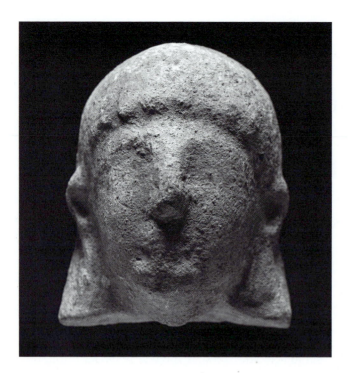

CAT. NO. 1

face, prominent nose, and fleshy chin. Black pigment is preserved on the right eyebrow. The ears are slightly protruding. Though worn, there is the suggestion of dangling, triangular-shaped earrings below the ears. Flattened back.

COMMENTARY: This fragment appears to be of a Cypro-Archaic period female votive figure with an "Egyptian-style" hairdo and triangular dangling earrings (cf. Hermary 1989:321–35), but it is so worn that little else can be deduced. See **12** for discussion of and references to "Egyptianizing" statuettes from Cyrus.

2

STATUETTE FRAGMENT: LEFT FOOT

MS 151
Idalion, Cyprus
Cypro-Archaic period, 6th c. BC
White limestone
P. H. 0.046; H. Plinth 0.015; P. W. 0.10; Max. P. D.
0.08 m.
ACQUISITION: Ohnefalsch-Richter Collection Catalogue
#252.
Publications: Unpublished.

CONDITION: Single fragment broken at mid-point of foot. Little toe broken. Missing chip from plinth in front. Discolored and encrusted.

DESCRIPTION: Approximately half-lifesized left foot on oval plinth. Elongated toes with square toe nails delineated. Four rings around each of the middle toes and one on the little toe. Flat bottom of plinth and hollow behind foot. Slight trace of reddish pigment on toes.

COMMENTARY: For examples of terracotta Cypriot sculp-

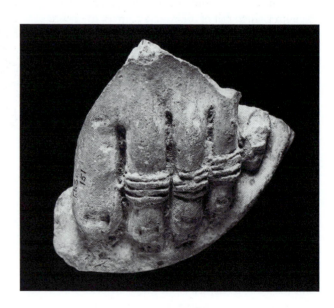

CAT. NO. 2

ture from the Astarte Sanctuary at Idalion with feet and hands adorned with multiple rings see Ohnefalsch-Richter 1893: pl. LII, nos. 8–10. Also collected by Ohnefalsch-Richter from Idalion: Schürmann 1984: nos. 95–96.

3
APHRODITE STATUETTE

MS 161
Near Idalion, Cyprus
Cypriot, Late Hellenistic period, 2nd–1st c. BC
Pale limestone
P. H. 0.215; Max. W. 0.128; Max. Th. 0.10 m.
ACQUISITION: *Ohnefalsch-Richter Collection*
Catalogue #261.
PUBLICATIONS: *Unpublished.*

CONDITION: Single fragment preserving lower body from waist to bottom of plinth. Upper break is irregular. Drapery and column to left side are also broken off near the top. Chips missing from side of drapery over column, around perimeter, and from bottom of plinth. Some darkened discoloration on front, especially on protruding drapery folds. Some white incrustation, especially on the back.

DESCRIPTION: Small statuette of a standing, partially draped Aphrodite with her right leg straight and her left leg bent with the left foot resting on a small triangular projection. Her lower body is wrapped in a *himation* with a thick roll of folds crossing over the lower torso and cascading down the left side, with zigzag folds at the front. The folds of the *himation* over the lower body describe a series of loops and diagonals, rendered as sharp ridges. She wears sandals on her feet. To the left of Aphrodite is a column with a torus base on which the other end of the *himation* is draped, obscuring the column from the front. The plinth is oval in front and squared off at the back (H. 0.018–0.025 m.). The back is treated in broader planes with protruding buttocks and broad diagonal folds.

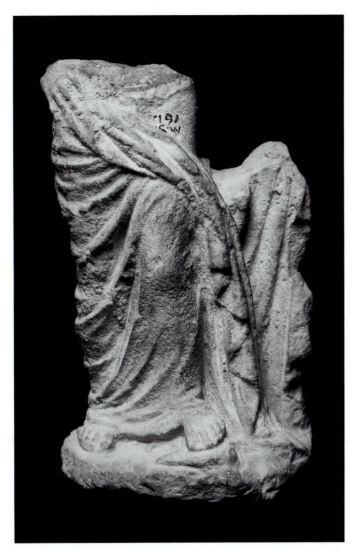

CAT. NO. 3

COMMENTARY: This Aphrodite statuette, manufactured of local Cypriot limestone, is a variation of the so-called Urania type from Cyrene (*LIMC* II, Aphrodite: 70–71, nos. 605–22) which is characterized by the nude torso with himation draped over lower body, leaning on a pillar or *herm* (or Eros) to her left, and with the left leg bent with the foot turned out and resting on a small projection. The copies are thought to imitate an original Attic work of the 4th c. BC (see discussion in *LIMC* II, Aphrodite: 70), though the many examples in large and small scale, in stone, terracotta, on gems and coins range in date from the 4th c. BC (coin type from Kyzikos: *LIMC* II, Aphodite: no. 622) to the late 1st c. BC (a statuette from Pompeii: *LIMC* II, Aphrodite: no. 606).

4

DOUBLE HEAD

MS 155
Sanctuary of Artemis Paralia, on eastern edge of the Salt
* Lake, Kition, Cyprus*
Cypro-Archaic/Cypro-Classical period or later(?)
Soft white limestone
H. 0.122; W. at top 0.076; Th. 0.085 m.
Acquisition: Ohnefalsch-Richter Collection Catalogue
* #255. See Ohnefalsch-Richter 1893:11, no. 7 for*
* reference to his examination of the site in 1879.*
Publications: Ohnefalsch-Richter 1893:210, pl. XCIII, 4–6.

CONDITION: Single fragment preserving a double head
from top to neck. Chips missing from one side of triangular
face; large chip from chin/neck or end of beard of one face.
Nose on one side cut off. Top worn and chipped. Bottom
has modern hole drilled through for the attachment to a
base; the area around the hole is chipped and broken.

DESCRIPTION: Roughly worked triangular head on one
face with crude mask on other face, flattened top and sides.
Side A: A fringe of hair, delineated by vertical grooves,
covers the forehead, marked by an incised line at the bottom
of the fringe. The eyes are incised ovals with drilled circular
depressions for pupils. Elongated nose is broken off below
bridge. Small closed mouth with full lower lip. On the right
side of the mouth an incised line rises at a diagonal, perhaps
marking the edge of the beard; below this line are vertical
striations to indicate a beard(?) On left side is the crude
beginnings of an ear(?) Side B: The opposite face is flattened
with a carved and incised mask-like face with two sets of
eyes: one on the forehead composed of shallowly incised
ovals with tiny incised dots for the centers; the lower are
larger incised ovals with larger drilled cicular depressions for
pupils. An elongated, beak-like nose is cut out of a depressed
area in the center of the face. A shallowly inscribed arch
describes the smiling mouth. The lower part of the face is
triangular and may have been meant to indicate a beard.

COMMENTARY: Ohnefalsch-Richter (1893:210) describes
this double-sided head as a votive offering from the grove of
Artemis Paralia-Ashera on the salt lake at Larnaca. This head
is rather unusual, though there are parallels from Cyprus
from both graves and sanctuaries for a type of crude triangular
face with the eyes, nose, or lips emphasized, e.g., Kara-
georghis 2000:258, no. 417: a Hellenistic votive face from
Golgoi, a possible dedication to a healing divinity with eyes
and large mouth on a triangular plaque (see Masson

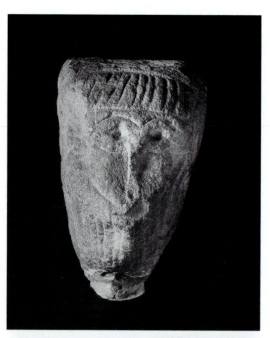

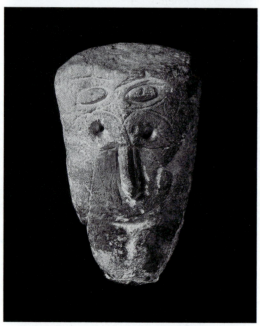

CAT. NO. 4

1998:25–29 for a discussion of these anatomical votives from
Golgoi); and from burial contexts, see Ohnefalsch-Richter
1893: pl. CLXXX, 2, from grave 257 in the necropolis of
Marion-Arsinoë, and pl. XCIII, 7, also from Marion-Arsinoë.

Perhaps related in purpose to our double head is a
limestone plaque from Arsos with three eyes in relief

(Hermary 1989: no. 938) and a rather rudimentary lime-stone figure which was a votive offering in the Sanctuary of Aphrodite at Amathous (Hermary 2000:144, no. 965, pl. 82). See also a double-headed terracotta figure from Ayia Irini (Gjerstad et al 1935:789, no. 1560, pl. 233,9).

There are also examples of similar rudimentary trian-gular heads with prominent facial features from late 2nd millennium Syria (Carter 1970:22–40) and other heads of this type from stelai from a possible Nabataean (1st c. BC–1st c. AD) sanctuary at Risqeh in the extreme southeastern part of Jordan (Kirkbride 1969:116–21, 188–95). In both cases the figures are interpreted as ancestor spirits or idols.

5
HEAD OF MALE VOTARY

MS 160
Near Idalion, Cyprus
Cypro-Classical I period, perhaps second quarter of 5th c. BC
Soft white limestone
P. H. 0.16; W. 0.117; Th. 0.09 m.
ACQUISITION: Ohnefalsch-Richter Collection Catalogue
#259, from site no. 38, east of village of Idalion, given
to him by shepherds (Ohnefalsch-Richter 1893:18).
PUBLICATIONS: Unpublished.

CONDITION: Head broken off at neck. Gash on front of neck. Surface of top of head rough. Flattened depression at lower left back; left ear chiseled off; fragments of crown missing at center and right side. Minor surface abrasions. Face is much worn.

DESCRIPTION: Small male head with flattened profile in frontal position wearing a projecting crown of upright leaves with egg-shaped buds set below the leaves. Framing

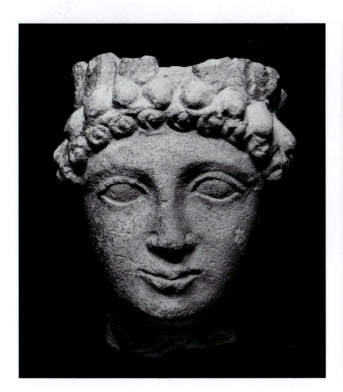
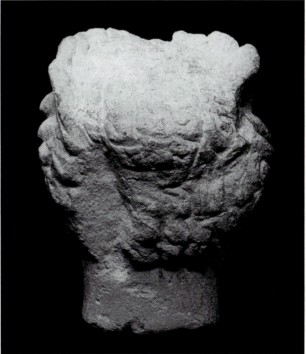

CAT. NO. 5

the forehead is a row of snail curls with protruding centers. The face is broad with wide-open, almond-shaped eyes with slightly convex eyeballs. Nose is straight and spreads at nostrils. Lips are tightly pursed, protruding, and slightly upturned in a smile, with a dip above the top lip. Poorly executed ear set back very far on right side. In back, the hair is arranged in layers of flattened curls. Back of neck is flat. Traces of red pigment on hair, crown, eyes, and lips.

COMMENTARY: This votive head and **6** were collected by Ohnefalsch-Richter from the same site, described only as a place to the east of Idalion where there were underground tombs and a sanctuary to a female divinity. Gaber-Saletan

(1986:26–30) discusses the local Idalion production in limestone of smaller male figures such as this one and concludes that the general rounding of the features in the Cypro-Classical period makes the Idalion small sculptures indistinguishable from the products of other sites. Hermary (1989:112) discusses Cypriot male votaries who wear wreaths of leaves and their associations with divinities like Apollo or Aphrodite in whose sanctuaries these votives were given. For the very common beardless type see Hermary 1989:135–218. The parallels for the combination of facial features, hairstyle, and crown put this head in the Cypro-Classical I period, probably around the second quarter of the 5th c. BC (Hermary 1989: nos. 409, 413, 427).

6

HEAD OF MALE VOTARY

MS 159
East of Idalion, Cyprus
Late Hellenistic period, ca. late
* 2nd–1st c. BC*
Soft white limestone
H. 0.17; W. 0.096; Th. 0.08 m.
ACQUISITION: *Ohnefalsch-*
* Richter Collection Catalogue*
* #260: from site no. 38, east of*
* the village of Idalion, given to*
* him by shepherds (Ohnefalsch-*
* Richter 1893:18).*
PUBLICATIONS: *Unpublished.*

CONDITION: Joined from two fragments at the chin and neck, broken off at the lower neck. Part of the top and upper back of the head missing. Gash on lower forehead and top of nose. Much worn. Darkened as if from burning, especially on lower part.

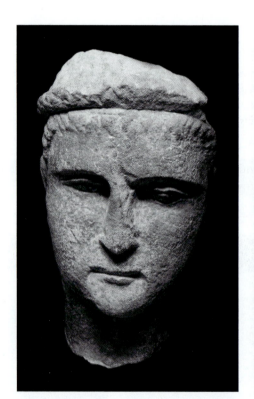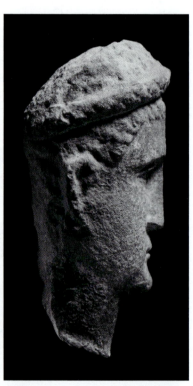

CAT. NO. 6

DESCRIPTION: Small male head in frontal position wearing a narrow wreath or crown projecting from front of head. Closely cropped fringe of hair above forehead and ears. Hair behind wreath is roughly finished. Broad flat forehead; long narrow eyes beneath sharp brow ridge; upper eyelids are sharp ridges with upper overlapping the

lower; protruding eyeballs, slanting sharply inward from top to bottom; straight nose with downturned slashes at the corners; small horizontal mouth with corners deeply hollowed and downturned; small jutting chin. Small elongated ears with no lobes but a long arching ridge on edge of cheek. Thick, flat and elongated neck. Lower back of

head roughly flattened.

COMMENTARY: See **5** for another votive head from the same site. The features of this head are stylistically later than **5** and should be dated to the Late Hellenistic period. It lacks the fuller modelling of many Cypriot works of the Hellenistic period from Idalion (see Connelly 1988:62–74 for Hellenistic votive sculpture from Idalion), but the facial features, including the hard, narrow eyes, the horizontal line of the mouth with downward slashes at the corners, and jutting chin are close to a head reportedly from Akhna in the British Museum (Connelly 1988:83, pl. 40, figs. 147–48; British Museum C 192), dated by Connelly to the end of the Hellenistic period (late 2nd–1st c. BC).

7
ANIMAL FRAGMENT: RAM

MS 154
Acropolis at Chytroi, Cyprus
Cypro-Classical or Hellenistic period?
Soft white limestone
L. 0.101; Max. H. 0.048; Max. Th. 0.03 m.
ACQUISITION: *Collected 1885. Ohnefalsch-Richter*
 Collection Catalogue #254. See Ohnefalsch-Richter
 1893:13–14 for references to his work at Chytroi.
PUBLICATIONS: *Unpublished.*

CONDITION: Single fragment with tip of nose/mouth chipped, left ear/horn broken. Worn.

DESCRIPTION: Small flattened elongated tubular sculpture ending in a ram's head with horns curled around sides of head. Long snout, protruding eyes in sockets, flattened forehead. Right side of body is more fully treated with a shallowly carved chevron pattern for the hair on the upper part.

COMMENTARY: It is possible that this is a handle fragment such as Hermary 1989: nos. 944–45 or, less likely, a stylized votive animal. Ram statuettes are rare in the corpus of Cypriot limestone sculpture, though more common in terracotta (for a limestone example of a ram reclining on a plinth from Samos see Kourou et al. 2002:20, 49, pl. VI:5, SA-13).

CAT. NO. *7*

Kourion Sculpture (8–11)

Four of the Cypriot sculptures in the UPM are from Kourion on the southwest coast of Cyprus (8–11). Although archaeological explorations in the area of the Sanctuary of Apollo Hylates at Kourion (Fig. 2 and CD Fig. 5), located about 3 km. west of the ancient city, had been conducted in the 19th c. by Luigi Palma di Cesnola, the first systematic excavations of Kourion were carried out beginning in 1934 by the University of Pennsylvania Museum under the direction of George H. McFadden, a research associate of the UPM, with the collaboration of Bert Hodge Hill. McFadden worked in and around Kourion from 1934 until his death in 1953, with an interruption during World War II from 1941 to 1945. Three of the UPM's Kourion sculptures come from McFadden's excavations in the Archaic Precinct of

Apollo. Four sculptures, along with other artifacts from the Kourion excavations, were awarded to the Museum in 1954 as a division of the excavation finds, by agreement with the Department of Antiquities of Cyprus.

McFadden published only preliminary reports of his excavations, but the excavation records, including extensive photographic documentation preserved in the archives of the University of Pennsylvania Museum, augmented greatly by the work of later American teams at the site, principally that of D. Soren and D. Buitron from 1978 to 1984, have contributed to an excellent understanding of this important site (Buitron and Soren 1981; Soren 1987; and Buitron-Oliver 1996).

Any assessment of these four sculptures from Kourion should be framed within the context of the

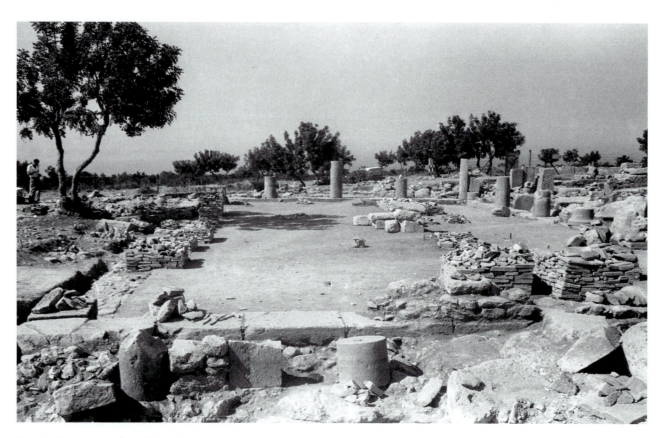

Fig. 2. Sanctuary of Apollo Hylates, Kourion, Cyprus. View of the Southeast Building, looking south, ca. 1950–51. Photograph from UPM Archives.

overall sculptural corpus from the site. Reports on the stone sculptures from the various excavations at Kourion, however, are scattered, and there has been no final publication of the sculptures excavated by McFadden and no published photographs of many of them. A brief preliminary publication of the sculptures excavated by McFadden in the Archaic Precinct is included by Young and Young in their study of the terracotta figurines (1955:173–76), and Hermary, in his publication of the sculptures from the excavations in the Archaic Precinct from 1978 to 1984, provides an excellent analysis of the limestone sculptures of Kourion, especially as they relate to the nature of the cult of Apollo Hylates (1996:139–40). The two limestone male votary figures from Kourion in the UPM (**10** and **11**) are consistent with the overall picture of votives representing predominantly males dedicated in this sanctuary to Apollo, while the two marble female heads fit into the wider view of the Hellenization and Romanization of Cyprus.

8

IDEALIZED FEMALE HEAD

54-28-21 (see CD Fig. 6)
Sanctuary of Apollo Hylates, Kourion, Cyprus
Roman Imperial, 1st c. AD
Fine white marble, possibly Pentelic
P. H. 0.205; H. face 0.13; Max. W. 0.15; Max. Depth 0.155 m.
ACQUISITION: Excavated by George McFadden, May 2, 1950, in the debris of room 2 of the Southeast Building at the Sanctuary of Apollo Hylates at Kourion (Kourion Excavation Inventory no. St 948; Notebook: McFadden Apollo X:1824, no. 922).
PUBLICATIONS: McFadden 1951:168, pl. 10A; McFadden 1952a:129; McFadden 1952b:588–90, esp. 590, fig. 13; Scranton 1967:55.

CONDITION: Excellent condition. Single fragment broken at the top of the neck. Nose is broken off and worn. Chips on upper edge of diadem, jaw on right side, right side of chin and ear; gouge on jaw at left side. Other signs of wear.

DESCRIPTION: Underlifesized youthful and idealized female head wearing a plain crescent-shaped diadem (Max. H. 0.038 m.), which is high at the front and tapers to a narrow band at the back. At the right and left sides of the front of the diadem is a ridge. The hair is parted in the center and drawn back along the brow in a series of thick wavy sections which cover only the tips of the ears and end at the back of the head in a, now broken off, long, low braid or chignon. The hair falls behind the ears in a vertical section, before it is broken off. Top of the head behind the diadem is treated with wavy ridges emanating from a central part and at the back roughly treated with a chisel, as if not meant to be viewed from the back. Small oval face with a short triangular forehead, sharp brow ridge with almond-shaped deeply-set eyes; thickened upper lids with downward sloping eyeballs; small, fine nose; small Cupid's bow mouth, with lips slightly parted and drilled at the outer corners; small rounded chin with slight cleft; small ears with drilled openings; smooth full volume for the cheeks. Face is slightly polished to a smooth sheen. Asymmetries are obvious in aligning the central hair part with the peak of the diadem and in the circle of the diadem, and in aligning the mouth with the nose and central hair part. Use of the drill is careful and sparing on the hair, ears, and mouth.

COMMENTARY: The Southeast Building, the structure in which this head and **9** were found, was first tentatively identified by Scranton (1967:66) as a palaistra, and the later excavators at Kourion have more confidently accepted this identification (see, e.g., Soren 1987:28, 33–34) (see Fig. 2 and CD Fig. 5). This rectangular building sits just outside the sanctuary proper and has a series of rooms facing three sides of a sizable courtyard, which was later colonnaded on all four sides (Scranton 1967:65–66). McFadden dated the original construction of the Southeast Building to sometime between the earthquake of AD 76/77 and AD 101 when the neighboring South Building was completed (McFadden 1952a:129), although in an earlier report McFadden suggested that the building may have been constructed before the earthquake, damaged by it, and rebuilt afterwards (McFadden 1951:168). Scranton admitted that there is little evidence for the specific date of the building, except that the foundation fill contains nothing later than the early part of the 1st c. AD (Scranton 1967:54). Soren's

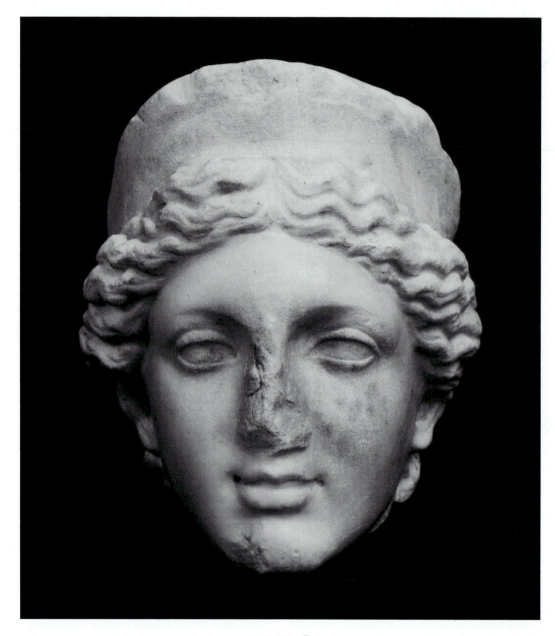

CAT. NO. 8

summary of the dating for the building is somewhat broader, and he indicates that the construction does not predate the 1st c. AD and that the building was still in place by the mid-2nd c. AD (Soren 1987:28).

Room 2 of the Southeast Building, in the debris of which the two heads (**8** and **9**) were found, is an impressive room in the center of the west side of the court. The room was approached by three steps and had a wide doorway flanked by two niches, presumably for sculpture. A limestone statue of a nude youth with a ball, identified by McFadden as Apollo Hylates or a local hero (1952a:129), and by Soren (1987:28) and Jensen (1984:281–84) as an athlete/ballplayer, was found in the debris nearby and may belong in one of the niches. Against the back wall of the room was a large moulded base for one or more statues, and benches lined the walls of the room, possibly a later addition (Scranton

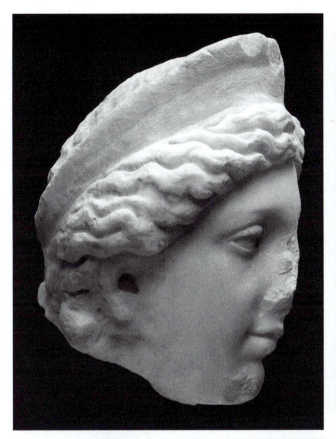 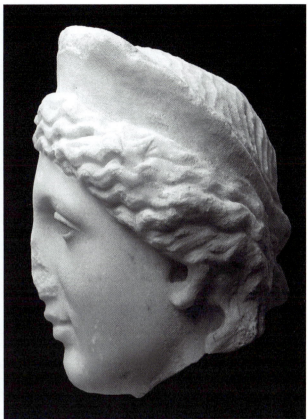

CAT. NO. 8

1967:65). It is recorded in the excavation notebooks that this head was found in the debris of this room along with one other female head (**9**); a nearly lifesized female head, possibly of Aphrodite (McFadden 1951:168, pl. 10B); an overlifesized fragmentary male head, possibly of Apollo according to McFadden (1951:168); a head and torso of a youth; a figure of an animal; and a marble shield. McFadden suggested that two female heads found in the vicinity of the podium (**8** and the nearly lifesized female head, possibly Aphrodite) may have stood on it (1952a:129).

The presence of the lunate diadem on this idealized female head almost certainly identifies it as a divine image, though there are idealized portraits of female members of the imperial family who wear this divine attribute, e.g., Drusilla, the daughter of Germanicus and Agrippina I, and Livia, the wife of Augustus, the first two to be deified, in AD 38 and 41, respectively. (For a discussion of imperial women as goddesses see Matheson 1996:182–93, and Bartman 1999:134 for a discussion of portraits of the deified Livia wearing the diadem and taking on a Juno-like role

as imperial matriarch.) This head, however, lacks individualized portrait-like characteristics that would allow it to be identified with a specific member of the imperial family, and it is much more likely that it represents a goddess. Because the lunate diadem is worn by a number of goddesses, especially Juno/Hera and Venus/Aphrodite, it is not possible to positively identify this head with any one of them on this basis alone, though Aphrodite might be the favored candidate because of her special affinity to Cyprus.

A date for the head in the first half of the 1st c. AD (Tiberian or Claudian periods) seems likely based on similarities of the features to portraits of this period, especially the treatment of the eyes and mouth on portraits of Livia and Agrippina I. Such a date fits well with the probable construction of the building in the early 1st c. AD, with the earthquake of AD 76/77 as the *terminus ante quem*. All of the sculptures from the Southeast Building and from the McFadden excavations at Kourion, however, should be studied as a whole before any final conclusions are reached about their identification and use.

9

FRAGMENTARY IDEALIZED FEMALE HEAD

54-28-20
Sanctuary of Apollo Hylates, Kourion,
* Cyprus*
Roman Imperial, 1st c. AD
Fine, compact small-grained white
* marble, possibly Pentelic*
P. H. 0.175; Max. W. 0.12; P. Depth
* 0.08 m.*
ACQUISITION: Excavated by George
* McFadden, May 2, 1950, in the*
* debris of Room 2 of the Southeast*
* Building of the Sanctuary of Apollo*
* Hylates at Kourion (Kourion Exca-*
* vation Inventory no. St 941; Note-*
* book: McFadden Apollo X:1810,*
* no. 909; 1929: no. 1031).*
PUBLICATIONS: Unpublished.

CONDITION: Joined from two fragments obliquely across the left eye and forehead, preserving most of the right side of the face to just above the right eye; a small portion of the hair on the right side, most of the left eye and left temple, the mouth and chin with a tiny piece of the turn to the neck. Nose is broken off. The entire back and top of the head are broken off. Surface that is preserved is mottled tan with some accretions.

DESCRIPTION: Underlifesized youthful, idealized head with a small oval face with subtle modelling of the facial planes. Sharp ridge for brow with thickened area beneath; wide-opened eyes with sharp ridges for lids; drilled nostril; small Cupid's bow mouth with lips parted and drilled at corners; full jutting chin with slight cleft. Hair is drawn from the face in waves before broken off; some use of the drill on the hair.

COMMENTARY: See above (8) for a discussion of the

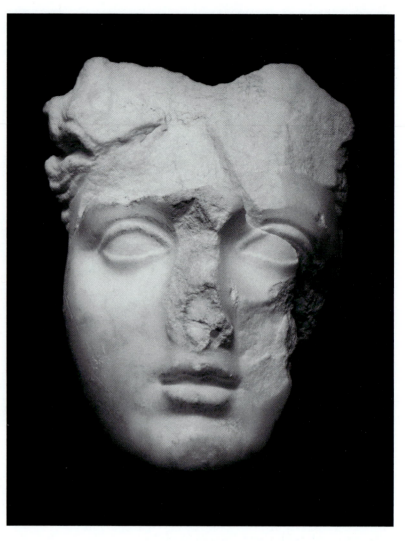

CAT. NO. 9

context in the Southeast Building. Although its state of preservation makes an assessment difficult, this head is strikingly close to the female head found in the same context (see 8). The marble, the style of carving, the facial features and the scale (this head is only millimeters smaller than 8) can be closely matched, and both heads were almost certainly carved by the same sculptor.

10
DRAPED MALE VOTIVE STATUETTE

54-28-22
Said to have been found below a cliff, near
 Sanctuary of Apollo, Kourion, Cyprus
Cypro-Archaic period, later 7th–early 6th
 c. BC
Limestone
P. H. 0.38; Max. W. at shoulders 0.22;
 Th. 0.07 m.
ACQUISITION: University Museum Expedi-
 tion to Kourion (Kourion Excavations
 Inventory no. St 956; Notebook:
 McFadden, Apollo XVI:3107, F3000:
 brought in by a local shepherd).
PUBLICATIONS: Unpublished.

CONDITION: Preserved from base of neck to
hem of garments with stubs of legs/feet. Right
shoulder repaired. Gashes on lower left side
and on neckline of garment; chip missing from
lowest hem of garment. Many dark blotches on
back from deposition.

DESCRIPTION: Standing frontal male statuette
with arms held down, open palms and elongated
fingers against his sides. Figure wears three
garments: an undergarment which appears at the
neckline with short strokes defining its upper
edge and above the legs/feet as tightly packed
folds; a short-sleeved tunic with two vertical
bands on the sleeves, horizontal bands forming
the cuffs, ending in a fringe defined by short
strokes, and with a hem over the legs with small
drill holes indicating the sewn edge; and a mantle
or shawl worn over the left shoulder and drawn diagonally
across body beneath right arm to right thigh. A row of trian-
gles in relief along its edge defines the fringe of the latter
garment. Rounded stubs of the legs/feet are preserved beneath.
A drilled hole in the bottom is a modern mounting device. The
back is left as a roughened surface with the suggestion of the
continuation of the crinkly undergarment at the lower end.

COMMENTARY: The details of the garments depicted on
this Cypriot male statuette make it an exceptionally inter-
esting piece with better parallels on Cypriot figurines and
sculpture in terracotta rather than in stone. The basic
garment is a short-sleeved tunic, but with decorative

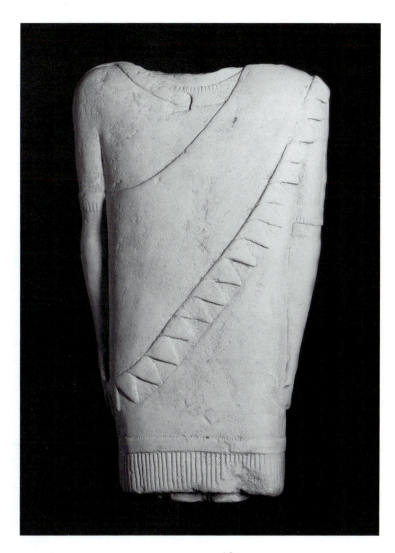

CAT. NO. 10

edging which can be paralleled in terracotta sculpture
with incised and painted details, e.g., Karageorghis
1993:21, no. 45, pl. XI:4 from Ayia Irini. The closely
packed folds above the feet represent either an extra piece
of finer material sewed onto the heavier material or, more
likely, a finer garment, like a Greek *chiton*, worn beneath
the heavier tunic and seen only at the bottom. See Kara-
georghis 1993:24–25, no. 61, pl. XV for an example of a
male figure with a lighter garment beneath the tunic.

The fringed mantle, a probable Near Eastern borrowing,
perhaps Assyrian filtered through the Phoenicians, is worn
by bearded male figurines wearing conical headdresses or
coiffures of the Cypro-Archaic period (Karageorghis

1995:19–22, Type I [ii]; Monloup 1984:173–76) and appears as early as ca. 670/660 BC, if Schmidt's chronology is correct, on fragments of larger Cypriot terracotta sculpture from the Samian Heraion (Karageorghis 1993:18; Schmidt 1968: pls. 7–10). In fact, in larger terracotta sculpture the mantle worn obliquely across the left shoulder is common, and some of these are represented as fringed with a rick-rack edge

(Karageorghis 1993:83–85 and 19, figs. 9–12).

If the general trends in stone sculpture follow those in terracotta, as seems to be the case on Cyprus (see Counts 1998:32, 117–18), the flattened body forms of this statuette should move it chronologically toward the end of the 7th or early 6th c. BC (see comments of Karageorghis on the Neo-Cypriote Style [1993:26]).

11
STANDING MALE VOTIVE STATUETTE

54-28-19
*Sanctuary of Apollo, Archaic Precinct fill (Archaic
 Altar), Kourion, Cyprus*
Cypro-Archaic period, 600–550 BC
Fine-grained cream-colored limestone
H. 0.463; W. 0.136 m.
ACQUISITION: *Excavated by George McFadden, Univer-
 sity Museum Expedition to Kourion, probably April
 1937 (Kourion Excavation Inventory no.: St 401:
 Archaic Altar, just south of stone slab Θ, east 2).*
PUBLICATIONS: *J. and S. Young, 1955:173, St 401, pl. 69.*

CONDITION: Head broken off and reattached. Intact, except for chips missing from right elbow, along neck break, and two large depression on back. Paint partially preserved.

DESCRIPTION: Standing male figure in a frontal pose with his feet together, his right arm bent across his chest possibly holding some object, and his left arm at his side; both fists are clenched. He stands on an irregular and sloping base, which may have served as a tang to be set into a plinth. He is dressed in a plain short-sleeved tunic and a mantle that is draped over the shoulders and in which the bent right arm is slung. He wears a conical helmet with upturned earflaps that come to a peak at the top of the cap and expose his large violin-shaped ears. The figure is staring straight ahead with chisel marks for eyebrows, a straight nose, vague eyes, a small mouth, and a pointed clean-shaven chin. Long hair falls from below his cap to behind his shoulders in a triangular mass. The back of the figure is flat with broad chisel strokes. There is evidence of painted details, e.g., red on the cap, mouth, and on the *himation* near the left arm and along the bottom.

COMMENTARY: It was confirmed by the later excavations at Kourion that the trenches dug by McFadden in the area he

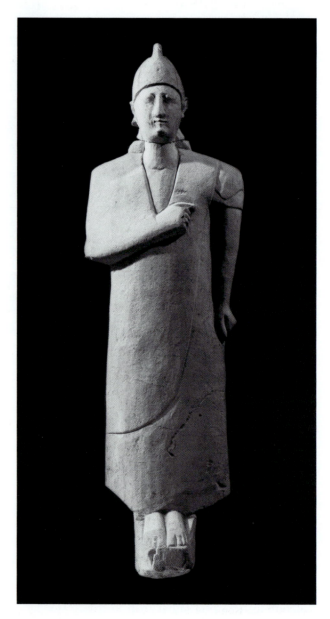

CAT. NO. *11*

14
FEMALE HEAD

MS 5840
Probably from Cyprus
Hellenistic period?
Soft white limestone
P. H. 0.036; W. 0.03; D. 0.035 m.
ACQUISITION: *Found uncatalogued and undocumented*
 in the collection in 1979.
PUBLICATIONS: *Unpublished.*

CONDITION: Single fragment broken at neck. Much worn.

DESCRIPTION: Tiny female head, possibly from a relief with part of the background preserved. Head in frontal pose, hair brushed back from forehead and framing face. At back of head is a protruding section of stone, flattened at the back, possibly used as the attachment surface for a relief.

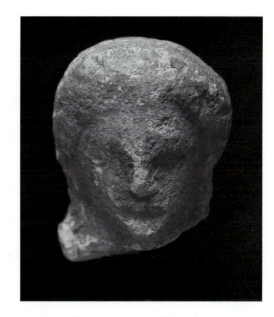

CAT. NO. 14

COMMENTARY: The poor state of preservation and the lack of context for this piece make any definitive judgment regarding its date, use, or iconography difficult. The soft white limestone is compatible, however, with the stone used on Cyprus, and it would not be unlikely that this piece is Cypriot, probably from a small votive relief. The date, to judge from the hairstyle, may be in the Hellenistic period.

15
MALE VOTARY HEAD

MS 5674
Cyprus
Late Cypro-Archaic period, ca. 500–480 BC, or possible
 forgery
Soft white limestone
H. 0.302; W. 0.21; Th. 0.24 m.
ACQUISITION: *Collected by Nicholas Christofi, 1920.*
 Gift of John Cadwalader.
PUBLICATIONS: *Hall 1921:201–3, figs. 69–70.*

CONDITION: Excellent condition preserving head and neck, broken off at the lower neck. Nicks or gouges on neck, edges of ears, nose, locks of hair, and edges of neck. Encrustation and discoloration on face, hair, and neck.

DESCRIPTION: Frontal lifesized male head with small narrow face, narrow forehead, and broadly arching eyebrows treated as raised surfaces. Almond-shaped eyes are shallowly cut with slight convexity to the eyeballs and thin ridges for eyelids. High cheekbones. Long pointed nose with large and deep nostrils. Small mouth with pursed upturned lips. Well-formed ears. Hair is arranged in large snail curls with protruding ends framing the forehead. Curls of the same type but more summarily finished cover the rest of the head, while large and crudely rendered looping locks cover the nape of the neck. Binding the hair behind the front row of curls is a rolled *taenia* tied in a "Herakles knot" with elongated flat oval ends. The beard forms a sharp point in front, jutting at an

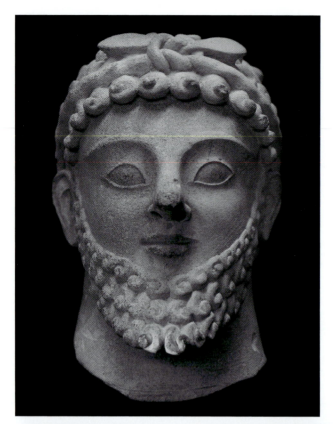

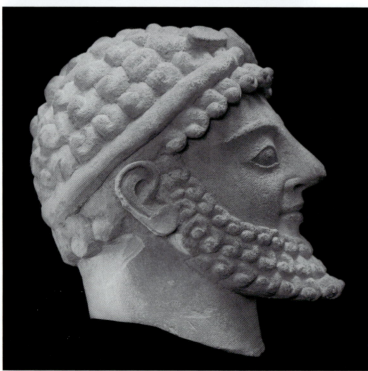

CAT. NO. 15

angle from the chin, and flat beneath. Hair of the beard is composed of three rows of snail curls with protruding ends. Broad neck with no definition except a flattened ridge broken off at the front edge. In the center of the bottom of the neck is a large square dowel cutting (ca. 0.04 m. sq. x 0.045 m. deep) which is almost certainly modern. Paint is well-preserved on the head: red on some locks of hair, beard, mouth, and raised lip at front of neck; black painted circles on eyes.

COMMENTARY: The lack of provenience for this head and its exceptional quality and preservation draw attention to the possibility that it is a forgery, yet most of the individual elements are not inconsistent and lead to a possible date of ca. 500–480 BC. The *taenia* tied at the front by a "Herakles knot" makes its appearance in Cypriot sculpture by around the second or third quarter of the 6th c. (see Hermary 1989:55, no. 74). A "Herakles knot" with broad flat ends similar to that on the UPM example is paralleled on the pointed cap of a votary of the end of the 6th c. from Golgoi (Karageorghis 2000:122, no. 188), and on a head, possibly from Idalion, of the end of the 6th or beginning of the 5th c. BC (Hermary 1989:53, no. 69), though the short hair bound by a *taenia* with the "Herakles knot" continues into the first half of the 5th c. (Hermary 1989: nos. 83:480–470 BC; 84: 480 BC; and 86: mid-5th c.).

The thick, popping snail curls, the treatment of the top of the head with thick curls, the fringe of curls at the nape of the neck, the flattened, circular earlobe, and the thick neck are closely paralleled by a bearded head from Idalion, dated (perhaps too late) by Senff to the mid-5th c. (Senff 1993:33, C100, pl. 11, j–m). At the early end of this sequence is a beardless head from Golgoi with these same popping snail curls at the forehead, thick locks over the top of the head, and curls on the nape, dated by Hermary to around 540–530 by comparison with Greek kouroi (Hermary 1989:63, no. 91). The facial features and the thick neck are very close to a beardless head from Idalion of ca. 500 BC. The flattened ridge painted red at the front edge of the neck must be the neckline of a garment or a necklace along which the head broke off, such as that on Karageorghis 2000:112–13, no. 176; 114, no. 179; 117, no. 182.

16
HAND HOLDING BIRD

MS 292
Cyprus
Cypro-Classical period, probably later 5th–4th c. BC
Soft limestone
P. H. 0.105; W. 0.03; Depth 0.05 m.
ACQUISITION: *Gift of F. C. Macauley, 1890, possibly*
 collected by Luigi Palma di Cesnola, according to a
 notation in the Mediterranean Section ledger.
PUBLICATIONS: *Unpublished.*

CONDITION: Single fragment broken off at top. Fragment missing from left side of base and lower left side of bird. Scratches on body of bird.

DESCRIPTION: Fragment of a statuette with a right hand grasping a bird by upraised wings. The bird is sitting upright on a thickened, irregular rectangular base. The features of the bird are crudely rendered: the wing feathers are defined by slashes; the eyes are depressed gashes; and the beak is a triangular protrusion. The hand is well formed. Some traces of red pigment on the body of the bird and the back of the base.

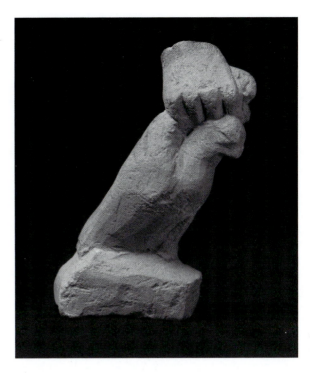

CAT. NO. 16

COMMENTARY: Birds, identified as pigeons and doves, are frequently represented in Cypriot sculpture, both individually and held by votaries (see Hermary 1981:56, no. 54, n. 30–31 for a discussion). The gesture of holding a bird by its wings in this manner can be paralleled on Cypriot votive sculpture, e.g., a bearded male votary from Golgoi of the Cypro-Classical period where the bird is identified as a dove (Karageorghis 2000:209, no. 336). And, so-called temple boys, representations of seated young boys given exclusively as votives in sanctuaries of male deities (see Karageorghis 2000:268 and Hermary 1989:69 for discussions of the meaning of these votives), also hold birds by the wings in this way (e.g., Karageorghis 2000:230, no. 362; Hermary 1989: nos, 108, 109). The base beneath the bird is a resting surface and thus the fragment is probably part of a "temple boy," where the bird is held to the right side or between the legs of the crouching or seated boy.

Greek Sculpture (17–43)

Attic Grave Monuments (17–23)

17
INSCRIBED FUNERARY
LOUTROPHOROS-HYDRIA

MS 5710
Probably near Markopoulos, Attica, Greece
Greek, 380–370 BC
Pentelic marble
P. H. 0.81; Max. D. 0.372; H. letters 0.012–0.013 m.
ACQUISITION: *Purchased from Joseph Brummer, 1926.*
PUBLICATIONS: *Dohan 1928:256–60; IG II² 11118 =*
SEG 14.244; Richter 1954b:257, pl. 55; Himmel-
mann-Wildschütz 1956:21–24, n. 78; Mastrokostas
1966:292, no. XIV (δ); Frel 1969: no. 163; Schmaltz
1970:38–39, 47, 151, no. D6; Stupperich 1977: no.
539; Kokula 1984:99, 104, 186, no. H4; Vierneisel-
Schlörb 1988:32, 126, n. 17; Clairmont 1993: no.
3.319; Bergemann 1997:13, n. 79, 210, pl. 4.1.

CONDITION: Broken across neck and above the foot, preserving the body of the vessel. Major chips missing from the lower neck. Surface scratches and nicks, especially on the head of the bearded male and lower bodies of bearded male and female. Surface worn, especially on the younger female.

DESCRIPTION: Funerary *loutrophoros-hydria* with a long ovoid form and a handle behind the neck ending at the back in a rolled bolster. On the right and left sides of the vessel above the inscription are two holes with the remnants of the rivets for attaching horizontal handles.

On the front is sculptural decoration in low relief. At the left is a veiled standing woman in three-quarters profile to her left, wearing a *chiton* and *himation*, with her right arm across her waist holding the edge of her *himation* and with her left arm bent and her hand resting against the side of her face in a gesture of mourning. To her left in the center of the composition is an older bearded male standing leaning on a staff (which would have been painted) with his left leg

crossed over the right, wearing a *himation* draped over his left shoulder and around his waist, covering his lower body. He is turning with his head in full profile to his left clasping the hand of the young female figure to his left. At the far right of the composition is a young standing girl, rendered as the smallest of the three figures, with her head bound by a fillet in full profile to the right, draped in a sleeved *chiton* and a *himation*, clasping the hand of the bearded male; in her left hand she may be holding a rounded object. The figures stand on a wide groundline hatched with a chisel.

The inscription above the figures reads:

ΔΗΜΟΚΡΑΤΕΙΑ ΔΗΜΟΤΕΛΗΣ ΜΑΛΘΑΚΗ

translated "Demokrateia, Demoteles, Malthake."

COMMENTARY: The shape of this stone grave marker is copied from ceramic three-handled vessels traditionally used to supply purified water for funeral and wedding ceremonies. (For the meaning of the *loutrophoros-hydria* as a grave marker see Bergemann 1997:46–47.) Here the horizontal handles are separately made and attached with bronze rivets. This example is one of only 15 of this shape of Attic marble funerary monuments gathered by Kokula (1984:185–88; see also Koch-Brinkmann and Posamentir 2004a for the stele of Paramythion with a *loutrophoros-hydria* in relief with a painted scene and details).

The inscription seems to have been "enhanced" by recutting the letters slightly deeper to make them more legible, but there is no evidence that the letter forms have been altered.

Although the provenience of this vessel was not recorded, its association with a stele in the Metropolitan Museum of Art in New York also bearing the inscribed names of Malthake, daughter of Demoteles, and Demo-

krateia, daughter of Demoteles, and with a reference to the *deme* of Prasiai (near Markopoulos) suggests that her burial plot was in that vicinity (Clairmont 1993: no. 3.846).

In addition to the New York and Philadelphia memorials, a *lekythos* in Berlin (Clairmont 1993: no. 4.850; Vierneisel-Schlörb 1988:32) bears an inscription with the same three names as the UPM *loutrophoros-hydria* and certainly belongs to the same family plot. (For discussions of the family relationships see Himmelmann-Wildschütz 1956:21–24 and Vierneisel- Schlörb 1988:32.) On the stele in New York Malthake, a young woman, stands with her head inclined and her hands folded gazing at her father, the bearded, elderly Demoteles. Behind Demoteles stands Demokrateia, Malthake's older sister. Malthake seems to be the deceased on both the stele in New York and on the UPM vessel, suggesting that this vessel was a secondary memorial, adjacent to the larger stele on the same plot. Such inscribed and sculpted marble vessels were usually secondary memorials set up at the corners of family plots (Schmaltz 1970:80–81). On the Berlin *lekythos*, the young Malthake stands with her head inclined and her forearms over her chest. The elderly Demoteles supports himself on a staff, and shakes hands with Demokrateia, while a servant girl squats on the ground behind her holding an infant. This *lekythos* is apparently mourning Demokrateia, perhaps having died after giving birth to a child. On our *loutrophoros-hydria*, Demokrateia, the older sister, is in an attitude of mourning behind Demoteles, the bearded father, who shakes hands in the traditional gesture of *dexiosis* with his deceased young daughter Malthake, her young age indicated by her diminutive size.

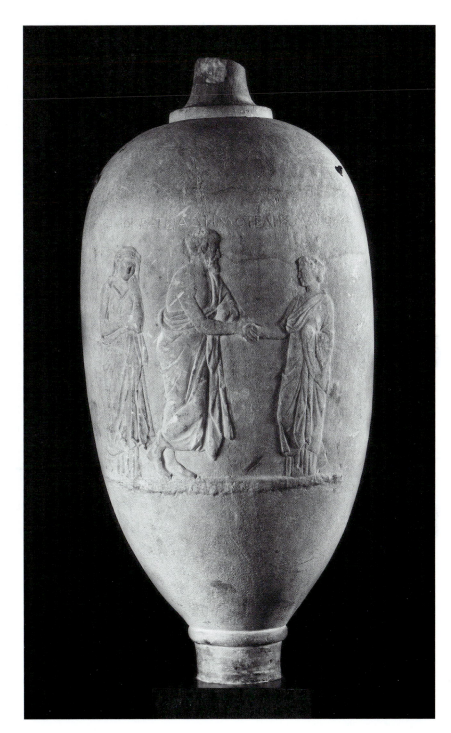

CAT. NO. *17*

The carving of the figures on the Berlin *lekythos* and the UPM *loutrophoros* are close enough to have been made in the same workshop, while the New York stele bears the

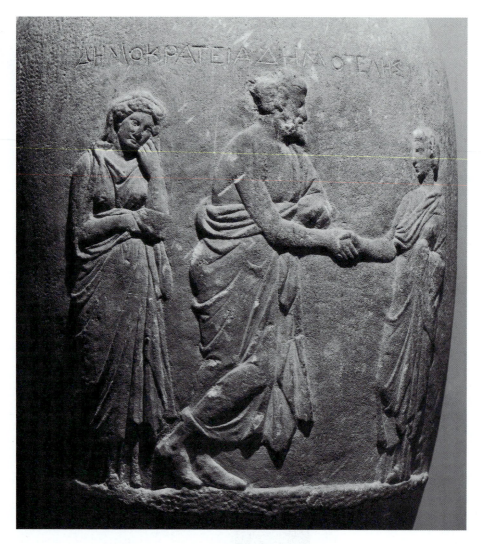

CAT. NO. *17*

mark of a different sculptor's hand (Vierneisel-Schlörb 1988:32). Although various dates have been given for these marble vessels (e.g., Schmaltz 1970:39, 47: UPM *loutrophoros*: beginning of second quarter of 4th c. BC; Berlin *lekythos*: 340–330 BC; Kokula 1984:104, 186: UPM *loutrophoros*: ca. 370 BC; Berlin *lekythos*: ca. 350s; Vierneisel-Schlörb 1988:32: UPM *loutrophoros*: ca. 380 BC; Berlin *lekythos*: 370s BC), a close dating of the Berlin and UPM vessels seems to follow from the stylistic similarity. An interpretation of the family history requires an earlier dating for the UPM *loutrophoros*, probably ca. 380–370 BC. Malthake seems to have died first (possibly young and unmarried) and is mourned by her father and sister on the UPM *loutrophoros*. (See Closterman 1999:47–48, 196–97 for a discussion of stone vessels in the context of family burial plots of the Classical period in Attica and the meaning of *loutrophoroi* in this setting as commemorative monuments for the unmarried deceased.) Then not long afterwards, Demokrateia dies, probably in childbirth, and is commemorated on the Berlin *lekythos*, presumably with her recently deceased sister, her father, and her baby. The inscription on the large stele in New York names and shows both daughters of the bereaved family, though neither is represented in *dexiosis*. It is likely that this impressive stele was a central monument commemorating both Malthake and Demokrateia in the family plot and the marble *loutrophoros-hydria* in the UPM and the Berlin *lekythos* were secondary memorials.

18

INSCRIBED FUNERARY
LEKYTHOS

MS 5709
Manufactured in Attica, Greece
Greek, 375–350 BC
Pentelic marble
P. H. 0.832; Max. D. 0.361; H. letters
 0.008–0.01 m.
ACQUISITION: *Purchased from dealer*
 Joseph Brummer, 1926.
PUBLICATIONS: *Dohan 1928:252–59;*
 IG II² 782, no. 11874 = SEG
 14.266; Clairmont 1993: no.
 3.354; Schmaltz 1970:27, 37, 39,
 95–96, 126, no. A81; Richter
 1954b:257, pl. 56.

CONDITION: Body of vessel preserved,
broken off at the lower neck and upper
foot. Large chips and crack at edge of
shoulder above inscription and on left
side. Damage to back right and lower left
side with diagonal surface crack on left.
Much damage to the groundline. Many
surface chips and scratches.

DESCRIPTION: Funerary *lekythos* of long
ovoid shape with thickened strut for
handle behind the neck. Low-relief deco-
ration consists of three figures on a thick-
ened ground line. In the center a bearded
male wearing a *himation* is seated on a
klismos with his feet on a footstool,
holding up his left hand and grasping an
object which must have been a painted
staff. With his right hand he clasps the
hand of the standing female to the right
in a traditional gesture of *dexiosis*. The
standing female with her head in full
profile wears a *chiton* and *himation*, with
the excess of the *himation* over her large
and awkwardly rendered left hand.
Behind the bearded male figure is another
standing female wearing a *chiton* and
himation and resting her left hand on the
back of the *klismos*. She wears a short
hairdo with a roll around the forehead and nape of the
neck and bound with a *taenia*. Her right hand holds the

CAT. NO. 18

edge of her *himation* as it wraps around her waist.
The inscription above their heads reads:

ΚΛΕΟΣΤΡΑΤΗ ΠΧΘΟΚΛΗΣ ΜΕΛΙ(Τ)Τ[Α]

which probably translates: "Kleostrates, Pythokles, Melitta."

COMMENTARY: The inscription is problematic and the stone cutter may have been illiterate: instead of Pythokles with an *upsilon* (Y), it has become a *chi* (X). Kleostrate is the standing female; Pythokles is the seated old bearded man (see Meyer 1989:66–74 for a discussion of the characteristics of the older seated male) who shakes hands with Melitta, a young woman. The deceased is probably Melitta who may be bidding farewell to her father Pythokles. Kleostrate could be the elder sister or wife of Pythokles.

CAT. NO. 18

19
ATTIC GRAVE STELE

MS 5675 *(see CD Fig. 7)*
Said to have come from Cyprus; Manufactured in Attica, Greece
Greek, ca. 360–350 BC
White marble
P. H. 0.925; W. 0.795; Max. Th. 0.25 m.
ACQUISITION: *Purchased in 1926 in Philadelphia from Sotirios S. Anastasios who said the stele came from Cyprus.*
PUBLICATIONS: *Dohan 1928:250–54; Schmaltz*

1970:58, n. 79: possible incorrect reference; Introduction to the Collections 1985:36, fig. 15; Clairmont 1993:254–55, no. 2.307; Ridgway Fourth-Century Styles: 170, pl. 44; Bergemann 1997:173, no. 553.

CONDITION: Missing all of top and upper left edge of the stele. Surface breaks near the broken edges and on the front of the foot of the female. Shoulders and head of the seated female have been broken off.

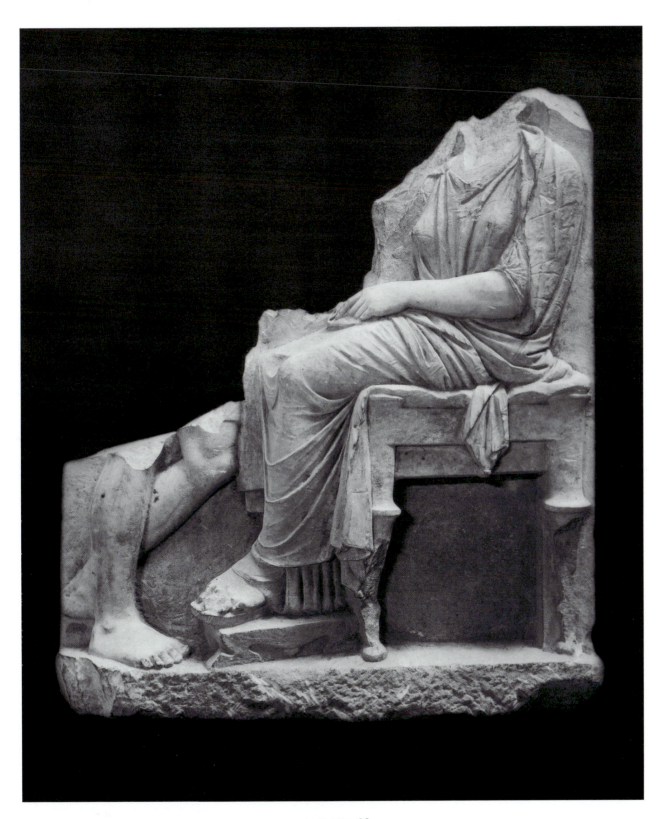

CAT. NO. 19

DESCRIPTION: Grave stele with the frame on the viewer's right side and two figures preserved, a draped female at the right side seated on a stool with the back leg of the stool on the frame. Her left foot with a high-soled sandal is resting on a footstool. She is wearing a sleeved *chiton* with buttons and a *himation* which covers her shoulders and is wrapped around her lower body with the excess held by her left hand on her lap, while the other edge falls over the front of the stool with a tassel hanging at the end. Her upper body is twisted in a three-quarters pose to the front, while her lower body is nearly profile. On the left side of the stele is a youthful bare-legged male figure. His left leg is bent and lifted slightly off the ground while his right is straight. Between the two figures is the remnant of possibly the *himation* or *chlamys* of the male figure. No inscription is preserved.

COMMENTARY: This fragmentary grave stele is probably of the *naiskos* type with *antae* (as **20**, **21**, and **22**). The scene may represent a seated mother bidding farewell to her son, in heroic nudity with a garment over his shoulder, probably in a gesture of *dexiosis*. The carving of this stele is extremely fine with careful attention to the texture of the fabrics and details such as the buttons on the sleeve, the press folds of the *chiton* above the footstool, and the end of the *himation* with a tassel or weight. Dohan (1928:

253–54) points out that the finely inscribed strokes on the *chiton* and *himation* would have been painted to indicate the texture of the woven material or a striped fabric. (For a discussion of painted details on Attic funerary monuments see Posamentir 2001; Koch-Brinkmann and Posamentir 2004b).

Ridgway (*Fourth-Century Styles*:170) assigns a date to this stele in the second quarter of the 4th c. BC, based on the texturing of the press folds. Bergemann (1997:173, no. 553) compares this stele with one in Copenhagen (Bergemann 1997: no. 487, pl. 123) and puts both in the same chronological frame of ca. 360–330 BC (Moltesen 1995:90–91, no. 33: 360–350 BC). The treatment of the drapery folds is similar. Schmaltz (1970:58, n. 79) suggests the possibility that a marble *lekythos* in Boston may have been made by the same sculptor as this stele (Boston, Museum of Fine Arts 63.1040), but there is so little correspondence that this reference may be erroneous.

If the information that this Attic grave stele came from Cyprus is correct, this would add another example of Greek marble funerary sculpture to the small corpus of works of Greek artists working in Cyprus or of imports to Cyprus in the Classical period (Karageorghis 2000:199–200; Tatton-Brown 1986:449–50). In this case, the purely Attic style of the stele suggests that the stele was imported ready-made.

20

ATTIC GRAVE STELE

MS 4019
Manufactured in Attica, Greece
Greek, ca. 360–330 BC
Pentelic marble
P. H. 0.435; Max. P. W. 0.708; Max. P. Th.0.145;
 H. letters 0.12–0.13 m.
ACQUISITION: *Purchased from Paul Arndt of Munich*
 through Alfred Emerson, with funds from Lucy
 Wharton Drexel, 1904.
PUBLICATIONS: *Bates 1912:101, no. 2; IG II² 11012;*
 Rambo 1919:149–55, fig. 57; Luce 1921:180, no.
 54; Clairmont 1993: no. 3.408; Bergemann
 1997:172–73, no. 550, 220, no. 224.

CONDITION: Upper part of stele preserved, missing the

left *acroterion* and entire left figure. Below pediment, flat molding, on which is inscription, is broken on bottom edge. Heads of two figures preserved on right side of stele. Chips missing from edge of pediment, hair, and face of male figure. There are three (modern?) dowel holes in the top, three in the back, and three along the broken bottom edge. All of these range in size from 0.015–0.05 m.

DESCRIPTION: Relief stele of *naiskos* type with gable with palmette-type *acroteria* at the peak and corners and *anta* with simplified capital framing the right side. The pediment is a flat blank surface. On a flat molding below the pediment are the inscribed names: [ΓΛ]Υ[Κ]ΕΡΑ ΦΙΛΙΠΠΗ, translated "Glykera and Philippe." In the center of the stele is a young female figure carved in low relief, probably

Philippe. She faces frontally with her *himation* over her head, tilted slightly to her right. Her hair is parted in the middle and drawn to the sides. She has blank staring eyes and a full face. At her right is a bearded male figure in high relief with his head overlapping the band of the inscription. His head is in three-quarter profile to his right. The back is roughly worked.

COMMENTARY: The inscribed names are both female, thus it is probable that the missing figure at the left of the stele is a female, perhaps Glykera, and it is possible that the stele is a monument to that woman. Philippe, the young woman in the middle of the stele, may be the daughter of the deceased, and the unnamed man to the right the deceased's husband. Glykera may have been seated and was probably reaching across to the older male (her husband?) to shake his hand.

The more or less frontal face of the central figure, Philippe, and the way her head and neck are enveloped by the *himation* (symbolic of mourning?) are somewhat unusual on Attic grave stelai. The completely frontal face is usually reserved for servant figures though the seated female on the Demetria and Pamphyle stele-*naiskos* in the Kerameikos has nearly a frontal head (Ridgway *Hellenistic Sculpture I*: pl. 8). (See also the discussion of the frontal female, a priestess?, with veiled head on the Boeotian Polyxena Relief in Ridgway *Fifth Century Styles*: 148–49.)

The name Glykera appears on at least seven other Attic grave monuments (Clairmont 1993: Vol. V, 53) but without patronymics, demotics, or other evidence it it not possible to tell if any of those funerary monuments are related to this one.

CAT. NO. 20

21
ATTIC GRAVE STELE

MS 4020
*Said to have been found at Menidi in
 the deme of Acharnai, Attica,
 Greece*
Greek, ca. 360–330 BC
White Pentelic marble
*P. H. 0.93; W. 0.59; Max. P. Th.
 0.135 m.*
ACQUISITION: *Purchased from Paul
 Arndt in Munich through Alfred
 Emerson, with funds from Lucy
 Wharton Drexel, 1904.*
PUBLICATIONS: *Rambo 1919:
 149–55, fig. 59; Reinach
 1912:208, no. 5: line drawing;
 Luce 1921:178, no. 49; Frel
 1969: no. 334; Clairmont 1993:
 no. 3.436a; Bergemann
 1997:173, no. 551.*

CONDITION: Intact except top part
which is broken off horizontally at level
of base of neck of the two standing
figures. Many chips, gouges, and
scratches on front surface. Light
brownish pink patina on the marble.

DESCRIPTION: Rectangular stele of
naiskos type with three figures carved in
relief. At the right is a woman seated on
a *klismos* in profile to her right, her right
arm clasping the extended right hand of
a standing male figure in three-quarter
view facing her in the traditional gesture
of *dexiosis*. Both are in relatively high
relief. The woman's feet rest on a low
footstool. Her left forearm rests on her
thigh. She wears a *chiton* and a *himation* loosely draped down
her left upper arm, over her left upper thigh, and looped over
her left hand. The man wears only a *himation*, draped over his
left shoulder, leaving his chest and right arm bare. His left hand
is raised to grasp the folds of the *himation* just below the shoulder.

Immediately to the left of the head of the seated
woman, in very low relief, are the lower neck and chest of
a second woman, standing frontally wearing a *chiton* also and
a *himation* whose folds she raises with her right hand to the
level of her upper chest. Her left arm is bent with the *hima-*

CAT. NO. 21

tion looped over the wrist. Below the scene is a roughly
chiseled area (H. 0.17 m.) for insertion of the stele into a
plinth. The stele is uninscribed.

The right and left sides of the stele are carefully
finished with claw chisel marks. On each of these edges
there is a hole (D. 0.01 m.) drilled horizontally (ca. 0.28
m. from the top) into the thickness of the stele. There are
remains of a modern wood plug in the left hole. There is
a flat frame (W. 0.07 m.) on the right side of the relief
beside the chair, but no frame on the other side. The back

of the stele is left as a roughened surface.

COMMENTARY: Although Clairmont (1993: Vol III, 362) interprets the male figure on this stele as the deceased, without an inscription it is impossible to tell whether this is a memorial to the male or the seated female figure. The scene is probably that of a mother, father, and daughter. Frel (1969:46–47, no. 334) puts this stele in a group of works by a "pauvre" artist of around 350–325 BC ("le sculpteur du Musée Rodin"), under the influence of the Ilissos master, but for a discussion of the validity of Frel's attributions see Clairmont 1993: Intro. Vol., 100–107, esp. 106.

22
ATTIC GRAVE STELE

MS 5470 (see CD Fig. 8)
From the inscription, probably from the deme *of Lamptrai, Attica, Greece*
Greek, ca. 360–330 BC
Pentelic marble
H. 1.555; Max. P. Th. Plinth 0.265; Max. W. cornice 0.97; H. letters 0.011–0.015 m.
ACQUISITION: *Purchased in 1917.*
PUBLICATIONS: Luce 1917:10–14; Bates 1917b:352, fig. 3; Luce 1921:178–80, no. 53; Rambo 1919: 151; Chase 1924: pl. after 100, fig. 122; IG II² 11911; Braun 1960:51–55 (with incorrect acc. no.); Frel 1969: no. 271; Schmaltz 1970:103, n. 180; Clairmont 1970:169; Kokula 1984:48, n. 36; Vierneisel-Schlörb 1988:41, n. 4; Meyer 1989:62, with n. 79 (with incorrect acc. no.); Pfisterer-Haas 1990:185, pl. 32, 2 (with incorrect acc. no.); Clairmont 1993: Vol. 3, 312–13, cat. no. 3.409; Ridgway Fourth-Century Styles: 169, pl. 41; Bergemann 1997:38, n. 27; 87, n. 190; 89, n. 217; 93, n. 250; 100, n. 36; 101, n. 52, n. 54; 102, n. 74; 107, n. 128; 109, n. 114, n. 218; 115, n. 233; 145, n. 142; 173, no. 552; 214, no. 34; 217, no. 69; pls. 49,3.4; 78,3.4; 100,3.4; 110.1; 110.3.

CONDITION: Stele preserved in two major fragments broken across the upper body of the seated female and across the lower body of the standing male at the right. A large fragment is missing from the lower left corner. Large chips from the upper and side edges, especially the upper left corner, and from the edges of the broken fragments. Surface of the marble is dark pink from its deposition in iron-rich soil.

DESCRIPTION: Large grave stele in the form of a *naiskos* or architectural niche framed by *antae* with low moulded capitals and the roof with roof tiles ending in *antefixes* and an *acroterion* at each corner. On top of the roof are the remains of a bent bronze rod. Within the niche three figures are rendered in relief. At the viewer's left is a mature woman in high relief seated on a stool, clasping the hand of a bearded male to the far right in the traditional gesture of *dexiosis* and looking up at him. Her back and the stool overlap the frame while the back of her head rests against the inside of the frame. She wears a short hairdo with snail curls framing the side of her face. Her eyes are wide open with lids defined by full ridges; her cheeks are sagging and the edges of her mouth downturned. She wears a *chiton* and *himation* over her shoulders with the excess on her lap and falling between her legs and on the front edge of the stool. She wears pointed thick-soled shoes. In the center is a man with a long beard and hair wearing a *taenia* around his head. He is in lower relief, standing in the background with his head in profile looking to his left and his body twisted slightly toward the bearded male to his left. He wears a *himation* over his shoulders and wrapped around his left arm. At the viewer's far right is a man with a short beard and short hair standing with his head and body in three-quarters profile to his right. His *himation* is wrapped around his waist, left shoulder, and over his left arm. His elegantly rendered left hand rests against his upper left thigh.

The sides of the stele are finished with a chisel. Inscribed in shallow irregular letters on the recessed architrave beginning near the left edge is a barely legible inscription in varying sized letters (IG II² 11911):

at left: ΚΡΙΝΥΛΛΑ ΣΤΡΑΤΙΟΥ ΘΥΓΑΤΗΡ
in center: ΝΑΥΚΛΗΣ
 ΝΑΥΚΡΑΤΟΥΣ
 ΛΑΜΠΤΡ[Ε]ΥΣ
at right: ΝΑΥΚΡΑΤΗΣ
 ΝΑΥΚΛΕΟΥΣ
 ΛΑΜΠΤΡ[Ε]ΥΣ

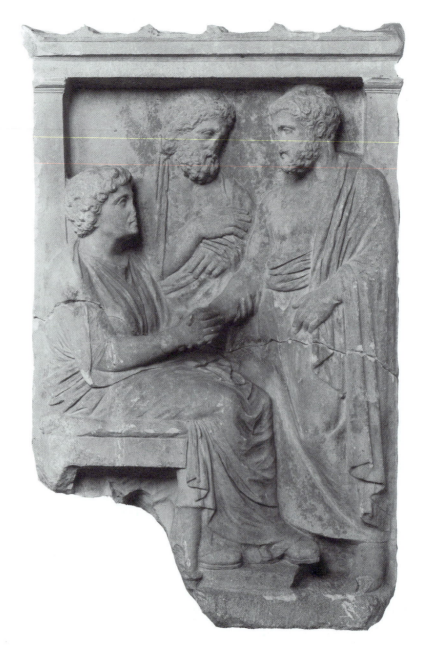

CAT. NO. *22*

Translated, "Krinylla, daughter of Stratios
Naukles, son of Naukrates of Lamptrai
Naukrates, son of Naukles of Lamptrai."

COMMENTARY: Though the inscription is difficult to read and allows for some varying interpretations, the name of the *deme* of Lamptrai is clear, indicating that the burial plot was probably somewhere in that *deme*. The naming of the *demotic* for each male member of the family emphasizes their political and social status as citizens (see Bergemann 1997:142–50 for a discussion of Attic grave monuments of citizens and *metics*).

There are varying interpretations regarding the iden-

tification of the figures. It is agreed that the mature woman seated on the stool at the left, identified by her short hair with snail curls, sagging cheeks, and sloping shoulders, should be Krinylla, the daughter of Stratios. According to Clairmont (1993: Vol. III, 312–13), she is shaking hands with her husband, Naukrates, son of Naukles of the *deme* of Lamptrai, and it is probably Naukrates who is the deceased. In the background between the two figures stands the elderly bearded Naukles, who turns his head to look at his deceased son.

The more acceptable interpretation is that of Ridgway (*Fourth-Century Styles*:169, following Pfisterer-Haas 1990:185 and Meyer 1989:62), who points out that the bearded man with short hair shaking hands should be younger than the bearded long-haired man in the middle,

making the deceased Naukrates the son of the seated Krinylla with her husband, the father of the deceased, looking on. Although three-figure compositions are very common on Attic grave reliefs of the Classical period, there are fewer with this arrangement of the figures (i.e., female, male, male) (Clairmont (1970:169).

The reason so many of these Attic grave relief representations are difficult to interpret stems from the fact that most were almost certainly not made to order. They were probably chosen from pattern books with various figure types or were even readily available in the sculpture workshops in Attica with examples in various figure combinations to which an appropriate personal inscription could be added (for this discussion see Clairmont 1993: Intro. Vol., 66–72; Clairmont 1970:62–64).

23
ATTIC GRAVE RELIEF

63-6-1 (see CD Fig. 9)
Attica, Greece
Roman Imperial, Antonine period, ca. AD 140–150
Pentelic marble with streaks of green mica
P. H. 0.64; P. W. 0.30; Max. Th. 0.09 m.
ACQUISITION: Gift of Joseph V. Noble, 1963.
PUBLICATIONS: Guide to the Etruscan and Roman Worlds 2002:83, fig. 123.

CONDITION: Single fragment of the right side of a relief panel, broken at the top above the head, at the bottom at the ankles of the figure, and down the entire left side. Surface fault running across the stomach of the figure to finished edge and to back; a large surface patch is missing at the right edge on the frame; smaller patches missing beside and below left hand. Small surface gouges. Nose, area of right ear, and left eyebrow broken.

DESCRIPTION: Grave relief with a draped female figure in high relief standing in a frontal pose at the right edge beside a raised frame. Her right arm is bent across the front of her body muffled in her *himation*, while the left is curved down beside her body and partially covered by the *himation*. The figure has her head very slightly turned to her right. The hair is arranged in deep divisions from the forehead and frames the face with wavy scalloped locks. On top of her head is what appears to be a flattened *polos*

or a diadem. Low triangular forehead; sharp ridge for eyebrows; wide-open, almond-shaped asymmetrical eyes with ridges for lids; broad, flattish cheeks; large, slightly parted lips; full, rounded double chin. Thick neck with undulations for throat and flesh. Figure has right hand across chest holding edge of garment; left hand is at her left side grasping edge of garment. Figure stands with her right leg slightly forward and knee bent and is enveloped in drapery: the lower edge of the *chiton* is visible at the bottom of the fragment. The *himation* is wrapped over the back of the figure, with one edge crossed over, hanging down left side of figure with a cylindrical weight or tassel at its bottom edge. The other edge of that *himation* overfold is wrapped around the right wrist as if to form a cuff and falls down beside the left arm in a triangular section. Catenary folds form over the stomach and broad diagonal folds fall over lower body and legs. A tapering pilaster-like frame forms right edge of relief. Side of frame is roughly worked; back is unworked.

COMMENTARY: This funerary monument continues the tradition of Attic grave reliefs of the Classical period. After the decree of 317/16 BC banning luxurious grave monuments, grave reliefs reappear in Athens in the 1st c. BC. This relief belongs to the Early Antonine period, ca. AD 140–150, to judge from the hairstyle with the deep sections of hair and the scalloped contour at the forehead.

The pose of the standing female is copied after the main type of the so-called Small Herculanensis, with the right arm muffled in the *himation* and crossing over the front of the body, a type very commonly used for representations of young women on Attic grave stelai from the 1st to 3rd c. AD (von Mook 1998:65–66; see Trimble 2000: esp. 54–59 for a discussion of replication of the type in imperial Italy; see also **125** for a discussion of the Small Herculanensis).

The *polos*, generally a divine attribute, possibly worn by this mortal woman can be variously interpreted. *Stephanai* (see Clairmont 1993: Vol. VI, 163–64 for list of Attic examples) and *poloi* worn by women on grave reliefs are not without parallel in Attic grave monuments of the Classical period, and are thought to denote the heroizing of the deceased (Friis Johansen 1951:134–35, fig. 68: 5th c. BC Boeotian gravestone to Amphotto). Sometimes the *polos* or diadem, together with other attributes and costume, directly link the deceased to a specific cult, often to the cult of Isis (e.g., Moltesen 2002:113–15, no. 25; von Mook 1998:160, no. 398, pl. 55b). The other possibility is that instead of a *polos* or diadem, the cylinder on the head should be interpreted as a stylized (or unfinished) *turban frisur* or wrap of braids (von Mook 1998:36, female type 11 hairstyle: compare no. 204, pl. 25c where the turban looks very much like a *polos*).

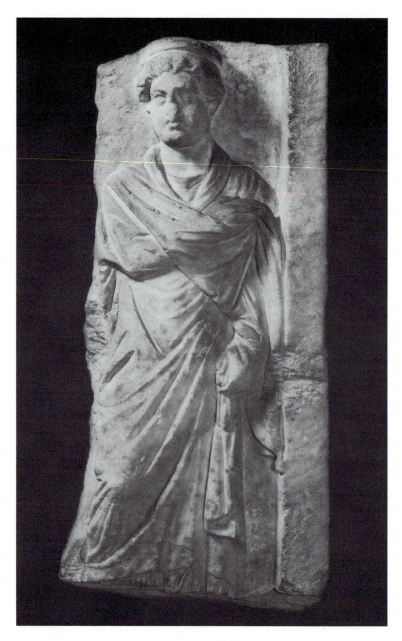

CAT. NO. 23

East Greek Grave Stelai (24-26)

24
EAST GREEK FUNERARY STELE

38-19-1
*Said to have come from the area of Smyrna,
 Asia Minor*
East Greek, 1st c. BC
White marble
P. H. 0.615; W. at break 0.337; W. at bottom
 0.342; Th. 0.06; H. letters ca. 0.013 m.
ACQUISITION: *Collected on the retreat of the
 Greek population from Smyrna in 1920s.
 Gift of Menander T. Constant, May 1938.*
PUBLICATIONS: *Pfuhl and Möbius 1977:152,
 no. 473; Pfuhl and Möbius 1979:393, no.
 473c, pl. 232; Ancient Greek World
 1995:36.*

CONDITION: Upper part missing. Well-
preserved surface except a few nicks and
scratches.

DESCRIPTION: Rectangular grave stele with
two rectangular sunken panels in low relief. The
upper register contains a scene of funerary
banquet with a male figure reclining on a *kline*,
propped on his left elbow on a pillow and
holding a squat jar in his left hand and another
object, perhaps an egg, in his right hand
extended toward a seated, draped female figure,
probably his spouse. In front of the stool in very
low relief is a tiny standing female figure, a
servant girl, in an attitude of mourning with her
left arm across her waist and her right hand to
her head. At the head of the *kline* at the right
edge of the register is a small standing male
figure in a short costume, a servant boy. In front
of the *kline* is an animal-legged tripod table with
two bunches of grapes and two apples and cakes.

 In the bottom relief register at the left is a
standing draped female in an arch. To the left of
the arch is a prancing horse with a rider with a *chlamys*
flying behind moving to the right. Between the upper and
lower registers is a partially illegible inscription:

[ΗΙΠΠ]ΟΔΟΡΟΣ ΜΕΝΑΝΔΡΟΥ ΧΡΗΣΤΕ ΧΑΙΡΕ

CAT. NO. 24

translated "Farewell, worthy Hippodoros(?), son of
Menander."

 Beneath the female in the arch is another inscription,
largely illegible: ...ΩΙΣ

33

COMMENTARY: This is a conventional type of East Greek (i.e., western Asia Minor and the eastern Greek islands) funerary banqueting relief (*totenmahlrelief*) with many parallels (see Pfuhl and Möbius 1979:353–495 and Fabricius 1999 for the latest exhaustive discussion).

This stele, dated to the 1st c. BC, combines three motifs in different registers that are common on East Greek stelai: the funerary banquet, the standing draped female in an arch, and the horse and rider. First, the scene of the funerary banquet in the upper register of a reclining male holding a vessel and a seated female with tripod table and small servant figures is similar to a large group of stelai ranging in date from the second half of the 3rd c. BC to the Early Imperial period: e.g., Pfuhl and Möbius 1977 and 1979: no. 1540 (from near Smyrna, Early Imperial period); no. 1589 (from Samos, end of 2nd c. BC); no. 1597 (from Istanbul; 1st c. AD); no. 1600 (2nd c. BC); no. 1601 (Early Imperial period); no. 1611 (from Odessos, 1st c. BC); no. 1609 (from Karacabey, 1st c. BC); no. 1613 (from Kyzikos, 2nd c. BC or later); no. 1637 (from Byzantion, 2nd c. BC). The cross-legged male servant in front of the head of the *kline* is repeated on many of these East Greek grave stelai (e.g., Pfuhl and Möbius 1977 and 1979: nos. 1597, 1601, 1617, 1619, 1620, 1625, 1626, 1628, 1631, and 1637).

In general, Greek representations of the funerary banquet (*totenmahl*) on votive reliefs can be traced back to the Archaic period, with origins in the Near East and with examples geographically widespread throughout the Greek world (see Thönges-Stringaris 1965 for a catalogue of Greek examples, and Dentzer 1982 for a thorough discussion of the Near Eastern origins of the funerary banquet). There is a shift from the votive use of these reliefs to the funerary in the Hellenistic period, certainly with connotations of the heroization of the deceased, and through the Hellenistic and Roman periods the *totenmahl* motif on East Greek grave reliefs loses its personal associations with the deceased and takes on more general symbolism (Fabricius 1999:21–33, 335–43).

Similarly, the horse and rider, a motif used for centuries in Greece as a reference to a deceased hero, is found often on East Greek stelai, sometimes alone and sometimes with an altar or servants (see Pfuhl and Möbius 1977:310–14; 1979:310–48). The single draped standing female in a frontal pose is also a typical motif on many of these stelai (Pfuhl and Möbius 1977:130–56). The combination of these elements on a single stele suggests a workshop production of stelai that might be suitable for a grave monument of a male or female, needing only the addition of an inscription to identify the deceased, in this case Hippodoros(?), probably the reclining figure. The illegible inscription below the female may suggest that the stele was also used to commemorate a female family member.

25
EAST GREEK GRAVE STELE

MS 4023
Unknown provenience
Greek, Late Hellenistic period–Early Imperial period, 1st c. BC–early 1st c. AD
White marble
P. H. 0.705; W. gable 0.40; W. base 0.47; Max. P. Th. ca. 0.085; H. letters 0.013–0.015 m.
ACQUISITION: *Gift of Mrs. J. Harrison, prior to 1919. Said to have been acquired in Athens. Original Museum accession number painted on top of stele: 15459.*
PUBLICATIONS: *Rambo 1919:153–54, fig. 58; IG II² 12091; Luce 1921:180–81, no. 55; Ancient Greek World 1995:36.*

CONDITION: Intact, except surface fragments missing from around edges, especially bottom corners. Surface of left *acroterion* missing. Some nicks and chips from front. Dark brown discoloration on the background: behind the left arm of the reclining male, on the left arm of the seated female, near small figure on the right, and on the table leg.

DESCRIPTION: Funerary stele with gabled top and flattened palmette-type *acroteria*. In an arched recess flanked by pilasters in shallow relief is a scene of the funerary banquet with an unbearded male wearing a *chiton* and *himation* reclining on a *kline*, leaning on his left elbow supported by a pillow and holding a wreath toward the seated female with his right hand. Seated on a stool at the foot of the *kline* is

CAT. NO. 25

a woman, probably his wife, in an attitude of contemplation with her left hand holding the edge of her *himation* near her shoulder and her right hand in her lap. She is wearing a *chiton* and a *himation* over her head; her feet are resting on a footstool. Behind the stool and at the head of the *kline* are servants, executed in a smaller scale. The one to the right is male, wearing a short *chiton*; the one to the left is female, wearing a *peplos* and carrying a conical vessel. In front of the *kline* is an animal-legged tripod table laden with food.

Inscribed in two lines on the architrave is the Greek inscription:

ΜΕΝΕΜΑΧΕΔΙΦΙΛΟΥ
ΧΡΗΣΤΕ ΧΑΙΡΕ

translated "Worthy Menemachos, son of Diphilos, Fare-
well." The letter forms include a broken bar *alpha*, flattened
oval *phi*, and prominent serifs. The bottom area of the
stele is blank; the bottom surface is roughly finished. The
sides and top of the stele are roughly chiseled.

COMMENTARY: This stele bears a stock motif of the
funerary banquet of which hundreds exist in the East Greek
repertoire from the 3rd–2nd c. BC to Early Imperial times
from sites in western Asia Minor (see above, **24**). The

gabled architectural form of this stele and the motif of the
reclining male figure holding out a wreath (for an exhaus-
tive discussion of the meaning of the wreath see Fabricius
1999:236–48) are very characteristic of a series of stelai
from Byzantion (see Fabricius 1999:225–75, especially pl.
24a,b). Tombstones of this type with an arch framed by
pilasters belong to the 1st c. BC and the early 1st c. AD (e.g.,
Pfuhl and Möbius 1977: no. 420 (1st c. BC), no. 698 (1st
c. BC), no. 956 (Late Hellenistic); Pfuhl and Möbius 1979:
no. 2036 (1st c. BC). The letter forms with the broken bar
alpha and prominent serifs suggest a date as late as the Early
Imperial period. The deceased, Menemachos, is the
reclining male, while the seated female is probably his wife.

26

FRAGMENTARY EAST GREEK GRAVE STELE

38-19-2
Area of Smyrna, Asia Minor
East Greek, Late Hellenistic or Early Imperial period,
 1st c. BC–1st c. AD
Large-grained grayish-white marble
P. H. 0.21; P. W. 0.178; Th. 0.055 m.
ACQUISITION: *Said to have been picked up on the*
 retreat of the Greeks from Smyrna in 1921. Gift
 of Menander T. Constant, May 1938.
PUBLICATIONS: *Unpublished.*

CONDITION: Upper right corner of stele preserved.
Much worn so that features of head and face are indis-
tinguishable.

DESCRIPTION: Grave stele preserving the head and
shoulders of a figure, probably male, wearing a *himation*
draped over the left shoulder and arm, reclining with
the left elbow propped on pillows. The figure holds a
bowl in the left hand at chest height. The right arm
is raised at the shoulder. The stele is framed by a
pilaster at the right and a plain architrave above. No
inscription survives.

COMMENTARY: Like **24** and **25**, this fragmentary
grave stele is an East Greek, Late Hellenistic/Early Impe-
rial type, with a plain architrave framed with pilasters and
with a banqueting scene in a simple rectangular field. For

CAT. NO. 26

parallels for the probable stele type see Pfuhl and Möbius
1979: no. 1985 (probably 1st c. BC), no. 1986 (1st c. BC),
and no. 1996 (Late Hellenistic or Early Imperial).

Hellenistic Divine and Idealized Images (27–34)

27
HEAD OF A GODDESS

30-7-1 (see CD Fig. 10)
Unknown provenience; probably Italy
Late Hellenistic/Late Republican period, ca. 100 BC
White marble
P. H. 0.375; Max. W. head 0.35; H. face from hairline to chin 0.282 m.
ACQUISITION: *Purchased from Spink and Son, 1930. Formerly from the residence of the Hope family, the Deepdene, near Dorking in Surrey, England. B. S. Ridgway (1997:271) points out that after the majority of the Hope Collection was sold off in 1917, the piece was found in the man-made tunnels dug into the hillside behind the residence. Before the Deepdene was purchased by Thomas Hope in 1807, it was the residence of the Howards and the Arundels who were also collectors of ancient sculpture. The most likely owner of the head, however, according to Ridgway (1997:271) and Waywell (1986:62, 93), was Henry Thomas Hope (1808–1862) who purchased much of his collection in Italy.*
PUBLICATIONS: *Dohan 1931:150–51, pls. 4–5; Vermeule 1981:138, no. 107; Waywell 1986:61–62, 93, no. 49, pl. 57.2–3; Introduction to the Collections 1985:36, fig. 16; Ancient Greek World 1995:26; Ridgway 1996; Ridgway 1997; Ridgway Hellenistic Sculpture II:246, pl. 70a–b; Giustozzi 2001:32, n. 67, 34, figs. 53–54; Mattusch 2004:229, fig. 5.98.*

CONDITION: Excellent condition except for wear leaving the surface slightly pitted. Surface scratches on the cheeks, around the mouth. Chips from the back of both ears. Nose is restored in marble from the bridge.

DESCRIPTION: Overlifesized female head in frontal position, tipped downward. Full oval face with a high and broad forehead; well-defined open eyes with thick ridges for lids, the upper overlapping the lower at the outer

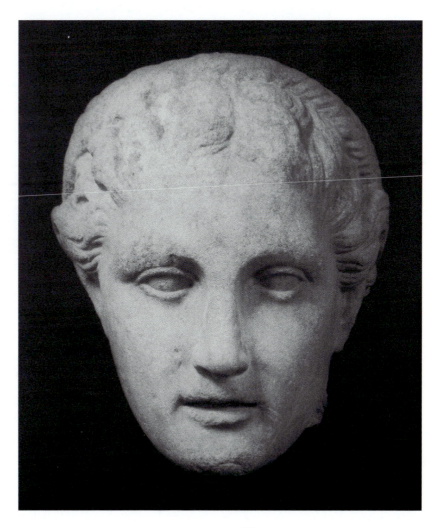

CAT. NO. 27

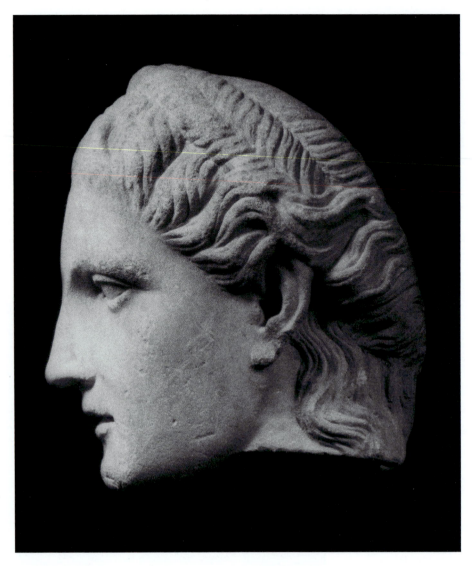

CAT. NO. 27

corners. The bridge of the nose is broad. The mouth is open with the outer edges drilled and the teeth rendered as slight ridges; the upper lip is thin, while the lower lip is more full. The chin is rounded and fleshy with a dimple in the center. Traces of a slight polish to the face.

The hairdo is complex with an off-center central part and the hair brought back from the forehead in wavy sections. Surrounding the crown of the head are two thick braids over which are drawn some of the longer locks behind the ears. Longer locks are rendered on the sides of the neck and in summary fashion on the nape. Deep beneath the chin the surface is roughly cut before a sharp turn to the flattened,

finished bottom surface of the neck. There are two modern drill holes in this bottom surface, one of which is drilled into the center of an ancient square dowel hole with a horizontal channel (pour channel for lead?) leading from it to the back center of the neck. (This is no longer visible because of the modern mounting device but is described in the conservation report of 9/3/92). At this back edge is a rectangular cutting for a horizontal dowel, but it is not clear if this is ancient or more recent. The back of the head behind the braids is hollowed out and not visible from the front view. This hollowed-out cavity has been left in its roughed-out state with large chisel furrows. It measures over 0.20 m.

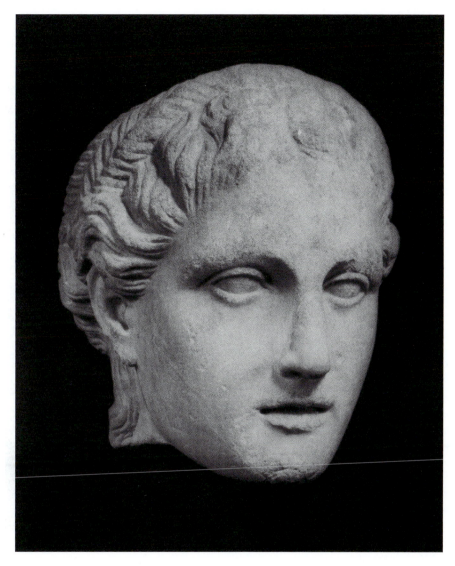

CAT. NO. 27

deep; 0.323 (front to back) x 0.278 m. (side to side), while the smaller cutting toward the bottom is ca. 0.10 x 0.08 m., tapering to 0.065 m. (Ridgway 1997:275, n. 6).

There are marked asymmetries in the head and face, most obvious in the misalignment of the central part of the hair with the nose and mouth and in the treatment of the hair on the sides. Also, the right side of the face is fuller than the left; left ear set is lower than the right; and right eye is more elongated than the left.

COMMENTARY: Ridgway (1996, 1997, and *Hellenistic Sculpture II*:246) has presented convincing evidence for identi-fying this overlifesized head as a Late Hellenistic/Late Republican acrolithic cult image in Classicizing style of around 100 BC, and has included this among the list of cult images made by Greek sculptors for temples on Italian soil. Among the latter group are the acrolithic female head identified as the *Fortuna huiusce diei* from Temple B in the Largo Argentina in Rome, generally dated to the end of the 2nd c. BC (Martin 1987:213–15) and the two acrolithic cult image heads of Diana, one in Copenhagen and the one in the UPM (**44**), from the Sanctuary of Diana at Lake Nemi, both of which belong to this same late 2nd c. BC time frame. We can add to this group another possible cult statue head in Classicizing

style from the Sanctuary of Fortuna Primigenia (P. H. 0.38 m.; Parian marble) dated to the same approximate period (Agnoli 2002:52–55, no. I.5; Martin 1987:234–35).

It is clear from the hollowed out back and the unfinished curls on the back of the neck that the head was only meant to be seen from the frontal view, a point which supports the notion that the head was part of a cult image. The impressive size, static frontality, and Classicizing style also point to its use as a cult image.

There are few clues to the identity of this divinity. Ridgway shows that the bronze head from the Villa of the Papyri at Herculaneum is the single parallel for this specific version of the melon coiffure (twisted strands framing the face, two tightly coiled braids around the head with "wings" of hair rising over the braids on the right and left sides, and with longer locks on the nape) (Ridgway 1997: 272–73; Mattusch 2004:225–30). The combination of the youthful melon coiffure with the longer strands on the neck, a more matronly feature, suggest an identification with a goddess like Hera/Juno, Persephone/Proserpina, or a perhaps a personification, like Fortuna.

One of the more interesting aspects of this piece is its sculptural technique. It seems probable, as Ridgway discusses (1996, 1997, and *Hellenistic Sculpture II*:246), that this head is part of an acrolithic statue in which the marble head was hollowed out to reduce its weight for securing it to a mast or central core, while the drapery portions of the statue would be rendered in a light weight material, such as gilded or painted wood or bronze sheeting (for a discussion of the practice of painting bronze sculpture see Born 2004). The square cutting in the base of the neck was for a vertical support which was probably secured with lead. A rectangular "key-hole" cutting at the center of the back, if ancient, may be for securing the head horizontally to a background. On the Nemi cult statue head in Copenhagen there is also a cutting at the back center edge of the neck for a horizontal bar (W. 0.05; H. 0.02; Depth 0.05 m.) which Guldager Bilde interprets as for

CAT. NO. 27

the attachment of a quiver (Guldager Bilde 1995:197–98, n. 24, fig. 4).

The hollowing out of the back of the head is a feature common to overlifesized cult images of the Republican period, as H. G. Martin has observed (1987:247). The technique of this head is unlike that of the Nemi cult statue head of Diana in the UPM (**44**), though the latter may also have been an acrolithic image. In that case stucco was possibly used to complete the back of the head. Though accomplished in different ways, it appears that there is a necessity in large-scale acrolithic images to reduce the weight of the head when a wooden core is used for the support. For an excellent discussion of the acrolithic technique of the Nemi cult images see Guldager Bilde 1995:191–217, esp. 213–15; for the technique in general see Giustozzi 2001.

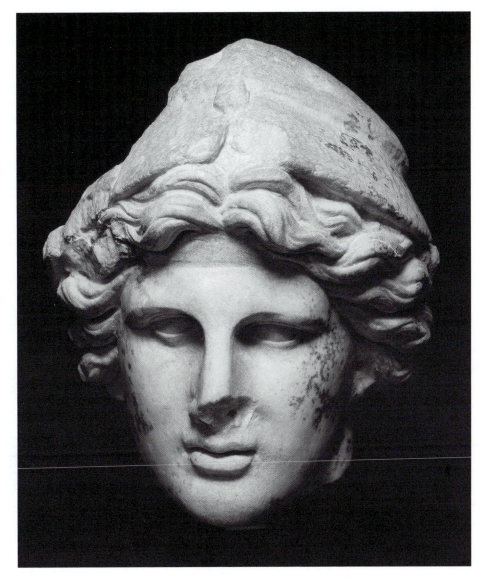

CAT. NO. 28

28
HEAD OF ATHENA

MS 4026
Unknown provenience
Late Hellenistic period, 2nd–1st c. BC
Large-grained white marble
H. 0.30; H. face 0.19; W. 0.24; Th. 0.16 m.
ACQUISITION: *Purchased in Cairo through E. P.*
Warren, with funds from Lucy Wharton Drexel,
November 1901.

PUBLICATIONS: *Furtwängler 1905:260, no. 26; Bates*
1912:101, no. 1; Luce 1921:172, no. 21; The
Classic World 1986:4; Luce 1921:172, no. 21;
Ancient Greek World 1995:21.

CONDITION: Single fragment preserving the head broken
off at the upper neck, preserving a small fragment of the
neck on the left side. Fragments missing from the front,

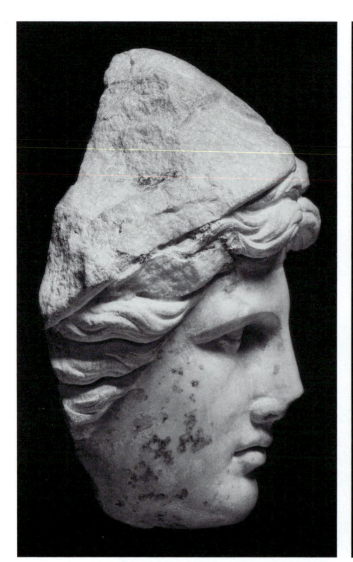
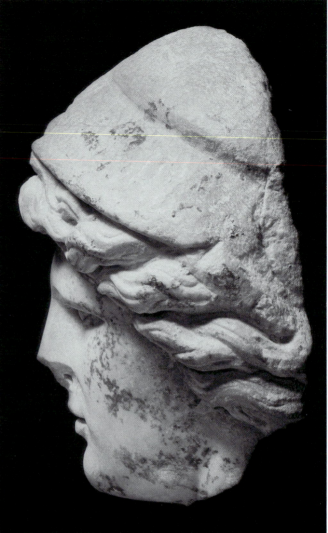

CAT. NO. 28

top, and most of right side of helmet. Surface of lock of hair on right side broken off. End and left side of nose broken off. Dark brown staining on the face, hair, and helmet, especially on left side. Surface damage to upper lip.

DESCRIPTION: Lifesized helmeted head of Athena turned slightly to her right, probably from a relief. Oval face with flat cheeks, swelling below eyes. Deep furrow in forehead. Deeply and closely set eyes, with the right eye larger than the left. Sharply arching brows with swelling eyebrow muscle.

Thickened ridges for eyelids with the upper lid overlapping the lower and a deep depression at the angle of the

overlap. Flat and broad bridge of straight nose with deeply drilled nostrils. The mouth is slightly parted with the upper row of teeth exposed. The lips are thick and curving with the depression of the upper lip off center. Full chin. The face is highly polished. The earlobes are suggested but with no definition.

The hair is arranged in thick wavy locks pulled back from the face with drilled channels separating some of the locks from the face. A Corinthian helmet sits on the top of the head. The surface of the helmet is roughly chiseled and polished as if to suggest hammered metal. The back of the head appears to have been cut off and roughly flat-

CAT. NO. 28

tened. There are two rectangular notches cut into the back, one 0.035 m. square, above the center; the other 0.025–0.053 m. at the approximate center. Two circular modern mounting holes are drilled below the center.

COMMENTARY: The foreshortening of the head and the treatment of the back which looks deliberately cut with two possible ancient holes suggest that the head once was part of a relief. Its size and the theme of the helmeted Athena might indicate that the head was part of a frieze composition for a temple or monumental altar or, less likely for the time period, a pediment.

The parted lips with exposed teeth (see Ridgway *Hellenistic Sculpture III*:200) and flamboyant hair with some drilled channels put this head in the Late Hellenistic period, perhaps the 2nd or 1st c. BC. The somewhat dramatic nature of this piece with the exuberant hair, parted lips, and intense expression are representative of a "Baroque" style of Late Hellenistic sculpture which is best exemplified by the 2nd c. BC Gigantomachy frieze of the Great Altar of Pergamon or the 1st c. sculptures with epic themes like the Sperlonga figures or the Laokoon (for a discussion of the dating of the 1st c. sculptures see Ridgway *Hellenistic Sculpture III*:6–81, 87–90).

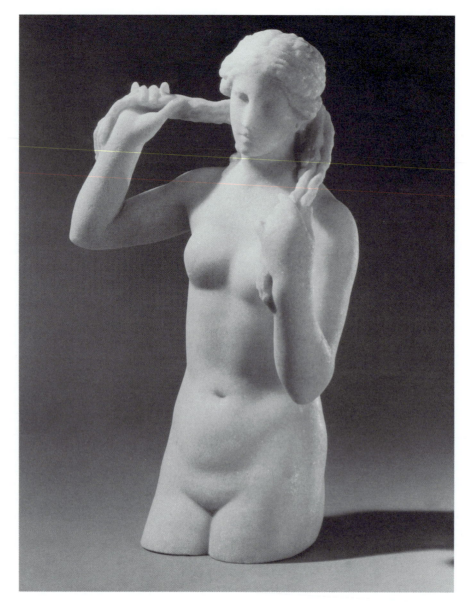

CAT. NO. 29

29
STATUETTE OF APHRODITE
ANADYOMENE ("BENGHAZI VENUS")

69-14-1 *(see CD Fig. 11)*
Probably from Euesperides/Berenike, near Benghazi, Libya
Late Hellenistic period, ca. 2nd–1st c. BC
Large-grained white Parian Lychnites marble (confirmed
by stable isotopic analysis by Dr. Norman Herz,
1996: $\delta^{13}C$ 5.318; $\delta^{18}O$ -2.945)

H. 0.32; L. 0.21; Max. W. 0.135; Max. W. at bottom
0.11 m.
ACQUISITION: Purchased in 1902 from an Arab man
who claimed to have found it in the ruins near Ain es-
Selmani at ancient Berenike by Dr. Jean Perrod, a
medical doctor who practiced in Benghazi and moved

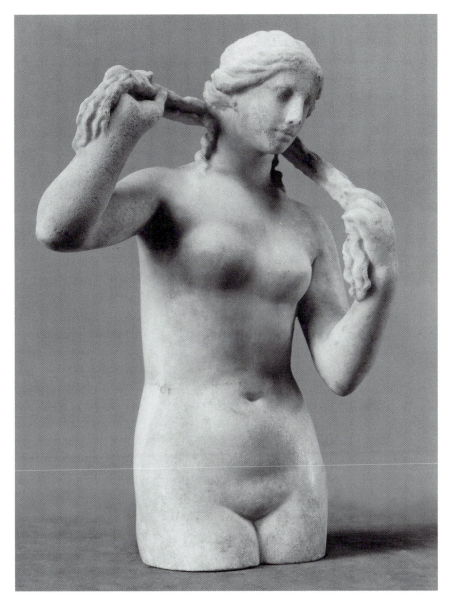

CAT. NO. 29

1907:290, fig. 531a; Reinach 1910:205; Calza 1913; Michon 1913:165; De Mot 1913:157, n. 1; Mariani 1913–1914:15, fig. 6; Mariani 1914:180–81; Ghislanzoni 1915:72–73; Curtius 1925:49; Ghislanzoni 1927a: 164, n. 2; Ghislanzoni 1927b: 115, n. 1–2; Brendel 1930: 52–53, figs. 5–6; Riemann 1940: 117–19, no. 39; Mingazzini 1958:472; Expedition 1, 3, 1959: inside back cover; Winter 1970; Gualandi 1976:112; Brinkerhoff 1978:63, pl. xlviii; Hill 1981:93, fig.1, 16, 17–18; The Pennsylvania Gazette 82, 5, 1984:26; LIMC II, Aphrodite: 77, no. 677; Ancient Greek World 1995:21 and cover; Farrar 1998:109; Quick 2004:117, no. 105; White, forthcoming.

CONDITION: Intact with some minor chips on the hair and on the right shoulder. Some abrasion on the forehead, upper lip, right forearm, left hand and fingers. Some light brown staining on the face and front of torso.

DESCRIPTION: Statuette of Aphrodite Anadyomene, cut off at the upper thighs. The figure is nude with both arms raised, the head is tipped slightly forward, to the left and down. The body is leaning to the left with the weight on her left leg. In each hand she holds a long strand of crinkly hair. The hair is parted in the middle, bound with a fillet, and gathered in a chignon at the nape. One long twisted lock of hair falls from the chignon down each side of the neck and two short locks down the back of the neck. The earlobes are pierced for the addition of earrings, probably in gold. The face is small and narrow with a low forehead, a long pointed nose, barely defined hollows for eyes, a small finely shaped mouth, and rounded chin. Heavy neck with a single roll of flesh. The torso is elongated; the breasts are large and firm and the

to Turin. Sold around 1906–7 to the Italian painter Carlo Chessa in Turin, Italy (Mariani 1914: 180–81). Acquired by Arthur Edwin Bye of Byecroft, Holicong, Pennsylvania, and sold to Mrs. Thomas H. Greist on June 27, 1936. Gift to the Museum of Mr. and Mrs. Beaumont W. Wright, May 1969, in memory of Thomas Haines Greist and Mary Cooper Johnson Greist. Formerly L-262-1.
PUBLICATIONS: Perrot 1906:117–35, pl. 10; Springer

abdomen is full with a horizontal depression for the navel. The fingers are long with fingernails carefully rendered. The back is well modelled. A fine polish is preserved on the statuette. The bottom surface is flat and smooth with one small modern attachment hole and no sign of wear.

COMMENTARY: This Aphrodite statuette almost certainly comes from Euesperides/ Berenike, the Greek settlement near Benghazi on the North African coast in modern Libya. There was at Berenike, according to Strabo (17, 3, 20) and Lucan (IX, 355), a temple to Aphrodite on an island in Lake Tritonis. White (forthcoming) points out the general popularity of the cult of Aphrodite in the North African Pentapolis, and the large number of Aphrodite statues from North African contexts, from Egypt as well as from Cyrene, the largest and most systematically excavated site in the Pentapolis. The cult of Aphrodite held special significance for the Ptolemaic rulers of the region, especially for Berenike II and Arsinoe II, and it was in a temple of Aphrodite Zephyritis in Egypt that Berenike dedicated a lock of her hair, an event that was immortalized by the 3rd c. BC Alexandrian poet Callimachus (*Aetia* 110: *The Lock of Berenike*).

The Aphrodite Anadyomene type represented by this statuette shows the goddess at the moment of her birth rising from the foam of the sea and wringing water from her hair. It is a popular theme in the Hellenistic and Roman periods, and the prototype is often ascribed to a 4th c. BC painting of the birth of Aphrodite by Apelles, supposedly hung in the Asklepieion in Kos (Pliny, *NH*, XXXV.91; Strabo, XIV, 657; Benndorf 1876:50–66; *LIMC* II, Aphrodite: 54).

There are many examples of the Aphrodite Anadyomene type in various media, either completely nude (*LIMC* II, Aphrodite: nos. 424–54) or with a *himation* wrapped around her lower body (*LIMC* II, Aphrodite: nos. 667–87). In the semi-draped version the *himation* is generally wrapped very low on the thighs, knotted in

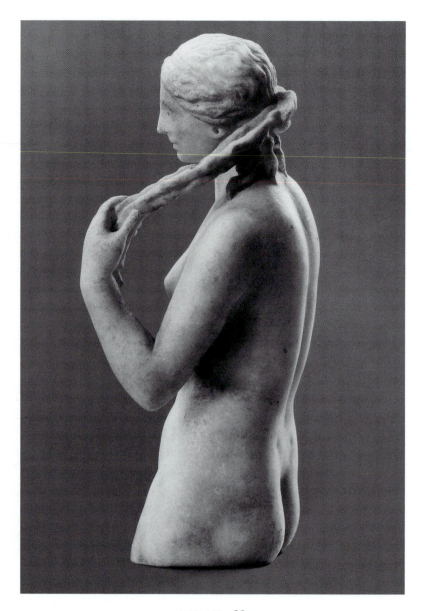

CAT. NO. 29

the front. The garment can be wrapped on an oblique angle as in the statue from Sinuessa in the Museo Nazionale, Naples (Brendel 1930:47, fig. 3; *LIMC* II, Aphrodite: no. 675), dipping in the front, as in the bronze statuette from Horbeit, Egypt, in the Louvre (Brendel 1930:49, fig. 4; *LIMC* II, Aphrodite: no. 682), or arranged nearly horizontally, as in the statuette from Egypt in Copenhagen (*LIMC* II, Aphrodite: no. 672). The semi-draped type seems to be a creation of the Hellenistic

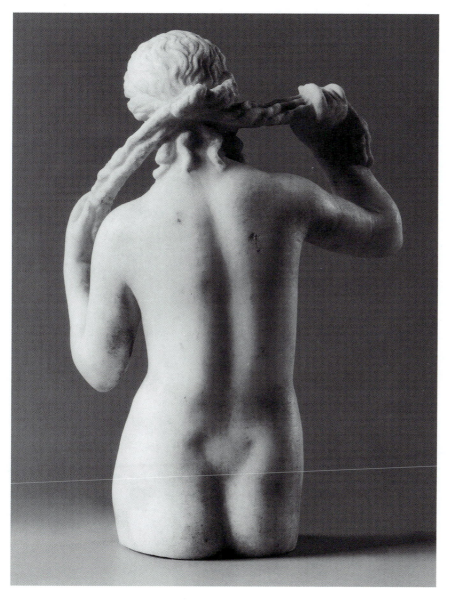

CAT. NO. 29

that the cut at upper thigh level is not ancient, i.e., there is no evidence of modern saw marks. The upper part of the statuette was, therefore, probably made to be keyed into a drapery-covered leg fragment, with no dowel and with the drapery wrapped in a horizontal fashion disguising the join. The lack of a roughened or scored joining surface, typical when adhesives are used, would suggest that the join was made without adhesive and with pressure and a "locking-in" technique.

D. K. Hill (1981) and others (e.g., Brinkerhoff 1978:63) have argued that this "Benghazi Venus" cut off at the upper thighs could have been used effectively in a pool of water so as to appear rising from the sea in imitation of Apelles' painting. Although statues of Venus/Aphrodite were ubiquitous in Roman gardens and many were used as fountain sculptures (see Farrar 1998:108–10), there are several objections to this suggestion. First, the statuette probably belongs not to the Roman period but to the Late Hellenistic period (see discussion below), from which the gardens and sculptural garden ornament are not well studied; second, the piece shows no signs of water damage, even at the lower end, which one might expect if used in a fountain; and third, one would expect a dowel or some kind of attachment device if this relatively small and unstable statuette were to be sitting in a pool of water or in a fountain.

The *sfumato* treatment of the figure, especially the soft rendering of the facial features and the eyes, is a characteristic of some sculpture of the Hellenistic period, and has been especially associated with the sculptural production of Alexandria (Bieber 1961a:89–90), although this has not been demonstrated in any systematic study of Alexandrian sculpture.

period, perhaps of the 3rd c. BC, and is copied widely later in the Hellenistic period and into the Roman period (*LIMC* II, Aphrodite: 76).

In the extensive bibliography on the "Benghazi Venus" the discussion inevitably turns to the reconstruction of the lower half of the figure and the statuette's use. The most probable reconstruction is of a semi-draped Anadyomene type with a separately made leg fragment surrounded by her *himation*. There is no reason to think

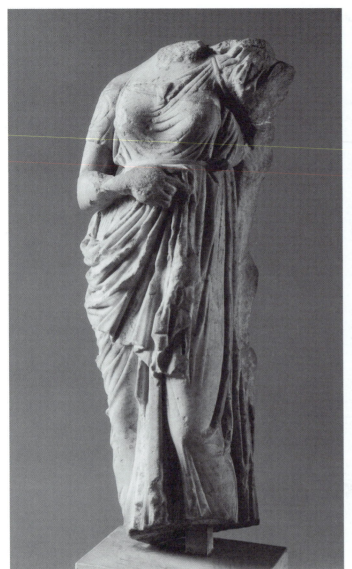

CAT. NO. 30

30
FEMALE STATUETTE: APHRODITE

MS 4025
Unknown provenience
Late Hellenistic or Early Imperial period
White marble
P. H. 0.406; Max. W. 0.15; Max. Depth 0.108 m.
ACQUISITION: *Purchased in Rome in 1901 through E.*
 P. Warren with funds from Lucy Wharton Drexel.

PUBLICATIONS: *Luce 1921:174, no. 31.*

CONDITION: Joined from two fragments, the upper chest
and the rest of the body, preserving the figure from the
lower neck to the ankles. Lacking the head, the lower part
of the drapery, the feet, the left arm, and a support to the
left side. Fragments broken off the right forearm; chip off

CAT. NO. 30

shoulder. The right shoulder is lowered and the left is raised. She wears a short-sleeved belted *chiton* with buttons on the upper right arm. The *chiton* slips off her right shoulder and the neckline describes a broad curve rising to the left shoulder. A cord helps to bind the *chiton* and is looped behind the neck and beneath the arms and around the body above the waist. The breasts are full and widely spaced with catenaries falling between and below. Bunches of cloth are shown beside the breasts, caused by the binding cord. The *himation* covers most of the back of the figure and is draped over the left shoulder where it is probably held up by the missing right hand. The *himation* is folded over at the upper edge, draped diagonally under the right arm at the hips, and caught up by the right hand of the figure. The overfold is treated with deep ridges and valleys at the front, fanning in diagonal folds in the center, and forming poorly executed swallowtail folds at the left edge. The straight right leg is covered by catenary folds and a large bunch of folds is positioned between the legs. On the left side some of the *himation* is falling toward the back where a pillar or some other support was probably positioned. The back of the figure is treated with a series of diagonal folds from the upper left to the lower right. The statue may have been meant to be viewed in the round.

The drill is used rather sloppily in the areas of the left shoulder, beneath the left arm, and beside the right breast. The smoothed patches on the upper right arm and at the lower left side of the figure are not likely to have been for the attachment or repair of separately made pieces. The head and the right arm were made in one piece with the statuette. Through the bottom of the piece is a large dowel hole (0.04 x 0.032 x Depth 0.08 m.) for the attachment to a base. The bottom surface is roughly finished.

COMMENTARY: This voluptuous female with her left arm raised adjusting or holding her *himation* and wearing a *chiton*, bound by a cord, which slips off her right shoulder is an active young goddess like Aphrodite or Artemis. The motif of the *chiton* slipping off the shoulder can be identified as early as the Parthenon sculptures (e.g., the figure of Aphrodite from the east pediment), though it becomes a feature of images of active goddesses like Artemis and especially of draped Aphrodite images of the Classical, Hellenistic, and Roman periods (see *LIMC* II, Aphrodite: nos. 157, 159, 177, 196, 204, 255, 344). Artemis is only rarely shown in a long garment (e.g., in the Colonna type: *LIMC* II, Artemis: nos. 163–68) and is adjusting her garment in the Gabii type, though in reverse pose to our statuette (*LIMC* II, Artemis: no.190).

The motif of the goddess adjusting the *himation* at the shoulder is also well known in Aphrodite images, especially

right breast; many chips on drapery. Projecting areas on front are much worn: right hand, left knee, and drapery overfold in front. Back is much discolored and encrusted. Smoothed patches on outside of right upper arm and lower left side of support, for repairs(?).

DESCRIPTION: Standing draped female in frontal position in contrapposto pose with her weight on the right leg and the left leg bent at the knee and pulled back. She holds her *himation* in her right hand at waist height and raises her left, probably pulling up her *himation* at the

in representations of the so-called Aphrodite "from Fréjus" type (*LIMC* II, Aphrodite: 34–35, nos. 225–40), but in these examples she lifts her mantle with her right hand, while the left breast is bare; the handling of the rest of the drapery is very different from this statuette.

The motif of Aphrodite leaning on a support is also paralleled in several 5th and 4th c. Aphrodite types and variations that are popular in statuettes in the Roman period (e.g., *LIMC* II, Aphrodite: nos. 182–224). The closest of these to this statuette are the variations of the late 5th or early 4th c. BC type known as the Aphrodite from Daphnai, showing the goddess leaning on a pillar or tree at her left side or with an Eros figure on the left shoulder and her *chiton* slipping off her right shoulder (*LIMC* II, Aphrodite: 31–33, nos. 200–21).

This UPM statuette was executed in the Late Hellenistic or Early Imperial periods, echoing this Classical image of the draped Aphrodite from Daphnai.

31

HEAD OF HERAKLES

MS 4031
Said to be from Samsoun, Asia Minor
Greek, Hellenistic period, ca. 300–100 BC
White, medium-grained marble
P. H. 0.185; H. face (top of forehead to chin) 0.105; Max. P. W. 0.132; Max. P. Depth 0.134 m.
ACQUISITION: *Purchased from Paul Arndt with funds from Lucy Wharton Drexel, 1904.*
PUBLICATIONS: *Wakeley and Ridgway 1965:156–60, pls. 43–44; Uhlenbrock 1986:107, pl. 26; Kansteiner 2000:15, n. 99.*

CONDITION: Single fragment of head broken off on a diagonal at the neck. End of nose broken; chips missing from edges of vine leaves; breaks much worn. Dark speckled incrustation, especially on right side; dark orangish-brown stain on right side. Hole drilled through bottom of neck for insertion of modern mounting rod.

DESCRIPTION: Half-lifesized head of a mature, bearded Herakles wearing a vine leaf wreath. Head is tipped down and to the left and is best seen from a three-quarters right view. Short forehead with protruding, knitted brow; deep-sunk almond-shaped, open eyes with thin ridges for eyelids, with muscle overlapping the outer corners. Finely shaped nose

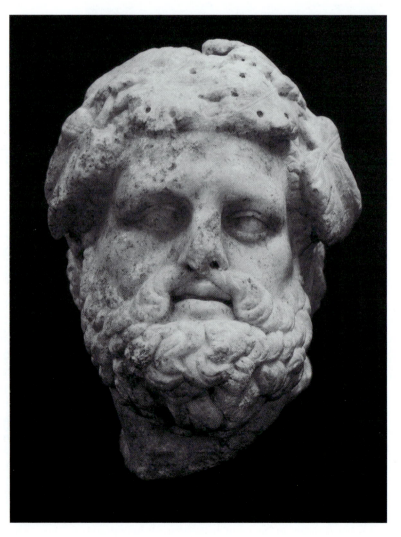

CAT. NO. 31

with small drilled nostrils. High finely shaped cheekbones and small pouch on right side above moustache. Large coiled moustache, drawn up so that upper lip is visible. Full lips are slightly parted, rendered with a fine drilled furrow. Full jutting chin covered with thick curly beard that also covers the sides of the face in individual tufts and the lower chin and upper neck in larger clumps. Small ears with drilled hole for the opening. Hair is visible only between the vine leaf wreath, rendered as small curly tufts, or along left side of brow as incised lines, and on top of the head in stylized, flattened comma-shaped curls radiating from a central point. Small tufts of hair on top of neck in back. Encircling head is fillet with ten vine leaves rendered with scalloped edges and divided by incised lines into lobes; drill holes further define the division of the lobes. Around the back of the head the fillet is wound around in tubular fashion with two long ends hanging down the back of the neck to the right and left. The back is finished in summary fashion, probably not intended to be seen.

COMMENTARY: This is an exceptionally fine Hellenistic sculpture of the mature bearded hero Herakles in a lighter moment, perhaps at rest after a drunken revel. The reference to a Dionysiac orgy is clear in the vine wreath, yet a sense of dignity is preserved in the unemotional face.

A reconstruction of the statue of which this head is a part presents interesting possibilities. It could belong to the wreathed type of the hero standing with the lion skin draped over his lowered left arm, holding his club or a cornucopia

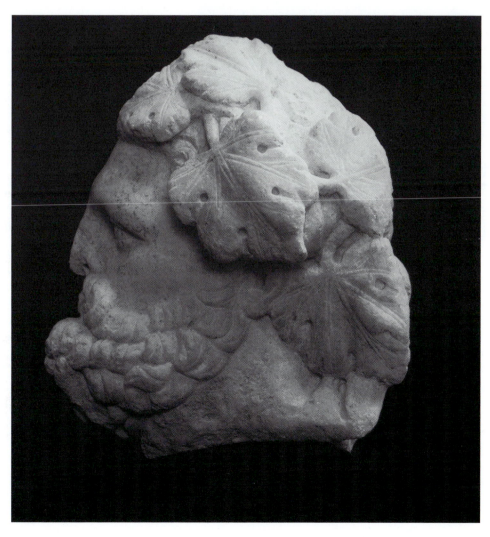

CAT. NO. 31

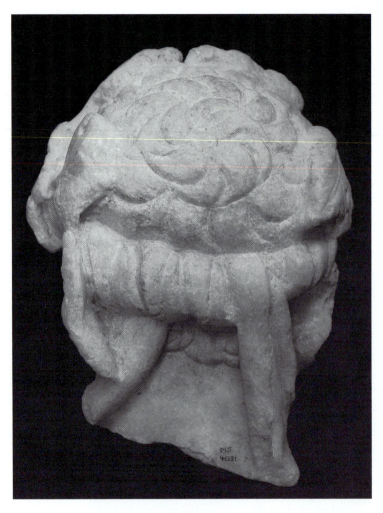

CAT. NO. 31

and turning his head to the left to gaze at the cornucopia, as in the statuette in the Museo Nazionale in Rome (*LIMC* IV, Herakles: no. 574). Wakeley and Ridgway (1965), on the other hand, associate this head with a type, often attributed to Lysippos, of the Herakles in repose who leans on his club to his left and turns his head down and to the left (see *LIMC* IV, Herakles: nos. 666–737; Moreno 1995:103–10 for examples of the type). Wakeley and Ridgway point to the various asymmetries in the head and details of finishing which suggest that the head was meant to be turned and therefore seen from a three-quarters view from the right.

If Ridgway and Wakeley's dating of ca. 300 BC for this head is correct, this would be a very early copy or variant of the Herakles in repose and a rare example in which Herakles wears the wreath. Kansteiner does not accept the dating of the head in the Early Hellenistic period, but rather sees the "heavy" drillwork as a sign of a product of a copier's workshop of the Imperial period. She compares the UPM head to a head of Dionysos in the Museo Chiaramonti, dated to the Flavian period (2000:15, n. 99), but the latter shares none of the subtle modeling or discriminate use of the drill of the Herakles head. A date for the Herakles head in the Hellenistic period seems correct, though perhaps in the Late Hellenistic period.

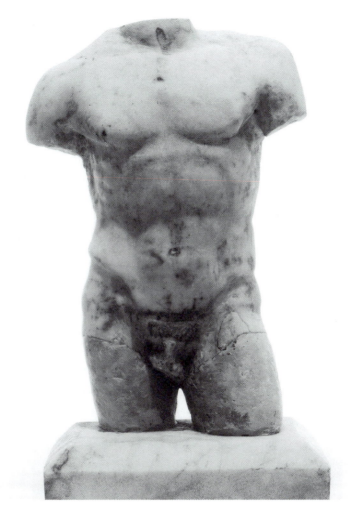

CAT. NO. 32

32
TORSO OF AN IDEAL NUDE MALE

77-2-1
Unknown provenience
*Late Hellenistic or Early Roman Imperial period, ca. 1st
 c. BC–1st c. AD*
*Fine-grained white marble with blue veins, possibly
 Carrara*
Max. P. H. 0.23; Th. 0.08; W. 0.17 m.
ACQUISITION: *Collection of Hans F. Dresel, Philadel-
 phia; then acquired by Mrs. Clara Baumgartner, New
 York. Purchased by the Museum February 16, 1977.*

PUBLICATIONS: Aspects of Ancient Greece 1979:
 156–57, no. 76.

CONDITION: Torso lacking the head, arms from the biceps,
legs from the mid-thighs, and genitalia. The head would
have been separately attached with a small iron dowel,
part of which is still preserved. An additional round dowel
hole in the neck is filled with plaster. The left arm and legs
would also have been separately attached. The right arm is
broken off above the biceps (above the attachment surface)

but was also probably added separately. There are two small round drilled depressions on the sternum and small drill holes at the front of the armpits. Surface erosion with pitting, dark stains especially on the back, some incrustation, and surface scratches.

DESCRIPTION: Small nude male torso from a statuette in frontal position with broad shoulders and slim compact torso. The left leg is slightly advanced and turned out; the right leg is straight. The left shoulder is raised and pulled back slightly, with the left arm probably held away from the body. The right trapezium muscle above the clavicle is bulging as if the right arm was bearing some weight. The musculature is well modelled with firm, well-developed pectorals, prominent epigastric arch, and bulging hip muscles. The pubic area is treated as a raised triangle with a bumpy surface for pubic hair. The back shows little of the careful modeling of the front and is treated in broad planes with a slash for a spinal furrow, some bulges at the hips, and a low buttock.

COMMENTARY: This small nude male torso certainly harkens back to a Greek heroic or ideal type which is often identified with an athletic statue, the Diskophoros ("Discus-bearer") of the 5th c. BC Argive bronze sculptor Polykleitos, or the Diskobolos ("Discus-thrower") by Naukydes, one of his pupils (for discussions of these see Arnold 1969:6–8;110–31; Ridgway 1995:189–90; Bol 1996; Borbein 1996:74–76; Kreikenbom 1990:21–44). Despite the fact that none of their original sculptures survives, the *oeuvre* of the famous Polykleitos and his followers has long been the subject of intense scholarship and is rightly seen as critical to an understanding of Classical Greek sculpture. Only recently, however, has the subject turned to the supposed copies or adaptations of "Polykleitan" works and their function in Hellenistic and Roman contexts (for three different approaches see Maderna 1988:56–116; Pollini 1995; Marvin 1997; Koortbojian 2002:192–94).

If we are to reconstruct this statuette as an adaptation (in mirror pose?) of a "Polykleitan" work, it depicts a resting athlete, preparing to throw the discus with his right hand (though Borbein [1996:74] shows it could also have been a spear), while the left arm seems to be held out

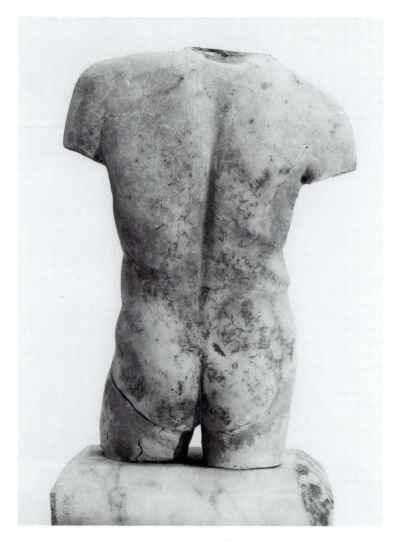

CAT. NO. 32

in a balancing motion and the left leg planted in a forward position. Athlete statues as decorative pieces for Roman villlas is a topic that has been much explored (see, e.g., Warden and Romano 1994:235–40), and it is possible that this small statuette was displayed in a setting with a mirror twin, like the two Lysippan Eros figures from the Sanctuary of Diana at Nemi (**66** and **67**; see also Bartman 1988 for a discussion of the Roman penchant for the display of pendant statues).

The workmanship, especially the joining technique and the small scale, is compatible with that of the statuettes from the Sanctuary of Diana at Lake Nemi (below, pp. 79–81) and probably belongs to the Late Republican/Late Hellenistic period, ca. 1st c. BC–1st c. AD.

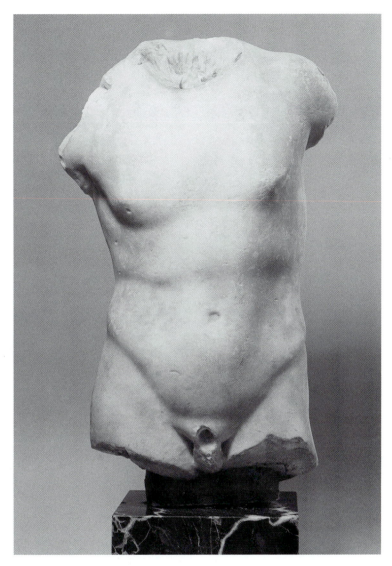

CAT. NO. 33

33
NUDE MALE TORSO

MS 5461 (*see CD Figs. 12–14*)
Said to have come from Athens
Late Hellenistic or Early Roman Imperial period, 1st c.
 BC– 1st c. AD
Fine-grained white marble, possibly Pentelic
P. H. 0.54; P. W. *across shoulders* 0.32; Max. Depth
 0.19; H. *base of neck to pubes* 0.37 m.
ACQUISITION: *Purchased from H. Kevorkian, 1916.*

PUBLICATIONS: *Luce 1916:87–88; Luce 1921:177,*
 no. 47; Bates 1917a:104, fig. 7; Aspects of
 Ancient Greece 1979:186–87, no. 90.

CONDITION: Torso preserving upper arms and upper
thighs; missing head, lower arms, legs, and genitalia. The
head, arms, legs, and penis would have been separately
made and attached in antiquity. Large surface fragments

broken off around right arm join. Surface pitting and scratches on the front and back, especially on left breast and stomach. Large patch of abrasion on outside of right thigh. Some brown surface discoloration on front.

DESCRIPTION: Underlifesized torso of a nude youth in contrapposto with the left leg slightly forward bearing the weight, the body bent at the waist slightly to the right with the right shoulder dipping, the right arm in a downward

position, and the left held away from the body at a 45 degree angle; the head is turned slightly to the left. The features are soft with sloping shoulders, fleshy chest, protruding abdomen with depressed circular navel and prominent groin line. No pubic hair delineated. The back of the torso is well modelled with a broad and deep furrow for the spinal column and a drilled channel for the division of the buttocks.

For the attachment of the head there is a broad oval

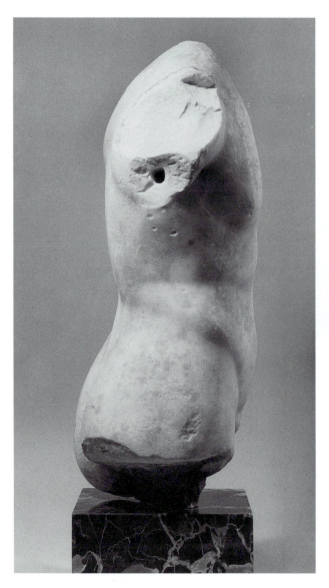 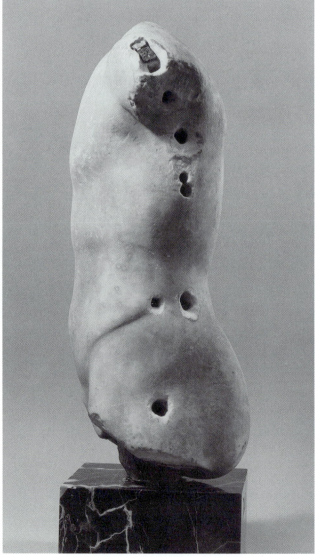

CAT. NO. 33

cavity (W. 0.10; Max. Depth 0.05 m.) with a deeply scored surface and two dowel holes, one round, possibly modern (D. 0.015 m.; Depth 0.09 m.), the other oval (Max. D. 0.028; Depth 0.045 m.) with a fragment of an iron bar preserved. The attachment surfaces for the right and left arms are smoothed and scored with circular dowel holes drilled deeply (D. 0.015; Depth left 0.048; right 0.06 m.). The attachment surfaces for the legs are smoothed and have large, deep square dowel cuttings (right: 0.035 x

0.035; left: 0.03 x 0.03 m.) with deeper circular holes (probably modern) drilled within. The penis was separately attached with a deep cavity (W. 0.02; Depth 0.015 m.) and a small round hole drilled at the center of the cavity. Traces of another round hole below the attachment surface on the testicles. On the outside of the proper left shoulder is a rectangular cutting (L. 0.047; W. 0.02; Depth 0.015 m.) with a circular hole (Diam. 0.015 m.) near the lower end. From armpit of same shoulder to the thigh are a series of five more circular holes and one small square hole of various sizes; the large one towards the back on the hip is probably modern. In one of the circular holes at mid-chest height on the left side placed immediately next to a larger circular hole is an iron dowel. On the back in line with the spine is a square cutting (0.02 x 0.02 x 0.015 m. deep) with a furrow above, probably for a modern mounting device.

COMMENTARY: This young nude male stands with the left leg bearing the weight, his head turned slightly to the left, the right arm down, while the left arm is away from the body in some action that is causing the trapezium muscles on the back to bulge slightly. We could restore an athletic figure (perhaps a Diskophoros or Diskobolos like **32**) or another youthful mortal, or a hero or divinity, like Hermes.

Classical or Classicizing ideal, nude male types, especially of Hermes (Maderna 1988:81–116), are frequently copied and quoted for various purposes to represent divine or heroic figures or for honorific or funerary (Maderna 1988:109–112) portrait statues in the Late Hellenistic and Roman Imperial periods (see discussion above, **32**). It is impossible to be certain of the identification of this figure.

The extensive use of the piecing technique, with a separately attached head, arms, legs, and penis, the elongated proportions, and "soft" body forms suggest a date in the Late Hellenistic or Early Imperial period (cf. the nude boys from Nemi, **59–67**). The series of holes on the left side of this body, some ancient and some modern, indicates a complicated history to this torso, probably with some secondary

CAT. NO. 33

ancient use. The substantial ancient cutting on the outside of the shoulder should be interpreted as a device to attach something to the shoulder, possibly a bunched-up mantle, such as **116**, that would also be consistent with the quotation of a Hermes type. (The ingenious suggestion that the cutting in the left shoulder is for the addition of a cornucopia and that this statue was transformed into a *Genius Populi Romani* seems speculative [*Aspects of Ancient Greece* 1979:186].) In fact, most of the holes along the left side of the body may be interpreted for the attachment of a support such as a tree stump or pillar. The support would have been a later addition to the original statue since the left side is carefully finished and such supports are normally carved in one piece with the body.

CAT. NO. 33

34
STATUETTE OF HERMAPHRODITE

MS 5970
Said to be from Erythrai, Asia Minor
Late Hellenistic or Early Imperial period
White marble
P. H. 0.295; P. W. 0.144; P. Depth 0.085 m.
ACQUISITION: *Purchased by the Museum from Max Ohnefalsch-Richter in 1895. Most of the collection which Ohnefalsch-Richter sold the Museum came from Cyprus (see above, Cypriot Sculpture, pp. 1–7). This statuette, however, was sold as a single item, separate from the Cypriot material, and was shipped from Germany to the Museum. Luce (1921:193, no. 67) records a hermaphrodite statue in his catalogue which is said to have come from Smyrna. The measurements do not match and the description of the figure seated on a rock seems incorrect for this statue, but Reinach (1897:791, no. 8) shows a drawing of this statuette and gives the provenience as Smyrna. In a letter from Ohnefalsch-Richter to Sara Yorke Stevenson (August 19, 1895), he describes "a very fine Hermaphroditos*

from Erytraea" which must be this one. Although there are several classical sites with a similar name (one in Attica, a port in central Greece, and one on the west coast of Turkey), because of the confusion of the provenience with Smyrna, the Asia Minor Erythrai seems very probable.
PUBLICATIONS: *Reinach 1897:791, no. 8; Luce 1921:193, no. 67; Androgyny in Art 1982: no. 3; LIMC V, Hermaphroditos: 275, no. 46.*

CONDITION: Complete except head and neck, left forearm, right leg from just below knee, and left ankle and foot. Bottom of drapery/vertical surface at back is broken off. Surfaces worn. Small chips missing from front edge of drapery and genitalia. Some incrustation on outside of right and left arms and some light brown stains on surfaces.

DESCRIPTION: Statuette of frontal Hermaphrodite wearing a short-sleeved *chiton* and lifting it to reveal the male genitalia with a small erect phallus. The figure leans back

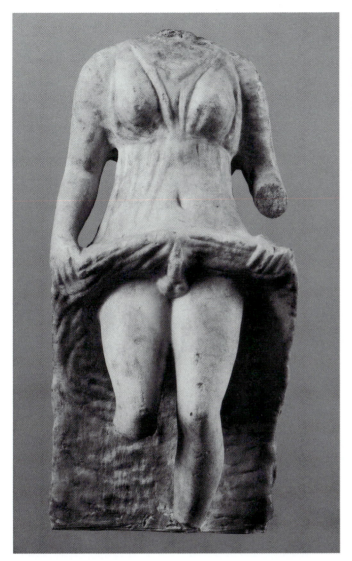
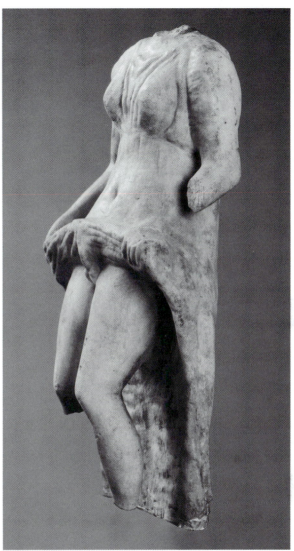

CAT. NO. 34

against the upright surface formed out of the back of the *chiton*. The right and left arms are bent at the elbow and the schematically rendered hands lift the rolled *chiton* at the front. Both knees are bent slightly. The *chiton* forms a deep V between the full female breasts; the short sleeves on the upper arms are rendered with criss-crossing lines; the *chiton* is belted high under the breasts, although no belt is indicated; the folds of the *chiton* in front are rendered as shallow grooves and ridges. The navel is indicated as an indentation. Behind the legs is a curving curtain wall which seems to be the continuation of the back of the *chiton*; the surface is horizontally rippled. The back of the piece is only summarily worked with slight indications of folds on the

upper back; the rest is roughly smoothed with traces of the pick, chisel, and fine claw. The piece was obviously not meant to be viewed from the back. The traces of an iron dowel in the top of the neck suggest that the head was added separately. The missing limbs appear to have been carved in one piece with the statuette and broken off. The front of the piece has been polished, especially the flesh surfaces.

COMMENTARY: The combination of a female in body form and dress with the male genitalia, i.e., the combination of Aphrodite with Hermes, was a deity worshipped as Hermaphrodite in the Greek and Roman worlds from the 4th c. BC through the Roman Imperial period. (For an

analysis of the iconography of Hermaphrodite, see Raehs 1990.) This Hermaphroditos is classed by Ajootian (*LIMC* V, Hermaphroditos: 274–75) as the *anasyromenos* type, i.e., displaying the genitals. In the standard type the figure wears a high-belted *chiton*, either sleeveless or with short sleeves, often a mantle draped over both shoulders or arms, sometimes covering the head, and both breasts are usually draped. The figure raises the skirt of the garment with one or both hands to reveal a small phallus which is often erect (see Ajootian 1997 for an excellent discussion of the type).

The earliest examples of the Hermaphrodite *anasyromenos* type, in stone, bronze, and terracotta, belong to the Hellenistic period (e.g., *LIMC* V, Hermaphroditos: 274, no. 30, a marble relief from Delos), and, in fact, the earliest datable representations of Hermaphrodite can be assigned to the end of the 4th c. BC (*LIMC* V, Hermaphroditos: 283). The dating of this particular statuette is unclear, and the workmanship and the technique of the separately manufactured and joined head could belong to the Late Hellenistic or Early Imperial period.

How the piece might have been used is open to interesting speculation: in a sanctuary of a private shrine dedicated to Hermaphrodite, as a minor dedication in a larger sanctuary (for a discussion of the use of such images as votive offerings in sanctuaries in Greece and Italy see Ajootian 1997:227–29), or as a decorative piece of bric-a-brac, a "conversation piece," in a private home. Ajootian records (*LIMC* V, Hermaphroditos: 283) that appropriate places for images of Hermaphrodite include gymnasia, baths, theaters, and household settings.

Late Hellenistic/Imperial Roman Female Heads (35–41)

35
SMALL FEMALE HEAD: APHRODITE?

65-26-2
Unknown provenience
Late Hellenistic or Imperial Roman
Fine-grained white marble
P. H. 0.082; W. 0.05; P. Th. 0.06 m.
ACQUISITION: *Gift of Mrs. James A. Hays, 1965.*
PUBLICATIONS: *Unpublished.*

CONDITION: Single fragment broken off irregularly at neck, weathered and battered. Front of face and hair chipped off. Chips missing from hair on top and in back.

DESCRIPTION: Small head of female turned to the left. Wavy hair parted in the middle. An incised line indicates a ribbon encircling the head and holding the hair in place. Above the nape of the neck is a bun. At the front above the ribbon, the hair is pulled up to form a broad bowknot behind which is an incised line from which zigzag locks emanate. Suggestion of ears below hairline. Right eye has deep inner corner and incised line for outer angle; swelling of eyebrow. Polish on face and neck.

COMMENTARY: The poor condition of this female head wearing a bowknot hairdo allows little analysis. The hairdo

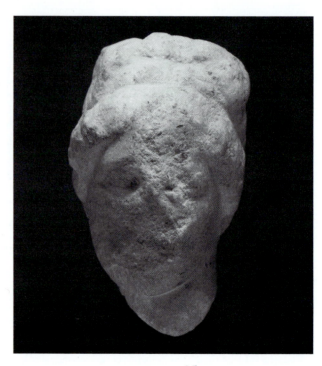

CAT. NO. 35

along with the polish on the face and neck suggest a Late Hellenistic or later date.

36
SMALL FEMALE HEAD: GODDESS

L-64-531
Unknown provenience
Roman Imperial period
White marble
P. H. 0.08; W. 0.05; P. Depth 0.052 m.
ACQUISITION: *Gift of Thomas S. Harrison to Philadelphia Museum of Art, 1908 (08–122). Exchange loan to UPM, 1935.*
PUBLICATIONS: *Unpublished.*

CONDITION: Single fragment preserving head broken off at neck. Hair at nape is broken off. Chip missing from mouth and chin and surface missing from hair to right of part. Much worn and discolored.

DESCRIPTION: Female head from a statuette, with asymmetrical features, tipped to the right. The head is lopsided.

Hair is parted in the center and drawn back in a large roll framing the face and over the top of the ears, with the individual strands defined by chiseled strokes. The hair is gathered in a knot at the nape. On the top of the head is a diadem with the peak off center to the left. The hair behind the diadem on the top and back of the head is summarily rendered with some chiseled strokes. The small face is long and narrow with a short forehead; large shallow eyes, defined on the left by an inscribed oval, the right more modelled; the right eye is set much lower than the left; thin nose, drilled left nostril; fleshy chin and neck with "Venus rings" defined by engraved lines. Raised knobs for earrings or earlobes. Polish on face.

COMMENTARY: This crudely rendered head of a female divinity, identified from the diadem, is a provincial work of the Roman period.

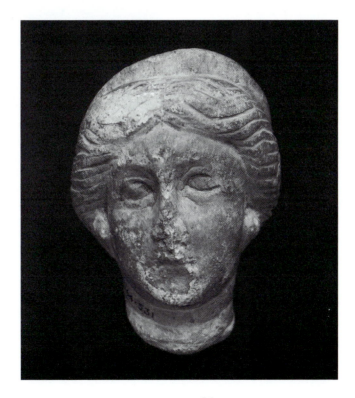

CAT. NO. 36

37

SMALL HEAD FROM STATUETTE: APHRODITE?

MS 5700 (see CD Fig. 15)
Said to be from Rethymnon, Crete
Late Hellenistic–Early Imperial period
White marble with inset eyes
P. H. 0.09; W. 0.07; Depth 0.075 m.
ACQUISITION: *Said to have been found in Rethymnon,*
 Crete, by E. D. Morris. Gift of John Frederick Lewis,
 1924.
PUBLICATIONS: *Unpublished.*

CONDITION: Single fragment broken at the neck. Fragments missing from back of head. Chip from chin. Much worn on top and back of head. Large darkened areas, especially blackened around left eye.

DESCRIPTION: Small head, either male or female, in frontal position with inset carnelian or orangish glass pupils. Hair is divided in the center, pulled away from the face in thickened clumps with deep divisions between, and arranged on top of the head in a bowknot. Drilled hole at the front of the bowknot and drilled depression behind the bow at the right. Top of the head is worn smooth. At the nape of the neck are the remains of a large bun or chignon. The face is rectangular with a low forehead, long, thin nose, large, deep eyesockets with ridges for eyelids, rounded cheeks, small protruding lips with slash between, full, fleshy chin. Face is highly polished, over which are traces of a white groundcoat and pigment which has darkened. Hair at the nape and the back of the neck are joined into one mass.

COMMENTARY: The hairdo, completed with a bun or chignon at the back, could be that of a female divinity such

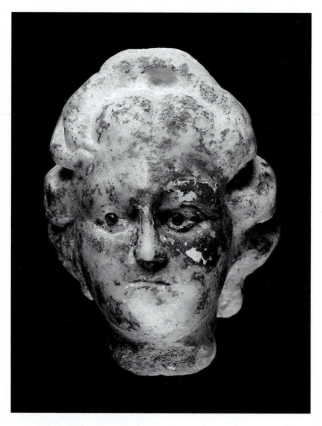

CAT. NO. 37

as Aphrodite, or a god such as Apollo. The hairstyle, the modest use of the drill, and the facial features with the small mouth suggest a date in the Late Hellenistic or Early Imperial period. The inset carnelian or glass eyes are unusual, but paralleled by a marble statuette from Pompeii of Aphrodite with Priapus in which Aphrodite has inlaid red glass paste eyes (Ward-Perkins and Claridge 1978: no. 208).

CAT. NO. 38

38
FEMALE HEAD

L-123-25
Said to have come from Heliopolis (Baalbek), Syria
Late Hellenistic–Roman Imperial period
White marble
P. H. 0.105; W. 0.062; Depth 0.07 m.
ACQUISITION: Gift of Mrs. McCoy to Academy of
 Natural Sciences (no. 29420). Exchange loan
 between Academy of Natural Sciences and the UPM,
 1936; converted to acquisition, 1997.
PUBLICATIONS: *Unpublished.*

CONDITION: Single fragment broken off at the neck diagonally from lower right to upper left. Nose broken, chips missing from lips, right eyebrow, front of hair and back right side of hair. Much worn, some incrustation.

DESCRIPTION: Female head turned slightly to the right. Hairstyle consists of a thickened roll framing face, rising to a peak on the top of the head at the front. A broken off lump appears behind the left ear. Hair on the sides is sketchily rendered with short, sloppy chisel strokes creating peaks and valleys. The back of the bun is left smooth, while the top of the head is roughly rendered. The face is long and narrow with a triangular forehead with flat transition to bridge of nose; asymmetrical large eyes with the left more deeply set than the right; upper eyelids are thickened ridges; no suggestion of a lower lid on the right, while on the left there is a crease; well-shaped mouth with large lips with downward dip of upper lip. Flattened cheeks. Slight polish on the face. Ear on right side is a flattened lobe with no definition; only a small raised area represents

the left ear. Full, fleshy neck. Back of hair melts into thickened neck.

COMMENTARY: The hairdo on this small head from a statuette is similar to that of the Muse with the double pipes on the so-called Mantinea base in the National Museum in Athens, dated ca. 330–320 BC or a little earlier (Ridgway *Hellenistic Sculpture I*: pls. 132a–c; Ridgway *Fourth Century Styles*: 206–9, 230, n. 50), on female figures on Attic grave reliefs of the second half of the 4th c. BC (e.g., Ridgway *Fourth Century Styles*: 160, pl. 34) or of the statue of Themis from Rhamnous by the sculptor Chairestratos of the late 4th or early 3rd c. BC (Ridgway *Hellenistic Sculpture I*:55–57, pl. 31). The workmanship of this head is uneven, however, with a sloppy rendering of the hair and ears, contrasting with the more careful treatment of the face.

The lump behind the right ear might be explained as an attachment strut, suggesting that this head may be part of a relief. On this small scale only a votive relief or funerary relief would seem a possible use. The hairstyle and facial features seem to reflect an Early Hellenistic inspiration for the head, though the workmanship seems to put it in the Late Hellenistic or Roman Imperial period. The possible provenience of Heliopolis would also suggest a Late Hellenistic or Roman date. Since the hairstyle harks back to an earlier Greek model, it is possible that the statuette represents a divine figure such as a Muse.

39
FEMALE HEAD FROM STATUETTE

CG2004-6-1
No provenience
Hellenistic or Roman period
Very large-grained white marble
P. H. 0.062; W. 0.05; Max. D. 0.046 m.
ACQUISITION: *Found in basement June 1999 with no documentation. Number in black ink: 1610 or 1810.*
PUBLICATIONS: *Unpublished.*

CONDITION: Single fragment preserved to the top of the neck, with the back of the head broken off. Nose and chin restored. Surface worn. Gouges on right and left sides of face below ears. Orangish-brown iron(?) stain on break on back of head. Face much blackened. Modern drill hole in base of neck for mounting.

DESCRIPTION: Small female head from a statuette in a frontal or slightly turned position. Hair is parted in the center and drawn to the sides in deeply engraved strands, leaving only the lower part of the ears visible. Long narrow face with a low forehead, open almond-shaped eyes with barely any definition. Small mouth with pursed lips.

COMMENTARY: The lack of documentation and the fragmentary nature of the head make any specific identification or dating impossible.

CAT. NO. 39

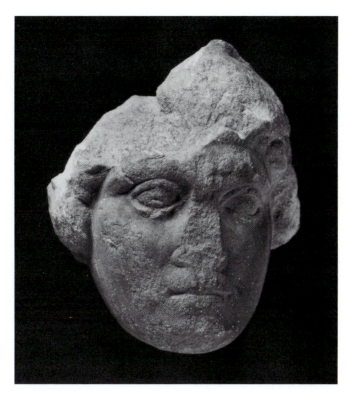

CAT. NO. 40

40
SMALL FEMALE HEAD

MS 5439
Unknown provenience
Late Hellenistic or Roman Imperial period
Fine-grained white marble, patinated yellow on broken
* surfaces.*
P. H. 0.12; P. W. 0.10; P. Th. 0.055 m.
ACQUISITION: Unknown
PUBLICATIONS: Unpublished.

CONDITION: Single fragment preserving front of head including face to below chin and part of hair framing face above and on sides. Nose, surface of lips, and part of chin broken off. Small crack on right pupil. Crack down center of back. Blackened from burning.

DESCRIPTION: Small female relief head wearing some kind of headgear. Hair is pulled back from forehead on the right and left sides in wavy strands. On top of the head is some headgear, possibly a helmet or cap which appears as

a rounded form on the upper left, and with a boss in the center (earflap or ram's horn) on the right upper side of the cheek. Above the left side of the forehead is a small circular feature. Face is broad with widely spaced, wide-open eyes with thickened ridges for lids and convex pupils. Broad nose with wide nostrils. Small horizontal mouth with indentations at outer corners. Full rounded chin. Polish on face.

COMMENTARY: The broad face, slight ridge below chin, and regular edges around jaw line suggest that this head is from a relief. The frontal position may indicate that it is not from a full figure but rather an individual head in relief, like those on a garland sarcophagus (e.g., Østergaard 1996:150–2, no. 65). The polish on the face and the full face with staring eyes suggest a Late Hellenistic or Roman date, and the unpierced eyeballs indicate a probable date before the mid-2nd c. AD. The identity of the female is hard to establish, perhaps Athena, an Amazon, or Medusa.

41
SMALL FEMALE HEAD

50-1-110
Unknown provenience
Late Hellenistic or Roman Imperial period
White marble
P. H. 0.06; P. W. 0.041; P. Depth 0.052 m.
ACQUISITION: *Gift of Mrs. R. Hare Davis, Ithan,*
Pennsylvania, in 1950, from collection of her husband,
R. Hare Davis.

CONDITION: Single fragment preserving head from top to neck. Much battered and worn, with nose and mouth mostly missing, back left side of head broken off, and chip missing from front of hair above right brow. Dark spidery discoloration over surface.

DESCRIPTION: Female head turned to the right and down. Marked asymmetry with left side flattened. Hair is arranged in a roll of locks framing face and continuing around to the back of the head where there is a protrusion. A slight thickening on the back of the neck and on the right side of the neck may indicate the hair continued down the neck. On the left side of the face the hairline forms a scalloped edge; on the right the roll is thicker with more volume and less surface treatment. A flat band may have encircled the head above the roll of hair. On the left a ball earring is visible but no ear is represented. The face is round with a low triangular forehead; the eyes are large and open with pronounced ridges for lids, deep indentation at the inner corners; broad nose; drilled outer corners of the mouth; full left cheek and

CAT. NO. *41*

flattened right cheek; thick neck.

COMMENTARY: The battered condition and lack of provenience for this head allow few conclusions concerning its date or use. The drilled outer corners of the mouth may be an indication of a Late Hellenistic or Roman date, and the pronounced asymmetry of the head may indicate that it was part of a relief, too small for an architectural use but a possible scale for a sarcophagus, votive, or grave relief.

Roman Copies/Adaptations of Greek Works (42–43)

42
HERM HEAD

30-51-1 (see CD Fig. 16)
Unknown provenience
Roman, 1st c. AD or later, after a 5th c. BC Greek work
Fine-grained white marble, probably Pentelic
H. 0.34; Max. W. 0.23; Depth 0.15 m.
ACQUISITION: *Purchased at the sale of the collection of Baron Heyl by Dr. Valentine Müller, 1930.*
PUBLICATIONS: *Dohan 1931:151–53; Ancient Greek World 1995:1.*

CONDITION: Single fragment preserving head broken off in back behind ears and at neck. Several snail curls broken off top and right side. Hair behind ear on right side broken. Upper and lower lip chipped. Some signs of wear on edges and sides of beard. Top surface of nose is broken from bridge to nostrils. Gouges on right eyebrow. Dark root marks on surface. Some incrustation on back.

DESCRIPTION: Lifesized *herm* head with long beard and moustache. Hair is arranged in three rows of spiraling corkscrew curls with protruding centers framing the forehead and sides of face, behind which is a *taenia*. On top of the head the hair is arranged in fine wavy locks radiating from the top. The face is broad with a low flat forehead and swelling high cheekbones. Eyebrow on right swells, while on the left it forms a sharp edge. The eyes are wide open with slightly canted, flattened eyeballs. The eyelids are thickened ridges, the upper lid overlapping the lower at the outer corners; the inner corners are drilled. The nose is broad with drilled, wide nostrils. The mouth is open with a drilled channel separating the thick lips, surrounded by a long handlebar moustache with the ends curling in on the beard. The long beard forms a rectangle, jutting out in front and treated on the upper surface with curly locks in clumps, some with spiral ends. The underside of the beard is flat. The ears are finely executed with deeply drilled channels and centers. Behind the ear on the right side is a thickend section of hair broken off, a small fragment of which appears on the neck below the ear. Thick neck.

COMMENTARY: This head is part of a *herm*, a tradition that goes back to the Archaic period in Attica where *herms* are associated with Hermes as the protector of roads and entrances. This type of the bearded archaizing male head is adapted from a famous *herm*, probably created by Alkamenes ca. 430–410 BC and characterized by the triple row of snail curls framing the face, as is shown by an inscribed Roman copy from Pergamon (see Harrison 1965:108–41 for

CAT. NO. *42*

a summary of Attic *herms*; see also Francis 1998:61–68 who questions that association of the Pergamon head with the inscribed shaft and therefore the assocation of this *herm* type with Alkamenes; and Stewart 2003 who provides evidence for two original *herms* by Alkamenes which the Pergamon [*Herm* A] and Ephesos [*Herm* B] types copy).

It is likely from the way the back of this head broke off or was cut off (though there is no evidence of tool marks on the back) and from the thick neck seen on the right side that it may have been part of a double *herm*. The most typical of these double *herms* combine an older bearded archaizing head such as this one, with a youthful beardless type. Various other combinations of double *herms* are known, however, such as the example from Minturnae of a bearded Herakles and youthful Hermes with wings (see **88**). For examples of *herms* combining the older and younger Hermes types see Giumlia 1983:43–54, cat. nos. 16–45, including the 2nd c. *herms* from the Panathenaic stadium in Athens. See also the discussion of double *herms* in Seiler 1969. The evidence of the careful but deep drill-work (especially on the ears and mouth) and the fact that double *herms* are almost certainly a product of Roman decorative art (Seiler 1969:62) place this head in the 1st c. AD or possibly later.

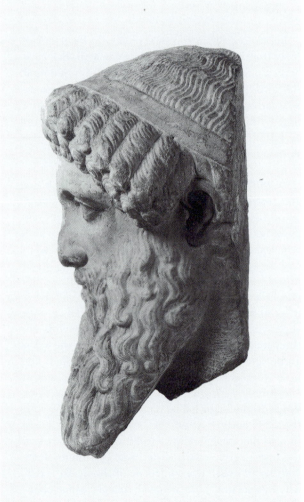

CAT. NO. *42*

43
HEAD OF MENANDER

MS 4028 (*see CD Fig. 2*)
Montecelio, Latium, Italy
Roman Imperial period, late 1st c. BC or early 1st c. AD
 copy of Greek original of early 3rd c. BC
Compact, small-grained white marble
H. 0.345; W. 0.21; Th. 0.27 m.
ACQUISITION: *Found in 1897 in an area of Montecelio (Latium) called "Grottelle" (after a subterranean vaulted room) on the property of the Tuzzi brothers. Acquired by E. P. Warren (Lewes House, Sussex) in Rome in 1897. Bought from Warren by the Museum, with funds from Lucy Wharton Drexel, November 1901.*
PUBLICATIONS: *Mariani 1897:148; Bernoulli 1901:112–13, no. 15; Furtwängler 1905:261, no. 36; Bates 1912:101, no. 5; Hall 1914c:122–24, fig. 68; Studniczka 1918:13, 14, 18, 24, pl. 8, 1 (mistakenly said to be in Boston); MusJ June 1920:44, illustration opposite; Luce 1921:172, no. 22; Lawrence 1927:98, pl. 18b; Crome 1935:69, no. 22, figs. 14, 15; Robinson 1940:471–72, pl. IV; Fay 1959; Richter 1965:233, no. 40, figs. 1608–10; Fittschen 1977:27; Aspects of Ancient Greece 1979:170–71, no. 83; Röwer 1980; Introduction to the Collections 1985:37, fig. 17; Neudecker 1988:171, no. 26.1; Ridgway Hellenistic Sculpture I: pl. 110a; Quick 2004:125, no. 113.*

CONDITION: Large break on left side and back of neck, repaired. Finished edge of neck well preserved on left side; remaining edges chipped or smoothed down. Missing outside edges of both ears, part of left brow, chips from tip of nose; gouge on upper right cheek and over right eyebrow, smaller scratches on face. Faults emanating from neck and chin. Dark patches of incrustation on right side of face, hair and neck. Some of damage to head occurred in 1988 attempted theft: chips and bruises to tip of nose, hair on forehead and above left ear, left side of jaw, and left earlobe. Orangish discoloration on forelocks, forehead, nose, mouth, and chin.

DESCRIPTION: Lifesized male head turned up and slightly to his right with bottom of neck roughly finished for insertion into a bust or statue. Clean-shaven with hair carefully combed in longish locks emanating from back of head sweeping across the back of the head and onto the forehead in an S-curve. Several locks curl in front of the ears and a fringe of locks covers the nape of the neck with thickened locks curling toward the ears. Careful use of the drill in the hair. Closely set, wide open, deeply sunken eyes with rounded eyeballs beneath prominent brow ridge, creases in forehead, cheeks, above ridge of nose, and framing mouth. Closed mouth with carefully drilled corners. Slight cleft in chin, prominent "Adam's apple," and muscular neck. Large circular hole drilled into the base of the neck is for modern mounting device.

COMMENTARY: This distinctive portrait is one of over 60 known marble copies (most of which are collected in Richter 1965:224–36; with additions by Fittschen 1977:25–29) of the Athenian New Comedy poet Menander (342/1–293/2 BC). All of these heads, ranging in date from the 1st c. BC to the 5th c. AD, are presumed to copy the head of an original seated bronze statue of Menander (on this issue see Schultz 2003:189 and n. 27). This original was probably made soon after Menander's death, supposedly by the Greek sculptors Kephisodotos and Timarchos, the sons of Praxiteles, and set up in the Theater of Dionysos in Athens. The portrait was seen by Pausanias in the 2nd c. AD (I. 21,1) and an inscribed base of this statue was found in 1862 in a wall behind the Theater of Dionysos (AE I, 1862: cols. 158, 178, no. 183).

The portrait heads share certain characteristics, especially the turn of the head to the right, the S-curve of the locks of hair on the forehead, deep-set eyes, and the creases in the forehead and cheeks. Discussion of whether this portrait type belongs to Menander or to the poet Virgil or another 1st c. BC notable was on-going in the archaeological literature, especially in the 1950s (e.g., Carpenter 1951; Hafner 1954:93ff; Crome 1952), but the topic seems more or less to have been put to rest by the appearance of a small bronze bust of the late 1st c. BC–1st c. AD in the Getty Museum with the name of the poet inscribed on its base (*Getty Handbook* 1991:35). Ridgway and Pollitt, nevertheless, wisely caution an open-minded approach since this beardless portrait type seems to have been an influential Hellenic model for portraits of Roman men of affairs in the 1st c. BC, such as Virgil, Cicero, and Octavian (the Actium type) (Pollitt 1986:77–78; Ridgway *Hellenistic Sculpture* I:226–27).

This head of Menander was found in a Roman villa at Montecelio, Latium (the information in Hall 1914c:122 that the head was found at Pausola in Marche is incorrect),

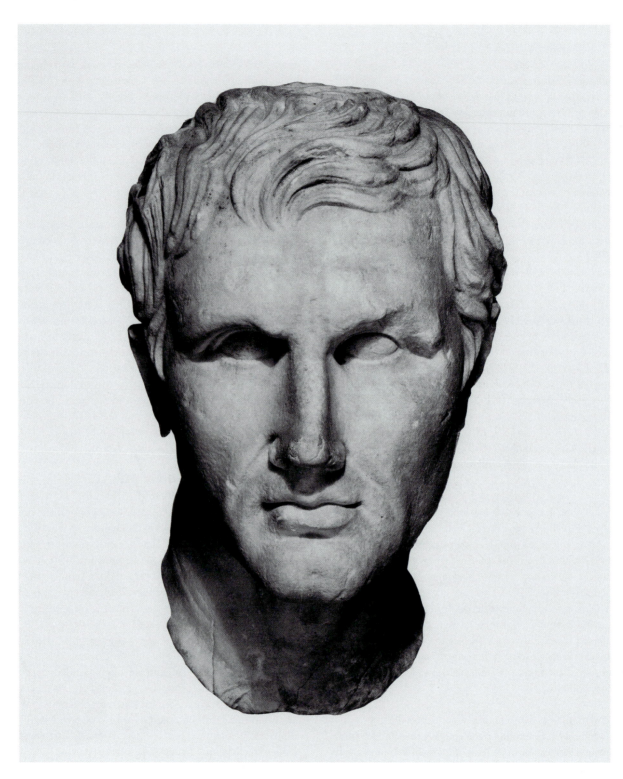

CAT. NO. 43

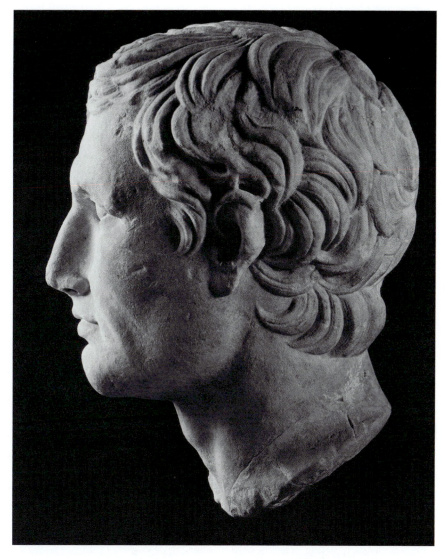

CAT. NO. 43

along with at least ten other marble sculptures, as well as lead pipes, coins, decorative colored marble fragments, and lamps. The sculptures are certainly types suitable for display in a Roman villa garden or portico and include an Eros head, a double *herm*, a satyr head, a torso of Apollo, an archaizing female figure, and a *symplegma* group (Mariani 1897:148–50; Neudecker 1988:170–71).

This portrait head is fashioned as if for the insertion into a body, or more likely, in the villa context, into a *herm*. That a portrait *herm* of Menander is an appropriate subject for a Roman villa in Latium is proven by the discovery in 1887 of a *herm* shaft (H. 1.40; W. 0.34; Th. 0.23 m.) inscribed

Μένανδρος in the area of a Roman villa along the shores of Lake Nemi (in the locality of Santa Maria) (Borsari 1888:26; Richter 1965:226, no. 5). This villa has recently been excavated by the Nordic Institutes in Rome (1998–2002), with final reports forthcoming under the direction of Pia Guldager Bilde of Aarhus University (Guldager Bilde 2005).

This particular portrait should be placed among the earlier of the copies, in the late 1st c. BC or early 1st c. AD, to judge from the careful use of the drill and the higher relief of the locks of hair (Fittschen 1977:27, n. 20: Late Hellenistic or Early Augustan; *Aspects of Ancient Greece* 1979:171: mid-1st c. AD; Röwer 1980: Claudian).

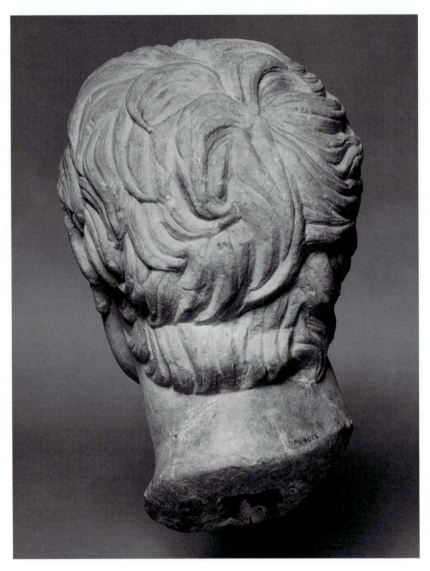

CAT. NO. 43

Sculpture from the Sanctuary of Diana Nemorensis, Lake Nemi (44-82)

Introduction

The corpus of 39 stone sculptures from the Sanctuary of Diana Nemorensis on Lake Nemi, Italy, in the University of Pennsylvania Museum comprises the largest and most significant sculptural collection in the Mediterranean Section. Purchased by the UPM in 1896 from dealers in Italy through Arthur Frothingham and with funds from Lucy Wharton Drexel (see below, pp. 75–77; *Guide to the Etruscan and Roman Worlds* 2002:1–4; Guldager Bilde 1998:36 for discussions of the roles of Frothingham and Drexel in the acquisition of this collection), this was among the first major classical collections to be acquired by the newly founded University Museum, and is still regarded as one of the most important collections of Republican and Early Imperial votive sculpture and cult images from a sanctuary site in central Italy.

The history of the Nemi collection, its discovery and acquisition, and many other topics relating to the Sanctuary of Diana have been thoroughly discussed recently in excellent publications by Pia Guldager Bilde, Mette Moltesen, and others. (Though the bibliography regarding Nemi is extensive, the following represent the major recent works relevant to the sculpture from the Sanctuary of Diana Nemorensis: Guldager Bilde 1995:191–217; Moltesen 1997:211–17; Guldager Bilde 1997a:53–81; *In the Sacred Grove of Diana* 1997; Guldager Bilde 1998:36–47; Bentz 1998/99:185–96; Guldager Bilde 2000:93–109; Moltesen 2000:111–19; Guldager Bilde and Moltesen 2002; Moltesen, Romano, and Herz 2002:101–6.)

Sanctuary of Diana Nemorensis: History, Chronology, and Topography

The Sanctuary of Diana Nemorensis is located on the northern shore of the volcanic Lake Nemi, approximately 25 kilometers southeast of Rome in the Alban Hills in the heart of ancient Latium (see CD Figs. 17, 18). The early history of this sanctuary is murky, but from historical evidence and archaeological finds it is possible to trace the beginnings of worship of Diana on that spot to at least the Archaic period (ca. 500 BC) when it was the site of the federal sanctuary of the Latin towns (see Alföldi 1965:48–56; and for an inscription transcribed by Cato the Elder mentioning this confederation of Latin towns see Priscianus, *Institutionum Grammaticarum* 4, 21. 7,60 = Keil 1855:II 129, 137). The earliest finds indicating temple building activity at the sanctuary are the architectural terracottas of ca. 300 BC (Känel 2000:131–39) and the votive temple models of the same approximate date (Blagg 2000:83–90). Architectural terracottas also confirm subsequent building phases of around the mid-2nd c. BC and ca. 100 BC (Känel 2000:131–39), and small finds and inscriptions also indicate a high level of activity in the sanctuary during the 3rd and 2nd c. BC. The plan of the sanctuary with its vast artificial terraces and retaining walls seems to have been completed in the late 2nd c. BC, though it continued to be an important site in the Early Imperial period with donations of large-scale votive sculptures, e.g., the portraits of Tiberius, Germanicus, and Drusus, now in the Glyptotek in Copenhagen (*In the Sacred Grove of Diana* 1997:138–40), and with major architectural modifications in the Hadrianic period (Ghini 2000:53–64). After the reign of Marcus Aurelius (Ghini 1997b: 179–82, esp. 180), there is no evidence of building activity at the sanctuary, and that combined with the lack of finds indicates that the life of the sanctuary had come to an end towards the later 2nd c. AD, perhaps by some natural disaster.

A general plan of the Sanctuary of Diana was drawn by the architect Pietro Rosa in 1856 showing the terracing of the site, rising up from the lake and defining several of the major zones of the sanctuary (Guldager

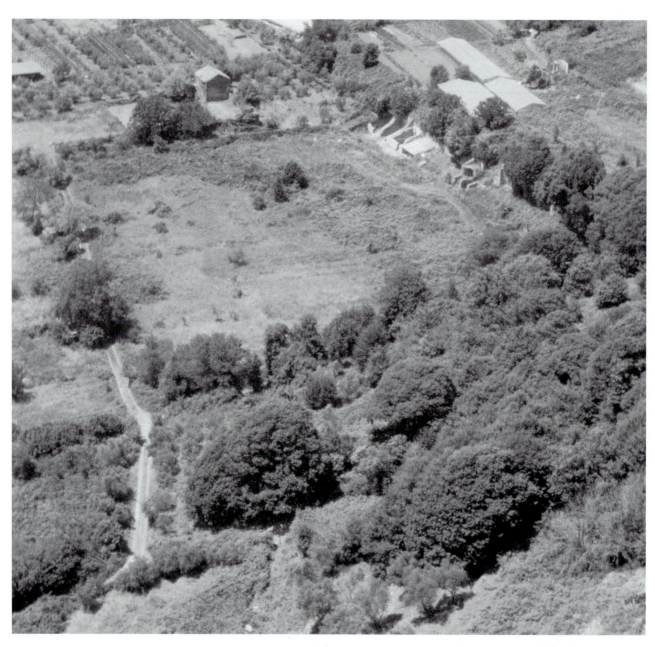

Fig. 3. Sanctuary of Diana Nemorensis, Lake Nemi, Italy. View from the town of Nemi above. Photograph by author.

Bilde 1998:37, fig. 1). At the end of the 19th c. the sanctuary was explored by the amateur archaeologist British ambassador in Rome, Sir John Saville Lumley (1885) and by the Roman art dealers Luigi Boccanera (1886–1888) and Eliseo Borghi (1895–1896), and by Wolfgang Helbig (1891) with licenses from the property owner, Count Filippo Orsini. It was during these explorations that most of the sculpures in the University of Pennsylvania Museum and in the Ny Carlsberg Glyptotek in Copenhagen were recovered.

The main temple terrace included a temple (KKK on the plan of Lord Saville; see Fig. 3 and CD Figs. 18, 19), surrounded on three sides by a substantial arched retaining wall with porticos in front of it. Along the north portico and against the back retaining wall were built a series of small rooms, votive chapels, *exedrae*, and storage rooms, in one of which the bulk of the UPM's Nemi sculptures was found.

From 1924 to 1928 excavations also took place to the west of the main terrace under Lucia Morpurgo (1931) during which a small theater and a bath building were uncovered. Since 1989 the Soprintendenza archeologica per il Lazio, under the direction of Dr. Giuseppina Ghini, has been conducting excavations, cleaning, and restoration in the area of the main terrace bringing much clarity to the architecture of this part of the sanctuary (Ghini 2000:53–64; Gizzi 2000:65–82).

Diana Nemorensis: Myth and Cult

The mythology and worship of Diana Nemorensis held a fascination for both ancient and modern authors. The cult of Diana at Nemi and the strange ancient tradition regarding the succession of the *rex nemorensis*, the priest-king of the sanctuary, serve as the opening of Sir James Frazer's 1890 *opus* on the history of religion, *The Golden Bough*. Ancient sources record that after Orestes and Iphigenia fled the Crimea with the cult image of Artemis Tauropolos, the image was subjected to extensive travels and was set up in various sanctuaries in the eastern Mediterranean, as well as in a sanctuary near Aricia, the town near Lake Nemi that administered the cult of Diana (Servius's 4th c. AD commentary on Virgil's *Aeneid*, VI, 136 and Strabo, 5.3.12). There was a tree in this sanctuary (interpreted sometimes as a mistletoe tree but more likely the evergreen holm oak species) from which it was forbidden to break a bough. Yet, if a runaway slave managed to capture a bough, he won the right to fight a duel to the death with the incumbent *rex nemorensis* and become the next priest-king of Diana's cult.

As we can attest from the sculptural representation from Nemi of Diana wearing her short costume and hunting boots, she was worshipped there as goddess of the hunt in the verdant woods surrounding the lake, but like many Greek divinities in the Roman sphere, Diana's identity was complex. She was associated with Hekate, the goddess of the underworld, and like Hekate was worshipped as *Trivia* ("at the crossroad"), as a triple-bodied figure, and with torches lighting the way to the darker realm (Propertius II.xxxii.9–10; Ovid, *Fast.* III.269–70; Grattius, *Cynegetica* 484). A Roman denarius of 43 BC of Publius Accoleius Lariscolus bears on the reverse three female images in archaizing dress, linked by a yoke or beam at shoulder height, and each holding attributes: a bow, a flower or branch of apples, and a staff or torch. This has been variously interpreted as a representation or a reflection of an archaic or archaizing cult image of Diana from Nemi or as an elaborate Republican period votive in archaistic style dedicated to Diana (see Gradel 1997:200–203; Guldager Bilde 1997b:199–200; Fullerton 1990:15–22).

The many anatomical votives from the site (e.g., *In the Sacred Grove of Diana* 1997: nos. 67–70) and ancient sources (Grattius, *Cynegetica*, 477–96; Servius's commentary on Virgil's *Aeneid* IV. 5. 11) inform us that Diana Nemorensis was also a healing divinity. Ovid (*Fast.* VI. 733–72) and Vergil (*Aeneid* VII.767–9) record that Diana aided Asclepius in restoring Hippolytos to life with healing herbs and incantations after he was dragged to his death behind his chariot. Hippolytos lived his resurrected life as the divine Virbius, a servant to Diana in her sanctuary at Nemi.

Diana's cult seems to have especially attracted female worshippers (Hänninen 2000:45–50). She was also associated with Isis, the Egyptian goddess of childbirth and healing whose cult throughout the Hellenistic and Roman worlds attracted many female worshippers. From treasury lists of the Late Republican period we know that a temple dedicated to Isis existed at Nemi (Ghini 1997a:335–37). The UPM's pygmy and crocodile relief (**74**) may be a remnant of that shrine to Isis.

Acquisition of Nemi Sculpture

In 1896 the UPM's emissary in Rome, Professor Arthur L. Frothingham of the American School (later the American Academy in Rome), negotiated with Roman art dealers for the purchase of the Nemi sculptures. The sculptures arrived at the Museum in 1897

Fig. 4. Sculptures from the Sanctuary of Diana Nemorensis, Lake Nemi, in a storage room in Italy in 1895. From left to right: 55 (head); 50 (body); 66; 68? (head below); 61; 56? (head); 67 (body); 60; MS 4035: cornice fragment; 59; 44; Diana head in Ny Carlsberg Glyptotek (IN 1517). Photograph from UPM Archives, by R. Moscioni.

with an export license from the Department of Antiquities of the Ministry of Public Instruction under Felice Barnabei. (For a thorough discussion of the archival evidence for the purchase of the sculptures see Guldager Bilde and Moltesen 2002:7–10.)

Vying with Frothingham through its emissary in Rome, Wolfgang Helbig, for the acquisition of the substantial Nemi collection was the newly founded Ny Carlsberg Glyptotek in Copenhagen. Thus, the bulk of the Nemi sculptural corpus came to be split between the two institutions, with the Glyptotek acquiring mostly the large-scale imperial portrait statues and *herms*, and the UPM purchasing the smaller Republican-period votive sculptures, along with several major cult image fragments and marble vessels (two of which went to Copenhagen). Savile Lumley's substantial division of the finds from his explorations, including several large sculptures, many architectural and votive terracottas, and coins was given by him to the Castle Museum in Nottingham, England (MacCormick 1983), while those

retained by Count Orsini were put up for sale and dispersed, some now in the Villa Giulia Museum in Rome and others in the Museum of Fine Arts in Boston and elsewhere.

The Nemi sculptures in the UPM were recovered mostly from one of the rooms in the northern portico of the main terrace (see CD Fig. 20). Guldager Bilde fully discusses the complex details of the Nemi sculpture findspots (Guldager Bilde 2000:94–100, esp. 99–100) and points out that the scant records from these 19th c. explorations leave an imprecise picture. It is clear, however, from an anonymous find-list that Guldager Bilde uncovered in the Archivio dello Stato in Rome (EUR) that the majority of the Nemi sculptures in the UPM were recovered in the explorations of Eliseo Borghi in 1895 in the small vaulted room (2.85 m. wide) near the east end of the votive rooms (Guldager Bilde's room 9; Room F on Savile Lumley's plan; see Guldager Bilde 2002:12, fig. 4; see CD Figs. 19, 20). Apparently, Savile Lumley excavated this

room in 1885 but found no sculpture, while in 1895 Borghi dug completely to the back of the room to uncover the sculptures (Borsari 1895:424–31). All eight marble vessels (six in the UPM (**75–80**) and the two in Copenhagen), the large cult statue heads of Diana in Copenhagen (IN 1517) and in the UPM (**44**), and many of the small votive sculptures were found here. A photograph from the UPM archives probably taken in 1895 records a group of these, including the two cult statue heads and many of the small votive statuettes (Fig. 4).

It is unclear exactly why the sculptures were in this small room along the northern portico. The jumble of fragmentary and whole pieces of mixed chronology (Late Republican and Early Imperial periods) and with different functions (votives as well as cult images) suggests that the sculptures were cleared from other places in the sanctuary and that they were not in their primary use context. That this small vaulted room was a storage/treasury room for sanctuary material seems the most likely hypothesis. Other rooms along this northern portico seem to have served a similar function, while still others were used as portrait galleries.

Guldager Bilde (2000:93–109) and Moltesen (2000:111–19) sort out the findspots of the Nemi sculptures in Philadelphia and in Copenhagen, and shed some light on the varying character of some of the rooms. One room at the west end (Guldager Bilde room 1, labeled 'g' on the Savile Lumley plan; see CD Fig. 19) was an exedra containing an overlifesized statue of Tiberius with portraits of his designated successors Germanicus and Drusus, all now in Copenhagen. In this room the sculptures are in their primary context. The adjacent rooms (Guldager Bilde room 2 and 3) contained some of the *herm* shafts that are also now in Copenhagen. In room 4 ('b' on the Savile Lumley plan), probably a storage/treasury room, was found the acrolithic cult statue of Asklepios, now in Nottingham, and other unspecified fragmentary sculpture. The most elaborate of the rooms was Room 5 ('A' on the Savile Lumley plan) with a black-and-white style, inscribed mosaic floor. The construction of this room can be dated to the mid-1st c. BC (Guldager Bilde 2000: 100–101). The most spectacular portrait sculptures were found here: full-sized portraits identified by inscriptions of the freedman and actor Fundilius Doctus and his former patroness, Fundilia Rufa, *herm* portraits, and other portraits of some of the local *nouveaux riches*, all dating to the first half of the 1st c. AD. Moltesen (2000:113) and others have suggested that these sculptures were an elaborate show of gratitude from Fundilius to his former patroness, while at the same time a thank offering to Diana. Although the room was not built to house these sculptures, its later use was clearly as a sort of sculpture gallery of local dignitaries.

An analysis of the construction of the rooms indicates that they were probably built in the second half of the 1st c. BC (Guldager Bilde 2000:100–102; Guldager Bilde and Moltesen 2002:14). It is, of course, not certain that the deposition of the material occurred in a single moment, but the *terminus post quem* for the deposition is given by the date of the latest sculptures that certainly came from room 9, the marble griffin cauldron vessels of the late 1st c. BC or early 1st c. AD (**77–80**).

There are a few major pieces in the UPM's Nemi collection that do not appear on the 1895 daily log

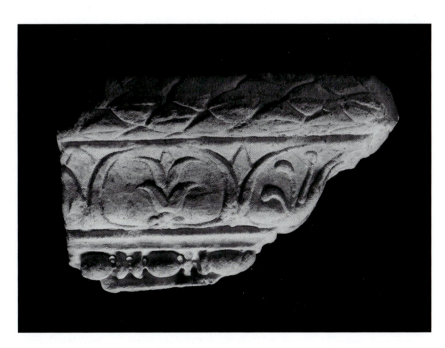

Fig. 5. MS 4035: *Marble cornice fragment, from Sanctuary of Diana Nemorensis, Lake Nemi, Italy, in UPM.*

with the list of objects recovered from room 9: the large satyr with the wineskin (**65**), the Dionysos *herm* (**72**), the plaque of Pan and Dionysos (**73**), and the Nilotic relief (**74**). Because the character of the rest of the Nemi corpus is so consistent and these pieces are all very different and somewhat spectacular by comparison, their provenience needs to be examined. The large satyr (**65**) is a curious and difficult piece that was pieced together from many fragments, possibly found at Nemi and elsewhere. Its attribution to Nemi is certainly questionable. The relief plaque (**73**) was offered to the UPM by A. Barsanti separately from the main group of Nemi objects (sometime after September 30, 1897) with the provenience recorded on the catalogue card as either Lake Nemi or the Villa of Marius at Tivoli. It was catalogued by the Museum with the Nemi sculptures, and it is very likely that its provenience is Nemi, perhaps originally used in the theater where other plaques of this type were excavated by Morpurgo (now in the Palazzo Massimo of the Museo Nazionale alle Terme).

The Nilotic relief (**74**) belongs to the sphere of the Egyptian cult of Isis, for whom there was a shrine at Nemi, or can be attributed to the general interest in Egypt and "Egyptianizing" scenes in the period of the 1st c. BC and 1st c. AD. There is no reason to doubt the Nemi provenience. The Dionysos *herm* (**72**), however, does leave some room for doubt. It is a unique piece and shows signs of some attempts to give it an "antique" appearance. It is possible that the Roman art dealers added this extraordinary *herm*, along with the satyr with the wineskin, to the group of sculptures to attract Frothingham to purchase the lot, although the Dionysiac iconography of both pieces fits well into the *milieu* of the Nemi corpus. Also questionable is the small acid-washed head of a satyr (**70**) which has, at a minimum, been reworked.

In addition to the sculptures included in this catalogue, the UPM also acquired two non-sculptural objects from the Sanctuary of Diana at Lake Nemi: a marble corner architectural revetment fragment (MS 4035, see Fig. 5; Guldager Bilde and Moltesen 2002: 47–48, Cat. no. 43), shown in front of a group of statuettes in the 1895 photograph taken in Italy after the Nemi material was excavated (see also Fig. 4); and a

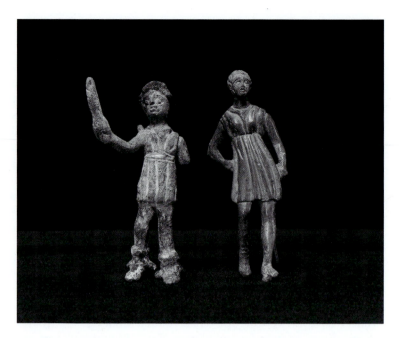

Fig. 6. Bronze figurines of Diana from Nemi in UPM. Left: MS 1619; right: MS 1623.

stone weight (MS 4038; Guldager Bilde and Moltesen 2002:48, Cat. no. 44). Two small bronzes in the Mediterranean Section collection can also be identified as coming from Nemi, and are probably those that are mentioned in the correspondence as having been offered for sale by Alfredo Barsanti in December of 1897, identified only as "small bronzes from Nemi: $60." These are MS 1619, a small bronze figurine of Artemis/Diana wearing a short *chiton*; and MS 1623, a small bronze figurine of Diana holding a torch(?) in her right hand, wearing a short *chiton* and boots, gilding on hair, clothing, and boots (Fig. 6).

Chronology of Sculpture

In general, the UPM's Nemi sculptural corpus presents a consistent chronological picture. The statuettes (with the exception of **65**, the problematic large satyr, and **53**, the head of Aphrodite, which seems to belong to the Early Imperial period) can be dated by style to the late 2nd or 1st c. BC and belong to the world of Late Hellenistic/Late Republican sculptures with their best parallels from Rhodes and Delos (see discussion below pp. 81–83). The cult image fragments (**44** and **45**) can also be placed in this same time frame. The CHIO dedi-

cation of eight marble vessels belongs to the late 1st c. BC or early 1st c. AD, while the relief plaque of Pan and Dionysos (**73**), whose specific findspot is not known, may be the latest sculpture in the corpus and can be dated firmly in the 1st c. AD.

Typology and Function of Sculpture

The UPM's Nemi sculptural corpus also divides rather easily into categories by type, as the ordering of the catalogue suggests, with 2 cult statue fragments of Diana, 13 female votive figures, 14 male votive figures, 2 reliefs, 6 marble vessels, and 2 table supports. Among the females, images of Diana and Aphrodite are identifiable, while among the male statuettes there are two dancing youths, including one probable hermaphrodite (**60**), the problematic standing satyr with wineskin (**65**), one satyr head (**70**) and one bearded Silenos head (**71**), four leaning youths (**61–64**), two Eros figures (**66–67**) (and one probable head of Eros: **68**), and a *herm* of Dionysos (**72**).

An interpretation of the youthful male images from Nemi is one of the intriguing problems presented by this corpus. The dancing youthful males could be satyrs on the basis of their soft physiques and of the parallels for the poses of some of them, though none have tails, the obvious satyr characteristic. The rather effeminate physiognomy of the four leaning youths is similar, and one might think of them all as representing fauns or young satyrs, if it were not for the lack of tails. Guldager Bilde and Moltesen have offered the intriguing and attractive interpretation that these effeminate, young nude male statuettes may be images of Hippolytos/Virbius, the young god who served the cult of Diana at Nemi in his reincarnated state (Guldager Bilde and Moltesen 2002:25; *In the Sacred Grove of Diana* 1997:111, 207, n. 242). In mythology the Greek hero, Hippolytos, was dragged to his death behind his chariot, restored to life by Asclepius to live in the Sanctuary of Diana as Diana's attendant, Virbius (Callimachus fr. 190 Pf.; Vergil, *Aeneid* 7. 765–82). According to the version of the myth told in Ovid (*Met.* 15.533–4, 539, 543–4) the Greek Hippolytos aged when he was transformed to the Latin god Virbius, and there is a possibility that Hippolytos was also depicted in the Roman period as bearded (Guldager Bilde 1995:212–13).

Elizabeth Bartman shows, however, that the phenomenon of "sexy boys," as she calls these androgynous youths, especially in leaning poses, is very wide-spread in Roman art, and that these images of youthful eroticism convey Greek homoerotic sentiments within a Roman world in which homosexual practices were accepted within prescribed social limits (Bartman 2002: esp. 265–71; see also Williams 1999). Artemis/Diana, herself, is a deity of ambiguous sexuality, an active goddess of the primarily male hunt. The presence in the Sanctuary of Diana at Nemi of so many of these "sexy boys," leaning and dancing, and including Eros, challenges the modern scholar to interpret notions of sexuality, femininity versus masculinity, heterosexuality versus bisexuality and homosexuality, but these distinctions may not have been so relevant in antiquity. These androgynous youths may simply have been pleasing ideal Greek images which found suitable places as votives in a public sanctuary in Italy in Late Republican times.

The statuettes seem mostly to have been used in outdoor settings to judge from the signs of weathering on many. The two Eros figures (**66** and **67**) are obvious exceptions among the male figures; their relatively pristine surfaces indicate that they were probably set up indoors or in a protected location. Some of the statuettes show greater wear on the fronts than the backs (e.g., **61**) suggesting that some were set up in niches. The marble vessels (**75–80**) show few signs of serious weathering; this can be attributed either to their protected location or to a possible short life in their original setting before their deposition in room 9. The four pieces whose specific proveniences are in doubt (above, pp. 77–78) stand out as the sculptures whose functions diverge from the rest of the corpus: the large satyr with the wineskin (**65**) which originally may have been used as a fountain device; the relief plaque of Pan and Dionysos (**73**) which may have been used as decoration in the little theater; the Nilotic relief (**74**), a possible decorative piece or from the Isis shrine; and **72**, the *herm* of Dionysos which probably served either as a votive dedication or as a decorative piece in a garden or domestic context.

Manufacturing Techniques and Marble Sources

The most obvious technical characteristic common to the Nemi statuettes is the use of multiple separate pieces, not only separately carved heads, arms, and feet, but also added drapery fragments and separately made upper and lower bodies. (See also Guldager Bilde and Moltesen 2002:15–16.) The joins between these sepa-

rate pieces are consistently secured by circular or, less frequently, rectangular holes with iron dowels or pins, many of which are preserved or leave traces in the dark brown discoloration on the marble. There is no evidence for bronze pins or the use of marble tenons. The joining surfaces are carefully worked, scored with a rasp, chisel, or point; adhesive may have been applied to further secure the join. In the case of one statuette (**49**) the head was set into a shallow cavity with no dowel, probably secured with adhesive. Some smaller pieces were secured with adhesives alone (e.g., the penis of **64**).

The two cult statue fragments were also manufactured in a piecing technique. The head of Diana (**44**) is part of an acrolithic cult statue, in which the parts with bare skin were made of marble while the draped body would have been made of wood, bronze, or stucco. In the case of this cult statue of Diana, stucco probably completed the back of the head and neck, while a wooden core supported the body. The arms and feet would have been of marble, while the drapery would have been made in a lighter material, perhaps sheet bronze or marble veneer, attached to the core. The shoulder fragment belonging to another cult statue of Diana (**45**) had a separately fashioned head set into a deep bowl between the shoulders and secured without a dowel but probably with adhesive. The bare right upper arm with a join for the separately made lower arm and the marble drapery suggests that it was not an acrolithic statue.

There is ample discussion regarding the commonly used Hellenistic sculptural technique of piecing and the rationale for it (see summary in Guldager Bilde 1995:213–15). Economizing on the use of expensive imported marble is the most commonly cited explanation for the technique since it requires smaller pieces of marble and less waste. While in the manufacture of smaller statuettes the technique may have saved costly marble, it would not have reduced manufacturing time or the need for a skilled sculptor. It may, in fact, in many cases have made the process more complicated with the making of dowel holes and dowels, working the joining surfaces, measuring, aligning, and setting the separate pieces, all aimed toward creating a seamless effect. This suggests that the imported marble material was perhaps more expensive than the labor to create the piece of sculpture. Guldager Bilde and Moltesen (2002:16) and Merker (1973:9) also point out that the use of these internal dowels and adhesives strengthened the statuettes, thus requiring fewer unsightly external supports (see a more positive view on struts in

Hollinshead 2002).

Among the Nemi statuettes the use of the piecing technique with internal dowels did not completely eliminate the use of supports. Many of the nude leaning or dancing figures have preserved supports in the form of tree stumps (e.g., **59**, **60**, **65**); others have only the oval or circular trace left on the buttocks or back of the thigh where a similar support would have been carved in one piece with the lower body (e.g., **62** and **66**). One statuette of Diana (**47**) has a substantial support behind the right leg, while two statuettes use pilasters for supports (**52** and **63**). In other examples the support is not preserved but the pose does not seem feasible without a support of some kind (e.g., **61**).

In the course of conservation of the Nemi corpus, attention was paid to possible evidence for preserved painted surfaces. Possible traces were discovered on five sculptures, though further study and analysis of the pigments will be needed to confirm the visual observations, enhanced by examination with ultraviolet light. On the drapery of one of the statuettes of Diana (**46**) traces of the white undercoat survive. On the dancing figure (**60**) there are possible traces of dark pigment over a white groundcoat on the upper torso, on the belt, and on the drapery to the left side of the figure. In addition, a swath of dark reddish-brown running diagonally across the back of the figure from the waist at the right side to the left hip may be a "ghost" of a painted area (a pelt?) or discoloration from an object (pelt?) added in metal. The problematic satyr with the wineskin (**65**) has much pigment preserved: on the hair, eyes, mouth, left hand, pinecones, and wineskin, yet there is a good possibility that these were added by the restorers who concocted the piece. Light orangish-pink paint on the earlobes, face, neck, and hairline of a female head (**53**) has been detected. The "ghost" of dark paint was detected on the iris of the right eye of the Dionysos *herm* (**72**) by Guldager Bilde and Moltesen (2002:39), though it is no longer visible. And, there is dark coloration on the mask of Pan (and on the thyrsos) on the plaque (**73**), which may be the remnants of some painted or treated surfaces, and perhaps a conscious attempt to distinguish the beastly old Pan from the beautiful polished face of the youthful Dionysos.

Stable isotopic analysis of the marbles of the majority of the Nemi sculptures by Dr. Norman Herz, both in the UPM and in Copenhagen, has resulted in a clearer picture of the marble sources and suggests some possible conclusions regarding the local versus

foreign workshops for the sculptures. This topic has been thoroughly discussed by the author with Mette Moltesen and Norman Herz (Moltesen, Romano, Herz 2002) and by Guldager Bilde and Moltesen (2002: 14–15). It is recognized that the technique does not result in unequivocal results, since isotopic "signatures" often overlap with one another and visual inspection along with archaeological and historical information has to be applied to establish the marble identifications. The picture that emerges, however, is that a significant percentage of the young nude male statuettes, of Eros and dancing and leaning figures, were probably made of Parian Lychnites marble (**59–62, 66, 67**). It is possible that these were made in one or two local workshops by sculptors, possibly Greek, working in a technique, style, and iconography well-known in the Greek sphere. The female statuettes present a less consistent picture, with examples of Parian, both of the Lychnites (**46, 50**) and Chorodaki (**49**) variety, of Asia Minor marbles (**47, 52**), and one of Carrara (**51**). The CHIO vessels, with the exception of **76**, are of Carrara marble, whose quarries northwest of Pisa began to be fully exploited in the second half of the 1st c. BC. The two cult statue fragments are made of different marbles, probably Iznik for the head (**44**) and Dokimeion for the shoulder (**45**). Both of the reliefs (**73** and **74**), as well as the Dionysos *herm* (**72**), seem to have been made of Pentelic marble.

Nemi Sculpture in the Context of Late Hellenistic/Late Republican Sculpture

The UPM's sculptural corpus from the Sanctuary of Diana Nemorensis represents an important and instructive group illustrating the artistic trends of the late Republic and very early Empire. In the late 2nd and 1st c. BC, a period when the sanctuary at Nemi is at its peak and from which most of the UPM's Nemi sculptures date, Rome is bringing into its sphere of dominion the Greek kingdoms and exerting its considerable influence on artistic trends, thus creating new markets on the Italian mainland for certain types of Greek sculptural production. The sculptures from the 1st c. BC Mahdia (*Das Wrack* 1994) and Antikythera (Bol 1972) shipwrecks, all of which, it can be argued, were almost certainly headed for the Italian mainland, represent part of this story.

The sculptures from sanctuary sites in Latium like those at Nemi and Praeneste, whose Sanctuary of

Fortuna Primigenia undergoes a major reorganization in the last decades of the 2nd c. BC (Coarelli 1987:35–84; Agnoli 2002:11–21), and from the homes of wealthy Romans at Praeneste and at the villa at Fianello Sabino in northern Latium (Vorster 1998) share common elements pointing to links with the Aegean islands of Rhodes and Delos and with Attica. The cult image fragments from Nemi find comfortable parallels in mainland Greece, as well as in Rome and Latium, suggesting the likelihood of Greek artists working in Italy in the later 2nd and early 1st c. BC, employed to create new marble cult statues for a series of new temples.

The preferred marble for the later 2nd and 1st c. BC statuettes at Nemi is Parian, just as it is on Delos (Jockey 1998:178), Rhodes (Merker 1973:6), and for the Praenestean production (Agnoli 2002:17). Then, in the Nemi sculptures of the later 1st c. BC and the early 1st c. AD the emergence of a new impetus in sculptural styles coincides with the first exploitation of the local Italian marble quarries at Carrara (e.g., the CHIO dedication). The culmination of this transfer of artistic influence from Hellenization to Romanization is documented in the remarkable 1st c. imperial portraits from Nemi in Copenhagen.

Rhodian Connections

Guldager Bilde and Moltesen have already discussed the fact that the closest connections in types, style, technique, and marble for the Nemi statuettes are with sculptures from the island of Rhodes (2002:17–18). The nude male statuettes with elongated proportions, some in exaggerated, mannered poses, and the statuettes of Eros find their closest parallels in the sculptural corpus from Rhodes (Merker 1973:11, esp. nos. 62 and 111; Μαχαίρα 1998:138–40; Gualandi 1976:191–9). The Diana statuette of Artemis Laphria type (e.g., **46**) is also found on Rhodes in great numbers (Merker 1973:27–28; Μαχαίρα 1998:140–1, fig. 7), and an unfinished example from Delos may suggest that this type was manufactured there (see below, p. 82). The Artemis-Hekate statuette type, represented at Nemi in one example (**49**), is found in great numbers (at least 20 examples) on Rhodes around the second half of the 2nd c. BC (Gualandi 1969:233–72). And, statuettes of the leaning Aphrodite of Tiepolo type of which there are two probable examples from Nemi (**51, 52**) are so well documented on Rhodes that they must have enjoyed a local preference (see Gualandi 1976:96–110, nos. 47–61). It

is, of course, not certain that the statuettes at Nemi with Rhodian parallels were made on or imported from Rhodes. The fact that there are several with ties to both Rhodes and Delos may suggest that we would be on safer grounds to talk about a general Aegean *koiné* with several workshops specializing in these small marble statuettes. For the Aphrodite made of Carrara marble (**51**) we must postulate the presence of a Greek sculptor, possibly a Rhodian, working in Italy, creating statuettes that are a Rhodian speciality.

Rhodian connections with other sanctuary sites in Italy have already been pointed out. For example, J. Pedley discusses a group of four marble statuettes from the Santa Venera Sanctuary at Paestum, citing other evidence for the importation of statuettes from Rhodes to Italy in the material from the Artemis Mephitis Sanctuary at Rossano di Vaglio in Lucania (Pedley 1998:199–208, esp. 205; Denti 1992:29–33). At the Lucanian sanctuary the statuettes, including figures of Artemis, a head of Aphrodite, an Eros and a torso of a Hermaphrodite, are thought to have been made on Rhodes or nearby and brought to the sanctuary some time in the 2nd c. BC, some as late as 100 BC.

Closer to the geographical sphere of Nemi is the sculptural corpus from the Sanctuary of Fortuna Primigenia and from the nearby town and villas at Praeneste. Connections have been made between Praenestean sculptural works and Rhodes, with the statuette types of the Nymph on the Rock and the Dancing Muse finding specific parallels on Rhodes (Agnoli 2002:19–21). And, the statuettes from the Villa at Fianello Sabino on the northern border of Latium show strong ties to the sculptural output of Rhodes, as well as of Delos. While none of the types are specific parallels for the Nemi statuettes, the statuette of Artemis of the hunt is a generic type which would fit well into the corpus at Nemi (**46, 47**) (Vorster 1998:37–8, fig. 21, pls. 20–21).

Delian Connections

The role of Delos as a commercial center for the dispersal of Late Hellenistic sculptures of a modest scale, mostly made of Parian marble, and of certain types has recently been given careful attention by P. Jockey (1995:87–93; 1998:177–84; 2000). J. Marcadé previously discussed these marble workshops and emphasized the important role of the community of Italians on the island (1969:102–15, 307–54). Limited epigraphical evidence regarding the Hellenistic marble sculptors on Delos tells us that these are not "Delian" sculptors but rather Greek artists from Ephesos, Paros, and Athens mostly living and working on the island (Jockey 1998:178; Marcadé 1957).

Excavations on Delos have revealed strong evidence for local sculptural activity with more than 160 unfinished marble sculptures, including some of colossal size as well as statuettes; most were found in the sanctuary, while some are from the living quarters, and the production generally dates between 166, when Delos becomes a free commercial port, and the early 1st c. BC before the disasters of 88 and 69 BC (Jockey 1998:179). The large number of unfinished sculptures found in the Agora of the Italians suggests that there was some commercial activity on the island relating to the market in Italy in the 2nd and 1st c. BC. In the Agora of the Italians, built around 120 BC, two sculptors' workrooms were excavated revealing 30 unfinished works, and a thick layer of marble dust and chips (Jockey 1998:179). Activity here can be precisely dated to ca. 100–80 BC (see also Jockey 1995:89–90), the time frame of the large number of Nemi statuettes.

There is no particular thematic unity to the Delian products but they include pieces of furniture such as table supports, statuettes, a funerary stele of Isis Pelagia, a minature copy of the Herakles Farnese, and a fragmentary pieced statuette of Artemis, most of which Jockey characterizes as garden decoration. From the workshop of the Stoa of Philip there are multiple unfinished copies of three Aphrodite types in various stages of the production process, and these same types are also found in the houses on Delos (Jockey 1998:180–82; 2000). Only two of the unfinished Delian products can be specifically identified in the Nemi corpus: the small knotty club table support type (**81**) which finds its closest parallel in the Delian marble workshop at the southwest corner of the Agora of the Italians (Deonna 1938:53–54, no. 3894, pl. 171; Jockey 1998:179) and the statuette of Diana of Artemis Laphria type (**46**). An unfinished example of the latter comes from the House of Kerdon (*LIMC* II, Artemis: 641, no. 195), suggesting that the type was made on Delos. The leaning Aphrodite of Carrara marble (**51**) also finds comfortable parallels on Delos, as well as on Rhodes and elsewhere in Italy, indicating that Nemi is within the same artistic sphere of influence as the Aegean islands in the later 2nd and 1st c. BC.

The modest size of the Nemi statuettes and the piecing technique are also shared by the Delian production. A composite technique is used in some of these Delian statuettes, i.e., piecing together in marbles with different physical characteristics, sometimes called

"pseudo-acrolithic" (Jockey 1998:182–83; Jockey 1999:305–13). On Delos a fine white marble and a blue-gray variety are combined in eight statues using the technique Jockey calls "straddling," in which details of drapery are carved on the nude parts to disguise the joins; examples of this are also present on Kos. Although there are examples of the "pseudo-acrolithic" technique in the sculptures from Nemi (e.g., **50**), the "straddling" technique is not used.

Other Greek Connections

We know that Attic sculptors of the Hellenistic period were active outside of Attica, in the Peloponnesos, on Delos, on Rhodes, in Pergamon, in Rome, and elsewhere (see Ridgway *Hellenistic Sculpture II*:246–47 for discussion and references). For connections between Attica and Nemi, sculptures made of the marble from Mt. Pentelikon provide some evidence, though the source of the marble does not always indicate the origins of the sculptors or the location of the workshop. In the case of "Neo-Attic" sculpture of the late 1st c. BC and 1st c. AD, however, Pentelic marble is the preferred material. The decorative relief plaque of Pan and Dionysos (**73**) and the Dionysos *herm* (**72**), both of Pentelic marble, stand out in the Nemi corpus as eclectic works whose Classicizing tendencies invite parallels with "Neo-Attic" works of the Late Hellenistic and Early Imperial period. The Nilotic relief with pygmies and crocodiles of Pentelic marble (**74**), on the other hand, seems to bear no relationship to "Neo-Attic" works and is thematically part of a general interest in "Egyptianizing" art in Italy following the annexation of Egypt after 30 BC, with Delos possibly playing some intermediary role in trade between Alexandrian Egypt and Italy.

For the cult image fragments of Classicizing style (**44**, **45**) the Greek connections are unmistakable. While the cult statue head of Diana from Nemi in Copenhagen (see Fig. 4, far right) is probably made of Parian Lychnites marble, the Philadelphia cult image head of Diana (**44**) is made of a coarse-grained marble, probably from Iznik in Asia Minor, and the shoulder fragment is also of an Asia Minor marble, probably from Dokimeion (Moltesen, Romano, and Herz 2002:102 and 106). The parallels for these cult image fragments, most of them acrolithic in technique, include images in Greece itself (e.g., at Lykosoura, Athens, and Aigeira in the Peloponnesos; for a summary see Ridgway *Hellenistic Sculpture II*:232–42), as well as in Rome at the Largo Argentina and in the region of Latium, at Nemi and Praeneste, and elsewhere in Italy (Agnoli 2002:52–55 and see also Martin 1987: esp. 195–204 and Giustozzi 2001).

Conclusions

J. Pedley (1998:206) makes the bold statement that "most practitioners of sculpture in Italy itself in the 1st c. BC were of Greek origin,…" Certainly there is evidence for Greek sculptors working within the burgeoning Roman economic market in Italy, using marbles, themes, and styles familiar to them. There is also ample evidence, from Delos, for example, of local island workshops whose smaller sculptural production was exported to Italian sanctuaries and villas. For the Nemi statuettes with Rhodian connections, it is probable that some were made on Rhodes and exported to Italy (see Guldager Bilde and Moltesen 2002:18), while at least one was made in Italy of the local marble (**51**). For the works with Attic connections, the decorative relief plaque and the Dionysos *herm*, these were probably made by Attic sculptors working either in Greece or in Italy. The cult image fragments were likely to have been special commissions, created for a specific temple location, manufactured in Italy by Greek artists using the island and Asia Minor marbles available to them, and working in a purely Hellenistic style. The only items in the UPM's Nemi corpus that we can be certain were made on Italian soil are the ones made of Carrara marble: the Aphrodite statuette (**51**), the CHIO dedication (**75–80**), and the lower part of the large satyr with the wineskin (**65**), a pastiche of questionable Nemi provenience.

Cult Statue Fragments (44–45)

44
OVERLIFESIZED ACROLITHIC FEMALE HEAD: DIANA(?)

MS 3483 (see CD Fig. 21; see also Fig. 4)
Sanctuary of Diana Nemorensis, Lake Nemi, Italy (see Introduction, pp. 73 ff.)
Late Republican period, second half of the 2nd c. BC
Coarse-grained white marble with a warm honey patina. Sample taken for stable isotopic analysis, March 24, 1999, from back of head. Results from Dr. Norman Herz, University of Georgia: $\delta^{13}C$ *4.268;* $\delta^{18}O$ *-7.775: Asia Minor marble (Sardis or Iznik). Guldager Bilde and Moltesen 2002:20: "Autopsy suggests it is Parian, whereas isotopic analysis gives Asia Minor (Iznik)."*
P. H. 0.447; H. hairline to chin 0.22; Max. W. head 0.285; W. at neck 0.17; P. Depth nose to back of head 0.21 m.
PUBLICATIONS: *Luce 1921:189, no. 24; Guldager Bilde 1995:191–217, esp. 202–5; In the Sacred Grove of Diana 1997:90, figs. 60–61; Guldager Bilde 1998:42, Fig. 5; Ridgway Hellenistic Sculpture II: 245; Moltesen, Romano, and Herz 2002:102, 105; Guldager Bilde 2000:100; Guldager Bilde and Moltesen 2002:20–21, Cat. no. 1, figs. 6–9; Guide to the Etruscan and Roman Worlds 2002:54, fig. 80.*

CONDITION: Single piece preserving the front half of the head and neck. Back of head would have been separately fashioned and attached. Right side of neck is broken on a diagonal, though one area preserves an ancient diagonal cut. Surface chips missing from nose, left side of chin, right side of upper lip, and to the left of the corner of the mouth. Dark reddish orange surface discoloration, especially over the right side of the face, the area of the right eye, on the left side of the neck, and on left side of hair; a fine line of orange discoloration on the left side of the chin. Some white incrustation, especially on forehead and bridge of nose.

DESCRIPTION: Overlifesized head of female deity, probably Diana, in a frontal position, though with marked asymmetries. In profile view the head is very flat. The hair is parted just off-center to the left and wavy locks are drawn to the sides over the top half of the ears and towards the nape of the neck. The forehead forms a low, broad triangle; brow ridge is a sharp ridge with a slight bulge beneath. The small eyes are deeply set, the right set slightly higher than the left, and wide open with thick ridges for lids, the top lid overlapping the bottom slightly at the outer corners; eyeballs slant slightly in from top to bottom. The straight nose has a broad bridge and flaring nostrils which are drilled; the mouth is open with the front teeth indicated; the upper lip is thin forming a "Cupid's bow," while the lower lip is thicker with only a slight indentation in the middle; the outer corners of the mouth are deeply indented with a flat chisel. The chin is rounded and jutting with a pronounced dimple in the center and a deep double chin. The planes of the cheeks are broad and flat. The ears are set low with the bottom of the ear level with the bottom of the lower lip; the interior of the ears is drilled out, especially crudely done on the right ear. Above the left ear a drill hole remains at the hairline; above the right ear is a drill furrow along the hairline. The neck is broad and deep with pronounced Venus rings of flesh on the front. The angle of the neck to the shoulder is approximately 100 degrees and there is a slight ridge indicating a collarbone on the left side. On the right side the neck and bust seem to have been cut off on a diagonal, possibly indicating the line of the drapery in another material.

The face and neck are polished. On top of the head behind the hair to the right and left of the central part is a recessed area (P. W. 0.02–0.03 m.), partially worked with a claw chisel and a point, possibly for the addition of a diadem in another material (bronze?) and/or for the joining of the stucco back. Behind that the crown of the head slopes down slightly and is left roughly worked. At the back of the piece in the center of the upper surface is a large and deep vertical round dowel hole (D. 0.023; Depth 0.093 m.) with a "keyhole" opening on the back to a depth of ca. 0.05 m., possibly for the attachment of some kind of head piece (a crown? or a veil?). The back of the piece has a broad, flattened surface sloping slightly out from top to bottom and worked with a claw chisel. At the approximate height of the middle of the neck the piece is cut in at approximately 100 degrees and is treated with a large chisel. On the left side of the bottom, surface is finished with a broad claw chisel in a band approximately 0.025–0.03 m. in width, behind which the rough chisel work continues. On

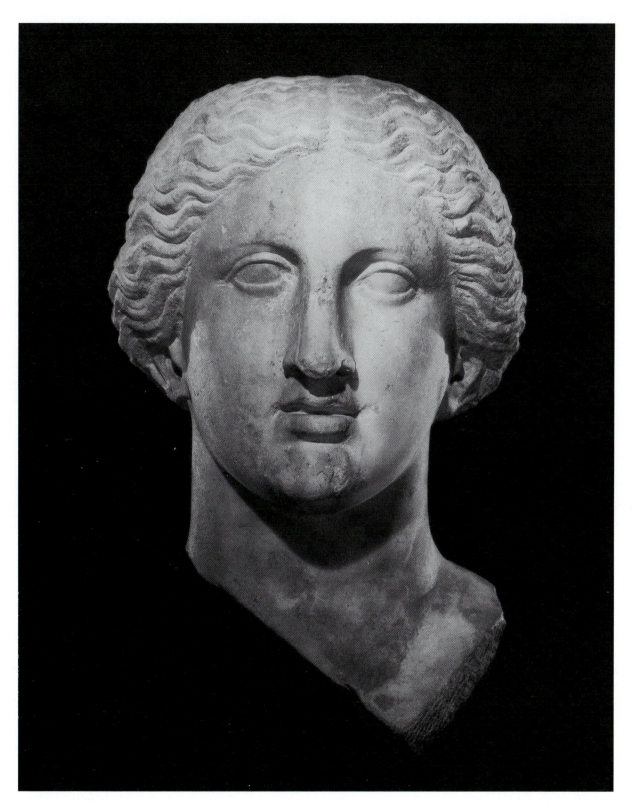

CAT. NO. *44*

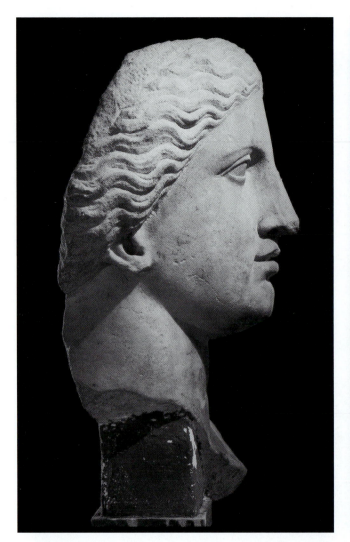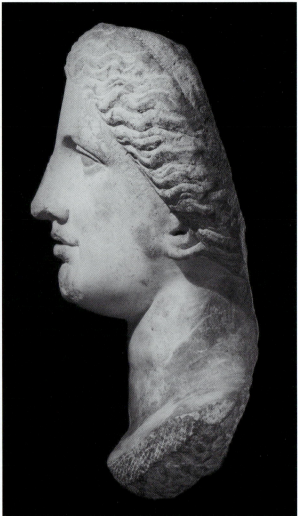

CAT. NO. 44

the right side of the neck, which is broken on a diagonal, there may be a preserved edge, indicating that the piece was originally finished off on a diagonal.

COMMENTARY: This head has been identified by Guldager Bilde (1995; 1998:42) as part of an acrolithic cult statue, probably of Diana, of the second half of the 2nd c. BC from one of the temples at the Sanctuary of Diana at Nemi. Because the sanctuary at Nemi is devoted to the cult of Diana, she is the obvious deity to associate with this head. The matronly appearance of the head leaves some room for doubt, however. Another female head, of youthful type, from Nemi in Copenhagen (Cat. no. 87, IN 1517) with a drapery fragment in the Castle Museum in Nottingham (N 791) has also been iden-

tified by Guldager Bilde as parts of another cult statue of Diana, also of the second half of the 2nd c. BC. Lastly, an acrolithic head of a bearded male divinity (Asclepius/Virbius?) has been published as another cult image from the same period from Nemi, although none of these heads seems to form a group of cult statues. The Copenhagen cult statue head and the UPM head, however, seem to have been excavated in the same campaign, probably 1895, and may have come from the same context, though perhaps secondary. See the late 19th c. Italian photograph in which both heads appear side-by-side and with other statuettes from the same site (Fig. 4).

We know that there were several temples and shrines of Diana at Nemi: probably an archaic temple or shrine on the terrace above the main terrace (see Ghini 1997b:181–82); a

monumental temple (KKK) of late 4th–early 3rd c. BC date, decorated with standard Etrusco-Italic terracottas; and finally a thorough renovation of that 3rd c. temple in the 2nd c. BC with a major enhancement of the terrace around 100 BC (Känel 1997:186–87). The two cult statues of Diana, Guldager Bilde concludes, were for the two temples of Diana, one on the upper terrace of late 2nd c. BC date (which Ghini now identifies as an archaic shrine site) and the renovated temple on the main terrace (Guldager Bilde 1995:215). If, indeed, there was an archaic shrine on the upper terrace which was renovated in the later Republican period, it would not be unusual for a "modern" cult image to have been added to the temple, to stand alongside the old or to replace the old (for the use of multiple cult images in early Greek cult see Romano 1980:257–62). As for the cult image identified as Asclepius/ Virbius, we do not have any information about a temple dedicated to either deity at Nemi.

Guldager Bilde's arguments (1995) for dating the UPM head in the second half of the 2nd c. BC are based on comparisons with the acrolithic female cult image from Kalydon (Dyggve et al. 1934: figs. 94–96), with the acrolithic cult image identified as *Fortuna huiusce diei* from Temple B in the Largo Argentina in Rome, the latter of which has been closely dated to around 101/100 BC, corresponding with the construction date of the temple (Coarelli et

CAT. NO. *44*

al. 1981:38, pl. 7.1–3), and with the female heads on 2nd c. BC *antefixes* from Nemi of Hellenistic date (see *In the Sacred Grove of Diana* 1997:154, nos. 47–48; Guldager Bilde 1995:204–5). The Classicizing UPM head also exhibits some old-fashioned, archaizing traits, and if the figure on the terracotta *antefixes* reflects this cult image type, Diana would have been clothed in archaizing *chiton* and *himation*, possibly wearing a diadem and some other head ornament or veil, and carrying a quiver over her right shoulder and a bow in the left hand.

The exact techniques used for this statue are not known since only the head is preserved. It seems clear that it was an acrolithic statue with marble for the front of the head; stucco may have been added to complete the back of the head and neck, which would have been keyed into a wooden

core to support the body. It is unclear how the draped parts of the figure would have been handled: either as a marble veneer over the wooden core or in bronze sheets. The arms and feet would have been executed in marble.

This cult statue head and the others from Nemi, as shown by Guldager Bilde (1995), fit well into a group of Late Republican cult statues made for temples in Rome and in Latium, possibly by Greek artists working in Italy. Many of these were made in an acrolithic technique, in Greek marbles, and in Classicizing style and have parallels from this same late 2nd–early 1st c. BC time frame on mainland Greece (e.g., for the cult group at Lykosoura). For a discussion of the larger group of Late Republican acrolithic cult images see Martin 1987 and Giustozzi 2001.

CAT. NO. 45

45
SHOULDER FRAGMENT OF FEMALE
STATUE: DIANA(?)

MS 3484
*Sanctuary of Diana Nemorensis, Lake Nemi, Italy (see
 Introduction, pp. 73 ff.)*
Late Republican period, 1st c. BC
*White marble with some gray veins and mica. Sample
 taken for stable isotopic testing, March 24, 1999,
 from inside neck cutting. Results from Dr. Norman
 Herz, University of Georgia: $\delta^{13}C$ 2.734; $\delta^{18}O$
 -5.078: Afyon or Pentelikon; Guldager Bilde and
 Moltesen 2002:15: Pentelic; Moltesen, Romano, and
 Herz 2002:102, 105: probably Dokimeion.*
P. H. 0.25; P. W. 0.33; P. Depth 0.34; Max. D. neck
 cutting 0.21; D. neck 0.22 m.
PUBLICATIONS: In the Sacred Grove of Diana 1997:
 92, 199, fig. 63; Guldager Bilde 1998:42, fig. 6:
 probably Diana, ca. 60 BC; Guldager Bilde and
 Moltesen 2002:21–22, Cat. no. 2, figs. 10–13;
 Moltesen, Romano, and Herz 2002:102, 105.

CONDITION: Single fragment preserving upper right arm
and shoulder, upper back and chest on right side, and one-
half of deep cutting for neck. Locks of hair on shoulder are
broken; fragments of drapery over chest and at front
bottom edge of chest broken off. Chip missing from back,
and surface flaws in marble over back on left side.

DESCRIPTION: Overlifesized female, probably seated, in a
frontal pose with long hair and wearing a *peplos*. Three long
snake-like tresses of hair with much drill and chiselwork fall
over the right shoulder and chest. The upper right arm is bare
and fleshy and is held down and away from the body. The
peplos covers the back and is pinned at the right shoulder with
a round clasp, falling from the edge of the neck cutting over
the protruding right breast in triangular pleats. The folds in
back are treated in broader, flatter planes, as if not meant to
be seen. A large, deep bowl, broken off at both sides but with
a finished rim and open at the bottom, has been hollowed

CAT. NO. 45

out for the insertion of the head and neck. An upper band (H. 0.03–0.035 m.) has been smoothed with a chisel on the inside upper edge, while the rest of the interior of the neck cutting is rough picked with a point. The bottom of the arm is roughly flattened for the attachment of the forearm, while there is a lip at the front edge of the underside for fitting into the upper body fragment. Polish on arm and drapery in front. Back is smoothed with a claw.

COMMENTARY: That the female figure was seated is implied by the way in which the bottom of this fragment is finished off, as if for attachment to another piece, and by the angle of the upper arm which suggests that it was resting on an armrest. A join at this point would make little sense for a standing figure, but is logical if the piece to which this attaches forms the lower chest and torso to the lap of the figure.

The frontality and monumental scale of this female figure point in the direction of a cult image. Guldager Bilde and Moltesen (1997:199; 1998:42; 2002:21) identify it as a fragment of another possible cult image of Diana and associate it with five other fragments in Nottingham of a

right hand, a lower right arm, two fragments of another arm, and a finger (Castle Museum N 610, 797–9, 803; Guldager Bilde and Moltesen 2002:21). The right hand is outstretched with the palm up, possibly meant to hold a patera, perhaps of bronze. A large-scale seated figure in terracotta from the architectural decoration, possibly from the pediment, of a late 2nd c. BC temple at Nemi is closely related to our figure, though it is only known from an 1885 photograph (see *In the Sacred Grove of Diana* 1997: fig. 65, right).

Guldager Bilde and Moltesen date this figure to the second quarter of the 1st c. BC with parallels to Classicizing Late Republican/Late Hellenistic statues (*In the Sacred Grove of Diana* 1997:199, n. 192; Guldager Bilde and Moltesen 2002:21–22): the Seated Cybele from Formiae, probably from Pompey's villa and now in the Ny Carlsberg Glyptotek in Copenhagen; the Muse statues from the portico of Pompey's Theatre in Rome, the construction of which can be dated between 60 and 55 BC; and the caryatids from the Gate of Appius Claudius Pulcher at Eleusis, dated to just after 51 BC (for the latter see the excellent summary in Ridgway *Hellenistic Sculpture III*:3–8).

Votive Statuettes: Female (46–58)

46
STATUETTE OF DIANA

MS 3479
Sanctuary of Diana Nemorensis, Lake Nemi, Italy (see Introduction, pp. 73 ff.)
Late Republican period, late 2nd c.–1st c. BC
Coarse-grained white marble. Sample taken for stable isotopic analysis, March 24, 1999, from bottom of drapery at back. Results of isotopic analysis from Dr. Norman Herz, University of Georgia: $\delta^{13}C$ 3.662;

$\delta^{18}O$ -3.590 (Thasos, Cape Vathy) (Guldager Bilde and Moltesen 2002:25: Parian).
P. H. 0.372; P. W. hips 0.152; P. Depth 0.127 m.
PUBLICATIONS: *Luce 1921:190–91, no. 61; Furtwangler 1905:261, no. 33; In the Sacred Grove of Diana 1997:109, 207, n. 240; Guldager Bilde 1998:43, fig. 7; Guldager Bilde 2000:109, n. 143, 144; Guldager Bilde and Moltesen 2002:25–26,*

CAT. NO. 46

Cat. no. 5, figs. 21–24; Moltesen, Romano, and Herz 2002:103, 105.

CONDITION: Single fragment preserving the torso from the shoulders to just above the knees. Arms, head, and upper shoulders at the back (and lower legs?) would have been added separately. The attachment surfaces for the head and for the upper shoulders have been prepared with a rasp and point. Part of an iron pin is preserved in the neck surface. Surface, especially between folds, is much encrusted with dirt and white substance (undercoat for paint?). Many chips missing from drapery.

DESCRIPTION: Draped, elongated statuette of Diana, standing frontally wearing a short, sleeved *chiton* and a *himation* wound around her waist. The right leg is straight bearing the weight and the left leg is bent and slightly left and forward. The left breast is set slightly higher than the right; and the left arm is held downward but drawn back slightly, while the right seems to have been uplifted. The *chiton* has a deep overfold and is belted high under the breasts. The folds of the *chiton* are treated as deep valleys and peaks and there is much careful use of the drill. The

himation is draped over the left shoulder, diagonally across the back, and around the waist in a thick roll with one end tucked under the roll beneath the right breast. Tassels at the corners of the *himation* are shown. The back of the figure is treated in broader planes and with less volume and was probably not meant to be seen.

The top of the statuette is treated as a flattened surface with a hollowed out area for the attachment of the separately manufactured neck (partially preserved) and head, which were secured by a dowel in the center. The arms would have been separately attached to flattened surfaces (partially preserved on the right arm) and secured with dowels, traces of which appear on the right.

COMMENTARY: See also **47** for Diana in a similar pose wearing her traditional costume. Guldager Bilde and Moltesen (2002:26) point out the parallels for this so-called Artemis Laphria type, with examples found on Rhodes (especially Gualandi 1976:55, fig. 29) and Delos (unfinished and may be one of the local Delian works) that can be well dated to the end of the 2nd c. BC (*LIMC* II, Artemis: nos. 194–5). For a discussion of the popularity of this Artemis type in Hellenistic Rhodian sculpture see Μαχαίρα 1999:140–41.

47
STATUETTE: DIANA

MS 3453 (*see CD Fig. 22*)
Sanctuary of Diana Nemorensis, Lake Nemi, Italy (see Introduction, pp. 73 ff.)
Late Republican period, perhaps 1st c. BC
White marble. Sample taken for stable isotopic analysis, March 24, 1999, from back of support behind right leg. Isotopic analysis results from Dr. Norman Herz, University of Georgia: $\delta^{13}C$ *2.842;* $\delta^{18}O$ *-2.954 (Marmara or Mylasa).*
P. H. with plinth 0.55; W. joining surface at top 0.124; Max. W. hips 0.19; Max. Depth 0.16 m.
PUBLICATIONS: *Luce 1921:174, nos. 32; In the Sacred Grove of Diana 1997:109, 207, n. 240; Guldager Bilde 1998:43; Guldager Bilde 2000: 103–4, fig. 5, n. 143; Guldager Bilde and Moltesen 2002:26, Cat. no. 6, figs. 25–27; Guide to the Etruscan and Roman Worlds 2002:55, fig. 81; Moltesen, Romano, and Herz 2002:103, 105.*

CONDITION: Single fragment preserving figure from waist to plinth. Missing left leg from below knee, upper body, which was separately attached, head, and arms. Lower part of tree support and object in front of it broken off; plinth is broken all around except front edge. Dark discoloration and nicks on the lower leg, plinth, left side of support, and right foot. Chips on drapery edges; large chip from back upper edge of piece. Surface has much dark and light incrustation, but surface is generally in good condition, better preserved on the drapery than on the legs, support, and plinth.

DESCRIPTION: Statuette of Diana with an elongated body wearing a short *chiton* and boots, standing with her right leg straight and the left leg bent back at the knee. The *chiton* has a deep overfold. The looping ends of a belt hang from the upper finished edge of the piece; on the right side at the upper edge of the piece the belt is seen as a thickened roll. Just below the belt loops a thick roll of a mantle is tied

around the waist, beginning over the right back side on a diagonal and looped over the top of the roll at the front right side of the figure. The drapery folds are well defined with volume, with the use of the drill to undercut the overfold and create deep valleys. In back the drapery is treated in broader planes and the back of the support is cursorily finished, as if the statuette was not meant to be viewed from the back. The roll of the upper edge of a boot is shown below mid-calf, while the lower part is open-toed, with a thin sole and a strap horizontally behind the toes attached to a triangle (perhaps a leaf) above the angle of the big toe and second toe. Toes are elongated.

The upper half of the torso was added separately in marble along the line of the belt. The joining surface is smoothed with a rasp and punctuated with a point; a deep circular hole (D. 0.02; Depth 0.073 m.) is cut for a dowel to the right of center.

Attached to and behind the right leg is a broad support, probably a tree trunk (H. 0.273 m.) which rests on the plinth. At the lower end attached at the right side of the support is part of an object with an oval tip, probably part of a dog seated on the plinth. The plinth (P. H. 0.01–0.026 m.) has a curving front edge and roughly worked upper surface.

COMMENTARY: This is one of the better-preserved images of Diana in the Museum's Nemi collection. She is wearing the typical costume of Diana, the huntress: her short *chiton*, a cloak tied around her waist so that it doesn't interfere with her physical activities, and short leather boots. She often wears a quiver for her arrows, carries a bow or arrows, a spear or a torch, and is accompanied by a hunting dog or a deer, all of which are missing in this case. The partially preserved object to her right against the tree stump cannot be securely identified, but one of Diana's animals is likely. For other statuettes of Diana in the Museum's collection see especially **46** (a statuette of similar type), **48**, and probably **54** and **55**.

Guldager Bilde and Moltesen (2002:26) point to the elongated proportions of the figure and the open-toed boot type as indicators of a probable pre-Imperial date, perhaps in the 1st c. BC.

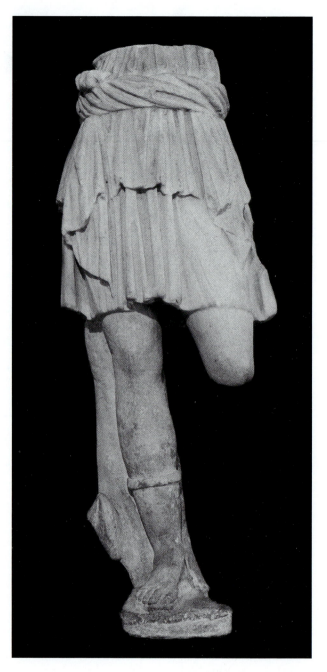

CAT. NO. *47*

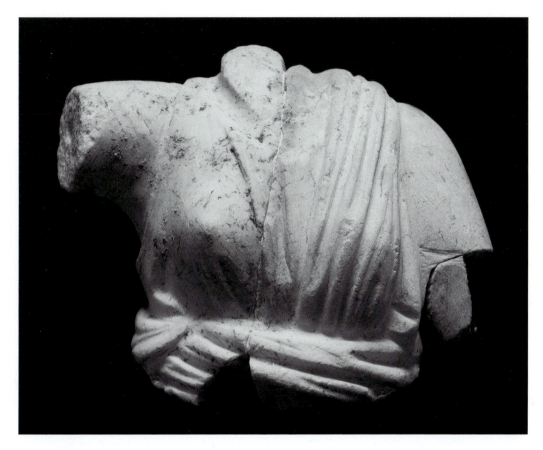

CAT. NO. 48

48
STATUETTE: DIANA

MS 4034
Sanctuary of Diana Nemorensis, Lake Nemi, Italy (see Introduction, pp. 73 ff.)
Late Republican period, late 2nd–1st c. BC
Fine-grained white marble
P. H. 0.165; P. W. shoulders 0.195; P. Depth 0.12 m.
PUBLICATIONS: In the Sacred Grove of Diana 1997:109, 207, n. 240; Guldager Bilde 1998:43; Guldager Bilde 2000:109, n. 143; Guldager Bilde and Moltesen 2002:26–27, Cat. no. 7, figs. 28–31.

CONDITION: Joined from two fragments vertically down the center of the piece. Figure is preserved from the neck, broken off, to the waist in front and to the upper back on the back side. The separately attached pieces of the right and left arms are missing, with the exception of a small fragment of the left biceps which survives in two fragments with its iron dowel. A fragment is missing from the front at the waist. Much dark surface discoloration and some surface chips.

DESCRIPTION: Statuette of Diana wearing a *chiton* and *himation*. The body is standing frontal with the right arm

raised and extended sideways at the level of the shoulder and the left arm lowered. The sleeveless *chiton* forms V-shaped folds at the neckline. A *himation* is worn over the left shoulder, diagonally across the back, wound around the waist in a thick roll, and tucked over the top of the roll on the right front. Deep grooves define the folds of the *himation*. The preserved portion of the neck indicates the head was turned slightly left. The back of the figure is roughly treated in broader planes and was not meant to be seen. The arms of marble were added separately to a flattened

surface worked with a point and with a dowel hole. The lower half of the statue would have been added in a separate piece. The bottom joining surface is prepared with a point and chisel; a modern hole has been drilled in the center for attachment to a base.

COMMENTARY: For similar statuettes of Diana from Nemi wearing this same costume, see **46** and **47**. Here Diana is in an active pose with the right arm extended, perhaps with her bow or removing an arrow from her quiver.

CAT. NO. 48

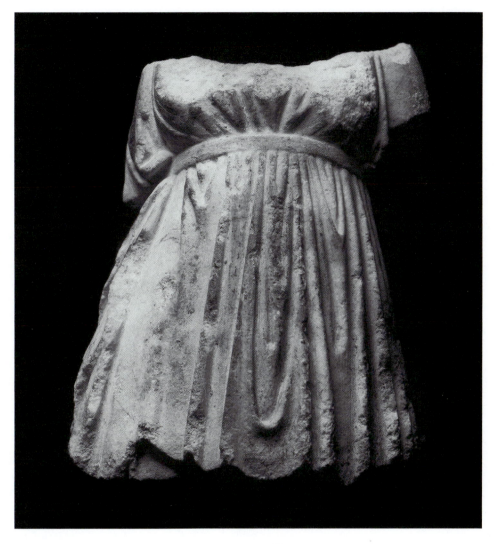

CAT. NO. 49

49
FEMALE STATUETTE: DIANA-HEKATE(?)

MS 3480
Sanctuary of Diana Nemorensis, Lake Nemi, Italy (see Introduction, pp. 73 ff.)
Late Republican period, late 2nd–1st c. BC
White marble. Sample taken for stable isotopic analysis, March 24, 1999, from underside. Results from Dr. Norman Herz, University of Georgia: $\delta^{13}C$ 1.149; $\delta^{18}O$ -1.073 (Paros Chorodaki or Carrara).
P. H. 0.22; P. W. bottom edge 0.165; P. Depth 0.143; D. neck cutting 0.071 m.

PUBLICATIONS: *Guldager Bilde and Moltesen 2002:28–29, Cat. no. 9, figs. 36–39; Moltesen, Romano, and Herz 2002:106.*

CONDITION: Single fragment preserving torso from base of neck to lower body. Head and neck, arms, and lower body would have been added separately. Surface break on upper chest and top of shoulders. Other surface chips, especially on lower edge. Dark discoloration especially on front.

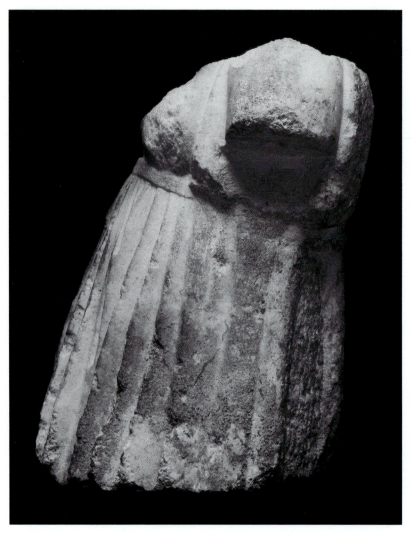

CAT. NO. 49

forming a conical block. The back is unfinished and treated with a claw chisel, with a broad raised area below the belt. The piece was certainly not meant to be seen from any vantage point other than the front.

The cutting for the neck is a shallow cavity, slightly roughened with a claw and point. The right arm was separately fashioned and attached at the shoulder to a flattened circular area, fastened by a dowel, part of the hole for which is preserved; the left arm is also attached separately at the upper arm, with a flattened surface prepared with a rasp and a hole for a dowel; beneath the attachment surface a hollowed out area has been created for the vertical extension of the arm. The bottom surface of the statuette is roughly worked with a rasp. A modern dowel hole is drilled in the center for the attachment to a mount.

COMMENTARY: The conical form of this statuette and the old-fashioned *peplos* are the key elements to the identification of the figure. These are compatible with the archaistic representations of the triple-bodied Diana-Hekate whom we know from literary sources was worshipped at Nemi under the name Trivia (Guldager Bilde and Moltesen 2002:28). The relationship of this statuette to the triple figure represented on the denarii of 43 BC of P. Accoleius Lariscolus, identified by Alföldi (1960:137–44) as the cult image of Diana from the sanctuary, is unclear. (For a discussion of this archaistic Artemis without reference to the Philadelphia collection, see Fullerton 1990:15–22.) Guldager Bilde and Moltesen (2002:28, esp. n. 95), following others, suggest that the representation on the coin may be a Late Hellenistic votive group of Diana-Hekate at Nemi, while our statuette may be a small version of it. This suggestion is very appealing, though difficult to prove. The presence of similar statuettes from Rhodes dating to around the second half of the 2nd c. BC (Gualandi 1969:233–72) indicates a wider sphere of interest in this statuette type in the Hellenistic world and the probability that its origin is not necessarily at Nemi.

DESCRIPTION: Statuette of draped female, probably Diana, wearing a short belted *peplos* with the opening on the right side. The left arm seems to have been held along the body, while the right was probably held away to judge from the right angle of the joining surface. *Peplos* is belted high under the breasts and the folds are gathered in pleats between the breasts. Below the belt the folds of the garment fall vertically, with deep vertical loops in front and a large flat expanse below the right breast. On the right side, the garment is bunched beneath the right arm and falls on either side of the groove of the opening in stylized zigzag folds; the left side of the figure is treated in flatter, larger planes. The body forms are large with full breasts, protruding stomach, and unusual depth from front to back,

50
STATUETTE OF DRAPED FEMALE

MS 3458 (+ MS 3471, MS 3472) (see also Fig. 4)
*Sanctuary of Diana Nemorensis, Lake Nemi, Italy (see
 Introduction, pp. 73ff.)*
Late Republican period, late 2nd–1st c. BC
*Statuette: large-grained (2–3 mm.) grayish-white marble;
 plinth: fine-grained gray marble. Two samples taken
 for stable isotopic analysis, March 24, 1999, from
 base at back and from statue from bottom of drapery
 at back. Results from Dr. Norman Herz, University
 of Georgia: body: $\delta^{13}C$ 4.169, $\delta^{18}O$ -3.909 (Paros,
 Lychnites, or Sardis); plinth: $\delta^{13}C$ 1.933, $\delta^{18}O$
 -1.956 (Paros Chorodaki or Hymettos). Guldager
 Bilde and Moltesen 2002:27: statue is probably
 Parian and plinth is probably Carrara.*
*P. H. with plinth 0.56; P. H. without plinth 0.505;
 Max. W. knees 0.145; P. Th. knees 0.12; L. neck
 cutting 0.08; W. neck cutting 0.065; Depth neck
 cutting 0.028; L. plinth 0.21; W. plinth 0.17; H.
 plinth 0.051 m.*
PUBLICATIONS: *Hall 1914d:120–21, fig. 67; Luce
 1921:169–70, no. 17 (incorrectly published as MS
 3478 = **54**); Guldager Bilde and Moltesen
 2002:27–28, Cat. no. 8; 38, Cat. Nos. 30–31, figs.
 32–35 (feet); Moltesen, Romano, and Herz
 2002:105.*

CONDITION: Preserved from shoulders to bottom edge of drapery, with a plinth which is probably not its original ancient plinth. Missing head and arms that were separately attached. A 19th c. Italian photograph shows this statuette with a head (**55**) and neck added, as well as separately fashioned feet (MS 3471 and MS 3472) (see Fig. 4). Fragments around both shoulders broken off and repaired; large fragments of lower left leg and drapery and of bottom at back broken and repaired; other fragments of drapery on left side broken off; bottom edge of drapery broken off in front. Much orange discoloration, iron stain, around arm attachment surfaces and on surface of missing drapery fragment on the left side. Surface of front of statue is badly pitted and calcified, while back is better preserved. Many small chips and nicks over entire statue.

DESCRIPTION: Standing, youthful, draped female with elongated proportions and the upper body in a frontal pose with the hips twisted slightly to the right. The left leg is straight and the left foot is positioned straight ahead, while the right leg is bent and pulled back with the right foot at an angle to the right. Left hip is swung out to the side; the right shoulder is raised. The right arm, separately attached above the biceps with a smooth attachment surface and an oval dowel, was held down and slightly away from the body. The left arm was made separately and attached higher. The left arm attachment surface is scored with fine grooves and has both a large dowel cutting and a smaller circular hole below it. A large iron dowel at the left hip is also preserved at waist height on the left side where the *himation* edge hangs down, probably to support the arm resting on the hip. The figure wears a short-sleeved *chiton* with a *himation* over it. The folds of the *chiton* are visible below the hem of the *himation*. *Himation* is draped over the left shoulder, with the rolled edge dipping between the breasts to the right side where it disappears on the back; folds of the *himation* fall down the left side in zigzag folds; *himation* is treated over the front of the figure as surface ridges, arching over the stomach and following the contours of the legs, and forming a strong diagonal between the legs from upper left to lower right. The depression of the navel shows through the garments. Body proportions are slim and elongated with full peaks for breasts, slender hips, and long legs.

The head and feet were also made separately. The cutting for the neck is hollowed out from shoulder to shoulder and the added piece would have been secured with an oval dowel, the cutting for which survives. There is a hollowed out area for the right foot and a dowel hole for its attachment, yet there is no corresponding hole on the foot fragment. The place where the left foot should be attached is plugged up with grayish plaster (modern) and there is a modern drill hole on the attachment surface of the left foot. The feet (MS 3471 and MS 3472) which were associated with the statue when it was photographed at the end of the 19th c. (Fig. 4) have been temporarily reattached, but it is unlikely that they are original to the statuette.

The back has been worked in broader planes with the expanse of the *himation* falling vertically down the back, broken by horizontal folds over the right hip. The finer *chiton* material forms crinkly folds at the bottom edge. Across the back is a deep horizontal groove, a roughened rectangular area, and a drilled hole for the attachment of an attribute or an additional drapery fragment which rested on top of shoulder.

The rectangular plinth on which the figure stands is probably not its ancient plinth. It is fashioned separately from the statue, of a different material with a hole cut out

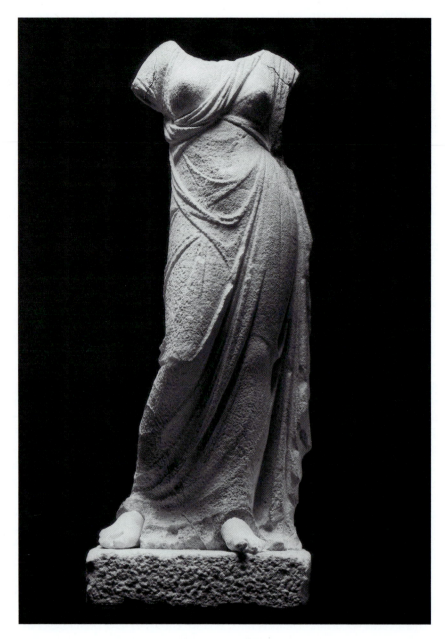

CAT. NO. 50

for the contours of the statue. It is rough picked all around with a smoothed area on the top surface leaving the traces of the contours of the feet and the front edge of the drapery.

COMMENTARY: The identity of this youthful female is open to debate because of the lack of an attribute. Kore, a Muse, Aphrodite/Venus are possibilities. The costume

and/or stance seem unlikely for Diana, though the hole on the back of the shoulder may be for a quiver. Guldager Bilde and Moltesen (2002:28) allow for the possibility of an Artemis/Diana-Hekate figure and point to a very close parallel for the type and style in a statuette of ca. 150–100 BC in Copenhagen, found in Egypt but possibly manufactured on Rhodes (Nielsen and Østergaard 1997:32–33, no. 8).

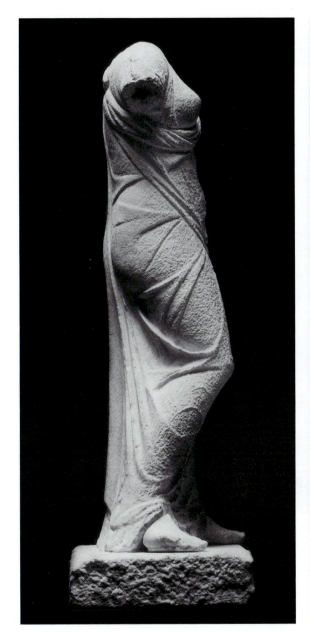
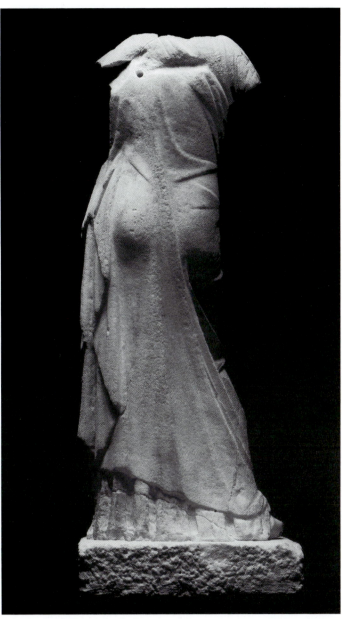

CAT. NO. 50

The high degree of preservation on the back, but poor surface on the front, opens questions of the use of the statue. The statue was carved as if to be viewed from all sides, but the back side was protected in some way, while the front was exposed to severe conditions, causing pitting and corrosion, perhaps in a secondary context. The feet which are associated with this statue (MS 3471 and 3472) are probably not original or even ancient; the right foot does not fit well, and the lack of a corresponding hole in the statue for the dowel on the foot fragment suggests that the foot is a replacement. On the left foot there is a modern drill hole on the attachment surface and the attachment surface on the statue is smoothed off. Across the top of the feet is a smooth, polished band, while the toes are roughened with a suspicious stippling, as if deliberately treated to match the poor condition of the body.

51
STATUETTE OF FEMALE: APHRODITE

MS 3474
Sanctuary of Diana Nemorensis, Lake Nemi, Italy (see Intro-duction, pp. 73 ff.)
Late Republican period, 1st c. BC
White marble. Sample taken for stable isotopic analysis, March 24, 1999, from bottom at back. Results from Dr. Norman Herz, Univer-sity of Georgia: $\delta^{13}C$ 2.301; $\delta^{18}O$ -1.845 (Carrara).
P. H. 0.275; P. W. 0.24; P. Depth 0.145 m.
PUBLICATIONS: *Luce 1921:169, no. 2; In the Sacred Grove of Diana 1997:109, 207, n. 241; Guldager Bilde 1998:46, fig. 16; Guldager Bilde 2000: 109, n. 148; Guldager Bilde and Moltesen 2002:29–30, Cat. no. 12, figs. 45–47; Moltesen, Romano, and Herz 2002:103, 106.*

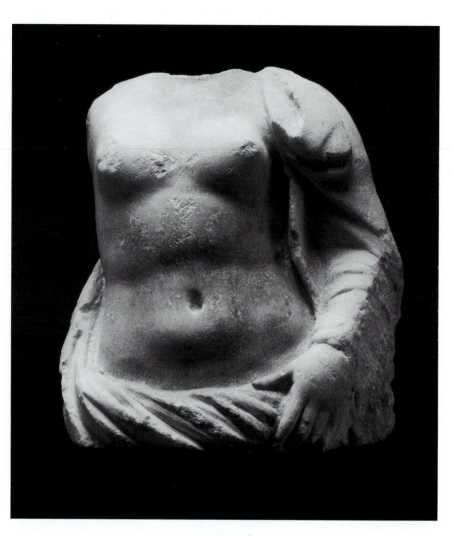

CAT. NO. 51

CONDITION: Single fragment preserving the left arm and the upper body from the shoulders and base of neck to the hips. The right shoulder is partially broken off. The upper part of the back of the piece is broken off. Chips on drapery edges, on both breasts, thorax, and hand. Much orangish (iron?) discol-oration surrounding neck break, on lower torso, drapery, on bottom, and on back of piece.

DESCRIPTION: Female figure in a frontal pose twisted slightly to her right, with a nude upper torso. A *himation* is wrapped around her body below the hips, up the right side of the back and over the left shoulder; one end falls between the left arm and torso and is wound around the left arm, forming a cuff at the wrist. The left arm is bent with the upper arm close to her side, while her left hand grasps the roll of drapery below her hips. The breasts are full and the right breast is positioned slightly lower than the left. The torso is well modelled, with a protruding stomach and deeply drilled round navel. The right hip forms a gentle convex curve, probably over a bent right leg, while the left hip is thrust out to account for a straightened left leg. The flesh areas are polished. While the folds of the *himation* are given deep pockets on the front and along the right side, the material is treated in rather large flat planes over the left shoulder and upper left arm. A drill hole is preserved on the drapery on the right side. Along the left side of the lower left arm is a roughly chiselled surface as if the piece were recut to fit up against a surface. Along the left side the body has been separated from the drapery by a broad drilled furrow. A shallow cavity is formed for setting the separately made neck and head, and on the back of the piece, part of an iron dowel

CAT. NO. 51

c. BC from Rhodes, Ambracia, and Delos, and have pointed to the Aphrodite figure on the later 2nd c. or early 1st c. BC frieze of the Temple of Hekate from Carian Lagina who grips her cloak in the same mannered way as the UPM figure. The Aphrodite from Arles type, in which the drapery covers the lower body and the left arm is bent holding or wrapped in drapery, is generally thought to date to a later 4th or 3rd c. BC (Ridgway 1976:154 argues for a downdating of the type to a Classicizing creation of the 1st c. BC, which she admits in *Hellenistic Sculpture I*:104, n. 30, has not found acceptance; see also Ridgway *Hellenistic Sculpture III*:197–99 for more discussion of the downdating issue and of Pollini's theory [1996] regarding the Roman use of a variation of the Arles Aphrodite type in Pompey's Theater in Rome).

This statuette from Nemi differs from the main type in the left hand holding the bundle of drapery at the hips and the way the garment is wrapped around the back of the figure, falling from the left shoulder before winding around the left arm. See also *LIMC* II: Aphrodite: nos. 549–50 for two Roman statues close to Nemi example which are thought to copy a late 2nd c. BC variant of the Aphrodite of Arles.

is preserved at the top for the attachment of this piece. Iron stains on the broken right shoulder indicate that the right arm was made separately and attached with an iron dowel. It appears that the right arm was at least partially raised. The lower part of the back, below the broken upper surface, was roughly finished as a flattened surface with a claw chisel, and the piece was certainly not meant to be seen from the back. Bottom is worked with a chisel for joining to lower piece. An iron dowel is preserved to the left of center, while a plug (D. 0.015 m.) made of a whiter marble is set in the center.

A marble statuette of the leaning Aphrodite type, assigned a 1st c. BC date, from the Santa Venera sanctuary at Paestum is also close to the Nemi example (see Pedley 1998:201, fig. 3). It is interesting that the Nemi statuette is made of the local Italian Carrara marble, whose quarries were not exploited until around the mid-1st c. BC. The closeness of the parallels to Rhodian examples might suggest the presence of a Rhodian sculptor working in Italy.

COMMENTARY: Guldager Bilde and Moltesen (2002:29–30) have provided an excellent discussion of similar Aphrodite statuettes of the second half of the 2nd

See **52** for a statuette of Aphrodite on the same scale and with the same motif of the bare torso and *himation* wrapped around the lower body.

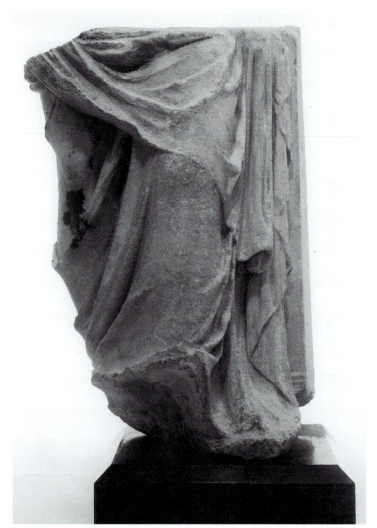 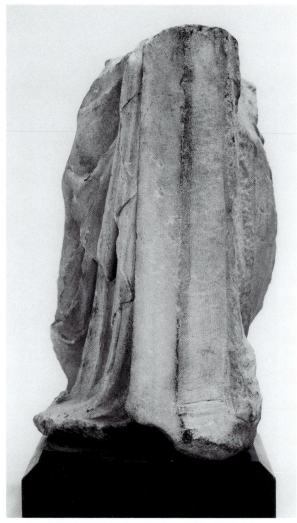

CAT. NO. 52

52
STATUETTE OF DRAPED FIGURE

MS 3454
*Sanctuary of Diana Nemorensis, Lake Nemi, Italy (see
 Introduction, pp. 73 ff.)*
Late Republican period, late 2nd–1st c. BC
*Large-grained white marble. Sample taken for stable
 isotopic analysis, March 24, 1999, from bottom of
 cutting for left leg. Results from Dr. Norman Herz,
 University of Georgia: δ^{13}C 3.082; δ^{18}O -5.543
 (Sardis or Afyon).*
P. H. 0.362; P. W. 0.26; P. Depth 0.20 m.
PUBLICATIONS: Aspects of Ancient Greece

1979:190–91, no. 92; In the Sacred Grove of Diana
1997:109, 207, n. 241; Guldager Bilde 2000:109, n.
148; Guldager Bilde and Moltesen 2002:30–31, Cat.
no. 13, figs. 48–51; Moltesen, Romano, and Herz
2002:103, 106.

CONDITION: Single fragment preserving lower portion of
draped figure and support, finished on the upper surface for
attachment to a separate upper piece; piece at bottom
right side (for foot) would also have been made separately
and attached. Fragment missing from bottom of pilaster

and plinth on left side; the plinth is also broken on the right side. The end of the drapery falling down the back of the pilaster is broken off. Large rust stain on right leg below knee, and large brown stain on the joining surface below the left foot. Many chips missing from drapery folds; gouges on pilaster. Surface pitted and weathered on the front, especially on forward left leg.

DESCRIPTION: Statuette of a draped figure, leaning on a pilaster to the left side. The figure stands with the right leg straight, and the left leg bent slightly at the knee and forward with the foot probably lifted off the ground (on something now missing). A single garment, a *himation*, envelopes the lower part of the figure; the upper part of the *himation*, probably wrapped around the figure below the waist, was, no doubt, completed on the upper joining piece, with the joins masked by the folds of the drapery. The *himation* is wrapped around the body (on a diagonal at the upper end of the piece) with the overfold falling diagonally over the forward left leg and the excess brought up in a bunch beside the pilaster and down the back of the pilaster in zigzag folds. The tip of the mantle is broken off where it was cut free, leaving only a small fragment attached. The left arm of the figure may have rested on top of or against the pilaster and the drapery would have been carried over that arm. The *himation* falls in long arcs between the legs and over the right leg with deeply drilled out pockets of folds. On the back of the piece the folds are continued behind the right leg, but the back of the fragment in the center zone is roughly finished. The lower edge of the *himation* has a turned-up hem that forms a scalloped fold on the plinth on the left side of the left foot, and arches over the left ankle. An area is hollowed out beneath the left leg and drapery, extending back to beneath the right leg, as if for a separate foot piece to be added, though

there are no dowel holes and no scoring of the joining surface. At the left side of the figure is a pilaster with a molding on the lower edge; the back of the pilaster is worked with a fine claw chisel. The low plinth (H. 0.019–0.025 m.) has a simple rounded front edge roughly worked. In the bottom of the plinth (below the drapery in front of the pilaster) is a large rectangular cutting (0.025 x 0.035 m.; Depth 0.045 m.), with no rust stains detectable, but with a wide pouring channel, probably for securing the statuette to its base or position in its setting. A small modern dowel hole is drilled through the bottom. The top joining surface of the piece is carefully smoothed with a claw chisel and in the center (over the left leg) is a deep rectangular cutting (0.02 x 0.002; Depth 0.042 m.) for an iron dowel, with rust stains all around.

COMMENTARY: Because of the lack of an undergarment and the probability that the upper torso was nude, Ridgway (*Aspects of Ancient Greece* 1979:190) entertains the notion that the figure represented here could be either a male (Dionysos or Apollo) or a female (Aphrodite or a nymph, of which there are several types leaning on props). Taking into account the entire corpus of statuettes from Nemi, a male figure is a possibility. However, another statuette from Nemi, **51**, provides a very close parallel for an Aphrodite with a nude upper torso and drapery over the left shoulder and waist. There are also examples of an Aphrodite type in terracotta from Nemi which show the goddess partially nude leaning on a pilaster (see *In the Sacred Grove of Diana* 1997:159, no. 58: with references to other similar ones). For the parallels for the Aphrodite type in marble see Ridgway (above). Ridgway suggests the possibility that the figure may have been part of a fountain arrangement and that the rust stain on the right leg relates to that function, but this could equally be from some secondary context.

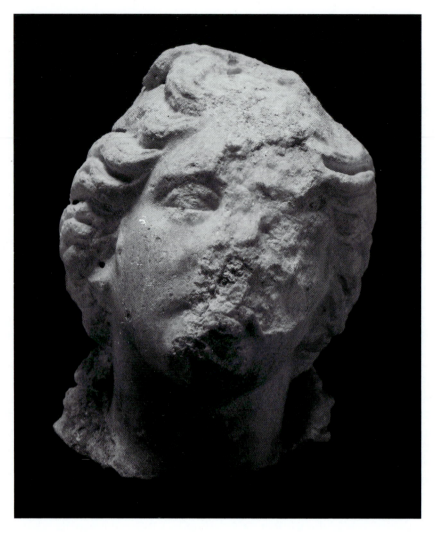

CAT. NO. 53

53
FEMALE HEAD: APHRODITE

MS 3467
Sanctuary of Diana Nemorensis, Lake Nemi, Italy (see
 Introduction, pp. 73 ff.)
Early Imperial period
Large-grained white marble with micaceous particles
P. H. 0.18; W. 0.13; Depth 0.159 m.
PUBLICATIONS: *Luce 1921:189, no. 23; Guldager*
 Bilde 2000:109, n. 148; Guldager Bilde and
 Moltesen 2002:37, Cat. no. 26, figs. 91–93.

CONDITION: Head broken off at lower neck. Surface is

mostly missing from the center and left side of the face, the hair above the forehead, the top of the head. Tip of chin missing and fragment from left side of chignon. Lower right side of neck surface broken. Some dark surface discoloration. Orangish-pink coloration (ancient paint?) on earlobes, face, neck, and hair at the hairline.

DESCRIPTION: Half-lifesized female head tilted to the left. Hair is parted in the middle and swept to the sides in thick waves which are gathered at the nape of the neck in a squarish chignon. Thick strands fall from the roll down the sides of the

CAT. NO. 53

neck, and the hair at the very front of the forehead is piled on the top front of the head in a soft mound or bowknot. One small curl falls on cheek in front of each ear. Subtle drillwork defines the depth of the waves on the sides of the head, while the hair on the top and back of the head, including the roll, is delineated by shallow ridges. Right earlobe is large and flat, with a tiny drilled hole for an earring just above the lobe, while the left ear is not as well defined. The face is long and narrow with a low forehead; open eye is shallowly carved beneath a thickened upper lid; flat cheeks; full pursed lips with indentations at outer corners. Full neck with slight indenta-

tion for Venus ring. Polish on face and neck.

COMMENTARY: Aphrodite seems the most likely possibility for the identity of this figure. Guldager Bilde and Moltesen (2002:37, Cat. no. 26) suggest that this figure could be male or female, since Dionysos and Apollo are depicted with this kind of hairdo. Conservation of the head and the removal of the plaster restoration that obscured the details of this worn head revealed the presence of a drilled hole above the earlobe for an earring. The sloppy use of the drill suggests a date in the Imperial period.

CAT. NO. 54

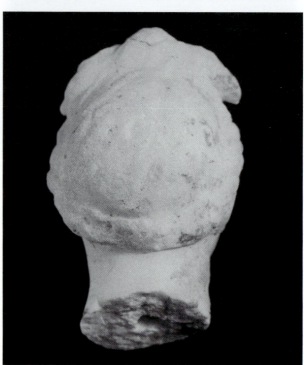

54

SMALL FEMALE HEAD: DIANA(?)

MS 3478 (see CD Fig. 23)
Sanctuary of Diana Nemorensis, Lake Nemi, Italy (see
 Introduction, pp. 73 ff.)
Late Hellenistic, second half of 2nd–1st c. BC
Fine-grained white marble
P. H. 0.12; W. 0.07; Depth 0.085 m.
PUBLICATIONS: *Guldager Bilde 1998:43; Guldager Bilde*
 2000:103–4, fig. 6; 109, n. 144; Guldager Bilde and
 Moltesen 2002:29, Cat. no. 10, figs. 40–42.

CONDITION: Single fragment of female head preserved from the top of the head to the lower neck, broken in an irregular line at the neck. Chips at end of nose on right side, front of topknot on left side, and back of neck. Worn back of head. Dark incrustation on the right side, especially along the jaw and neck, and many spidery dark lines over the entire piece.

DESCRIPTION: Head from a small statuette of a young female, probably Diana, slightly inclined to her right and tilted back. Hair is parted in the middle and rolled up in front along her forehead and behind the ears and in back at the nape of the neck. A thick double knot, looped over and tied with a thick strand over the middle, is positioned

on the top of her head. In back the head is summarily worked with a chisel to suggest strands of hair. Face is generally long and narrow; high triangular forehead; eyes are deep-set beneath thickened brow ridges; finely shaped nose; small Cupid's bow mouth with lips slightly parted; dimpled chin. Slight polish on the face. Ears are small and not well-defined, with a hole at the center. A thick roll of flesh bulges at the front of the neck.

COMMENTARY: The presence of numerous statuettes of Diana, especially in hunting costume, at the Sanctuary of Diana Nemorensis might indicate that this young female could also be identified as Diana (Guldager Bilde 1998:43). The relationship of this head type and hairstyle to the Late Hellenistic head identified as a cult image of Diana from Nemi is further indication of the identity of the figure (see Guldager Bilde 1995: esp. 196–9, figs. 3–6). In general, the type imitates the style of 4th c. BC Greek sculptures, but it is possible to date the head to the second half of the 2nd c. or 1st c. BC based on historical evidence (the 2nd c. BC renovation of the sanctuary being a likely *terminus post quem*) and a comparison with both the large-scale images and the small terracotta figurines and *antefixes* from Nemi (see Guldager Bilde 1995: figs. 16–18; *In the Sacred Grove of Diana* 1997: nos. 2, 43, 47–49, 72). The *sfumato* technique with a slight polish on the face and roughly worked hair and ears is also typical of the Hellenistic period (Merker 1973:7–8; see also **55**).

55

SMALL FEMALE HEAD: DIANA(?)

MS 3477
Sanctuary of Diana Nemorensis, Lake Nemi, Italy (see Introduction, pp. 73ff.)
Roman Republican period, late 2nd–1st c. BC
Large-grained white marble with soapy surface texture
P. H. 0.115; W. 0.075; Depth 0.10 m.
PUBLICATIONS: *Guldager Bilde 1998:43 (probably Diana); Guldager Bilde 2000:109, n. 144; Guldager Bilde and Moltesen 2002:29, Cat. no. 11, figs. 43–44.*

CONDITION: Single fragment preserved from the top of the head to the neck. End of nose broken. Large blackened patch (burning) on right side of forehead and eye, and orange stain (rust?) on right side of head and on some areas on top on left side.

DESCRIPTION: Small youthful female head tilted slightly to her right. Hair parted slightly off-center to the right with wavy tresses pulled away from brow and above the ears. A loose bowknot sits at crown of head; some signs of work with a drill on the bowknot. The back of the head is summarily worked giving the impression of tufts of hair. Long oval face with softly modelled cheeks and slight polish. Low, triangular forehead with sharp ridges for brows. Deep- and close-set eyes, sharply sloping in from top to bottom, with a slight ridge for the upper lid. Long

CAT. NO. 55

straight nose; puffiness to area above upper lip; small mouth with tightly pursed lips, carefully drilled at the outer corners; firm rounded chin, slightly jutting; small, softly modelled ears.

COMMENTARY: The assumption is that the majority of the sculptures at Nemi of this type of youthful female wearing her hair piled on top of her head represent Diana, and that these were dedications in the sanctuary. (See **54** for a head of similar scale with a similar surface polish and style of carving giving a soft *sfumato* appearance.) This head appears mounted on **50** in the late 19th c. photograph taken while the pieces were still in Italy (see Fig. 4), but it certainly does not belong to that statuette. The scale of the head is too large for the body, and the weathering and degree of preservation differ greatly on these two pieces, making their association dubious.

CAT. NO. 56

56
SMALL FEMALE HEAD

MS 3455
Sanctuary of Diana Nemorensis, Lake Nemi, Italy (see Introduction, pp. 73 ff.)
Late Republican period, late 2nd–1st c. BC
White marble
P. H. 0.12; W. 0.095; Depth 0.105 m.
PUBLICATIONS: *Guldager Bilde 2000:109, n. 148; Guldager Bilde and Moltesen 2002:31, Cat. no. 14, figs. 52–55.*

CONDITION: Single fragment preserving head from top to lower neck. Circular area at the left back of the head repaired in marble or marble paste, possibly in antiquity. Much dark surface discoloration, especially on repair in back. Head is much worn with end of nose broken, flat area at top of head broken off and left with a smoothed surface; chin chipped.

DESCRIPTION: Head of a young female from a statuette, perhaps a dancing figure. The head is tilted up and to the

left. Her hair is parted in the middle and drawn to the sides in waves, leaving the lower part of the ears exposed. The top of the head is more summarily treated in low relief with ridges. At the front above the forehead a piece of the hair is missing and the surface is smoothed as if for the addition of a separate fragment. The left side of the hair is also missing, leaving a flat smoothed surface (discolored brown) for the addition or repair of a separate piece. At the sides and nape of the neck is a fringe of curls. The face is small: a low triangular forehead, a swelling brow, deep-set almond-shaped eyes with ridges for upper lids, straight nose; full lips slightly parted; small chin and full, strong neck. Well-shaped ear with drilled center on right side, while left ear is exaggeratedly long and thick, looking

more like a flame-like lock of hair. Tiny depressed pinholes on the earlobes, but not drilled through. Slight polish on face and neck.

COMMENTARY: This head appears in the 19th c. photograph taken in Italy where it is placed on **67**, an Eros statuette (Fig. 4). The head is certainly the wrong scale for the body and cannot belong. Guldager Bilde and Moltesen suggest the possible identification of this head with a dancing figure, perhaps a maenad, based on its torsion. This is a very appealing suggestion, for a dancing maenad would fit well with the iconography of the sylvan world of Diana and Dionysos at Lake Nemi. The *sfumato* treatment of the eyes gives the figure a languorous expression.

57
SMALL FEMALE HEAD

MS 3468
Sanctuary of Diana Nemorensis, Lake Nemi, Italy (see Introduction, pp. 73 ff.)
Late Republican period, late 2nd c.–1st c. BC
White marble with medium-sized crystals
P. H. 0.126; P. W. 0.095; P. Depth 0.11 m.
PUBLICATIONS: *Guldager Bilde 2000:109, n. 148; Guldager Bilde and Moltesen 2002:32, Cat. no. 15, figs. 56–57.*

CONDITION: Single fragment preserved from the top of the head to the lower neck, missing the left side of the face and large circular area at the back of the head and neck. At top of the head on the right side is a circular surface fault in the marble. Head is extremely pitted and worn, leaving almost no original surface area preserved.

DESCRIPTION: Small female head from a statuette turned slightly to the left. The hair is drawn to the sides of the head in waves, gathered in a roll over the ears and to the back of the head in a thickened bunch. Above the forehead the hair rises in a peak, with a slight part in the middle, possibly the remains of a diadem. Neck has a thickened roll at the front.

COMMENTARY: The poor condition of this head allows little specific comment about the piece. The identity of the female may be presumed to be either Diana or Aphrodite,

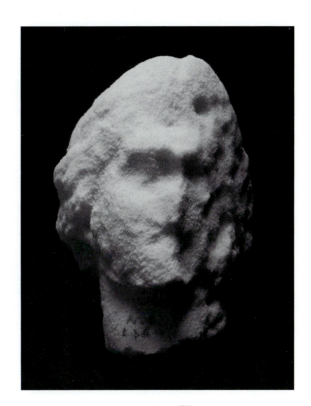

CAT. NO. 57

based on the presence of other votive statuettes of these two divinities at the Sanctuary of Diana. For references to sculptures of Diana wearing a diadem see Guldager Bilde and Moltesen 2002:32.

58
RIGHT FOOT: FEMALE

MS 3463
Sanctuary of Diana Nemorensis, Lake Nemi, Italy (see Introduction, pp. 73 ff.)
Probably Late Republican period
Large-grained white marble
P. H. 0.065; P. L. 0.124; P. W. 0.055; Max. D. leg at break, front to back 0.049 m.
PUBLICATIONS: Guldager Bilde and Moltesen 2002:37–38, Cat. no. 27, figs. 94–95.

CONDITION: Single fragment preserving the complete foot with the sole of a sandal and a portion of a plinth beneath, broken off at the ankle. Chip missing from big toe. Edges of plinth broken off all around. Surface abrasion near holes for sandal straps. Small modern drill hole in the bottom of the plinth for attachment to a base.

DESCRIPTION: Sandaled right foot for a small human statuette, resting flat on a plinth. Plinth, sandal, and foot are carved in one piece with grooves defining the edges of the sole of the sandal from the foot and plinth. The front of the sandal has an indentation between the big toe and second toe, indicating a thonged sandal. On the instep of the foot are four small drill holes for the attachment of the sandal straps in metal.

COMMENTARY: Guldager Bilde and Moltesen tentatively date this to the Late Republican period (late 2nd–1st c. BC) based on the sandal type. The indentation of the sole between the first and second toes is a uniquely diagnostic detail of Greek footwear which, according to Morrow (1985:144–45), was in vogue beginning around 200 BC and evolved in the course of the 2nd c. BC with a deeper and narrower indentation. Morrow also shows that only females wear the thonged sandal (1985:90).

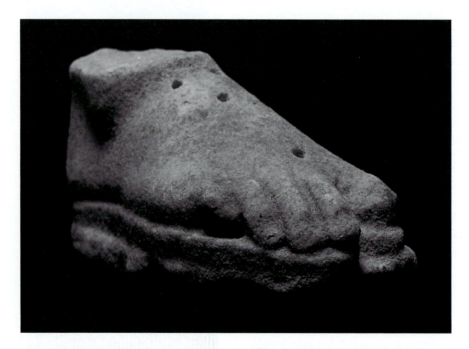

CAT. NO. 58

Votive Figures: Male (59–72)

59
STATUE OF DANCING(?) YOUTH

MS 3466 *(see Fig. 4)*
Sanctuary of Diana Nemorensis, Lake Nemi, Italy (see Introduction, pp. 73ff.)
Late Republican period, 1st c. BC
White Parian marble. Sample taken for stable isotopic analysis, March 24, 1999, from back of left leg near bottom break. Results from Dr. Norman Herz, University of Georgia: $\delta^{13}C$ 5.200; $\delta^{18}O$ -3.305 (Paros, Lychnites).
P. H. 0.905; Max. P. W. tree trunk and legs 0.22; Max. P. Depth buttocks 0.155 m.
PUBLICATIONS: *Furtwängler 1905:261, no. 31; Luce 1921:191, no. 63; In the Sacred Grove of Diana 1997:111, 208, n. 245; Guldager Bilde 1998:46; Guldager Bilde 2000:109, n. 147; Guldager Bilde and Moltesen 2002:23–24, Cat. no. 4, figs. 18–20; Moltesen, Romano, and Herz 2002:105.*

CONDITION: Mended from four fragments, preserving torso, lower neck, legs to shins, and tree support. Missing head, both arms, both lower legs and feet, and fragments from bottom of tree at side and back, penis, chip from left buttocks. In archival photo of group of Nemi sculptures taken around 1895 in Italy the right biceps was intact (Fig. 4), but has since been broken. Many small surface chips and scratches. Dark orange (iron?) discoloration on back, right side of torso and right leg, and front of right leg. Stump of left arm is dark brown, possible stain from iron dowel. Modern hole for mounting rod drilled through bottom of right buttocks.

DESCRIPTION: Statue of an elongated naked male in a twisted pose. The right arm was upraised; the head and neck turned sharply to his left; the left forearm may also have been raised, to judge from the right angle of the attachment surface. Right leg is forward and straight; left leg is back and bearing the weight as hips and legs are twisted to the left and backwards, supported by a tree trunk. Stomach is protruding as the lower back forms a concavity. The penis was separately made and attached. Body forms are long and lean with modelling in subtle planes. The tree trunk is carved in one piece with the lower left leg and is joined to the leg by a marble strut at

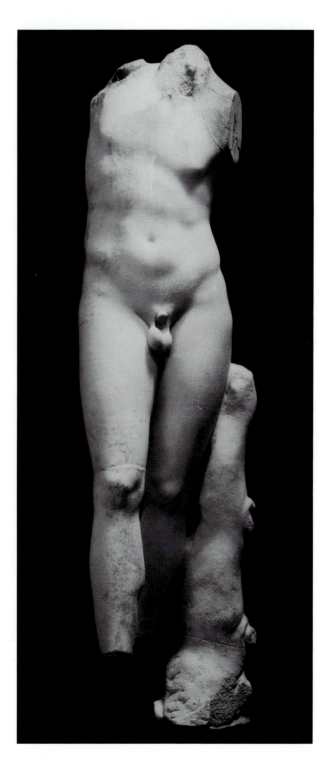

CAT. NO. 59

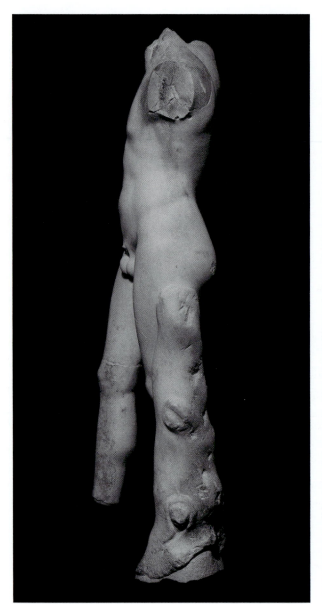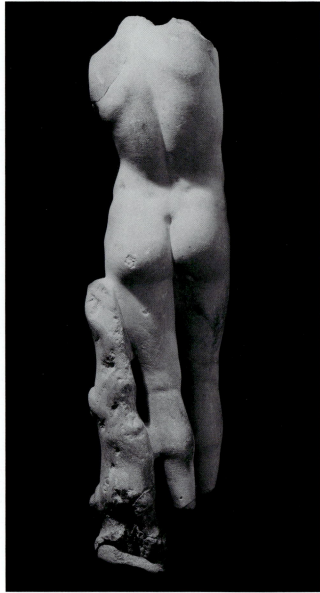

CAT. NO. 59

the side of the mid-calf and at the side of the upper thigh. The tree trunk tapers from a broad base with a ledge at the inside edge, to a narrow rounded top. On the outside of the trunk there are two circular knots. Head was made in one piece with the statue. Right and left arms were made separately and attached to flattened joining surfaces above each biceps with iron dowels. On the back of the tree trunk at the bottom are remnants of a large iron dowel for the attachment to a plinth.

COMMENTARY: This is one of the larger of the votive sculptures in the Nemi corpus, with the exception of **65**, a composite piece. The twisted pose with at least one arm raised suggests the possibility of a dancing figure. See **60** for another possible dancing figure, identified as a hermaphrodite, although **60** has a "brassiere." It is also possible that, rather than dancing, this elongated figure is striking an erotic, sensuous pose (see the discussion above, p. 79, of "sexy boys").

60
STATUETTE OF DANCING YOUTH: HERMAPHRODITE

MS 3457 + MS 3462 (see Fig. 4)
Sanctuary of Diana Nemorensis, Lake Nemi, Italy (see Introduction pp. 73 ff.)
Late Republican period, late 2nd–1st c. BC
Lower body: large-grained white marble; upper body: fine-grained white marble. Sample taken for stable isotopic analysis, March 25, 1999, from back of left leg stump of MS 3457. Results of analysis by Dr. Norman Herz, University of Georgia: δ¹³C 4.713; δ¹⁸O -3.959 (Ephesos or Parian Lychnites).
P. H. two fragments joined 0.76; Max. W. 0.15; Max. Depth 0.135; W. torso join 0.125; Depth torso join 0.11; P. W. at shoulders 0.17; P. Depth shoulders 0.15 m.
PUBLICATIONS: *Luce 1921:192, no. 65; In the Sacred Grove of Diana 1997:111, 208, n. 245: dancing satyr; Guldager Bilde 1998:46, fig. 14: probably a hermaphrodite; Guldager Bilde 2000:109, n.147; Guldager Bilde and Moltesen 2002:35–36, Cat. no. 21, figs. 74–78; Moltesen, Romano, and Herz 2002:103, 106.*

CONDITION: Made in two pieces and joined at the upper chest preserving the torso from the neck to the lower legs, including the lower left leg and the front of the right foot. The upper torso fragment has most of the right arm missing; the left arm (with traces of rusty iron dowel in splintered joint) and the head would have been separately attached. Lower torso piece is in two fragments joined at the height of the knees. Penis is broken off. Front of plinth is broken off. Many chips and nicks, especially large surface chips above navel, on left thigh, and on outside of tree trunk at top. Much dark surface discoloration, especially on the front, perhaps evidence of ancient paint. Surface preservation of the lower half of the torso is poor, while the polish on the upper part of the body is apparent.

DESCRIPTION: Nude male with elongated body in twisted pose bending to his right. Head appears to have been turned to the right, as if looking over his shoulder. He wears a wide band below the breasts. The breasts are sagging with the right lower than the left. The right arm, once separately attached and secured with a dowel, was held to the right at a downward angle, while the separately attached left must have been lifted high. The thighs are close together; straightened right leg is forward bearing the weight with

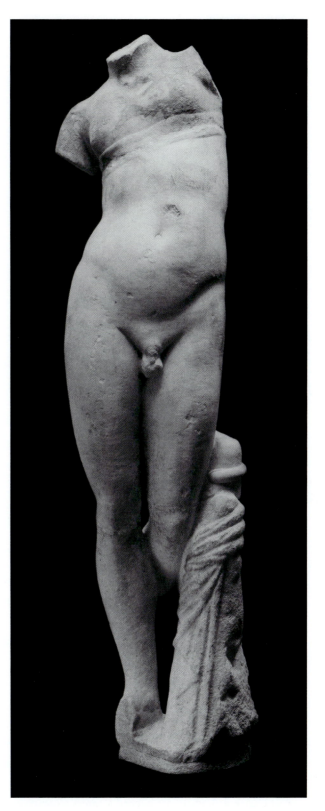

CAT. NO. 60

113

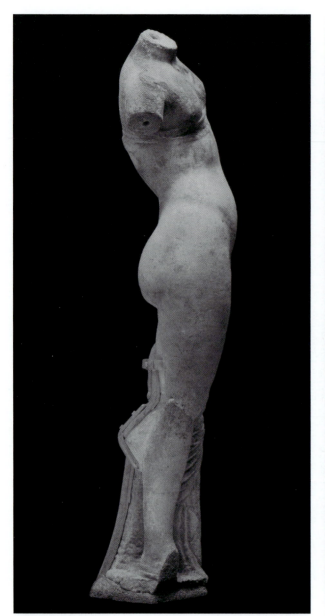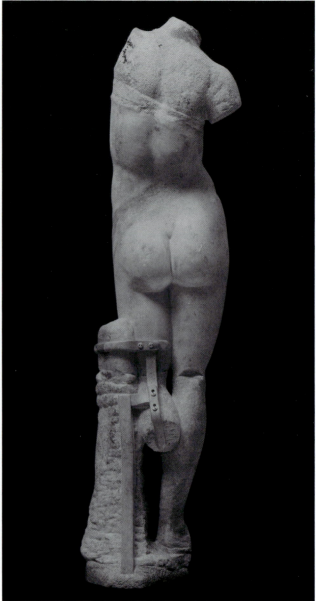

CAT. NO. 60

the right foot out-turned; the left leg is bent back and is held up behind the right leg. The lower left leg was added separately and attached to a roughened surface with a dowel, the cutting for which survives. The right forefoot was separately attached. There is a slight suggestion of the sole of a sandal below the remains of the right foot.

The back is dramatically arched forming a concavity at waist height, while the stomach protrudes. The body forms are long and effeminate with pronounced breasts, wide hips, full stomach and buttocks, and long legs. At the outside of the left leg from above the knee is a support in the form of a tree trunk covered with drapery. The roughened bark of the trunk is defined on the back, while the drapery is carefully arranged on the front with closely packed diagonal folds and the end falling vertically with a corner overfold. An oval(?) plinth (P. L. 0.145; P. W. 0.113;

H. 0.015–0.02 m.) with a roughened upper surface is carved in one piece with the right foot.

The head was separately fashioned and once attached with a dowel and a roughly worked joining surface. The separate upper body fragment is fitted over the scored rim at chest height; the upper surface of the lower torso fragment is scored with a chisel and point (probably for bonding of the adhesive) and in the center is a large circular dowel hole (D. 0.02 m.) filled with a white substance that may be degraded lead or stucco.

A slightly raised band appears on both the upper and lower torso fragments. A wide orangish-brown streak runs diagonally across the back from upper right to the lower left hip, possibly the remnants of an object added in another material, such as a metal belt or animal pelt. There are traces of dark paint over a white ground on front of upper torso, on belt masking join, and on the drapery. The front of the upper torso is finished with a slight polish, while its back is rough and unfinished.

COMMENTARY: The dramatic pose of the figure, with one leg back and up, back arched and body bending to the right, is like that of a dancing satyr, a popular Hellenistic theme. Two marble statues (P. H. of 1.56 and 1.22 m.) of a dancing satyr type were recovered from the Antikythera shipwreck, establishing a solid date for its popularity in the Italian market of the 1st c. BC (Bol 1972:72–74, nos. 30 and 50, pl. 41, 1–5). For a spectacular bronze example, the Mazara Satyr, recently recovered from the sea between Sicily and Tunisia, see Petriaggi 2003.

There are overtly feminine characteristics in this figure including the band or "brassiere," as Guldager Bilde and Moltesen identify it (2002:35), pushing up the large breasts. Dancing women like maenads wear such a belt to keep their garment from falling off and exposing them-

CAT. NO. 60

selves completely (see Bieber 1961a: figs. 90–92). In addition, the body forms and the sandaled foot are feminine and indicate a probable hermaphrodite. For the type of the nude dancing (*kallipygos*) hermaphrodite see *LIMC* V, Hermaphroditos: 272. The examples of the type are restricted to a small group of bronze figurines and "Neo-Attic" reliefs, such as the two marble *kraters* from the Mahdia shipwreck, submerged between ca. 80 and 60 BC, where the hermaphrodite is dancing with the drunken Dionysos and his companions (nos. 12–14). There are no large-scale sculptures in stone of this type. The iconography of the dancing hermaphrodite fits well in the Dionysiac world, as is shown on the Mahdia *kraters*, and would not be out of keeping with the Nemi sculptural corpus. See also **59** for another possible dancing figure, on a slightly larger scale.

61
STATUETTE OF NUDE YOUTH

MS 3481 (see Fig. 4)
Sanctuary of Diana Nemorensis, Lake Nemi, Italy (see Introduction, pp. 73 ff.)
Late Republican period, late 2nd–1st c. BC
Large-grained white marble (+1 mm.). Sample taken for stable isotopic analysis, March 24, 1999, from back of right thigh. Results from Dr. Norman Herz, University of Georgia: $\delta^{13}C$ 4.174; $\delta^{18}O$ -3.377 (Paros, Lychnites).
P. H. 0.587; W. Shoulders 0.173; W. hips 0.132; D. neck break 0.045 m.
PUBLICATIONS: Furtwängler 1905:261; Luce 1921: 191, no. 64; In the Sacred Grove of Diana 1997: 111, 207, n. 242; Guldager Bilde 1998:46; Guldager Bilde and Moltesen 2002:33–34, Cat. no. 18, figs. 64–66; Moltesen, Romano, and Herz 2002:106.

CONDITION: Preserved from neck to legs. Both legs broken off above the knees and mended. Lower right leg and foot missing from above ankle; front of left foot missing. Both arms missing from below shoulder stumps. Circular patch (0.032 x 0.039 m.) on side of left buttocks where support is broken off. Small knob-support (D. 0.01 m.) on outside of right hip where right hand rested. Surface of body has many chips and patches of discoloration. Entire surface is pitted and very worn. The degree of wear on the front is more severe than on the back.

DESCRIPTION: Statuette of standing nude male in a frontal pose with the left leg crossed over the right. The right leg is the supporting leg and the right hip is thrust out to the side, although a supporting member, such as a tree stump, must have added to the stability of the piece on the left side. There are traces of a support under the left heel. The right shoulder dips dramatically lower than the left and the small support on the right hip indicates that the right arm was bent and held at hip height. The left arm was down. The head appears to have been turned upwards toward the left. Body has elongated proportions with well-defined musculature, including a pronounced epigastric arch. Drill has been used to separate the genitalia from the thighs, to define the break between the right and left thighs, both in front and in back, and to define the arms from the torso.

COMMENTARY: The crossed ankles, leaning pose, tilt of

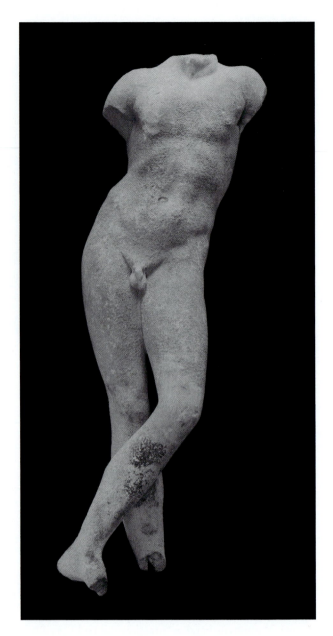

CAT. NO. 61

the head to the left, and probable support on the left side of this figure are reminiscent of the copies and variants of a famous statue of Pothos, the personification of erotic desire. The Pothos's attribution to the late 4th c. Skopas is a subject of much discussion, and it may, in fact, be a Late Hellenistic type (for discussions of the issues see Ridgway *Hellenistic Sculpture* I:87–88; *Fourth Century Styles*: 253–4). It would be difficult to date this statuette in a time period

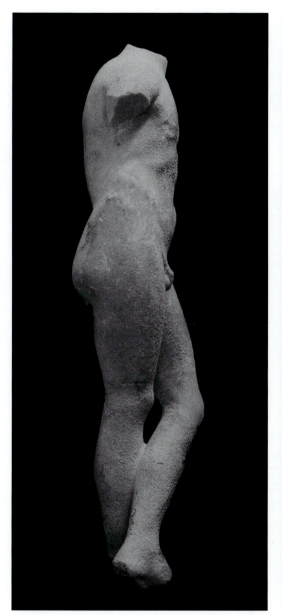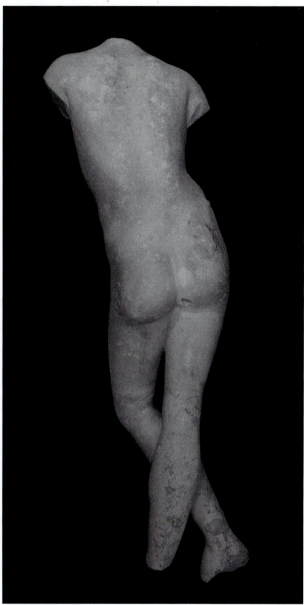

CAT. NO. 61

any earlier than the late 2nd c. BC, as it fits so well into the same *milieu* as the rest of the Late Republican votive sculpture from Nemi. Thus, if the pose is imitating the Pothos, the type had to have been created by the late 2nd or 1st c. BC and cannot be an Imperial Roman creation, as some have suggested. As Ridgway points out (*Fourth Century Styles: 254*), characteristic of many of these Pothos copies and variants are the effeminate body forms and hair style reminiscent of Eros or Hermaphrodite. In the case of this particular statuette from Nemi, the body forms do not seem especially feminine, while in other examples from Nemi of the nude leaning youth, such as **62**, the effeminate nature of the figure is pronounced. See also **63** for another leaning nude male, but with the cloak to the left side preserved. See p. 79 above for a discussion of the identitiy of the nude male figures.

62
STATUETTE OF NUDE YOUTH

MS 3465 (+ *associated fragments MS 6012a, b and MS 3464; see CD Fig. 24*)

Sanctuary of Diana Nemorensis, Lake Nemi, Italy (see Introduction, pp. 73ff.)

Late Republican period, late 2nd–1st c. BC

Large-grained white marble. Sample taken for stable isotopic analysis, March 24, 1999, from patch on back of left thigh. Results from Dr. Norman Herz, University of Georgia: $\delta^{13}C$ 3.955; $\delta^{18}O$ -3.665 (Paros, Lychnites).

P. H. 0.66; P. W. shoulders 0.29; D. neck break 0.085 m.

PUBLICATIONS: *Luce 1921:191, no. 62; Furtwängler 1905:261; In the Sacred Grove of Diana 1997:111, 207, n. 242: Hippolytos(?); Guldager Bilde 1998:46: possibly Eros; Guldager Bilde 2000:109, n.148; Guide to the Etruscan and Roman Worlds 2002:56, fig. 83; Guldager Bilde and Moltesen 2002:34, Cat. no. 19, figs. 67–70; Moltesen, Romano, and Herz 2002:103, 106.*

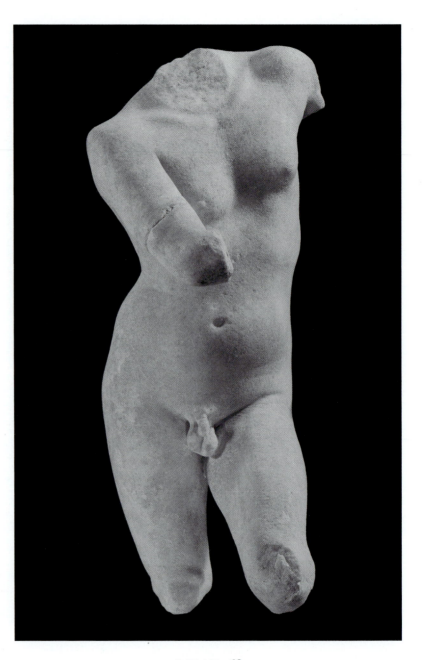

CAT. NO. 62

CONDITION: Missing the head, entire left arm (which was pieced), the right arm below the elbow (which was pieced), both legs below the knees. A fragment of the right arm is attached above the elbow; a fragment of the left leg and genitals is attached at the top of the leg. Large surface fragment missing from left buttocks and thigh where ancient support was carved. Chip missing from back on left side. Many small chips, scratches, and areas of discoloration, especially over left back and shoulder. Entire surface of statue is worn and rough to touch.

DESCRIPTION: Statuette of a nude youth leaning forward with his right leg straightened and back, bearing the weight, while the left leg is bent and in a forward position.

The body is twisted to the left in an S-curve. The right shoulder is lowered and the right upper arm held close, while the lower arm is bent across the front the body above the height of the navel. The left shoulder is high. From the remaining neck surface the head appears to have been leaning forward. The body forms are effeminate with full

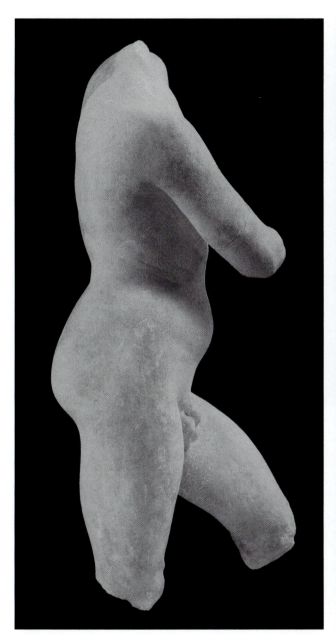 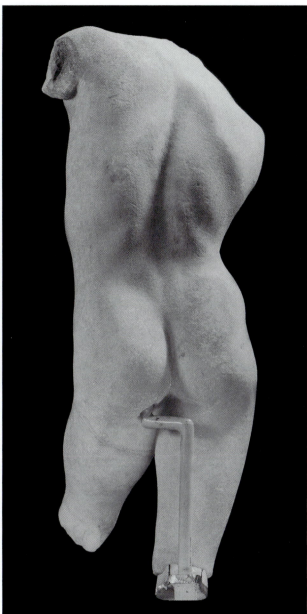

CAT. NO. 62

breasts, prominent nipples, and paunchy abdomen, while the male genitalia are small. The collarbones form a pronounced arching ridge below the neck. The buttocks and hips are full and taut, and the back of the figure presents a more masculine appearance.

Head and neck would have been carved in one piece with the body. Right arm was separately attached below the elbow (circular hole: D. 0.013; Depth 0.03 m.); the left arm was attached separately at the shoulder where the remnants of an iron dowel are embedded, leaving much reddish discoloration on the stump of that arm. The left leg below the knee is separately attached.

CAT. NO. 62A

CAT. NO. 62B

ASSOCIATED FRAGMENTS:

A. *LEFT FOOT ON ROCK*
B. *LOWER LEFT LEG*
MS 6012a–b
Sanctuary of Diana Nemorensis, Lake Nemi, Italy (see Introduction, pp. 73 ff.)
Late Republican period, late 2nd–1st c. BC
Large-grained white marble
A: P. H. 0.208; Max. P. W. plinth 0.25; Max. Depth plinth 0.14 m.
B: P. H. 0.19; W. upper break 0.068; W. lower break 0.047 m.
PUBLICATIONS: *Luce1921:191, no. 62: mentions a left leg on a rock; Guldager Bilde and Moltesen 2002:38, Cat. no. 29, figs. 98–100.*

CONDITION:
A: Single fragment missing tips of all the toes, the back and left sides of the plinth. Small fragments around ankle join have been reattached. Chips from front and right sides of plinth and other small knicks and chips.

B: Single fragment preserving lower leg, with upper surface broken on a diagonal, dowel hole and small area of joining surface preserved; bottom of fragment has modern hole drilled for attachment. Some dark discoloration.

DESCRIPTION:
A: Left foot resting on a pile of rocks which, in turn, rests on an oval plinth (H. 0.025–0.03 m.). The foot rests flat on the top of the rocks, with the toes and the heel overhanging the rocks. The foot is short and wide with finely shaped ankle bones. A small hole is drilled beneath the foot between the big toe and second toe. A dowel hole is cut through the upper joining surface of the fragment (D. 0.018; Depth 0.02 m.), with the remnants of a modern metal dowel. The rocky pile is two or three levels high with naturalistically rendered, rounded and sharp boulders projecting in all directions. The plinth is flat on top and has an oval outline as it is now preserved. The bottom surface of the plinth is roughly picked.

B: Lower left leg from below knee to above ankle. Well-defined shinbone and calf which tapers to slim lower leg.

CAT. NO. 62C

Top surface has deep dowel hole, probably modern, drilled through for the attachment to the upper leg and knee (D. hole 0.013; Depth hole to attachment surface 0.05 m.).

C. FOOT: HUMAN
MS 3464
Sanctuary of Diana Nemorensis, Lake Nemi, Italy (see Introduction, pp. 73 ff.)
Late Republican or Early Imperial period
Large-grained white marble
P. H. 0.115; P. L. 0.14; P. W. 0.07; Max. D. leg at break (front to back) 0.065; P. H. plinth 0.024 m.
PUBLICATIONS: *Guldager Bilde and Moltesen 2002:38, Cat. no. 28, figs. 96–97.*

CONDITION: Single fragment preserving part of a foot and lower leg, missing front of the foot and the edges of the plinth on which the foot rests. Broken off above the ankle-bone on a diagonal with the front of the leg preserved to a greater height. Discoloration on inside of heel.

DESCRIPTION: Bare right foot of a half-lifesized statuette of human resting flat on a plinth. Foot is well shaped with high arch; foot widens at the break where the toes begin. Strong delineation of the ankle bones. Plinth carved in one piece with the foot.

COMMENTARY: Luce (1921:191, no. 29) describes this statuette of a youth resting his left leg on a rock. A left foot resting on a rock and a lower left leg fragment (MS 6012a, b) may have once been restored with this statuette, but there are no direct joins. The scale and the marble look compatible, but the surface wear is so different as to make the association of all of them questionable. The leg fragment MS 6012b preserves a fine polish; the surface of the foot and rock pile fragment MS 6012a is well preserved, although slightly discolored. On the other hand, the surface of the body of figure **62** is sugary and worn. MS 3464 and MS 6012a are almost certainly from the same statue, and both could belong to **62**, while MS 6012b is dubious.

The association of a nude statuette with a rocky ground fits well into the picture of the corpus of sculpture from the sanctuary at Nemi. The wooded environment of Diana and Dionysos and his followers is suggested by the rocky pile, just as tree trunks are appropriate supports for the statuettes of fauns, satyrs, and other creatures of the woods. Guldager Bilde and Moltesen correctly point out that this device is a popular one in Hellenistic sculpture and is especially well-documented in Rhodian sculpture (e.g., Merker 1973: no. 12, fig. 11).

121

63

STATUETTE OF NUDE YOUTH

MS 3482
Sanctuary of Diana Nemorensis, Lake Nemi, Italy (see Introduction, pp. 73ff.)
Late Republican period, late 2nd–1st c. BC
Fine-grained white marble. Sample taken for stable isotopic analysis, March 24, 1999, from bottom of drapery in back. Results from Dr. Norman Herz, University of Georgia: $\delta^{13}C$ -7.553; $\delta^{18}O$ -6.297 (unknown).
P. H. 0.20; W. 0.24; Depth 0.165 m.
PUBLICATIONS: In the Sacred Grove of Diana 1997:111, 207, n. 242; Guldager Bilde 1998:46; Guldager Bilde and Moltesen 2002:34–35, Cat. no. 20, figs. 71–73; Moltesen, Romano, and Herz 2002:106.

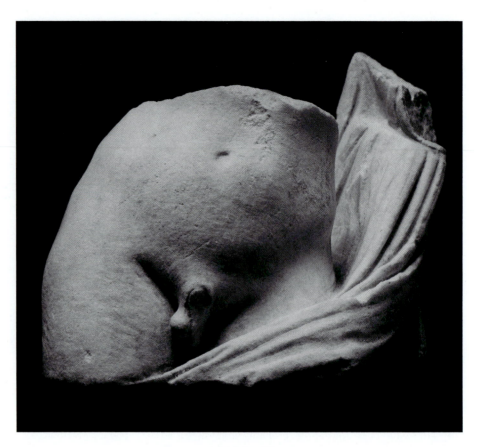

CAT. NO. 63

CONDITION: Single fragment preserving the body from above the navel to the upper thighs with drapery adjoining the upper thighs. On left side of drapery is a flattened surface for joining to a pillar. The bottom surface of upper legs is finished for joining to the separately fashioned lower part of the statue. Penis broken off. Many small chips and nicks, especially along edge of drapery. Some reddish orange discoloration on left side of stomach. Separately attached left arm missing.

DESCRIPTION: Statuette of a nude youth in a frontal pose, standing on his right leg and leaning his left side against a supporting pillar which is covered by drapery. The figure may be standing with the left leg crossed over the right, as in **61**. The separately attached left arm was leaning on the pillar, while the *himation* envelops the left arm. The drapery falls down in a large sweep the full depth of the statuette and twists to cover the front of the upper left thigh. A smaller section of the garment falls vertically at the left edge in front of the pillar. Deep drilled channels define the folds of the garment. At the left side of this fragment is a finished flat surface of a pilaster with three small drill holes for the attachment of some decoration. Above that area is another smoothed surface with two drill holes (one small and one larger), probably for the attachment of a capital. The circular attachment surface for the left arm survives at the front of the drapery with remnants of two small drill holes (each 0.005 m.). The body forms are full with a slightly protruding stomach and large thighs. The back of the figure is only summarily worked, and was not meant to be seen.

COMMENTARY: The typology and pose of this figure are related to that of **61**, reminiscent of the leaning Pothos, often attributed to Skopas. In this case, however, the drapery and support for the figure are partially preserved. The body proportions are more solid and less elongated than those of **61**. See above, p. 79, for an interpretation of the nude male statuettes at Nemi.

64
STATUETTE OF NUDE YOUTH

MS 4036
Sanctuary of Diana Nemorensis, Lake Nemi, Italy (see Introduction, pp. 73 ff.)
Late Republican period, late 2nd–1st c. BC
Fine-grained white marble
P. H. 0.21; Max. W. 0.15; Max. P. Depth 0.12 m.
PUBLICATIONS: In the Sacred Grove of Diana 1997: 111, 207, n. 242; Guldager Bilde 1998:46; Guldager Bilde and Moltesen 2002:36, Cat. no. 22, figs. 79–80.

CONDITION: Preserved from near waist to upper thighs, including genitalia. A portion of the finished upper surface for the attachment of the upper body is preserved. Left side of fragment broken off on a diagonal near an iron dowel that has left orange discoloration on the back and joining surface. Left buttock broken off and a piece (probably not original) is reattached. The separately attached penis is missing. Many small nicks and flaws in the surface.

DESCRIPTION: Nude male in frontal pose with right and left thighs positioned close together with the weight on the right leg. The exact leg position is difficult to assess given the state of preservation, although it does not appear to be a twisted pose since that would be reflected in the hips. The

CAT. NO. 64

lower back has a pronounced concave curve. The upper part of the body was added separately. The preserved upper oblique surface has been smoothed and scored with a rasp and point. In the center of the fragment are the remnants of an iron dowel (D. 0.01; Depth 0.045 m.) for the attachment of the upper and lower segments. A drill hole for the separately attached penis is preserved. The body forms are full and well modelled with slightly protruding stomach and large buttocks. Back of the figure is well-finished with a drilled groove separating buttocks. Modern dowel hole is drilled into the broken bottom surface.

COMMENTARY: **60**, probably a dancing satyr, may be in a similar pose, and both statuettes had the upper torso fashioned separately, joined on oblique angles.

CAT. NO. 64

65
STATUE OF A SATYR WITH WINESKIN

MS 3452 (*see CD Figs. 25, 26*)
Sanctuary of Diana Nemorensis, Lake Nemi, Italy (see Introduction, pp. 73 ff.)
Pastiche of Late Republican period–Early Imperial period, with some modern additions
Marble of various kinds, including probably a Parian head; torso, wineskin, and left hand of Asia Minor marble; right arm of another Asia Minor marble; and the lower body and plinth of grayish veined Carrara. Samples taken for stable isotopic analysis, March 24–25, 1999, from various parts. Results of isotopic analysis from Dr. Norman Herz of the University of Georgia: head:

$\delta^{13}C$ 5.810; $\delta^{18}O$ -4.255 *(Sardis or Paros, Lychnites); left side of abdomen:* $\delta^{13}C$ 2.703; $\delta^{18}O$ -2.935 *(Marmara); chest:* $\delta^{13}C$ 2.578; $\delta^{18}O$ -3.092 *(Uşak or Marmara); back:* $\delta^{13}C$ 2.457; $\delta^{18}O$ -3.118 *(Uşak or Mylasa); right leg:* $\delta^{13}C$ 2.102; $\delta^{18}O$ -1.860 *(Paros, Chorodaki, or Carrara); plinth:* $\delta^{13}C$ 2.123; $\delta^{18}O$ -1.912 *(Carrara or Paros Chorodaki); strut:* $\delta^{13}C$ 2.178; $\delta^{18}O$ -2.154 *(Carrara); right arm:* $\delta^{13}C$ 2.658; $\delta^{18}O$ -8.018 *(Pentelikon or Iznik).*
H. 1.237; H. face brow to chin 0.11; H. plinth at front 0.05; H. plinth at back 0.10; Depth plinth 0.38; W. plinth 0.308 m.

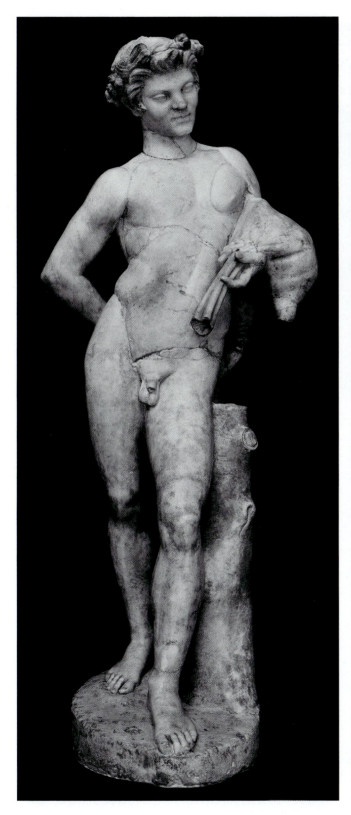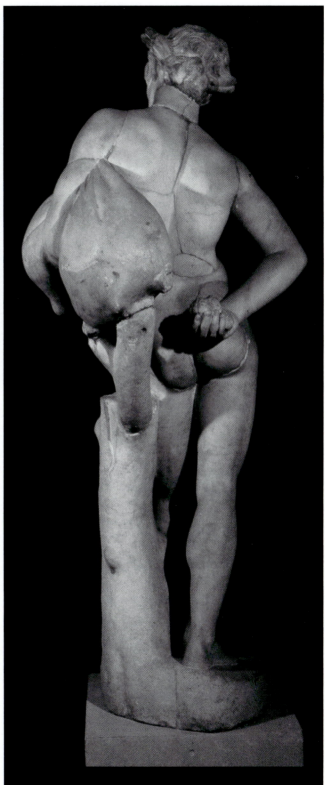

CAT. NO. 65

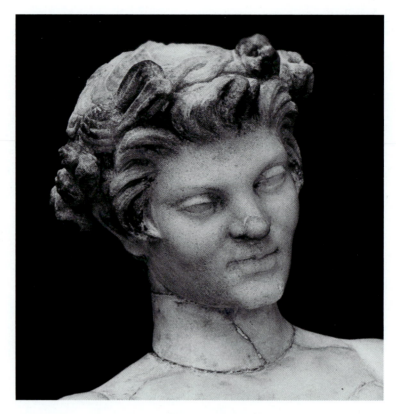

CAT. NO. 65

PUBLICATIONS: *Furtwängler 1905:261, no. 32; Bates 1910c:30, 32–33; Bates 1911:231–32, fig. 6; Luce 1921:172–73, no. 26; Reinach 1924, Vol. V: 51, 8; Edwards 1958:5, fig. 1;* In the Sacred Grove of Diana *1997:111, 207–8, fig. 79; Guldager Bilde 1998:43, fig. 8; Guldager Bilde 2000:109, n. 147; Guldager Bilde and Moltesen 2002:22–23, Cat. no. 3, figs. 14–17; Moltesen, Romano, and Herz 2002:102–3, 105.*

CONDITION: Restored from over 20 fragments, including the head with the tip of the nose; the neck in two pieces; the torso in numerous fragments; the right arm and hand in single piece; the left arm in at least four pieces with the wineskin; the legs and tree support in one piece with the upper left leg and plinth. Left foot broken at ankle and repaired, one toe of left foot restored in plaster. Missing penis, tip of one corner of wineskin. Traces of black paint on the hair, the eyes, left hand, and pinecones in right hand; brownish red paint on the wineskin and on the mouth.

DESCRIPTION: Standing young nude satyr holding a wineskin in the crook of his left arm and pinecones in his right hand behind his back. His right leg is straight with the right hip thrust out, the left leg forward and bent slightly. The upper torso is twisted to his left, while the head is tipped to his left and down. At his left side is a tree trunk support.

On his head he wears a wreath composed of two twisted strands decorated with pinecones and stalk-like bundles. The hair rises above the brow in thick locks, while thick comma-shaped curls fall in front of the ears on the upper cheek. Comma-shaped curls emanate in rows from the crown of the head. The face is effeminate and broad with a low forehead, widely spaced almond-shaped eyes with pronounced lacrimal glands and finely carved lids. The eyeballs are flat and slope in from top to bottom. The short nose has drilled nostrils. Full "Cupid's Bow" lips; high cheekbones; full chin with dimple in center. The ears are of human form but with additional extensions elongating their form blended into the locks of hair below the wreath. The face is carefully polished while the hair is not. The right shoulder dips lower than the left, as the arm is bent with

the forearm behind his back. In the upturned right hand the faun holds three circular pinecones. The back of the hand rests on the right buttock. The left shoulder is level and the arm is bent. In the crook of the arm is a full wineskin. In his upturned left hand he grasps the bunched-up neck of the skin, with the index finger of the left hand partially extended. Above the third finger is a small opening into the wineskin, partially concealed by a bit of iron. The upper torso is well modelled; the (restored) left breast is fuller than the right. The stomach protrudes as the lower back is arched, forming a concave curve. Above the buttocks is the stub of a tail. Body is polished.

To the left side of the figure, adhering to the upper thigh and to the back of the left calf, is a large tree stump support with a large oval knot in the front and other undulations to indicate its uneven surface. A large awkward "branch" support (oval in section and probably modern) attaches in two places from the back of the wineskin to the back of the tree trunk near the top. The stump of an ancient support survives on the back inner side of the wineskin. A hole has been drilled through this support at the upper back.

The statue is carved in one piece with the oval plinth which is thicker at the back than at the front so that the back right leg of the figure is on slightly higher ground than the left. To the right of the left foot a hole is drilled into the top of the plinth.

COMMENTARY: This satyr statue presents a vexing conservation and scholarly puzzle. The number of fragments of which the figure is comprised and the blending of marbles of different types suggest that it is a pastiche of ancient elements with a 19th c. restoration, created by the Roman art dealers in whose hands the Nemi collection was before its purchase by the UPM. While most of the Nemi statuettes are heavily pieced with appendages and heads missing, the completeness of this piece is, in itself, suspicious. Also the scale and style of this statue are not consistent with the rest of the corpus of Nemi sculptures, and Guldager Bilde and Moltesen rightly doubt that it came from Nemi at all (2002:22).

The head, though remarkably beautiful, strikes one as unusual; the hair is handled (especially the locks on the top of the head) much like that of the Dionysos *herm* (**72**) and may have been copied from that piece to link it to the Nemi corpus. Guldager Bilde and Moltesen (2002:23), however, cite the similarity of this head to copies of the so-called Satyr in the Garden type. They defend its authenticity and tentatively assign it a late 1st c. BC date. The head of the faun with grapes and panther in the Villa

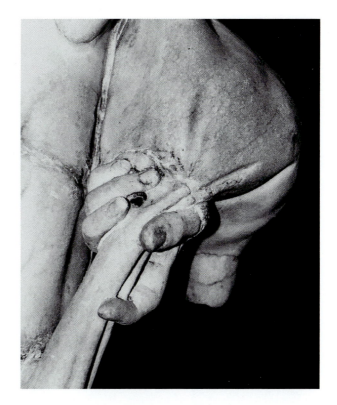

CAT. NO. 65

Albani dating to the late 2nd or 1st c. BC is close to the the head of this satyr and may be a close parallel or the source of inspiration for the late 19th c. copy (Bol 1990:316–24, no. 237, pl. 215).

The right arm and hand with pinecones, left hand, left breast, and support from the tree trunk to the wineskin are probably 19th c. restorations. Guldager Bilde and Moltesen point out (2002:23) that the pose of the right hand behind the back is a misunderstood quotation from the Herakles Farnese type holding the apples of the Hesperides from which it may have been copied. The lower body with the tree support and the plinth, all of a single piece of Carrara marble, are almost certainly ancient and can be dated to the very late 1st c. BC or 1st c. AD. The wineskin appears to have a small opening at the neck. This part of the statue, excluding the left hand fragment, may be original and the opening may be for a small pipe through which water flowed. (The other end of the pipe may be concealed behind the 19th c. strut at the back, though it is not possible to confirm this without X-rays.) Satyr statues were common in Roman gardens and this one may have been used as a fountain element with the water, suggesting wine, spurting out of the mouth of the wineskin.

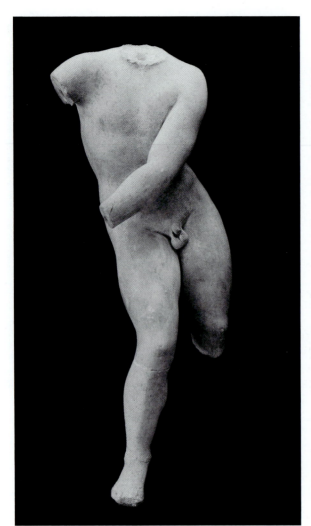 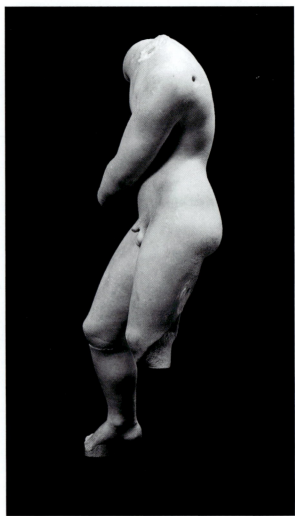

CAT. NO. 66

66
STATUETTE OF NUDE BOY: EROS UNSTRINGING BOW

MS 3456 (see Fig. 4)
Sanctuary of Diana Nemorensis, Lake Nemi, Italy (see Introduction, pp. 73ff.)
Late Republican period, probably late 2nd–1st c. BC
Large-grained white marble. Sample taken for stable isotopic analysis, March 24, 1999, from patch on back of left leg. Results from Dr. Norman Herz, University of Georgia: $\delta^{13}C$ 5.187; $\delta^{18}O$ -3.064 (Paros, Lychnites).
P. H. 0.575; Max. W. shoulders 0.23; Max. Depth left arm to hip 0.154 m.

PUBLICATIONS: *Furtwängler 1905:260, no. 7; Bates 1910c:30–31, fig. 17, incorrectly restored with a cast of* **69**; *Bates 1911:231; Hall 1914d:119, fig. 66; Luce 1921:173, no. 27; Döhl 1968:54, no. 27; In the Sacred Grove of Diana 1997:109, 207, n. 241, fig. 77; Guldager Bilde 1998:46, fig. 15; Guldager Bilde 2000:103, n. 148; Guldager Bilde and Moltesen 2002:32–33, Cat. no. 16, figs. 58–59; Moltesen, Romano, and Herz 2002:103, fig. 4, 106.*

CONDITION: Missing head, right arm, left hand, left leg from below knee, toes of right foot, and support behind the left leg. Right leg broken and mended below knee; right foot reattached. Excellent surface preservation with many small surface scratches and nicks. Holes drilled for modern mount below right buttocks and in bottom of right foot.

DESCRIPTION: Nude boy in a frontal pose with torso leaning forward and twisted slightly to the right, while the left arm is lowered across the front of the body at the height of the navel, and the right arm, to judge from the position of the stump, is raised at an angle to the right. The head would have been turned slightly to his right. The right leg is bent and is stepping forward and outward, while the left is slightly bent and positioned back, bearing the weight. A cylindrical strut, possibly a tree trunk, is broken off behind the left thigh leaving an oval patch (H. 0.053; W. 0.04 m.). The bottom of the right foot has an irregular protrusion broken off, probably part of a plinth.

The upper back forms a convex curve. On the right upper back two holes are drilled for the attachment of some object; on the back of the left shoulder one hole is drilled. A dark greenish-brown plug is visible in one of the holes and may indicate that these attachments were of bronze.

The head, entire right arm, left hand, and left leg below the knee were separately fashioned and attached by dowels and finished joining surfaces. Joining surface of the right arm has been punctuated with a point for the adhesion of glue. Part of iron dowel is embedded in right arm stump; left leg is discolored orange where iron dowel would have been inserted.

The body forms are soft and somewhat effeminate with full chest, stomach and hips. Small genitalia. Shinbone is well defined. Surface of body is treated with a polish.

COMMENTARY: The date of this statuette cannot be established with any certainty, but the style and technical comparisons with the rest of the corpus of Late Republican period statuettes from Nemi suggest it belongs to the late 2nd–1st c. BC (Guldager Bilde and Moltesen 2002:32). If that date is correct, then this figure is one of the earliest sculptural copies of the 4th c. BC Lysippan type of Eros Unstringing His Bow, mentioned by Pausanias (IX, 27.3) in a sanctuary of Eros in Boeotian Thespiae. (See Moreno 1995:111–29, especially 115, no. 4.15.3 which Moreno dates to second half of the 1st c. BC and identifies as the earliest copy of the type of which he knows.) Although Pausanias does not describe the statue, there are numerous Roman copies of this Eros type in various media, all of

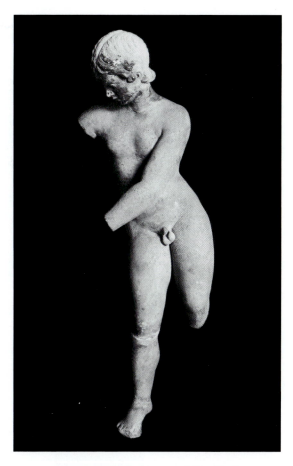

CAT. NO. 66 (*with cast of 69 added*)

which must go back to a single source. C. M. Edwards (1996:138–40) analyzes the pose of this Eros type and convincingly shows that Eros is neither stringing nor unstringing his bow in the copies, but rather testing the tension on the string. Another figure of Eros, **67**, of a different though related type, is on the same scale, of the same marble, and probably by the same hand or workshop as **66**. The two Eros figures from Nemi were almost certainly made as companion pieces, and were probably displayed in juxtaposition to one another, either as votives or as decorative elements in the Sanctuary of Diana.

As in the case of **67**, the small holes on the shoulders would have supported rather small wing attachments, probably very lightweight, perhaps of sheet bronze. Two marble statuette of Eros from this same period have similarly small holes on the back of the shoulders, one in Copenhagen from Kos (Nielsen and Østergaard 1997:30–31, no. 7) and one from Rhodes (see Merker 1973:29, no. 62, figs. 40–41).

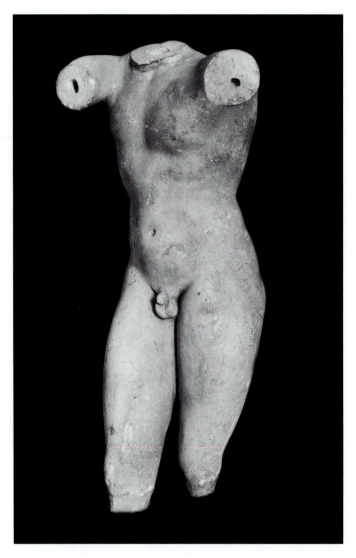

CAT. NO. 67

67
STATUETTE OF NUDE BOY: EROS
DRAWING OR SHOOTING BOW

MS 3473
Sanctuary of Diana Nemorensis, Lake Nemi, Italy (see
Introduction, pp. 73 ff.)
Late Republican period, late 2nd–1st c. BC
White marble. Sample taken for stable isotopic analysis,
March 24, 1999, from back of left leg. Results from
Dr. Norman Herz, University of Georgia: $\delta^{13}C$
5.182; $\delta^{18}O$ -3.336 (Paros, Lychnites).

P. H. 0.433; Max. P. W. shoulders 0.19; Max. P.
Depth buttocks 0.11; D. neck join 0.05; D. right arm
join 0.042 m.
PUBLICATIONS: *Furtwängler 1905:260, no. 28; Luce*
1921:174–75, no. 33; LIMC III, Eros: 881, no.
356; In the Sacred Grove of Diana 1997:110, fig.
77, 207, n. 241; Guldager Bilde 1998:46; Guldager
Bilde 2000:109, n. 148; Guldager Bilde and

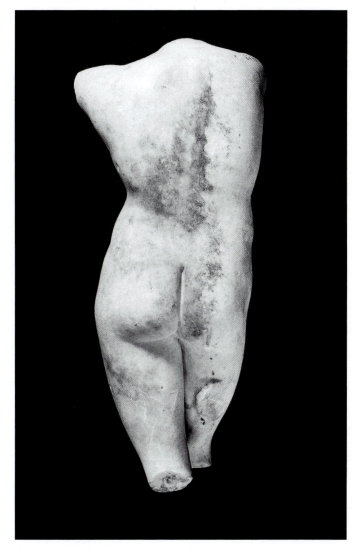

CAT. NO. 67

Moltesen 2002:33, Cat. no. 17, figs. 64–66;
Moltesen, Romano, and Herz 2002:103, 106.

CONDITION: Single fragment preserving the torso from the bottom of the neck to the knees. Head, most of arms and lower legs missing; end of penis broken off. Joining surface of the left arm is broken off. On the outside of the left thigh is a small hole, probably modern, that has been plugged with plaster. At the back of the right thigh is a circular patch (D. 0.043 m.) where a cylindrical support, probably a tree trunk (see below), was carved in one piece with the leg. (A plaster cast of this figure in the collection of the Museum, made in the 1960s or 1970s, shows a tree trunk support at the back of the figure. If there was a surviving support on the original, it is now missing from the collection.) Dark discoloration on back. Many small nicks and surface scratches, but in general, surface is in excellent condition.

DESCRIPTION: Statuette of young nude male in frontal pose with torso twisted to the left and the right leg in advance of the left. The back has a pronounced convex curve as the right arm is raised at shoulder height towards the front of the body; the left is raised to shoulder height and is extended at

131

an angle to the left. The body forms are soft with smooth transitions between the planes; the breasts and upper thorax are well-defined, while the stomach is slightly paunchy; full thighs and large buttocks. Small genitalia. The forms of the back are broadly rendered and muscular.

The head and arms were fashioned separately and attached to smoothed surfaces with oval dowels (dowel in neck: D. 0.015; Depth 0.043 m.; dowel for right arm: D. 0.009–0.01; Depth 0.03 m.). On the top of the right shoulder are three small attachment holes of different sizes (the largest, closest to the front: D. 0.008 m.); on the back of the left shoulder blade is one small hole (D. 0.007 m.). Drill was used to define the separation of the buttocks and the transition to the thighs. Surface of body has been polished.

COMMENTARY: This statuette is a variant of the Lysippean Eros drawing or shooting his bow (Guldager Bilde and Moltesen 2002:33; Döhl 1968:49–57; see *LIMC* III, Eros: 880–1, nos. 352–61) with a close parallel of Late Hellenistic date from Delos (*loc. cit.*, no. 356). The convex curve of the back and the forward position of the arms, characteristic of that Eros type (see Moreno 1995:166–67; yet see Edwards 1996:138–40 for a discussion of the meaning of the pose), together with the pairing of this figure with a copy of the Lysippan (un)stringing his bow (**66**), justify that identification. The head of this type should be turned sharply to the left looking over his left shoulder. Catalogue no. **66** is almost certainly made by the same hand or same workshop; the marble is from the same source (Parian) and both figures are on the same approximate scale (this figure is only millimeters smaller than **66**). The two Erotes might be thought of as a pair and may have been erected as a part of the same sculptural group.

There is only one small hole on the back of the left shoulder, while three of various sizes are on the right. Small wings must have been added of a light material like sheet bronze or gold (see examples under **66** for similar wing attachments), and the multiple holes on the right side might indicate the addition of an attribute like a quiver.

68
SMALL HEAD OF YOUTH

MS 3476 (see Fig. 4)
Sanctuary of Diana Nemorensis, Lake Nemi, Italy (see Introduction, pp. 73ff.)
Late Republican period, late 2nd c.–1st c. BC
White medium-grained marble
P. H. 0.135; P. W. 0.87; Depth 0.107 m.
PUBLICATIONS: In the Sacred Grove of Diana 1997: 111, cf. 208, n. 245; Guldager Bilde 2000:109, n. 147; Guldager Bilde and Moltesen 2002:36, Cat. no. 23, figs. 81–83.

CONDITION: Single fragment of a head from the top of the head to the lower neck. Left side of head and face, including part of left eye and left side of the mouth, broken off. Nose also broken off. Surface badly pitted amd worn. Dark discoloration and incrustation. Modern drill hole in base of neck.

DESCRIPTION: Male head from a statuette. Head is tilted sharply back, upward, and to the right, bound with a plain fillet. The hair is arranged in curly locks framing the face and covering the right ear. The curls are defined by a deep drill, sloppily rendered, and the transition from the hair to the neck in back is defined by a drilled furrow. The top and back of the head are covered by curls, rendered in lower relief by ridges and valleys. The hair falls over the neck in back in thicker vertical sections. The facial features are rendered in a *sfumato* effect with a low triangular forehead, open, slightly askew, downturned eyes, with a ridge defining the left eyebrow, while the right eye, which is set much lower, has no definition for the brow. Flat cheek, small mouth with pursed lips, long chin, strong neck. Ridge at the back of the left side of the neck possibly indicates the presence of a garment or an object held over the left shoulder.

COMMENTARY: The quality of the carving and execution of this head are poor. The identity of the male is open for speculation. Guldager Bilde and Moltesen identify the head as a faun, on the basis of the presence of so many other young male statuettes (fauns?) in the Nemi corpus (*In the Sacred Grove of Diana* 1997:111, cf. 208, n. 245).

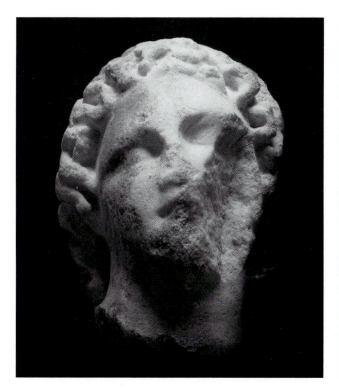 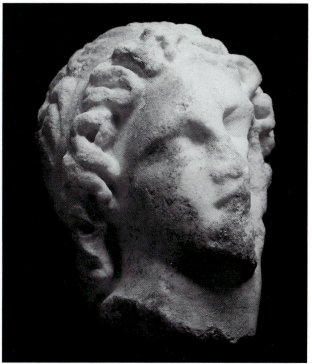

CAT. NO. 68

Clues to this figure's identity, however, are limited to the fillet, which can be worn by deities and mortals (e.g., athletes) alike. The other faun's head in the Nemi collection, with pointed ears and curly hair surrounded by a plain fillet (**70**), was, unfortunately, probably "doctored"

in the 19th c. If a young satyr, the type might be akin to the popular and much copied "Leaning Satyr" which has the same downturned gaze (Guldager Bilde and Moltesen 2002:36). See above p. 79 for a discussion of the interpretation of the young male figures.

69
HEAD OF CHILD FROM A STATUETTE: EROS(?)

MS 6028
Probably from the Sanctuary of Diana Nemorensis, Lake Nemi, Italy
Late Hellenistic/Late Republican period or Early Imperial period (late 2nd–1st c. BC)
Fine-grained white marble
P. H. 0.12; P. D. at neck 0.045–0.05 m.
ACQUISITION: *Found uncatalogued and undocumented in Museum basement in 1983. A cast of the head*

*was attached to **66** and appears in a photograph taken in the UPM in or before 1910 (Bates 1910c:30–31, fig. 17).*
PUBLICATIONS: *Unpublished.*

CONDITION: Single fragment of head. Right ear abraded. Surface of marble is much worn and pitted, although a slightly polished surface is preserved on the back of the neck.

DESCRIPTION: Head tilted toward proper right. A braid is brought up from the nape over top of head, with a longitudinal furrow running from the back of head to the forehead. Hair on either side of braid is carved in undulating waves. At the nape of the neck the hair is gathered in a horizontal bowknot. Bottom of neck is worked and circular hole drilled for dowel to attach head to body. Head was polished, as shown on the preserved surface at back of neck.

COMMENTARY: The hairdo is that of a child and is common on statues of Eros (see Bieber 1961a: figs. 88–89). The scale, style, joining technique, iconography, and date of this piece bring it into the sphere of the statuettes from the Sanctuary of Diana at Lake Nemi. The scale is exactly right for the two headless Eros figures from Nemi (**66** and **67**), but the marble and wear pattern are not. There is no specific record of this head among the Nemi corpus. The descriptions of some of the sculptures in the day-to-day finds list, published by Guldager Bilde in summary (Guldager Bilde and Moltesen 2002:49–50), are vague

enough (e.g., "un pezzo di testa marmo") that we would not recognize this specific piece. We also know, from the correspondence in the Museum's archives, that there were a few sculptures and small bronzes bought by the Museum separately from the initial group, offered by the Roman art dealer Alfredo Barsanti in September of 1897 and purchased in December 1897. Among these was a "Roman head from Nemi," purchased for $100. It is not possible to confirm if the reference is to this head, and there is no explanation of how this small head might have become separated from the main corpus of the Museum's Nemi sculptures.

For various discussions of this hairdo see Romano and Romano 1999:9–10, no. 14 (on a Cypriote statuette with associations to Isis); Daremberg-Saglio I, 2, 1918, *coma*: fig. 1810: Greek children, boys, cf. N. 53 for Erotes with hairdo; Thompson 1982:155–62; Raftopoulou 2000:1–3: hairdo is common on sculptures of infants; Herrmann 1993:304–7. Cf. Comstock and Vermeule 1976:212–13, no. 336: Julio-Claudian head from Attica.

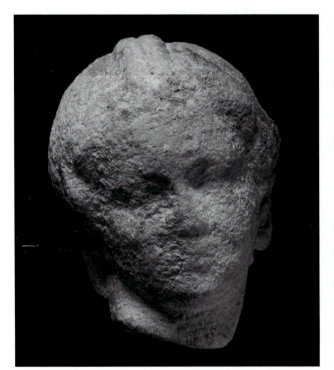
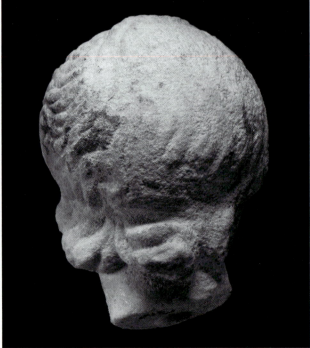

CAT. NO. 69

70
HEAD OF A FAUN

MS 3470
Sanctuary of Diana Nemorensis, Lake Nemi, Italy (see Introduction, pp. 73 ff.)
Late Republican period, late 2nd–1st c. BC with later recutting
Fine-grained white marble, possibly Parian (no marble testing)
P. H. 0.145; Max. W. above ears 0.09; P. Depth 0.15 m.
PUBLICATIONS: In the Sacred Grove of Diana 1997: 111, 208, n. 245; Guldager Bilde 2000:109, n. 147; Guldager Bilde and Moltesen 2002:36–37, Cat. no. 24, figs. 84–87.

CONDITION: Single fragment of head broken off just below the Adam's apple in front and at nape of neck in back. Tip of nose and chin damaged; tips of horn buds broken off. Some wear on top of head on locks behind fillet and on back of head. Surface condition is otherwise oddly pristine, as if the head was cleaned in the 19th c. The texture of the stone is soapy, especially on the face, and it appears that the head has been washed in acid.

DESCRIPTION: Head of faun with pointed ears in a frontal pose, with head tilted slightly to the right. Curly hair bound with plain fillet. Two comma curls fall down on forehead with the buds of two horns positioned behind them. Shock of hair with strands delineated with grooves at front above horns. On right side the curls are drawn back from brow above ear in large comma curls, while on left, a large curl forms a circle with a smaller lock above. In back the hair is brushed forward from a part below the crown of the head; below the part the hair radiates from a central point off center to the right. Below the fillet the hair hangs in longer curly locks along the nape of the neck. On the left side the curls on the neck swirl in a circular fashion. In front of ears a curving "kiss curl" rests on the upper cheek on each side; the right "kiss curl" droops much lower than the left; a drill channel separates the left "kiss curl" from the ear. The ears are elongated with the left longer than the right and with an oddly shaped lobe against cheek. The facial features are crisply carved. Fine incisions for creases mark the high forehead; the brow ridge on the left side is fuller and more pronounced than that on the right; the eyes are wide open and the lids are defined as ridges; finely incised lines on the bridge of the nose and crow's feet beside the eyes; finely sculpted thin nose with nostrils deeply drilled; to right and left of nostrils are deep furrows; area around

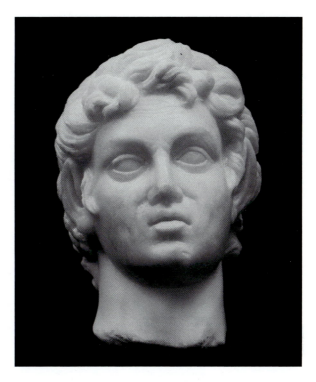

CAT. NO. 70

mouth is puffy with deep indentation on lower cheek; mouth is slightly open with drilled separation; full chin with double chin below. Strong neck with prominent Adam's apple.

COMMENTARY: There are serious questions about the complete authenticity of this head. At a minimum the head has been cleaned with acid to produce the slick, waxy surface. In addition, oddities of the carving, especially on the left side, suggest some recarving of the piece. The variety of the curls, the crispness of the facial features, the fine lines on the forehead, the furrows from the nose to the mouth and the indentation on the lower cheek are unlike the features of other small sculptures from Nemi or of the general time period. The head has a Baroque quality that does not fit well into the corpus of small sculpture from the site. The "kiss curls," however, on the upper cheeks—a feature that appears commonly on mannered sculptures of the 2nd c. BC—suggest that some aspects of this head may be genuine and fall within the *milieu* of the rest of the Nemi corpus. Guldager Bilde and Moltesen (2002:36–37) believe that the head is a reworked ancient sculpture of a young satyr who has been turned into an older satyr with the addition of the furrows, wrinkles and pouches. It is, of course, unclear whether this reworking is by an ancient sculptor or a late 19th c. one. I am inclined to accept the latter view.

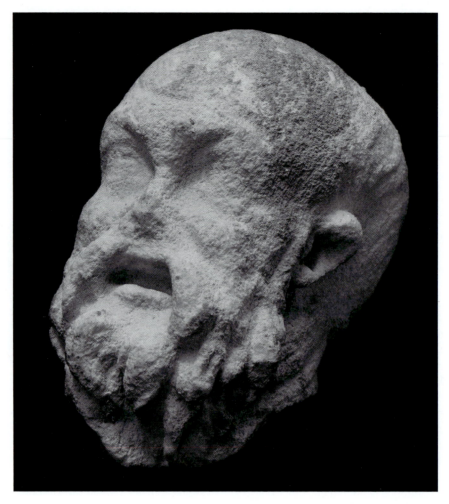

CAT. NO. *71*

71
HEAD OF SILENOS

MS 3469
Sanctuary of Diana Nemorensis, Lake Nemi, Italy (see Introduction, pp. 73 ff.)
Probably Late Republican period, late 2nd–1st c. BC
Very large-grained white marble. Sample taken for stable isotopic analysis, March 24, 1999, from back of neck. Results from Dr. Norman Herz, University of Georgia: $\delta^{13}C$ 3.892; $\delta^{18}O$ -3.560 (Paros, Lychnites)
P. H. 0.19; W. 0.109; Depth 0.143 m.
PUBLICATIONS: *Guldager Bilde and Moltesen 2002:37, Cat. no. 25, figs. 88–90; Moltesen, Romano, and Herz 2002:106.*

CONDITION: Single fragment preserving the head from the top to the neck in back and to the bottom of the beard in front. Much battered and worn, leaving no finished surface intact. Tip of nose and top of moustache broken.

DESCRIPTION: Half-lifesized bearded head of an old Silenos. Mostly bald, round head with some indications of hair in back and above and in front of ears. Creased brow; deeply sunken wide-open eyes beneath arching brows; small nose; open mouth, defined with drillwork at corners with slight suggestion of upper teeth; cheek bones emphasized; full drooping moustache; long beard with clumps of

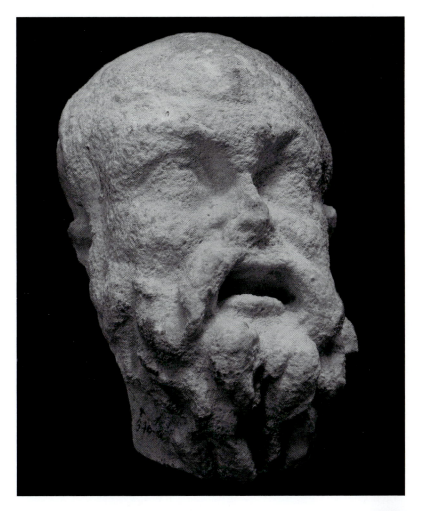

CAT. NO. *71*

hair hanging from his face and chin, separated by deep furrows. Small ears with out-turned thick tops.

COMMENTARY: The entourage of Dionysos plays a part in the ensemble of votive gifts in the Sanctuary of Diana Nemorensis. This old Silenos and the Pan on the plaque (**73**) are the only examples of the older generation of the woodland creatures in the Museum's Nemi sculpture collection, but Silenos is also depicted on late 4th c. BC Etruscan-type terracotta *antefixes* from the site (e.g *In the Sacred Grove of Diana* 1997:150, no. 40). The bad condition of this head belies the excellence of the carving and power of the depiction of this figure.

72
HERM BUST OF DIONYSOS

MS 3475 *(see CD Fig. 27)*
Possibly Sanctuary of Diana Nemorensis, Lake Nemi,
Italy (see Introduction, pp. 73ff.)
Ca. 1st c. BC–1st c. AD
Fine-grained white marble with micaceous green veins.
Sample taken for stable isotopic analysis, March 24,
1999, from square cutting for left "arm." Results
from Dr. Norman Herz of the University of Georgia:
$\delta^{13}C$ *3.030;* $\delta^{18}O$ *-8.541 (Sardis or Iznik), but*
visual appearance is close to Pentelic.
H. 0.41; W. 0.292; Depth 0.195 m.
PUBLICATIONS: *Luce 1921:189, no. 25; In the Sacred*
Grove of Diana 1997:111, 208, fig. 78; Guldager
Bilde 1998:43, fig. 9; Guldager Bilde 2000:109, n.
147; Guldager Bilde and Moltesen 2002:39–40, Cat.
no. 32, figs. 101–4; Moltesen, Romano, and Herz
2002:106.

CONDITION: Repaired from two major fragments, joined
on the right side of the bust, through the neck and right
side of the hair. Circular surface chip missing from hair
above right ear may have been separately made and reat-
tached in antiquity. One large hair fragment on the right
side of the head has been reattached (with modern adhe-
sive). Locks to proper right of central part are abraded and
much reduced from the original surface. Missing nose,
fragments of the hair and beard, piece at back of left side
of fillet, and large chip from bottom edge at front of bust.
Some orange-brown discoloration on the hair, beard, and
neck and on left arm attachment. Weathered surfaces on
the shoulders and in back. In back the surface of the hori-
zontal section and the left vertical section of the fillet are
broken off. The back surface is worn.

DESCRIPTION: Frontal head and *herm* bust of a bearded
male god wearing a fillet. Behind a central hair part is a
flat fillet which wraps around the head in several folded
sections, criss-crossed at the back with one end falling on
the right shoulders and looped up over the front of the
right shoulder in a wide band; the other end of the fillet
falls on top of the left shoulder and terminates at the back
of the shoulder in a diagonal "figure 8" tassel. On the
front of the fillet are a series of stippled patterns. The hair
is parted in the center and is pulled off the forehead in
horizontal wavy strands; on the proper right of the part
the locks are flat and worn, while on the left they are
defined by drilled ridges and valleys. The locks fall beside

the face in curls, most of which are long and corkscrew-
shaped, ending in tight spirals with drilled centers. Above
the fillet at the front is a row of flame-like curls. To right
and left of these are longer strands (longer on the left
than on the right). At the top of the head are larger
comma-shaped locks with less definition, producing a
whirligig at the upper back of the head. In back the hair
hangs down low on bust in somewhat flat, undulating
locks. From the top, front, and back there is a marked
asymmetry to the hair, possibly evidence of recutting.
Behind the ears the hair is combed over the front of the
fillet, with longer, less-well defined locks on the left than
on the right. The ears are well-formed and the left ear
protrudes as the mass of hair behind seems to push it

CAT. NO. 72

CAT. NO. 72

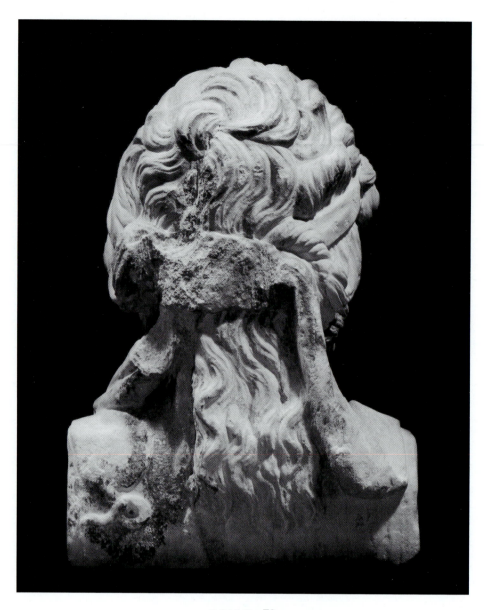

CAT. NO. *72*

forward. The hair blends into a long triangular beard with locks treated the same way as the hair. The right side of the beard is cut more deeply than the left. The moustache is of handlebar shape with the ends terminating in spirals with drilled centers.

The face is very flat, conveying a passive and expressionless air. Forehead is narrow and triangular; small almond eyes set close to the nose with the upper lids over-lapping the lower at the outer corners and pronounced tear ducts; on the left eye is a slightly roughened circular area for the iris (Guldager Bilde and Moltesen 2002:39 detected traces of black paint on the right iris which are no longer visible); high cheekbones and flat cheeks with somewhat gaunt sunken areas beside the mouth; mouth is open with well-formed small lips with little drill holes at the edges. Face is polished. Stippling with tiny pin-sized holes covers

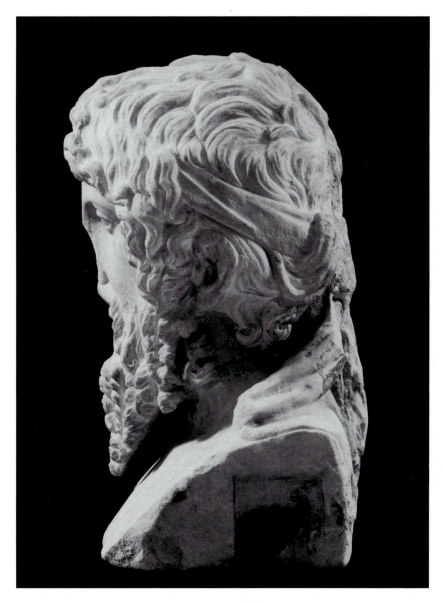

CAT. NO. *72*

parts of the forehead and cheeks, similar to the stippling on front of fillet.

The entire front of the bust is polished. The sides of the bust are finished for the insertion of post-arms. A recessed square contains within it a deep square cutting (ca. 0.05 x 0.05 m.) with a circular hole for the insertion of the "arms." The back of the bust is finished, with the hair and fillet well modelled. Bottom of *herm* has a flat surface.

COMMENTARY: As discussed in the Introduction to the Nemi sculptures (see pp. 77–78), the findspot of this piece is unclear. It is not listed in the day-to-day inventory of the finds from Nemi, though it was sold as part of the Nemi corpus. The possibility exists that the *herm* was added to the Nemi sculptures to enhance the marketability of the group. The asymmetries of the head, especially on the hair, may be evidence of some recutting

of this piece, and the stippling on the face may have been an attempt to "antique" the head or to provide a surface to which some other substance could adhere. The latter "doctoring" with the stippling is probably modern (end of 19th c.).

Although there are many examples of Dionysos *herms*, this *herm* bust is an eclectic example in Classicizing style with no very close parallels. For the general type, Guldager Bilde and Moltesen (2002:39, n. 149) point to Pochmarski 1974:Type B. Guldager Bilde (1998:43) dates this *herm* to around the second half of 1st c. BC, and identifies in it a combination of elements from different periods, noting the appeal of that eclectic style to Roman taste. The motif of the complicated fillet wrapped around the head and tucked back into itself and over the shoulder recalls, as Guldager Bilde and Moltesen (2002:40) rightly point out, the *herm* from the Mahdia wreck (see Mattusch 1994:431–50). The bronze Mahdia *herm*, signed by the

sculptor Boethos of Kalchedon, was being shipped around 80 to 60 BC, while the marble example that is its twin comes from Pompeii and can be dated around a century later in the 1st c. AD, an illustration of the way in which styles linger over a longer period of time than we generally assume. (For a discussion of the Mahdia *herm* and this phenomenon of lingering styles see Mattusch 1998: 152–54.) And, the general facial structure and the way the hair undulates across the forehead and "turns the corner" into ringlets are reminiscent of the Riace Warrior A whose date continues to be much discussed (see Ridgway *Hellenistic Sculpture III*:199–201, 214 n.33 for a discussion of a Late Hellenistic date for both Riace statues which Ridgway sees as Classicizing eclectic creations). The *herm* in the Nemi collection certainly fits into the general milieu of eclectisism, Classicizing tendencies and the "Neo-Attic" styles of the end of the 1st c. BC and continuing into the Early Imperial period.

Reliefs (73-74)

73

RELIEF PLAQUE WITH MASKS OF PAN AND DIONYSOS

MS 3459 *(see CD Fig. 28)*
Probably Sanctuary of Diana Nemorensis, Lake Nemi, Italy (see Introduction, pp.73 ff.; see also discussion of confusion regarding provenience in Guldager Bilde and Moltesen 2002:41)
Imperial Roman period, 1st c. AD
White marble with gray grains and fine mica. Sample taken for stable isotopic analysis, March 24, 1999, from side of plinth on satyr side. Results from Dr. Norman Herz, University of Georgia: $\delta^{13}C$ 2.131; $\delta^{18}O$ -2.055 (Carrara), although visual analysis indicates that the marble is more likely Pentelic (Guldager Bilde and Moltesen 2002:40 say "probably Pentelic").
P. H. 0.322; L. 0.44; Max. Depth 0.105 m.
Publications: Furtwängler 1905:261, no. 37; Reinach 1912b:208, no. 4; Reinach 1912a:73: incorrectly places this relief in the Metropolitan Museum of Art; Rambo 1920:36; Luce 1921:177–78, no. 48; Cain 1988:136–37, 203, no. 62, fig. 29; In the Sacred

Grove of Diana 1997:208, n. 252; Guldager Bilde and Moltesen 2002:40–41, Cat. no. 33, fig. 105; Guide to the Etruscan and Roman Worlds 2002:56, fig. 84; Moltesen, Romano, and Herz 2002:106; Quick 2004:122, no. 110.

CONDITION: Broken at all four corners, along the bottom ledge at front and middle of top edge. Broken and repaired at bottom right corner. On Pan chips missing from hair, nose, and brow ridge; tip of one horn broken off and most of other horn from above base. On Dionysos chips missing from hair; nose broken off. Top of *thyrsos* broken off. Tawny discoloration on front surface, especially on Pan head. Small bits of incrustation on the face of Dionysos. Some surface cracks.

DESCRIPTION: Rectangular relief plaque (*pinax*) with two masks in three-quarters profile view in high relief facing each other, divided in low relief by a *thyrsos* wrapped with

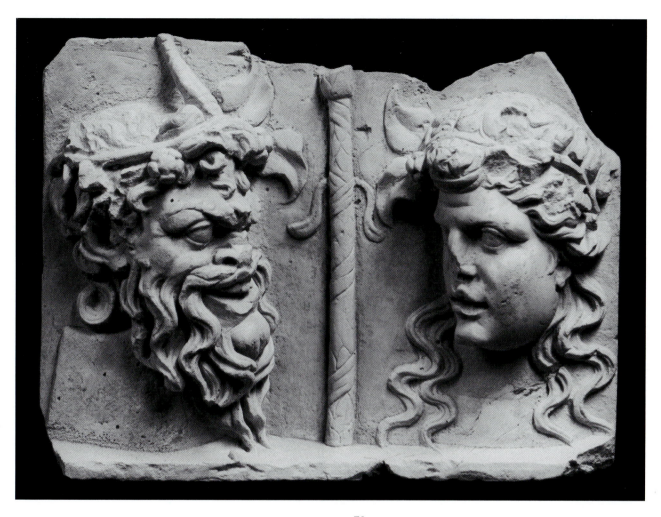

CAT. NO. 73

a ribbon and topped by a pine cone. The back of the panel is flat with a smoothed surface and two holes (ancient?) just below the top edge drilled on a downward angle so as not to penetrate the front of the plaque. The side edges are finished with a flat, smoothed surface. At the approximate middle on both the right and left edges of the panel is a single small drill hole (ancient?) (D. 0.006 m.) for attachment of the panel. At the bottom is a ledge as if the masks are resting on it. The bottom surface of the plaque is roughly worked with three modern drill holes.

At the viewers' left is a mask of a wreathed Pan with bestial features in three-quarters profile facing to his left, resting on a box or *cista*. He has large popping eyes beneath a deeply overshot, hairy brow ridge, a pug nose with large nostrils, and an open mouth with lips pulled back exposing the line of his top teeth. He has a full beard and moustache

with deeply drilled curly beard locks hanging down the sides of his face and neck; two longer locks fall beneath the chin, with the tips resting on the edge of the ledge. The satyr's hair is also curly with large curls raised on the background behind his neck. Two long horns rise from the front of his head. On his head he wears a wreath of ivy leaves with two rounded lobe acorns or berry clusters. Two of the ivy leaves are sculpted in low relief against the background. The face and hair of Pan have a brown discoloration that may be related to some ancient pigmentation of the piece.

The facing mask in three-quarters profile to the viewers' right is of a youthful Dionysos. He has long snake-like locks that fall against the background to the floor of the ledge and preserve a brown coloration. His hair is drawn off the face in deeply carved locks. He wears a ribbon-like fillet at the front above the forehead, as if

holding back locks of hair; behind that is a wreath of ivy leaves and rounded lobed acorns or berry clusters. The forehead is furrowed; the brow is deep; large open eyes; flaring nostrils; the top lip is curled up and the mouth is open with the top line of teeth showing; chin is jutting; the cheeks are full. The face is finely polished.

The *thyrsos* between the two masks is in low relief against the background and is wrapped with a ribbon (in incisions) with the ends fluttering to the right and left in low relief. The *thyrsos* has a honey-toned discoloration.

COMMENTARY: This is an extremely fine piece with careful modelling and detail, contrasting the bestial mask of Pan with the idealized one of the youthful Dionysos. One element of the contrast which would have been much less subtle in its original state is the brown coloration on the Pan versus the polished surface of Dionysos. It must be pointed out that this may also be due to some selective cleaning of the surfaces at the end of the 19th c.

Both Rambo (1920:36) and Luce (1921:177–78) record that this relief was said by the dealer to have come from the villa of Marius at Tivoli, and archival sources indicate that it was sold to the Museum sometime after September 1897 by A. Barsanti separately from the main group of Nemi sculptures. The original catalogue card lists both Tivoli and Nemi as possible proveniences.

Based on the comparison with other *pinakes* from the Sanctuary of Diana at Nemi, it is likely that Nemi was the source of this plaque and that they all may have been used as decoration in the small theatre at Nemi. Three in the Terme Museum are described in Morpurgo 1931:269–72, figs. 29–33. For a discussion and dating of one of these in the Claudian period see Hundsalz 1987:238–9, no. K148. For a discussion of the use of the Nemi theater in relation to the cult of Diana see *In the Sacred Grove of Diana* 1997:187–90.

Dwyer (1981:247–306) classifies the *oscilla* or decorative plaques from Pompeii; this one, based on the single-sided relief, belongs to the category of the so-called stationary *pinax* that were placed atop pilasters within garden areas or embedded in walls (285–88). The mask motifs on these *pinakes* are usually taken from the world of Dionysos (and also the world of the theater), and fit well into the *milieu* of the Nemi sculptural corpus where images of Dionysos and his entourage are as common as those of Diana. Hundsalz (1987:95–99) discusses the chronology of the Roman invention of the "mask relief" which seems to have been created in the Augustan period, reached its height in the Claudian-Neronian period, and came to an end in the second half of the 2nd c. AD. Parallels with the Pompeian examples (especially Dwyer 1981:286, no. 150, pl. 130 = Hundsalz 1987:219–20, no. K126) suggest a date for the Nemi plaque close in time to these examples, in the Claudian-Neronian period, though Cain points to parallels with portraits of the Neronian or Early Flavian period for the full, fleshy quality of the face of Dionysos (1988:136). The Classicizing style, the crisp carving of the relief, and the Pentelic marble put it in the sphere of "Neo-Attic" works of the 1st c. AD.

74
ARCHITECTURAL RELIEF FRAGMENT: SCROLL AND PYGMIES WITH CROCODILE

MS 3460 (see CD Fig. 29)
Sancturary of Diana Nemorensis at Lake Nemi, Italy
 (see Introduction, pp. 73 ff.)
Roman, late 1st c. BC–1st c. AD
White Pentelic marble with horizontal foliation with green
 mica. Sample taken for stable isotopic analysis from
 back on right side, March 24, 1999. Results from Dr.
 Norman Herz, University of Georgia: $\delta^{13}C$ *2.772;*
 $\delta^{18}O$ *-5.477 (Pentelikon or Afyon).*
P. L. 0.592; P. H. 0.119; Depth 0.032 m.
PUBLICATIONS: *Luce 1921:190, no, 60; Moltesen*
 1996:211–17; In the Sacred Grove of Diana 1997:
208; Guldager Bilde and Moltesen 2002: 46–47, Cat.
no. 42, figs. 115–16; Moltesen, Romano, and Herz
2002:106; Versluys 2002:288, n. 328, 456.

CONDITION: Single fragment broken off at left side and bottom, preserving most of the top surface and top edge of right side. Front and back surfaces intact except large chip from upper edge at back and surface flaws on the front which appear to be mostly from horizontal foliations in the marble. Some fresher chips, for example on the abdomen of the pygmy with the hat, on the stalk just in front of him, and on the left arm of the bald pygmy.

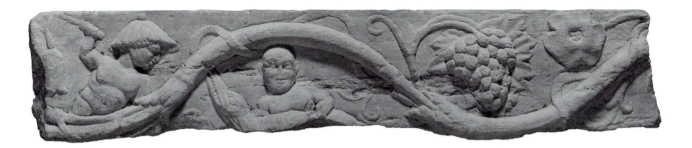

CAT. NO. *74*

DESCRIPTION: Small rectangular relief fragment with a flat back; finished upper edge with a circular hole cut just above the head of the pygmy with the hat (D. 0.014; Depth 0.025 m.); part of another hole is preserved in the top surface at the broken left edge of the relief (D. 0.012; Depth 0.031 m.). The lower surface of the fragment is poorly preserved, although it is clear from the composition that we have nearly the entire height of the frieze.

On the front surface of the block is a relief scene of two pygmies or dwarves with a crocodile and floral scroll. At the left is a naked pygmy leaning forward with his body facing frontally and his head in profile to his left; his legs are hidden by the stalk of the scroll. He has a muscular trunk with the groin line sharply set off from the leg. He has short chubby arms with his right arm aloft behind him as he brandishes a long rectangular weapon, possibly a *harpé*. He wears on his head a segmented conical hat with a knob on the top which may be a lotus flower turned upside down. A series of curly locks peek out from beneath the hat at his brow. His mouth is slightly open and his eyes are opened wide.

In the approximate middle of the fragment beneath the arch of the scroll is a second pygmy or dwarf facing frontally. Preserved is the upper torso and head of this bald and naked figure. He holds before him a crocodile, whose lower body is broken off and which is shown in left profile facing toward the pygmy with the hat. The crocodile raises its snout with jaws slightly opened to the stalk above. The bald pygmy's exaggerated features resemble the Egyptian god Bes: large round head, large protruding ears, large eyes, nose with full lips, slightly parted, and full cheeks. His neck is compressed and his upper torso is muscular and his arms are stunted.

The scroll is a composite of various incongruous elements. A thick stalk describes a wave from one end of the fragment to the other, from the lower left in front of the pygmy with the hat, arching in the middle to frame the bald pygmy, dipping down again to frame a grape bunch

above it, and ending above the middle at the right edge. The scroll is divided into three sections, with the open scalloped ends of each section generating new faceted shoots, like an acanthus stem. At the upper left edge of the fragment is a lotus bud, hanging upside down by its stem. At the upper edge near the right end of the fragment is a fully open triple-lobed flower with a segmented round center, attached by its stem to the corner of the fragment. A large bunch of grapes fills the right third of the scene with large grape leaves in low relief in the background. The grape bunch is attached to one of the thick main sections of the scroll by a narrower shoot with a closed lotus blossom in the triangle where the shoot separates into two branches. Finer tendrils, in lower relief, appear at the lower right end of the fragment, to the right of the bald pygmy, and in front of the crocodile; a flat ribbon-like tendril is wound around the thick main sections between the pygmies, at the top middle of the fragment, and at the left end of the stalk.

COMMENTARY: This relief with a Nilotic scene is unusual in the corpus of Greek and Roman sculpture. Although examples of scenes with pygmies or dwarves in "Egyptianizing" settings can be pointed to in wall paintings (e.g., Versluys 2002:143–49), mosaics, which are probably derived from wall paintings, in terracotta plaques, and other minor arts (see Moltesen 1996:214–16), there are very few sculptural examples, giving this small relief from Nemi added importance.

Moltesen's extensive and excellent discussion of this relief (1996:211–20) leaves little to be augmented here, except a note regarding the dating of the piece. Moltesen argues that representations of pygmies or dwarves and imagery associated with Egypt and the Nile enter the repertoire of art in Italy in the Late Hellenistic period, with one of the earliest and most spectacular examples being the

large Nile mosaic from the Sanctuary of Fortuna Primigenia at Praeneste, dated to the very end of the 2nd c. or beginning of the 1st c. BC (Moltesen 1996:214). It was, in general, during the 2nd c. BC that strong commercial ties were formed between Egyptian centers, such as Alexandria, and the towns of Latium and Campania, and the ports of central and southern Italy, with Delos serving as an intermediary for goods and contact between Egypt and Italy. And, it is in the 1st c. BC and 1st c. AD that the Nilotic motif gained in popularity in Italy (Versluys 2002:285–90).

Guldager Bilde and Moltesen date this relief to the 1st c. BC, around the second or third quarter (2002:47), and Moltesen assigns it to the same workshop in Rome or in Nemi as that of the marble amphorae from Nemi, based on the similarity of the form of the floral scroll on three of these amphorae and the relief (1996:212–13; 2002:47; see discussion of the date of these below). Moltesen does not venture to suggest a specific use for the relief, although she speculates that the frieze could belong to one of two temples in a sanctuary of the Egyptian goddesses Isis and Bubastis, which we know from a treasury inscription existed at Nemi (1996:216; *In the Sacred Grove of Diana* 1997:189, 208). Epigraphical evidence dates at least one of the temples of Isis and Bubastis to the Augustan period (*CIL* XIV, 4184; Morpurgo 1931:311–12). One other possible location for the frieze is in association with the small theater at the Sanctuary of Diana, tentatively dated to the 1st c. BC, which also had strong associations with the Egyptian goddesses (*In the Sacred Grove of Diana* 1997:187, 189–90).

Versluys (2002:456) questions the dating of the frieze to the 1st c. BC and assigns it a 1st c. AD date based on a comparison with the wall painting in the Iseum in Pompeii showing pygmies and other Egyptian elements in a "peopled" scroll (see Versluys 2002:143–46, no. 061). He also argues that the content of Nilotic scenes in Late Hellenistic/Roman art, in general, undergoes a change following the annexation of Egypt after the Battle of Actium, and that a previously somewhat clinical and ethnographic interest in Egypt gives way after 30 BC to more stereotypical depictions of Egypt as a land peopled with pygmies and dwarves (Versluys 2002:288).

Marble Vessels: The CHIO Dedication (75-80)

Eight solid marble vessels inscribed with the name CHIO and D D (*donum dedit*) were recovered from the Sanctuary of Diana Nemorensis: four of the cauldron type with griffin protomes and four of the Panathenaic amphora type. All four of the cauldrons (**77–80**) and two of the Panathenaic vessels, one with relief decoration and one plain (**75–76**), are in the UPM's collection, while the remaining two Panathenaic amphoras with relief decoration are in the Ny Carlsberg Glyptotek (IN 1518–1519). The group of marble vessels was unearthed in Eliseo Borghi's excavations in 1895 in one of the rooms of the northern portico of the main terrace at Nemi together with the large cult statue head of Diana in Copenhagen (Inv. 1517) and the statuettes which are in the University Museum's collection (Borsari 1895:425; see Fig. 4 for the late 19th c. photograph of a group probably found together).

Marble analysis shows that seven of the vessels in the CHIO group are made of Carrara marble, while the one plain, somewhat problematic Panathenaic amphora in the UPM is made of two different kinds of marble. The CHIO dedication has generally been dated to the 1st c. BC or 1st c. AD, but within that time frame more precise dates have varied. Although at first Guldager Bilde (1997:73) allowed for a broader dating in the late 2nd–early 1st c. BC for the Panathenaic vessels from Nemi, in the 2002 catalogue of the Nemi sculpture, Guldager Bilde and Moltesen (2002:42) are "content...with a date in the 1st c. BC." Bentz (1998/99:191–95), following Grassinger (1991: 18–19, n. 31), opts for a closer dating in the late 1st c. BC, while Cain and Dräger (1994b:820) date the Nemi relief amphoras to the 1st c. AD. The griffin type on the Panathenaic relief vessel (**75**) finds parallels in marble ornaments of the 1st c. BC, and perhaps into the 1st c. AD. The floral decoration of the upper body zone of the Nemi vessels is close to that on the Nilotic frieze (**74**) and should belong to the same general time period. (For the 1st c. BC dating of the marble lamps from the late 2nd–1st c. BC villa of Fianello Sabino with similar acanthus scroll motifs, see Vorster 1998:49–52.)

Guldager Bilde and Moltesen place the cauldrons with griffin protomes in the Augustan or perhaps Tiberian period, when the CHIO inscriptions were added to the amphoras (1997:72–73; Guldager Bilde and Moltesen 2002:42). Bentz (1998/99:191–95) dates the entire group of eight vessels to the same period, namely the Augustan period.

The dedication of eight marble vessels in the Sanctuary of Diana was a significant gesture and one would like to know who this CHIO is. Guldager Bilde argues that the name Chio is a Latinized version of Χίων, "the Chiot," and that the dedicant must be a freedman from the Greek island of Chios (1997:67). Steinbauer (in Bentz 1998/99:195–96) agrees that the name

derives from the Greek Χίων, but that the social status of the individual cannot be determined.

We also do not fully understand in what context this dedication was placed in the sanctuary. Guldager Bilde points out the funerary associations of griffin cauldrons of this type, and suggests that it was in the context of some kind of funerary structure, such as a small shrine or heroon, that the Nemi vessels would have originally been used, perhaps a hero shrine to the local divinity Hippolytos/Virbius (1997:67–75). Bentz (1998/99: 191–95) argues against the notion that there has to be a funerary association for the Nemi vessels, and instead suggests that at least the amphoras were dedicated in commemoration of a victory in the *ludi Apollinares*.

75

INSCRIBED PANATHENAIC AMPHORA WITH RELIEF DECORATION

MS 3446

Sanctuary of Diana Nemorensis, Lake Nemi, Italy (see Introduction, pp. 73 ff.)

Late Republican/Early Imperial period, 1st c. BC

Fine-grained white marble with rare thin gray veins. Sample taken for stable isotopic analysis, March 24, 1999, from beneath molding/groundline. Results of analysis from Dr. Norman Herz, University of Georgia: $\delta^{13}C$ *2.234;* $\delta^{18}O$ *-2.341 (Carrara or Marmara).*

P. H. ca. 0.58; Max. D. 0.407; D. top of neck join 0.077; H. letters 0.04–0.045; Th. chisel for letter 0.003–0.004 m.

PUBLICATIONS: Borsari 1895:424–25, 427, fig. 2, no. 5; Furtwängler 1905:260, no. 25; Rambo 1920:37; Luce 1921:175, no. 36; Kraus 1954:46, n. 89; Grassinger 1991:33, n. 81, 92, 113, 145, 220; In the Sacred Grove of Diana 1997:112, 208–9; Guldager Bilde 1997:53–81, esp. 62–64, no. 3; Guldager Bilde 1998: 44–45, fig. 10; Bentz 1998/99:185–96, esp. 191, pl. 2, 3–4; Guldager Bilde 1998:44, fig. 10; Guldager Bilde 2000:99, n. 111; Guldager Bilde and Moltesen 2002:43, Cat. no. 34, fig. 106; Moltesen, Romano, and Herz 2002:103, 106.

CONDITION: Preserved from lower neck to bottom of body, missing upper part, including handles (except attachments to shoulders), and foot which is restored in marble

(probably 19th c.). Many surface scratches and chips. Some faults in marble creating surface breaks, e.g., across tongue pattern and through body of deer on D D side. Much reddish discoloration on neck, probably iron stain. Traces of iron dowel preserved in hole in upper surface of neck for attachment of separately made upper neck and lid.

DESCRIPTION: Marble amphora of Panathenaic type with relief decoration and Latin inscription on shoulder (CHIO on one side and DD on the other, presumably *Chio d(onum) d(edit)*, "Chio gave the gift." Narrow neck, sloping shoulder, elongated piriform body with sharp molding encircling lower body, serving as the exergue for the scene. The tongue-shaped base of each vertical strap handle is carved in one piece with the shoulder of the vessel. In the joining surface of each handle is a drill hole for the attachment of the rest of the handle.

In low relief radiating from the neck over the shoulder are elongated tongues with darts between at the lower end. Inscription is incised over tongue pattern. Tongue pattern is not carved beneath handle zone, suggesting that handles were fashioned and in position when decoration was carved. Emanating from handle attachments on each shoulder is an open acanthus leaf in low relief that covers floral zone. A zone of floral decoration (H. 0.062 m.) in low relief surrounds vessel below shoulder (see drawing in Guldager

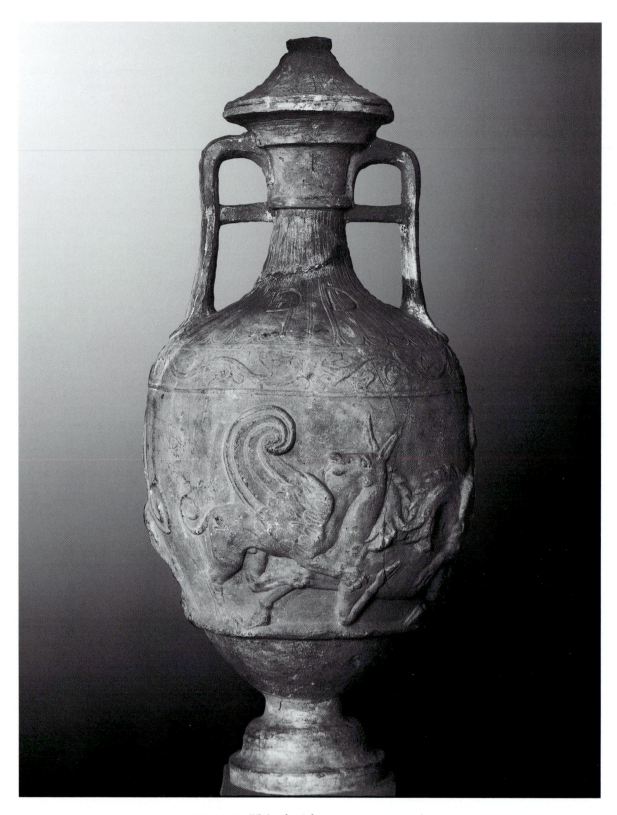

CAT. NO. 75 (*with 19th-century restorations*)

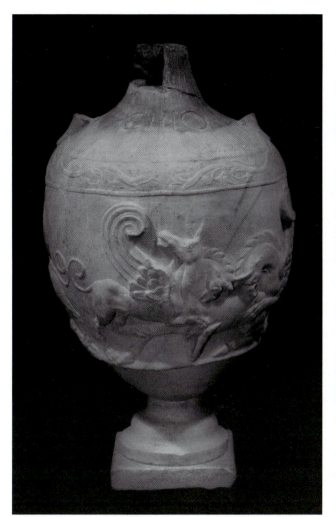
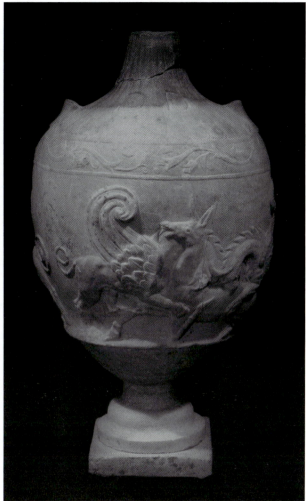

CAT. NO. 75

Bilde 1997a:63, fig. 13), composed of four separate acanthus-type scrolls with tendrils ending in spirals, open flowers, and lotus buds meeting at the center on each side.

The central body zone is decorated in higher relief with an identical scene, on each side of the vessel, of a doe attacked by two winged griffin-like creatures, a combination of a lion, horse, and bird of prey. In each case the scene is slightly off-center, the spiralling tails of the creatures meeting not beneath the handles, but to the right of each handle. On the CHIO side the tails almost touch, while on the D D side a space of ca. 0.025 m. has been left between. The doe on each side has been brought to its knees, while one fantastic animal attacks its mid-body and the other attacks the neck. The doe has an elongated neck, its head raised with ears upright, eyes wide open, and mouth open

with tongue protruding. The attacking creatures are variations of a griffin: winged with rows of short feathers at the base of the wing and the upper part rising and arching to end in a wave-like spiral. The creatures have the legs and paws of a lion, a leonine tail ending in a spiral with a thickened end, the upright mane/spine and head of an equid, but the beak of a raptor. Below the molding defining the lower end of this relief zone, the vessel is undecorated and the surface is marked by a claw chisel.

COMMENTARY: The vessel seems originally to have been made in at least two pieces, with the upper neck and lid joined to the lower neck and body with a dowel, in just the same way as one of the Nemi amphoras in Copenhagen (I.N. 1519: Guldager Bilde 1997a:58) and probably **76B**. A

photograph taken in 1895 in Italy shows this amphora with an upper neck, lid, handles, and a foot attached (on p. 148).

Guldager Bilde (1997:64) identifies the griffin type on this Panathenaic vessel as one well known from other marble pieces, such as table supports, of the Late Republican and Early Imperial period (Cohon 1984: type III; see also examples from Delos: Deonna 1938: pl. 15.104, 106, 108; 16.110, 112; 17.118). Guldager Bilde also points to a marble vessel with a remarkably similar scene of two eagle-griffins attacking a hind, the so-called Aglié krater, said to

be from a villa at Tusculum, now in Turin, dated by Grassinger to the end of the 3rd quarter of the 1st c. BC (Grassinger 1991:215–17, pls. 302–3). A krater from Palestrina in the Museo Nazionale in Rome also duplicates this scene (Cohon 1993:330, Appendix II, no. 7: "possibly 1st c. AD"). Equally interesting for an interpretation of the group of marble vessels from Nemi is the fact that the scene takes place before a column topped by a lidded griffin cauldron vessel of the type of **77–80**.

76

INSCRIBED PANATHENAIC AMPHORA

MS 3447 A,B
Sanctuary of Diana Nemorensis, Lake Nemi, Italy (see Introduction, pp. 73ff.)
Late Republican/Early Imperial period, 1st c. BC
A: *Body: fine-grained, white marble. B: Lid and upper neck with upper handles: gray-blue marble. Two samples taken for stable isotopic analysis, March 24, 1999, one from underside of lid on handle fragment, the other from the neck behind the restored handle. Results of the marble analysis from Dr. Norman Herz, University of Georgia: upper part:* $\delta^{13}C$ *2.905;* $\delta^{18}O$ *-1.698 (Marmara or Paros, Chorodaki); body:* $\delta^{13}C$ *2.863;* $\delta^{18}O$ *-5.056 (Pentelikon or Afyon). Guldager Bilde and Moltesen 2002:43 indicate that B, the upper part, is probably of gray Carrara marble, while A, the body, is probably of Asia Minor marble.*
P. H. body 0.54 without plinth; Max. D. body 0.318; H. lid fragment 0.14; H. plinth 0.46; W. plinth 0.173; D. lid 0.185; H. letters 0.035–0.04; W. chisel for letters 0.004 m.
PUBLICATIONS: *Borsari 1895:429, no. 8; Furtwängler 1905:260, no. 25; Luce 1921:190, no. 59; Edwards 1957:323, n. 6, pl. 87, left; Ridgway Fourth-Century Style: 180, n. 10; Guldager Bilde 1997:53–81, esp. 58–59, 64–65, no. 4, fig. 14; In the Sacred Grove of Diana 1997:112, 208–9; Guladager Bilde 1998:44, fig. 11; Bentz 1998/99: 185–96; Guldager Bilde 2000:99, n. 111; Guldager Bilde and Moltesen 2002:43–44, Cat. no. 35, fig. 107; Moltesen, Romano, and Herz 2002:103, 106.*

CONDITION: Preserved are two separate pieces: A, the body, with no join and plastered between, and B, the neck with lid, plus the plinth. Missing most of two handles, knob on top of lid, and portions of rim of foot restored in plaster. Lid is broken around approximately 1/4 of rim. Numerous scratches and small chips on body. Incrustation on underside of rim and on one break on rim.

DESCRIPTION: Inscribed marble amphora of Panathenaic shape, plain except for Latin inscriptions on shoulder. On one side: CHIO; on opposite side: D D; presumably to be understood *Chio d(onum) d(edit):* "Chio gave the gift." Letters have serifs.

Two separately made pieces form this amphora:
A: Long neck widening towards sloping shoulder. Long piriform body narrowing to join high conical foot in two degrees. The bases of the vertical strap handles are carved in one piece with the shoulder, positioned asymmetrically. An iron pin is preserved in one of these handles and iron stain is visible in the other.
B: Flaring conical lid carved in one piece with the upper neck and upper handles. Neck has a collar ridge and thickened struts on sides where upper part of vertical strap handles, oval in section, is carved. One handle is broken off below the curve, while the other has a prepared joining surface and a small drill hole where it joins the neck. At mid-point of neck is rounded molding below which is the break. In the top of the lid is a drill hole (D. 0.008 m.) for the attachment of a knob. In the bottom of the fragment is a large (D. 0.018 m.) and deeply drilled hole (D. 0.055 m.) for the attachment of the upper piece to the body.

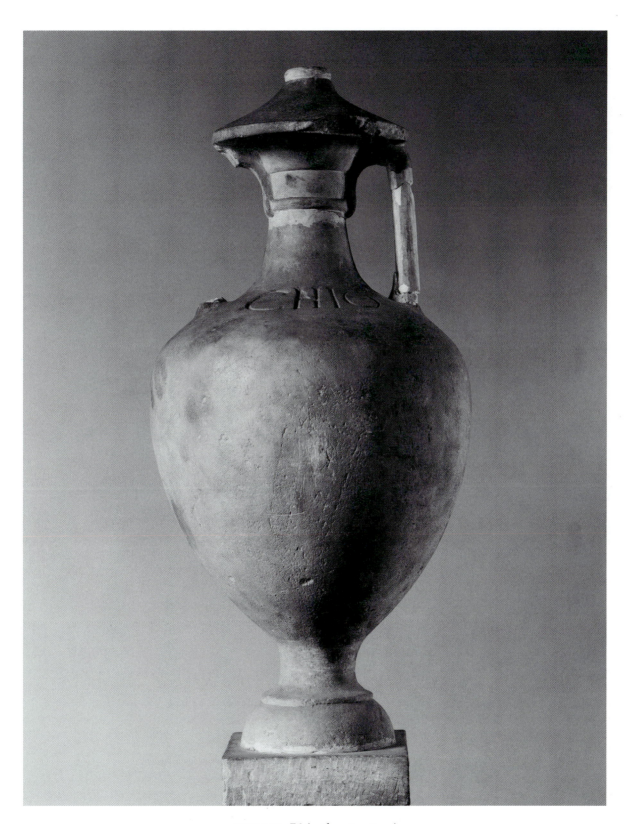

CAT. NO. 76 (*with restorations*)

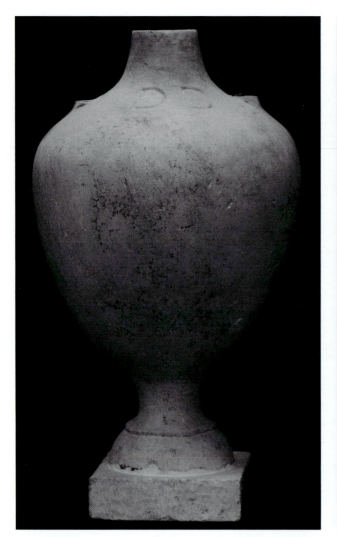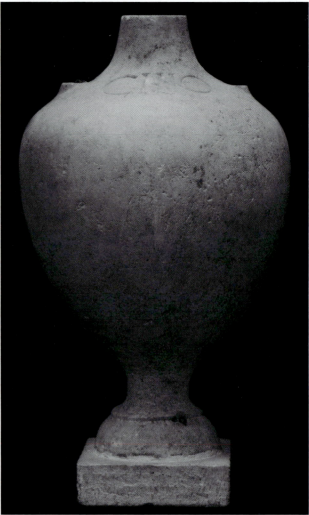

CAT. NO. 76A

Uneven bottom surface with some iron stains.

Plinth, probably modern, is square block and is separately made and attached to amphora. Rasp marks are visible on the surface of the body. The upper surface of the body where the neck joins the separately made neck and lid section is deeply scored and drilled with a dowel hole which has traces of iron stain.

COMMENTARY: Of the group of four of these Panathenaic type amphorae from Nemi inscribed CHIO D D, this is the only plain one, without relief decoration. See **75** for the same type with relief decoration and the other two of this type in Copenhagen (Guldager Bilde 1997: nos. 1 and 2).

Cleaning, conservation, and marble analysis of this amphora revealed that the two parts, neck with lid and body, do not join except with plaster, and that they are made of different kinds of marble. Before conservation, Guldager Bilde (1997:59) had already recognized that the lid was not its original one, and suggested the possibility that the upper and lower parts belong to two different ancient vessels. (The lids of **75** and one of the amphoras in Copenhagen [I.N. 1519] were also separately made and attached with dowels in antiquity.) According to Guldager Bilde and Moltesen (2002:44), this vessel might also have been repaired in antiquity, with the iron pin in the base of one handle cited as further evidence for this repair. Because

the neck fragment and the body fragment do not join and the 19th c. dealer had to reconstruct this amphora with plaster joining the two pieces and the marble is completely different, it is more likely that the two finished pieces belong to two different amphoras, though of the same approximate scale and manufactured in the same piecing technique. The day-to day find list which Guldager Bilde summarizes (2002:11, 48) indicates that a separate "collo di anfora marmo" was found on June 3, 1895, in the small vaulted room 9 in which most of the UPM's Nemi sculpture was found, and this neck and lid piece may be associated with that reference.

CAT. NO. 76B

77

INSCRIBED CAULDRON WITH GRIFFIN PROTOMES

MS 3448 (*see CD Fig. 30*)
Sanctuary of Diana Nemorensis, Lake Nemi, Italy (see Introduction, pp. 73 ff.)
Late 1st c. BC–early 1st c. AD; Augustan–Tiberian period
Vessel: fine-grained white marble with blue-gray veins. Two samples taken for stable isotopic analysis, March 24, 1999, one from under rim of lid, the other on the side of the plinth. Marble analysis results from Dr. Norman Herz, University of Georgia: body: $\delta^{13}C$ 2.564; $\delta^{18}O$ -2.041 (Marmara or Carrara); plinth: $\delta^{13}C$ 3.061; $\delta^{18}O$ -0.706 (Marmara or Thasos, Aliki).
H. *without plinth* 0.62; H. *plinth* 0.048; D. 0.46; D. *lid* 0.254; H. *letters* 0.045; W. *chisel for letters* 0.001–0.002 m.
PUBLICATIONS: *Borsari 1895:425, fig. 1, 425–6, no. 1; Furtwängler 1905:260, no. 25; Guldager Bilde 1997:53–81, esp. 66, no. 5, figs. 15–19; In the Sacred Grove of Diana 1997:112, 208–9, fig. 83; Guldager Bilde 1998:45, fig. 12; Bentz 1998/99: 185–96, esp. pl. 2, 1; Guldager Bilde 2000:99, n.*

112; Guide to the Etruscan and Roman Worlds 2002:55, fig. 82; Guldager Bilde and Moltesen 2002:44, Cat. no. 36, fig. 108; Moltesen, Romano, and Herz 2002:103, 106.

CONDITION: Intact except for part of knob on lid, small section of rim, parts of beaks of two griffins, and chips from lower edge of foot. Some reddish and brown surface discoloration.

DESCRIPTION: A lidded marble griffin-protome cauldron inscribed on the shoulder between the griffins: CHIO, on one side, and D D, on the other. Conical lid, carved in one piece with body, with button-like knob on top, pierced in center, and a sharp bevelled rim with slope beneath. Cauldron has short, narrow neck, a globular body. Three griffin protomes rise from the shoulder of the vessel. The separately made foot is conical in three degrees, ending in a straight rim at bottom. The vessel sits on a square plinth (0.25 x 0.246 m.), which is possibly modern.

The upper zone of the lid is decorated with ribbing in high relief, bordered on the lower end by a rounded

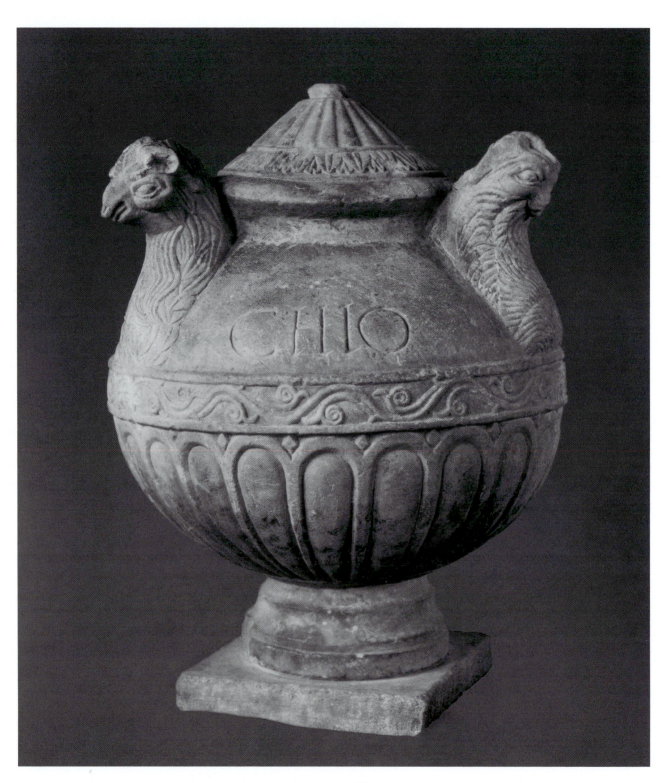

CAT. NO. 77

molding. In a middle zone of the lid is a ribbed pointed leaf motif interspersed with smaller double leaves. The rim zone of the lid is plain. Rising from the shoulder of the vessel are three griffin protomes. The griffins' feathers are marked by a leaf pattern at the lower neck, sides, and central section, with long wavy hair hanging down from the upper neck. A raised mane/spine defines the top of the head. Long pointed ears are laid against the head. Pop-eyes with thickened rims; closed hooked beak. On the flattened surface of one of the griffin's beaks is a small drilled hole as if for the reattachment of the beak, a possible ancient repair. Shoulder zone is undecorated except for inscriptions (letters with serifs) centered between the griffins' necks. Around center of vessel is a zone (H. 0.052 m.) decorated in high relief with a floral design of a continuous acanthus scroll linked by three acanthus stalks, one below each griffin. The tendrils of the stalks end in spirals with shoots. Below this zone, the lower body is decorated in high relief with a tongue pattern with darts at the top. The foot (made in one piece with the body) is conical in three degrees ending in a straight rim. Vessel sits on a square plinth (0.25 x 0.246 m.) that is probably not ancient.

COMMENTARY: Based on the lid design this cauldron should be paired with **78**.

78
INSCRIBED CAULDRON
WITH GRIFFIN PROTOMES

MS 3449
Sanctuary of Diana Nemorensis, Lake Nemi, Italy (see Introduction, pp. 73 ff.)
Late 1st c. BC–early 1st c. AD; Augustan–Tiberian period
Fine-grained white marble with some blue-gray veins
H. with plinth 0.635; Max. D. 0.465; D. lid 0.227; H. letters 0.046–0.049 m.
PUBLICATIONS: *Borsari 1895:425–26; Luce 1921:175–76, no. 38; Furtwängler 1905:260, no. 25; Guldager Bilde 1997:53–81, esp. 66, no. 6; In the Sacred Grove of Diana 1997: 112, 208–9; Guldager Bilde 2000:99, n. 112; Bentz 1998/99:185–96; Guldager Bilde and Moltesen 2002: 44, Cat. no. 37, fig. 109; Moltesen, Romano, and Herz 2002:103.*

CONDITION: Upper part of lid and one griffin head mended from fragments. Missing part of knob of lid, one entire griffin neck and head, beak of another griffin, and fragment from side of neck of

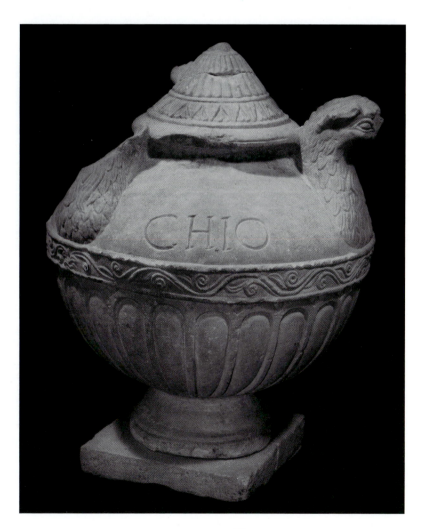

CAT. NO. 78

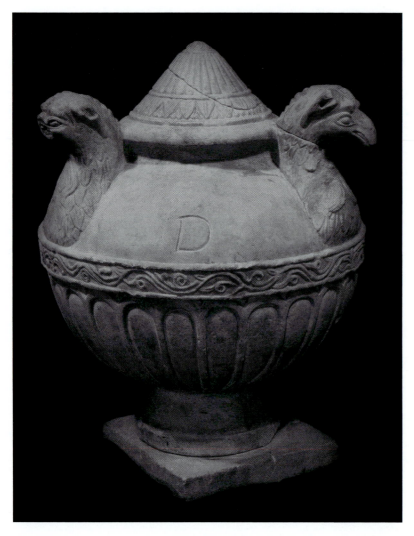

CAT. NO. 78

third griffin. Repair holes drilled in neck of one griffin (joining surface worked with a point and thus repair is probably ancient) and in beak of another griffin. Plinth, probably modern, cracked and repaired ar one corner. Minor surface chips and scratches.

DESCRIPTION: Lidded marble cauldron with griffin protomes and Latin dedicatory inscription.
Lid: Conical lid with button knob on top. Upper zone is deco-

rated in relief with ribbing, defined on the lower end by a rounded molding. Below this is a zone of ribbed pendant leaves with smaller heart-shaped leaves between sitting on a ledge. Rim is rounded.

Upper body: Short neck turns to broad sloping shoulder from which rise three griffin protomes. Between the protomes on the upper body is the Latin inscription: CHIO D D, presumably *Chio d(onum) d(edit)*, "Chio gave the gift." The letters are deeply incised with serifs. The griffins rise frontally with the feather/hair of the neck rendered as ribbed leaves with longer ribbed locks of hair in front hanging from the neck and parted in the center to reveal the central "leaf." Griffin's head arches on top with a serrated mane or spine running from the forehead down the back to the point at which the back meets the rim of the lid. Long ears are laid against the side of the head. The eyes are wide open and bulging. The beak is hooked with depressions for the nostrils and a closed mouth. *Lower body:* At the maximum diameter of the body is a relief zone, defined at the top by a bevelled molding and at the bottom by a rounded molding, composed of a continuous acanthus scroll with open acanthus stalks beneath each griffin neck. The tendrils of the stalk end in tight spirals with drilled centers. On the lower body are large tongues in relief with small darts at the top.

Foot: The foot is made in one piece with the body and has a double curve (convex, then concave) before an offset straight rim.
Plinth: The square plinth (H. 0.047 m.), probably modern, is separately carved and has been worked with a claw chisel.

COMMENTARY: One of a pair with **77**, to judge from the lid decoration.

79

INSCRIBED CAULDRON
WITH GRIFFIN PROTOMES

MS 3450
Sanctuary of Diana Nemorensis, Lake
Nemi, Italy (see Introduction, pp.
73 ff.)
Late 1st c. BC–early 1st c. AD;
Augustan–Tiberian period
Fine-grained white marble with some
dark gray veins. Sample taken for
stable isotopic analysis, March 24,
1999, from underside of lid.
Results from Dr. Norman Herz,
University of Georgia: $\delta^{13}C$
2.363; $\delta^{18}O$ *-2.011 (Carrara or*
Marmara).
P. H. 0.625 with plinth; D. lid 0.22;
W. plinth 0.248; H. letters
0.04–0.045 m.
PUBLICATIONS: Borsari 1895:
425–27, no. 3 or 4 on 426; Furt-
wängler 1905:260, no. 25; Luce
1921:175–76, no. 39; Guldager
Bilde 1997:53–81, esp. 66–67,
no. 7, figs. 20–22; In the Sacred
Grove of Diana 1997:112,
208–9; Guldager Bilde 1998:45,
fig. 13; Guldager Bilde 2000:99,
n. 112; Bentz 1998/99:185–96;
Guldager Bilde and Moltesen
2002: 44–45, Cat. no. 38, fig.
110; Moltesen, Romano, and
Herz 2002:103, 106.

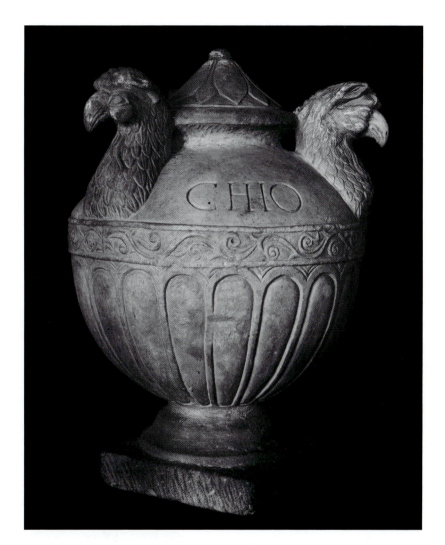

CAT. NO. 79

CONDITION: Missing one griffin head, part of the other
two; one is repaired from two fragments. Knob missing on
lid. Corner of plinth is broken off.

DESCRIPTION: Lidded marble cauldron with griffin
protomes and dedicatory inscription.
Lid: Conical lid with knob (missing) on top. Relief design
of petals with smaller petals between. Bevelled molding on
lower end of zone. Plain rim zone with rounded rim.

Upper body: Short neck turning sharply to rounded shoulder
from which rise three griffin protomes. Zone is plain except
inscribed serifed letters beween the griffins' necks: CHIO
D D, for *Chio d(onum) d(edit)*, "Chio gave the gift."

Griffins have ribbed petal-like feathers/hair on the
neck with longer strands of hair hanging from beneath
chin, parted to reveal petals in the center. On top of the
head from the forehead to the back of the head where the
neck meets the rim of the lid is a serrated spine or mane.
The griffin neck is cut free from the vessel just below the
rim leaving a small rounded opening. To the right and left
of the spine are diagonal grooves. Long ears are laid against
the head. Overhanging brow has large knobs. Large
almond-shaped bulging eyes; the pupils of the eyes of one
griffin have been drilled. Hooked beak.
Lower body: The middle zone at the maximum diameter is
decorated in relief with a continuous acanthus scroll
bordered on the top by a bevelled molding and on the

bottom by a rounded molding. Beneath each griffin is a poorly rendered acanthus stalk. Tendrils of the scroll end in spirals with drilled centers.
Lower Body: The lower body is decorated in relief with a tongue pattern with darts at the top.
Foot: The foot is carved in one piece with the body of the vessel and has a short straight neck with a double curve below (convex-concave) and a short straight rim.

Plinth: The square plinth (H. 0.045 m.) is carved in one piece with the vessel and is treated with a claw chisel. An iron nail is preserved in one of the broken corners for a repair.

COMMENTARY: See **80** for a match, based on the lid decoration, and the way in which the back of the griffins' necks are cut from the neck of the vessel. All of these characteristics are not present on **77** and **78**.

80
INSCRIBED CAULDRON WITH GRIFFIN PROTOMES

MS 3451
Sanctuary of Diana Nemorensis, Lake Nemi, Italy (see Introduction, pp. 73 ff.)
Late 1st c. BC–early 1st c. AD; Augustan-Tiberian period
Fine-grained white marble with gray veins
P. H. with plinth 0.63; W. plinth 0.23; Max. D. lid 0.216; H. letters 0.04–0.042 m.
PUBLICATIONS: Borsari 1895:425; Furtwängler 1905:260, no. 25; Luce 1921:175–76, no. 40; Devoti 1987:129; Guldager Bilde 1997: 53–81, esp. 67, no. 8; In the Sacred Grove of Diana 1997:112, 208–9, fig. 82; Guldager Bilde 2000:99, n. 112; Bentz 1998/99:185–96; Guldager Bilde and Moltesen 2002:45, Cat. no. 39, fig. 111; Moltesen, Romano, and Herz 2002:103.

CONDITION: Missing knob on top of lid; hole drilled for repair, probably ancient. Missing head of one griffin; hole for repair, probably ancient. Also missing beak of one griffin; two corners of plinth. Ears of both griffins chipped.

DESCRIPTION: Lidded marble cauldron

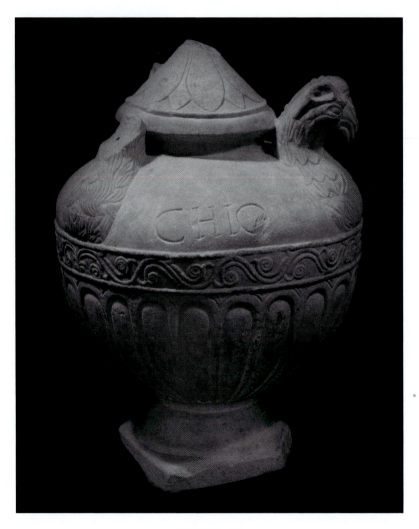

CAT. NO. 80

with griffin protomes and dedicatory inscription.

Lid: Conical lid with design in low relief of large petals with smaller pointed petals between. Ridge defines lower end of design, above a sloping plain rim with sharp bevel.

Upper body: A short neck turns sharply to a rounded shoulder from which rise three griffin protomes, the back of the necks of which are attached to the edge of the rim of the lid. Neck of the griffin is detached from the neck of the vessel leaving a small opening below the rim. The upper zone is blank except the Latin inscription in serifed letters between the griffins: CHIO D D, for *Chio d(onum) d(edit)*, "Chio gave the gift." The griffins' necks are decorated with a ribbed leaf design with longer strands of hair hanging below the chin. The top of the head has a serrated spine or

mane from the forehead to the point of attachment to the rim of the lid. To the right and left of the spine the head is divided into raised ribs. Long ears are laid against the head. Protruding knobs define the brow ridge. The eyes are large, bulging, and open. Beak is hooked; mouth is closed.

Lower body: At the point of maximum diameter is a relief zone bordered by rounded moldings with a continuous acanthus scroll broken between the head of each griffin by an open acanthus stalk. The tendrils of the scroll end in spirals with drilled centers. On the lower body is a relief decoration of tongues with rounded tops and darts between.

Foot: The foot is carved in one piece with the body of the vessel and has a straight neck with a concavity before sloping to a straight rim.

Plinth: The square plinth (H. 0.049 m.) is carved in one piece with the foot.

COMMENTARY: This cauldron is paired with **79**, to judge from the lid decoration and the treatment of the separation of the neck of the griffin from the neck of the vessel.

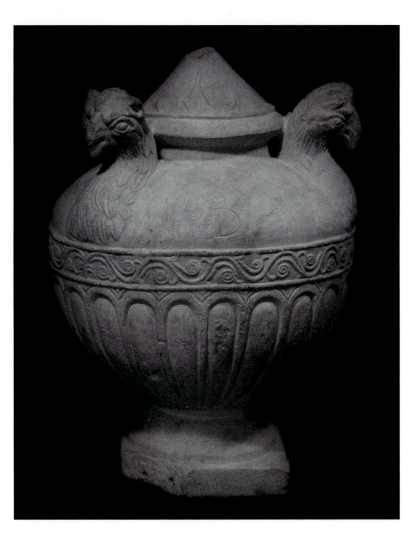

CAT. NO. 80

Marble Furniture Fragments (81–82)

81
SMALL TABLE SUPPORT: KNOTTY
CLUB TYPE

MS 4037
Sanctuary of Diana Nemorensis, Lake Nemi, Italy (see
* Introduction, pp.73 ff.)*
Late Republican period, late 2nd–1st c. BC
Large-grained white marble
P. H. 0.159; P. W. near bottom 0.069 m.
PUBLICATIONS: Guldager Bilde and Moltesen
* 2002:45–46, Cat. no. 41, fig. 114.*

CONDITION: Single fragment with broken top and bottom
surfaces, although a hole (probably ancient) is drilled through
top for attachment. Part of upper molding broken off; other
chips missing. Some discoloration and spidery surface incrus-
tations. Traces of ancient rasp marks on the surface.

DESCRIPTION: Club or trunk of a small tree used as a
support for a small table. Oval in section. Around the
lower part of the trunk are two moldings, the uppermost,
a rounded torus, and the lower, a cyma reversa. Around the
trunk are five oval knot holes or stumps of branches.

COMMENTARY: Guldager Bilde and Moltesen (2002:46)
identify this fragment as a small version of a support of the
knotted club type from a votive table, with a close parallel
from the marble workshop area at the southwest corner of
the Agora of the Italians on Delos (Deonna 1938:53–54,
no. 3894, pl. 171). C. F. Moss (1988:36–37; A354–361;
326–27) discusses this relatively rare table support type,
citing examples from Pompeii and Ostia. It is significant

CAT. NO. 81

that this type was probably being manufactured on Delos
in the later 2nd–1st c. BC.

82
TABLE SUPPORT: ANIMAL PAW

MS 3461
Sanctuary of Diana Nemorensis, Lake Nemi, Italy (see
 Introduction, pp. 73 ff.)
Late Republican or Imperial period
Medium-grained, compact white marble
P. H. 0.11; P. W. 0.12; P. Depth 0.15; H. plinth
 0.03 m.
PUBLICATIONS: *Guldager Bilde and Moltesen 2002:45,*
 Cat. no. 40, figs. 112–13.

CONDITION: Single fragment preserving animal paw on plinth, broken off at the top of the foot and back of plinth. Much dark surface discoloration. Modern drill hole in the bottom of the plinth.

DESCRIPTION: Feline paw carved in one piece with a rectangular plinth, the bottom of a table leg. Four digits end in sharp pointed talons resting on ball-like paws. On the right and left sides of the piece are two lobes in low relief. The surface of the digits and the lobes are etched with chiseled hatch marks as if to suggest the feathers of a bird or hair of a mammal. Bottom surface is treated with a rasp.

COMMENTARY: For this feline table support type see Richter 1966:113, type 5; Cohon 1984:112–22. Examples range in date from the 2nd c. BC to the 2nd c. AD, with the earliest examples from Delos (e.g., Cohon 1984: nos. 245–46).

CAT. NO. 82

Sculpture from Colonia Minturnae (83–90)

Introduction

The eight marble heads from Colonia Minturnae constitute the only major collection of stone sculpture in the Mediterranean Section which was systematically excavated by the University of Pennsylvania Museum. Colonia Minturnae was excavated in three campaigns from 1931 to 1933 by the UPM (in cooperation with the Associazione Internazionale di Studi Mediterranei) under the direction of Jotham Johnson (1905–1967), who received his Ph.D. (1931) from the University of Pennsylvania (*Minturnae I* 1935; *Minturnae II* 1933). The eight sculptures in the UPM represent a small fraction of the more than 100 pieces of sculpture uncovered by Johnson, all of which were included in a catalogue by A. Adriani (1938). A study of the Minturnae sculpture, including the eight pieces in the UPM, was undertaken by Erika B. Harnett for her doctoral dissertation at Bryn Mawr (Harnett 1986).

The Minturnae sculptures in the UPM were granted to the Museum through an agreement with the Soprintendenza alle Antichità della Campania and the Department of Antiquities of the Ministry of National Education as part of the division of the finds from Johnson's excavations. One of the sculptures (**89**), excavated by Johnson in 1931, was given by the Italian government to Gustav Oberländer, a donor to the Minturnae excavations and a member of the Museum's Board of Managers from 1931 to 1936; it was given to the UPM in 1939 by a relative of Oberländer's.

The bulk of the sculptures from Johnson's excavations remained in Italy, though, sadly, many were misplaced or lost in the course of World War II. (For a discussion of the dispersal of the Minturnae sculptures see Harnett 1998.) As part of the division of the finds from the excavations, the UPM was also given two terracotta heads of Aphrodite and Apollo (Johnson 1932a), pottery, lamps, and a very important collection of architectural terracottas ranging from the 3rd c. BC to the 1st c. AD (Livi 2002).

History, Chronology, Monuments, and Archaeology of Minturnae

Minturnae is strategically situated on the Via Appia where it crosses the ancient Liris river (the modern Garigliano), 140 kilometers south of Rome on the border of ancient Latium and Campania. The site was originally inhabited by the Italic tribe of the Aurunci who were conquered by the Romans in 313 BC. In 295 BC the Romans founded the site as a *colonia civium Romanorum* which served as a small military outpost and a port town. Its important position on the Tyrrhenian coast, on the river Liris, and on the main north-south road made Minturnae critical to maintaining control of the local Italic populations, including the Samnites to the south. After devastating fires in the middle of the 1st c. BC, Colonia Minturnae was recolonized as a veterans' colony by Augustus and rebuilt on a grand scale with a new forum and temples, a theater, and amphitheater. The city experienced another urban renewal in the early 2nd c. AD and flourished as a commercial center throughout the Imperial period, finally being abandoned around AD 590. (For an assessment of the evidence for the chronology of the site, see Coarelli 1989:35–66.)

Before the systematic work of Jotham Johnson, Minturnae was explored by various antiquarians, including Domenico Venuti in 1787 and the Austrian General Laval Nugent von Westmeath in the early 19th c. (The finds from Nugent's explorations are in the archaeological museum in Zagreb. For the sculptural finds see Crema 1933:25–44.) The Soprintendenza archeologica di Roma and the Soprintendenza archeologica per il Lazio have been excavating at Minturnae sporadically since 1942 and have undertaken the restoration of many of the monuments at the site. Also, an American team lead by Brother S. Dominic Ruegg conducted underwater excavations of the Roman port intermittently from 1967 to 1981 (Ruegg 1995).

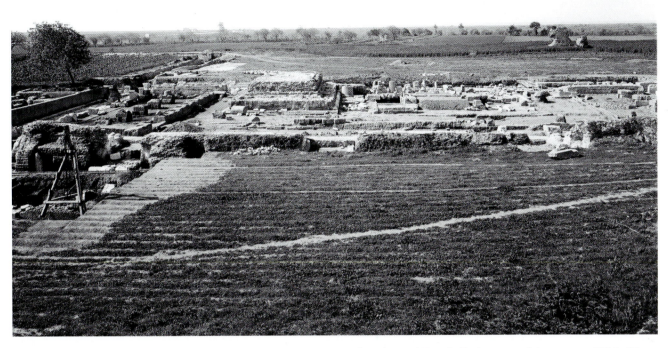

Fig. 7. Colonia Minturnae. View of Republican Forum at center with podium of Temple B, from top of theater, ca. 1932–33. Photograph from UPM Archives.

The area of Colonia Minturnae excavated by Johnson included part of the defensive walls of the Roman *castrum*; the Republican forum with its three-sided portico and shops, the small Temple of Jupiter (from which the UPM has significant architectural terracottas of 3rd c. BC date), and the 2nd c. BC Capitolium; the Imperial Forum; the theater; and five temples (see Fig. 7 and CD Fig. 31). The sculptures in the UPM come from two general areas of Minturnae: Temple B and Temple L.

Temple B, a small tetrastyle Ionic temple in an enclosing portico, was built in *opus reticulatum* in the second half of the 1st c. BC and renovated within the Augustan period (Livi 2002:32). It was dubbed by Johnson the "Temple of Julius Caesar" (see reference to the Temple as such in Johnson 1933b:70) from the discovery nearby of an inscribed base for a statue dedicated to the Divus Julius, set up in accordance with the *Lex Rufrena* of ca. 42 BC (*Minturnae I* 1935:6, 34). In a more recent assessment of this temple, the inscribed base, and the sculptural finds nearby, this hypothesis

has been upheld and the temple identified as the Caesareum of the Augustan colony (Coarelli 1989:56–57). It is significant that all four of the UPM's Minturnae portraits (**83–86**), at least one of which is definitely a portrait of a member of the imperial family (Germanicus: **85**), come from the area of Temple B. Eighteen other sculptures were excavated from the same area, mostly images of divinities, including the UPM's bearded god (**89**) and sculptures representing Tyche, Aphrodite, and Dionysos, in addition to a late 1st c. BC cuirassed torso and a togate statue of the 2nd–3rd c. AD. The head of the bearded god and the togate statue are the latest sculptures from this area. Johnson (1933b:70) thought that the statue of the bearded god, along with many other sculptures found next to Temple B, must have been set up in the vestibule of the temple. (See Coarelli 1989:62–63 for summary of sculptural finds from this area with reference to Adriani's catalogue.)

Temple L was a large brick (*opus reticulatum/latericium*) temple on a vaulted podium to the southeast of

the Republican Forum. This was only partially exca-vated by Johnson and mentioned briefly in publication (*Minturnae I* 1935:7, 77). Livi, in her assesment of the architectural terracottas, assigns Temple L a date at the end of the 1st c. AD (2002: 33). From this area come the Hygieia head (**87**), double-headed *herm* (**88**), and comic mask (**90**).

Summary of Minturnae Sculpture in UPM

The sculptures from Minturnae in the UPM are an eclectic group with pieces ranging in date from the Late Republican period to the 2nd or 3rd c. AD. The corpus comprises sculptures with a variety of functions: commemorative or honorific portraits of individuals (**83–86**), including members of the imperial family (**85**; perhaps **86**), votive sculpture of divinities (**87–89**), and one mask with a decorative function (**90**). Since we are lacking the original field notebooks from Johnson's excavations (according to Johnson [*Minturnae I* 1935:iii], he himself had never seen "the official field journal" which was kept by A. Adriani), there is not adequate information in the Minturnae Official Inventory of Finds (in the UPM Archives) or in Johnson's and Adriani's publications to assign specific contexts to the sculptures or identify exactly where they might have been set up. At least one was definitely found in a secondary context (**84**: in a Byzan-tine water trough near Temple B). A final assessment of the entire corpus of sculpture from Minturnae will have to take into account the more than 100 found in the 1930s excavations and those from subsequent work at the site.

Portraits (83-86)

83
MALE PORTRAIT: "JULIUS CAESAR"

32-36-64 (see CD Fig. 32)
Minturnae, southwest corner of Temple B
Roman, Late Republican or Early Imperial period, second half of 1st c. BC
White marble with black flecks
P. H. 0.20; W. 0.13; Depth 0.16 m.
PUBLICATIONS: *Minturnae Field no. 235; Johnson 1936:303; Adriani 1938:198–99, no. 48, figs. 26–27; Curtius 1938–39:120; Vessberg 1941:231–33, pl. LXXV; Giuliano 1957:10, no. 11; UPMB 22, 2, 1958: cover illustration; Vermeule 1964:109 and 120, fig. 4; Madeira 1964: illustration (no page or plate number); Guide to the Collection 1965:64–67; Vermeule 1981:274, fig. 231; Intro-duction to the Collections 1985:38, fig. 20; Harnett 1986:18–19, 215, A48, pls. 66, 67b, and 101; Coarelli 1989:62; Guide to the Etruscan and Roman Worlds 2002:58, fig. 86.*

CONDITION: Single fragment broken off at the lower neck in front and at mid neck in back. Tip of nose broken.

Chips from both ears, eyebrows, right eyelid, right and left cheeks, and chin. Four holes drilled through upper back of head: one large and deep (0.01 m.) with iron staining; another smaller deep one (0.03 m.) nearby, in center of head; two adjoining shallow ones to the left side of back. Iron stains on back of neck, bottom of front, in front of right ear, and one spot over left eyelid. Fine surface crack down right front side of neck.

DESCRIPTION: Underlifesized male head in frontal position and tipped forward and very slightly to his left, as seen from the back. Close-cropped hair carefully arranged in individual straight and curly locks, brushed forward from mid back of head onto forehead and around hairline, with locks in front of ears. Pronounced creases in forehead and above nose. Small almond-shaped open eyes, deeply sunk, with ridges for eyelids. Indentation at nose bridge. Straight nose with small drilled nostrils. Puffy area above mouth. Tightly closed mouth with drilled corners. Rounded chin. Deep creases in face from nose to chin. High cheekbones and sunken cheeks. Small, finely shaped ears. Back of head finished in summary fashion.

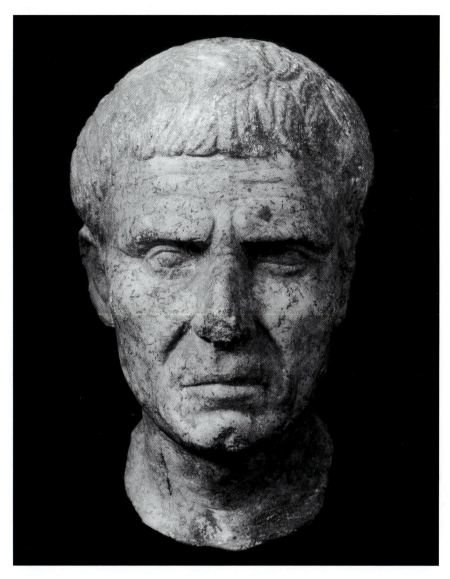

CAT. NO. 83

COMMENTARY: Although this head has been identified as a portrait of Julius Caesar, the lack of securely identified portraits of Julius Caesar makes this association unlikely. Immediately after his death the enemies of Julius Caesar engineered a successful *damnatio memoriae*, eradicating most contemporary portraits of him. Some portraits may have been created during the early years of the empire when his memory was cherished by Augustus and his successors. The one outstanding characteristic of Julius Caesar's appearance described in literary sources is a slight deformity of the head with an elongated lump at the rear of the crown. The Minturnae head does not display such a lump which one might expect in an otherwise veristic portrait. On the other hand, the posthumous portraits of Julius Caesar of the Augustan period (the Pisa-Chiaramonti type) show him with an Augustan hairdo which is not unlike the Minturnae head (see Kleiner 1992:44–46 for a summary of the portraiture of Julius Caesar).

Vermeule (1964:109) suggested, on the basis of a comparison of coin portraits, that this head represents M. Junius Brutus, the assassin of Julius Caesar, but it seems

unlikely that Brutus would be honored in the same area of Temple B where at least one monument to Julius Caesar was erected (Harnett 1986:215; see Temple B, above, p. 163). On balance, it is more probable that this is a portrait of an unknown individual of the second half of the 1st c. BC. The use of the holes, at least one of which held an iron dowel, in the upper back of the head is intriguing and may be related to an attachment of some object to the head. However, the small size of the head, its forward tilt, the less well-finished back, and the holes in the upper back could also be used to support the theory that this head was secured to a background, perhaps part of a honorific monument. A funerary monument seems unlikely given its discovery outside a cemetery area.

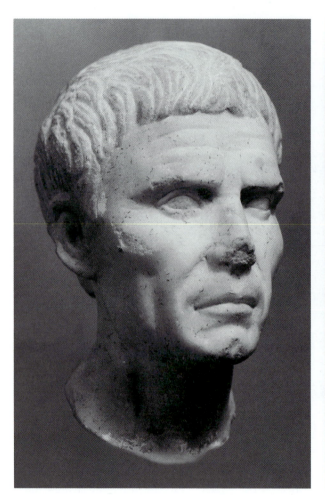 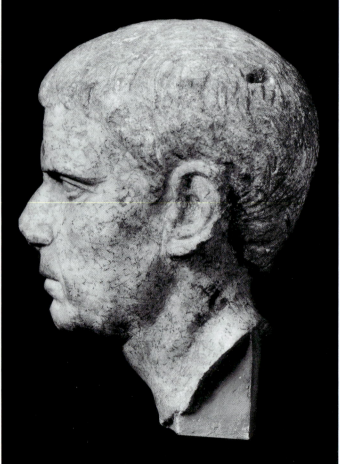

CAT. NO. 83

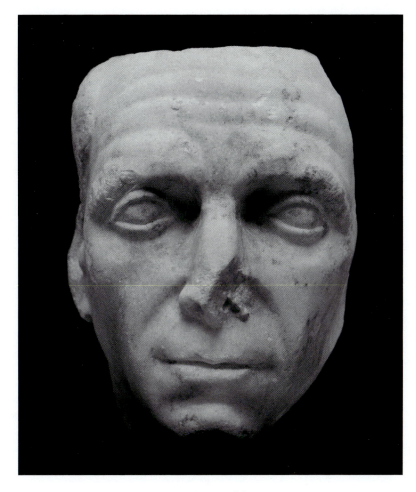

CAT. NO. 84

84
PORTRAIT OF MIDDLE-AGED MAN

32-36-63
Minturnae, in a masonry Byzantine wash-trough, east side
of Temple B
Roman Republican period (second half of 1st c. BC) or
Flavian/Trajanic period (ca. AD 100)
White marble
P. H. 0.26; P. W. 0.20; P. Depth 0.26 m.
PUBLICATIONS: *Minturnae Field no. 853; Mostra*
d'arte antica 1932:54–55, pl. 44; Technau 1932:
494–95, fig. 17; Schrader 1932:507; Illustrated
London News May 21, 1932:853; Strong 1932:9;

Johnson 1933c: pl. 3, fig. 6; Johnson 1933a:49–53,
pl. 10; Johnson 1936:303, fig. 4; Adriani 1938:195,
no. 44, fig. 24; Robl 1970: no. 16; Harnett
1986:17–18, A44, pls. 63–64; Coarelli 1989:62.

CONDITION: Single fragment broken at upper neck. Left side of head from in front of ear broken off. Right side of head is unfinished from ear and above. Back of head left roughened and stippled with a point. In the center back of head is a large rectangular cavity (H. 0.045; W. 0.038 m.) plugged with lead. Top of head is flattened and rough-

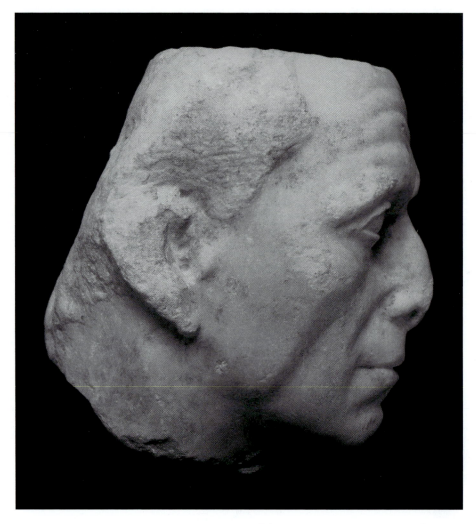

CAT. NO. 84

ened with chisel and point. Nose is broken on left side; eyebrows are chipped.

DESCRIPTION: Overlifesized mature male head in a probable frontal position with markedly asymmetrical features (eyes, cheeks, mouth) and a receding hairline. Rounded head with a broad forehead with undulations for brow wrinkles. Deeply sunken large open eyes with thick overhanging brow ridges and arching upper eyelids, the right more arched than the left. Smooth, slightly flattened eyeballs. Broad nose with indent at bridge, flattened on top, and deeply drilled nostrils. Puffy area above mouth. Closed lips with thick lower lip, slightly drilled at the outer corners. Large rounded double chin, flattened on

front with indication of cleft. Broad cheeks with high cheekbones and sunken zone from nose to mouth. Large ear. The right side of the head and ear are unfinished, worked rough with a chisel, while the left side is broken off. The back of the neck is extremely broad and not meant to be seen.

COMMENTARY: Adriani (1938:195–96) identifies this head as a provincial work of a robust man of the second half of the 2nd c. BC or beginning of the 1st c. BC and assigns it to the category of Republican portraits derived from funerary masks, judging from the treatment of the mouth and eyes. Given the history of the site and the chronology of Temple B (see above p. 163), and the fact that this head

CAT. NO. 84

the lower cheeks, and the fullness of the area between the nose and upper lip and the full lower lip are close to Johansen 1994:64–65, no. 20: "original: shortly after middle of 1st c. B.C." It has been increasingly recognized that many of the extremely veristic portraits that we think of as Republican in date are, in fact, more likely to belong to a phenomenon of "Republicanizing" or realistic private portraits of the Flavian or Trajanic periods around the turn of the 1st to 2nd c. AD (see, e.g., Goette 1984: esp. 98–104). Without the rest of this statue and the additional evidence that the hairstyle might provide, it is difficult to definitively date this portrait. The possibility is open that it may, in fact, belong around AD 100.

The treatment of the back of the head, left in a roughened state and prepared with a large circular cavity in which the lead packing is still preserved suggests that an additional piece was added to complete the head. The right ear is unfinished and even the sides of the head were not meant to be seen. The head was almost certainly *capite velato*, i.e., veiled with the toga brought up over the back. The veil could have been completed in another piece of stone or in stucco. In Roman visual iconography *capite velato* is a symbol of pietas, but more specifically it signals the status of an individual as pontifex or a holder of another priestly office such as augur. Augustus himself, for example, on the Ara Pacis and in the well-known portrait of him as pontifex maximus in the Museo Nazionale delle Terme (Kleiner 1992:65, no. 41), as well as members of the imperial family, such as Gaius and Lucius (see Pollini 1987:30–32), are shown *capite velato*. (See **86**, a possible *capite velato* portrait of a young member of the Julio-Claudian family.) If this suggestion is correct, this overlifesized Minturnae portrait is of an individual of high social rank, holding a priestly office.

was found in the area of the Forum of Minturnae, it should belong to the second half of the 1st c. BC or later, and be assigned a function as a honorific statue.

Veristic funerary and honorific portraits of the Roman nobility are well documented in the Republican period as late as the second half of the 1st c. BC and very early 1st c. AD (e.g., Johansen 1994:28–29, no. 3; 30–31, no. 4; 56–57, no. 16; 64–65, no. 20; 66–67, no. 21; 68–69, no. 22; 70–71, no. 23; 80–81, no. 28). The plastic treatment of the deep creases on the forehead, the sharp eyelids and bags beneath the eyes, the groove extending from the nose to

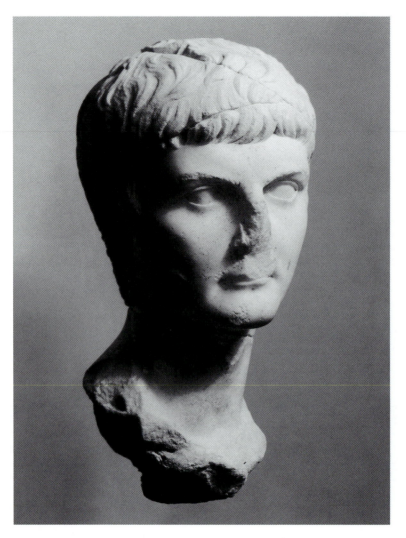

CAT. NO. 85

85
MALE PORTRAIT HEAD: GERMANICUS

32-36-66
Minturnae, southwest corner of Temple B
Roman Imperial period, early 1st c. AD (AD 4–23)
White marble
P. H. 0.415; W. 0.21; Depth 0.235; H. chin to crown
 0.26 m.
PUBLICATIONS: *Minturnae Field no. 102; Curtius
 1935:283, n. 1; Curtius 1938–39:120; Johnson
 1936:303; Adriani 1938:208, no. 55, pl. XV, 1–2;*

*Fuhrmann 1940:510–12, fig. 45: Nero Drusus,
"Elder"; Pietrangeli 1949:31; Matthews 1958–59:
36–37: Drusus or Germanicus; Vermeule 1981:287,
fig. 244: Drusus Major, type ca. AD 41–45; Poulsen
1960:14, no. 11; Vermeule 1964:109–10;
Aurigemma and de Santis 1964:52; Guide to the
Collections 1965:64, 67; Jucker 1977:223; Andrén
1965:127, no. 9; Fink 1972:185, 285–87, pl. 9,1;
Kiss 1975a:106, n. 104, 119, 128, fig. 433:*

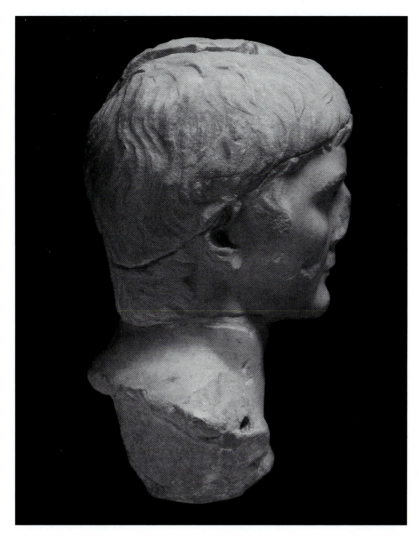

CAT. NO. 85

Germanicus; Fittschen 1977:44, n. 17; Massner 1982:90; Fittschen and Zanker, Katalog I:31, under no. 24; Harnett 1986:21, A55, pls. 79–83; 231–32; Coarelli 1989:63, pl. IV, 4; Guide to the Etruscan and Roman Worlds 2002:58, fig. 87.

CONDITION: Broken and repaired, with the neck broken off irregularly at bottom where it sits in bust or statue. Nose and top lip broken off; surface abrasion to above right side of lip and on eyebrows. Large hole in right cheek. Fragments missing from right ear. Many other chips missing, especially on top of head where separately made fragments join each other. Neck piece filled with plaster in front where fragment is missing. The remnants of an iron dowel are preserved in the top of the head on the left side.

DESCRIPTION: Lifesized male head, clean-shaven with short hairdo. Head is turned sharply and tipped to his right. The hair is combed down on the forehead in individual thickened locks with a slight part above the left eye and a wider one above the right eye. The locks radiate from a central depression at the back of the crown of the head.

171

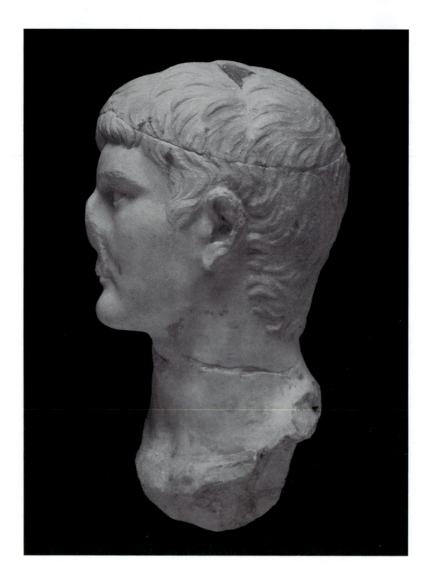

CAT. NO. 85

Locks on the top, back and sides of head are summarily worked. Locks appear in relief in front of the ears on the sides of the face. Two large sections of the top and upper back of the head were separately fashioned and attached with carefully prepared cavities, of which one finished edge is clearly visible on the top. The iron dowel in the center of this added section has caused it to split. Finely shaped and well-executed ears with thickened lobes. Large square face with strong brow and full brow ridge; eyebrows defined by individual hairs. Open, almond-shaped eyes with defined lacrimal glands. Slightly thickened upper lids. Full cheeks; strong jutting nose at bridge. Closed mouth, slightly drilled at outer corners with finely shaped

thin lower lip. Full jutting chin with slight depression for cleft. Full muscular neck. Bottom and sides of neck and upper neck ends are finished for setting into a bust or statue. A small circular hole is drilled on right side of lower neck and a narrow rectangular slot on the left side of the neck.

COMMENTARY: This head stands out in the Minturnae corpus as a portrait of an identifiable member of the Julio-Claudian family. It has been variously identified as: Germanicus (15 or 16 BC–AD 19), son of Drusus Major and Antonia Minor, and brother of Claudius, adopted by Tiberius in AD 4 at the same time that Tiberius was adopted

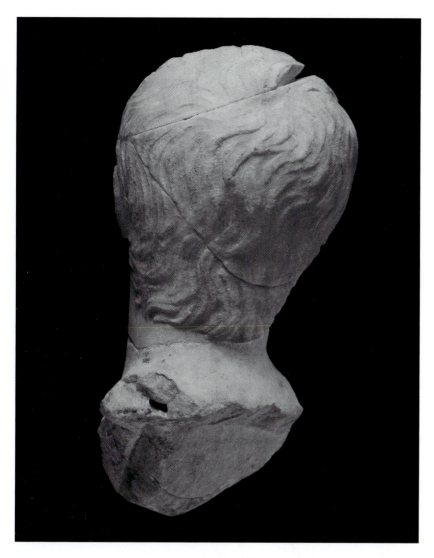

CAT. NO. 85

by Augustus as his successor; as Drusus the Elder (38–9 BC), the brother of Tiberius; or as Drusus the Younger (ca. 13 BC–AD 23), son of Tiberius. This head is, in fact, a fairly standard portrait type of the clean-shaven Germanicus made after his adoption by Tiberius in AD 4.

This portrait has been compared to the portrait from the forum of Béziers in the Musée Saint-Raymond in Toulouse (Jucker 1977:223, though he accepts the Béziers type as Drusus II; Poulsen 1933:43, figs. 62–64; and Fink 1972:284, pl. 6,1) and to the portrait of Germanicus in Copenhagen (Kiss 1975a:111–30, figs. 375–76, for a discussion of the type). Fittschen and Zanker (*Katalog* I:31) also compare a fragmentary portrait of a Julio-Claudian prince (Germanicus or Drusus Minor) with this Minturnae head and classify it as the "Leptis type" of Germanicus which shows a mature Germanicus with facial hair. (For the idealized, colossal, posthumous portrait of Germanicus from Leptis Magna in the Archaeological Museum in Tripoli see Aurigemma 1941:56–59, figs. 36–38.) The Leptis head is dated by Kiss (1975a:129) to ca. AD 14 when Tiberius assumed power, and he puts the Minturnae head in a group of early portraits of Germanicus as a young man of 19–20 years, executed ca. AD 4 (Kiss 1975a:119, 128). (A more recent assesment of the Leptis portrait by Rose [1997:64] puts it in the period shortly after AD 23.) In this same group Kiss assigns portraits in Berlin's Staatliche Museum (Kiss 1975a: figs. 416–17), in Copenhagen (Kiss 1975a: no. 760, figs. 418–19), and one from Nomentum (Mentana) in the Museo Nazionale in Rome (Kiss 1975a: figs. 434–35). The last is stylistically the closest to the Minturnae head (Poulsen 1960:14, no. 10) and can be closely dated to the period from AD 7–11 (Rose 1997:97, pl. 86).

The hole and slot at the sides of the neck may be related to some repair of the statue, while the use of the iron dowel in the top of the head is unclear. Stucco almost certainly would have disguised the piecing of the head and the dowel.

86
PORTRAIT HEAD OF A YOUTH OF THE JULIO-CLAUDIAN FAMILY

32-36-67
Minturnae, in hollow west of Temple B
Roman Imperial period, first half of 1st c. AD
White marble
P. H. 0.33; Max. P. W. 0.145; P. Depth nose to back 0.165 m.
PUBLICATIONS: *Minturnae Field no. 450; Adriani 1938:211, no. 60, pl. 13, 3; Harnett 1986:22, A60, pl. 84.*

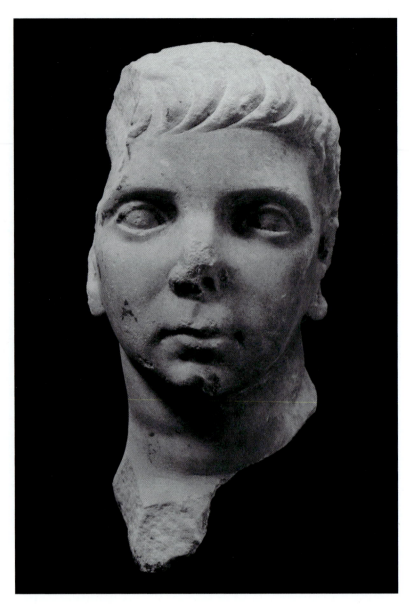

CAT. NO. 86

CONDITION: Single fragment preserved from top of head to lower neck on right side. Missing right upper side of head, back of head and neck, neck on left side. Large surface chip from right side of neck. Chiseled area flattened behind right ear. Chips from nose and chin. Generally battered and worn.

DESCRIPTION: Lifesized portrait head of a young man with short-cropped hair brushed forward with individual curving locks on forehead. On right and left cheeks one lock is rendered in relief; on right side lock is beside top of ear; on left side it is higher and incurves awkwardly. Broad forehead; pronounced thickened brow ridge. Deep-set, open almond-shaped eyes with smooth eyeballs and arching ridges for upper eyelids. Broad nose with drilled nostrils. Puffy area between nose and upper lip with deep indentation in center. Off-center (to right) closed mouth with "Cupid's Bow" upper lip. Thickened lower lip. Deep chiseled indentations for outer corners of mouth. Cleft in full chin. Full cheeks rendered in flat broad planes. Large, poorly rendered ears with thick lobes that are drilled beneath in order to offset lobes. Long, thick neck with rolls of flesh indicated by undulations. On right side of neck at the bottom edge is a small piece of the finished neck for its setting into a bust of statue. Back of the neck and lower head are roughly picked and not meant to be seen. Behind the row of locks of hair on top the head is stippled with a point.

COMMENTARY: This portrait, though a provincial work of modest quality, probably represents a young member of the Julio-Claudian family in his honorary role as a holder of a priestly office. The top and back of the head are roughly picked for the addition of another piece of marble or stucco, evidence that the head was probably *capite velato* or veiled with the toga over the top of the head. Though older males outside the imperial family could hold various priestly offices (see **84** for another Minturnae portrait *capite velato*), it is unlikely that a young man such as that

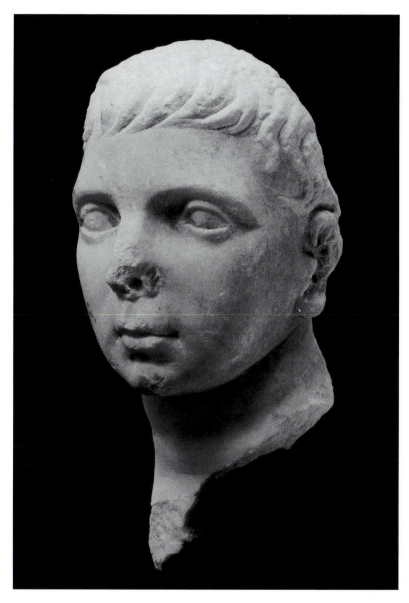

CAT. NO. 86

these young princes were set up during the Augustan period and occasionally during the Tiberian period and bear a close similarity to one another (see Rose 1997:62 for a summary of the portrait types with the evidence). The characteristic features of the portraits are the hair treatment, combed down over the forehead with the locks forming a "pincer effect," squarish face, "Cupid's bow" upper lip, broad rounded chin, slightly fleshy cheeks, full, large eyes but not deeply set, and faint Venus rings on the neck. These features are all present on the Minturnae head, though the "pincer effect" is not as pronounced as in many of the portraits. If this is correct, this *capite velato* portrait of a youth would be identified with one of the young heirs of Augustus who died tragically young. Gaius had been *pontifex* and would thus have been shown *capite velato*, and Lucius held the priestly office of *augur* (see Pollini 1987:31–32, pls. 12, 14, 17, 28, 1–3). There is another possible portrait of Gaius or Lucius from Minturnae, now in the Antiquarium at the site (De' Spagnolis 1981:40, fig. 9) which was excavated after Johnson's work at the site.

Another possibility is that this portrait may be of Tiberius Gemellus (born AD 19), the only son of Drusus II and Livilla, who was named in Tiberius's will as co-heir with Caligula. Caligula had the will annulled in AD 37, adopted Tiberius Gemellus in AD 37, and had him killed later that year or in AD 38. All of the portraits identified as Tiberius Gemellus show him as a young man, probably when he was adopted by Caligula. This head bears some similarities to the heads from the dynastic groups in Leptis Magna (Rose 1997: pls. 228–29) and Augusta Emerita (Rose 1997: pls. 176). The portrait of a younger Tiberius Gemellus from Velleia (Rose 1997: pls. 137–38) shows him *capite velato*.

It must be admitted, finally, that there may not be enough evidence from securely identified portraits to assign this head as a specific young member of the Julio-Claudian family.

depicted here could have had that status. The long neck indicates that the head was meant to be set into a statue body or bust.

This head bears some similarities to portraits of several young members of the Julio-Claudian family. Two possibilities are Gaius (20 BC–AD 4) and Lucius (17 BC–AD 2), Augustus's grandsons by his daughter Julia and Agrippa, adopted by him and named as his successors. Portraits of

Divine and Idealized Images (87–89)

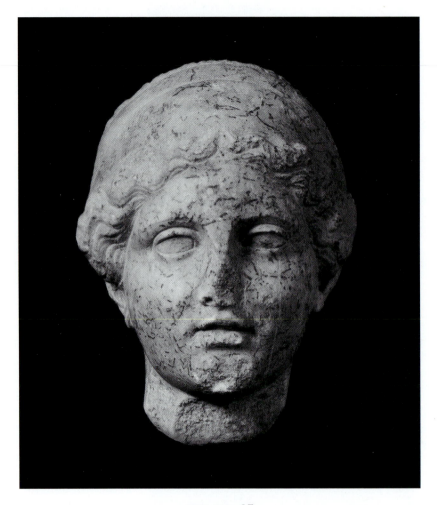

CAT. NO. 87

87
HEAD OF HYGIEIA

32-36-65
Minturnae, near doorway to south vault of Temple L
Roman Imperial period, 1st c. AD
White marble
P. H. 0.154; W. 0.11; Depth 0.128 m.
PUBLICATIONS: *Minturnae Field no. 2904; Adriani*
1938:187–88, pl. VII; Johnson 1932b:289; Picard
1948:695–96, fig. 301; Fuhrmann 1940:511;

Kabus-Jahn 1963:109, n. 13; Lippold 1950:253, n.
1; Giuliano 1979:28, no.143; Introduction to the
Collections 1985:38, fig. 19; Harnett 1986:15,
159–60, A30, pls. 41–42; Sobel 1990:92, no. 6.

CONDITION: Single fragment broken off at the neck. Chips
missing from nose, chin, front of neck, hair at brow, back right
side of bun, right and left ears. Much worn with tiny brown

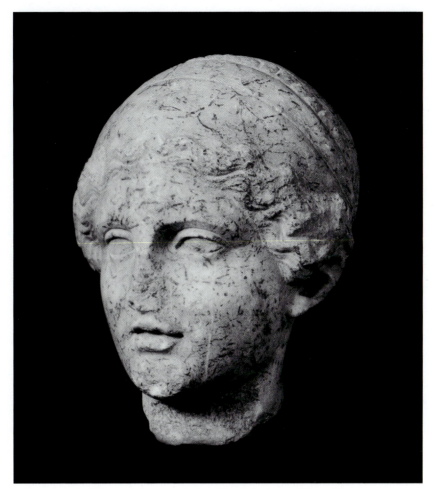

CAT. NO. 87

surface lines from deposition. Scratch down left side of face.

DESCRIPTION: Small female head in frontal position wearing a *kekryphalos* wrapped around her head. Hair protrudes in front at brow and is drawn to sides in wavy curls to form thick roll in front of ears. Hair is gathered at the back of the head in a protruding bun. Narrow forehead, fine brow ridges; almond-shaped open eyes with thickened ridges for eyelids. Small nose with flattened bridge and drilled nostril. Small mouth with lips slightly parted,

drilled at outer corners. Flattened cheeks.

COMMENTARY: This head from a small statuette was first recognized by Adriani (1938:187–88) as a Roman copy or version in reduced size of the Hope type of Hygieia, named after the statue from Ostia, formerly in the Hope collection and now in the L.A. County Museum of Art (*LIMC* V, Hygieia: no. 160; see also 565–66, nos. 161–87). For a summary of the scholarship on the Hope type see Kabus-Jahn 1963; Giuliano 1979:228, no.143; Sobel 1990:24–26,

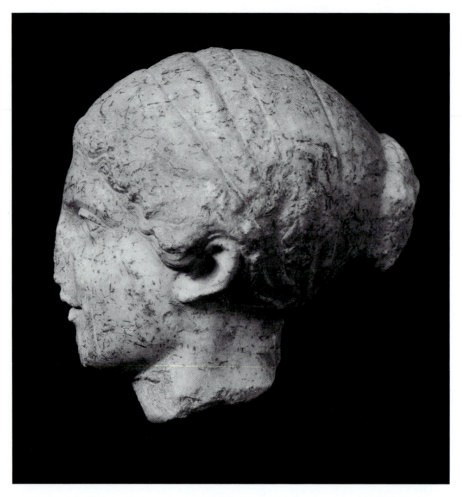

CAT. NO. 87

87–92. The Minturnae head diverges from the main type in the position of the head. While ours is in a frontal position, the Hope type head is turned to the right to look at a phiale in the right hand; a snake moves obliquely across her body to drink from the phiale. The original statue has been assigned a 4th c. BC date, though there is little agreement on the sculptor. Kabus-Jahn (1963:85–87) believes the original was from a Peloponnesian workshop of bronze sculptors of around the first quarter of the 4th c. BC, though Ridgway believes the date could as easily be later than the mid-4th c. BC (*Introduction to the Collections* 1985:38). Sobel agrees that the date of the original should be in the first quarter of the 4th c. based on the pose, and that it must have been an important cult image (Sobel 1990:25–26).

The findspot of this head near Temple L at Minturnae suggests that it may have been used as a votive statuette. Sobel lists 20 statuettes of the Hygieia Hope type (in addition to 3 other heads of small scale), with proveniences in Athens, Epidauros, Sparta, Thessaloniki, Crete, Cyrene, and Rome from a variety of contexts (Asklepieia at Epidauros and on south slope of the Athenian Acropolis; the Agora at Cyrene; baths at Cyrene; and in the so-called Stadion on the Palatine in Rome) (Sobel 1990:89–92). The Hope Hygieia statuette type seems to have served various functions in the Roman period. The differences in size, chronology, and findspot of this Hygieia and the head of the bearded god, possibly Asclepius (**89**), indicate no association of the two sculptures.

CAT. NO. 88

88
DOUBLE-HEADED *HERM* BUST OF HERAKLES/HERCULES AND HERMES/MERCURY

32-36-68
Minturnae, in area of Temple L
Roman Imperial period, 2nd c. AD
White marble
P. H. 0.25; H. face youthful figure 0.106; Max. P. W.
 bust 0.141; Max. P. Depth 0.152 m.
PUBLICATIONS: Minturnae Field no. 2902; Johnson
 1932b:292; Le Vie d'Italia 39, 1933:698; Johnson
 1940: col. 489; Adriani 1938: 190–91, no. 34, figs.
19–20; Seiler 1969:96, no. 92; Giumlia 1983:244,
no. 169; Harnett 1986:15, A34, pl. 36a and b.

CONDITION: Intact except front of bust on bearded side which has been partially restored in plaster. Crack through left shoulder of youthful bust. Much worn with chips missing from bearded head: nose, beard, edges of lion skin; and from youthful head: nose, chin, and hair. Dark discoloration and especially worn on left side of face and head of youthful figure and upper right side of bearded figure.

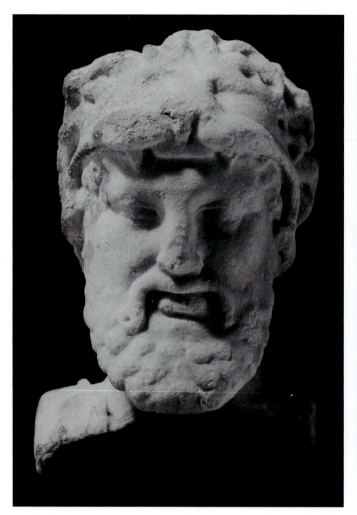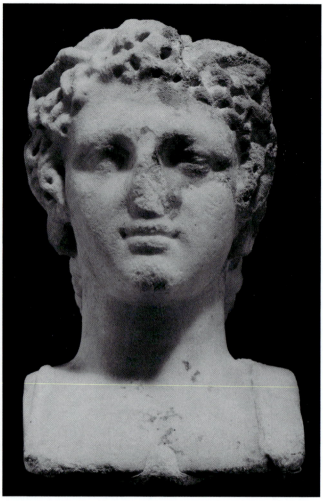

CAT. NO. 88

DESCRIPTION: Double-headed *herm* bust with back-to-back half-lifesized heads of the youthful god Hermes/Mercury with wings in his hair and of a bearded mature Herakles/Hercules wearing a lionskin over his head.

Hermes has a small triangular face with narrow forehead, widely spaced eyes barely open, turned very slightly to the right, with eyelids with little definition. Flattish cheeks, small closed mouth with well-defined lips. Full, jutting chin. The much worn hair rises from the center of the forehead in a pile of curly locks with drilled centers; the same type of curls cover the sides of the head. In front of each small well-formed ear a long lock of hair is positioned. To the right and left of the central locks are raised elongated wings. The neck is well modelled with a crease. On the front of the bust are the ends of the fillet which

disappears in his hair, depicted as narrow raised vertical elements, one on each side, set asymmetrically. The sides of the bust are flattened with no cuttings for arms. The bottom is roughly flattened.

Herakles has a rectangular face with a shallow forehead, small close-set eyes below a thickened brow ridge. His gaze is downwards and slightly to the right, with half-opened eyes and shallow ridges for lids. Raised cheekbones with sunken area around moustache. Handlebar moustache with spiral at ends with center drilled on right side. Small mouth with slightly parted lips; well-defined lower lip. Full triangular beard treated with individual raised circular curls. Hair is only visible to right and left of brow as raised curls. On top of head is a much worn lionskin, the pointed fangs of which appear in relief on the forehead. The nose,

eyes, and curly mane are delineated. On the right side of the front of the bust is a raised loop of a fillet.

COMMENTARY: In Greek mythology Hermes and Herakles are half-brothers, both fathered by Zeus, and they are linked in various ways in Greek mythology. (For many depictions of them together, especially on Greek vases, see *LIMC* V, Hermes: 328–33.) The juxtaposition of a youthful male deity with an older bearded deity is typical in double *herms*, but there are few parallels for the joining of Herakles/Hercules and Hermes/Mercury in a *herm* and, unlike the Minturnae *herm*, the other examples show both gods as youthful and beardless. For example, the *herm* in Copenhagen (Inv. 1809; Giumlia 1983: no. 172; Poulsen 1951:199, no. 267) shows both gods beardless, with Hermes wearing his characteristic winged *petasos*, while another *herm*, on the art market in the 1960s (von Heintze 1966–67:251–55), shows two youthful beardless gods back to back, with the Hermes type similar to the Atalante (Locris) statue in the National Museum in Athens (Nr. 240; von Heintze 1966–67: pl. 92, 2.3).

The two heads of the Minturnae *herm* are inspired by different Greek sculptural sources, as is the case with many double *herms*. The bearded Herakles head is an archaistic image and bears a relationship to *herms* of Hermes of the 4th c. through the Hellenistic period (see *LIMC* V, Hermes: 299–300, nos. 58–70), though Harnett points out that the downward gaze of Herakles's eyes suggests that the head was copied from a statue type rather than a *herm* (Harnett 1986:144–45). The Hermes of the Minturnae *herm*, without his cap and with wings in his hair, is similar to Roman adaptations of a supposed 5th c. Polykleitan type (e.g., *LIMC* V, Hermes: nos. 946a–e), though it is likely that that the wings in the hair are a purely Roman element (see Ridgway 1995:190 and n. 44). The soft facial features and unruly hair put this Minturnae Hermes in the Hellenistic eclectic tradition (no. 953b; see also the Chatsworth Hermes: Furtwängler 1901:214–15, no. 4, pls. XI–XII). The date of the Minturnae *herm* in the 2nd c. AD comes from the traces of the deep drilling of the Hermes's hair and Herakles's beard and lionskin.

While each of these *herm* heads is modelled after a generic Greek style, this eclectic double *herm* is a Roman creation with a completely different purpose. While the Greek *herm* served primarily a religious function, the Roman double *herm*, a probable innovation of the 1st c. AD, seems to have had mostly a decorative purpose, with the ones from the gardens and peristyles of Pompeii and the other Vesuvian towns the earliest datable examples (Seiler 1969:9–13, esp. 12; 117, 118, 122, 128, 129, 131, 132, nos. 4 and 12, figs. 537–40, 562–65; Giumlia 1983:4). It is not clear where this double *herm* would have stood in the Roman Forum at Minturnae and how it might have been used, but the juxtaposition of Hermes/Mercury, the god of trade and commerce, with Herakles/Hercules, a god with associations with trade, colonization, and cattle, seems competely appropriate in the context of the important colony of Minturnae (see discussion of these associations with Hermes and Herakles in Ridgway *Fourth Century Styles*: 297–98, 315, n. 31).

89
HEAD OF BEARDED GOD

39-42-1
Minturnae, southwest corner of Temple B
Roman Imperial period, 2nd–3rd c. AD
Large-grained white marble, possibly Parian
P. H. 0.31; Max. W. 0.205; Max. Depth 0.23 m.
ACQUISITION: *This head was excavated on September 10, 1931, and was presented by the Italian government to Gustav Oberländer, a member of the Museum's Board of Managers and a patron of the Minturnae Excavations, in appreciation for his support of the excavations. The head was given to the Museum in 1939 by Mrs. Harold M. Leinbach, a*

member of Oberländer's family.
PUBLICATIONS: *Minturnae Field no. 379; Johnson 1933b:67–70, pl. V; Johnson 1936:303; Adriani 1938:191–92, no. 36, fig. 21; Harnett 1986:16, 208–9, A36, pls. 60–62; Coarelli 1989:62.*

CONDITION: Single fragment broken on a diagonal at the neck. Nose broken off at tip; chips off right side of moustache and right side of hair above forehead.

DESCRIPTION: Just under lifesized bearded male head turned slightly to the right. Hair is swept up off forehead

in full locks that also fall to frame the sides of the face and neck. Random deep drillwork defines the locks and a deep channel sets off the sides of the face from the hair. Hair on top, sides, and back of head is left undefined, and head is only summarily finished in back, indicating that it was meant to be seen only from a strictly frontal view. Beard is full in two layers, with a central division of the lower layer; clumps of curls project on the upper chin and fall onto the neck. Deep drillwork in channels or circular holes defines the curls. The moustache is full and bushy with outturned ends. The forehead is deep with a bulge above brow. The brow ridge is a sharp crease. The eyes are open and almond-shaped; the upper lid is a thickened ridge. The iris of the eye is a compass-drawn circle and the pupil is a drilled lentoid depression positioned pendant from the upper lid and looking slightly right. Nose is broad and straight with drilled nostrils. Mouth is open with indications of teeth. Full lips. Full muscular neck. Face is polished.

COMMENTARY: The lack of a specific attribute to identify this divine image allows the possibilities of Jupiter, Asclepius, Serapis, or Neptune. Landwehr (1990:101–22) argues for the interchangeability in Roman sculpture of the head type of the bearded *Vatergott* for standing or seated images or busts of Jupiter, Serapis, Asclepius, Neptune, and even Ammon and Saturn. This lack of iconographic specificity in the use of this bearded type is symptomatic of the syncretistic nature of Roman religion. The salient characteristics of this type that can be matched with this head are the rising peak of hair above the forehead (*anastolé*), the handlebar moustache, the small, slightly open mouth, and the short, neat beard with a double row of curls. The Minturnae head lacks the band around the head that is shared by many of these images, yet it fits well into the Hellenistic and Roman concept of the mature male divinity, the *Vatergott*.

The Zeus/Jupiter type that has traditionally been associated with the bearded god with *anastolé* hair is the 4th c. seated statue of Zeus attributed to Bryaxis (*LIMC* VIII, Zeus: no. 219). This affectation of the hair is also associated with the cult statue of Serapis, said by a late author to have been created by Bryaxis for his temple in Alexan-

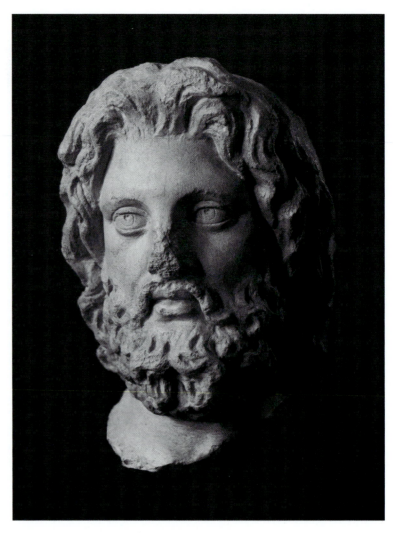

CAT. NO. 89

dria. Yet, in Roman versions Serapis more often wears a *modius/kalathos*. (For a discussion of the latter see Ridgway *Hellenistic Sculpture I*: 95–97.) In general, the handling of the hair in *anastolé* fashion, the hairdo associated with Alexander the Great and his Hellenistic successors, should put at least part of the inspiration for the general image in the Hellenistic period.

Of Asclepius types, the ones most abundantly represented and with the most variants are the Giustini and Este types (*LIMC* II, Asklepios: nos. 154–233, 320–54). The former is a standing statue with the *himation* draped over the left shoulder and with the head turned slightly to the right. Neugebauer (1921:78) suggested from the number of variants of the type in Pentelic marble that the statue was

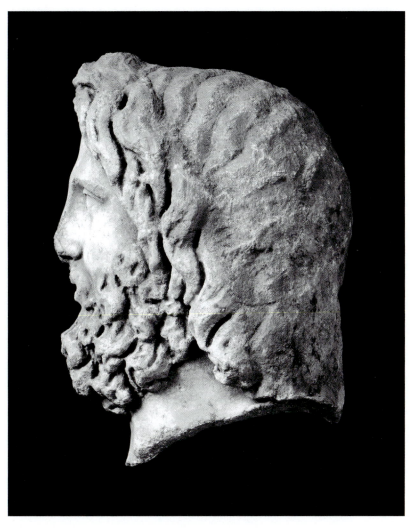

CAT. NO. 89

an Athenian cult image of the 5th c., perhaps by Alkamenes, while a more recent assessment of the type puts it in the beginning of the 4th c. BC (Kabus-Jahn 1963:83–85; *LIMC* II, Asklepios: 894). The hair and slightly parted mouth of the Minturnae head are, however, much closer to the Cherchel seated type (*LIMC* II, Asklepios: 871–72, no. 47; see Landwehr 1990 for a full discussion), although the head in Algeria is turned to the left. For a close parallel see *LIMC* II, Asklepios: no. 348, a 2nd c. AD variant in Copenhagen of the Este type, probably created at the end of the 4th c. BC (895).

This bearded head is the latest of the Minturnae sculptures in the UPM corpus, with a date at the end of the 2nd or beginning of the 3rd c. (Severan period) given by the engraved iris and lentoid-shaped, drilled pupil. The unfinished back of the head suggests that the head was positioned where the back would not have been seen, perhaps in a niche. Johnson indicated that this head was found at ground level at the southwest corner of Temple B and thought that it must have been set up inside the vestibule of the temple along with other sculptures (Johnson 1933b:70).

Miscellaneous (90)

90
COMIC MASK

32-36-62
Minturnae, vaults under Temple L
Roman Imperial period, 1st c. AD
White marble
H. 0.40; Max. W. 0.28; Max. D. 0.198 m.
PUBLICATIONS: *Minturnae Field no. 3549+3696;*

Johnson 1933b:70, drawing on cover; Adriani 1938:193, no. 39, fig. 23; Minturnae II 1933:5; UPMB 13, 1947:5 for photo; Bieber 1961b:244–45, fig. 807; Harnett 1986:16–17, A39; Fuchs 1987:35.

CONDITION: Mended from two large fragments of upper head and beard (with break through bottom lip) and two

smaller fragments at upper right side. Missing left side of face including part of left eye, ear, and back left side of head (now restored in plaster). Missing large fragment from upper back of head. Right and left sides of face are much pitted and worn. Interior of lower lip is worn and smooth. Tip of nose broken. Much incrustation on head and forehead.

DESCRIPTION: Overlifesized comic mask with open eyes and mouth pierced through. Cap-like hairdo (*speira*) with rolled edge decorated with diagonal incisions and coming to a peak at the center of the forehead. Top of head/cap is undecorated. Overhanging forehead with deep pendant furrows; arching brows over deep-set, wide-open pierced circular holes for pupils (D. 0.019 m.), surrounded by bulging irises. Deeply indented lacrimal gland. Nose is flattened out with deeply undercut nostrils. Wide-open oval mouth (L. 0.098; H. 0.05 m.) pierced through the back of the mask. Upper lip is drawn up at the corners; a ridge beneath the upper lip suggests an upper row of teeth; the lower lip is defined as a ridge with no teeth indicated. Puffy cheeks beside nose. Small ear partially hidden by roll of hair. Behind ear is a small clump of hair that hangs down side of face and is grooved. Beard is long and rectangular, divided into five vertical sections with diagonal grooves ending in drill holes to suggest spiralling locks. Back of beard is flat, while the back of the mask proper is hollowed out.

COMMENTARY: This mask represents one of the basic characters of New Comedy as described by Pollux (*Omomasticon* IV, 143–54). Rather than a slave mask, which generally has the open megaphone-type mouth and a short beard (see Bieber 1961b:102–3), this mask represents the old man/father whose visual characteristics are the cap of hair (*speira*), wrinkled forehead, the broad and flat nose with flaring nostrils, the large eyes under arching brows, the open grimacing mouth, and stylized beard. This type is close to the old man shown in a relief in Naples (Bieber 1961b:92, fig. 324) and to a large terracotta statuette in Paris representing the father of comedy (Bieber 1961b:93, fig. 325). A mask from Pompeii in Dresden with a similarly stylized beard with spiraling locks is close to the Minturnae example (Bieber 1961b:94, fig. 330), and the 1st c. date proposed for this mask is based on that parallel. For a recent publication

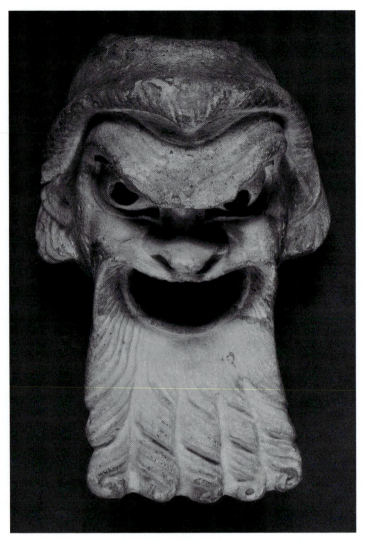

CAT. NO. 90

of terracotta theatrical masks, though with none of this type, see Bernabò Brea and Cavalier 2002.

Johnson thought that this mask and three others found in the same area, one other comic mask and two tragic masks (Adriani 1938: nos. 95–97), were all probably part of the theater decoration (*Minturnae II* 1933:5). Yet, these four masks were not found in the area of the theater but some distance away in the area of Temple L to the southeast of the Republican Forum. One would have to presume that all four were removed to a secondary context or, more likely, that they belong to another structure and served a decorative function, like those from the houses at Pompeii and other sites in the Vesuvian region (Bieber 1961b:244).

Sculpture from Teanum Sidicinum (91-92)

Teanum Sidicinum was an important and large ancient town located in a strategic position at the northern border of Campania on the Via Latina (Strabo 5.3.9). Originally the capital of an Oscan tribe of the Sidicini, the town came under Roman control in 334 BC and became a Roman colony in the 1st c. AD (Johannowsky 1976:888). The 4th c. BC orthogonal layout of the town has recently been confirmed by a geophysical survey by the British School at Rome (Strutt and Johnson 2002; Johnson, Baldwin, and Strutt 2003). On the banks of the river Savone there is an important sanctuary of Loreto with finds dating back to the Late Archaic period (Johannowsky 1963:132–51). A well-preserved Hellenistic theater (Johannowsky 1963:152–59) and sanctuary complex lies below to the southwest, with a Roman amphitheater nearby.

In 1907 and 1908 E. Gabrici excavated part of an extensive Roman bath structure in the sprawling ancient city at Teanum, in the district called Santa Croce. Gabrici dated the final phase of the bath to the 2nd or 3rd c. AD. He did not venture a date for its earlier phases (1908:414), though Johannowsky assigns it a date in the Sullan period, with various rebuilding phases into the late empire (1976:888). The young Leonard Woolley, acting as an archaeologist for hire, excavated on behalf of the UPM as a member of Gabrici's excavation staff. The two sculptures in this corpus from Teanum (**91** and **92**) were given to the UPM as a division of the finds for the Museum's participation in this excavation. In addition to the two sculptures in this catalogue, Gabrici excavated four other sculptures in the bath building at Teanum: two Erotes, a young satyr, and a head of a youth (1908:404–10, figs. 5, 7, 8–9). These were assigned a 2nd c. AD date (Gabrici 1908:414).

91
VENUS STATUE

MS 5671
Teanum Sidicinum, northern Campania, Italy, Bath
* Building, Room XVI, locus b*
Roman Imperial period, 2nd or 3rd c. AD
White marble
P. H. 1.425; Max. W. at thighs 0.465; W. at shoulders
* 0.42 m.*
ACQUISITION: *See Introduction, above.*
PUBLICATIONS: *Gabrici 1908:409, 411, fig. 10; Bates*
* 1910a:128; Luce 1921:192, no. 66.*

CONDITION: Missing head and upper neck, right forearm and hand, left hand from wrist, and ankles and both feet with plinth and lower part of support and drapery. Surface is much corroded, perhaps from water damage, especially back of right leg. Surface stains on the back from contact with iron; back of garment has dark gray stains. Two

modern screws in back of drapery.

DESCRIPTION: Standing, almost lifesized nude Venus, leaning slightly forward from the waist with the right arm sharply bent, the right forearm across the mid-torso with the right hand touching the left breast. No traces of locks of hair on the shoulders. The left arm is slightly bent at the elbow and would have extended across the left hip to the right thigh to cover the genitalia. The connecting points of the right forearm on the mid-torso, of the right hand on the left breast, and the fingers of the left hand on the right upper thigh survive. The right leg is bent and is in advance of the left. The left leg is straight and is connected to a support to the left composed of a columella or vessel on a tall base over top of which is Venus's garment. The garment is executed with deep folds defined by drillwork. The left side and back of the drapery are squared off and treated in broad, less well

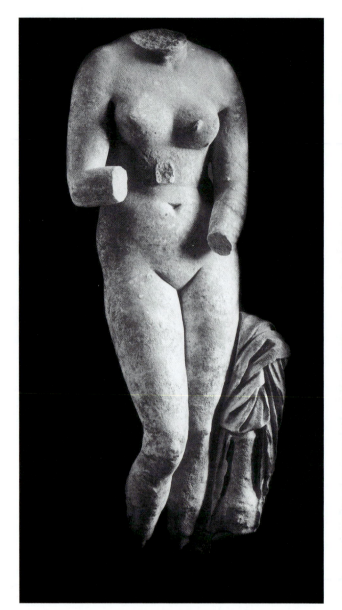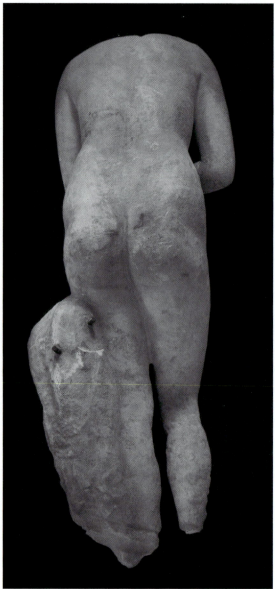

CAT. NO. 91

defined folds, suggesting that these were not meant to be seen by the viewer. In general, the modelling is crude with large volumes for the shoulders, breasts, arms, stomach, genitalia, and legs. The navel is a deep cavity. The head and forearms with hands were carved in one piece with the statue. The lower legs and feet from the ankles and the lower part of the support and drapery were carved separately and would have been inserted into the recessed cavity in the lower left leg and bottom of the support. In the bottom of the right leg is a circular tenon which would have attached

the foot, possibly carved in one piece with a plinth.

COMMENTARY: This water-damaged Venus statue was found in the Teanum bath building in area XVI, locus *b* (see plan in Gabrici 1908:401), in the southeast corner of a large open courtyard (Gabrici 1908:409).

The statue is a fairly faithful Roman copy of the Capitoline Aphrodite, a Hellenistic type variously dated from the later 4th to 2nd c. BC, characterized by the figure bending slightly, her bent right leg, and her hands most

often interpreted as shielding her nudity as she is surprised at her bath. Missing here, however, are the locks of hair that would be visible on the shoulders of the statue. In most of the copies and adaptations the goddess's garments are placed atop a vase to her left. In this case, the poor state of surface preservation of the piece does not allow us to distinguish the exact form of the support.

The poor preservation also makes it difficult to be precise about the date of this statue. The deep drillwork suggests a date from the Flavian period on. Gabrici (1908:414) dated the final phase of the bath structure at Teanum to the late 2nd or 3rd c., and this statue could be equally as late.

The bath building at Teano is a fitting context for a nude image of Venus, and the statue was certainly a decorative sculpture, possibly in connnection with a pool or fountain. Statues and statuettes of Venus were especially popular in Roman baths (see Manderscheid 1981:32–33 for discussion of Venus in Roman baths, with many examples catalogued). As the goddess governing sexuality, nude images of Venus in bath buildings celebrated fertility, beauty, and femininity; in this context, the Venus Capitoline type depicting her at a vulnerable moment during her bath is also perhaps an overt reference to feminine beautification rituals (see D'Ambra 2000:101–4).

92
MASK OF A WATER DIVINITY

MS 4917
Teanum Sidicinum, northern Campania, Italy.
 Bath Building, Area XV, locus f
Roman Imperial period, late 1st or 2nd c. AD
White marble
H. 0.75; Max. P. W. 0.57; Max. P. Depth
 0.255 m.
ACQUISITION: *See Introduction, above, p.185.*
PUBLICATIONS: *Gabrici 1908:405, 407, fig.*
 6; Bates 1910a:128; Luce 1921:178, no.
 5; Guide to the Etruscan and Roman
 Worlds 2002:49, fig. 70.

CONDITION: Right side of face, hair, ear, and beard missing. End of nose, top of mouth and moustache, lower lip, and right cheek broken. Gouge from right eye. Fault in stone down left side of face. Severe signs of wear, most probably from water damage.

DESCRIPTION: Four times lifesized mask of a water divinity. Hair is parted in center and drawn to the right and left in thick wavy tresses; two comma-shaped curls are positioned on forehead and one is in front of left ear. The hair spreads out beyond or behind the ear. The top of the head, behind the hair over the forehead, is roughly worked without indications of locks of hair. The ear is large, with a flattish circle for the lobe. Long,

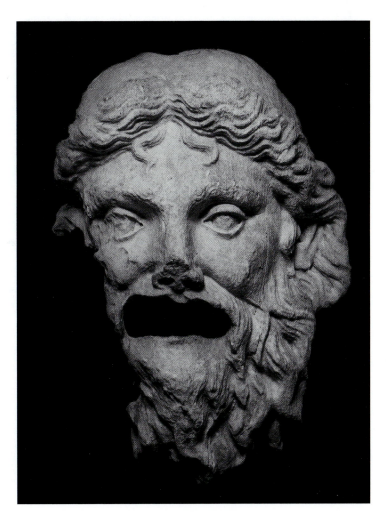

CAT. NO. 92

drooping moustache and long beard with thick wavy sections deeply drilled. Prominent ridge brow with hair of eyebrows indicated by wavy grooves. Large open eyes with prominent lids and deep lacrimal glands indicated; the eyeballs slant in from top to bottom. Broad nose with large, deeply drilled nostrils. High cheekbones. Large open mouth with elongated oval cavity, open to the back; no indication of teeth. Back of head is hollowed out in the central section and roughly finished. In the top of the head near the back is a rectangular cutting for attachment (L. 0.018 x W. 0.01 x Depth 0.005 m.).

COMMENTARY: This mask was recovered in an area of the bath labelled XV, a large open courtyard just south of a fountain basin against a southern wall (Gabrici 1908:405; fountain marked "vasca" and location of mask marked 'f' on the plan p. 401).

The form of the mask with the large open mouth, the iconography of a water divinity, the find spot in the bath building at Teano, and the water damage on the piece all suggest its use as a fountain device. See Manderscheid 1981:30–31 for a discussion of the presence of images of various divinities associated with water in Roman bath buildings. For a parallel for a water divinity mask used in a fountain setting in the Glyptotek in Copenhagen, see Østergaard 1996:224, no. 126: 2nd c. AD. The deep drilling and rich treatment of the flowing hair and beard are paralleled by masks on plaques of the Flavian period, e.g., one showing Polyphemos in the Thorwaldsen Museum in Copenhagen (Inv. H 1483; Cain 1988:137, no. 29, fig. 30) and the mask of Pan on a plaque in the Glyptotek in Copenhagen (Inv. 1810; Cain 1988:139, no. 28, fig. 32).

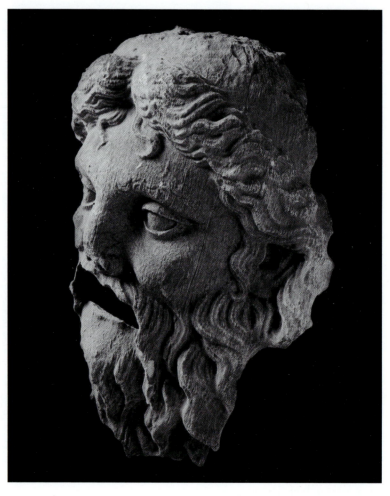

CAT. NO. 92

Sculpture from Nysa Scythopolis (93–101)

Beth Shean/Beisan in ancient Palestine, known as Nysa Scythopolis or Scythopolis in the Hellenistic and Roman periods, is a city on the southern bank of the river Naḥal Ḥarod (Jalûd), 25 miles south of the Sea of Galilee, at the junction of two important ancient routes (see Negev 1976 and Mazar, Foerster, and Tzori 1993:214–35 for summaries of the site's history and archaeology) (see Fig. 8). The site was occupied almost continuously from the Late Neolithic to the Early Arab periods, with times of great prosperity, especially in the Late Bronze Age and Roman period. The large tell of Beth Shean and the Northern Cemetery cut into the cliff face along the northern bank of the river were excavated by the Palestine Expedition from the University of Pennsylvania Museum in 10 field seasons from 1921 to 1933 (Fig. 7), and it is from these excavations that the nine sculptures included in this catalogue derive.

The Hellenistic and Roman city of Nysa Scythopolis was named, in part, after the nymph Nysa to whom Zeus gave the baby Dionysos to rear in the sacred grove at the site (see discussion of the sacred grove and the nymph Nysa in Nieto Ibáñez 1999). The city's other name, Scythopolis, seems to be a reference to a supposed 7th c. BC occupation of the region by Scythians (Herodotus I, 105). See discussion of the founding of the city in the Hellenistic period in Fuks 1976:59–73.

Excavations since 1986 under the direction of G. Mazor, G. Foerster, and Y. Tsafrir for the Israel Department of Antiquities and Museums and the Hebrew University have explored Middle and Late Bronze Age and Iron Age I strata on the tell, as well as extensive areas of the Hellenistic, Roman, Byzantine, and Early Arab city at the foot of the mound to the south (see summary in Mazar, Foerster, and Tzori 1993:214–35). On the tell itself, the only substantial remains of the Hellenistic or Roman periods are of a monumental temple of which the foundations of the podium survive, along with marble architectural fragments including Corinthian capitals (see 93, below, for discussion of the temple). Of the nine Beth Shean sculptures in the UPM corpus, three are from the tell: a limestone archi-

tectural fragment depicting Bacchus or a satyr (94), and two marble fragments, including digits from a colossal statue (93) and a small ram's head (101).

In the Roman and Byzantine city at the foot of the mound, recent excavations have revealed a large theater dating to the Severan period, an amphitheater with a seating capacity of between 5,000 and 7,000, probably of the same date as the theater, colonnaded streets and stoas, baths, a basilica, an odeion or bouleuterion, a nymphaeum, and a prostyle podium temple with a circular *naos*, possibly dedicated to Dionysos/Bacchus or Tyche (Mazar, Foerster, and Tzori 1993:223–30), all testimony to a significant Roman settlement at Nysa Scythopolis. The general plan of this Roman city seems to have been drawn up in the second half of the 2nd c. AD (Mazar, Foerster, and Tzori 1993:223).

In the Roman period Scythopolis was an important commercial center, famous for its manufacture of high-quality linen (Rowe 1930:4–5; Fuks 1976:167–71), and the largest city, according to Josephus (*The Jewish War* III, ix, 7), of the Decapolis, a league of ten cities which included Gerasa, Philadelphia, and Damascus. Vespasian quartered the 15th legion in Scythopolis in AD 66/67 (Josephus, *The Jewish War* III, ix, 1), and during the Jewish Revolt, Josephus records that the Jews of Scythopolis took the side of the local citizenry and fought against the Jewish insurgents (*The Jewish War* II, xviii, 3). Epigraphical evidence (from the period of Marcus Aurelius, AD 121–180, and from the early 3rd c. AD) points to the celebration of athletic games at Scythopolis (Rowe 1930:46).

UPM excavations in the 1920s in the Northern Cemetery uncovered over 230 graves and tombs from the Middle Bronze Age I to the Roman/Byzantine period, cut into an extensive travertine terrace. While the earlier graves and their contents were published by Oren (1973), the Hellenistic, Roman, and Byzantine rock-cut tombs remain unpublished, though there is extensive information in an unpublished manuscript by G. M. FitzGerald ("Excavations in the Northern Cemetery Area, 1922–1931," ca. 1932), along with field notes, drawings, and photographs in the UPM archives,

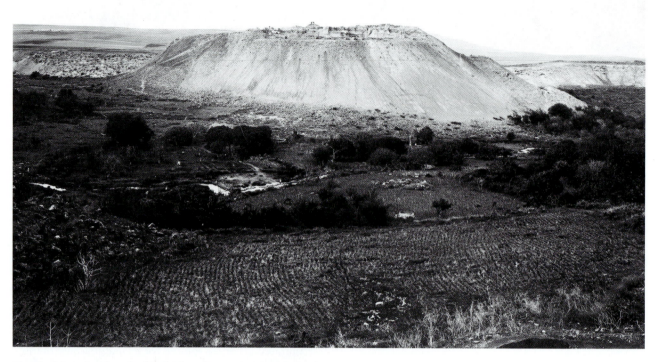

Fig. 8. Nysa Scythopolis (Beth Shean/Beisan), Israel. View of tell at end of 1928 season, taken from the south with the Northern Cemetery to the far left. Photograph by Fadil Saba. Photograph from UPM Archives.

as well as many of the finds themselves in the Museum's Near Eastern Section. Other finds from these excavations are in Jerusalem, in the Rockefeller Museum, and in the Israel Museum.

Skupinska-Løvset (1983) published 161 funerary busts from Scythopolis, including 5 in the UPM (**95, 97–100**) and others in Jerusalem from the University of Pennsylvania Expedition, along with more brought to light since that time. Many are also in museums and private collections in Europe and Israel. Since many of the Beth Shean tombs were looted prior to excavations, the surviving busts probably represent only a fraction of the original number from the Roman tombs. For those busts that do survive, few were found *in situ*. Skupinska-Løvset lists 15 funerary busts from 10 tombs for which specific find spots in the North Cemetery at Beth Shean are known; 4 tombs have 2 busts each (1983:100–101). We are lacking field numbers and specific locations for 4 of the 6 UPM busts. Some of

these may have been found and brought to the excavators by Bedouins (Skupinska-Løvset 1983:100). The disassociation of the sculptures from their specific tombs or their contents is regrettable and makes dating these crude busts dependent on stylistic and technical evidence, which Skupinska-Løvset (1983) convincingly and thoroughly presents. Traces of some hard white substance (plaster, mortar, or stucco?) on a few of the UPM busts (**96, 97, 98**) suggest that at least some of these funerary busts were set into or against walls in the tombs. In one case, a bust was found *in situ* set into a wall at the back of a tomb (G. M. FitzGerald, "Excavations in the Northern Cemetery Area, 1922–1931": 50, tomb 292).

Some of the Beth Shean busts are inscribed with the name of the deceased in the nominative or genitive, sometimes with a patronymic, though none of the UPM examples are inscribed. These inscriptions, written in Greek script, attest to the multi-ethnic population at

cosmopolitan Beth Shean in the Roman period. Some of the names are of Greek origin, some have Semitic roots, and others have Latin roots (Skupinska-Løvset 1983:117–20). Despite their crude style, these funerary busts, dating mostly to the 2nd and 3rd c. AD, are unique artistic and cultural expressions of North Palestine, while depending to some extent on Imperial prototypes.

93
FRAGMENTS (7) OF COLOSSAL STATUE: FINGERS

29-107-924
Nysa Scythopolis (Beth Shean/Beisan), Israel, all fragments from the tell
Roman Imperial period, 1st–3rd c. AD
Medium- to large-grained white marble with some gray veins, possibly Proconnesian from the island of Marmara. (Dolomitic marble has been eliminated by testing with dilute hydrochloric acid.)
a: elongated finger with fingernail; field number 695, from the summit, large cistern, west side of inner circle; P. L. 0.37; P. W. 0.225; P. Th. 0.125 m.;
b: right thumb and index finger; field number 25-11-160, debris from reservoir south of temple; P. L. 0.375; P. W. 0.245; P. Th. 0.215 m.;
c: finger fragment?; field number 27-8-47, Area N.W. W. of 1173; P. L. 0.22; P. W. 0.115; P. Th. 0.125 m.;
d: finger fragment with dowel holes; field number 696, from the summit, large cistern, w. side of inner circle P. L. 0.20; P. W. 0.10; P. Th. 0.09 m.;
e: finger fragment; field number 25-11-610, debris of reservoir south of temple; P. L. 0.225; P. W. 0.10; P. Th. 0.06 m.;
f: thumb fragment?; field number 3199, from the summit, P.B.L., room 60 x 1; P. L. 0.115; P. W. 0.096; P. Th. 0.088 m.;
g: small squared-off fragment with small circular dowel hole; unknown context; P. L. 0.07; P. W. 0.055; P. Th. 0.035 m.
ACQUISITION: *Excavated by the UPM Palestine Expedition to Beisan in 1921, 1923, 1925, and 1927 on the tell. See above for specific findspots for the fragments.*
PUBLICATIONS: *Fisher 1923:239; Rowe 1930:45, pl. 45; FitzGerald 1931:44, pl. XXV, 1.*

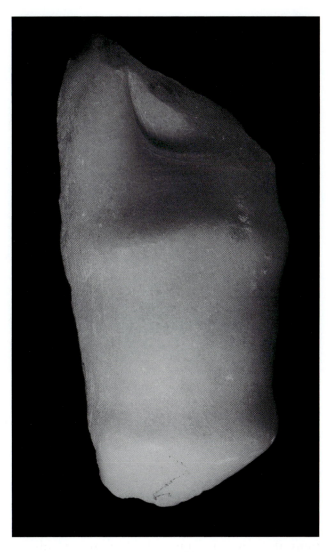

CAT. NO. 93a

CONDITION: *Seven individual fragments with no joins. Some surface chips missing from 'b.' Some iron stains and mortar on broken surfaces from secondary deposition.*

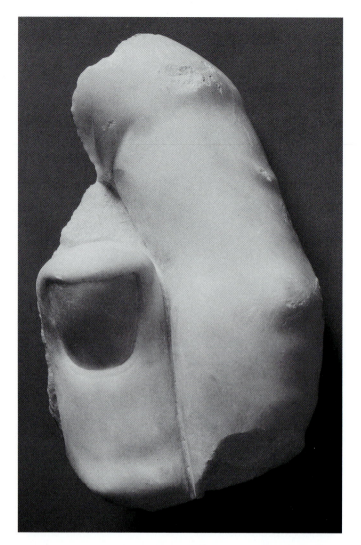

CAT. NO. 93c

CAT. NO. 93b

DESCRIPTION: Fragments of colossal fingers. The largest fragment (b) represents a right thumb alongside a bent index finger, with the latter rendered disproportionately large, as if several fingers in thickness. The joints are rendered as raised knobs. A raised vein runs across the index finger. The triangle between the thumb and finger has been left as a rough surface. Other fragments (a, d, e) are of elongated fingers with squared-off fingernails. In the back of fragment 'd' is a round dowel hole (D. 0.022; Depth 0.04 m.) and in the end opposite the fingernail is another dowel hole (D. 0.02; Depth 0.05 m.). Fragment 'f' may be the left thumb. One fragment (c) may be of a finger at a

joint with a broken squarish surface on the back, perhaps from a strut. All of the fragments are highly polished.

COMMENTARY: All of these colossal marble fragments were found in secondary contexts, mostly in the large reservoir south of the temple on the summit of the mound (see Rowe 1930:43, fig. 9, for a plan of the relationship of the reservoir to the temple). This large (37.05 x 22.08 m.) temple, the so-called Hellenistic Temple, with well-preserved foundations beneath a church (FitzGerald 1931:44) and scattered finds of columns and entablature, was dated by the excavators to the Hellenistic period (ca. 3rd c. BC) (Rowe 1930:43–44, fig. 9; Fisher 1923:239), but was reported to have been unfinished and then renovated in the Roman period (Fisher 1923:239). A reexamination

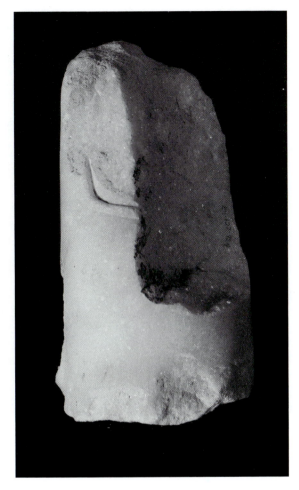

CAT. NO. 93d

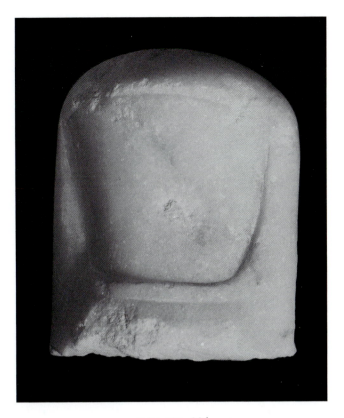

CAT. NO. 93f

of the architectural remains may, in fact, show that the original construction was of Roman date (Negev 1976:815; Fuks 1976:113). The temple was thought to be dedicated to Dionysos/Bacchus or Astarte-Atargatis, though the evidence is scanty (Rowe 1930:44–45). The UPM fragments of the colossal statue are associated by the excavators with this temple and are proposed to be that of Dionysos/Bacchus or a Roman emperor set either inside the temple or just outside it (Fisher 1923:239). (A marble overlifesized, beardless male head [P. H. ca. 0.42 m.], identified as Alexander the Great or Dionysos, was found in the same cistern on the south side of the temple as many of the fragments of digits [Rowe 1930:44–45, pl. 55; Thiersch 1932:52–76], but the scale of the head is too small to belong to the same statue as the digits.)

The largest of these fragments, the right thumb and the index finger (b), was meant to be seen with the hand down with the thumb facing forward, in a position where the disproportionate thickness of the index finger would not have been visible to the viewer. This would make the remaining fingers (a, d, and e) parts of the left hand, with 'f' the left thumb. Fragment 'd' with its dowel holes shows that the underside of the hand was attached to something and that the finger was doweled into another fragment. It is possible that these fragments belong to an acrolithic statue, with the flesh parts made of marble and the rest of the statue of a less expensive material or covered with sheeting, but that is not confirmable from these fragments.

The evidence from these fragments is also not conclusive enough to identify whether the figure is male or female, though colossal images are generally reserved in the Roman period for divinities and emperors. The date of the statue, to judge from the high polish, belongs in the 1st through 3rd c. AD, but there is little stylistic or technical evidence to establish a more specific chronology.

94
ARCHITECTURAL FRAGMENT: DIONYSOS/ BACCHUS OR SATYR HEAD

29-107-919
Nysa Scythopolis (Beth Shean/Beisan), Israel, from debris on the tell
Roman Imperial period, late 2nd–early 3rd c. AD (Severan period)
Pale limestone
P. H. 0.25; P. W. 0.245; P. Th. 0.11 m.
ACQUISITION: *UPM Expedition to Beisan, April 17, 1923, from debris on the summit of the tell (P.B L. N.W. area). Field number 3112.*
PUBLICATIONS: *Fisher 1923:239; Rowe 1930:44; FitzGerald 1931:44, pl. XXV, 3; Fuks 1976:106–7.*

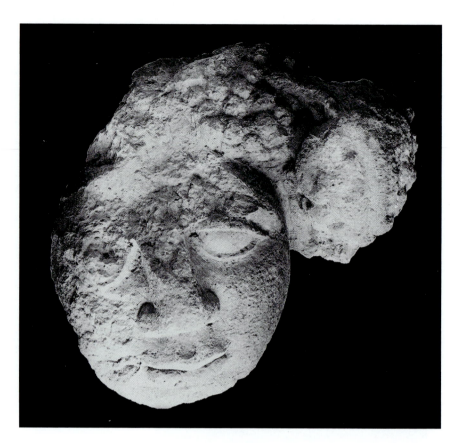

CAT. NO. 94

CONDITION: Single fragment preserving part of a face and head ornament with grapes to left side. Broken off on right side along upper forehead, chin, and in back.

DESCRIPTION: Overlifesized, frontal anthropomorphic relief head with asymmetrical features. Round face with large protruding eyes with sharp ridge above left eye and thick ridge for upper lid on right eye. Left eyeball protrudes with no indication of iris or pupil. Right eye is largely broken off but seems to be set lower. Very large bulbous nose with large drilled nostrils. Flattened gouge beneath nose. Thick parted lips with deep channel between. Rounded chin with cleft. On top of the head to the left side and separated from the forehead by a drilled channel are two protruding clumps covered with individual rounded raised elements, probably grape clusters. At the top of the head and behind the clusters is a flattened, slightly sloping finished surface. Back of the head is broken off; a roughly finished sloping surface survives at the top of the head on the proper left.

COMMENTARY: Rowe (1930:44) and FitzGerald (1931:44) identify this head as that of Bacchus from a frieze of the temple. The head was found in the same context with marble architectural fragments from the temple. The identification of the head as Dionysos/Bacchus or one of his entourage, like a satyr, wearing a headdress with grape bunches seems likely, and it was almost certainly used in some way as architectural decoration.

The most likely architectural use for this fragment is on a figured capital of a type that has been well documented in Roman Palestine in marble and local stones (e.g., see Fischer 1990:64–65, nos. 245–263, Type IV', Pls. 44–47; Fischer 1991:119–144, esp. nos. 7–8, figs. 7–8). (I am grateful to Moshe Fischer for his assistance in identifying the probable use of this fragment and pointing out the parallels.) On some of these Corinthian capitals, anthropomorphic heads, masks, or busts such as of Dionysos/Bacchus, Pan, a satyr, or other mythological characters are carved at the center of the abacus in place of the flower. In general, these capitals date to the Severan period, from around the turn of the 2nd to 3rd c. to the mid-3rd c. AD (Fischer 1991:133–135). One such figured limestone capital with a head of Pan was found recently at Beth Shean near a temple at the eastern end of

the main street, Paladius street, leading from the tell (Tsafrir and Foerster 1990:32, fig. 40). In addition, two figured limestone capitals, one with a bust of Bacchus and the other with a theatrical mask, are set up at Beth Shean at the western edge of the Paladius street at a propylon building (see CD Figs. 33 and 34). The capital with the Bacchus bust was found reused in a Byzantine building but is thought to be from the theater (Foerster and Tsafrir 1992:122, 134, fig. 11). It is probable that the UPM head has been broken off one of this type of figured capitals.

Close stylistic and iconographic parallels for the head come from other architectural sculptures from Beth Shean, such as the marble "peopled" scroll friezes decorating the *scaenae frons* of the theater at Beth Shean, dated to the late 2nd–early 3rd c. AD (Severan period)(Ovadiah and Turnheim 1994:125). The theme of Dionysos and his entourage is a popular one in "peopled" scroll decoration, especially in theaters where Dionysos has a special role (Ovadiah and Turnheim 1994:98) and at Nysa Scythopolis, a city with special mythological connections to the god. Among the

theater decorations at Beth Shean is a male bust protome (Bacchus?) with grape bunches to either side of the head that has been broken off (deliberately defaced?) from frieze block 7 (Ovadiah and Turnheim 1994:37–38, Ill. 50–54, pl. II). The scale, the placement of the grape clusters, and the slight turn of the head to the right/asymmetricality on both the marble frieze protome and the UPM limestone head are so closely compatible that it is possible that it was made in the same workshop or taken from a stock figure in a pattern book for the "peopled" scroll frieze ornamentation that was prevalent in the region (Ovadiah and Turnheim 1994:148). A Medusa head in relief on another frieze block (Ovadiah and Turnheim 1994:52–54, Block 27, Ill. 139) and a tragic mask on a coffer block (Ill. 228–29) also offer close stylistic parallels for the full facial features, especially the large eyes and bulbous nose. In addition, in the most recent excavations of the lower city of Scythopolis, excavators have found blocks with "peopled" scroll friezes of a more schematic and crude style, made in local limestone (Ovadiah and Turnheim 1994:122, 160, n. 22, as yet unpublished).

95
FEMALE FUNERARY BUST

29-107-918
Nysa Scythopolis (Beth Shean/Beisan), Israel, Northern Cemetery
Roman Imperial period, first half of the 3rd c. AD
Hard buff limestone
P. H. 0.30; Max. W. bust 0.30; Max. Th. 0.25 m.
ACQUISITION: *UPM Palestine Expedition to Beisan, September 27, 1926, in Northern Cemetery IV, surface debris above Tomb 210. Field number 26-9-401.*
PUBLICATIONS: *James 1961:34, lower left; James, Kempinski, and Tzori 1975:220; Skupinska-Løvset 1983:42, 183–84, 249, cat. no. 27, pl. XXX.*

CONDITION: Complete with chips from nose, mouth, tip of chin, hair on left side, and lower edge of back. Surface worn.

DESCRIPTION: Frontal female bust, armless, crudely executed with flat chisel. Hair is parted above the forehead and drawn back in sections with sharp edges to form a thick roll. Hair covers tops of ears, exposing summarily executed lobes from which hang earrings composed of a vertical rod and circular pendant. Hair is gathered in thick plaits with a

chignon set low at the nape of the neck. Some traces of black pigment on hair. Asymmetrical facial features. Squarish face with low, triangular forehead; straight nose. Large oval eyes set beneath sharp brow ridge; lids are outlined by ridges, with traces of black pigment; the right eye turns down at the outer corner, while the left is set horizontally. Irises are raised flat circular surfaces, with black pigment preserved. High cheekbones with flat cheeks. Well-defined lower lip with sharp edges; jutting chin with cleft. Broad neck turning sharply to rounded shoulders with no arms. Two garments are worn: a tunic and a type of shawl (*ampechonon*) draped over both shoulders and hanging in thickened pendant folds across the front, with a small V-shaped kink in one of the upper folds, just off-center. On the lower bust the folds of the tunic are vertical, and two small rounded protrusions represent breasts. Back of head slopes to thickened, rounded back of bust, crudely finished with flat chisel strokes. Bottom of bust forms an ovoid contour, roughly finished in uneven but stable resting surface.

COMMENTARY: Tomb 210, above which this bust was found, is typical of the Roman tombs from Nysa Scyth-

opolis, with a central chamber, in this case containing a stone sarcophagus, and multiple chambers or *loculi* on the long sides and back end. According to the field notes and FitzGerald's unpublished manuscript on the Northern Cemetery, the contents of tomb 210 included pottery, lamps (including one with a volute nozzle), and glass vessels of Roman date, but a specific date for the tomb is not ascertainable by this author since only a small group of these artifacts is in the UPM. In addition, since the funerary bust was found above, rather than in this tomb, we cannot be certain of its direct association.

The hairstyle of this female is reminiscent of one that was popular among Severan women (e.g., Julia Domna, Julia Maesa), and it is likely that this bust should be dated to the first half of the 3rd c. AD (see Skupinska-Løvset 1983: 178–85, 249 for a discussion of the workshop of the so-called Elaborate Hair Family, which she dates to the period from Caracalla to Severus Alexander). The rod and circular pendant earring is seen on Palmyrene funerary sculptures of the early 3rd

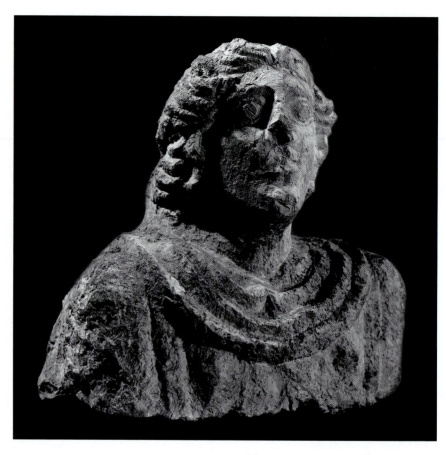

CAT. NO. 95

c. AD (see **132**; see also Skupinska-Løvset 1983:128–29 for discussion of earring types on Beth Shean funerary busts).

96
FEMALE FUNERARY BUST

29-107-921
Nysa Scythopolis (Beth Shean/Beisan), Israel, probably Northern Cemetery
Roman Imperial period, second half of 2nd–first half of 3rd c. AD
Pale, hard porous limestone
H. 0.41; Max. W. bust 0.265; Max. Th. 0.14 m.
ACQUISITION: *UPM Expedition to Beisan, 1921–3(?).*
No field number. Two funerary busts from Beth Shean

*were given the same UPM accession number, 29-107-921. This bust retained this number, while the male funerary bust was renumbered 29-107-980 (**100**).*
PUBLICATIONS: *Unpublished. (This bust is not included in Skupinska-Løvset 1983.)*

CONDITION: Complete except large chips missing from sides, back, and bottom. Break on nose. Poor surface preservation. Traces of hard substance (mortar?) adhere in spots

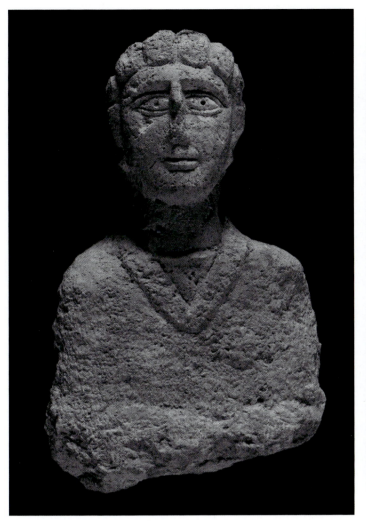
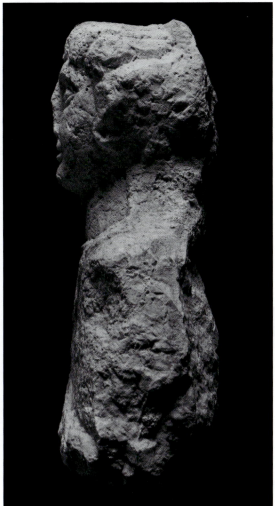

CAT. NO. 96

to sides, back, top of head.

DESCRIPTION: Frontal female bust with flat features. Crudely rendered. Hair is worn in a melon coiffure, parted in large, thickened sections from the forehead to meet in a flattened bun at the back of head. Ridges on both sides of the neck possibly indicate locks also fell to the sides. Low forehead with a sharp ridge for the protruding brow. Large eyes, the left more deeply set than the right; ridges for eyelids, protruding oval eyeball, and deeply drilled holes for pupils. Thin, straight nose. Small mouth with thick lower lip and gouge separating upper and lower lips. Little modeling of the cheeks. Slightly jutting chin. Angled flattened areas for small ears with raised circular earrings with depression in centers (hoops?). Long conical neck. Two garments are indicated: a tunic represented by a horizontal ridge at the neckline, and a shawl (*ampechonon*) with a rolled V at the front. Bust is square with flat front with rough, unfinished? zone at the front bottom edge. Rough, uneven bottom; rough sides; roughly finished back.

COMMENTARY: This bust matches some of the workshop characteristics of Skupinska-Løvset's Pierced Eyes Family (1983:234–35, cat. nos. 87–89) of the Severan period. The melon coiffure and drilled pupils are consistent with this date, though the possibility of hooped earrings suggests a slightly earlier date in the Hadrianic or Early Antonine period (Skupinska-Løvset 1983:128).

197

97

FEMALE FUNERARY BUST

29-107-923
Nysa Scythopolis (Beth Shean/Beisan),
 Israel, probably Northern Cemetery
Roman Imperial period, 3rd or early 4th c. AD
Pale, porous limestone
H. 0.410; W. shoulders 0.355; Max. Th.
 0.26 m.
ACQUISITION: *UPM Expedition to*
 Beisan, 1921–3(?). No field number.
PUBLICATIONS: *Skupinska-Løvset 1983:*
 43, 195–98, cat. no. 28, pl. XLIV.

CONDITION: Complete except fragment
from back right and top of head. Very poorly
preserved surfaces. Traces of whitish
substance on bust.

DESCRIPTION: Armless bust of female with
head turned slightly to left. Crudely rendered.
Hair is parted in large sections from forehead
in melon coiffure. Locks fall down back sides
of neck, and there is a thickening at the back
of the head. Oval face with broad forehead;
large oval eyes with outlines inscribed and
drilled pupils. Broad nose with no nostrils
represented. Gouged out separation between
lips with mere suggestion of lower lip. Raised
areas on right and left sides of head to indicate
ears. Jutting chin. Thick neck. Low, rectan-
gular torso with shawl (*ampechonon*) forming
a collar below neck. Broad sweeping ridges for folds. Bottom
of bust is flat with extensive traces of the claw chisel and with
a small (ca. 0.01 m.) square hole towards left edge. Back of
head describes broad convex curve to roughly finished back.

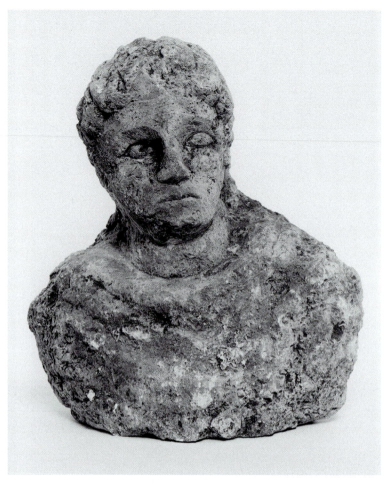

CAT. NO. 97

COMMENTARY: The quality of this bust is poor, and
Skupinska-Løvset (1983:195–98) assigns this to a sub-
standard workshop after AD 212, possibly into the Tetra-
chic period (early 4th c.).

98

FEMALE FUNERARY BUST

29-107-920
Nysa Scythopolis (Beth Shean/Beisan), Israel, probably
 Northern Cemetery
Roman Imperial period, early 3rd c. AD (Severan period)
Hard buff limestone

P. H.0.475; Max. W. shoulders 0.28; Max. Th. head
 0.20 m.
ACQUISITION: *UPM Beisan Expedition, 1921–3(?).*
 No field number.
PUBLICATIONS: *Skupinska-Løvset 1983:43, 197–98,*

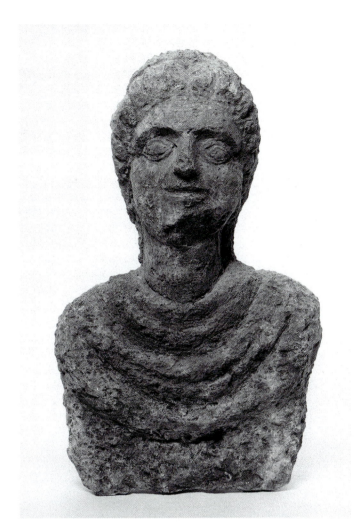

CAT. NO. 98

Cat. no. 29, pl. XXV.

CONDITION: Single fragment. Complete except chips from nose, left side of chin. Very worn, some whitish deposits.

DESCRIPTION: Armless female bust, crudely executed. Hair parted in the center and drawn back in thick sections separated by grooves framing the forehead and face. At the front of the crown of the head is a drilled depression; a deep groove encircles the head at this point, representing the edge of the finished front of the head. A ridge on the sides of the neck serves similarly as the edge of the finished area. The features are asymmetrical. Face is squarish with a low, broad forehead, large eyes set beneath sharp brow ridges.

The eyes are defined by ridges for lids, protruding eyeballs; iris on right eye defined by groove with inner corner drilled. Short, narrow nose, large horizontal mouth with broad groove separating thin lips and diagonal cut at corners. Full cheeks. Thick neck ending in drilled groove. Neck turns sharply to flattish shoulders. Flat, rectangular bust tapering slightly to straight lower edge. On front of bust are multiple pendant folds of the shawl (*ampechonon*). No arms represented. Back of head and bust are crudely worked.

In back of the head at the midpoint are two small (L. 0.018 m.) vertical clamp cuttings with drilled holes at the ends. The center of the back of the bust is hollowed out in a depression. In the center of the depression is a

depressed irregular rectangular area (ca. 0.04 m. square). The bottom surface of bust has a discolored orange patch, from iron contact(?). Possible traces of buff substance on the back side of bust and back of head.

COMMENTARY: Skupinska-Løvset (1983:43, 197–98) assigns this somewhat abstract bust to the "Family with a Stela-like Torso" and dates the workshop to the Severan period, between AD 212–22.

99

MALE HEAD FROM FUNERARY BUST

29-107-922
Nysa Scythopolis (Beth Shean/Beisan), Israel,
* Northern Cemetery*
Roman Imperial period, early 3rd c. AD
* (Severan period)*
Hard, buff, porous limestone
P. H. 0.21; P. W. shoulder 0.145;
* P. Th. 0.13 m.*
ACQUISITION: *Excavated by the UPM Expedition to Beisan on September 15, 1928. Robbed tomb 1 in Northern Cemetery, West. Field number 28-9-207.*
PUBLICATIONS: *James 1961:34, lower right; James, Kempinski, and Tzori 1975:220; Skupinska-Løvset 1983:44, 203–5, Cat. no. 30, pl. LII; Mazar, Foerster, and Tzori 1993:234 photo.*

CONDITION: Single fragment broken off on a diagonal at the neck and shoulder. Poor surface preservation.

DESCRIPTION: Crudely rendered, frontal bearded male head with broad, flat features. Above forehead is a full roll of hair treated with broad chiseled gouges and claw chisel. Triangular face; broad, flat forehead; squared-off, elongated nose, flattened on top with no nostrils; sharp brow ridge; large, protruding oval eyes with ridges for lids. No modelling of cheekbones. Chiseled gouges above upper lid to represent moustache. Small lips, slightly parted, downturned. Narrow chin with chiseled gouges to indicate beard. Ears are summarily treated and slightly outturned from sides of cheeks. Short broad neck with segment of drapery(?) preserved on left side. On right side, neck turns sharply to flat shoulder(?) Roughly chiseled and

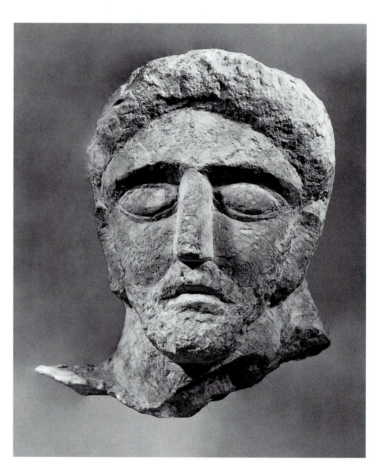

CAT. NO. 99

flattened back. Red pigment well preserved on mouth.

COMMENTARY: This male head was found inside a robbed-out Roman tomb, along with fragments of sarcophagi and two glass bottles. Skupinska-Løvset (1983:203–5, 249) assigns this head to the "Flat-faced Family" and dates it to the Severan period, perhaps the time of Caracalla.

100
MALE FUNERARY BUST

29-107-980
Nysa Scythopolis (Beth Shean/Beisan), Israel,
* probably Northern Cemetery*
Roman Imperial period, 2nd–3rd c. AD
Very hard, pale crystalline limestone with
* pinkish hue*
P. H. 0.525; Max. P. W. bust 0.29; Th. head
* 0.17 m.*
ACQUISITION: *UPM Expedition to Beisan,*
* 1922. Date in photo register [no. 224] is*
* June 4, 1922. No field number. According to*
* Skupinska-Løvset (1983:110–11, n.11),*
* with information from E. Oren, this male*
* bust came not from the cemetery but from the*
* area southwest of the tower, at the city wall*
* near the monastery, but this is not confirmed*
* by the field diary. Two funerary busts (***96***
* and ***100***) from Beth Shean were assigned the*
* same UPM accession number, 29-107-921.*
* This one was reassigned accession number*
* 29-107-980 in January 2005.*
PUBLICATIONS: *Skupinska-Løvset 1983:42,*
* 161, 169–70, 173, Cat. no. 26, pl. XX*
* (UPM accession number cited as*
* 29-107-921).*

CONDITION: Complete except chips from
bottom.

DESCRIPTION: Frontal, armless bust of a young
male with markedly asymmetrical features. Wig-
like cap of short hair, with fringe along forehead
rendered with short chisel stokes, while rest of
hair surrounding head and covering ears is
roughly chiseled. Hair covers ears, exposing only thickened
earlobes. Elongated, triangular face with protruding fore-
head; straight nose, flat on top and sides. Large open eyes
with thickened ridges; the upper lid of the left eye arches
in a pronounced fashion; the right eye is more bulbous than
the left; pupils are rendered as depressions close to upper
lids. Small pursed lips with wide gouge separating nose and
mouth. Upper lip forms a 'V'. Deep cleft in chin. Conical
neck, set off from sloping shoulders. Garment (tunic?) is
rendered as a ridge over the right shoulder and on front,
an incised line over the left shoulder, and claw chisel over
the front. Bust is flattened in front, tapering markedly. Left
side of bust has a flattened polished surface. On the right

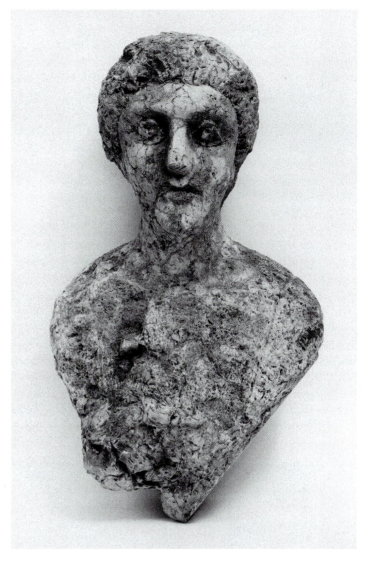

CAT. NO. 100

side there is a smoothed triangular depressed area. Back of
bust is flattened and polished with a small clamp cutting
at the lower left edge (L. 0.015 m.) with drilled holes at
each end and a small hole above. There are polished
surfaces on the forehead, nose, chin, left side and back of
bust, and lower back of head.

COMMENTARY: Of the UPM's funerary busts from Beth
Shean, this stands out for the higher quality of the stone
and its carefully prepared and polished surfaces. See
Skupinska-Løvset 1983:270 for a discussion of this
pinkish crystalline limestone and its local origin. This
better quality stone is used for many of the busts of the

so-called Cleft-chin Family, in which this bust is classified by Skupinska-Løvset. This class of funerary busts from Palestine is dated by Skupinska-Løvset from the Late Antonine period to the mid-3rd c. AD. The products of this workshop represent a local assimilation of various foreign strains and exercised much influence on other workshops in Beth Shean (1983:161, 169–70, 173, 249–53).

101
HEAD OF A RAM

29-107-917
Nysa Scythopolis (Beth Shean/Beisan), Israel, lower terrace of tell
Roman Imperial or Early Byzantine period, 1st–4th c. AD
Compact white marble
P. L. 0.11; P. H. 0.07; P. Th. 0.066 m.
ACQUISITION: *UPM Expedition to Beisan, April 27, 1922. Lower Terrace East, Cistern 6. Field number 787.*
PUBLICATIONS: *Unpublished.*

CONDITION: Single fragment preserving head of ram, broken off on a diagonal at neck. Much worn with end of snout broken.

DESCRIPTION: Head of ram from a statuette, twisted slightly to the left. Thick neck, curled horns set close to the sides of the head. Flat top of snout. Shallow eyes set beneath shallow brow ridge. Inner corners of eyes more deeply drilled. Shallow incision for mouth. Hair on neck defined by vertical thickened ridges and grooves.

COMMENTARY: The cistern from which this marble ram's head was excavated belongs to the upper levels of the tell and contained mixed debris, some of Roman date.

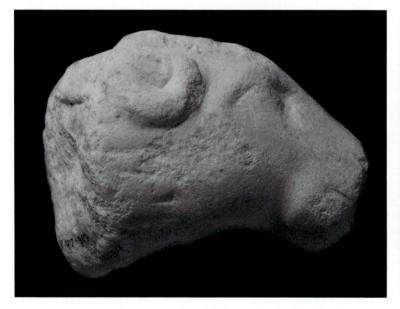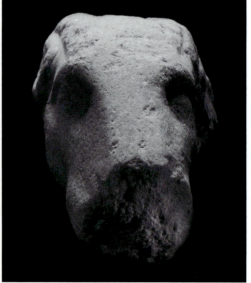

CAT. NO. *101*

Other Roman Sculpture (102–124)

Portraits (102–112)

102
PORTRAIT HEAD OF MIDDLE-AGED WOMAN

MS 4919 (see Frontispiece and CD
 Fig. 35)
Said to have come from Sardinia
Roman Imperial period, second
 quarter of 1st c. AD
Medium-grained white marble
H. 0.355; Max. W. neck 0.22; W.
 head 0.18; Depth 0.21 m.
ACQUISITION: *Purchased through*
 Edward Perry Warren from
 Fausto Benedetti in 1913.
PUBLICATIONS: *Hall*
 1914a:28–30, fig. 16; Bates
 1914a:416; Luce 1921:169,
 no. 14; Poulsen 1921:47, pl.
 22; Furnée-van Zwet 1956:13,
 15, fig. 14; Guide to the
 Etruscan and Roman Worlds
 2002:77, fig. 112; Quick
 2004:130, no. 118.

CONDITION: Well preserved from
the top of the head to the bottom of
the neck which is prepared for setting
into a statue. Crown of head broken
off. Large fragments missing from the
chignon and lock above forehead on
left side. Smaller fragments missing
from right ear and nose. Chips on
left ear, right eyebrow. Surface
scratch across right cheek seems
more recent, although noted in Hall
(1914:28); left cheek worn and
abraded. Other signs of wear and
abrasion.

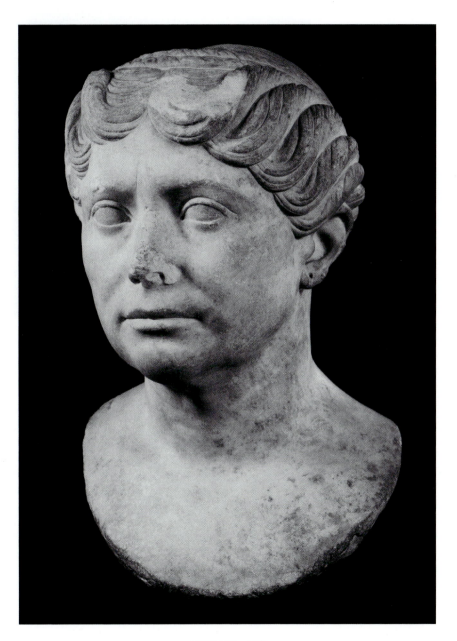

CAT. NO. 102

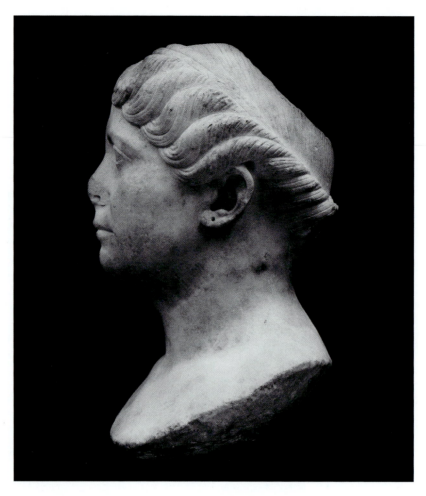

CAT. NO. 102

DESCRIPTION: Lifesized portrait bust of an unknown middle-aged woman turned slightly to her right. Her hair is parted in the center and sectioned along the brow into a modified melon coiffure. The thick, sculptured waves form a scalloped design framing the face and are rolled toward the back leaving the ears uncovered. Along the neck behind the ears the hair is similarly rolled in sections that meet above the nape where a small bun or braid is broken off. Around the top of the head are two narrow braided rows that disappear beneath the side rolls of hair on the preserved left side. Behind the braided rows the hair is indicated by fine parallel incisions from the central part. The ears are finely executed with holes pierced for the insertion of earrings. Full, squarish face with fleshy appearance over well-defined high cheekbones, a strong lower jaw and chin. Finely incised wrinkles above the bridge of the nose; widely spaced eyes with thickened brow ridge but no incised eyebrows; wide-open eyes with sharply defined eyelids and downward slanting eyeballs undrilled; short broad nose with drilled nostrils; broad, closed mouth with the corners carefully tooled; strong neck with muscular definition on the right matching the slight turn of the head. The lower edge of the "bib-bust" is finished and the convex underside left in a roughed state for the insertion into a statue.

COMMENTARY: A date for this portrait in the late Tiberian or Caligulan period, ca. AD 30–40, is suggested by a comparison of the hairstyle with dated portraits of the women of the Caligulan principate, especially Antonia II and Drusilla. Antonia II (36 BC–AD 38) was the daughter of Octavia II by M. Antony, the wife of Drusus I, the mother of Claudius and Germanicus, and the grandmother of Caligula. She was given the title Augusta by Caligula in AD 37 and was

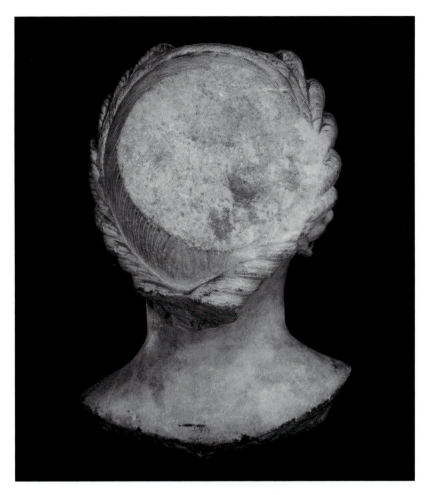

CAT. NO. *102*

accorded special honors during his reign. Drusilla was the daughter of Germanicus and Agrippina I and a beloved sister of Caligula. Drusilla was the heir to Caligula's *imperium* by his will of AD 37. After her unexpected death in AD 38 she was deified, the first Roman woman to be given that honor. The official portraits of both Antonia II and Drusilla show them with the *melonenfrisur* hairstyle, especially deeply waved in the case of Drusilla and with a row of pin curls on the forehead and in front of the ears. For the portraiture of Antonia II see Polaschek 1973; Rose 1997:65–66 and 248, n. 101, and for Drusilla see Rose 1997:68; Wood 1995:471–79. A similar hairdo appears in posthumous portraits of Augustus's wife Livia (d. AD 29, deified AD 41), especially in Caligulan dynastic groups (see Rose 1997:60; Bartman 1999:144–45, figs. 116–17: "Salus mode," 165, no. 44; Furnée-van Zwet 1956:12–13, figs. 10–15; Winkes 2000:33–35). The elements of the hairdo are the central

part, deep and wavy melon coiffure, small braids around the head, rolled at the sides, and a short chignon above the nape. In fact, the facial features of this portrait are close to those of the portrait of the mature Livia in the Metropolitan Museum of Art (Bartman 1999:164, no. 41, fig. 148).

The impact of official portraiture of important female members of the imperial family was considerable, and aspects of this imagery lasted for decades and influenced both the public and the private realm (see Bartman 1999:126–27). Portraits of unknown women, such as this one, assimilated the features and especially the hairstyles of favored members of the imperial family. Although the subject of this expressive portrait is not identifiable as a member of the imperial family, the image suggests a woman of great nobility and strength of character, one that is strongly influenced by the official portraits of the women of the Caligulan principate.

CAT. NO. 103

103
FEMALE IMPERIAL PORTRAIT HEAD: AGRIPPINA I OR AGRIPPINA II

MS 213 (see CD Fig. 36)
Said to have been found along the shores of the Dard-anelles near Troy
Roman Imperial period, ca. AD 37–59, possibly recut from an earlier portrait
Fine white marble
P. H. 0.345; W. 0.245; Depth 0.25 m.
ACQUISITION: *Purchased with funds from John Harrison, 1895. According to the Mediterranean Section inven-*

tory ledger, this head was clandestinely excavated on the shores of the Dardanelles near the Plain of Troy by "natives." Professor Hermann V. Hilprecht, curator of the Museum's Babylonian Section at the time and a scholar well acquainted with the antiquities trade in Constantinople, provided the information that in order to move the statue the head was cut off and the body reburied. The head, Hilprecht said, was brought to Constantinople and the body of this statue was later

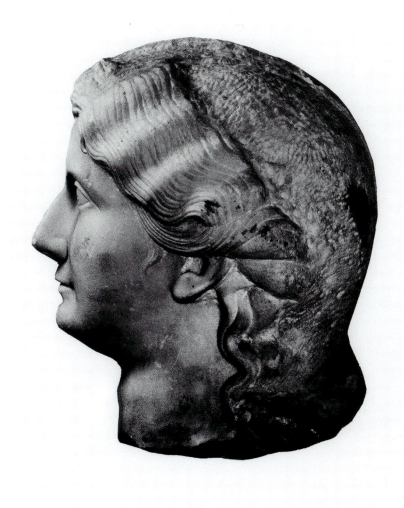

CAT. NO. 103

the front left side missing and an irregular lower edge. Chip from right eyebrow; other chips and gouges from face and neck. Surface of nose and left side of face worn. Some discoloration over head, especially on the hair.

DESCRIPTION: Overlifesized frontal female head with hair parted in middle and drawn off brow in oblique wavy tresses with finely drilled strands. The hair dips over the upper part of the ears and ends in thickened bunches behind the ears; a wide drill channel separates the back of the ear from the hair on the right side. The hair falls in thickened snake-like tresses down the side of the neck, with more depth on the left side than on the right, and deep drilling for the locks on both sides. A small lock of hair appears in very low relief on the right cheek, and in higher relief on the left. Across the top of the head from the edge of the hair to the back are three flattened sections with roughly picked surfaces. Behind the curled tresses at the brow, the head is treated with a claw chisel and gouges. In back at the nape of the neck is a protruding area, as if to suggest a broad, flat chignon. Right ear is crudely modelled with drilled center; left ear is more carefully executed.

The facial features are full with large smooth planes; a broad, flat forehead with sharp ridges for brows; large wide-open eyes with ridges for lids, the upper lid overlapping the lower at the outer corner; large nose with flattened bridge and shallow nostrils; small mouth with pursed lips; full strong chin with large second chin. Neck is powerful with slight swelling for flesh. The surface of the face and neck is treated with a light polish.

unearthed and sold to the Berlin Museum, according to information from an Armenian in Constantinople. The curator of the Staatliche Museen in Berlin's Antiken-sammlung, Prof. Dr. Wolf-Dieter Heilmeyer, in a personal correspondence of March 12, 1999, indicated that no such piece exists in their collection.

PUBLICATIONS: *Luce 1921:190, no. 58; Vermeule 1964:110, fig. 14; Vermeule 1968:192–93, fig. 122; Inan and Alföldi-Rosenbaum 1979:150–51, pl. 86; Vermeule 1981:288, fig. 245.*

CONDITION: Single fragment preserved from the top of the head to the lower neck which has a large piece from

COMMENTARY: This portrait head presents some serious problems. It was identified by Vermeule (1964:110; 1968:192–93; 1981:288) as a portrait of Agrippina I (Agrippina the Elder; ca. 15/14 BC–AD 33), the daughter of M. Agrippa, Augustus's wealthy lifelong friend and supporter, and Julia, Augustus's daughter. She married Germanicus and gave birth to nine of his children,

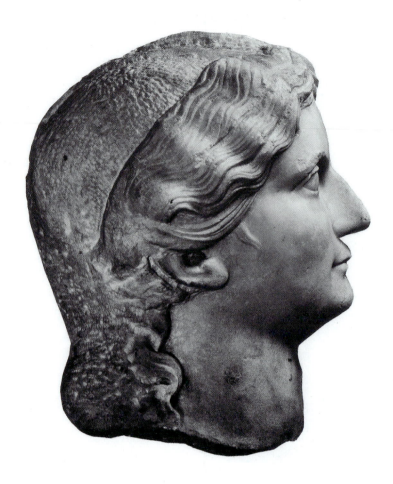

CAT. NO. 103

including the future emperor, Caligula. After the death of Germanicus, Agrippina ran afoul of the emperor Tiberius, whom she suspected of having a hand in her husband's death. She was eventually banished from Rome and died in exile of starvation.

The telltale features of portraits of the adult Agrippina I, based on securely identified ones from imperial groups at Leptis Magna and Velleia, are an ovoid face, heavy jaw line, and a hairdo which is parted in the middle and drawn to the sides in waves ending in corkscrew curls, presumably ending in a chignon at the nape (Rose 1997:66, pls. 142, 224). It is clear, however, from the number of portraits that have been identified as those of Agrippina I that the Agrippina-type (see, e.g., Fittschen and Zanker, *Katalog* III:5–6, no. 4, with references), especially her hairdo, was much copied and that some of these portraits may be of

private individuals (see Furnée-van Zwet 1956:21–22).

The hairstyle with the parted wavy locks is also like that of portraits of Agrippina II (AD 15–59). Like her mother Agrippina I, Agrippina II was among the most remarkable women of the empire. She was the daughter of Germanicus, gave birth to the future emperor Nero in AD 40 by her first husband Domitius Ahenobarbus, became the fourth wife of her uncle Claudius in AD 49, poisoned the emperor in AD 54, and was murdered by her own son in AD 59. The hairstyle, facial features, especially the strong jawline, and general physiognomy in portraits of both Agrippinas are close (see discussion in Rose 1997:69–70, 250, n. 165). The general physiognomy and the strong jawline of this portrait are similar to that of Agrippina I and II, but a firm identification of this head with either is hampered by the lack of corkscrew curls framing the brow.

CAT. NO. 103

The long spiral tresses behind the ears are found on portraits of Agrippina II after her marriage to Claudius, e.g., her portraits from the imperial reliefs in Aphrodisias (Rose 1997: cat. no. 105, pls. 104, 107). (See also Ridgway 1972:86 for a discussion of the spiral locks.)

The interpretation of the stippled area behind the front locks and tripartite flattened area on the top of the head presents interesting problems. The flattened sections may be interpreted as remnants of a hairdo with deeply parted waves, reminiscent of the *melonenfrisur*. Alternatively, it is suggestive of a recutting from a *nodus* hairstyle in which a section of hair is brought forward over the top of the head. This *nodus* hairdo was popular in the late Republic (from around the 40s) into the Augustan age, and is one of two basic hairstyles shown in portraits of Livia, but was rarely used after her official adoption into the

Julian family after the death of Augustus in AD 14 (Rose 1997:60). It is, in the end, possible that this portrait was reworked from an earlier one (Inan and Alföldi-Rosenbaum 1979:151).

It is also possible that the rough stippling on the top and back of this head may indicate that it was covered with a veil added in marble or stucco. In the Velleia portrait group (Rose 1997: pls. 141–42, 148–49) and elsewhere, Agrippina I and II are shown *capite velato*, wearing the mantle or veil over the head. The meaning and use of the veil is not consistent in portraits of imperial women (Rose 1997:76), but in this case the addition of the mantle or veil might have disguised an earlier hairdo.

The overlifesized scale of this head renders it of unusual interest and that, together with the fact that it may have been *capite velato*, make it more likely that it is a portrait of a member of the imperial family rather than a private portrait inspired by portraits of members of the imperial family. If indeed this is a portrait of Agrippina I, it was probably sculpted posthumously after Caligula became emperor in AD 37, in the reigns of Caligula or of Claudius, who also honored his mother-in-law (Vermeule 1968:191). If a portrait of Agrippina II, the portrait could date to the Caligulan period when the emperor honored his two sisters, Drusilla and Agrippina II, or to the period after Agrippina's marriage to Claudius in AD 49 and before her death in AD 59.

Because of its purported findspot on the shore of the Dardanelles near Troy, Vermeule assigns the portrait to a group of Julio-Claudian monuments which were erected at Troy, the city of Aeneas from whom the Julio-Claudians traced their ancestry (1964:110). (For the known Julio-Claudian family portrait groups from Ilium, see Rose 1997:177–79, Cats. 119–20.) While this suggestion is an attractive one, it is not certain that the provenience was Troy itself or some other Roman city in the Troad or north-west Asia Minor.

104

BUST OF MANTLED WOMAN

L-51-2
Hierapolis (Membidj), northern Syria
Roman Imperial period, 3rd c. AD, Late Severan period, ca. AD 218–235
Hard buff limestone with small black inclusions, many of which have popped out leaving pockmarks on the surface
H. 0.84; Max. W. 0.51; Max. Depth 0.31 m.
ACQUISITION: Loaned by Baron Max von Oppenheim in 1933 or 1934; loan renewed by Eleonore Countess Matuschka-Greiffenclau, 1984.
PUBLICATIONS: von Oppenheim 1925b:91–92, fig. 46; Müller 1927:4–7, fig. 3, pl. 2; Dohan 1936:20, 22, pl. 8; Jucker 1959:275–80; Jucker 1961:104–5, St 53, pl. 43; Andreae 1965:510; Matthews 1970:5 top; Wegner 1971:157; Skupinska-Løvset 1983:125, 184, 238, 264, n. 133, pl. CI.

CONDITION: Intact with only minor chips, e.g., around bottom and front edge of pedestal and on edges of folds of garments.

DESCRIPTION: Armless bust of an older draped and veiled woman on a high molded pedestal. Female wears a shawl (*ampechonon*) over the top of her head that covers the right shoulder and upper arm and is looped across the front of the chest and over the left shoulder. The folds are treated in broad bands. She also wears a folded veil over her head that is visible in front of the shawl. She wears a tunic which forms a 'V' at the neckline. Her hair is parted in the center and drawn to the sides over the ears in long, fine wavy locks. Her forehead is creased; the eyebrows, with bushy hairs indicated, arch over open eyes. Thick ridges for the upper lids overlap the lower at the inner corners. The eyeballs are large and protruding with the iris indicated as a circular ridge; the pupils are drilled circular depressions; both iris and pupil partly disappear under the upper lid. The sculptor has indicated pouches beneath the eyes and a deep crease sets

CAT. NO. 104

them off from high, pronounced cheekbones. The cheeks are sunken in, as is the area around the mouth. There is a drilled depression above the upper lip surrounded by a puffy area. The mouth is closed and the lower lip is thick. The chin is pointed and jutting. The aquiline nose has a bump at the bridge, incurving before the tip. The nostrils are drilled, flaring and drawn up. The face is polished. There are vertical tool marks visible on the thickened neck. The arms are finished off at the mid-point of the

CAT. NO. *104*

upper part of the piece curves gently from the top of the head in a smoothed surface. Indications of folds of the drapery on the sides only.

COMMENTARY: Baron von Oppenheim (1925b) and V. Müller (1927) first identified this as a portrait of Julia Maesa (died AD 224), based on a comparison with coin portraits and the find spot in Syria. Julia Maesa was the older sister of Julia Domna, the wife of Septimius Severus (AD 193–211), the aunt of the emperor Caracalla (AD 211–217), and the grandmother of the emperors Elagabalus (AD 218–222) and Alexander Severus (222–235). She was descended from an old ruling and priestly family of Emesa (Homs, on the Orontes River) in the Roman province of Syria and was one of a group of prominent women in the Severan dynasty who wielded considerable political and social power. Julia Maesa and her daughter Julia Mamaea ruled jointly for a period while Alexander Severus was too young and inexperienced to govern. Following her death during Alexander Severus's imperial rule, Julia Maesa was given the official title of *Iulia Maesa Augusta Avia Augusti Nostri*, and commemorative coins were struck in her honor (see Wegner 1971: pls. 36–37).

Doubts have rightfully been expressed about the identification of this portrait as Julia Maesa (Andreae 1965), though the strong facial features of this portrait (the piercing eyes, aquiline nose, strong jaw) seem close to those on the coins (e.g., Wegner 1971: pl. 37 a, b c). The lack of securely identified stone portraits of Julia Maesa with which to compare, however, makes the identification of this portrait tentative. (For a discussion and catalogue of the possible portraits of Julia Maesa see Wegner 1971:153–60.) It is more likely that this portrait is, in fact, of an unknown woman. The presence of the stylized motif of the acanthus leaf/bud joining the lower end of the bust to the pedestal may indicate the portrait's funerary associations (Jucker 1961).

This portrait seems to have little in common with the marble sculptural output of the coastal cities of Roman Syria, like Antioch or nearby Daphne (see Vermeule 2000

upper arm and are undercut. The bust tapers off above the waist with a stylized floral element: an arching, slightly scalloped ridge above an ovoid protrusion with raised rays.

The tall circular pedestal is carved in one piece with the bust and consists of an upper disk with vertical sides (H. 0.05 m.); a recessed zone (H. 0.06 m.); and a wide lower cylinder (H. 0.098; Diam. 0.305 m.) with vertical sides. The back was not meant to be seen, as the lower half of the piece has been left in a roughly finished state. The

for a general discussion of the sculpture of Roman Syria with an emphasis on Antioch) and should be viewed in the context of its provenience of Hierapolis/Membidj, northeast of Aleppo in northern Syria (see Parlasca 1982:4 for map). Although Jucker saw in the linear treatment of the drapery and the raised circle for the iris and drilled dot for the pupil of this portrait an affinity to female portraits from Palmyra of the same period (1961:105, n. 3 and 4; see also **130** and **132** for Palmyrene female portraits of the same period), Parlasca shows that the funerary monuments from the northern part of Syria share some of these characteristics but retain a distinct style (1982:9–14). There is a general similarity of this limestone portrait bust to the series of funerary monuments of the 1st to 3rd c. AD from the area of Hierapolis/Membidj and Belkis/Seleucia on the Euphrates. These are mostly inscribed (in Greek) limestone reliefs with single or multiple busts set into niches (see Parlasca 1982: pls. 6–16). Skupinska-Løvset (1983:125, 238) relates the bust typologically to funerary busts from northern Palestine, such as those from Beth Shean (see **95** to **100**) or, closer still, to those from Samaria-Sebaste. This bust, however, is a more elaborate funerary portrait, of higher quality in terms of its carving, lifesize, and fully in the round. The roughly finished back of the UPM bust probably indicates that it was meant to be placed within a niche. The acanthus leaf motif at the foot of the bust is common on funerary portraits from Rome and other parts of the empire, including on funerary monuments from Syria, such as the column with two relief shrines (*aedicula*) containing busts that sit on moulded pedestals like that of our bust (Parlasca 1982:19–20, pl. 22,3; 23, from near Qartaba, dated to the early 3rd c. AD).

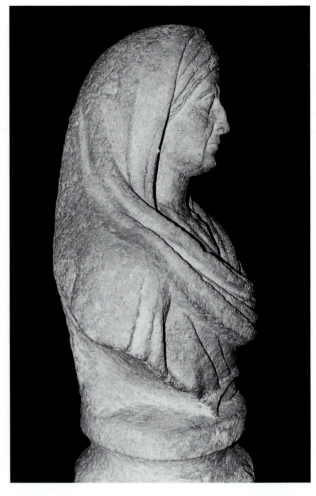

CAT. NO. 104

105
PORTRAIT HEAD OF A BOY

MS 4030 *(see CD Fig. 37)*
Unknown provenience, possibly Italy
Roman, Julio-Claudian period, early 1st c. AD
White marble with tawny patina and polish
H. 0.20; W. 0.145; Depth 0.155; H. chin to crown
 0.17 m.
ACQUISITION: *Purchased through E. P. Warren in Naples, with funds from Lucy Wharton Drexel in November 1901.*
PUBLICATIONS: *Furtwängler 1905:261, no. 35. Luce*

1921:174, no. 30; Poulsen 1921:46–47, pl. 21; Robl 1970: cat. no. 17; Gercke 1968:89, cf. FK 11; Kiss 1975a:150, figs. 537–38; Boschung 1989:124, cf. Kat. 96–99; Portraits and Propaganda 1989:129, no. 123; Guide to the Etruscan and Roman Worlds 2002:81, fig. 121.

CONDITION: Single fragment preserving head from top to lower neck with a small fragment of the bust on the proper right. Repair to right side of nostril. Lower back of head is

finished off as a flattened, canted surface Black spidery veins visible on back side.

DESCRIPTION: Lifesized head of young boy in a frontal position from a bust. Hair is brushed forward in straight clumps from the crown onto the forehead. Round head with rounded face. Low forehead. Open almond-shaped eyes with ridges for lids. Deep incurving bridge spreading to broad nose with wide nostrils with drill holes beneath. Full cheeks with definition to cheekbones. Small ears with large openings. Rounded chin with cleft. Fleshy neck. On right side of neck is a small fragment upturning to the bust. Back of head is cut off and flattened from the mid-back to the back of the neck. Upper part of the back of the head is summarily finished and was not meant to be seen.

COMMENTARY: This child's head is very close to a marble head of a child from Sabratha, first published in 1962 (Sichtermann 1962:524, fig. 84). Gercke (1968:89, FK 11) and Boschung (1989:124, Kat. 96–99) have compared the Sabratha head with the UPM head and have identified them both as private portraits of different individuals, while Kiss (1975a:150) interprets both heads as portraits of the boy Caligula, comparing them with the head of the baby Caligula on the Grand Camée de France (Kiss 1975a: figs. 472 and 530). The similarity of the two portait heads suggests that they might be replicas after the same type, but the practice of idealizing portraits of private individuals and modelling them after types of members of the imperial family makes identifying this portrait with any individual problematic.

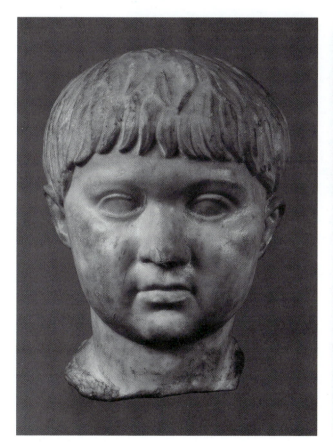 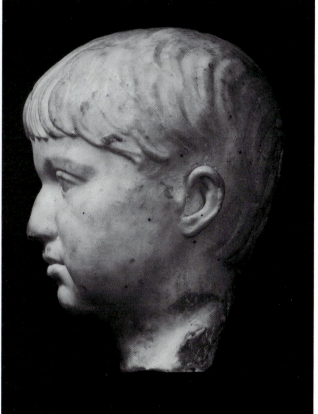

CAT. NO. 105

CAT. NO. 106

106
PORTRAIT HEAD OF YOUTH

MS 5702 (see CD Fig. 38)
Said to have come from Cyprus
Roman Imperial period, 1st c. AD
Coarse-grained white marble with purplish veins
P. H. 0.235; W. 0.17; Depth 0.18 m.
ACQUISITION: *Purchased in 1926 from dealer Sotirios*
 S. Anastasios in Philadelphia.
PUBLICATIONS: *Unpublished.*

CONDITION: Single fragment preserved from the top of the head to the mid-neck where it is broken off. Chips are missing from the nose, mouth and front of hair, the left eyebrow, and

a small chip from the chin. Dark discoloration, especially on the right side of the hair and the bottom right edge of the neck.

DESCRIPTION: Underlifesized frontal portrait head of a youthful male. His hair is brushed forward from the crown with thick locks on his forehead, rendered straight in the center and corkscrewed to the right and left, especially on the left side where one looks like the remains of a snail curl with a drilled center. The drill is used to define deep grooves between the locks around the face. The hair on top of the head and back is treated in locks emanating from the crown. Locks of hair cover the tops of the ears and curls project

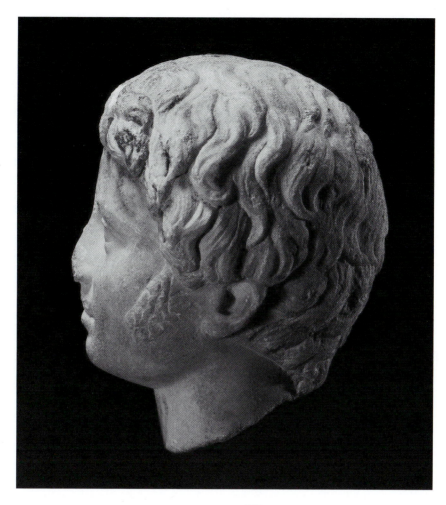

CAT. NO. 106

onto the side of the face in front of the ears. In low relief on the sides of the face are continuations of the sideburns as puffs of curls, as if the beginning of a beard. The forehead is high with creased brow ridges, puffy beneath. The eyelids are ridges. The eyes are wide open. Near the inner corner of the left eye is an inscribed circle; the surface of the right eye has a depressed roughened area, possible damage. The inner corners of the eyes are drilled. Small nose with drilled nostrils. Small mouth with pursed lips. Rounded chin with full fleshy face. Well-modelled ears. Small neck with only subtle indications of musculature. Back of head, especially on back left side, is not as carefully finished.

COMMENTARY: This idealized yet individualistic portrait of an unknown youth should probably be dated by the hairstyle (and the lack of drilled pupils) to the Julio-Claudian period in the 1st c. AD. (The incised circle on the left eye appears to have been added later.) The hair can be compared with that on portraits as early as Drusus the Elder (de Kersauson 1986:62–63, no. 26 of the very end of the 1st c. BC or beginning of the 1st c. AD) or as late as that of Nero in the 60s (Frel 1981:45, no. 30). The dealer from whom the head was purchased indicated that it came from Cyprus, and the head would certainly be at home in that eastern setting, possibly made in Asia Minor.

The beginnings of a beard on this youth's upper cheeks indicate the stage of life prior to his *depositio barbae*, the ceremonial shaving of the first fully grown beard of a young Roman man.

107
HEAD OF PRIEST OF ISIS

MS 1120
From Italy
Roman Imperial period, late 1st–first half of 3rd c. AD
Black basalt
P. H. 0.152; Max. P. W. 0.177 m.
ACQUISITION: *Collected by Arthur A. Frothingham,*
Jr., in Italy for the John Wanamaker Expedition,
1896–97. The head was mistakenly described as a
portrait of Scipio Africanus in the correspondence and
early inventories of the Museum.
PUBLICATIONS: *De Puma 1988:56–57, no. 21.*

CONDITION: Single fragment preserving the top of the head fractured horizontally just below the eyes. The right ear is mostly broken off with a large gash extending behind it; the top of the left ear is preserved with the back of it chipped. Circular surface abrasion or spalling on the right side of forehead. Chips from broken edge at back of head.

DESCRIPTION: Head of older male with shaved egg-shaped skull and a cross-shaped scar carved into the skull on the right side of the forehead. The surviving ear is prominent and projects from the side of the head. Two horizontal lines are incised in the forehead to indicate creases. The brow ridge is a sharp, undulating crease; furrows are modelled above nasal ridge. The temple on the left side is indicated as sunken in. Narrow, open, almond-shaped eyes have sharp ridges for lids, the upper lid overlapping the lower at the outer edge.

COMMENTARY: The identification of this head as a priest of the cult of the Egyptian goddess Isis comes from the black basalt stone, commonly used in Egyptian sculpture and for images of the priests of Isis, and from the shaved head and the cross-shaped scar on the skull of the figure, the *stigmata hiera*, a ritual mark associated with the priesthood of the cult of Isis (for an excellent discussion of the *stigmata hiera* see Dennison 1905:32–43).

The fact that this priest's head was collected by Arthur A. Frothingham in Rome is a good indicator that it came from Italy. The head was probably originally from a sanctuary of Isis in Rome or elsewhere in Italy, of which there were many. The most famous of these was the one in the Campus Martius, probably vowed in the second triumvirate in 43 BC (Dio Cassius 47.15.3) and rebuilt by Domitian (Dio Cassius 66.24.2) (Haselberger and Romano 2002:152 for summary and other references; see Versluys 2002:9–13 for a general discussion of the cult of Isis in Italy). De Puma shows that there are close parallels for this head from Rome or Italy (De Puma 1988:57, n. 4 lists: Paris, Bibliotèque Nationale Inv. 3290: Adriani 1970: pl. 37, 4); Rome, Museo Barracco: Drerup 1950: pl. 10; Rome, Palazzo Rospigliosi, of unknown provenience: Giuliano 1984:112–16, no. III, 6).

R. S. Bianchi argues that heads such as these are probably not portraits of individual priests of Isis, but rather non-idealized generic images, in this case of an older priest. The similarity of many of these heads indicates that the sculptors were maintaining the Egyptian tradition of creating images which reflected the appropriate station, role, or age, rather than portraying the unique features of an individual. The shaved egg-shaped head, according to Bianchi, is an iconographic symbol used to represent an older priest of the cult (Bianchi 1989:55–64; Bianchi 1982:149–51). See Wood 1987:123–41 for a discussion of two groups of Isis priest heads: the idealized "eggheads" and the more portrait-like works.

Because of the conservative and formulaic nature of these images of priests they are difficult to date precisely. For this one from Italy, a general date in the late 1st through first half of the 3rd c. AD comes from the broad time period when the cult of Isis was popular in Rome and Italy, especially under Domitian whose life was saved by a priest of Isis, under Hadrian who had a passion for eastern religions, and reaching a climax in the first half of the 3rd c. AD under the Severans (Roullet 1972:2–5).

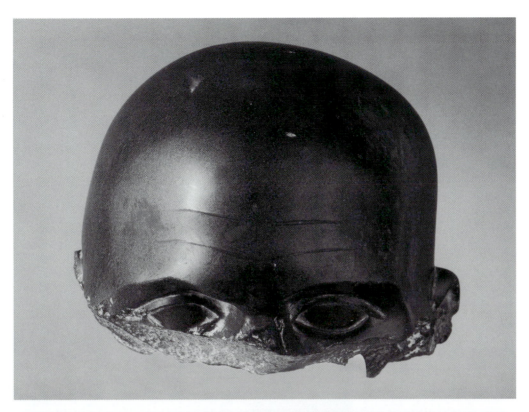

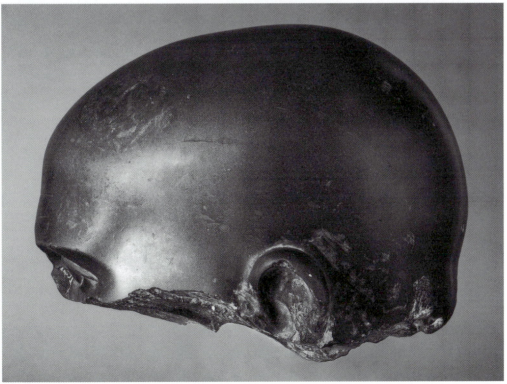

CAT. NO. 107

108

HEAD OF PRIEST OF IMPERIAL CULT

MS 215

*Said to be from Caesarea Cappadociae
(Kayseri), Asia Minor*

*Roman Imperial period, probably mid-
2nd c. AD (Antonine period)*

Fine-grained white marble

*P. H. 0.323; Max. P. W. 0.245; Max.
P. Depth 0.26 m.*

ACQUISITION: *Purchased by the
Museum through H. V. Hilprecht in
1895 in Constantinople where it was
brought by a native of Caesarea,
along with* **113**.

PUBLICATIONS: *Luce 1921:173, no.
28; Poulsen 1921:47–50, pl. 23;
Müller 1932:45–54, figs. 3–4;
Vermeule 1964:110, fig. 25; Ver-
meule 1981:322, fig. 276; Inan
and Alföldi-Rosenbaum 1979:
38–40, 275–76, no. 264, pl. 188,
275.4; Beck and Bol 1983:
495–96, no. 99; Fittschen 1984:
208, no. 264; LIMC III,
Dodekatheoi:655–56, no. 52;
Introduction to the Collections
1985:40, fig. 24; Rumscheid
2000:126–27, no. 26, pl. 16,
3–4; Guide to the Etruscan and
Roman Worlds 2002:51, fig. 74.*

CAT. NO. 108

CONDITION: Single fragment broken
off at the neck. Nose is broken off below
the bridge. Much worn, especially on the crown; surface
abrasion and chips missing from the cheeks, eyebrows,
beard, and edges of ears.

DESCRIPTION: Overlifesized bearded male head in
frontal pose wearing a fillet and a crown decorated with
eleven small busts of divinities. The hair is brushed
forward in thick strands onto the forehead and over the
tops of the ears. Below the *taenia* and behind the ear on
the right side the locks of hair are finer and are brushed
toward the front on the neck. The top of the head and
back are summarily worked. Around the crown of the
head is a fillet rendered as beaded in sections and tied at
the back with the ends falling down the back of the head

in a single mass. Above the fillet at the front of the head
is a crown with eleven projecting anthropomorphic busts,
so worn as to be nearly indistinguishable. The brow is
furrowed with deep grooves above the bridge of the nose.
Almond-shaped eyes are set deep beneath finely modelled
eyebrows with feathering to mark the hairs. Lentoid-
shaped depressions mark the eyeballs; thick ridges for
eyelids. Thick bags bulge beneath the eyes, deeper on the
right than on the left. The cheekbones are high and deep
grooves separate the cheeks from the nose and mouth.
The bridge of the nose is flat and the nostrils are drilled.
The closed lips are full with a thickened, moustached
upper lip creating a dip. The corners of the mouth are
drilled. Soft curls define the short beard. The ears are not

218

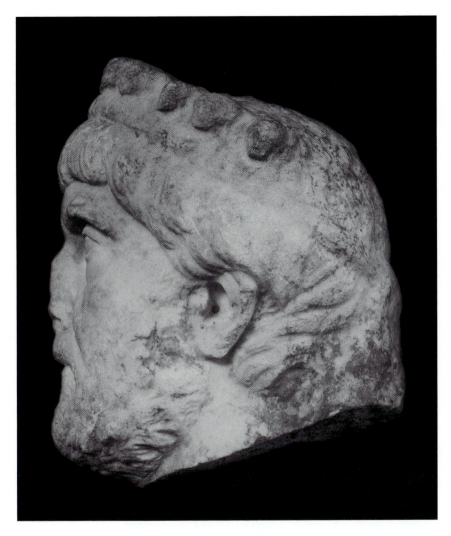

CAT. NO. 108

c. AD (see also Kron 1989:373–90 for a discussion of the Greek origins of the bust crown). Portraits and relief sculptures of priests wearing the bust crown have been found in various contexts in the cities of Asia Minor, in agoras, stadia, odeia, bouleuteria, theaters, in bath-gymnasia complexes, and sometimes in grave settings. Thus, the portraits were used both as honorific and funerary statues.

One of the most important roles of a priest of the imperial cult was as magistrate or *agonothetes*, organizing and presiding over both athletic and choregic games held in honor of the emperor-god (Rumscheid 2000:44–47; see also Wörrle 1988:186–88; Burrell 2004: 346–49). There is evidence in Severan times for Caesareian games in the province of Cappadocia (*Agon Koinos Kappadokias*), and that the city of Caesarea Cappadociae was granted the important title of *neokoros* (i.e., "temple-warden" of a temple to the living emperor) under Septimius Severus and held contests in the emperor's honor (see references in Rumscheid 2000:127, n. 722; and Burrell 2004:247–49 for the evidence at Caesarea).

The dating of this head is problematic, as Inan and Rosenbaum point out (1979:276). They tentatively assign it to the period of the Severans (AD 193–235) or Gallienus (AD 253–268), comparing the treatment of the hair and beard to a bust of a priest from Ephesos in Vienna (Inan and Rosenbaum 1966: no. 174, pl. 103, 1, 2; see Rumscheid 2000:122, no. 16, pl. 8, 1–2). Fittschen (1984:208, no. 264), however, followed by Rumscheid (2000:127), down-dates the UPM head to the Hadrianic period and assigns it to a larger group of portraits of Hadrianic (AD 117–138) date with hairstyles that are reminiscent of the Trajanic period (AD 98–117) (see Polaschek 1971:131–35, figs. 8–9; Fittschen 1997:32–36). In fact, the tendency in more recent sculptural scholarship is to follow Fittschen on this point, to question the dating of many private portraits

well modelled and a drill hole marks the center. The back of the head is summarily worked.

COMMENTARY: This bearded portrait is one of a large group of portraits from Asia Minor of priests of the imperial cult who wear crowns with tiny busts of divinities. This priest wears both the bust crown and a fillet which is rendered with irregular diagonal striations, suggesting not a plain ribbon but a twisted woolen fillet, the *infula*, worn by Roman priests in sacrifice. Rumscheid (2000:7–51) has gathered the archaeological, literary, and epigraphical evidence relating to the bust crown, and shows that it seems to be most at home in Asia Minor in connection with priests of the imperial cult, primarily during the 2nd and 3rd

219

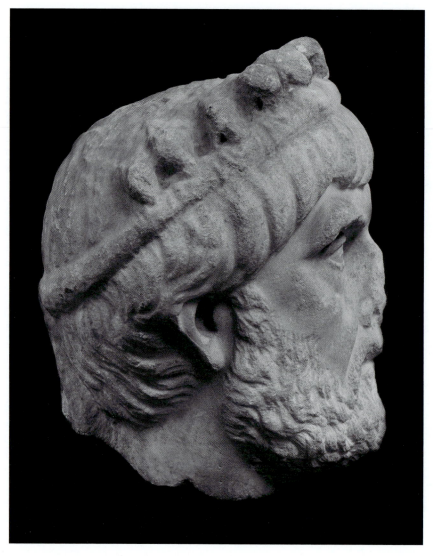

CAT. NO. 108

that were assigned to the Gallienic period, and to bring them down into the late Hadrianic and Antonine period (see, e.g., Smith 1998:56–93, esp. 58–59). The hairdo with thick locks brushed onto the forehead and partly covering the ears, and with locks brought forward on the neck behind the ears, is close to the hairdo of a bearded head from Kyzikos dated to the Hadrianic period (Inan and Rosenbaum 1966:109, no. 111, pl. 65; Rumscheid 2000:128, no. 28, pls. 5,3; 17, 4; 18,1–2). Compare also the similar treatment of the hair on another priest's head from Ephesos of the Hadrianic period (Rumscheid 2000:146, no.

69, pl. 32,3). The use of drilled depressions for the eyes was introduced in the Hadrianic period (ca. 130s) and is seen on two portrait statues of priests from Aphrodisias, which Fittschen (1984:207, no. 194: late Hadrianic or Early Antonine) and R. R. R. Smith (Smith 1998: pl. V, 3–4: mid 2nd c. AD) both date to the same approximate period. As portrait sculptures continue to be studied together with inscriptions and other archaeological evidence, the dating of this portrait will eventually be resolved. For the moment, it is probable that this head of a priest of the imperial cult belongs to the mid-2nd c. AD.

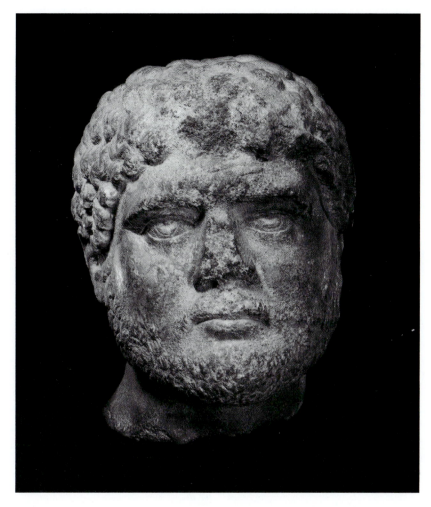

CAT. NO. 109

109
PORTRAIT HEAD: MARCUS AURELIUS ANTONINUS (CARACALLA)

MS 216
Rumeli Hisar, on the European shore of the Bosporus,
near Constantinople, Asia Minor
Roman Imperial period, AD 212–217
Relatively fine–grained white marble with purplish-red
surface patination
P. H. 0.27; Max. P. W. 0.195; Max. P. Depth 0.125;
H. chin to crown 0.23 m.
ACQUISITION: *Purchased by the Museum in 1895*
through H. V. Hilprecht from a Turkish widow.
PUBLICATIONS: *Luce 1921:189, no. 56; Vermeule*

1964: 110, fig. 41a–c; Vermeule 1968:401, no. 5,
fig. 160; Wiggers 1971:76; Inan and Alföldi-Rosen-
baum 1979:123–24, n. 71, pl. 63; Carra 1980:104,
n. 8,108, fig. 6, 111–12.

CONDITION: Head preserved from top to upper neck
which is broken irregularly. Much worn, encrusted, and
pitted with chips missing, especially from top of hair. Nose
is broken. Purplish-red surface coloration from deposition
in iron-rich soil. Stain on lower neck on right side is darker
brown-black.

DESCRIPTION: Lifesized bearded male portrait head turned slightly to the right. Block-like head and face with low forehead and jutting brow. Widespread eyes, open and almond-shaped with incised circle and round drilled pupils. Spreading nose with drilled nostrils. Closed mouth; bushy, downward drooping moustache; short beard with individual comma-shaped locks covering cheeks and chin; well-formed ears. Hair is composed of rounded tufts for locks, flattened and enlarged on the back of the head as if the back was not meant to be seen. On top of the head is a large rectangular cutting with an iron dowel preserved in it.

COMMENTARY: This head of the emperor Marcus Aurelius Antoninus, known by his nickname Caracalla (after *caracallus*, a close-fitting hooded cloak that he enjoyed wearing), belongs to Fittschen's "First Sole Ruler Type" and represents Caracalla after he assassinated his bitter rival and brother Septimius Geta, giving him sole claim to the imperial throne in AD 212 (Fittschen and Zanker, *Katalog* I:105–9, especially 106–7 for a list of examples from Italy, Greece, Asia Minor, North Africa, and Egypt. For a discussion of the type with examples see also Wiggers 1971:28–35.). Caracalla ruled for a brief six years before he

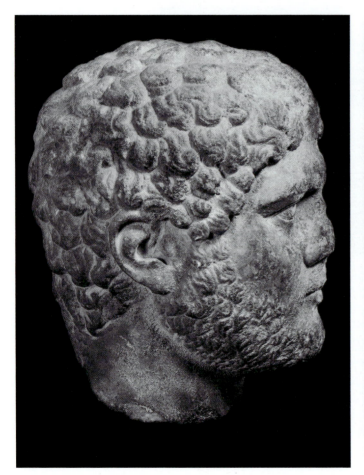
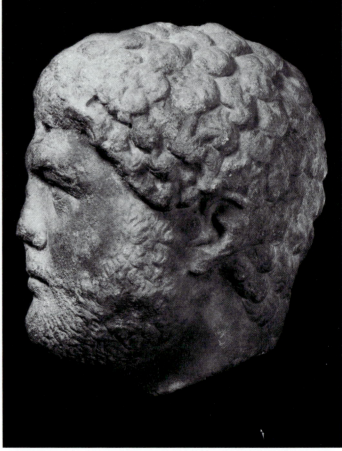

CAT. NO. 109

himself was assassinated at the age of 29 by his own veterans. Caracalla had an unusually ruthless nature and was sadistically inclined. Even after his death he was maligned by comparisons with Tantalus, a gladiator loathed by all for his short stature, ugly features, and bloodthirsty disposition.

The portraits of Caracalla of this "First Sole Ruler Type" share a ferocious expression, a block-like head shape, and closely cropped curls. The strong turn of the head is missing in this portrait, as it is in the colosssal red granite example of this same Caracalla type from Koptos,

Egypt (**110**). The substantial iron dowel in the top of the head is probably for the addition of some kind of head gear. Vermeule suggests that it might be for the addition of a crown or star, presumably in another material. His suggestion that this head may have been part of a monument commemorating the glories of the Severan Dynasty set up near Byzantium, where Septimius Severus had celebrated a major victory over Pescennius Niger in AD 193, is intriguing but needs archaeological corroboration (1964:110; 1968:401).

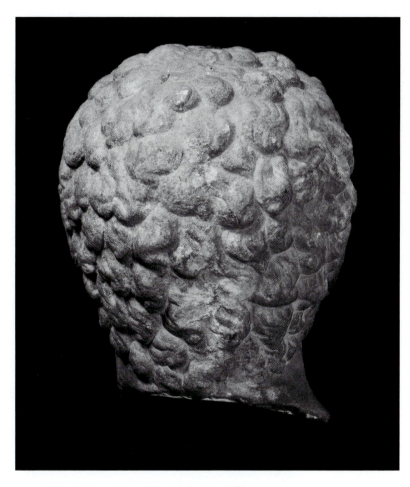

CAT. NO. 109

110
PORTRAIT HEAD: MARCUS AURELIUS ANTONINUS (CARACALLA)

E 976 (see CD Fig. 39)

Koptos (Qift), Upper Egypt, on the steps of the Temple of Isis

Roman Imperial period, AD 212–217

Syenite (red granite), probably from Aswan

H. 0.53; W. 0.375; D. 0.54; D. head 0.40; Max. P. D. back pillar 0.14; Th. back pillar 0.215 m.

ACQUISITION: *Excavated by W. M. Flinders Petrie on the steps of the Second Pylon of the Temple of Isis at Koptos in 1894 (Flinders Petrie 1896:23). As a major sponsor of the Koptos excavations though the Egypt Exploration Fund, the Museum was given this head and other objects from Koptos as a share of the finds.*

PUBLICATIONS: *Stevenson 1895: 350–51, fig. 40; Flinders Petrie 1896:23; Milne 1898:71, fig. 61; Furtwängler 1905:254; Porter and Moss 1937:132; Graindor 1939:145–46, pl. 71, no. 80; Segall 1939:115–16, fig. 4; Walters Catalogue 1947:23, no. 1, pl. 8; Ranke 1950:58–59, fig. 34; Drerup 1950:21; Jucker 1962:312; Nodelman 1964: 190–91, pl. 106; Parlasca 1966: 176, n. 24; Castiglione 1967: 110, pl. 3,2; Vermeule 1968: 299, 401–2, no. 13; Art of the Late Antique 1968:46, no. 2; Wiggers 1971:34, 46, 76; Kiss 1975b:302, pl. 87b; Romans and Barbarians 1976: 25, no.31; Grimm 1976:103, n. 13, no. 2; Hornbostel 1978:516, n. 54; Kiss 1979:379, 381, n. 17, pl. XXVII, 8; Jucker 1981: 721–22, n. 205; Vermeule 1981:352, fig. 303; Zanker 1983:39, n. 130, pl. 29, 3; Kiss 1984:82, 89, 93, 95, 184, fig. 209; Introduction to the Collections 1985:40, fig. 23; Cleopatra's Egypt 1988: 254–55, cat. no. 140; Kleiner 1992:325, fig. 288; Expedition 38, 2, 1996:back cover.*

CONDITION: Single fragment broken off diagonally at the neck; bottom of neck has been sawed smooth, probably for a modern mounting device. Top of head behind *uraeus*, top of *uraeus*, and top of pillar broken off. End of nose and chin broken off. Stevenson (1895:351) recorded faint traces of red paint on the statue, none of which is detectable today.

DESCRIPTION: Colossal head of block-like shape with scowling visage and a rectangular back pillar. Hair is treated with bead-like globules arranged in rows framing

CAT. NO. 110

forehead and continuing on sides and top of head. A wide, flat diadem with the *uraeus* at the front encircles the head. The short beard is treated the same way as the hair with round globules. Large ears with flattened lobes and a prominent globular tragus. Fleshy face with creases at side of mouth. There is a slight indication of a raised moustache blending with the facial planes. Forehead is modelled with deep creases over a projecting brow and deep-set eyes. The eyelids are thickened ridges with the upper lid continuing in a long ridge. Pupils are deep circular gouges. Thick nose with flat bridge with overhanging brow above. The lips are slightly parted and thickened, with a deep groove with a downward turn at the outer corners. Face is slightly polished while the rest of the head is left unpolished giving a rough appearance.

COMMENTARY: This is a remarkable portrait of the emperor Marcus Aurelius Antoninus (Caracalla) combining the official imperial portrait type conceived in Rome with Egyptian elements in a local Egyptian stone. The hieratic frontal position, the back pillar, and the *uraeus* signal obvious pharaonic connections.

According to Flinder Petrie (1896:23), the sacred temenos and temple of Isis at Koptos were originally built under Tutmosis III, rebuilt under Ptolemy II, and in use into the Roman period when this portrait of the emperor Caracalla was set up in close association with the temple. (See Herbert and Berlin 2003:14 for a discussion of the work of Flinders Petrie and other early excavators at Koptos and of the condition of the site today.) Caracalla's imperial visit to Egypt around AD 115 was marred by a brutal massacre of Alexandrians, a retaliatory gesture for some unspecified insult toward the emperor. Despite this, many portraits and monuments in Caracalla's honor, such as this colossal portrait, were erected in Egypt during the period of his rule (see Jucker 1981:722).

The UPM portrait is an especially stern representation of the emperor which falls in the general category of portraits created after Caracalla's bloody ascent to the imperial throne in AD 212. Kleiner (1992:325) categorizes this as a type 5 portrait, the characteristics of which are a massive, blocklike head, a deeply incised, X-shaped crease across the center of the face, and a fierce intensity. Type 5 portraits replace the closely related type 4 portraits around AD 212 or slightly later. This head is close in style and scale to another from Egypt in gray granite with a back pillar (in the Graeco-Roman Museum in Alexandria, inv. No. 3233) (Kiss 1979:379, pl. XXVIII). See also **109** for a more benign marble portrait of Caracalla of the same general type and time period from Asia Minor.

CAT. NO. 110

111
MALE HEAD AND BUST

MS 250 *(see CD Fig. 40)*
Unknown provenience
Head: Roman Imperial period, ca. AD 220–245; bust:
 probably late 1st–2nd c. AD
White marble
P. H. head and bust 0.425; H. head to neck join 0.183;
 P. W. bust 0.36; P. Depth 0.14 m.
ACQUISITION: *Joint gift of Dr. William Pepper and Carl*
 Edelheim, December 1895.
PUBLICATIONS: *Unpublished.*

CONDITION: Head and neck attached to bust that does not belong. Head is cut down or finished at the upper neck (not possible to tell because of the present join). A disk of marble, probably added in the late 19th c. before the head came to the Museum, finishes the neck and joins it to the bust. Missing end of nose; chips from right and left ears. Eyebrows are worn. Dark, reddish-brown discoloration on top of head, beard, and neck. Bust has large pieces missing from edges, which are very worn. Chips missing and wear on folds of garment. Dark discoloration on bust.

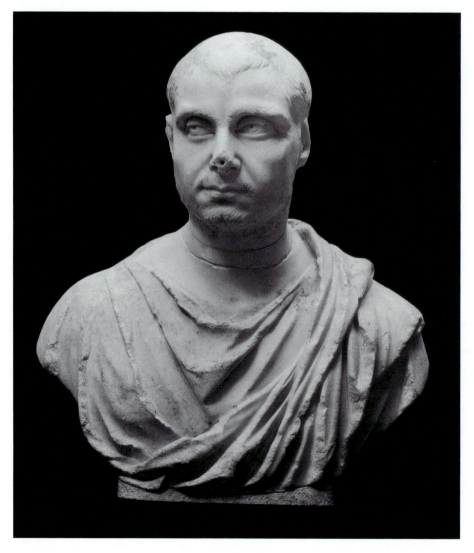

CAT. NO. 111

DESCRIPTION: Male head and bust do not belong and are joined at upper neck in front with an additional piece; joining surface was probably recut. Head is turned slightly to the right with eyes, especially the right one, averted right. Hair is close-cropped with receding hairline, coming to a peak at the middle of the forehead and with sideburns in front of ears. Elongated chisel strokes define the individual hairs in front, on top and on sides, while the back is more summarily worked. Well-defined temples and strong brow ridges with eyebrows defined by slanting chisel strokes. A deep drill line separates the upper eyelid from the brow ridge. Upper lids are one-quarter closed. Three-quarters of a circle inscribed for the iris, painted in black; the pupil is

a drilled circular depression, painted black. The lacrimal gland is deeply drilled. Arching nasal ridge with large drilled nostrils. Small hole is drilled through the broken surface of the nose for repair, probably in the 19th c. High, pronounced cheekbones; pouches of flesh from nose to sides of mouth. Flat cheek on left side. Moustache and beard are treated as a series of random chisel strokes on the face, while on the neck the hair is treated more sculpturally. At the middle of the upper lip is a circular drilled depression, below which the lip dips. The poorly defined mouth is tightly closed. Below the lower lip is a deep broad depression. The chin has a cleft defined by a deep chisel stroke. The ears are small, with the right more pronounced

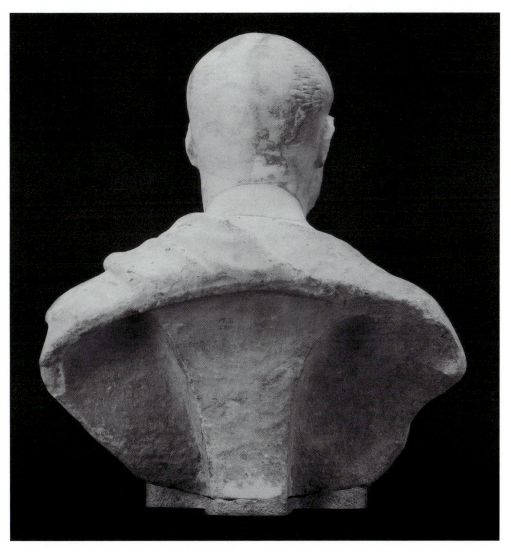

CAT. NO. 111

and protruding than the left. The back of the head is summarily carved and was not meant to be seen.

The oval bust is draped in a toga with a cowl neck and excess material over the left shoulder. The folds are treated sculpturally with deep valleys and high peaks. Back of bust is hollowed in concavities to right and left of a raised central area which tapers from a fan shape at the top to a square pillar at the bottom. The under surface of the pillar is treated with a series of depressed points from a chisel and has a circular hole drilled through (D. 0.013; Depth 0.057 m.) for attachment to a pedestal.

COMMENTARY: Although the head and bust do not belong together, the head is a fine individualized portrait of a middle-aged man with a receding hairline which can be placed, by comparison to imperial portraits, in the period from Severus Alexander (AD 222–235) to Gordianus III (AD 238–244). Compare, for example, the egg-shaped head with slight bulges at the sides, short-cropped hair, and the incised iris and drilled pupils set against the upper eyelids with portraits of Severus Alexander (Fittschen and Zanker, *Katalog* I:121–23, nos. 101–3) and of Gordianus III (Kleiner 1992:366–68, figs. 328–30). The rendering of the hair as chisel strokes is also characteristic of the period of the late Severans (see Wood 1986:63).

The individual represented here cannot be identified, but it is likely that the portrait was part of a funerary monument. Since the back of the head was not meant to be seen, the portrait was probably displayed in a niche such as in a *columbarium*. The bust is a fine ancient example, though not belonging to the head and dated earlier in the Roman Imperial period than the head, perhaps to the end of the 1st or 2nd c. AD.

112
PORTRAIT HEAD OF CONSTANTIUS II (?)

L-51-1 (see CD Fig. 41)
El Bab, ancient Batna (northeast of Aleppo), Syria
Roman Imperial period, ca. AD 335–361, possibly recut from an earlier head
White marble
H. 0.29; W. 0.17; H. chin to crown 0.245; Depth 0.17 m.
ACQUISITION: *Von Oppenheim records (1925) that the head was excavated in a "pre-War scientific expedition" in the town of Bab, northeast of Aleppo. Loaned by Baron Max von Oppenheim, 1933 or 1934; loan renewed by Eleonore Countess Matuschka-Greiffen-clau in 1984.*
PUBLICATIONS: *von Oppenheim 1925a:75, fig. 38; Müller 1927:3–7; Dohan 1936:20–22, pl. 8; Schweitzer 1954:178; Jucker 1959:275–80; Vermeule 1964:111, n. 72; Vermeule 1968:354–55, 517, n. 5; Wrede 1972: pl. 61, 1; 62, 1; Calza 1972:301, no. 210, pl. 105, 379; L'Orange 1984: 86, 134, pl. 57b; Kondoleon 2000:126, no. 16; Guide to the Etruscan and Roman Worlds 2002:44, fig. 66.*

CONDITION: Single fragment preserving the head from the crown to the lower neck. The back of the head is cut off for attachment to a joining surface and a large circular dowel hole (probably modern) is cut in the back for mounting. The nose is broken off, especially on the left side and bridge. The mouth and chin are damaged. Chips are missing from left eye, band and hair, neck and face; bottom right earlobe is broken off. Top left and left side of head, especially left ear, show evidence of ancient recutting.

DESCRIPTION: Lifesized portrait head of a youthful male with a wide headband (diadem or *taenia*?) (W. 0.038 m.) encircling the head above the ears. The head is frontal, though turned very slightly to his right. The hair is brushed down onto the forehead with broad flame-like locks; short sideburns have a serrated bottom edge on the right side. There are no indications of locks on the smooth crown, and short locks are visible above the neck on the back right side behind the ear. The face is long and narrow with a shallow forehead, the brow arching in a continuous curve with the left raised higher than the right and the right more swollen at the outer edge than the left. Long narrow eyes are shallowly carved with thickened ridges for lids, drilled circular depressions for pupils and drilled lacrimal glands at the inner corners. The nose is narrow with drilled nostrils. A small mouth has puffiness around; lips are pursed with little definition. Sharp crease beneath the mouth; rounded point

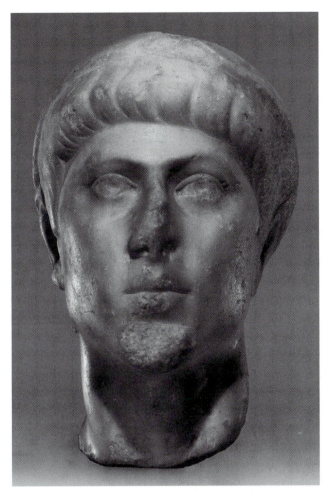

CAT. NO. *112*

to the chin. High cheekbones and flattened cheeks. The neck is well developed with a prominent Adam's apple. The right ear is large and puffy with a crease on the earlobe and a drilled center of the ear. Beneath the right earlobe is a drilled depression and below that on the neck is a raised flat feature (0.018 x 0.01 m.) which may be a remnant of the original sculpture from which this head is recut. The left side of the head has not been fully carved. The ear appears as a roughened raised area, and the headband is flattened and barely a raised surface. The bottom and left lower edge of the neck are roughly picked as if for insertion into a bust. Back of the head and neck are cut off with a flattened surface worked with a chisel. The large circular hole cut just above the center of the back of the head appears to be for a modern mounting device, though it is possible that an smaller ancient cutting was enlarged. Entire head is polished, except the back and undersurface. In general,

there is a soft quality to the piece, possibly due to a deliberate *sfumato* finishing.

COMMENTARY: Jucker (1959) and Vermeule (1968) identified this portrait with a Syrian provenience as that of Flavius Iulius Constantius, the third son of Constantine the Great and Flavia Maxima Fausta, known as Constantius II, perhaps of the years 335–337 when he lived as Caesar in Antioch. Vermeule suggests that the elongation of the face, the narrow eyes, and pointed chin are characteristics of this individual as well as of the sculptor, though there is no close parallel for these features among the portraits that have been tentatively identified as the sons of Constantine (L'Orange 1984:86–87). The lack of securely identified portraits of the sons of Constantine makes a positive identification of this head impossible.

It is not clear if the headband should be interpreted as

a *taenia* (wide ribbon wrapped around the head) or a diadem which is common on the portraits of the emperor and imperial princes in this late Roman period. E. H. Dohan (1936) believed that the small boss of stone under the right ear was the remnant of an earring and a sign of the "oriental" nature of this portrait. There is no corresponding trace on the left ear. Though Kondoleon suggested (2000:126) that the head may have been unfinished because of the flat unarticulated headband, the polish on the face shows that the portrait was finished. The head, rather, gives the impres-

sion of having been recut in antiquity from another head, explaining the somewhat flattened left side, the remnant of marble below the right ear, the lack of marble for the carving of the ear and headband on the left side, and the *sfumato* finish to disguise the recutting.

The flattened back of the head and neck suggests that the head was at one time in its history attached to a vertical surface, perhaps a pillar such as the tetrarchs from the imperial palace in Constantinople (see Kleiner 1992: figs. 366–67).

Divine and Idealized Images (113–121)

113

STATUETTE OF APHRODITE/VENUS

MS 214
Said to be from Caesarea Cappadociae (Kayseri), Asia Minor
Roman Imperial period
White marble
P. H. 0.607; Max. P. W. shoulders 0.162; Max. P. Depth thighs 0.155 m.
ACQUISITION: *Purchased by the Museum through H. V. Hilprecht in 1895 in Constantinople where it was brought by a local from Caesarea, along with* **108**.
PUBLICATIONS: *Luce 1921:170, no. 19.*

CONDITION: Missing the head, arms, right leg from mid thigh, front of left foot. Left leg from below knee reattached. Some spidery brown lines on surface and much dark discoloration. Holes drilled in buttocks and right thigh for modern mounting rods.

DESCRIPTION: Statuette of a standing nude Aphrodite/ Venus in frontal pose with torso twisted slightly to her left bending forward slightly; shoulders are rounded. Head was also turned to left. The right arm, to judge from the joining surface, was held out and forward, while the left upper arm was in the vertical position. The right leg appears to have been straight, while the left is bent. On the back of the neck and right shoulder are long intertwined locks of hair falling from a single source above. The figure is well modelled with full breasts and muscular mid-torso. Back and buttocks are

elongated. On right buttock is a flattened, finished patch. On bottom of left foot is a tang for insertion into a base. The head would have been carved in one piece with the torso. The arms were separately carved and attached with dowels. The joining surfaces are smoothed and holes are drilled for circular dowels. The entire figure has been highly polished.

COMMENTARY: This statuette from Cappadocia is a Roman adaptation of a nude Aphrodite type with fairly generic features: long locks escaping from her hairdo, here preserved on the right side of her neck, back, and shoulder; the turn of her head to the left; rounded shoulders; the forward right arm and downward left arm; the left leg bent and turned out slightly. There are numerous examples of nude Aphrodite statuettes with similar poses, mostly in bronze and terracotta, from the Roman east, but the type most consistent with the features of this statuette is the one in which she holds a mirror low with her left hand, turning her head to look into it and raising her right arm holding a long lock of hair (see *LIMC* II, Aphrodite [in Peripheria Orientali]: nos. 100–111). These look back to a Hellenistic type of Aphrodite "at her toilet" (*LIMC* II, Aphrodite: 59–60). There are also variations of a type found in numerous examples in the Roman East in which the goddess holds a folded fillet in the right hand, with the left arm down and extended outward slightly to her left side (see *LIMC* II, Aphrodite [in Peripheria Orientali]: nos. 132–53), which are also compatible with this statuette.

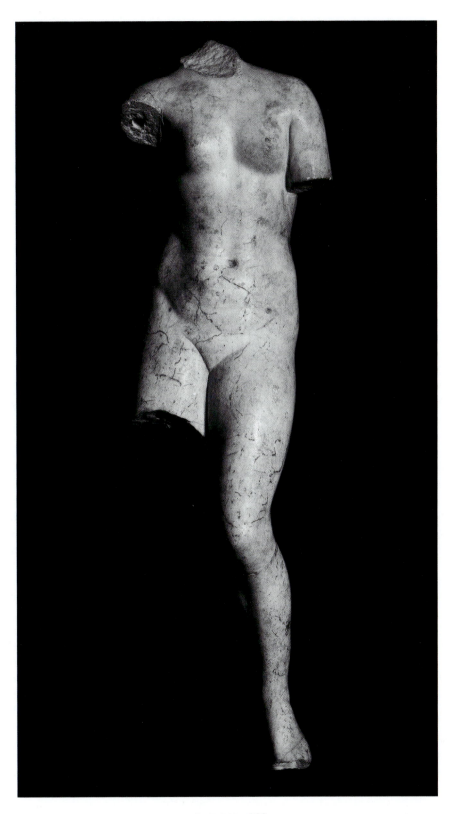

CAT. NO. 113

114
STATUETTE OF FEMALE GODDESS IN FLIGHT

MS 4029 (*see CD Fig. 42*)
Unknown provenience, probably Italy
Roman Imperial period, possibly mid-2nd c. AD (Anto-
nine period) after an Augustan prototype
Dark brown/purple brecciated marble with large speckles
and patches of gray-white and some streaks of dark
red-brown impurities, probably from the Greek island
of Skyros
P. H. 0.59; W. drapery at mid-body 0.281; Depth
bottom 0.18 m.
ACQUISITION: *Purchased with funds from Lucy*
Wharton Drexel in November 1901 from Alfredo
Barsanti through E. P. Warren in Rome.
PUBLICATIONS: *Furtwängler 1905:261, no. 34; Bates*
1912:101, no. 3; Hall 1914b:115–16, fig. 65; Luce
1921:173–74, no. 29; Lippold 1923:260, n. 41;
Reinach 1924, V: 205, 3; Gulaki 1981:212–15,
figs. 187, 188, 190, 193; Introduction to the
Collections 1985:39, fig. 21; Guldager Bilde and
Moltesen 2002:12.

CONDITION: Complete, preserving the body. The separately attached head, left arm, and right and left feet are missing; the right arm is broken off below the shoulder and may have been carved in one piece with the body. Fragments of drapery are missing from the right and left lower sides and from right upper side. The edge of the drapery is broken off over the left breast. Chips are missing from the front, on the left side of the torso, both upper legs, and the right lower leg. On the back below the overfold is some surface damage. The strut is broken off on the right side at the edge of the overfold.

DESCRIPTION: Statuette of a wingless draped female figure, striding or alighting with her right foot in advance of the left and her body twisting slightly to her left. She wears a sleeved *chiton* fastened by at least one button on the right shoulder. The garment balloons out at the back of the upper torso, and billows back to the right and left sides of the legs in deeply cut folds. The *chiton* slips off her right shoulder and clings to the body over the slightly protruding stomach and over the front of the legs, falling between the legs to end in a swirl around the lower legs and feet. There is a suggestion of a rolled belt just above the waist. The back of the statue is summarily treated as a series of rippling folds and the overfold of the *chiton* is tucked

under in a neat line. The frontal view is clearly the most desirable one.

The head and neck with the upper right shoulder, the left arm, and both feet were added separately, probably in different stone. The head would have been set into a deep and very long cutting in the top of the torso (Max. Depth 0.04; L. 0.166; W. 0.064 m.). The drapery arches up above the right breast masking the cutting at that point. The left arm would have been added separately, attached to a finished area masked by the drapery at the left shoulder (D. 0.053 x 0.068 m.). The left arm appears to have been raised. The right arm may have been carved in one piece with the statue since it is broken off below the shoulder and a broken peg-like strut survives (D. 0.02 x 0.03 m.) that may have supported the forearm. The right and left feet would have been added separately and secured in the hollows beneath the drapery. Two small dowel holes appear in the cutting for the right foot; none visible in left. Underside is roughly finished with two modern drill holes for mounting.

COMMENTARY: The marble from which this statuette was carved is probably from the quarries on the Aegean island of Skyros, a brecciated dark purple marble, exploited from the 1st c. BC into the Roman Imperial period and used mainly for architecture, e.g., at Leptis Magna and Piazza Armerina (*Marble in Antiquity* 1992:156–57; Lazzarini 2002:258–60; see also Schneider 1986:139–60, esp. 144 [Skyros] for a discussion of colored marbles in Roman sculpture, especially with reference to barbarian figures).

A Nemi provenience has been suggested for this statuette (Lippold 1923:260 n. 41; Guldager Bilde and Moltesen 2002:12), based primarily on the fact that it was purchased from the dealer Alfredo Barsanti. Barsanti was active in the negotiations for the Nemi sculptures that came to the UPM in 1897 and later offered the Museum other sculptures which were supposedly from Nemi (see above p. 78). There was no claim by Barsanti that this statuette came from Nemi. In fact, although Guldager Bilde and Moltesen point to the compatibility of the type, style, size, and piecing technique with the corpus of Late Hellenistic Nemi sculptures (2002:12), this flamboyant image with the somewhat baroque use of colored marble (with the possibility of a head, arms, and feet of another marble) is unlike any of the Nemi pieces.

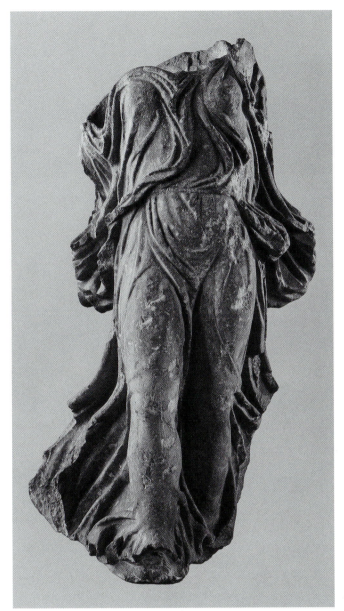 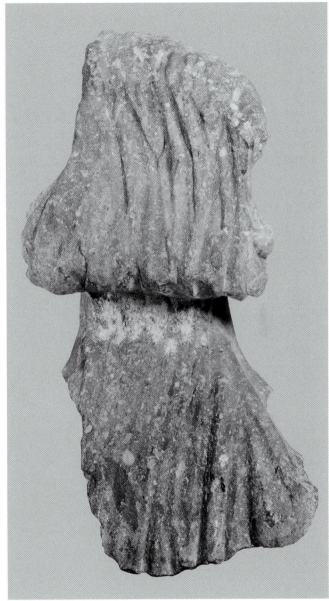

CAT. NO. 114

While Nike/Victoria is the obvious identity of this wingless goddess in flight, Iris, a Nereid, or one of the Aurai, personifications of the winds, are also possibilities. Lacking the possible attributes held in the hands, it is not possible to make a positive identification, though Gulaki (1981:212–15) includes this statuette in a larger group of Classicizing Nikai (or other goddesses in flight). The closest parallel for the motifs of the curving drapery lines between the breasts, the bare right shoulder, and the deep 'V' folds between the legs is the Nike *acroterion* from the Basilica Julia in Rome of Augustan date, (see Gulaki 1981:208–12, figs. 183–84). Another Augustan period statuette (P. H. 0.46 m.; lower torso preserved) in white marble (Pentelic?) in the Schloss Fasanerie near Fulda is also a close parallel for the UPM figure, although in a mirror pose (Gulaki 1981:213–14, figs. 189, 189a, 189b).

Gulaki (1981:214), followed by Ridgway (in *Intro-duction to the Collections* 1985:39), assigns the UPM stat-uette a date in the Middle Antonine period (ca. mid-2nd c. AD) based on the liveliness and sharpness of the drapery, but taking as its prototype a work of the Augustan period. The style is certainly an eclectic one, with the wind-blown drapery effects echoing Greek works of the last quarter of the 5th and early 4th c. BC, such as the wingless Nikai from the Balustrade of the precinct of Athena Nike on the Athenian Acropolis, ca. 410 BC; the Nereids from the Xanthos funerary monument in the British Museum, ca. 390–380 BC (Todisco 1993: figs. 66–71); the Nike *acroterion* from the west side of the Temple of Asclepios at Epidauros, ca. 380–370 BC (Todisco 1993: figs. 72, 74–76); and the *acroterion* from the Stoa of Zeus Eleutherios in the Athenian Agora of ca. 400 BC (Todisco 1993: fig. 20). The motif of the bare right shoulder looks back even further to figures from the Parthenon (e.g., Aphrodite from the east pediment), but repeated later on the Nike Balustrade.

On a larger scale in this same "pseudo-acrolithic" technique in a dark gray stone (*bigio antico*) are a statue from the Caelian Hill in Rome, the so-called Victory of the Symmachi, considered a Late Hellenistic/Late Repub-lican work (*Montemartini* 1999:68–70, fig. 43), and a 2nd c. AD statue of a dancing figure from Perge in the Antalya Museum (Dörtlük et al. 1988:87, 205, no. 103). The widespread use of a variety of colored marbles in Roman imperial sculpture is well documented beginning in the Augustan Age (see Schneider 2002:83–105, esp. 83). For an impression of the effect of a flying figure in dark mable with white marble arms and head see *Marmi Colorati* 2002:325–26, no. 23: an Aura with a portrait head of Matidia.

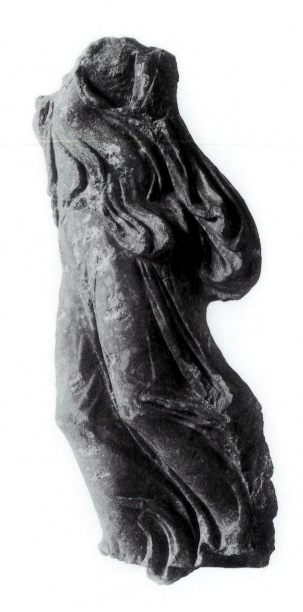

CAT. NO. *114*

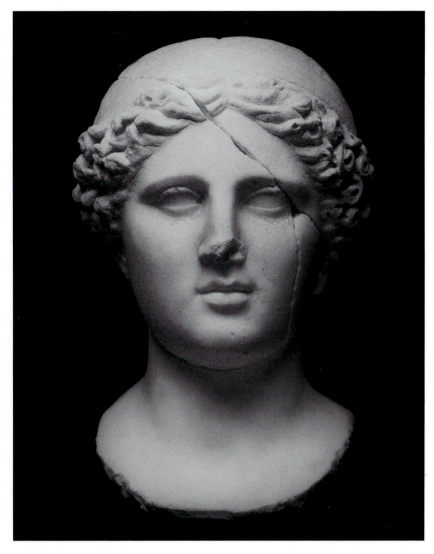

CAT. NO. 115

115
IDEALIZED FEMALE HEAD

MS 4033

Unknown provenience

Roman, 1st c. AD (late Tiberian-Claudian period), with
some ancient recutting and restoration at end of 19th
or early 20th c.

White marble

H. 0.345; W. at bottom of neck 0.18; W. face 0.14;
Depth nose to back of head 0.21 m.

ACQUISITION: *Gift of R. H. Lamborn, ca. 1905.*

PUBLICATIONS: *Luce 1921:189–90, no. 57.*

CONDITION: Joined from at least four major fragments:
(1) bust and lower back of head, probably a restoration of
end of 19th or early 20th c. in a different white marble; (2)
face and right side of head; (3) left side of face and top of
head across outside of left eye; (4) left cheek and ear.
Surface of face and neck well preserved. Many chips and
missing pieces on locks of hair, edges of ears, and tip of
nose. Hair worn, especially to right of central part. Below
eyes are circles made by stippling.

DESCRIPTION: Lifesized frontal female head wearing a *taenia*. Her hair is parted in the center (slightly off-center to the left) with thick wavy locks framing the forehead. Toward the sides the locks are given more volume and end in deep, tight snail curls with deeply drilled holes at the centers. At the back (restoration) the curls encircle the nape with the ends of the snail curls deeply drilled. A broad band across the top of the head tapers and disappears beneath the curls at the sides. The central part continues on top of the head, and the hair to the right and left is treated as a series of wavy ridges and grooves which flatten out and disappear into a summarily worked area at the back of the head. Some shallow remains of drill holes on the *taenia* and the shallow locks behind the *taenia*.

The face is heart-shaped with a high triangular forehead. Sharply creased brow ridges with bulges at the outer corners (especially prominent over the left eye). Wide-open, almond-shaped eyes with deeply inset inner corners; the right eye is slightly smaller than the left and has a slightly sharper ridge for the lower lid; thickened upper lids and smooth eyeballs. Nose is straight with flattened bridge, slightly flaring, drilled nostrils. Cheeks are full and well modelled. "Cupid's bow"–shaped upper lip with prominent dip above the center. Thicker lower lip, parted from the upper by a drilled line. Full rounded chin with flattened end. The face is polished. Ear on right side is set high and is poorly executed with little definition; the inside is drilled; the left ear is smaller. The top of the head behind the *taenia* is treated with shallow wavy locks. The restored neck is well modelled and polished to a high sheen. The edges of the bust are finished as if for setting into a body.

COMMENTARY: The idealized facial features and the band or *taenia* around the head suggest a divine image, though the hairdo is problematic in its current restoration, and one must think away the restored bust fragment which completes the back of the head in a different marble and in a style that is not ancient. In addition, there appears to be some ancient

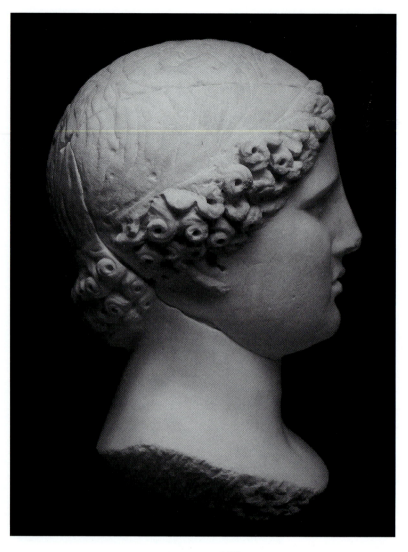

CAT. NO. 115

recutting of the hair, suggested by the vestiges of drill holes and the shallow wavy locks on top of the head and the rather wide *taenia*. The original hairstyle is probably of the late Tiberian-Claudian period, completed at the back in a chignon. The *taenia* may be part of the recutting where originally there would have been another row of snail curls or a braid (like the unidentified portrait on a *herm* from the Sanctuary of Diana at Lake Nemi (Ny Carlsberg Glyptotek I.N.759; Johansen 1994:190–91, no. 83). The locks on top of the head would have been carved more deeply. In general, this hairstyle with the hair parted in the middle and with a dense mass of ringlets with drilled centers surrounding the

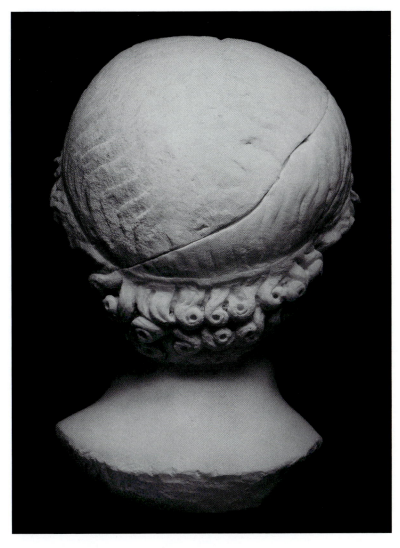

CAT. NO. 115

brow and over the tops of the ears is reminiscent of a typical Claudian hairdo that is associated with Agrippina the Elder (AD 14–33), the wife of Germanicus, and Agrippina the Younger (AD 15–59), the wife of Claudius (see Johansen 1994:150–51, no. 63; Fittschen and Zanker, *Katalog* III: nos. 4 and 5, pls. 4–6, Beilage 1–5). The hair is rolled in two large masses at the sides and gathered in a chignon at the back, while ringlets fall down the sides of the neck.

Portraits of private women in this same period, or slightly earlier in the late Tiberian period, wear this hairstyle, as for example the portrait, mentioned above, of an unknown woman from the Sanctuary of Diana at Lake Nemi (Ny Carlsberg Glyptotek I.N.759; *In the Sacred Grove of Diana* 1997:143–44; Johansen 1994: no. 83); the portrait *herm* of Staia Quinta from Nemi (Ny Carlsberg Glyptotek I.N.86; Johansen 1994:176–77, no. 76); and a portrait from the Licinian Tomb (Johansen 1994:196–97, no. 86). Even if one ascribes the *taenia* to the recutting, the facial features of the UPM head do not seem portrait-like, but rather like that of an idealized image, perhaps of a personification or a Muse (see Schneider 1999: for Muses from the hall of the Muses in the Baths of Faustina at Mileus, and esp. 18 for a discussion of the blurry line between portraiture and *Idealplastik* in these Roman Muse statues).

116
STATUE OF NUDE GOD OR MORTAL
WITH IDEALIZED BODY

MS 4018 (see CD Fig. 43)
Said to have come from Rome, outside the Porta Pia (ancient Porta Nomentana)
Roman Imperial period, 1st–2nd c. AD
White marble with gray veins, probably Carrara marble
P. H. 1.61; P. W. at shoulders 0.59; Max. P. Depth at abdomen 0.40 m.

ACQUISITION: *Said to have been discovered in excavations outside the Porta Pia in Rome in 1902. Purchased for the Museum with funds from Lucy Wharton Drexel in 1904, through Alfred Emerson from the dealer Alfredo Barsanti. Emerson (1905:171, 174) reports that a copy of the Praxitelean flute-playing faun with leopard skin over one shoulder (H. 0.84 m.) and the*

right leg of the Museum's statue were discovered in subsequent excavations on the site.
PUBLICATIONS: *Emerson 1905:169–75, Fowler 1905: 375; pls. XXIII–XXIV; Luce 1921:177, no. 45; Guide to the Etruscan and Roman Worlds 2002:52, fig. 75.*

CONDITION: Missing head, right arm, left forearm, and right leg from below the knee, all of which were separately attached. Also missing left leg from lower shin, back and lower part of tree support, fragments of the edges and lower part of the drapery. Missing the penis. Much dark discoloration on the body, especially the back; tawny discoloration on lower torso. Surface chips and scratches.

DESCRIPTION: Lifesized nude male in contrapposto stance with left leg straight, while the right leg is slightly in advance of the left, bent and trailing. The right arm is upraised above shoulder height; the left upper arm is vertical with the elbow bent and the forearm extended forward with the *himation* draped over it. The head appears from the neckline and throat to have been turned to the right, toward the right upraised hand. A mantle with a circular weight or ornament at one corner is looped over the left shoulder and lies along the left side of the chest, falling over the left side of the back and brought back up under the left elbow and over the left forearm to fall vertically to the left side of the figure in front of the tree stump support.

A palm tree stump, with a single oval knot at the front and two other knots summarily treated on the stump beside the inside of the left leg, is placed along the left side of the figure, carved in one piece with the back of the left leg and lower part of the *himation*. The tree stump is very broad at the back, providing support from beneath the left buttocks and left leg to the edge of the drapery. A vertical piece of the tree has been cut out between the leg and drapery leaving a strut of marble connecting the thigh and the tree support, giving a lighter feel to the piece when viewed from the front. The back view was clearly not meant to be seen, as the tree stump and drapery in back are only summarily treated. A separate block would have been added to complete the tree support at the back where a broad surface has been flattened and treated with a claw chisel. A large fragment of an ancient iron bar (P. L. 0.045; P. W. 0.03; P. Depth 0.04 m.) survives at the back of the stump behind the left thigh, probably for the attachment of the figure to a vertical surface behind it. Above the preserved iron bar is a deep square cutting, probably ancient (0.035 m. sq.; Depth 0.07 m.), cut at an upward angle. A channel has been cut down in the middle of the tree stump in the back, stained with iron from the bar above (P. L. 0.475; W. 0.035 m.). A

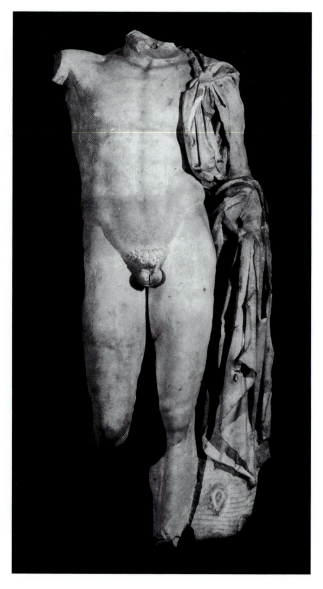

CAT. NO. 116

modern circular hole (D. 0.02; Depth 0.02 m.) has been drilled at the base of this channel near the preserved edge.

The body forms are mature, of heroic proportions, with powerful shoulders, chest, hips, thighs and buttocks, and pronounced epigastric arch. The pubic hair is treated as snail curls with drilled centers. The piecing technique is used to attach the right arm, left forearm and head (attached at mid-neck) with flattened surfaces and hole for iron dowel. A separately carved block was also added at the back of the tree stump support (see above). The flesh parts of the body have been polished. There is extensive use of

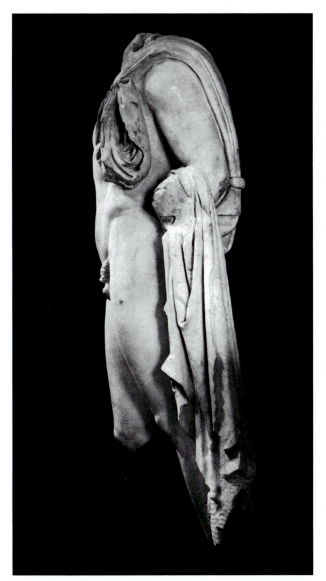

CAT. NO. 116

the deep drill visible on the drapery. The statue was meant to be viewed from a frontal position only.

COMMENTARY: This idealized nude figure is a quintessentially Roman creation, an eclectic work, emulating rather than imitating (for the distinction see Ridgway *Roman Copies*: 84) various Classical period works depicting a Greek god or hero, and probably completed with a portrait head of an important Roman citizen or member of the imperial family with a spear or sceptre held in the raised right hand.

The general ideal body type and stance with the weight on the left leg and the right leg bent and trailing and the mantle over the left shoulder and arm recall a mid-5th c. BC statue of Hermes Logios or Hermes Psychopompos, sometimes attributed to the sculptors Myron or Pheidias (see Ridgway *Fifth Century Styles*: 216–17 for a discussion of the so-called Hermes Ludovisi type; and Maderna 1988:81–82). The most famous of the Roman copies of this type is the statue in the Louvre signed by Kleomenes and identified by Säflund (1973) and Balty (1977:108–16) as a portrait type of Augustus's nephew Marcellus, though also known as the

"Germanicus" (see also Maderna 1988:223–25, pl. 26,2 and examples of Roman portraits of the type: pl. 27,3; 28, 1; 28, 2; 28, 3; 29, 1). The upraised right arm, in the case of the Louvre statue, is explained by Säflund as a heroizing reference to Hermes Chthonios and a gesture of meditation or of farewell (Säflund 1973:14–17). A related youthful, heroic Classical body, the 4th c. Hermes Richelieu type, is also frequently adapted in the Roman period (Maderna 1988:82–84, pl. 26,3) and is similar to the UPM statue in stance and arrangement of the drapery. The more active pose of the UPM body with the right arm raised, probably holding a spear or scepter, is similar to another heroic type which was also used for official Roman portraits of important figures or emperors (e.g., the 2nd c. AD portrait statue of Antoninus

Pius in the Palazzo Massimo alle Terme [La Regina 1998:98]), the so-called Cumae/Munich Diomedes, the Greek hero who lifts his right arm to ward off his attackers as he is carrying off the Palladion of Troy (Maderna 1988:56–78). While this helps to explain the derivation of the raised right arm, the leg position of the Cumae/Munich Diomedes type is the reverse of the UPM statue.

In summary, the eclectic nature of the UPM statue is such that one should not speak of a single source for the type but rather of a general quotation of various 5th and 4th c. representations of Hermes or other gods or heroes such as Diomedes or the Dioskouroi (see de Grazia Vanderpool 2000:106–16, esp.115), all of which are characterized by a youthful, athletic, heroic body.

117
STATUE OF SEATED DIONYSOS/BACCHUS WITH LION

MS 5483 (see CD Figs. 1, 44–48)
Unknown provenience, probably from Italy
Roman Imperial, 1st–2nd c. AD, with restorations of the early 17th c.
White marble
H. including plinth ca. 1.37; H. lion 0.76; H. Dionysos's head from neck break 0.26; H. plinth 0.05 at back–0.11 at front; L. plinth (front to back) 1.13; W. plinth 0.52 m.
ACQUISITION: *Purchased with funds from Lucy Wharton Drexel in 1911 from the dealer Simonetti on the Via Vittoria Colonna in Rome who had purchased the piece at an auction of the collection of the Collegio Nazzareno in Rome. The Scolopian Fathers, founders of the Collegio Nazzareno, received possession of the statue in 1622 when they inherited the Palazzo Ferratina in Rome and its collection acquired by Cardinal Michelangelo Tonti (1566–1622). (I am grateful to Dr. Olga Raggio for steering me in the right direction regarding the Collegio Nazzareno and Tonti.) See Commentary for fuller discussion of its post-ancient history.*
PUBLICATIONS: *Matz and von Duhm 1881:94, no. 359 (in courtyard of Nazzarene College, Rome); Cultrera 1911; Amelung and Arndt 1913:58, no. 2009; Hall 1913b:164–67; Luce 1921:175, no. 35; BrBr 1932: no. 745, fig. 5; Richter 1954a:27, no. 32; Furtwängler 1964:213, fig. xxxa; LIMC III,*

Dionysos: 438–39, no. 141a; Moreno 1984:21–22, fig. 3; Guide to the Etruscan and Roman Worlds 2002:88, fig. 129; Raggio forthcoming 2005: fig. 5.

CONDITION: On the lion the nostrils, left cheek, and lower jar are restored. The following are restorations to the Bacchus: the head, thumb, and forefinger of left hand; big toe of right foot; two pieces of right leg. The head shows some signs of damage (chips from the front and right side of neck at break; left eyebrow, tip of nose, locks of hair) and wear, especially visible on the hair on the upper right. The oval plinth is broken around the front edge and right side of the lion; a fragment is missing on the left side of the lion. There is a large fault in the marble on the outside of the upper right arm and a crack in the right forearm. The shoulders and back of the torso of Bacchus are eroded by water. There is much dark discoloration on the entire piece. Cuttings were made at some point in the statue's history to turn it into a fountain piece: one large and one smaller passage bored from the nape of the lion's neck through the mouth, and another large hole through the lower spine of Bacchus, now filled in, through to the broken penis. Another small hole above the genitalia, now plugged, may also have served as an outlet.

DESCRIPTION: Three-dimensional composition originally carved from a single block of marble on an oval plinth: a seated, nude Bacchus with a sejant lion to his right side.

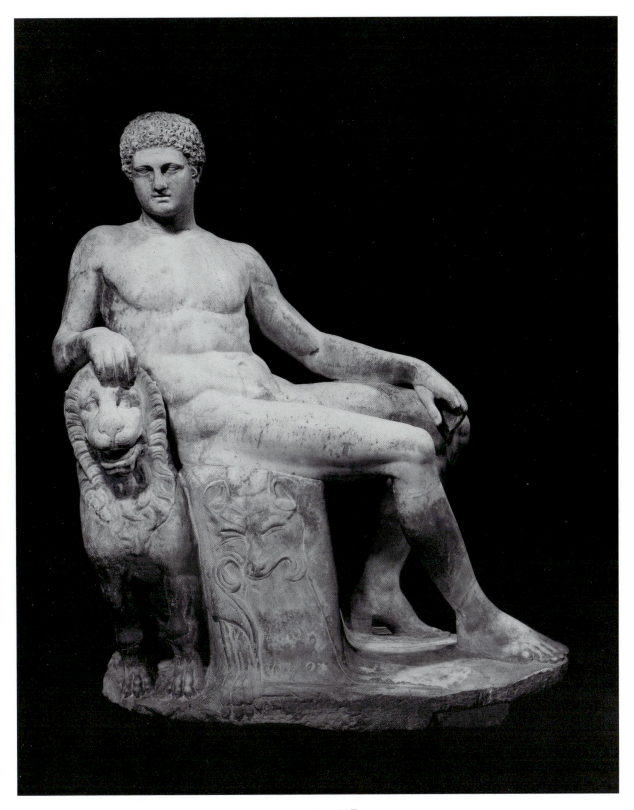

CAT. NO. 117

Bacchus sits on a rectangular block in a three-quarters right twisted pose, leaning backwards. His head and upper torso are twisted to the right, while his lower torso and legs are to the left. The right shoulder is raised and the right arm is bent with his right hand resting on a small rectangular block on the head of the lion. The left shoulder is lowered, the left elbow slightly bent, and left forearm resting on the left thigh with the left hand dangling over the side near the knee. Both legs are bent, the right in advance of the left. The right foot rests flat against the plinth, while the left heel is raised on a short block attached to the seat block. The torso is muscular. He has a deeply carved navel and exaggerated groin line. The pubic hair is roughly indicated as curls. The legs are muscular and the toes elongated.

The top surface of the rectangular block (H. 0.48; W. 0.28; L. 0.32 m.) on which Bacchus sits is sloping downward back to front. The block is covered with a garment and a feline skin, probably of a panther, the head of which appears in relief on the side of the block nearest the lion. The hind paws appear on the right and left sides of the block hanging over the edge of the plinth, while the two front paws appear flattened in relief on the top of the plinth; the tail appears flattened and in relief on the top of the plinth between the feet of Bacchus. Folds of a garment are shown on the back left side of the block.

The head of Bacchus is small and in an upright position, turned to the right and covered in short flame-like curls with much evidence of drilling; the hair has been treated or painted brown. Locks fall on the sides of the cheeks in front of the ears. The ears are elongated, the right badly modelled. His face is square with full cheeks and a rounded chin. The eyes are open and almond-shaped with sharp ridges for lids under sharply creased brow ridges. The nose has a broad flattened bridge. The lips are parted, with a deep dimple below the lower lip. The neck is well modelled.

The lion is sitting on its haunches with its front legs straight. His head is erect and turned very slightly to his left. A full mane of flame-like locks frames his face, while longer locks of the mane fall on the back and front of his neck and chest. Small ovoid ears appear free from the mane. There are no indications of hair on the rest of the

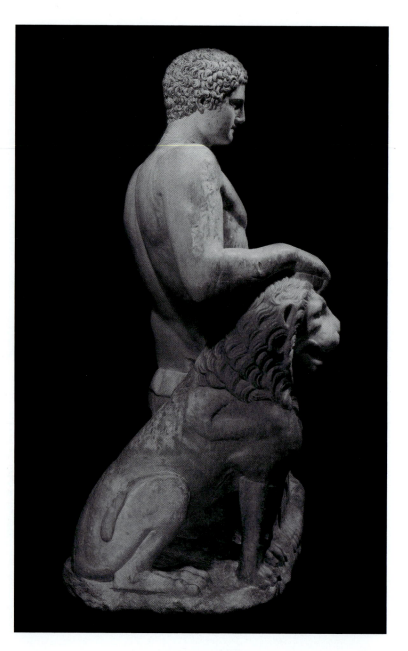

CAT. NO. 117

body. His tail is looped up over his right back haunches. Clawed feet are well developed. The oval pop eyes are set in deep sockets; incised circles for eyeballs (preserved on the left eye). The nose is broad with a groove down the center. The muzzle is restored, but the mouth is open and the skin around the side of the mouth retracted.

COMMENTARY: The head of this seated statue is not its orig-

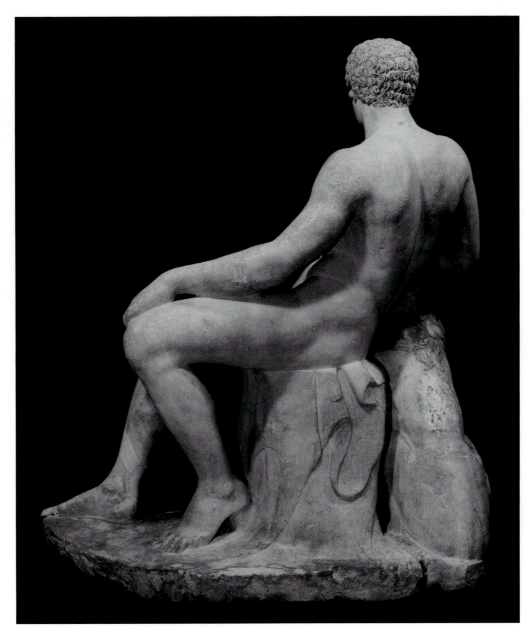

CAT. NO. 117

inal one, though it is possible that it is ancient with some recutting and "antiquing" in the 1600s, as indicated by the brown pigment on the hair and the wear on some locks of hair and crispness of others. The presence of the panther skin over the front of the seat indicates that this young god should be identified as Dionysos/Bacchus. There are only two other close examples of this statue type of Dionysos/Bacchus in this pose: (1) a statue in the Potocki collection, from Rome,

with 18th c. restorations by L. Pacetti (*LIMC* III, Dionysos: no. 141b; *BrBr* 1932: fig. 6): a short-haired Bacchus with a ram and drapery to the right side on which he leans his right arm; and (2) a now lost statue from the della Valle collection in the Uffizi in Florence, destroyed in a fire in 1762 and known only from drawings by Pierre Jacques in 1572–1577 and by Antonio Francesco Gori in 1740 (*LIMC* III, Dionysos: no. 141c; Mansuelli 1958:265, appendix no. 6, fig. 326; *BrBr*

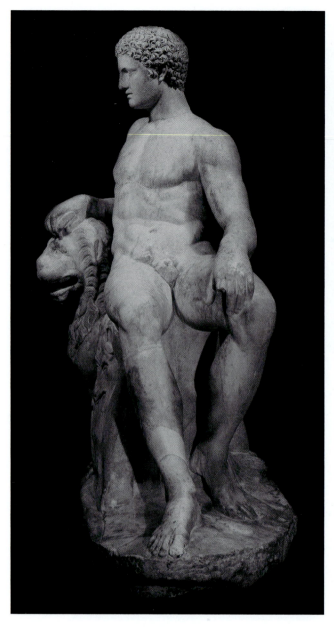

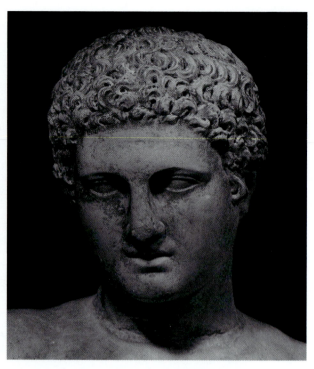

CAT. NO. *117*

1932: fig. 7; Moreno 1984:22, figs. 1 and 2). The latter shows the god with long locks (the head is restored but the locks on the shoulders may be original), seated on a rock covered with a panther skin, his body in the same position as the UPM statue, but holding a bunch of grapes in his right hand over the head of a crouching panther or lioness. The elements in common to all three images are the seated pose on the rock with the upper body twisted to the frontal plane and the legs crossed and to the left.

Although the Bacchus head of the UPM statue is restored, it is clear that there are no locks over the shoulders and, thus, that the hair of the original head was short. The panther skin over the rocky seat is very close in the UPM example and the Potocki statue. Although some doubt has been expressed (*LIMC* III, Dionysos: 438–39) that the lion of the UPM statue is original, there is no question that it was carved in one piece with the rest of the preserved statue and that only some portions of the muzzle of the lion are restorations. A variation of the theme of the seated Bacchus (with long hair) is seen in a much restored statue of the god seated on a panther in the Metropolitan Museum of Art, published first in the *Galleria Giustiniani* in 1631 (acc. no. 03.12.7; Richter 1954a:107, no. 209; Raggio forthcoming 2005).

The Potocki, Ufizzi, and UPM examples all point to an original type of Dionysos/Bacchus in repose. Gasparri (*LIMC* III, Dionysos: 439) suggests a relationship with the pose of the Pheidian Dionysos from the east pediment of the Parthenon and thus a possible 5th c. prototype, while Moreno attributes the type to Lysippos, related to the Lysippan Hermes in repose, and associates it with the bronze statue of Dionysos that Pausanias saw in the sanctuary on Helikon (Moreno 1984:21–22; Pausanias IX, 30, 1; see also Dörig 1973:125–30). There is no doubt that this statue of

Bacchus with the lion is Classicizing in spirit and style, but both of the above attributions seem extremely tenuous.

The post-ancient history of this Dionysos with the lion is an interesting aspect of the statue. Though the records in the UPM indicate that the piece was inherited by the Collegio Nazzareno in 1622 from the Duchi Caetani (Hall 1913b:164), it is now clear that it was not from any member of the Caetani family that the statue came, but rather from the collection of the Cardinal Michelangelo Tonti. The statue was in the courtyard of Tonti's palazzo on the Via Ferratina (now Via Frattina) near the Trinità dei Monti in Rome when the palazzo and its contents were bequeathed to the Collegio Nazzareno upon Tonti's death in 1622.

Michelangelo Tonti was born in Rimini in 1566 and became a financial assistant to Cardinal Camillo Borghese who became Pope Paul V in 1605. Tonti's close association with this Borghese pope brought him considerable wealth and a rapid elevation in his social position in Rome. Tonti was named an archbishop (prov. Bari) in October of 1608, and was quickly made a cardinal one month later. He is known to have commissioned the painter Antonio Carracci to complete the decoration of three chapels in S. Bartolomeo all'Isola in Rome around 1611 (Pressouyre 1984: vol. I, 114–16).

Cardinal Michelangelo Tonti had a close personal relationship with the French sculptor Nicolas Cordier, who was active in Rome and was known as "il Franciosino" (ca. 1567–1612) (Pressouyre 1984: vol. I, 114–16; *Grove Dictionary of Art* 1996, Cordier, Nicolas: 842–43). Tonti and Cordier lived in neighboring palazzi on the Via Ferratina, shared a close association with the Borghese family, and an active interest in art. Cardinal Tonti was also the godfather of Cordier's son, Giovanni Pietro Cordier.

Nicolas Cordier enjoyed a considerable reputation among Roman patrons at the beginning of the 17th c. and executed the sculptural decoration for the Aldobrandini Chapel in Santa Maria Sopra Minerva (1604–1608) and for Pope Paul V's Cappella Paolina in Santa Maria Maggiore (1609–1612), and a seated bronze statue of Pope Paul V in Rimini (1611–1614), a commission that was facilitated by Cardinal Tonti, a native of Rimini (Pressouyre 1984:296, document 197). Cordier took inspiration for much of his work from ancient and Renaissance models, while perfecting his sculptural technique in the traditional method of copying masterpieces. He chose as his ancient models sculpture that was visible in the city of Rome, like the reliefs of the column of Trajan and the Dioskouroi of Monte Cavallo that had been newly restored in 1589, and the works that were available to him in the gardens and palace of the Vatican, among which were the Apollo Belvedere, the Torso

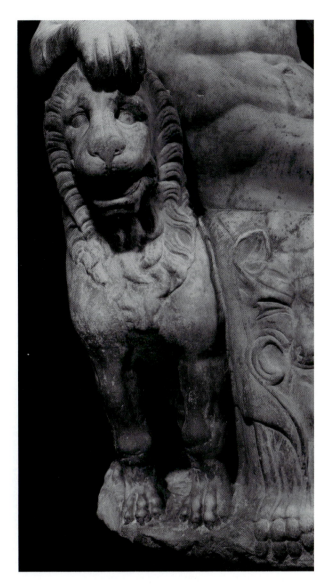

CAT. NO. 117

Belvedere, the colossal gilded bronze Hercules Victor, and the Laokoön (Pressouyre 1984:62–68). The latter group served as inspiration for figures in his Aldobrandini chapel commission (Pressouyre 1984:375–78, figs. 61–64). He was also active in Rome as a restorer of ancient sculpture, and one of his most famous restorations for the Cardinal Scipione Borghese was the heads and hands of the group of the Three Graces, sold in 1806 to Napoléon and now in the Louvre (Pressouyre 1984: vol. I, 114–16, 390–991, no. 11).

Though there is no specific evidence in the well-organized Cordier documents (though the archives of the Collegio Nazzareno, Fondazione Tonti, in Rome have not yet been

consulted), it would not be surprising if the restorations of the UPM's seated Bacchus with the lion are the work of Tonti's friend Nicolas Cordier.

Though the head of this statue has been dimissed as a post-antique addition to the statue, it seems probable that it is ancient. The signs of damage and recutting, described above, indicate that the head is probably an ancient one that was reworked to make it suitable for the seated statue. The head appears to be a Roman copy (perhaps of the Antonine period) of an idealized male type of Hellenistic date, such as a youthful Hermes of Praxitelean Andros type, of which another copy was known to Cordier, the so-called Antinoös Belvedere (*LIMC* V, Hermes: no. 950c; Bober and Rubenstein 1986:58, no. 10). The hair style is like that of a head in the British Museum from Cyrene, a possible Hellenistic ruler portrait of the 1st c. BC (no. 1383; Rosenbaum

1960:40–41, no. 11, pl. XI, 3–4; Hinks 1976:38–39), yet the pronounced drill holes and treatment of the locks seems reminiscent of that on portraits of the Antonine period (see Fittschen 1999: pls. 16–25). This restoration work would have taken place in the period between Tonti's purchase of his palazzo in Rome in 1609 (Pressouyre 1984:115, n. 124), when he began to amass his private art collection, and the death of Cordier in 1612. Though it is certainly possible that the statue was used in antiquity as a fountain piece with water pouring through the mouth of the lion (and the penis of Bacchus?), it is also possible that these modifications were carried out during the early 17th c. restoration of the piece. It was during this same period that Nicolas Cordier was engaged in creating several now lost fountain groups for the Vatican palace courtyards (e.g., Pressouyre 1984:289–90, document 163; 293, document 178; 419–22).

118
TABLE SUPPORT FRAGMENT(?): DIONYSOS/BACCHUS

MS 4027
Said to have come from Bovillae, Latium, Italy
Roman Imperial period, possibly 1st–2nd c. AD
White marble
P. H. 0.185; H. head 0.13; Max. P. W. 0.225;
 Max. P. Depth 0.125 m.
ACQUISITION: *Purchased for the Museum in*
 November 1901 in Rome from E. P. Warren
 with funds from Lucy Wharton Drexel.
PUBLICATIONS: *Bates 1912:101, no. 4; Luce*
 1921:169, no. 1.

CONDITION: Single fragment preserving head and right arm of a statuette, broken at the neck. Missing the little finger, the side of the fourth finger, chips from the right and left eyebrows, the nose, mouth, and chin. Large chip missing from wreath on the front left side at the top, and from edges of leaves on right and left sides. Some traces of dark incrustation on the arm, hand, and left side of the head. A yellowish patina is preserved on the face, arm, and hair.

DESCRIPTION: Wreathed head and right arm of a statuette of Dionysos/Bacchus. His head is frontal and tilted

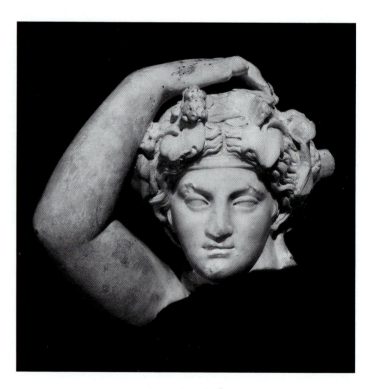

CAT. NO. 118

to his left with his right arm bent and held up with the right hand resting on the crown of his head. The hair is

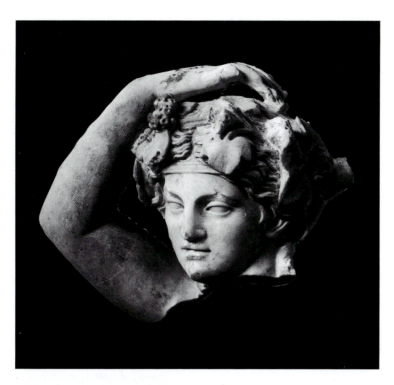

CAT. NO. 118

parted down the middle from the forehead to the back of the head in wavy strands which are separated by deep drilled grooves in the front; at the back the strands of hair are more shallowly modelled and no drill work is evident. A long strand of hair hangs down the sides of the neck on the right and left; the hair is gathered at the nape of the neck in a square chignon. The god wears a narrow fillet with horizontal striations (*mitra*) around his head, at the top of his forehead, which disappears beneath his hair and reappears at the back joining the roll of hair. He also wears an elaborately carved wreath of grape leaves and berries, part of which stands free of the head with deep drilled channels; the berries have drilled centers. At the back the grape wreath is not completed and is represented by a single grape leaf in low relief. Dionysos/Bacchus has a low forehead; small, open almond-shaped eyes with drilled lacrimal glands; thickened ridges for upper lids; flat nasal bridge; well-modelled cheeks; small closed mouth with finely drilled groove for separation between the lips; full rounded chin. The hair covers most of the right ear with only a suggestion of the right earlobe; the small left ear is half covered by the hair. A curved wisp of hair in relief appears on the right and left in front of the ear. At the left side of the head behind the ear is a circular strut

(L. 0.016; D. 0.022 m.) which projects perpendicular to the head. The right arm is well modelled and fleshy with finely carved elongated fingers; the index finger is raised slightly by a peg-shaped strut. Back of the head is not as well finished. In the bottom of the broken fragment are two modern drill holes.

COMMENTARY: Many copies of this Dionysos head type exist, with the example from Corinth among the best known (Johnson 1931:31–33, no. 25, fig. 25 = *LIMC* III, Dionysos: no. 200a). The basic body type and the gesture of the right arm over the head are thought to have been borrowed from the popular 4th c. BC Praxitelean Apollo Lykeios, but almost certainly the Dionysos/Bacchus variation of the type is an interpretation of the Late Hellenistic and Roman Imperial period (Schröder 1989). In this example, the youthful, drunken Dionysos rests his arm languidly over the top of his head which is bound with a fillet and garland of leaves and grapes or berries. The torso of this Dionysos/Bacchus type is usually nude or with a garment over the lower legs or a pelt worn diagonally across the chest. The god often leans with his left elbow on a *herm*, pillar, or some other prop (e.g., *LIMC* III, Dionysos: nos. 119–25) or with his left arm around the

shoulders of a satyr figure, as in the group in Venice (Traversari 1986:64–69, no. 21).

One interesting feature of this piece is the remnant of a strut on the left side of the head. That, together with its small size and the evidence that the back of the head is summarily treated, indicates that this head may be a fragment of a Roman table support (*trapezophoros*) in which Dionysos stands on a small base with a pillar at his back left side and probably with a satyr to his left. In fact, the theme of Dionysos with a satyr is one of the most popular for *trapezophoroi* (Stephanidou-Tiveriou 1993:96–98). See examples of this Dionysos type in Schröder 1989: nos. A13, A14, A17, A20, ranging in date from the late 2nd to first half of the 3rd c. AD; two examples from Argos in Holtzmann 1980:188–91, figs. 5–6; and Attic examples in Stephanidou-Tiveriou 1993:96–98, esp. 246–47, no. 44, pls. 20–21. For examples of the figural type of table support

from Thessalonike with other themes, such as Herakles, Eros, Dionysos, and satyrs, see Stephanidou-Tiveriou 1985. Examples are also common at Pompeii where marble tables against a wall are supported by a single large sculpted table leg (e.g., Ward-Perkins and Claridge 1978: nos. 63, 77, 113), though Moss points out that such tables also have uses in sanctuaries, in public settings, and in funerary contexts (Moss 1988:239–92).

These *trapezophoroi* with plastic supports probably begin in the Late Hellenistic period, perhaps by ca. 100 BC, but are certainly in the archaeological record by AD 79 at Pompeii and Herculaneum (see Stephanidou-Tiveriou 1993:73–76). According to Stephanidou-Tiveriou the height of their production in various centers in Asia Minor and Attica is in the mid-2nd c. AD, though by that time the fashion for these types of tables has declined in Italy where the acme of production was in the 1st c. AD.

119

HEAD OF BEARDED GOD: SERAPIS(?)

81-22-3
Probably Egypt
Roman Imperial period, 1st–3rd c. AD
Large-grained white marble with pink veins
P. H. 0.048; W. 0.03; Depth 0.037 m.
ACQUISITION: *Gift of Jay J. Dugan in 1981. Purchased in Cairo, Egypt, by Gordon McCormick between 1920 and 1928.*
PUBLICATIONS: *Unpublished.*

CONDITION: Single fragment of head broken off below the chin. Back of head partially broken. Orange discoloration on right and left lower sides. Much worn.

DESCRIPTION: Small head of bearded male god with hair parted in the middle and drawn to the sides and up. Single drilled hole in lock to right of central part. Behind locks in front, there may be the suggestion of a diadem. Top of the head is summarily treated. High triangular forehead; small, closely set hollows for eyes, possibly for inlaid pupils. Three deep drill holes for the mouth. Full beard.

COMMENTARY: Though a bearded male head of this type could represent Zeus, Poseidon, Asclepius, or Serapis, its probable Egyptian provenience suggests that Serapis is

CAT. NO. 119

most likely. For a discussion of the distinguishing features of images of the *Vatergott* including Serapis, see **89**. The deep drilling on the hair and mouth puts this head in the Roman Imperial period, though its small size, poor quality of workmanship, and worn condition prevent further analysis.

120
HEAD OF BEARDED GOD

L-29-160
Unknown provenience, possibly Asia Minor
Roman Imperial period
White marble
P. H. 0.05; W. 0.041; D. 0.04 m.
ACQUISITION: Collected by H. V. Hilprecht. Exchange
* loan with Philadelphia Museum of Art, December 1932.*
PUBLICATIONS: Unpublished.

CONDITION: Single fragment broken off at the neck. Part of left side of hair in front missing. Small chips from left eye and cheek. Much worn. Some dark incrustation and discoloration. Modern drill hole in base of neck for mounting.

DESCRIPTION: Small bearded male head from a statuette or a relief. Head turned slightly to the right. Hair is parted in center and is worn long beside the face over the ears. The curls framing the face are rendered with a deep drill in a sloppy fashion. There is the suggestion of a narrow fillet around the head. In back the hair is long and rendered in thick waves to the break. The figure has a full handlebar moustache and thick long beard rendered in tufts. The face is long and narrow with a shallow forehead; wide-open eyes; broad straight nose; flattish cheeks; thickened lower lip. Face is polished.

COMMENTARY: This very small bearded male head could be identified as any one of a group of male divinities such as Jupiter, Serapis, Asclepius, or Neptune (see **89** for a larger

CAT. NO. 120

example of the type). The lack of context for this piece (though most of Hilprecht's collecting was done in Asia Minor) and its minimal preservation make a specific identification impossible. The rather sloppy, deep drill work suggests a Roman rather than Greek date for the piece, but nothing more specific can be offered. The small scale of the piece suggests that it might have been either part of a relief, such as on a sarcophagus, or a votive statuette.

Reliefs (121-124)

121

"NEO-ATTIC" RELIEF: DIONYSOS AND PRIESTESS WITH TRIPOD

MS 4918
Unknown provenience
Late 1st or 2nd c. AD
White marble, possibly Pentelic
P. H. 0.645; W. 0.645; W. plinth 0.71; Th. 0.04 m.
ACQUISITION: *Formerly in the collection of the Duke of Genoa. Purchased by the Museum in 1913 on the advice of W. N. Bates (letter dated September 8, 1911, to Director G. B.Gordon).*
PUBLICATIONS: *MusJ IV, 4, 1913:168; Hall 1914a; Bates 1914a:416; Luce 1921:170, no. 18; Luce 1930: 320–21, fig. 3; Fuchs 1959:187, no. 3; Zagdoun 1989:91, 95, no. 352; Hackländer 1996: 82, n. 279, 87, 136, 139, 211–12, fig. 32.*

CONDITION: Mended from six fragments preserving most of the left side and bottom of the stele. Missing the lower left corner, fragments from the bottom edge, the entire top edge, most of the right side. Excellent surface preservation.

DESCRIPTION: Square panel sculpted in low relief with a composition depicting two draped figures flanking a tripod base on a pillar. The panel is carved in one piece with a ledge at the bottom which extends beyond the width of the stele on the viewer's left and on which the feet of the figures rest. The vertical edges of the panel are roughly smoothed as if not meant to be seen. The upper edge of the lower right fragment has anathyrosis, i.e., it is picked toward the back, while smoothed toward the front, and traces of an iron dowel in the broken inner edge suggest an ancient repair. The back is roughly finished.

On the front of the panel at the left side is a draped female figure, a priestess in three-quarters profile to her left standing in a mannered pose, barefooted, on her toes with her left foot in advance of the right. She wears a peplos in archaistic manner, belted with a deep overfold and with an opening on the right side of the upper body revealing the naked side of the torso. The garment folds are rendered as fine lines over the front of the upper torso, with the edges treated as zigzag swallowtail folds in archaizing fashion. The lower edge of the garment at the ankles is also treated with zigzag swallowtail folds. The female has her arms raised in front of her, holding a *taenia* in her right hand with which she is decorating a tripod. Her left hand is seen behind the tripod with the palm forward. In the middle of the scene is a pillar on a rectangular or triangular base or plinth. The pillar is topped by a torus molding with a flaring Pergamene-type capital above. On the pillar stands a three-legged vessel, a tripod with a cauldron or bowl. To the right on the panel is preserved the lower body of another draped figure, a male, standing in profile to his right with the right foot in advance of the left. The figure wears sandals, a *chiton*, and a *himation* with tassels or weights at the lower corners which hang down behind the figure. A long shaft, probably of a *thyrsos*, rest on the top right edge of the plinth. Front of panel has a fine polish.

COMMENTARY: This relief plaque with a two-figure composition represents a priestess in archaistic dress with upraised arms to the left, wrapping a *taenia* around a tripod, and a wreathed and bearded elderly Dionysos with his *thyrsos* to the right, flanking a tripod on a pillar. The meaning of Dionysos with the tripod must be an allusion to his role as the patron god of theatrical festivals and to the tripod prizes given for choregic or dramatic victories (Hackländer 1996:135–49).

This scene is replicated in relief on one side of a three-sided thymiaterion base in the Albertinum in Dresden, formerly in the Chigi collection in Rome (Cain 1985:154–55, Kat. Nr. 19, pl. 21,3). On another side of the Dresden base is a scene of Herakles carrying off the tripod with Apollo behind, while the third side shows Zeus with a priestess consecrating some object on a tall pillar (Cain 1985: pl. 21,4). We can restore the right side of the UPM relief, on the basis of the Dresden base, with Dionysos standing with his right leg forward and bent, his left arm bent with his left hand turned backwards resting on his hip, and his right hand resting on the top edge of pillar.

The priestess figure on two sides of the Dresden base and on the UPM relief is categorized by Cain as his type 3, with stylistic origins in the Late Hellenistic period (Cain 1985:134–35). Cain dates the Dresden base to the Hadrianic or Antonine period. The identical figures of Zeus and the priestess appear, along with Herakles and Apollo to the right, on two "Neo-Attic" reliefs from the Piraeus

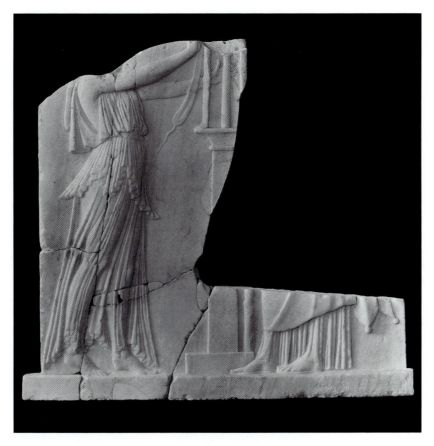

CAT. NO. *121*

(Piraeus Archaeological Museum nos. 2042 and 2118; Fuchs 1959:187, no. 4, pl. 28b). There are other replicas of this scene on "Neo-Attic" reliefs which Hackländer has collected: a possibly Late Augustan fragment in the Antikensammlung in Berlin preserving the Dionysos figure (1996: no. 71, fig. 31); a fragment in the Louvre preserving the priestess and tripod, also assigned an Augustan date (1996: no. 72; Zagdoun 1989:95, pl. 26, fig. 100); and a Hadrianic or Early Antonine fragment in San Antonio with the Dionysos figure (Hackländer 1996: no. 74). These same Dionysos and priestess figures are also repeated on other "Neo-Attic" compositions (Hauser 188:52–54).

The problem of dating these so-called Neo-Attic decorative works, like the marble relief kraters, candelabra, and plaques, is a vexing and longstanding one. Ridgway analyzes the issues and sorts out some of the problems which arise from a style which repetitively combines figural motifs with elements of the Archaic, Classical, and Hellenistic periods for decorative effect, probably using some kind of "pattern books" or templates (*Hellenistic Sculpture III*:226–40). Since so much

of the corpus of "Neo-Attic" works seems to be in Pentelic marble and so many of the prototypes for the figures are from Attic works, the logical conclusion is that Attic artists were responsible for the production. The marble kraters and candelabra from the 1st c. BC Mahdia shipwreck, which sank between 80 and 60 BC, were certainly made by Athenian artists in Greek marble and manufactured for clients in Italy; these provide the earliest closely datable examples of the "Neo-Attic" style (Grassinger 1994; Cain and Dräger 1994b). "Neo-Attic" production continues for several centuries, and the Dresden base and the Piraeus reliefs are among the latest examples of the style, dated to the mid to second half of the 2nd c. AD (for the dating of the cache of marble plaques from the Piraeus to the Late Hadrianic and Early Antonine periods, see Stephanidou-Tiveriou 1979:56–63; 183–84).

While it is certain that workshops specializing in this style existed in Attica in the 1st c. BC and into the second half of the 2nd c. AD, it is also probable that some of these Attic artists set up shop in Italy and continued the tradition there. The example in the UPM is probably part of the production of the late 1st (Flavian) or early 2nd c. AD, and could be as late as its closest parallels, the Dresden base and the Piraeus reliefs (late Hadrianic or Early Antonine period). Hackländer (1996:211–12) dates the relief stylistically to the Flavian period and compares the technical details of the handling of the drapery to the Cancelleria reliefs.

The use of these so-called Neo-Attic plaques is not entirely clear. Like other objects in the "Neo-Attic" production that were made for the Italian market, such as candelabra and marble vessels, their function seems to be purely secular—decoration for the villas of wealthy clients in Italy. Yet, scenes such as this one with religious overtones, and the fact that reliefs from Greek contexts repeating these same figure types were used for the decoration of altars or bases from sanctuaries like the Athenian Acropolis and Epidauros (see, for example, Sauter 2002 for the reconstruction of an altar at Epidauros; and Kosmopoulou 2002:211–15 for two bases from the Acropolis and its vicinity) suggest that we cannot exclude some religious function in shrines or sanctuaries in Italy.

122

HEAD OF HELMETED LEGIONARY FROM HISTORICAL RELIEF

54-3-1 (see CD Fig. 49)
Said to have come from Rome
Roman Imperial period, Late Domitianic period (ca. AD 90–96)
Pentelic marble, highly micaceous with greenish veins. Samples taken for stable isotopic analysis, February 2006. Results of analyses from Dr. Scott Pike: $\delta^{13}C$ 3.01, $\delta^{18}O$ -7.89 (Pentelikon).
P. H. 0.355; H. head from top of cap to bottom of beard 0.19; H. face from edge of helmet to chin 0.134; P. W. head 0.142; P. Depth 0.13 m.
ACQUISITION: *Collected by Robert Hecht in Rome; purchased by the Museum from Hesperia Art in Philadelphia in 1954 for $200.*
PUBLICATIONS: *Vermeule 1965:111; Of Time and the Image 1965: no. 3; Guide to the Etruscan and Roman Worlds 2002:48, fig. 69.*

CONDITION: Single fragment preserving three-quarters of head on right side with helmet to near top of crest. Back left side is broken off preserving some traces of ancient mortar with predominantly red and black inclusions. Proper left side of face from middle of left eye and edge of mouth is evenly broken off along a vein, perhaps deliberately, with significant deposits of ancient mortar. Back of proper right edge of helmet broken off along a vein; back of cap is broken off, partially through a vein, while the left side of the lower crest and crown of the helmet have been summarily finished with a fine claw chisel. The nose is partially broken; front of feathered plumes broken off. Minor chips, e.g., on right eye, and scratches. Dark reddish-brown iron stain on top lip.

DESCRIPTION: Three-quarters lifesized male head in high relief wearing a *galea*, a tall feather-crested helmet. Helmet sits low on forehead; strong brow ridge with open eyes deeply set, right eye more deeply than the left; thick rounded upper eyelid, overlapping the lower; finely indicated lacrimal gland; prominent nose with small drilled nostrils; high cheekbone on right; asymmetrical mouth is slightly open with teeth indicated; corners of mouth drilled. Figure has a full short beard with bushy moustache blending with tufts of beard over right jaw and chin. A wide cheek strap covers part of the right side of the face and beard, and tapers under the chin; it is decorated on the side with a floral frond in low relief with three spiraling appendages which have drilled centers. At top of strap are three raised bosses with drill holes

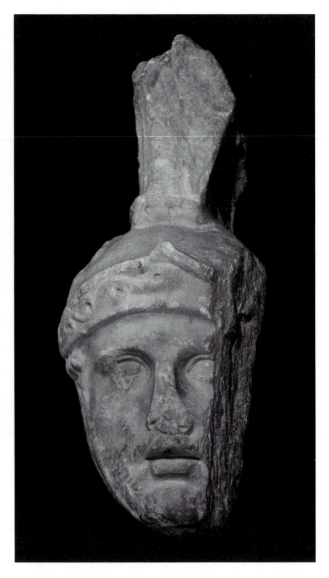

CAT. NO. 122

evident above and below. Finely sculpted ear, deeply drilled around the perimeter. The helmet consists of three parts: the peaked visor; the *calotte*; and the crest. The peaked visor is decorated in low relief with a wave pattern of five spirals with drilled centers. On the right side of the *calotte* of the helmet is an emblem in low relief of the foreparts of a crudely sculpted bearded goat (capricorn). The crest has a low base, narrow in front, with a series of partially drilled holes on the front and right side. A series of plumes or feathers rises from the base, each individually rendered with a central spine and ridges to right and left. The feathers bend over at the tips. At the top of the crest is a thick raised spine.

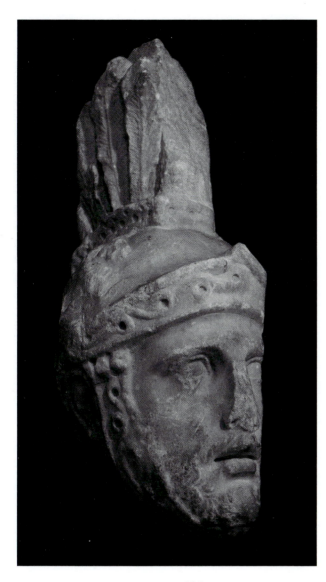

CAT. NO. *122*

COMMENTARY: The scale and theme of this relief fragment of a helmeted Roman legionary immediately suggest its association with some Roman historical monument. At first glance the head seems related to the many Roman soldiers wearing Attic-style plumed helmets on the so-called Great Trajanic Frieze from Rome. These eight relief panels (each 2.98 m. high), joined in pairs and reused in the Arch of Constantine, depict scenes of battle between Dacians and Romans, as well as a scene of the *adventus* of the emperor. The relief frieze is generally thought to commemorate the Roman conquests under Trajan of the Dacians in the First (AD 101–102) or Second (AD 105–106) Dacian Wars, the events also recorded in the reliefs on the Column of Trajan. While it is agreed that the reliefs belong to the Trajanic period (see Leander Touati 1987:91–93), it has been debated where the original monument stood in Rome and what form it took. Various locations in the imperial fora have been suggested. Leander Touati 1987:85–90 suggested that the blocks are part of an over 41 m. long frieze that decorated the attic of the east colonnade of the Forum of Trajan, while Kleiner argues that it decorated a wall inside the porticoes of the Forum (Kleiner 1992:220–23). Most recently, Packer (1997:113, 147, fig. 88, 445) has convincingly shown that the frieze belongs in the attic on the north façade of the Basilica Ulpia with pilaster separating each panel.

There are a number of relief fragments that have been associated with the "Great Trajanic Frieze," and thematically, stylistically, chronologically, and in scale (Leander Touati 1987:96: head heights range from 0.27 to 0.33 m.; height of the faces are from 0.18 to 0.22 m.) the UPM's Roman legionary's head is generally close to those on the frieze and many of the associated fragments. If Leander Touati is correct, however, in identifying the marble of the "Great Trajanic Frieze" as from Carrara (white and fine-grained with abundant gray veining [1987:83]), our legionary's head cannot be directly associated with the Frieze. The marble of our head is certainly Pentelic, with its characteristic greenish, micaceous veins and laminated breaks. In addition, there are important differences in the details of the head, especially the treatment of the faces. While the eyes of the figures on the Frieze are characterized by bulging forms and heavy, thick lids (Leander Touati 1987:113), ours are much more restrained with thin lids and a less prominent brow. Our soldier would seem much more at home in a ceremonial scene than in battle. Our face is notable for its idealized, detached air, while the majority of the figures in high relief on the Frieze display an intensity and a troubled expression with furrowed brow appropriate for soldiers in the midst of battle.

In an examination of the corpus of Roman historical reliefs of the general time frame of the late 1st or early 2nd c. AD for comparable fragments of Pentelic marble (Koeppel, *Historischen Reliefs II*, 1984:38–64; Koeppel, *Historischen Reliefs III*, 1985), one group stands out as closely comparable to the UPM's legionary head, the so-called Hartwig-Kelsey Fragments (*Dono Hartwig* 1994; Koeppel 1980; Koeppel, *Historischen Reliefs II*, 1984:13–15; 51–61, nos. 20–27; Gazda and Haeckl 1996). Fifteen fragments that form this group were found in 1900–1901 north of the north arm of the exedra of the Baths of Diocletian, and are divided between the Museo Nazionale Romano in

Rome and the Kelsey Museum at the University of Michigan. These Pentelic marble relief fragments are consistent in style and scale (head sizes between 0.155 and 0.195 m.), and are dated by Koeppel to the Late Domitianic period. They include a head of a *flamen* or priest wearing a spiked cap against a low-relief backdrop of a temple, a bull, two idealized heads, perhaps Victoria and the *Genius Populi Romani*, a head of Vespasian, two male caryatid figures, various entablature fragments, and fragments of two soldiers.

The monument to which these fragments have been assigned is the *Templum Gentis Flaviae*, a now-destroyed sanctuary to the Flavian dynasty built by Domitian in the 90s on the Quirinal Hill which also served as the mausoleum where members of this dynastic family were buried, including Domitian himself, his daughter Julia, and possibly Vespasian and Titus (Suetonius, *Dom.* 17.3; Martial 9.35.8; Stat., 5.I.237–41; Torelli 1987; Koeppel 1980; Gazda and Haeckl 1996:26–28). For a discussion of the location of the *templum* see Hartswick 2004:142–46. The fragments have been reconstructed by R. Paris in two relief panels, one with a scene of a sacrificial procession in front of a temple (the Temple of Quirinus), and the other an episode depicting the *adventus* to Rome of Vespasian as emperor in AD 70 (Gazda and Haeckl 1996:26–29). While stylistically the fragments compare well with the relief sculptures from the Arch of Titus (Gazda and Haeckl 1996:31–32), built by Domitian to honor his deceased brother, there is certainly a difference in tone in the treatment of the two monuments, both of which may commemorate the suppression of the province of Judaea. The theme of the arch's relief panels is Titus's colorful and exuberant return to Rome in AD 71 with the spoils of Jerusalem, while the reliefs of the *Templum Gentis Flaviae*, as far as we can tell from the limited number of fragments, are more formal and restrained in tone, with the reference to the province of Judaea subtly enunciated in the draped male caryatid figure leaning against a date palm tree, perhaps a personification of Judaea. The use of lavish, imported Pentelic marble for the sculptures of both monuments links them to two other Domitianic monuments dedicated to the deified Flavian emperors: the Temple of the Deified Vespasian and the Temple of Jupiter Optimus Maximus on the Capitoline (see Gazda and Haeckl 1996:17–18 for a discussion of the symbolism of the use of Pentelic marble).

Two soldiers are associated with the Hartwig-Kelsey Fragments, both of whom are in three-quarters or full profile looking to their left (Gazda and Haeckl 1996: nos. 7 and 10). They are restored to the right of Vespasian in a scene of the *adventus* of the emperor. If the UPM head is

part of this monument, it should also be placed to the viewer's left side of a panel, with the central action or focal point of the scene to the right of the soldier (Gazda and Haeckl 1996:28). The restrained air of the UPM's legionary is appropriate for the somewhat conservative, religious tone of the decorative program of this imperial funerary monument (Gazda and Haeckl 1996:31). The specific details of the eyes, discussed above, the slightly open mouth with the teeth indicated, the treatment of the beard with tufts of curls on the chin and wisps of hair on the cheek next to the cheek guard, and the drilled outline of the ear mirror closely one of the soldier heads of the Hartwig-Kelsey Fragments (Gazda and Haeckl 1996:50, no. 7). Finally, the Hartwig-Kelsey Fragments share with the UPM fragment incrustation of ancient mortar (*pozzolana?*) from their secondary use (see Koeppel, *Historischen Reliefs II*, 1984:14).

The Attic plumed helmet of our legionary was probably not actually worn in battle, but the type is depicted in battle scenes on historical reliefs, as on the "Great Trajanic Frieze" (see Leander Touati 1987:52). The symbols of the capricorn, seen in relief on the cap of our soldier's helmet, and the laurel wreath on the helmet of one of the soldiers of the Hartwig-Kelsey Fragments (Gazda and Haeckl 1996: no. 10) may be iconographic details that carry part of the message in the *adventus* scene. Leander Touati (1987:46–47, 54–55) cautions that one cannot read too much specifically into the emblems on the helmets and shields of the soldiers in the "Great Trajanic Frieze," and suggests that the variations in the costumes and their details are meant more generally to evoke the opulence of the Roman camp. On the helmets of the soldiers on the "Great Trajanic Frieze" the variety of decoration includes spiral scrolls, five-petal corollas, dolphins, laurel wreaths, crossed shields, and an eagle, while scorpions, winged thunderbolts, and scrolls appear as shield emblems (Leander Touati 1987:45–46). One might think, however, that in the more conservative decorative program of the *Templum Gentis Flaviae*, where religious or ceremonial occasions as opposed to military events are depicted, specific details might be critical to give meaning to each of the figures. The laurel wreath (on the Hartwig-Kelsey Fragment) is not an emblem that is known to be associated with a particular Roman legion, but, rather, it is a general symbol of victory. The capricorn emblem is associated with a large number of Roman legions, especially those founded by Augustus whose zodiac birth sign was capricorn, and include the following: I Adiutrix, II Augusta, II Italica, III Augusta, IV Macedonia, XIV Gemina, XX Valeria, XXII Primigenia, and the XXX Ulpia (LeBohec 1989:262–63). None of these is among the six legions garrisoned in Syria and Judaea during the Flavian period

(Webster 1998:47, n. 1), though several of them were stationed in Germany under Vespasian, Titus, and Domitian. Legio I Adiutrix was moved from Germany to take part in the Dacian campaign by Domitian and was involved in the decisive Roman victory at Tapae in AD 88 (Webster 1998:52, n. 2). Until more is pieced together of the sculptural program of the *Templum Gentis Flaviae* little more can be concluded from the emblem on the UPM fragment.

An unequivocal association of the UPM's legionary's head with the Hartwig-Kelsey Fragments and the *Templum Gentis Flaviae* is hampered, of course, by the lack of a secure provenience for the piece. We have only the information from the dealer that it came from Rome. It is, in addition, troubling that the head came to light as late as 1954, and that it is possible that the fragment was uncovered in the chaos of World War II and its aftermath.

123

HONORIFIC INSCRIPTION/RELIEF FRAGMENT FROM COMMEMORATIVE MONUMENT

MS 4916 (see CD Figs. 3, 50, 51)
Puteoli (Pozzuoli), Campania, Italy
Roman Imperial period; inscription: Domitianic period:
 AD 95–96; relief: Trajanic period (ca. AD 102)
Fine-grained (><1–2 mm.) white marble with gray
 patches and streaks, possibly Paros/Chorodaki. Stable
 isotopic analysis by Dr. Norman Herz, U. of Georgia
 (report May 14, 2004): $\delta^{13}C$ *2.79 ±0.05;* $\delta^{18}O$
 –1.43 ±0.06 (Marmara 92%; Paros/Chorodaki
 64%; Carrara 51%).
H. 1.62; W. 1.145; Max. P. Th. 0.285; W. viewer's
 right edge facing relief 0.22; W. viewer's left edge
 facing relief 0.18; Max. L. inscribed lines 0.97; H.
 letters 0.05 (at bottom row) –0.11 (top row) m.
ACQUISITION: *This block was discovered in fragments*
 around 1908 by Sig. Pasquale Elia while digging in the
 foundations of his house in Pozzuoli, ca. 150 m.
 southwest of the amphitheater. The Director of the
 Museum, G. B. Gordon, approved the purchase of
 the piece in 1908; it was bought in 1909. Archival
 records indicate that the relief was purchased for
 $1,390.89 through Lamont Young, a friend of
 archaeologist Leonard Woolley and of the property
 owner.
PUBLICATIONS: *Gabrici 1909:212–15; Bates 1910a:*
 391; Bates 1912:101, no. 6; Reinach 1912:208, no.
 2; Hall 1913a:142–46, figs. 125–26; Bates 1914b:
 526, fig. 2; Sieveking 1919:1–9; Luce
 1921:171–72, no. 20; Cagiano de Azevedo
 1939:45–56; Magi 1945:84–85, 163; Kähler
 1951:430–39, pls. 27–30; Vermeule 1964:109;
 Museo della Civiltà Romana Catalogo 1964:

198–99; Matthews 1966:30–36, esp. 34–36; Rotili
1972:63–64, figs. 59–60; AE 1973:137 = AE
1941:73; Vermeule 1981:231, no. 192, pl. 19;
Introduction to the Collections 1985: 39, fig. 22;
Kleiner 1983:72–73, 86, pls. XLIII, b, XLIV, a;
Leander Touati 1987:55, 120; De Maria 1988:
256–57, pl. 36; Keppie 1991:22; Kleiner 1992:
229–30; Zevi 1993:94–95; Kinney 1997: 143–44,
figs. 17–18; Knittelmayer and Heilmeyer 1998:
211–12, no. 127; Flower 2001; Guide to the Etrus-
can and Roman Worlds 2002:45–47, figs. 67–68.

CONDITION: Block joined from three large horizontal fragments: one large central fragment; one smaller fragment cut across the top through the heads of the figures; and a third fragment forming the bottom of the block. A fourth fragment (L. 0.13; W. 0.067; Max. Th. 0.05 m.) joins at the lower right edge on the inscription side. On the inscribed side of the block the top right and left and bottom right corners are broken off.

On the relief side of the block fragments are broken off the top edges. Large wedge-shaped surface fragment missing from (viewer's) lower left edge with crack emanating from corner of wedge, across lower leg of figure to vertical frame near center. Lower part of vertical frame and molding at center has surface broken off. Figure at viewer's left is cut in half by the edge of the block, but figure is also missing face, lower leg, foot, and part of spear. Figure in high relief to viewer's right has a badly worn face and head, especially on left side; chin is broken off; fragment missing from top center of head. Right forearm, hand, and vertical object he held are missing, preserving only the knobby attachment

CAT. NO. 123: *Side A*

struts of the vertical object above the right arm, below the right arm at the tip of the sheath of the sword, and on the lower part of the background. Chip missing from drapery below right armpit and top of sword pommel. Drapery on front, especially on upper body, is much worn; breaks on garment over left knee. Left lower leg and right foot are missing, along with bottom and right lower corner of panel below the feet of the figure.

DESCRIPTION:

SIDE A: INSCRIPTION. The inscription was originally framed on all sides by a molding (H. at top 0.103; P. W. right side 0.06–0.063; W. left side 0.084–0.085; H. bottom 0.09 m.), consisting of a flat frame on the outside, with a *torus* and a *scotia* inside of it. This molding is cut down to 0.02–0.025 m. in width on the lower part of viewer's left edge, while the right edge is broken off for most of its length. At the inside edge of the molding all around the frame is a decorative smoothed zone (W. 0.03 m.). The surface of the inscribed block was carefully treated with a fine claw chisel, still visible in areas not erased.

The block has finished edges on the bottom and sides. There is a square dowel cutting (ca. 0.025 m. deep and 0.05 m. square) in the bottom surface, toward the left side of the panel. In the top a division is created down the middle of its length with a smoothed dressed surface on the half toward the relief and a higher roughened surface on the half toward the inscription. The top of the block has several ancient cuttings, including a deep rectangular one (0.09 x 0.058 x 0.10 m. deep in the center), abutting this dividing edge on the dressed side; a pour channel from the cut from the inscription edge toward this central cutting. In the dressed half of the top surface are three smaller, more shallow cuttings (0.03 x 0.021 x 0.02 m. deep; 0.028 x 0.028 x 0.03 m. deep), ca. 0.11 m. from the right and left ends of the block. Closer to the left edge of the top of the block, facing the inscription side and abutting the dressed dividing zone, is a square dowel cutting with traces of iron (0.028 x 0.028 x 0.035 m. deep). These cuttings are all related to securing a block above which must have been half the thickness of the UPM block and set over the half facing the relief.

The inscription in eleven lines was carefully erased by deep and broad diagonal and horizontal chisel strokes. The height of the letters varies from ca. 5 cm. on the bottom row to 11 cm. at the top. Slanted acute accent marks (*apices*) are still visible in the interstices of the lines above certain long vowels. The erased inscription is transcribed as follows (Matthews 1966:35 and Flower 2001:629):

IMP CAESARI

DIVI VESPÁSIÁNI F

DOMITIÁNÓ AVG

GERMÁN PONT MAX

TRIB POTEST XV IMP XXII

CÓS XVII CÉNS PERPET PP

COLÓNIA FLÁVIA AVG

PVTEÓLÁNA

INDVLGENTIA MAXIMI

DIVINÍQVE PRINCIPIS

VRBI EIVS ADMÓTA

The translation reads (Flower 2001:629):

> To the Imperator Caesar Domitian Augustus Germanicus, son of the deified Vespasian, high priest, in the fifteenth year of his tribunician power, imperator for the twenty-second time, consul for the seventeenth time, perpetual censor, father of the country, the Flavian Augustan Colony of Puteoli [dedicates this] having been moved closer to his city by the indulgence of the very great and divine leader.

SIDE B: RELIEF. After the inscription was erased and the monument of which it was a part disassembled, the opposite side of the block was reused for another monument and carved in relief with Roman soldiers. The panel has parts of three figures preserved: two on the viewer's left half in lower relief and one on the right in high relief, separated by a vertical frame consisting of a projecting right-angled member (D. 0.04 x W. 0.04 m.), with a raised molding (W. 0.046 m.) abutting it to the right (*torus* and *cyma reversa*), which curves into the background to the right. A flat ledge encloses the relief panel on the top (H. 0.048 m.), and the feet of the figures rest on a ledge which is 0.05 m. wide below the left figures, but 0.13 m. wide on the viewer's right where the depth of the carving is greater.

On the edge to the viewer's right the surface has been smoothed, and there are three small drill holes, probably modern for a mounting device. A shallow channel

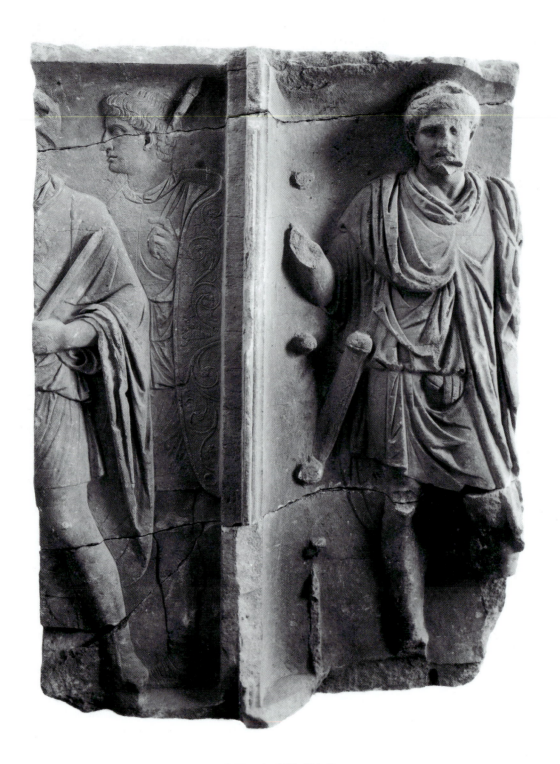

CAT. NO. 123: *Side B*

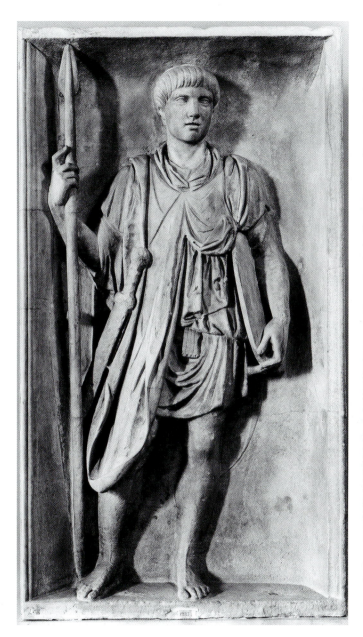

Fig. 9. Marble block joining UPM Puteoli block (123) in the Staatliche Museen, Berlin (SK 887). Photograph courtesy of the Staatliche Museen zu Berlin, Antikensammlung.

Fig. 10. Viewer's left side of Puteoli marble block in the Staatliche Museen, Berlin (SK 887). Photograph courtesy of the Staatliche Museen zu Berlin, Antikensammlung.

(ancient) (L. 0.14 m.) has been drilled from near the top edge toward the inscription side of the panel. The back edge (toward the inscription side) is broken near the top where the two large fragments are joined. The bottom edge of this face is broken off irregularly. On this right side another block (Figs. 9–10), now in the Pergamon Museum in Berlin, was attached at a right angle, on which the left arm and left foot of the figure and the frame were carved.

On the edge to the viewer's left a 0.08–0.09 m. wide band is smoothed at the front edge (relief side) down the length of the side. A 0.03–0.04 m. wide zone down the middle of this face is treated with a rasp or claw chisel. The

back half of this face (toward the inscription) is roughly picked and irregular. There are vague suggestions of letter forms in this roughly picked zone, but no specific letters or words can be identified. Another block (the thickness of the smoothed band and the chiseled and rasped zone or between 0.11 and 0.13 m.) would have joined to this left side to complete at least the one figure marching to his right.

One half of the figure to the viewer's left is preserved in relief. He marches to his right with his head in profile. He wears a short *tunica* and a *paenula* over his shoulders with the excess draped over his bent left arm. He holds his spear (*hasta*) in his left hand which leans against his left shoulder, passes in front of the back of the head of the figure behind him, and ends at the top frame. He wears on his feet heavy sandals or *caligae*, with a bundle of straps tied above the ankle.

In back of the left figure marches another figure in very low relief. His body is in three-quarters frontal position, while his head is in profile facing to his right. He is beardless and has longish wavy hair that is brushed forward to his brow and bound by a narrow band below the crown. He wears a short tunic and a cloak. His left arm is bent and he holds the looped strap of his shield by his left index finger, while a large oval shield (*scutum*) decorated with an elegant floral anthemion with a scorpion in low relief in the center is slung over his back left side. He also wears *caligae* on his feet.

On the viewer's right is a figure in high relief facing frontally with his right leg straight and his left bent slightly and pulled to the side. His right arm is bent and he holds a spear vertically, which is now largely broken off. The adjoining Berlin block shows that his left arm is down supporting a small oval shield (*palma*) at his left side (see Fig. 10). A sword (*gladius*) in its scabbard hangs from a strap over his right shoulder. He wears a *tunica*, a hooded *paenula*, and a *cingulum* or military belt in front. There is extensive use of the drill in defining the deep folds of the garments. He is beardless and has a short hairdo with the locks brushed from the top of the head forward along the forehead, with the locks thicker on the right side. The better-preserved right eye has a semi-circular depression for the iris. The ears are deeply drilled. The mouth is drilled at the outer corners. The background curves in deeply from the central frame to the right of the figure, a device to mask the transition to deeper relief.

COMMENTARY: As a rare legible inscription honoring Domitian, erased following his *damnatio memoriae*, and as a fragment of a Roman historical relief from a Trajanic monument, the Puteoli block is perhaps the most important object in the UPM's corpus of classical stone sculpture. It has deservedly received much attention, with the fullest treatments by Cagiano de Azevedo (1939), Kähler (1951), Matthews (1966) and, most recently, by Flower (2001). While referring the reader to Flower (2001) for an excellent discussion of the historical importance of the inscription and *damnatio memoriae*, this commentary will summarize some of the key points and focus on the sculpted side of the block, on some of the iconographic details which provoke questions, and on the nature of the Trajanic monument of which the relief was a part.

The Inscription

The inscription honors Domitian for a good deed for the city of Puteoli on the Gulf of Naples, and specifically for "having moved" Puteoli closer to Domitian's city of Rome. It is reasonable to conclude that the last line of the inscription refers to the Via Domitiana which Domitian is credited with completing in AD 95, linking Puteoli to Sinuessa, and thereby with the Via Appia, thus "moving" Puteoli into closer communication with Rome. The contemporary Statius extolls the virtues of this road and describes its construction in his poem, "Via Domitiana" (*Silvae* IV.3) (see Flower 2001:633, n. 46 for the date of the inauguration of the road and the date of Statius's poem). Significant fragments of the Via Domitiana have been uncovered in the western part of Puteoli (see Zevi 1993:94–95, esp. Fogli V and VI).

The inscription can be very closely dated from the titles listed. The most conclusive evidence for the date comes from the reference to Domitian holding the power of tribune for the fifteenth year, i.e., the fifteenth year of his reign, from September of AD 95 to September of AD 96. Domitian was assassinated in a palace coup, apparently with the knowledge and collusion of two prefects of the Praetorian Guard (see Jones 1979:46–48), just as he was beginning the sixteenth year of his rule, on September 18, AD 96. Almost immediately the Roman Senate voted to condemn Domitian's memory (*damnatio memoriae*) by removing all public traces of his rule, such as statues of him or inscriptions honoring him, and to deny him posthumous deification. The monument of which this erased inscription was a part was probably disassembled late in the year AD 96 as a result of the declaration of *damnatio memoriae*. The inscription in its original state was, therefore, visible for just one year. Flower makes the excellent suggestion that the carefully erased inscription and the monument of which it was a part (a statue of Domitian, she presumes [2001:627, 629]) were on view for some time after Domitian's *damnatio memoriae* as a public reminder of his disgrace (2001:629).

There are, regretably, no other positively identifiable traces of this Domitianic monument, and its nature is uncertain (see below p. 264 for references to fragments of an arch to the south of the amphitheater). That this somewhat narrow

inscription block (0.285 m.) itself formed a base for a statue is improbable, although we can assume that the thickness of the original block must have been reduced at least slightly when the block was recarved as a relief. The cuttings in the top and bottom of the block, unfortunately, do not provide any specific clues to the monument, for it is not exactly clear with which phase of the use of the block all the cuttings belong. It is evident, however, that the cuttings on the top cannot be made compatible with the setting of a statue of bronze or of marble on a plinth. The inscription may have been built into the façade of a larger monument, like an arch over the Via Domitiana or a monument crowned by a statue of Domitian. In this case, one would expect some kind of attachment devices on the back side which one would have to assume were obliterated by the relief carving.

The Relief

After the erasure of the inscription the marble block was reused and cut as a relief on the *verso*. The relief scene depicts three soldiers, one in high relief to the viewer's right, divided by a vertical molding from two to the left, one in low relief and one in high relief cut in half by the left edge of the block. A sculpted marble block in the Pergamon Museum in Berlin (see Figs. 9–11) joins at the viewer's right edge at a right angle turning back toward the inscription side (Sk 887; H. 1.59; W. 0.86; Th. 0.12 m.) (Sieveking 1919; Knittlmayer amd Heilmeyer 1998:211). The Berlin block was uncovered at Puteoli in 1801 in a context which is unclear and acquired by the Berlin Museum in 1830. It is a narrower block

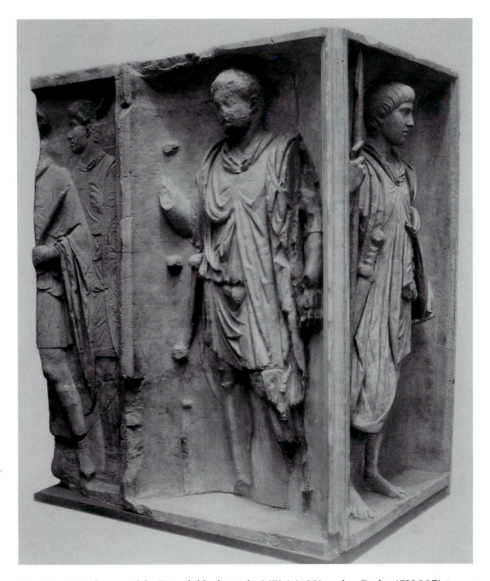

Fig. 11. Joined casts of the Puteoli blocks in the UPM (123) and in Berlin (SK 887) in Museo della Civiltà Romana, EUR, Rome. Photograph courtesy of Museo della Civiltà Romana, EUR, Rome.

than the UPM one (less than half the thickness), with a frame on the right and left front edges, and depicting in high relief another soldier in a frontal position wearing a *tunica*, a *paenula*, a *cingulum militare*, and *caligae*, with a *gladius* hanging at his right side, holding a spear at his right and a small oval shield, a *palma*, at his left side (Fig. 9). Casts of the UPM and Berlin blocks were made and assembled in Rome for the Mostra Augustea della Romanità in 1938, and for many years the casts were displayed in the Museo della Civiltà Romana in EUR, Rome (Fig. 11).

Though the casts are no longer on display and the two pieces have been disassembled, the important old photographs of the casts show the relationship between the two fragments.

Date of the Relief

It has rightly been observed by most scholars in discussion of the Puteoli relief that the date of the sculptured decoration can be pinpointed to the Trajanic period from the hairstyle of the figure on the Berlin block (Fig. 9) which imitates closely the hairstyle of Trajan himself (e.g., Kleiner 1992:229). The UPM relief has also often been compared stylistically to the Cancelleria reliefs in the Vatican, especially Relief A with a scene of the *profectio* or *adventus* of Domitian, dated to the Domitianic period with some recarving of Panel A in Nerva's reign. Specifically, the handling of the garments of the soldiers is very close, and the hairstyle of the head in very low relief on the UPM's relief can be paralleled by that on figures on the Cancelleria reliefs (e.g., Magi 1945: pl. II, two background figures, pl. XIII, left figure). Kähler thought that the Puteoli reliefs and the Cancelleria reliefs may even have been made in the same workshop (1951:437–38). The Cancelleria figures certainly share with those on the Puteoli reliefs small heads and a generally elegant, Classicizing style, though the two boldly frontal heads on the Puteoli Berlin and UPM blocks are a departure from the heads on the Cancelleria reliefs which are all in profile. The Cancelleria relief figures (H. of block 2.06 m.; average H. of figures 1.65 m.: Koeppel, *Historischen Reliefs II*, 1984:28–34) are slightly larger than the Puteoli figures (H. figure in high relief 1.46 m.; H. middle figure 1.43 m.). The dowel holes on the back of the Cancelleria reliefs suggest that these were attached as a decorative façade, probably to some major Flavian monument (Kleiner 1992:192).

Iconography and Message

The soldiers on the Puteoli reliefs are shown standing or processing, wearing only part of their military costume. They lack helmets and armor, but carry swords, spears, or shields; two wear the *cingulum*, and they all wear *caligae*, the typical heavy-soled, hobbed-nailed, strapped sandals of the Roman military. The fact that these soldiers are bareheaded and without their full military panoply allows an interpretation of the scene as one of procession, an occa-

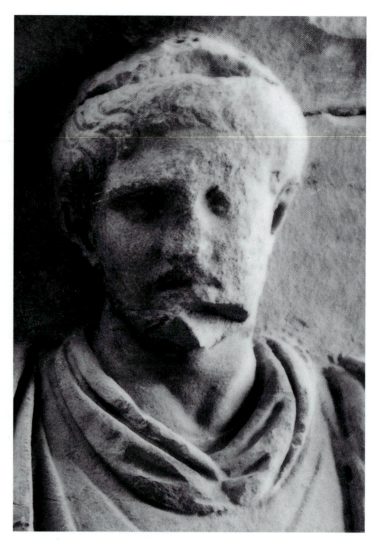

CAT. NO. 123 *(detail)*

sion of ceremony, rather than a march to or from battle. Leander Touati in her discussion of the "Great Trajanic Frieze" (1987:52) suggests that when soldiers are depicted in the *urbs* itself they are without helmets, artistic conventions that may have been borrowed from reality and the prohibition against wearing arms within the *pomerium*. This convention also signals the difference between a scene of warfare and a peaceful, ceremonial occasion, like one of *adventus* or *profectio*.

The elegant floral decoration on the shield of the UPM's Puteoli relief includes a scorpion, a symbol that is recognized as that of the Praetorian Guard and the birth sign of Tiberius, who established the camp of the Guard on the Viminal in Rome (Durry 1938:205, 213–14, 361–65). Can we then

CAT. NO. 123 (details)

assume, therefore, that all four of these soldiers on the Puteoli fragments should be understood as Praetorians? Koeppel, in his discussion of the "Great Trajanic Frieze," where the scorpion emblem appears on the cheek pieces of six cavalry men, two foot soldiers, and once on a shield carried by a foot soldier in mail (Leander Touati 1987: no. 83), argues that all of the many soldiers depicted on that relief are Praetorians, but Leander Touati shows that the details of all the soldiers are not consistent with this interpretation (Koeppel, *Historischen Reliefs III,* 1985:152; Leander Touati 1987:45–56). The array of soldiers presented in the "Great Trajanic Relief" is complex, pointedly so according to Leander Touati, and is meant to emphasize the opulence and impressiveness of the Roman military (1987:46–47, 54–55).

So, since we have only two fragments of the Puteoli monument, one should be cautious in assuming that all of these soldiers should be understood as Praetorians.

The relationship of Domitian to the Praetorian Guard was a complex one. Although he may have added a tenth cohort to the nine founded by Augustus and is credited with increasing the annual pay of the Praetorians from 750 to 1,000 denarii (*OCD*[2] 1970:873–74), the two prefects of the Praetorians were involved in his assassination (see Jones 1979:46–48). Despite being aware of the assasination conspiracy and having been chosen in advance to be Domitian's successor, Nerva was forced in his reign (in AD 97) to quell the mutiny of the Guard under Casperius Aelianus during which two of the supposed conspirators in

Domitian's assasination plot were executed by the Praetorians. One of Trajan's first actions upon being named emperor was to restore his authority over the Praetorian Guard by executing Casperius Aelianus and his mutinous group. (See Flower 2001:642–44 for a summary of the history of the Praetorians, especially in the Flavian and Trajanic periods.)

It is tempting to read a not so subtle political message into the reuse in a Trajanic period monument of this particular inscribed block, erased as a result of a decree of *damnatio memoriae* of an emperor who was assassinated with the collusion of the two prefects of the Praetorian Guard, and decorated with a depiction of at least one Praetorian on the *verso*. Was the reuse of this block meant to deliver an important political message regarding Trajan's control of the Praetorian Guard and the need for their respect and loyalty? It would be difficult to imagine, however, how the erased inscription side of the block could have been visible in the new Trajanic monument. While it seems unlikely that a political message was the single motivating factor in choosing this block of marble for the Trajanic monument, some importance was ascribed to the inscription since it seems to have been in no way defaced beyond the careful "erasure." If, as it seems to be, this block was reused as a decorative facing for a monument, one would expect some horizontal joining devices to attach the block to the background. In fact, none of these exist and all of the cuttings in the top and the bottom of the block are meant to secure the block vertically (see below). It is possible that not only was this inscription block from the Domitianic monument reused, but large parts of it might have been incorporated into the new Trajanic monument, delivering a not so subtle message of Trajanic power in the guise of the beneficence of the emperor. (See Kinney 1997 for a discussion of Roman spolia and the meaning of the reuse of spolia in later monuments.) One would wish to have a more complete picture of the monument to interpret its overall iconographic message.

An Arch of Trajan at Puteoli?

It has long been presumed that this relief was part of the decorative program for an Arch of Trajan at Puteoli, spanning a Roman road. One of Trajan's major public works at Puteoli was the completion in AD 102 of the continuation of the Via Domitiana toward Neapolis, a project that had been begun under Nerva (Johannowsky 1952). The UPM block was reportedly found used as fill between two superimposed east-west Roman road levels (ca. 5 m. wide), around 150 m. southwest of the amphitheater in the direction of the Cumana station in the Rione Ricatta (or Ricotti) district of the town (letter of sale,

September 26, 1909 in UPM archives; Gabrici 1909:212 where the rione is spelled Ricotti). The exact location of the find can no longer be pinpointed (see Zevi 1993: Foglio XIII, nos. 214, 91, 92 for the approximate area), but it was certainly from the area of the city with the densest traces of public monuments, including the large, well-preserved amphitheater of Flavian date (Zevi 1993: Fogli X and XIII, no. 61). Some architectural fragments of a Roman arch of uncertain date were found south of the amphitheater along the Via Rossini in the district called the Regio Portae Triumphalis, a name which almost certainly preserves the memory of a triumphal arch in the area (Zevi 1993:94–95; de Maria 1988:259, no. 44 with references). Johannowsky (1952:89–90) puts this arch at the entrance to the Puteoli-Naples road completed under Trajan, but there are no visible foundations for such an arch.

If the two joining blocks from Puteoli are part of an arch, their exact position on that arch is still debated. Magi (1945:134–35, n. 1 and 162–63), followed by Flower (2001:640–42), argues that the relief blocks were used in an attic story of an arch, pointing to the representation on Domitianic sestertii of a quadrifrons with sculptures in the attic. Flower further suggests that the Domitianic Porta Triumphalis in Rome (*terminus ante quem*: AD 85) which is identified in these coin representations may have served as a model for the Trajanic arch at Puteoli (2001:642; see also de Maria 1988:289–91, no. 75). It seems unlikely, however, that Trajan, who took care of the mutiny of the Praetorian Guard with such dispatch and moved decisively to establish a sense of confidence and stability in his government after the turmoil of the last years of Domitian's rule and the interim rule of Nerva, would chose a well-known monument of the disgraced Domitian as a model for his arch in Puteoli.

Kähler (1951:434–35) argues that the reliefs were decoration for the socle of an arch articulated above with pillars, like those on the Arch of Trajan in Ancona and the Arch of Gavi in Verona (early 1st c. AD), and though there are variations on this theme, the general idea that the reliefs decorated a socle or a plinth has been accepted by most scholars (Rotili 1972:63–64; de Maria 1988:256–57; Kleiner 1992:229–30). Sieveking (1919:8), on the other hand, puts the reliefs on a base for an equestrian statue of Trajan.

It is worthwhile examining closely the evidence of the blocks themselves to see if this question of the restoration of the monument of which they are a part can be clarified. The Berlin and Philadelphia blocks join cleanly at right angles to one another with no possibility of an intervening architectural element defining an edge (see Figs. 10–11).

The Berlin fragment is framed all around, and the carving on the viewer's left edge of the Berlin block completes the frame, the left arm holding a small round shield, and the leg of the soldier to the viewer's right on the UPM panel. The Berlin block has a fine-picked or smoothed, finished ancient surface on the viewer's right edge (Sieveking 1919:4; personal communication, Wolfgang Massmann, Conservator, Berlin Antikensammlung, September 2004), and it is questionable if it was ever joined to another block on that side. It is obvious that at least one block is needed to join the left edge of the UPM block to complete that figure, and from the treatment of this left edge of the UPM block (see description above), it is probable that this adjoining block was between 0.11 and 0.13 m. in thickness, the same thickness as the Berlin block, and that it joined flush to the front rather than at a right angle. We cannot be sure of the width of this block or if it, in turn, joined others, but the minimum width of that block would probably be 0.43 m. (the width of the viewer's left portion of the UPM panel from the central frame to the left edge).

The relatively narrow thickness of the UPM block (Max. Th. 0.285 m.) and of the even narrower Berlin block (0.12 m.) indicate that these would have to be used as facing panels rather than weight-bearing structural members. Though these dimensions for comparable architectural reliefs are difficult to determine, it is known that the "Great Trajanic Frieze" blocks are only 0.32 m. thick (Leander Touati 1987:86–87). The passageway reliefs for the Arch of Trajan in Benevento, for example, are carved into massive ashlar blocks, while the panels on the front are simply a facing with the relief carved into slender blocks. The reuse of the inscription block from the Puteoli Domitianic monument as a façade decoration in a new monument would have presented the engineer/builder with some technical problems. The Berlin block with a depth of 0.12 m. joins the UPM block which is more than twice as thick (0.285 m.), which in turn, as is shown by the anathyrosis, is joined on the same plane at the other edge to a block that is also about 0.12 m. thick. Unless the block to the viewer's left of the UPM block is backed with a block of equal thickness it cannot be attached or rest against the same surface as the UPM block. There are no dowel cuttings on the back of the UPM block, i.e., cut into the inscription side, to secure the block horizontally to a façade. The only joining devices, described above, are in the top and bottom surfaces for vertical attachments.

In addition to these problems, reconstructing these reliefs in the attic story of an arch presents difficulties on the basis of the scale of the sculpture, the finished treatment of the corner, and the depth of the carving. The size of the Puteoli relief blocks (UPM block H. 1.62; Berlin block 1.59 m.) is relatively small for a frieze in the attic story. In comparison, the sculpted attic zone of the Arch of Trajan at Beneventum is estimated at 2.50 m. in height, while that of the Arch at Ancona is just under 3 m.; those of the Arch of Septimius Severus and Arch of Constantine are estimated at over 3 m. high (estimates are taken from scale drawings). The height of the "Great Trajanic Frieze" blocks which Packer restores in the attic of the north façade of the Basilica Ulpia is 2.98 m. (Packer 1997:445). If the Puteoli fragments are from the attic story of an arch, the arch would have to be restored at a scale smaller than those at Beneventum and Ancona.

Other than the Arch of Constantine, whose sculptural program is so dependent on spolia from other monuments, the Arch of Trajan as Beneventum is the only arch with its sculptural decoration more or less intact, and it is also, fortunately, of the right time period. It is thus instructive to note that the figural carving on the blocks in the attic of that arch is extremely deep (see, for example, Rotili 1972: pl. VIII), while the Puteoli blocks show a variation in the depth of the carving with only the corner figures in high relief. Further, in every extant Roman arch, the attic story is framed at the corners by architectural members, by piers or pillars. The Domitianic coin representations of the Porta Triumphalis in Rome also show some kind of architectural framing device in the attic story. Magi (1945:134–35, n. 1, and 162–63) and Flower (2001:640–42) interpret this detail from the coin representations as a simple molded frame like those on the UPM and Berlin panels, though the medallion and relief representations of the period of Marcus Aurelius depicting the Porta Triumphalis (de Maria 1988:289–91, no. 75) show a heavy architectonic element at the corners. That the right edge of the Berlin panel is finished with a smooth surface and shows no sign of having been joined to another block to its right side is problematic in the attic location since 0.86 m. as the depth of an arch or at least of the attic story would be impossibly narrow.

There are equally strong objections to the restoration of the Puteoli relief blocks as decoration for a socle for a free-standing column at the front of an arch, such as those on the Arch of Septimius Severus or Arch of Constantine. Such a socle would be 1.62 m. high (the height of the UPM block), 0.86 m. wide (the width of the Berlin panel) on the side faces, and a minimum of 1.695 m. wide on the front face (a measurement determined by adding the width of the UPM panel, 1.145 m., plus the depth of the Berlin panel which completes the face of the UPM panel, 0.12 m., plus another block of minimum width of 0.43 m.). (De Maria 1988:257 calculates this front face as 2.30 m. by

assuming that the joining block on the viewer's left must be the same width as the Berlin block.) Thus, the front face would be approximately square (H. 1.62 x W. 1.695 m.), with the width of the front of the socle approximately twice the width of the side. In every case, however, where sculpted pedestals for single columns are preserved, like those of the arches of Septimius Severus and Constantine, they are of equal dimensions on three faces and higher then wide.

A further objection to restoring the blocks on single column bases at the front of an arch is the composition of the UPM relief. A framed single standing soldier in high relief combined with the lower relief soldiers moving to their right is not well suited for a position on a socle or pedestal where self-contained single-figure or double-figure compositions are the norm. On the only Trajanic arch more or less completely preserved with its sculptural decoration, the Arch of Trajan at Beneventum, there is a single fornix with attached columns articulating the corners and a wide undecorated socle (ca. 1.50 m. high and 4 m. wide) anchoring the massive piers. These Puteoli reliefs would fit comfortably on this type of rectangular socle or pier, but the only parallel for decoration in this position is on the much later Arch of Galerius (ca. AD 298–303) in Thessalonike.

The Puteoli monument may have taken an unusual form, like the pseudoquadrifrons monument of C. Memmius at Ephesos dated to the third quarter of the 1st c. BC (see Webb 1996:82–83, figs. 43–47) or the eclectic Monument of Philopappos in Athens, constructed between AD 114 and 116. In the latter, a sculpted frieze (est. H. 2 m.) just above a podium depicts the emperor Titus drawn in a chariot moving to the viewer's left, surrounded by lictors in flanking panels (Kleiner 1983: pls. XXX and XXXIII for restored drawings). Kleiner (1983:73, 86) rightly notes that the format and figural organization of the lateral panel on the Philopappos monument are comparable to the Puteoli reliefs. That is, in both monuments a group of figures moving from right to left are framed and static frontal figures define the corners, though the flanking panels in the Athenian monument contain multiple figures, similar to the multi-figured panels on the Arch of Trajan at Beneventum.

The Anaglypha Traiani/Hadriani offer another possible parallel for an historical frieze of around the same time period. Though we do not know the exact location

of these double-sided reliefs, they are often thought to have been the decoration for a ballustrade or formed a precinct wall with a metal fence attached above, in the area of the Roman Forum (see Kleiner 1992:248–50, 265 for recent discussion and bibliography). A reconstruction of the Puteoli blocks as part of a ballustrade or precinct wall seems attractive in that the erased inscription on the back might be visible to the public, but the variation in the thickness of the blocks, especially the one that can be restored on the basis of the *anathyrosis* at the viewer's left, is not easily explained.

Conclusion

The Trajanic monument of which the Puteoli reliefs are a part and the positioning of the panels is still a problematic issue, but the following six points summarize the critical issues to keep in mind in the restoration of the Trajanic monument:

1. The UPM and Berlin relief panels which join at right angles served as façade decoration for a monument.
2. The monument was of modest proportions or the panels decorated a lower zone of the monument.
3. The relief panels should be placed in a position where the difference in the thickness of the blocks can be absorbed by the construction.
4. The Puteoli blocks would fit most satisfactorily into a position on a monument where the soldiers advancing from right to left could be completed by a culminating scene (of the emperor and his retinue?) or by an architectural focal point such as a stairway, flanked on the opposite side by a similar scene.
5. The viewpoint of the monument is primarily frontal, though the front edges on the sides are visible to a width of 0.86 m.
6. These blocks would not be suitable for the corner of a monument exposed to heavy traffic or wear because of the "light" treatment of the corners.

In conclusion, the evidence suggests that the UPM and Berlin panels are best suited as decoration for the podium or lower frieze course of a monument. It is possible that this monument could be a monumental altar, like the Ara Pacis or the restored *Templum Gentis Flaviae* (see discussion and references under **122**). In such a case, the UPM relief would have been positioned at the right end of the main façade, with the soldiers moving from right to left toward a central focal point, perhaps steps.

124
SEPULCRAL RELIEF: DIONYSIAC PROCESSION

MS 4017 (see CD Fig. 52)
Unknown provenience
Roman Imperial, Severan period, late 2nd–early
* 3rd c. AD*
White marble
H. 0.681; L. 1.756; Th. 0.185 m.
ACQUISITION: *Gift of Harry Rogers around 1900.*
PUBLICATIONS: *Bates 1912:101, no. 7; Luce*
* 1921:175, no. 34; Matz 1969:263, Beilage 59:*
* drawing of 1870 by F. De Sanctis, pl. 142;*
* Pochmarski 1990:119, 125, 305, R64A; Hundsalz*
* 1987:20, 145, no. K20; Guide to the Etruscan and*
* Roman Worlds 2002:86, fig. 127; Quick*
* 2004:116, no. 104.*

CONDITION: Relief panel with frame, cut in three large vertical sections with breaks in front of centaur drawing chariot and beside right side of body of standing satyr at right end. The right third of the panel was carved in the 19th c. to match the other two-thirds. Additional breaks: frame and background, above head of bearded centaur drawing chariot; frame above head of larger satyr; upper

torso, left arm, and chin of satyr; left lower leg and foot of satyr with frame; large horizontal fragment from head of satyr, across head of bacchante to frame. Chips missing from face of figure at far right, from frame and from edge of cymbal held by bacchante above head of small figure. Small nicks and chips but surface is in general in excellent condition.

DESCRIPTION: Relief panel of a Dionysiac *thiasos* or procession. Dionysos at left riding in a chariot drawn by a young and old centaur and preceded and surrounded by maenads, satyrs, cupids, and wild animals, such as a lion and panthers. A raised flat frame (W. sides and top 0.04; W. bottom 0.053 m.) surrounds the relief on all four sides, roughly finished with a chisel. The back of the panel is rough picked with large furrows of a chisel visible on the two original pieces. Traces of iron bar clamps set with lead joined the two original sections. It is not certain if these are ancient or from the 19th c. restoration.

Left Fragment: Beginning at the viewer's left is a mature satyr with a tail in small scale who stands in three-quar-

CAT. NO. *124*

CAT. NO. *124 (back)*

ters profile to his right, looks up to Dionysos in the chariot, and supports Dionysos with his right hand against Dionysos's chest. Dionysos stands in a frontal position with his left leg supporting and his right leg slightly bent and extended to the right. His right arm is draped over the satyr's shoulder and is holding a *kantharos* behind the satyr's back. His head is turned partially to his right. He is wearing a wreath of grape leaves and bunches of grapes, which are positioned to the right and left of his face. He wears an animal pelt over his left shoulder and diagonally across the front of his body. His left arm is bent and his forearm is held up holding a *thyrsos* with a *taenia* tied just below Dionysos's elbow. He stands in a small two-wheeled open-backed chariot, shown in profile.

The side of the chariot is decorated in low relief with the profile head of a bearded satyr/Pan, behind which is a set of Pan pipes(?) and in front of which is the tip of a *thyrsos*(?). A large wreathed mature centaur draws the chariot. He is positioned with his horse's body in profile to his right and the upper body in three-quarters frontal position with a muscular bent right arm holding a *plektrum* against his chest. He holds in his left hand a lyre with arching projections at the upper corners; his hand clutches the central strings. His tail is arched and against the front of the cart. He wears the panther skin around his pelvis and over the top of his haunches with a knob (paw?) at the back and a panther head at the front. His right front leg is bent with the hoof turned back. He is bearded and has a full curly head of hair and elongated ears. A small pudgy winged Eros/Cupid stands on the back of the centaur, turning his head back to his right. He wears a cloak over his shoulders falling beside his right side. He holds a *lagobolon* over his right shoulder in his bent right arm. His left hand holds the other end

of his cloak and it rests on the right shoulder of the centaur. Below the centaur is a crouching panther or female lion with its head turned back in profile, its mouth open baring its teeth.

Central Fragment: Next in high relief in the procession are the foreparts of a young centaur helping to draw the chariot. He is beardless and has a softer, more feminine body than the bearded mature centaur. He is blowing into a long double-piped musical instrument, with one section in high relief with an upturned end, and the other in low relief against the background with a rectangular section and two perpendicular pieces. He stands in three-quarters profile to his left with his head in profile. His hair is long and wavy with one lock trailing over his left shoulder and back. Behind the legs of this younger centaur is a male lion with a bushy mane with his head in high relief facing three-quarters frontal. His front right leg and paw rest on the lower frame. His body is mostly in low relief or incision (e.g., to indicate the back legs and tail).

Managing the lion is a small bestial figure, a young satyr, leaning forward and holding a crooked flail (*lagobolon*) or a stick with a bent end in his upraised right hand, as if beating the lion, and his left hand on the head of the lion. We see just the upper body of this figure who looks forward with creased brow and flattened nose. He wears a cloak (*exomis?*) draped over his left shoulder diagonally across the front of his body. His hair is full and curly with perhaps the suggestion of leaves in it. Next is a mature bacchante or maenad in three-quarters frontal position dancing and holding a tympanum to her left side. Her hair is parted in the middle and drawn to the sides in waves. Her cloak is draped over both shoulders and beneath her armpits with the central section swirling up in an arc over

her head. She looks back slightly. Her right arm is crossed in front of her chest. She wears a *chiton*(?) with a deep overfold, open on the right side exposing her right leg. Her left hand is awkwardly placed under the *tympanum*, with the little finger curled up over the rim, while the right hand is placed flat against the outside face of the instrument. In front of her is a small winged Eros/Cupid standing frontally looking back to his right. He holds a *lagobolon* in his left hand and with his bent right arm turns his hand palm out against his chest.

Right Fragment: The right third of the relief was carved at the end of the 19th c. and includes a large muscular satyr standing in a frontal pose with his head in profile to his left. He has a bestial face, elongated and short-cropped hair. Only his right arm, turned back with his hand touching or grasping the garment of the Bacchante and his trailing right leg are part of the original relief. His left arm is held at shoulder height and holds up double pipes. In front of this satyr is another bacchante/maenad with her *himation* swirling above her head dancing with a cymbal in each hand. Her body is frontal, her arms bent, with her right across her body with the hemispherical cymbal facing out. She has long curly hair with one long lock trailing over her left breast. At the far right end of the panel is a very small muscular young satyr walking to his left and looking to the viewer. He has a curly head of hair and possibly the suggestion of leaves in his hair. He carries a *lagobolon* over his right shoulder and a vessel (*kantharos*?) in his left hand. Traces of a cloak appear over his right shoulder and behind his back. Between the small figure and the bacchante is a panther or female lion in profile in a sitting position with his front legs straight. It is snarling with its mouth open.

In the background of the far left section in low relief behind and above the heads of the figures is a stalk from which rise tendrils, bunches of grapes, and leaves. The central section has no floral background. A fragment above the head of the bearded centaur seems to be a 19th c. replacement. Above the head of the young centaur is a circular plug of marble (D. 0.023 m.). On the far right fragment is another stalk, awkwardly handled with tendrils, ivy/grape leaves, and bunches of grapes.

The style of the figures is awkward, with some heads too large, bodies too small or squat, awkward poses and transitions. The eyes have, in all cases, drilled pupils, and there is much use of drill work.

COMMENTARY: Dionysiac scenes, especially scenes of Bacchic processions, are common on Roman sarcophagi from ca. AD 130 to 300. The frequent appearance of

Dionyos/Bacchus, the son of Zeus and the mortal Semele, in funerary iconography is related to the god's own quest for immortality, his desire to be accepted as an Olympian god. The Bacchic procession representing Dionysos's triumphal entry into the Olympian realm is a parody of the aspirations of mortals to achieve immortality after death.

The frame around the scene indicates that this relief cannot be part of a sarcophagus but a separate relief panel. Nevertheless, Matz (1969:263) has included it, though unnumbered, in his catalogue of Dionysiac sarcophagi because of its affinity to scenes of this type on sarcophagi. He classes the type as "Dionysos Standing in a Wagon Drawn by a Centaur" (1969:245–67), the common elements of which are: (1) the figure of Dionysos to the viewers' left holding a *kantharos* in his right hand and a *thyrsos* in his left, standing frontally in a wagon drawn by a mature bearded centaur; (2) a satyr figure to the right right of Dionysos, sometimes supporting him, as in this example; (3) a bearded mature centaur drawing the cart holding a *plektrum* against his chest in his right hand and a lyre by the central strings in his left; (4) a youthful centaur playing the double pipes; (5) a panther or lioness in a crouching pose beneath the body of the mature Centaur; (6) Eros/Cupid on the back of the mature centaur; and (7) a bacchante or maenad dancing with a tympanum with her drapery swirling in an arc above her head. A close parallel for the scene and the general style is Matz 1969: no. 118, pl. 138, 1: Naples, Museo Nazionale, of the Early Severan period. The head of the bacchante with her mantle swirling over her head wears a hairdo that matches well the imperial hairstyles of the Early Severan period (see, for example, Fittschen and Zanker, *Katalog* III:96–97, no. 140, pls. 166–67).

The fact that the right third of the relief does not appear in a 1870s drawing of the relief (Matz 1969: Beilage 59: when it was in a shop in Rome, the Magazzino Palombi in Campo Vaccino) and that the section is of a different marble confirm that the right end of the panel was carved sometime between 1870 and 1900. In fact, the vegetal decoration on the right fragment seems rather poorly executed in comparison to that on the rest of the panel, and several of the figures are derivative of those of the other two-thirds, e.g., the second bacchante/maenad and the small version of the young satyr to the far right.

This relief certainly bears a close affinity to sarcophagi in its size, shape, and themes, but the continuous raised border around all four edges is unusual for a sarcophagus panel and puts it into the category of a sepulcral relief. It would have been set onto or into a wall enclosing a burial

loculus. Examples from the Isola Sacra at Ostia show that these are often decorated with portraits of the deceased (e.g., Calza 1964:34, no. 36), and sometimes with scenes of the funerary banquet (e.g., Calza 1964:100, no. 163, pl. 97; H. 0.86; L. 2.14; Th. 0.10 m.) or of the wedded couple framed in an arch and flanked by Erotes and masks (Calza 1978:38–39, no. 45, pl. 34: H. 0.86; L. 2.14 m.). The latter example is close in date (late 2nd c. AD) to the UPM panel.

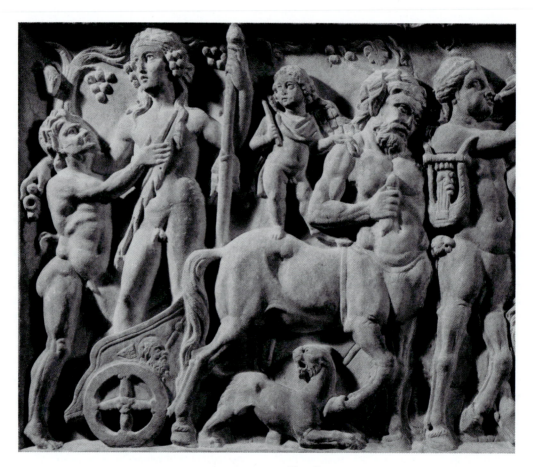

CAT. NO. *124 (detail)*

Uncertain Works or Forgeries (125–129)

125
STATUETTE OF STANDING FEMALE

MS 5681 (see CD Fig. 2)
*Said to have been found while digging foundations for a
building on the via Salaria in Rome*
*Possible late 19th c. copy of a Late Hellenistic or Roman
Imperial period work (late 2nd c. BC to 2nd c. AD)*
Fine-grained white marble
H. with plinth 0.71; H. head and neck 0.12; W. 0.22;
Th. 0.18 m.
ACQUISITION: *Bought by the Museum from the New
York dealer Dr. L. T. Caldarazzo (acting as an agent
through Adolphe Bassi for the owner in Rome) in
February 1926 for $35,000 with funds from an
anonymous donor secured by Charles C. Harrison,
President of the Board of Managers. Misnumbered
MS 5772 in 1977, then renumbered MS 5681.*
PUBLICATIONS: *MusJ 17, 1926:219: reference to
purchase of "a Greek statuette of Demeter";*
Philadelphia Public Ledger, *February 21, 1926:3;*
Aspects of Ancient Greece 1979:176–79, no. 86;
Albertson 1983:21–31; Vermeule and Brauer
1990:75; Bartman 1992:55, n. 18.

CONDITION: Complete. Missing left index finger and end
of attribute in left hand. Section of left top of head is repaired
(not an ancient repair). Nose is chipped. Head broken off at
the base of the neck in 1967 and reattached to body with a
dowel in 1978. Conservation reports in 1978 indicate that
there was evidence that the head had been previously
attached at the neck with adhesives and plaster. The joining
surfaces of the bottom of the neck and upper body seem to
be worked smooth and there is no ancient dowel. The surface
of the body in 1978 was covered with grayish and yellowish
accretions and thick patches of yellowish-tan material to fill
damaged areas. When all of these accretions and substances
were removed, it revealed a pitted surface. The surface
appears to have been treated in some way, producing a sugary
appearance and with some pitting and gouging, especially
deliberate-looking on the back. There is some dark staining

on the outside of the left hand, on the shoulders, breasts,
plinth, and upper back. Some incrustation, especially on
the drapery. Large chip from back right edge of pedestal.

DESCRIPTION: One–third lifesized standing female with
her right leg straight bearing the weight, and her left bent
and turned slightly to the side. Her right arm, beneath the
himation, is bent and turned with the back of her wrist
resting on her hip, while the left is slightly bent and held
down and forward holding a sheaf of wheat and poppy bud.

The head is turned to her left and slightly inclined.
The hair is styled in the melon coiffure, parted in rows with
the strands twisted and pulled back into a flattened bun at
the back, with one twisted strand looped around the base
of the bun. In front of each ear is a small "kiss curl." The
face is small and oval with a high triangular forehead;
deep-set, widely spaced elongated oval eyes with thickened
ridges for the lids; a long straight nose; a small mouth with
well-shaped protruding lips; and a fleshy chin.

The figure wears a sleeved *chiton* bound by a cord
under her *himation*. The deep folds of the *chiton* appear on
the lower legs and collapse on the tops of the feet. While
the *himation* has slipped off her left shoulder, it envelopes
the right side of her body, draped tightly so that it reveals
full breasts and heavy thighs. The folds form a strong diag-
onal from the right shoulder to the left wrist, looping
around the left arm with the excess falling along the left
side, ending in a weight or tassel resting on the left foot. She
wears thick-soled sandals with a slight indentation between
the first and second toes and a more shallow one between
the second and third toes. The back is summarily finished
in broad planes and was not meant to be seen. The statuette
is carved in one piece with a plain oval plinth (H. 0.03 m.).

COMMENTARY: On February 21, 1926, a sensational story
appeared in the *Philadelphia Public Ledger* with erroneous
information concerning the acquisition of this statuette.
The report in the press indicated that the Museum was

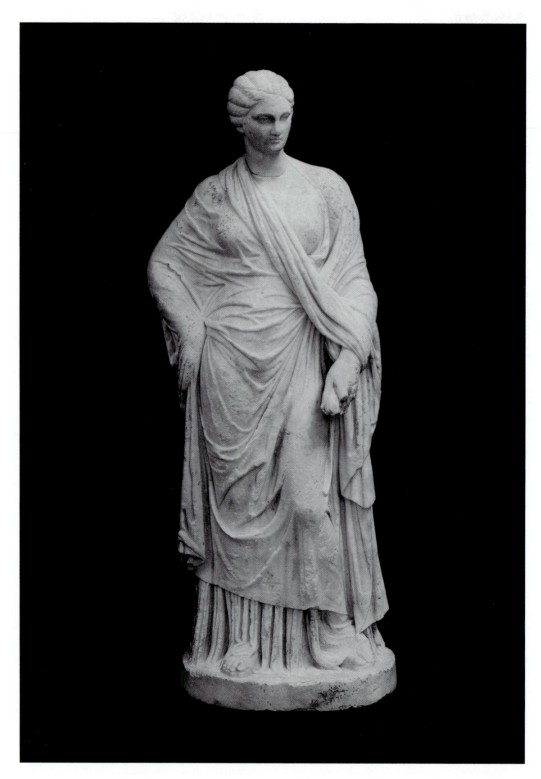

CAT. NO. 125

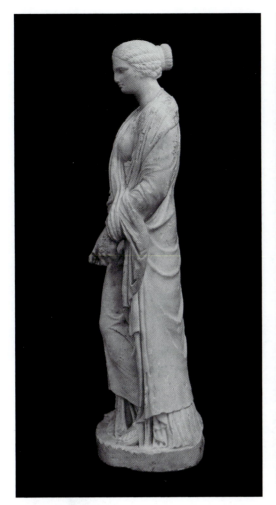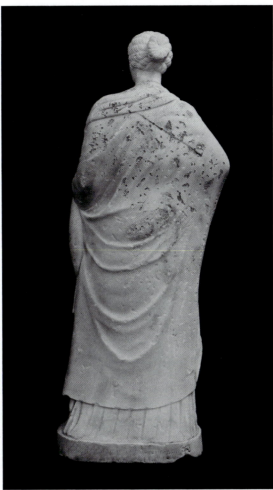

CAT. NO. 125

given the statuette by a prominent Philadelphian who had purchased it for $350,000 as an original by the sculptor Praxiteles. In fact, according to the records in the Museum's archives, the New York dealer Caldarazzo, acting as the agent for an owner in Rome where the statuette was said to have been found while digging foundations for a building on the via Salaria, negotiated directly by correspondence with Director George Byron Gordon to sell the piece. The original asking price was $350,000, but after several exchanges of letters the final purchase price was $35,000, still a significant sum in 1926. The Museum's Board President Charles C. Harrison was asked to secure funds to buy the piece of sculpture for the museum, but the source of the funds was never recorded. Sometime after 1927, the statuette was suspected of being a forgery and a notation to that effect was made by the curator Edith Hall Dohan on the

catalogue card. That the curatorial staff thought the statuette was possibly not ancient is perhaps the reason no articles ever appeared about it in the Museum's publications.

The statuette was first brought to the attention of the scholarly world in 1979 when it was studied for inclusion in an exhibition at the Allentown Museum of Art by Dr. Brunilde Ridgway and her student Karla Klein Albertson (*Aspects of Ancient Greece* 1979:176–79). In a fuller publication, Albertson (1983) weighs the question of the authenticity of the statuette with an open-ended conclusion.

There continue to be doubts today regarding the authenticity of the statuette or parts of it on three counts:

° First, the surface of the statuette may have been deliberately "antiqued" with some chemical, creating a sugary appearance, and with tooled pits or gouges, especially uniform over the

upper back. Also, it was noted in the conservation report of 1978 that a grayish-yellow substance was covering the statuette, a possible attempt to give it an "archaeological" appearance, perhaps to coincide with the assertion by the dealer that the statuette was excavated in Rome. The interpretation of these findings is not unambiguous, and there is also the possibility that an attempt was made before the statuette came into the possession of the Museum to cover up a harsh conservation treatment with the gray-yellow substance.

° Second, the head may have been made to fit this body, leaving open several possibilities, including: (1) the body and head are both ancient, but don't belong to one another; and (2) the body is ancient and the head is modern. The marble of the head may be a different variety than the body, to judge from the difference in coloration, but this has not been confirmed by testing. It is clear that this head was not made separately in antiquity, for photos taken during the 1978 conservation treatment show that there is no dowel in the neck and no scoring for adhesive (see photo at right). The joining surfaces of the neck, however, seem to have been carefully reworked to make a more or less smooth join sometime prior to conservation work in 1978, when the conservator noted that the head had been attached previously with plaster of Paris. It is also clear that the repair to the top left of the head is not an ancient one, for plaster is still visible at the edge of the join.

° Third, the statue is extremely close to a statuette of slightly larger scale in the Vatican, which was much copied from the 17th through the 19th c., discussed below.

In its present form, the statuette seems to be a one-third lifesized variation of a statue type known as the Small Herculanensis, named after a statue found in the theater at Herculaneum in 1706 and now in Dresden. Over 129 copies and adaptations were made in the Roman period of the Small Herculanensis (see Ridgway *Roman Copies*:101, n. 26; Kruse 1975:68–69, 294–340; Trimble 1999; Trimble 2000), used in a variety of settings as dedications, portraits statues, and funerary monuments to represent a young woman (e.g., in the Sanctuary of Demeter and Kore at Cyrene: Paribeni 1959:142, no. 410, pl. 179; in the Herodes Atticus Nymphaeum at Olympia: Bol 1984:180–82; and see **23**). The original identity of the Small Herculanensis is not certain (see Trimble 1999:15–21). Wrede has shown that the figure should not be associated with Persephone/Kore and that she may have been a priestess, poetess or heroine (1981:213–14, n. 4). Trimble points out that in Greek contexts both the Large and Small Herculaneum Women

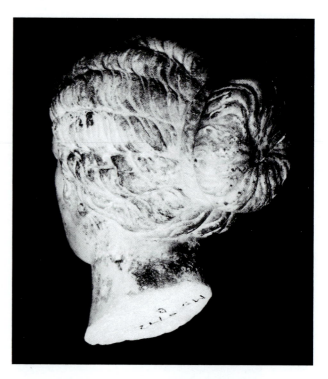

CAT. NO. *125 (detail, head)*

commemorate women with solemn funerary connotations (as **23**), while in contexts in Italy, these images honor women in public settings (Trimble 2000:50–51).

Although the date of a prototype for the Small Herculanensis is often thought to be the late 4th c. BC (Ridgway *Hellenistic Sculpture I*:106, n. 40), the only securely datable statue of the pre-Imperial period is the one from the House of the Lake on Delos, now in the Athens National Museum and dated to the late 2nd or early 1st c. BC (Ridgway *Hellenistic Sculpture I*: pl. 56a–b; Trimble 1999:22; Trimble 2000:48–49).

The UPM statuette differs from the main type (the Delian statue) in the weight-bearing leg and the position of the right arm. While in our statuette the weight is on the right leg and the right arm is akimbo beneath the *himation*, the characteristic of the main type is that she stands on the left leg with the right slightly bent and with the right arm crossed over the front of the body beneath the mantle, lifting the mantle as if to drape it over the left shoulder.

The UPM statuette is extremely close to the two-thirds lifesized (H. 1.065 m. with plinth) statuette in the Vatican Galleria dei Candelabri, known as the Mattei Ceres, acquired in 1770 with the Mattei collection and restored in 1771 (Lippold 1956:410–11, 555, pls. 174–75). Though the left hand of the latter is restored, the mannered turn of the right hand against the hip, the treatment of the folds, including the

collapse of the *chiton* on the feet, and the weight or tassel on the left foot are very similar to the UPM statuette. Details of the treatment of the hair are also close, though the face of the Vatican copy has a *sfumato* or blurred appearance, while the features of the UPM head, including the hair, are crisper.

Albertson points to the scholarly disagreement as to whether the head of the Vatican copy is original to that statue, and the authenticity of our statuette hinges to some extent on the certainty of the relationship of the Vatican head to the body (1983:27–28). A lifesized marble statue in the Museo Torlonia (H. 1.60 m.) with its head preserved is of this same type, though the authenticity of this too has been questioned (Albertson 1983:28). A statuette at Harvard University of the same type and size as the UPM example, purchased in 1928 in Paris and bequeathed to the Fogg Museum by Grenville L. Winthrop, lacks a head (Vermeule and Brauer 1990:75, no. 57). An example of the Small Herculanensis with the right arm akimbo excavated at Cyrene (Paribeni 1959:142, no. 410, pl. 179) confirms the body type, but, unfortunately, the Cyrene statuette also lacks a head.

It is perhaps most damaging to any argument in favor of the authenticity of the UPM statuette that the Mattei Ceres has been copied often since the beginning of the 17th c., in drawings, in plaster, and in marble (see Haskell and Penny 1981:181–82, no, 22, fig. 94 for this history). Thus, one has to question the antiquity of any of the copies that

have no provenience. The vast majority of these copies were, obviously, not made as forgeries. In the mid-18th c., J. J. Winckelmann (1717–1768) studied both the Large and Small Herculanensis in Dresden and praised them as Greek works of the first rank (Winckelmann 1755:22–23). As representations of a much admired ideal ancient statue, they were especially coveted by collectors in 19th c. Europe and America and also by new American art institutions as examples of ancient art that might inspire and improve public taste. By 1816, for example, Joseph Bonaparte owned a marble copy of the Small Herculanensis (H. 1.084 m.) by the French sculptor François-Joseph Bosio (1768–1845), now a part of the collection of the Boston Athenaeum, and another copy of the so-called Ceres once stood at the front entrance to the Pennsylvania Academy of the Fine Arts in Philadelphia (Cooper 1993:84–87, fig. 54). Marble copies of the type still appear on the art market from time to time, for example, a statuette sold at a Sotheby's London auction in 1970 (Vermeule and Brauer 1990:75, n. 57); and a late 19th c. one (H. 1.09 m.) signed by the Italian sculptor Ceccarini sold by Butterfield and Butterfield in Los Angeles in June 1993 (Butterfield and Butterfield 1993: no. 5498). In the final analysis, it is not possible to be certain of the antiquity of the UPM's Small Herculanensis statuette, and, in fact, there are good reasons to suspect that it may be a late 19th c. copy of the Mattei Ceres.

126
VEILED FEMALE HEAD

MS 4032
Unknown provenience
Neo-classical work of end of 18th or 19th c.
Fine white marble
P. H. 0.36; W. 0.24; H. chin to crown 0.25 m.
ACQUISITION: *Purchased for $200 from Paul Arndt through A. Emerson with funds from Lucy Wharton Drexel in 1904, along with* **31**, **20**, **21**. *Said to have been originally from the Panciatichi collection in Florence.*
PUBLICATIONS: *Luce 1921:169, no. 16.*

CONDITION: Intact, preserving head to finished base of neck. Fragment repaired on the top of the head in front of veil. Front edges of veil on bottom right and left sides are

broken. Chips from bottom edge of neck and other chips from edge of veil. Tip of nose abraded.

DESCRIPTION: Frontal lifesized female head wearing a veil over the head which falls to the bottom of the base of the neck and is connected to the sides of the neck. The veil is treated as a smooth surface except for the broad folds near the front of the sides. The hair is parted slightly to the left of the center of the head and is drawn to the sides in wavy strands. The hair covers the back half of the ears. The ear on the left side is unfinished and is treated as a broad lobe with a vague depression for the ear opening. On the right ear a drill is used to define the opening. The forehead is triangular and smooth. The brow ridge forms a sharp edge from the bridge of the nose to the side of the brow. The eyes

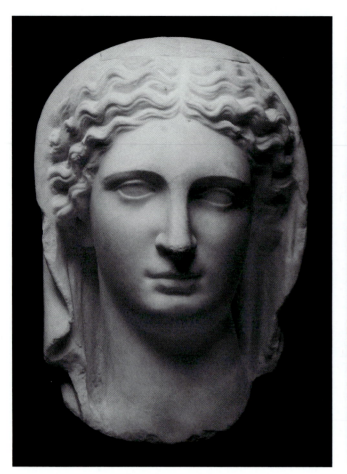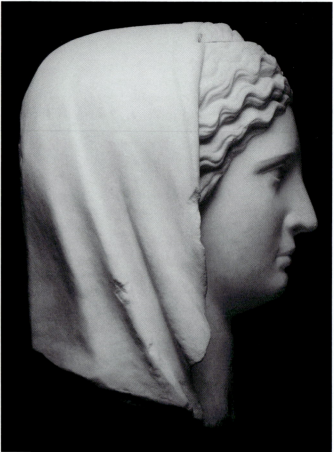

CAT. NO. 126

are shallowly carved, wide open, and almond-shaped with drilled inner corners; upper lid overlaps the lower at the outer corners. Long straight nose with flattened bridge. Drilled flaring nostrils. Broad flat cheeks. Small closed mouth with finely shaped lips, drilled at the outer corners. Full double chin. Full fleshy neck with undulations. Face, veil, and neck are highly polished. Bottom edge of neck forms a wide arc. On the underside there is a 0.02 m. wide raised edge at the front with a rough-picked surface sloping up toward the back. The back third of the bottom surface is cut back 0.02 m. In the bottom of the neck is a large square dowel hole, 0.35 x 0.03 x 0.055 m. deep. The back of the head is flattened and treated with a rasp in long vertical strokes.

COMMENTARY: This head is almost certainly not ancient. The hair should terminate in a bun or *nodus* that would make the veil protrude at the back. The eyes seem too small and shallowly cut, and the eyebrows, nose, veil, and hair are too sharp, almost metallic-like, suggesting, perhaps, a Neo-Classical (18th or early 19th c.) adaptation of a Roman woman.

127
FEMALE HEAD: GODDESS WITH *POLOS?*

L-123-24
Said to have come from Italy
Late Republican or Roman Imperial period?
White marble
P. H. 0.17; P. W. 0.125; P. Depth 0.11 m.
ACQUISITION: *Loaned to the UPM by the Academy of Natural Sciences, Philadelphia in 1936 (no. 11116); converted to a gift in 1997.*
PUBLICATIONS: *Unpublished.*

CONDITION: Single fragment, much worn, preserving head and headdress, broken off at mid-neck. Surface cracks on right and left sides of hair. Large fragment missing from back right side; chip from right side of chin. Dark discoloration on hair and black rectangular area on top of head; redddish-brown stain on face below left eye.

DESCRIPTION: Head from female statuette facing frontally. Above bangs on the forehead, hair is parted off-center in waves to right and left, covering most of ears except lobes. Hair falls down behind ears on neck to right and left. On top of head is a cushion or polos (H. 0.015–0.004 m.) which is flattened and squared off on the right side. The top is flattened and roughly hatched with a chisel. The sides of the head behind the hair are unworked. The back of the head is flattened and roughly worked. One small drill hole is visible on the back left side. The face is crudely rendered with a low forehead; a low brow ridge; incised asymmetrical almond eyes with no indication of lids; a long narrow and flat triangular nose with two tiny drill holes for nostrils; incised line for mouth; thick neck.

COMMENTARY: The poor modeling and crude style of this head suggest a provincial work and make any firm judgment

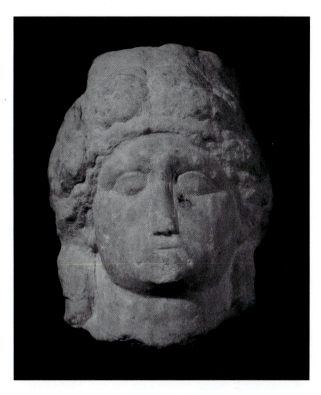

CAT. NO. 127

regarding its identification and date difficult. The use of white marble and the slight use of drilling suggest a work of the Late Republican or Roman period. The archaizing features of the figure and the polos worn on the head suggest its identification as a goddess, perhaps Kybele/Magna Mater (see Roller 1999 for a recent discussion of the Magna Mater; and Vermaseren 1977:126–44 for a discussion of Kybele in the Roman provinces) or, less likely, Hekate from a Hekate *herm* (e.g., Harrison 1965:104–5, no. 151). The shallow carving, flat back, and frontality of the piece may indicate that this was once attached to a surface or carved as a bust or *herm*.

128
FRAGMENT OF HUMAN HEAD: RELIEF?

MS 6027
Unknown provenience
Roman or 19th c. Neo-Classical
White marble
P. H. 0.095; P. W. 0.085; Depth 0.035 m.
ACQUISITION: *Found uncatalogued and undocu-*
mented in Museum basement in 1983.
PUBLICATIONS: *Unpublished.*

CONDITION: Front of face preserved from upper fore-head to lower face, broken off at the back. Lower lip and chin broken off. Surface badly discolored, gray and encrusted.

DESCRIPTION: Distorted, asymmetrical face with short, wide proportions and the right side summarily executed. Ledge-like forehead furrowed horizontally with two shallow gashes with vertical surface at the top of the break. Large, wide-open, slightly protruding eyes, wide set beneath sharp, ridged eyebrow on the left. Eyelids are thickened ridges, especially on the left. The inner corners of the eyes are deeply drilled, especially on the left. The line of the outer corner of the left eye continues in a chiseled line to the outer edge of the fragment. The nose is short and pudgy, spreading more on proper right than left and with a deeply drilled left nostril. The mouth is slightly open with thick lips, with the upper lip arching on the left side with a deeply drilled outer corner. The face is highly polished.

COMMENTARY: The asymmetrical features suggest that this face was once part of a relief, perhaps a sarcophagus,

CAT. NO. 128

and that the right side was not meant to be seen straight on. The deep drilling of the corners of the eyes and mouth, and the nostril, and the high polish of the face put it in the Roman Imperial period, though it is also possible that it could be as late as the 19th c. The lack of documentation and the size of the fragment hamper a definitive analysis.

CAT. NO. 129

129
ANIMAL HEAD: HORSE(?)

CG2004-6-2
Unknown provenience
Uncertain date
Soapy stone with some mica and dark inclusions
P. L. 0.125; P. H. 0.082; P. Th. 0.06 m.
ACQUISITION: *Found undocumented in the Museum*
storage room, 2002.
PUBLICATIONS: *Unpublished.*

CONDITION: Single fragment preserving left side of animal head with nostril chipped. Worn, with some incrustation, dark stains and streaks.

DESCRIPTION: Animal head, possibly a horse, in relief with attachment surface partially preserved on the right side of snout. Mouth is retracted and open with the upper teeth indicated. Snout is broad, flattened on top; nostril bulges to side, as if flaring. Eye is inscribed and bulging in a prominent arching socket.

COMMENTARY: It is possible that this relief fragment is not ancient Greek or Roman.

Palmyrene and Graeco-Parthian Sculpture
(130–154)

Introduction

Decorative limestone sculptures depicting men and highly adorned women of a wealthy merchant class from the caravan city of Palmyra in northern Syria have held the interest of western collectors since the 19th century, and many examples are scattered in many museum collections throughout Europe and the United States. The majority of these sculptures are funerary reliefs that were removed from the tower tombs and subterranean burial complexes of Palmyra (Fig. 12).

Palmyrene sculptures were among the earliest acquisitions of the Near Eastern Section of the UPM. Fifteen sculptures were catalogued by the Museum on January 26, 1909 (**130–137, 141–147**) and recorded as having been collected by Rev. John Punnett Peters during the expedition to Nippur in 1889–1890. (For a discussion of the acquisition history see Danti 2001:38–40.) The goal of the expedition was the acquisition of Near Eastern antiquities for the newly founded university museum. On route to Baghdad from Constantinople, Peters made a detour into the Syrian desert and to the evocative ruined city of Palmyra. He purchased Palmyrene sculptures brought to him by local people and possibly removed some from the site himself (Peters 1904:29–32). It is clear, however, from the Museum's archival records that in addition to those acquired by the Second Babylonian Expedition, some of the sculptures were already in the collection of the Museum by 1888 when they were part of the earliest display of antiquities at the University of Pennsylvania in College Hall (Thorpe 1904:424). Some Palmyrene sculptures were given to the University of Pennsylvania (some time before 1909) by Charles Howard Colket (1859–1924), a Penn graduate (class of 1879) and a member of the Museum's Board of Managers from 1892 to 1894, who made a trip to Palmyra in 1881. The pieces at the UPM possibly collected by

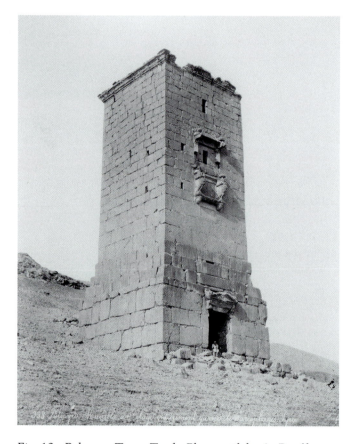

Fig. 12. *Palmyra, Tower Tomb. Photograph by A. Bonfils, ca. 1867–76. Photograph from UPM Archives.*

Colket are the group of four with slightly later accession numbers (**137, 144–146**). (For three other Palmyrene reliefs, at the University of Wyoming, collected by Colket see Albertson 2000:159–68.)

Sculptures **148** and **149** were collected prior to 1899 in Northern Syria by John Henry Haynes probably during

one of the campaigns to Nippur (1889 to 1900), according to Legrain (1928:207–8). Another group of five sculpture fragments was catalogued in 1989 and remains undocumented (**138–140, 153, 154**); three of these can be recognized as Palmyrene (or from the vicinity) by the style and limestone material, and two are probably Graeco-Parthian from Northern Syria. Two alabaster statuettes of a Graeco-Parthian style from Babylon or Babylonia were purchased from a dealer at the end of the 19th c. (**150, 152**), and one was a gift in 1889 from a member of the first Nippur expedition (**151**). (The term Graeco-Parthian is used here to define sculptures which are strongly influenced by Greek and Roman iconography and themes but which are in a style or material foreign to the Greek and Roman worlds and from regions under the influence of or controlled by the Parthians.)

Palmyrene Relief Sculpture (130–147)

130
RELIEF: ARMLESS FEMALE BUST

B 8912
Palmyra, Syria
Roman Imperial period, late 2nd–early 3rd c.
 AD
Hard buff limestone
P. H. 0.41; P. W. 0.27; P. Depth 0.11 m.
ACQUISITION: *See above, p. 280.*
PUBLICATIONS: *Legrain 1927:332, 347, fig.*
 3; Colledge 1976:261, W.

CONDITION: Single fragment broken off at the back and bottom edge. Surface damage to the left side of the face, the left eye, nose, lips, and chin.

DESCRIPTION: Female bust in high relief wearing a diadem, turban, and veil. The hair is drawn back from the sides of the face in sharp ridges and disappears into the veil. The diadem is rendered in low relief with two square registers separated by a narrow vertical element in the center with raised balls. Above the diadem are the folds of a turban, and over the top of this is a veil falling to the sides of the head. The woman wears a tunic rendered with looping ridges on the chest. She wears a mantle over her shoulders, looped from the right side over the left shoulder, forming a deep pocket over the chest in which her crossed arms are muffled. The bust tapers to below the muffled arms. The

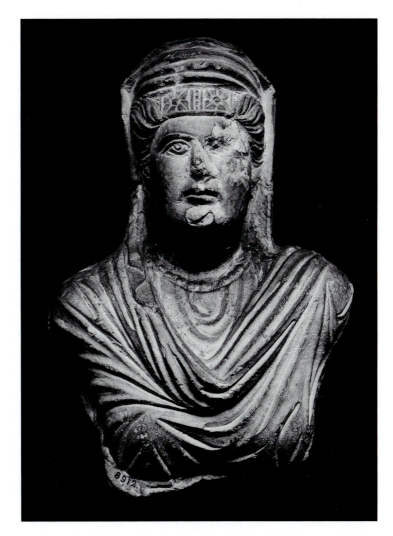

CAT. NO. 130

folds of the mantle are rendered as deep ridges, with deep gouges for the area over the arms. A beaded necklace rests just above the neckline of the undergarment. The face is rectangular with broad planes for cheeks; well-defined eyes with an incised brow above a brow ridge. The upper eyelids are rolled ridges and the iris is raised with an incised perimeter and a deep depression for pupil. Long straight nose; finely shaped mouth, slightly off-center. No ears or earrings rendered.

COMMENTARY: This type of armless bust, usually within a medallion, was generally popular in Palmyra from the first half of the 2nd c. AD, with inspiration from western (Roman) models. The fragment almost certainly comes from the long side of a sarcophagus or a *kline*-relief (e.g., Sadurska and Bounni 1994:86–89, no. 120, figs. 231–32, 235–36 [Hypogeum of Bôlḥâ]; 170–71, no. 231, fig. 237 [Hypogeum of Šalamallat]). According to Ingholt's general chronology, the sharp, linear folds of the drapery and the lack of elaborate jewelry are characteristics of his Period I (AD 50–150) (Ingholt 1954:2, introduction), while Colledge (1976:261) puts this example in his Group II (ca. AD 150–200). Closely comparable examples from the datable hypogea at Palmyra (above) suggest that this relief should be dated to the end of the 2nd or the beginning of the 3rd c. AD.

131

LOCULUS RELIEF: FEMALE BUST

B 8905
Palmyra, Syria
Roman Imperial period, ca. AD 190–200
White limestone
H. 0.50; W. 0.44; Th. 0.20 m.
ACQUISITION: See above, p. 280.
PUBLICATIONS: *Legrain 1927:329, 346, fig. 2; Ingholt 1928:138, n. 6, PS 419; Hillers and Cussini 1996:251, no. PAT 1781.*

CONDITION: Well preserved. Viewer's lower left and right corners broken off. Cracks along right and left edges. Crack through right forearm. Surface abrasion on right shoulder.

DESCRIPTION: Square inscribed loculus relief with bust of woman in frontal position. Right arm is bent across front of body; left arm is bent grasping edge of veil. Woman is wearing tunic and mantle pinned over left shoulder with circular brooch; the mantle falls in a broad curve below the right breast and with a loop on the bare right forearm. At the forehead she wears a diadem with a palm motif in the center, with a twisted turban and a veil over the top of the head. Her hair is drawn back in locks from the sides of the face, disappearing beneath the veil. Several long locks fall over her right shoulder. She wears two necklaces: a rolled necklace with a small jewel hanging from it and a chain with crescent pendant with knobs on the ends. On the little finger of her left hand are two rings with tiny stones represented. She has high cheekbones and broad, flat cheeks. The forehead is high with eyebrows on sharp ridges; prominent almond-shaped eyes, with thickened ridge for upper lid, overlapping the lower; raised circle with incision around perimeter for iris; drilled dot for pupil; emphasized lacrimal gland. Flattened bridge of nose with broad nostrils. Indentation between nose and mouth. Small mouth with thick lower lip and deep indentation separating lips; small projecting chin; strong jaw line. In the background is a *dorsalium* or curtain hanging from a rosette on each side with a palm branch above each. Inscription in four lines to right of head (Hillers and Cussini 1996:251, no. 1781):

> ydy`t brt
> sy`wn´ br
> tym´
> ḥbl

"Yedi`ât, daughter of Si`ônâ, son of Taimê. Alas!"
Traces of pinkish red pigment on *dorsalium*, on inscribed letters, on diadem, and on turban.

COMMENTARY: This is a loculus relief of the type that once sealed the burial slots of the deceased in the tomb towers and hypogea of Palmyra (for Schmidt-Colinet 1992: plan 6; Sadurska and Bounni 1994: fig. 231, plans I–XIV). Ingholt (1928:138) assigns this loculus relief to his Group II Bc (AD 150–200). The lock over the right shoulder and the treatment of the folds just below are identical on a relief in Damascus

(Ingholt 1928: pl. XIII, 4, PS 44) from the same period. Ploug (1995:54) shows that the shoulder locks still appear occasionally toward the end of the 2nd c., but rarely in the 3rd c.

The incised iris and drilled pupil belong to Ingholt's Group II (AD 150–200) (Ingholt 1954:2, introduction). The crescent pendant is popular in Roman contexts in the 1st and 2nd c. AD (Higgins 1980:180), and a silver earring with a crescent pendant was found in a 3rd c. hoard at Dura-Europos (Bauer and Rostovtzeff 1931:78, 80, no. 4, pl. XLV, 2). For the diadem type see Musche1988: pl. II, 1.8.1. The motif of the twisted turban with oblique folds

and decorative loop at the center and the shoulder lock in very low relief are paralleled on a loculus relief in Copenhagen, securely dated to AD 181 (Ploug 1995:53–56, no. 7; see also 149–51, no. 58 for a similar twisted turban).

See Stark 1971:90 for the personal names Yedi ʿât; 101 for Si ʿônâ, and 177 for Taimê. The name Taimê also appears on a relief in Copenhagen (Hvidberg-Hansen 1998:53, under no. 46), and a brother of Yedi ʿât is Ogê whose name is inscribed on a relief in Istanbul (Arch. Mus. Inv. 3758; Ingholt 1928: PS 289).

CAT. NO. *131*

132
LOCULUS RELIEF: FEMALE BUST

B 8904 *(see CD Fig. 53)*
Palmyra, Syria
Roman Imperial period, ca. AD 210–230
White limestone
H. 0.50; W. 0.40; Th. 0.27 m.
ACQUISITION: *See above, p. 280.*
PUBLICATIONS: *Legrain 1927:327, fig. 1, 345–46;
 Ingholt 1928:149, n.9, PS 499; Ingholt 1954: Cata-
 logue, no. 14; Colledge 1976:289, n. 509; Schmidt-*

*Colinet 1992:119, n. 432, 120, n. 439; Danti
2001:36–37, fig. 3; Guide to the Etruscan and
Roman Worlds 2002:85, fig. 125; Quick
2004:156, no. 142.*

CONDITION: Excellent condition. Viewer's lower right corner is broken off; parts of left edge are broken off. Thin crack all around back of figure and vertical crack through right side of body and right arm.

CAT. NO. 132

DESCRIPTION: Inscribed rectangular loculus slab with richly ornamented female figure in high relief. Woman is in frontal position with right arm bent and crossed over in front of body at waist height grasping the edge of her mantle. The left arm is bent and is raised to grasp the edge of the veil at shoulder height. She wears a tunic with a mantle fastened with a large circular jeweled brooch at the left shoulder and looped over her bare right forearm. She also wears a veil over the top of her head, the edge of which is scalloped and falls down the right side of the chest. Beneath the veil she wears a high, rolled turban with patterns in relief of rosettes, dots, and narrow bands.

Attached at the front of the turban is a pin with a rectangle linked to an oval jewel with three drops pendant on the forehead. Around her head she also wears a hair chain with circular jewels linked to each other. She wears drop earrings with a deeply drilled separation from the cheek. She wears four necklaces: the uppermost is rolled with a circular pendant; the second a chain with a circular pendant; the third beaded with a circular pendant; and the fourth and lowest a thick chain with a large oval pendant (with a representation of an oval stone in the center and small stones along the perimeter) with four suspended chains with drops on the ends, of the same type as worn at the center of the head ornament. She wears a thick spiral bracelet with studded decoration on each wrist, and a ring with a circular jeweled bezel on the little finger of her left hand. The left hand is poorly executed, while more attention is paid to the right with the fingernails represented.

The face is rectangular with broad planes for cheeks. The hair is drawn back and up in individual wavy locks. The broadly arching eyebrows are incised; the almond-shaped eyes are prominent with thickened upper lids overlapping the lower; protruding irises incised around the perimeter and with dark pigment. The nose is long and straight with deeply incised nostrils; an indentation separates the nose from the small mouth; finely shaped lips with gouges at the outer corners. Top of head is roughly finished. Inscription to viewer's right of head is false and was probably added in the 19th c. Back of relief is roughly finished with concavity in center.

COMMENTARY: Ingholt (1928:149) assigns this relief to his Group III C c (3rd c. AD) and Colledge to Group III A b of the first half of the 3rd c. (Colledge 1976:289, n. 509). The bust type with the left hand to the veil and the right hand extending over the chest horizontally to pull the mantle over the left elbow is one of the most popular of the first half of the 3rd c.

This relief is representative of the most elaborate of the female busts with copious jewelry and elaborate head ornaments. The high turban has relief patterns suggesting embroidery work, while the jewelry items include chains, pins, pendants, and a ring set with stones in bezels (see Musche 1988: pl. V, 3.4 for a similar type of head ornament). The twisted bracelets seem to represent openwork metalwork, probably filigree, called Partho-Sarmatian by Ingholt (1954:2, introduction; see also Schmidt-Colinet 1992:115, fig. 55). A closely comparable bracelet type in silver with "pseudo-granulation" was excavated at Dura-Europos in a 3rd c. hoard (Bauer and Rostovtzeff, 1931:10, 78, pl. XLIV, 2). See Witecka 1994 for a catalogue of jewelry items found in the tower-tomb of Atenatan at Palmyra, including a late 1st c. BC–1st c. AD bracelet of twisted bronze wires of a different type than this one (79, no. 10); a 2nd c. AD silver finger ring set with a banded agate in a raised bezel (78–79, no. 9); and a silver earring with drop pendants of pearls dating from the late 1st c. to early second half of 2nd c. AD (73–74, no. 2). For a discussion of the jewelry of Palmyrene women see Mackay 1949:160–87 and Musche 1988.

133
FEMALE HEAD

B 8911
Palmyra, Syria
Roman Imperial period, ca. AD 150–200
Soft whitish limestone
P. H. 0.225; P. W. 0.18; P. Depth 0.15 m.
ACQUISITION: *See above, p. 280.*
PUBLICATIONS: *Legrain 1927:340, fig. 9, 349;*
 Colledge 1976:261, under Group II X f.

CONDITION: Single fragment broken at the neck and in back; end of mantle on right side broken; lower part of hair and veil broken on left side. End of nose broken; chips from mantle. Many horizontal surface cracks.

DESCRIPTION: Female head from a relief in frontal position wearing a diadem, turban, and veil. Sitting low on the forehead is a diadem with vertical divisions, above which are the folds of a turban, over which is a veil which falls beside the head. The hair is visible on the sides of the face, drawn back in strands and disappearing under the veil. She wears earrings composed of a ball at the earlobe and a larger ball pendant from a vertical element. Square face with full cheekbones; low, flat forehead with inscribed arching eyebrows above a brow crease. The eyes are well defined with a thickened ridge for the upper lid, a raised circle for the iris, inscribed around the edge, and a drilled dot for the pupil. Well-shaped nose; small mouth with deep creases at outer edges; small jutting chin; thick, flattish neck.

COMMENTARY: Close to **134** and **135**. This head is almost certainly from a large banquet relief and is comparable to several from Palmyra (Sadurska and Bounni 1994:86–88, no. 120, figs. 232–34; 170–71, no. 231, fig. 237). See also the discussion in Colledge 1976:73–77. The inscribed iris with the drilled dot for the pupil is a hallmark of Palmyrene sculpture of the second half of the 2nd c. AD (Ingholt Group II) (Ingholt 1954:2, introduction). The simple diadem is popular on female busts of ca. AD 150–190 (Ploug 1995:55, 139).

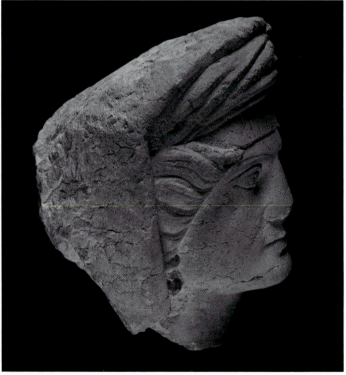

CAT. NO. 133

134
FEMALE HEAD

B 8909
Palmyra, Syria
Roman Imperial period, second half of
 2nd c. AD
Semi-hard buff limestone
P. H. 0.21; P. W. 0.175; P. Depth 0.12 m.
ACQUISITION: *See above, p. 280.*
PUBLICATIONS: *Legrain 1927:340, fig.*
 8, 349.

CONDITION: Single fragment broken at
the neck and on right side on a diagonal;
broken off in back. Mantle at top has
surface breaks.

DESCRIPTION: Frontal female head from
a relief wearing a diadem, turban, and veil.
The diadem covers most of the forehead
and is divided into registers, with the
central register filled with a palm in low
relief. To the right and left of that are
narrow registers with three flat circles, and
to right and left of those are wider regis-
ters with floating leaves. Above the
diadem are the folds of a wrapped turban,
and over the top of that is a veil that falls
to the sides of the head in a smooth
surface. The hair is drawn to the sides of
the face and swept upwards in thickened
locks, disappearing into the veil.

The figure wears earrings with a ball
on the earlobe and a pendant globular
element. The face is squarish with little
modelling of the cheeks; low, flat forehead,
inscribed eyebrows above well-defined eyes
with a thickened upper lid. The iris is an
inscribed circle with a drilled dot for the
pupil. Long straight nose with no nostrils
indicated. Small mouth with slightly parted
lips; small jutting chin; thick neck.

COMMENTARY: See **133** for a close
parallel.

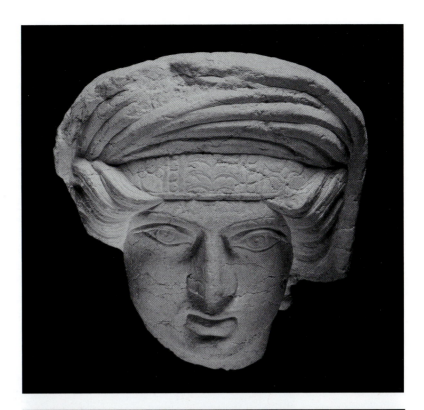

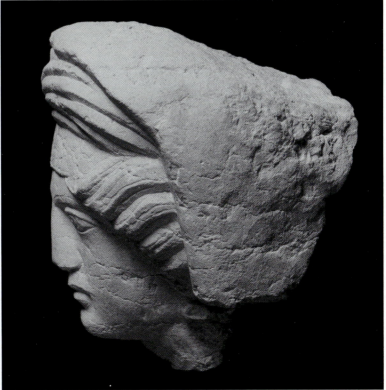

CAT. NO. 134

135
FEMALE HEAD

B 8910
Palmyra, Syria
Roman Imperial period, ca. AD 210–230
Hard buff limestone
P. H. 0.205; P. W. 0.185; P. Depth 0.12 m.
ACQUISITION: *See above, p. 280.*
PUBLICATIONS: *Legrain 1927:340, fig. 7, 348; Ingholt*
* 1928: 150, n. 3, PS 502; Colledge 1976:289,*
* n. 509.*

CONDITION: Single fragment broken below chin and on right side of veil. Damage to face, especially above left eye, lower forehead, nose, and left cheek. Headdress worn. In the crevices of the hair to the right and left of the face are areas of gray-black coloration.

DESCRIPTION: Female head from a relief wearing elaborate jewelry and headdress. Hair seems to be parted in the middle and drawn to the sides of the face with the individual strands represented as ridges and valleys. Earrings are a globule on the earlobe with a smaller ball below and a large dangling segment which loops toward the back of the ear. Deep drilled hole separates the earring from the cheek. Over top of the hair is a hair ornament composed of rounded elements (jewels) linked by triple horizontal elements (chain). On top of the head is a rolled turban, decorated in relief with a raised X motif with small bosses filling the arms and a six-petal rosette to the right and left, composed of a raised boss in the center with circles with raised perimeters. Attached to the front of the turban is an elaborate pin or pendant composed of a rectangular piece with a register in the center, below

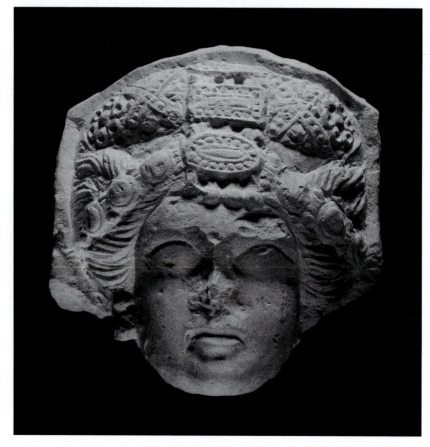

CAT. NO. 135

which is a large oval with a central incised oval and beads around the perimeter; dangling from this are four globules which rest on the upper forehead. Over the top of this head-piece is a veil which is finished on the top and left side with rough chisel work and is squared off on the right and left sides. The face is oval with well-modelled cheeks. The eyes are cursorily rendered with deep incisions marking the upper lids, flattish eyeballs with no incision for the iris or pupil. Small nose; horizontal, off-center mouth with deep chisel

gouge to right side. Small chin. Back of piece is roughly finished with deep chisel strokes.

COMMENTARY: See **133** for the same type of head from a large banquet relief. Ingholt (1928:150) assigns this head to his Group III D, 3rd c. AD. For heads of Palmyrene women wearing the same elaborate hair ornaments, see **132** and Ploug 1995: nos. 114, 115, 117–20, all of the first half of the 3rd c. AD, ca. 210–230.

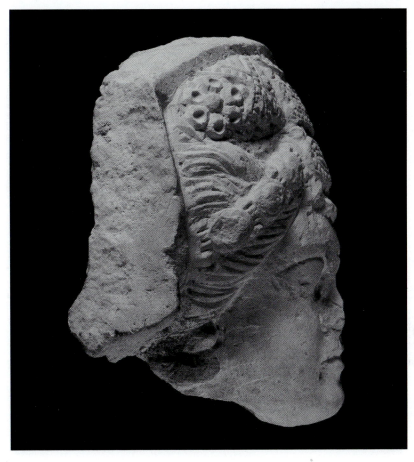

CAT. NO. 135

136
LOCULUS RELIEF: MALE BUST

B 8906
Palmyra, Syria
Roman Imperial period, ca. AD 150–200
Hard white limestone
H. 0.59; W. 0.38 m; Th. 0.13 m.
ACQUISITION: *See above, p. 280.*
PUBLICATIONS: *Legrain 1927:333, fig. 4, 347; Ingholt 1928:113, PS 209; Hillers and Cussini 1996:250, no. PAT 1766.*

CONDITION: Good condition. Viewer's upper left, lower left, and upper right corners broken off. Chips from lower edge and viewer's left edge. Surface abrasion on nose and drapery.

DESCRIPTION: Rectangular inscribed loculus relief with frontal bearded male bust to approximate hip level. Man wearing two garments: a tunic and a mantle over both shoulders which envelops both arms and falls down his left

CAT. NO. 136

side. His right arm is bent grasping the edge of the mantle; his left arm is bent and with the two middle fingers bent he holds a flat rectangular object (a book roll or *schedula*) against his chest tucked slightly beneath his mantle. Hair is rendered as flame-like locks from top of head towards forehead. Prominent, awkwardly rendered ears sitting almost perpendicular to the sides of his head. Deep creases over forehead. Sharp ridge for eyebrows. Very large almond-shaped eyes with thickened ridges for upper lids, overlapping lower. Incised circle for iris touching upper lid; drilled dot for pupil. Black pigment filling iris and outlining rim of eyes. Long straight nose with flaring nostrils deeply indented. Prominent cheekbones and furrows from nose to beard. Short beard with individual hairs of moustache and locks of beard rendered. Protruding lips with deep indentation between lower lip and jutting chin. Carefully rendered hands with fingernails represented. Ring with circular bezel on small finger of left hand. Inscription in Palmyrene dialect of Aramaic in four lines to the right of the head (Hillers and Cussini 1996:250, PS no. 209):

> m`n
> br br`´
> br zbd`th
> ḥbl

"Ma`ân, son of Bar`â, son of Zabd`âteh. Alas!"
Red pigment in letters of inscription.

COMMENTARY: Ingholt (1928:113) compares this bust to another in his Group II Ba (AD 150–200) with a similar treatment of the mantle folds and gesture. The fashion for beards seems to have been adopted by Palmyrene men after AD 150, following the fashion of Hadrian (Ingholt 1954:2, introduction; Ploug 1995:127). The incised circle for the iris and the drilled dot for the pupil belong to Ingholt's Group II (AD 150–200) (Ingholt 1954:2, introduction; see also Ploug 1995:126).

The book roll or *schedula* tucked just beneath the mantle is an attribute whose meaning is not understood. It might relate to the literate status of the individual or his profession, or it might contain the list of deeds that the individual carries with him to the grave (see Colledge 1976:154).

See Stark 1971 for the personal names Ma`ân (96), Bar`â (79), and Zabd`âteh (86). The family tree of this family can be reconstructed, and the identification of the brothers and sisters of Ma`ân from well-dated loculus plaques confirms the date of this relief to ca. AD 180 (F. Albertson, personal communication, July 2004).

137
MALE HEAD

B 9187
Palmyra, Syria
Roman Imperial period, late 2nd–early 3rd c. AD
Hard yellowish-pink limestone
P. H. 0.185; P. W. 0.14; P. Depth 0.14 m.
ACQUISITION: *See above, p.280.*
PUBLICATIONS: *Legrain 1927:342, fig. 11, 350.*

CONDITION: Single large fragment broken off at the neck and at the back of the head. Nose cracked across bridge; end of nose broken off and surface break to right and left sides. Many surface cracks and wear.

DESCRIPTION: Beardless male head in frontal position from a relief. Hair is arranged in a fringe of two rows of individual flame-like locks on the forehead with two more rows of locks over the top of the head summarily treated. Low forehead; narrow bridge of nose broadening to end. Large almond-shaped eyes with full ridge for upper lid and narrow ridge for lower; irises are incised circles with incised dot for pupil. High cheekbones and full cheeks. Small mouth with pursed lips with turned up ends. Jutting chin with flattened end. Ears are protruding out with hair against the back. Elongated neck. Black pigment defines eyebrows, eyelids, irises, and pupils of eyes.

COMMENTARY: This beardless male head represents a young man or adolescent from a large banquet relief (Sadurska and Bounni 1994: cat. no. 120, figs. 231–33).

The *coma in gradus formata* hairstyle (Ingholt 1928:21–22) was in vogue in Rome beginning in Neronian times, but continued to be popular at Palmyra into the early 3rd c., with the abundant hair belonging later in the period (see Ploug 1995:45–48, no. 5 for the hairstyle of AD 133/4 and no. 64 for a boy of ca. AD 190–210; Sadurska and Bounni 1994: cat. no. 90, fig. 100; no. 120, figs. 236–37 for late 2nd c. examples).

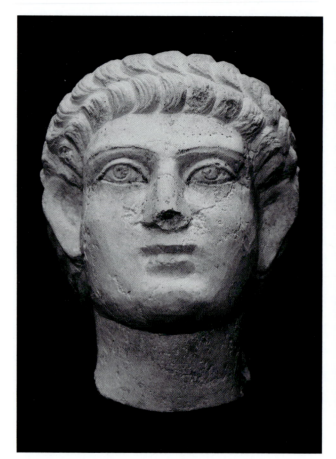
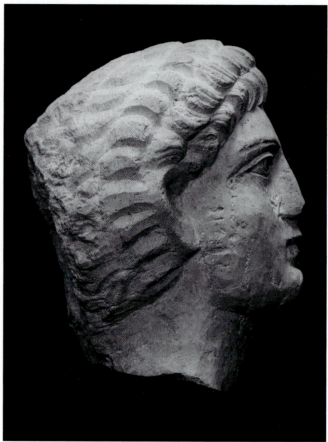

CAT. NO. 137

138
RELIEF FRAGMENT: PRIEST'S HEAD

89-22-5
Probably Palmyra, Syria, or North Syria
Roman Imperial period, first half of 2nd c. AD
Soft buff limestone
P. H. 0.234; P. W. 0.143; P. Th. 0.079 m.
ACQUISITION: *Undocumented.*
PUBLICATIONS: *Unpublished.*

CONDITION: Single fragment, mended from many smaller fragments leaving cracks across face and *modius*. Broken off in back and around perimeter. Head preserved from neck to middle of *modius*.

DESCRIPTION: Lifesized head of a priest wearing a *modius* surrounded by a floral relief crown. The lower part of the *modius* is divided into vertical registers, and at the bottom is a double edge, as if representing a lining. Face is full with broad flat planes for cheeks. Low forehead, raised line of eyebrows, deep-set eyes with thick arching lids meeting at corners; raised circle for iris and small incised circle for pupil. Thin nose with deep indentations for nostrils. Small horizontal mouth with thick upper lip and thin lower lip. Small jutting chin, thick neck. Earlobe preserved on right side.

COMMENTARY: The *modius* defines the figure as a Palmyrene priest. See **139** for a discussion of the *modius*. This head could be either from a banquet relief (e.g., Ploug 1995: no. 8) or from a relief bust (Ploug 1995: nos. 75–76). The incised concentric circles for the iris and pupil date this head to the first half of the 2nd c. AD (Ingholt 1954:2, introduction).

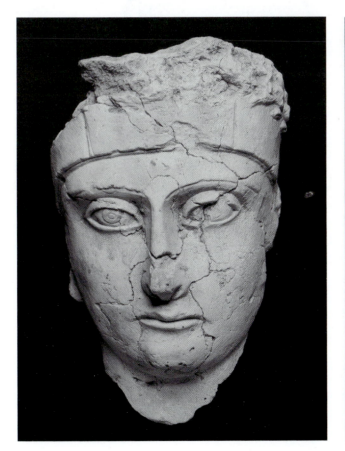
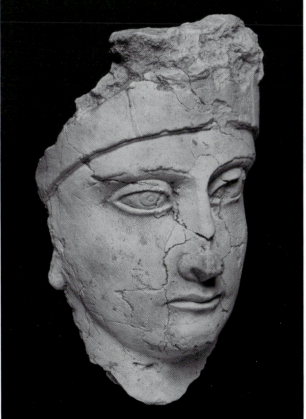

CAT. NO. 138

CAT. NO. 139

139
FRAGMENT OF PRIEST'S *MODIUS*

89-22-4
Probably Palmyra, Syria, or North Syria
Roman Imperial period, ca. AD 150–250
White limestone
P. L. 0.10; P. W. 0.08; P. Th. 0.07 m.
ACQUISITION: *Undocumented.*
PUBLICATIONS: *Unpublished.*

CONDITION: Single fragment broken all around, preserving front surface. Worn.

DESCRIPTION: Fragment from the front of a priest's *modius* with a small draped, armless bust in relief of a male wearing a *modius*. There is no encircling medallion around the bust. On the headpiece to the right and left are floral blossoms in relief with a tendril behind the head

of the bust.

COMMENTARY: Palmyrene priests are distinguished by a high cylindrical hat, a *modius*, so-called after the Roman grain measure. (For a discussion of the origins and meaning of the Palmyrene *modius* see Rumscheid 2000:93–108.) The male busts (both bearded and beardless) on the front of *modii* are variously interpreted as symbolic of the priest's rank, as a badge of a priestly clan, or related to ancestral cult (see Ploug 1995:61 for a discussion and references and Rumscheid 2000:103–5, 243–49, nos. 332–52). Wreaths decorating *modii* are not found until ca. AD 135–150 and continue into the 3rd c. (Ploug 1995:61). See Sadurska and Bounni 1994:26, no. 19, fig. 83 and Ploug 1995: no. 8 for examples of this type of armless draped bust without an encircling medallion on a *modius*.

140
RELIEF FRAGMENT: HAND

89-22-3
Probably Palmyra, Syria, or Northern Syria
Roman Imperial period
Hard buff limestone with large crystals
P. L. 0.166; P. W. 0.096; P. Th. 0.03 m.
ACQUISITION: *Undocumented.*
PUBLICATIONS: *Unpublished.*

CONDITION: Single fragment broken off all around, preserving hand to wrist and drapery. Ends of second and fourth fingers broken off.

DESCRIPTION: Right(?) hand holding edge of veil or mantle, broken off a loculus relief. Fingernails rendered.

COMMENTARY: The gesture of the hand grasping the veil or mantle is a common one on both male and female figures on Palmyrene reliefs, and it is difficult to say which is the case here.

CAT. NO. *140*

141
LOCULUS RELIEF: BANQUET SCENE

B 8902 (see CD Fig. 54)
Palmyra, Syria
Roman Imperial period, ca. first half of 3rd c. AD
Hard white limestone
H. 0.455; W. 0.57; Th. 0.12 m.
ACQUISITION: *See above, p. 280.*
PUBLICATIONS: *Legrain 1927:336, fig. 5, 348; Ingholt 1928:120, n. 8, PS 262; Ingholt 1935:70, 72–74, pl. XXXII; Colledge 1976:79, 278, n. 257; Hillers and Cussini 1996:250, no. 1772; Danti 2001:37, fig. 4; Guide to the Etruscan and Roman Worlds 2002:86, fig. 126.*

CONDITION: Well preserved with viewer's top left and lower right corners broken off. Viewer's left edge chipped off.

DESCRIPTION: Inscribed rectangular loculus relief with banquet scene composed of three figures: two boys and a reclining male. To the viewer's right is a beardless male figure reclining on pillows supported by his left elbow, with his body and head turned to the front. He holds a cup with a honeycomb pattern in his left hand, bent across his body, while his right hand rests on his right knee and holds a round object, a fruit or flower. His legs are crossed with the right bent and the left turned underneath, disappearing into the background. He wears a richly decorated (possibly with embroidery) Parthian-style belted, long-sleeved tunic with a central vertical band (with pattern of double palm fronds), neckline, cuffs (medallions), and lower edge (wave pattern) decorated in low relief. A *chlamys* is fastened over the right

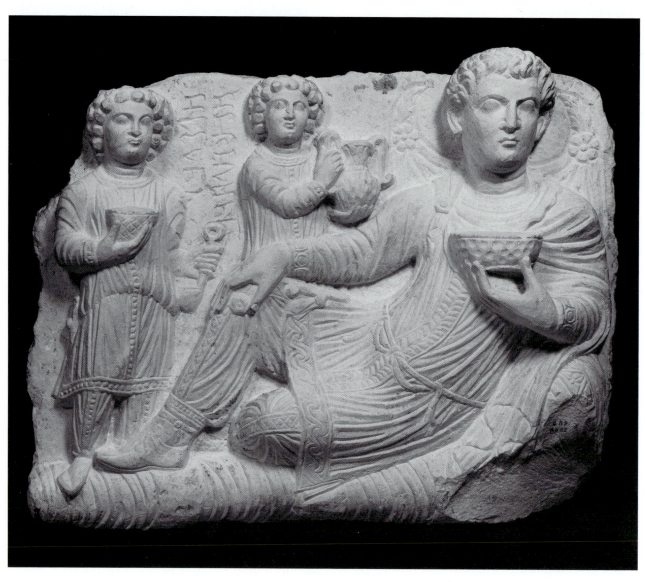

CAT. NO. *141*

shoulder with a circular pin, wrapped around left shoulder and over left arm. He wears loose trousers with many folds, cuffed above the ankle and with a decorated vertical panel, and square-toed boots with a central flap. His hair is brushed forward with locks on forehead; triangular face; large oval eyes with traces of dark pigment on the irises; broad nose; and small mouth. Behind this figure is a *dorsalium*, a veil suspended from two rosettes from which palm leaves rise.

In the center of the relief, behind the body of the reclining male is a small male figure holding to his left side an amphora with high-swung handles and body decorated in relief (honeycomb body, neck ornament, and tongues on neck). He is dressed in a long-sleeved tunic with a central vertical panel. His hair is rendered as a halo of globular curls. Another small male figure appears to the far left in the relief, wearing a long-sleeved patterned tunic with a deep *kolpos*, trousers, and pointed-toed boots. He holds a cup to the front of his body in his right hand, and a ladle with a looped handle in his bent left hand; he wears a sword at his right side. His hair is treated in the same way as the other servant. The groundline for the scene is a rolled mattress or pillow with vertical striations.

Between the two small figures are two vertical lines of an inscription in Palmyrene dialect of Aramaic (Hillers and Cussini 1996:250, PS no. 262):

mlkw br
mqymw ḥbl

"Malkû, son of Moqîmû. Alas!" (Legrain 1927:348). The back is roughly finished.

COMMENTARY: The reclining figure on the mattress and pillows, the cups, amphora, and ladle are common elements of a banquet scene, a popular theme in Palmyrene funerary art. For a discussion of banquet reliefs and their placement in Palmyrene tombs see Ploug 1995:58 and Colledge 1976:78–79 who dates the appearance of the small banquet relief type after AD 200. These small banquet reliefs seem to have been used in pairs within tombs (see Sadurska and Bounni 1994:20 and cat. nos. 13, 14, 193 for a discussion).

The inscription on this relief defines the deceased, the reclining male, as Malkû, son of Moqîmû. Both of these names are common in Palmyra (see Stark 1971:95–96; Hvidberg-Hansen 1998:33–34, under no. 8). The *dorsalium* hanging behind him gives further emphasis to the deceased figure. The small size of the two male figures indicates that they are servants (and also possibly young). The coiffure of these small figures with individual snail curls forming a halo effect is paralleled by several supposed servant figures in reliefs belonging to ca. AD 210–230 (Ploug 1995:231, no. 98). Parthian-style dress comes into vogue on Palmyrene reliefs beginning ca. AD 150 (Ingholt 1954:2, introduction) and continues into the 3rd c. For a discussion of the Parthian garments see Ploug 1995:60–61. Ingholt (1928:120, n. 8) compares features of this relief to other Palmyrene reliefs in his Group III Ab (AD 200–273).

142
RELIEF: MALE SERVANT

B 8903
Palmyra, Syria
Roman Imperial period, ca. AD 210–250
Hard buff limestone (see discussion of spectroscopic
 analysis in Howarth 1969:441, n. 2)
P. H. 0.54; W. 0.365; Th. 0.32 m.
ACQUISITION: *See above, p. 280.*
PUBLICATIONS: *Legrain 1927:338, fig. 6, 348; Ingholt*
 1935:72, n. 79; Howarth 1969:441, n. 2; Colledge
 1976:278, n. 262.

CONDITION: Good condition. Broken off around entire perimeter. Vertical crack down left side of face and contin-

uing below chin.

DESCRIPTION: Bust in high relief to below waist of beardless male figure with head turned slightly to proper right. Both arms are bent holding in front of his body an oval dish with a small animal (probably a lamb). He is attired in Parthian-style dress with a long-sleeved tunic with relief ornament at the neckline, down the central seam (rosettes within circles), and at cuffs. The many crinkled folds represent the lightweight fabric. Small narrow face surrounded by a halo of long hair rendered in individual protruding snail curls. Low forehead; incised

eyebrows; large eyes, elongated, with upper lid overlapping lower. Incised circle for iris (no pupils indicated); traces of black pigment on iris. Thin straight nose with drilled nostrils. Small mouth with indentation between lips and gouges beside mouth. Small rounded chin. Extremely long neck. False inscription to right and left of head.

COMMENTARY: This figure in high relief is probably from a banquet scene from the top of a sarcophagus such as Schmidt-Colinet 1992: pl. 70a: the grave monument of Agrippa. The figure represents a servant bringing the roasted lamb for the feast and is close to Charles-Gaffiot, Lavagne, and Hofman 2001:345, no. 156, pl. on 265 from Qaryatein. The beardless face and long hair with snail curls is paralleled by other banquet attendants in reliefs of ca. 210–250 (Ploug 1995:243, no. 113; see also Gawlikowski in Padgett 2001:359, no. 156).

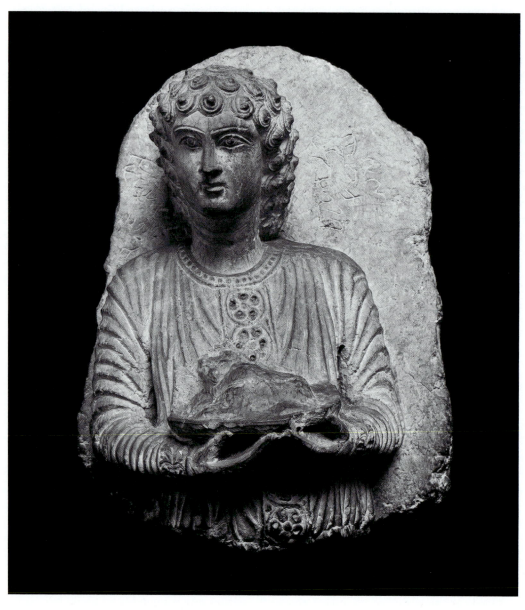

CAT. NO. *142*

143
MALE HEAD

B 8908
Palmyra, Syria
Roman Imperial period, second half of 2nd c.
 AD
Hard buff limestone
P. H. 0.098; P. W. 0.095; P. Depth 0.08 m.
ACQUISITION: *See above, p. 280.*
PUBLICATIONS: *Legrain 1927:344, fig.*
 12, 350.

CONDITION: Single fragment broken at the neck and in back. Chin broken off.

DESCRIPTION: Small bearded male head from a relief. Hair is arranged in a clump of locks over the forehead with the hairline receding in two arches to either side. Wrinkles on forehead above bridge of nose. The treatment of the hair over the top and sides of the head is cursory. The beard is short treated in broad slashes to indicate the hair; moustache treated the same way. Creases in the forehead above the nose. Thin elongated nose with arching nostrils. Broad arching eyebrows with summarily executed eyes with upper lid arching over the lower. Some trace of black pigment on the right eye. Finely shaped lips with bow-shaped upper with prominent dip. Small protruding ears.

COMMENTARY: The small size of this bearded head suggests that it is not from a bust but, rather, part of a

CAT. NO. *143*

banquet scene or from a relief stele (for the type see Ploug 1995:122–25, nos. 45–46). The hairdo, by Roman standards, should belong to the period of Antoninus Pius (ca. AD 140–160).

144
MALE HEAD

B 9188
Palmyra, Syria
Roman Imperial period, second half of
 2nd c. AD
Hard buff limestone
P. H. 0.155; P. W. 0.145; Depth
 0.145 m.
ACQUISITION: *See above, p. 280.*
PUBLICATIONS: *Legrain 1927:342,*
 fig. 10, 349.

CONDITION: Single fragment broken below the chin, on right side of the neck, the right side of the hair, and in back. Horizontal cracks across the forehead, nose, cheeks, and chin.

DESCRIPTION: Beardless male head from a relief with a hairdo of rows of large snail curls with popping centers above the forehead, diminishing in degree of finishing on the top of the head and behind the ears. Right ear sits nearly perpendicular to the head with deep drilling for the interior and a flattened rim and lobe. Low flattened forehead; incised eyebrows on brow ridge. Eyes are well defined with thickened ridges for upper lids, curving beyond the lower lids. The iris is an inscribed circle and the pupil is an incised dot. Long straight nose with indentation separating it from the small mouth with little indication of an upper lip and a deep gouge above the lower lip. Small jutting chin.

COMMENTARY: The hairdo with snail curls appears in

CAT. NO. 144

Palmyra on mortals between AD 135–150. The combination of an beardless male with this hairdo suggests that this head may be of a servant figure, perhaps in a larger banqueting scene on the top of a sarcophagus, such as Sadurska and Bounni 1994: Cat. no. 120, figs. 232–33.

145
SMALL MALE HEAD

B 9189
Palmyra, Syria
Roman Imperial period, first half of 3rd c.
AD(?)
Hard whitish limestone
P. H. 0.095; P. W. 0.098; P. Depth 0.10 m.
ACQUISITION: *See above, p. 280.*
PUBLICATIONS: *Legrain 1927:344, fig. 13,*
350.

CONDITION: Single fragment broken off in back, at the chin on the right, and lower face on the left, partially restored in plaster.

DESCRIPTION: Small beardless male head in high relief turned to his right. Hair arranged in two rows of rough snail curls framing face. On top and sides of head hair is summarily treated. Low forehead, sharp brows with shallowly carved eyes with little definition with some ghosts of dark pigment. Thin elongated nose; small mouth with horizontal line; full chin. Ear on left side set high and protruding, while on right it lies flatter.

COMMENTARY: The small size of this head suggests it is from a banqueting scene, and this beardless young man with snail curls could be one of the attendants (see **141** and **142** for discussion of these servant figures).

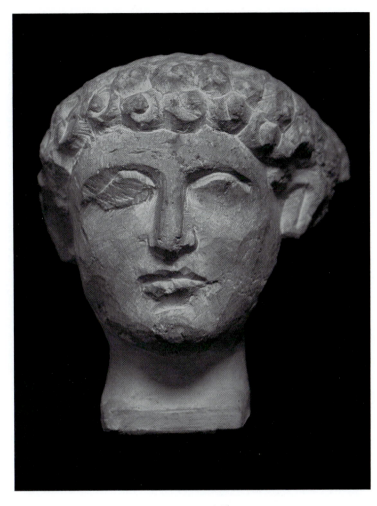

CAT. NO. 145

146
RELIEF FRAGMENT: *IMAGO CLIPEATA*

B 9186
Palmyra, Syria
Roman Imperial period, late 2nd–3rd c. AD
Hard white limestone
P. H. 0.13; P. W. 0.12; P. Depth 0.06 m.
Acquisition: *See above, p. 280.*
PUBLICATIONS: *Legrain 1927:347, fig. 14, 350.*

CONDITION: Single fragment broken on four sides and

in back. Orange stain (old adhesive?) on broken surfaces on back.

DESCRIPTION: Small *imago clipeata* with the bust of a bearded(?) male in low relief in a disk with a tongue pattern around the edges. The figure wears a tunic and mantle over the left shoulder. The hair and facial features are summarily treated. Large ears lying perpendicular to the background. Recessed at the top of the fragment are folds of a drapery

or floral background.

COMMENTARY: The meaning of the small male bust (gods or priests?) is not entirely clear, but they appear often in Palmyrene funerary sculpture on the front of *modii* worn by the Palmyrene priests (see **139**; Gawlikowski in Padgett 2001:355–58, nos. 153–55), on the medallions of necklaces worn by females (Schmidt-Colinet 1992: pl. 34, b, B1; pl. 72, f), in relief in the pediment of funerary structures (Schmidt-Colinet 1992: no. 501), and as decoration on the funerary couch on a relief or sarcophagus (e.g., Schmidt-Colinet 1992: pl. 69, c and pl. 74, b). The shape, size, and details of the fragment suggest that it is a decorative piece from the lower edge of the funerary couch on a sarcophagus. The tongue pattern behind the figure is well attested in the decorative details of funerary architecture (Schmidt-Colinet 1992: nos. 538, 550). These small *imagines clipeatae* on Palmyrene funerary architecture and on sarcophagi find their best parallels at the end of the 2nd and in the 3rd c. AD (Schmidt-Colinet 1992:108).

CAT. NO. 146

147
RELIEF PLAQUE: CHEETAH

B 8907
Palmyra, Syria
Roman Imperial period, first half of 3rd c. AD
Hard buff limestone
H. 0.355; W. 0.396; Th. 0.15 m.
Acquisition: See above, p. 280.
PUBLICATIONS: Legrain 1927:349, fig. 15, 350; Schlumberger 1951:83, n. 3; Ingholt 1954: Catalogue no. 10, fig. 10; Colledge 1976:54, 273, n. 147; Parlasca 1994:305, 304, fig. 13; Parlasca 1995:71; Parlasca 2001:322, under nos. 33–34.

CONDITION: Excellent condition with chips along top and minor chips around the border.

DESCRIPTION: Square plaque with relief representation of couchant spotted feline in profile to the left. Spots represented as incised circles on body, neck, and face. Feline is snarling with mouth open with sharp teeth represented with drill holes cut through the mouth. Snub nose with incisions for wrinkles; wrinkles beside eyebrow. Carefully executed eye with a depressed circular iris. Small rounded ear turned back. Long neck and compact body. Around the upper neck is a ruff of thick curls represented with vertical gouges. Ring projects from top of back with two straps looped through, one around lower neck and one around the abdomen. Powerful claws resting on molding in front. Tail looped around hind leg with strands of hair on end of tail resting on side of foot. Flat frame around perimeter with incised false inscription(?) on lower frame. Inside of frame is a leaf and dart and bead pattern on a molding. Red pigment on strap around neck and across abdomen and on lower and right frame. Black pigment in incised circles on body and neck.

COMMENTARY: The feline represented on this relief plaque is probably an Asian cheetah (*acinonyx jubatus venaticus*), sometimes incorrectly called a hunting leopard. The cheetah with its tawny coat and round black spots is found in Africa and southwest Asia, though the Asian variety which once

CAT. NO. *147*

roamed widely is almost extinct today and exists in only isolated places of Iran and Afghanistan. The cheetah is unique among the big cats for its non-retractable claws, as shown on the feline in this relief. They are tamable cats and were used for centuries in India for hunting game (Chernow and Vallasi 1993:518), also a favorite pastime of aristocratic Parthians (Colledge 1967:93–94). The ring and straps on this feline show it in captivity.

The plaque was probably not for sealing a loculus but rather for some decorative or religious purpose. There are three other known animal reliefs from Palmyra of similar size, with the same frame with leaf and dart and bead molding, two with representations of the Indian humped bull (zebu, *bos*

indica) and one other cheetah, the contexts of all of which are uncertain (see Colledge 1976:54, n. 147, fig. 52; Parlasca 2001:322, nos. 33–34; Dentzer-Feydy and Texidor 1993:137, no.147). Each plaque has a mate with the animals facing in opposite directions, and they may have been used in pairs, with the zebu and the cheetah juxtaposed, with possible religious significance (F. Albertson, personal communication, July 2004; see also references in Parlasca 1995:71, n. 23). A votive relief from Palmyra depicting two male dedicants and three divinities, one of which stands in a *biga* accompanied by two cheetahs (Schlumberger 1951:82–83, pl. XXXVIII, 2), also suggests that the cheetah has some sacred significance in Palmyrene mythology.

Graeco-Parthian Sculpture (148–154)

148
STATUETTE: TYCHE/FORTUNA(?)

B 9365
Northern Syria
Graeco-Parthian, 1st c. BC–2nd c. AD
White crystalline limestone or marble
P. H. 0.082; P. W. 0.047; P. Th. 0.053 m.
ACQUISITION: *Bought by John Henry Haynes in Northern Syria before 1899.*
PUBLICATIONS: *Legrain 1928:207–8, fig. 3.*

CONDITION: Single fragment preserving head from top of crown to bottom of chin. Surface chips from top and top front edge of crown and right side of head. Much worn.

DESCRIPTION: Frontal female head wearing a tall crown with vertical depressions to right and left of center and a raised arch in the front. The hair is parted slightly off-center and drawn to the sides in thick tresses, with long strands falling on the neck on the right side. On the cheeks on both sides is a "kiss-curl." High forehead, deep-set eyes with thickened lids with shallow drilling at inner corners, finely shaped straight nose, small mouth with pursed lips. At back of neck is a protruding remnant of garment, hair, or attachment surface. Small drill hole in the bottom of neck for modern mounting.

COMMENTARY: The tall headpiece with the vertical divisions and arch at the front seems to be a representation of a mural crown such as that associated with Kybele and Tyche/Fortuna in Greek and Roman representations and by the Palmyrene and Durene version of Fortune (Perkins 1973:79–84, 103–4, pls. 32, 44). The integration into eastern culture and the transformation of Graeco-Roman divinities into eastern iconography is a vast and fascinating subject (see various articles in Kahil and Augé 1981). For a discussion of the association of Tyche with Aphrodite at Dura see Downey 1977:161–62, and of Tyche with Atargatis see Downey 1977:47–48.

Specific dating of this statuette is difficult. The "kiss curls" on the cheeks appear in the Late Hellenistic period (see discussion under **70**), but are also seen on Palmyrene sculpture in the 3rd c. AD (Howarth 1969:444). Similarly, the slight drilling of the inner eye can be paralleled in Late Hellenistic and in Early Imperial sculptures.

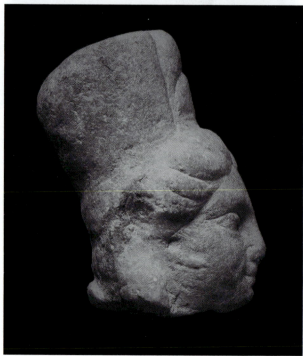

CAT. NO. 148

149
STATUETTE: APHRODITE/VENUS

B 9368
Northern Syria
Graeco-Parthian, 1st–3rd c. AD
White crystalline limestone or marble
P. H. 0.125; W. 0.08; Th. 0.045 m.
ACQUISITION: *Bought by John Henry Haynes in Northern Syria before 1899.*
PUBLICATIONS: *Legrain 1928:207, fig. 2.*

CONDITION: Single fragment preserving head and upper body, broken off above waist. Right upper arm, part of right hand, and left shoulder preserved. Nose, surface of right hand, and surface of back of head broken. Surface much worn. Dark gray discoloration on back and broken surface.

DESCRIPTION: Nude Aphrodite/Venus with head turned to her left with hair parted in the middle and drawn back in thick strands; two long strands fall over the right and left shoulders and a bowknot sits on top of the head. The right arm is bent across the front with the right hand

covering the left breast. The face is elongated with a small triangular forehead, wide-open eyes with shallow definition, and small protruding mouth with a slash separating the lips. Long neck; drill used to separate the long locks from the neck. Hair in back and back of figure less well defined. A groove defines the lower spine.

COMMENTARY: Aphrodite/Venus is among the most popular divinities represented at the Northern Syrian site of Dura-Europos (Downey 1977:153–69), and is generally popular in the Hellenistic period and especially in the Roman period in the east (*LIMC* II, Aphrodite [in Peripheria Orientali]:154–66). The majority of the Aphrodite representations from Dura are statuettes and come from household contexts, suggesting a local interest in the goddess of fertility in domestic worship (Downey 1977:168; Perkins 1973:75).

The types represented are thoroughly Graeco-Roman, with the semi-draped Aphrodite as the most common. The right arm reaching across the front of the body to the

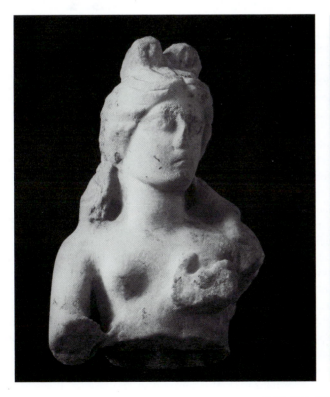
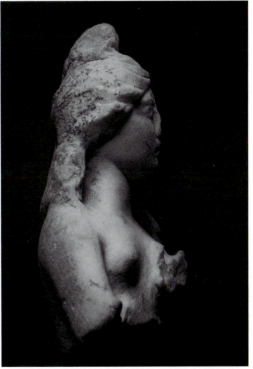

CAT. NO. *149*

left breast on this statuette is a typical pose on various nude and semi-nude Aphrodite statuettes from Syria (e.g., *LIMC* II, Aphrodite [in Peripheria Orientali]: nos. 10–19, 22–27; Charles-Gaffiot, Lavagne, and Hofman 2001:352, no. 185, pl. on 284: marble Aphrodite statuette). The statue type from which these ultimately derive is the nude Capitoline Venus (*LIMC* II, Aphrodite: 52–53). This statuette also shares the hairstyle (bowknot on top of the head and long locks over the shoulders) and the turn of the head to the left with the Capitoline type. The vast majority of the Aphrodite statuettes recorded from Syria are without good contexts, but those that can be securely dated belong to the Roman period (*LIMC* II, Aphrodite [in Peripheria Orientali]:154).

150
STATUETTE: RECLINING APHRODITE/VENUS(?)

B 318
Unknown provenience; probably from Babylonia
Graeco-Parthian, 1st–2nd c. AD
Translucent yellowish alabaster (calcium sulphate)
P. L. 0.215; H. 0.093; Th. 0.04 m.
ACQUISITION: *Purchased from dealer J. Shemtob in London in 1888.*
PUBLICATIONS: *Legrain 1928:204, 208–9, no. 4.*

CONDITION: Intact except chips from bottom of left leg, left thigh, and abrasions on breasts. Legrain (1928:209) describes the presence of white stucco on the piece. The most visible traces of a white substance are preserved around the head. Wax on surface is a remnant of a previous conservation technique for display.

DESCRIPTION: Semi-nude reclining female with body twisted in frontal position leaning on her left arm with a separately attached forearm. The right arm was separately attached from the mid-biceps and was held out along length of body, resting on the side of the buttocks where a small attachment surface is preserved. The attachment surfaces for the arms are smoothed flat with a small drill hole. The upper body upright and the right leg overlapping the left. The feet are not represented and the legs end in stumps. Drapery is wrapped around her lower thighs and legs and around her left upper arm. Heavy body proportions with large pointed breasts, full stomach with crease at bend, drilled navel, and full thighs. Below the left thigh is a drilled hole for the attachment to a mount, probably modern. Large rectangular head with hair summarily treated with a halo surrounding head and a bun at the back. Slits for eyes in shallow sockets, long straight nose, full lips. Neck is thick and elongated. Back is summarily treated with folds of drapery and depression for spine.

COMMENTARY: The identification of the reclining nude female with Aphrodite/Venus would seem secure in Greek or Roman contexts, but in an eastern context where the iconography is often mixed, it is not so certain. For example, on a relief from Dura-Europos the reclining semi-nude female wearing a Phrygian cap may be a personification of the Euphrates river or another acquatic divinity or a personification of an eastern province (Downey 1977:78–79), and the many examples of reclining nude and semi-nude females from Seleucia on the Tigris are not identified with certainty (Van Ingen 1939:21).

There are numerous specific parallels for this type of reclining figurine, both male and female (draped, seminude, and nude) in terracotta, marble, and alabaster from the site of Seleucia (Tel Umar) on the Tigris River, 32 km. south of Baghdad (Van Ingen 1939: nos. 613–89; 1664–78). Seleucia was founded by the Macedonian Seleucus (305–281 BC) and was a Greek autonomous city under Parthian control until AD 116 when it came under the control of the Roman Empire (Wilber 1976:822). All of the reclining figurines from Seleucia are in the same position, reclining on their left side supported on their left elbow, sometimes on a couch or with a cushion beneath the elbow. Many of the alabaster and marble examples from Seleucia have painted details on the clothing, sandals or feet, jewelry, navel, pubic triangle, eyes, and skin in brown, red, pink, and gold pigment over a white ground coat (Van Ingen 1939:17–18 and nos. 1664–66, 1668–69, 1671, 1673, 1675–77). The hair on some of the Seleucia alabaster figurines was completed in plaster (Van Ingen 1939:18), and it is probable that the incomplete hair around the brow

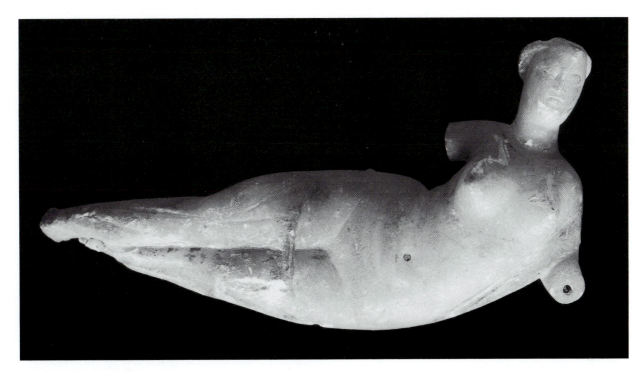

CAT. NO. 150

of this figure was finished in plaster or stucco. In fact, Legrain (1928:209) noted the presence of white stucco on the back of the head, and traces of it still exist. The technique of attaching the arms (or legs or head) with smooth attachment surfaces and small drill holes is also paralleled on the Seleucia figurines (Van Ingen 1939: no. 1666, 1668–73). The rectangular shape of the head and the long thick neck are close to several female heads from Seleucia (Van Ingen 1939: nos. 1692, 1694). The marble and alabaster examples of reclining females from Seleucia come from Levels I, II, and III (Level I: AD 115–120 to 200; Level II: AD 69–70 to 115–20; Level III: 143 BC to AD 69–70), though the vast majority of all of the alabaster figurines are from Levels I and II and belong to the 1st and 2nd c. AD (Van Ingen 1939:6–7).

The semi-finished back of this Aphrodite/Venus indicates that this figure was not applied to a piece of furniture or another object, but that it was at least partially free-standing. An alabaster statuette from Dura of a standing Aphrodite flanked by two small Erotes(?) figures was found built into an altar (Downey 1977:43–44, no. 26). Other small altars in gypsum, alabaster, and plaster from Dura (from both household and funerary contexts) perhaps provide clues to a possible use for these alabaster figures of Aphrodite and Eros (**152**) (Downey 1977:141–45, especially nos. 176–77). Most of the Seleucia examples of the reclining females were found in household contexts, perhaps from household shrines or used as bric-a-brac, though some from elsewhere have turned up in graves (with funerary significance or simply buried with the deceased as a favorite object?) (Van Ingen 1939:21). Legrain (1928:209) noted that this figurine and **152** were said to have come from tombs.

151
STATUETTE: APHRODITE/VENUS?

B 3988
Unknown provenience; said to be from Babylon
Graeco-Parthian, 1st–2nd c. AD
Translucent alabaster
H. 0.06; W. 0.054 m.
ACQUISITION: *Gift of Mr. Coleman, engineer of the*
 first Nippur Expedition in 1889.
PUBLICATIONS: *Legrain 1928:196, 206, no. 1.*

CONDITION: Single fragment broken below the breasts
and upper arms.

DESCRIPTION: Frontal nude female figure with head
slightly inclined. The hair is parted in the middle and
arranged in two protruding knots at the nape of neck,
with curls rendered as globules. The large eye sockets
are hollowed out for inlaid eyes. Elongated neck,
rounded shoulders, and full breasts.

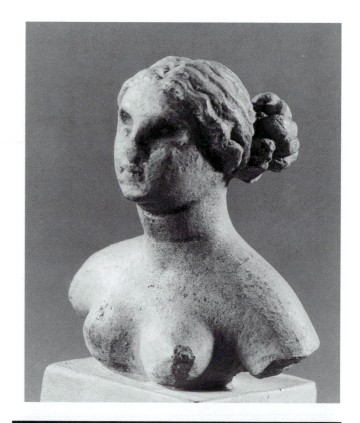

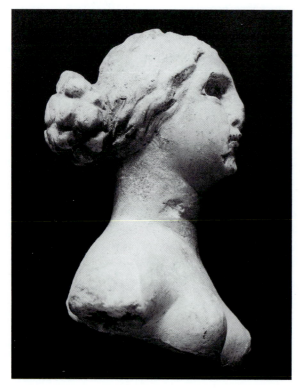

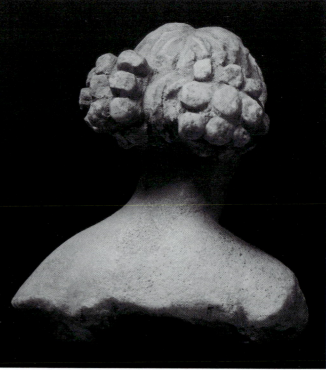

CAT. NO. 151

COMMENTARY: This statuette has not been located in the collection, and the dimensions and description are taken from photographs, information recorded on the catalogue card in 1960 by R. H. Dyson, and in the article by Legrain (1928:206). The material and style of this figurine are like **150** and **152** and find parallels in alabaster and marble figurines from Seleucia on the Tigris (see **150** for a discussion). In the case of this female figurine, the technique of the hollowed eye sockets for inlaid eyes of another material is very characteristic of the alabaster figurines from Seleucia, though it is not clear what material was used for the inlay (plaster and/or bitumen?) (Van Ingen 1939: nos. 1652, 1655, 1664, 1683, 1691, 1697). The treatment of the double knot in thick grape-like clusters is close to the hair or headdress of a male figurine from Seleucia (Van Ingen 1939: no. 1680).

152
STATUETTE: EROS THANATOS

B 319
Unknown provenience; possibly from a tomb in Baby-
 lonia
Graeco-Parthian, 1st–2nd c. AD
Translucent yellowish-white alabaster (calcium sulphate)
H. 0.12; W. 0.035; Th. 0.022 m.
ACQUISITION: *Purchased from dealer J. Shemtob in*
 London in 1888.
PUBLICATIONS: *Legrain 1928:207, 209, no. 5.*

CONDITION: Intact with chips from end of nose, chin, bottom of right leg (repaired), and end of cloak. Hard white substance adhering to front of end of cloak. According to the original catalogue card from 1888, the figure was "covered with plaster of paris," though Legrain (1928:209) says the head was covered with white stucco. Traces of a whitish substance are found all over the front of the body and especially in the grooves on the hair and sides of the head.

DESCRIPTION: Standing nude, chubby wingless Eros with right arm bent across front of body and his left arm bent with his hand supporting his head on the side of his face; his left elbow is resting on the top of some vertical support. He stands with his right leg straight and his bent left leg crossed over in front with his foot turned out. To his left side is a vertical object on a slight diagonal, a torch or drapery over an upright. His head is turned slightly to his right. The hair is summarily treated, with gouges for locks on top and sides of head flattened. On the lower right and left are projections. Round face with large eye sockets with slit for separation of lids and a small mouth. Small drill hole in bottom of left leg used for modern mounting. Back is roughly worked and flattened.

CAT. NO. 152

COMMENTARY: Like Aphrodite/Venus, Eros/Cupid/Amor is a popular divinity in the Graeco-Roman east (see *LIMC* III, Eros [in Peripheria Orientali]:942–52). There are many terracotta figurines of Eros (both wingless and winged) from Seleucia on the Tigris (Van Ingen 1939: nos. 812–43), though none recorded in alabaster. The pose of this Eros is close to a type which appears on coins, gems, and appliqués, in bronze and terracotta figurines, and in marble sculpture

of the Hellenistic and Roman periods in which the god, sometimes wearing a necklace or garland around his neck and/or a wreath on his head, has his legs crossed and is leaning with his left hand supporting his head in sleep, and his left elbow on a torch or a draped tree trunk (*LIMC* III, Eros: nos. 984–93; Eros/Amor, Cupido: nos. 117–18). The type is generally called Eros-Thanatos (i.e., Eros in the guise of the personification or genius of death), and representations of this type sometimes occur in funerary art (see De Luca 1976:46–47 for a discussion and bibliography).

Legrain (1928:209) noted that this figure, as well as **150**, was found in a tomb, presumably based on information from the dealer from whom it was purchased. See **150** for a discussion of the probable original context of these Graeco-Parthian alabaster figurines in the region of Babylonia and

a 1st–2nd c. AD date based on the contexts of those from Seleucia on the Tigris. The two statuettes are so close stylistically, and in terms of size (a small boy versus an adult female), material, and workmanship that they could have been made as a decorative ensemble. The flat back of this Eros figure suggests that it was not meant to be seen in the round, while the reclining female seems to have been finished to be viewed in the round. If indeed the two figures belong together, the identification of the reclining female as Aphrodite seems more secure in the presence of Eros.

The presence of plaster of Paris or white stucco on the head of the figure may be the remnants of the material used to complete the hair and a wreath(?), and the white over the body is probably the white ground coat over which painted details were added (see **150**).

153
STATUETTE FRAGMENT: FEET

89-22-2
Unknown provenience; possibly Palmyra, Syria, or
* Northern Syria*
Roman Imperial period
Grayish-white calcite or highly crystalline limestone
L. 0.093; W. 0.085; H. 0.046 m.
Acquisition: Undocumented.
PUBLICATIONS: *Unpublished.*

CONDITION: Single fragment with surface abrasions on front and top of toes.

DESCRIPTION: Side-by-side sandaled feet with finished end before ankle and flat bottom, from a statuette. Double straps cross feet behind the toes with thong between the big toe and second toe, decorated with a diamond-shape on top. Toes are elongated forming curved contour at front. Incised line at base of fragment indicates a low sole. Beveled gouge separates feet which rise in curve to finished end.

COMMENTARY: See **154** for comment on provenience. This material is unlike the local limestones from which most of the Palmyrene sculptures are made, although stones described as alabaster and crystalline gypsum are used for the sculptures from Dura-Europos and Hatra. The

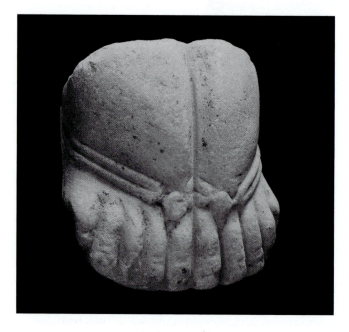

CAT. NO. 153

style also seems foreign to Palmyrene sculpture of the 1st to 3rd c. AD, and would be an import to the site if the provenience is correct. The sandal type, however, is inspired by Graeco-Roman models. In the corpus of Parthian sculpture from the city of Hatra in the Syrian Desert, it is only female divinities who wear sandals (Homès-Fredericq 1963:29).

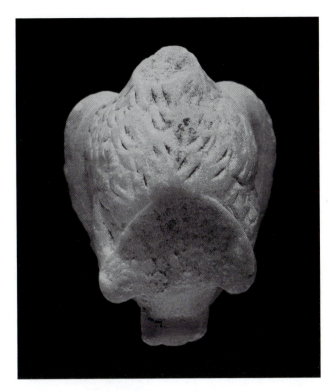 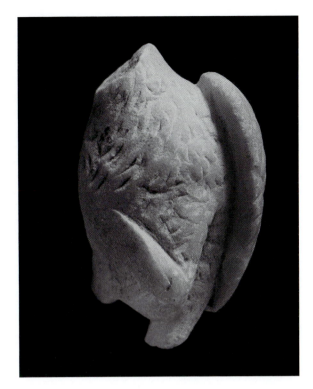

CAT. NO. 154

154
EAGLE ATTACHMENT

89-22-1
Unknown provenience, possibly Palmyra, Syria, or
* Northern Syria*
Roman Imperial period
White calcite or highly crystalline limstone
P. L. 0.075; P. W. 0.052; Th. 0.04 m.
Acquisition: Undocumented.
PUBLICATIONS: *Unpublished.*

CONDITION: Single fragment with head, lower body, and feet missing, broken off as if attached at lower body. Small spot of brown discoloration on back of body.

DESCRIPTION: Fragment of a small upright, seated eagle with wings together on back with feathers in relief; breast feathers represented in relief and with incisions.

COMMENTARY: The only clue to the North Syrian provenience of this piece is that it was catalogued with Palmyrene fragments. The stone is unlike the local limestone from Palmyra and, if the provenience is correct, would be an import to the site. Eagles (in alabaster and crystalline gypsum) are well documented in the sculpture of the Roman period from Dura-Europos on the Euphrates (Downey 1977:137–39, pls. 38–39 and 15, no. 4 for a Palmyrene relief from Dura with the eagle as the attribute of the Gad of Dura), and are often depicted in Parthian iconography (Colledge 1977:135). This small eagle (like Downey 1977: no. 165) may have been broken off the corner of a small household shrine or altar.

Bibliography

Abbreviations follow those recommended by the AJA 104, 2000:10–24.

Adriani 1938 = A. Adriani, "Minturno-Catalogo delle sculture trovate negli anni 1931–33," *NSc* 16:159–226.

Adriani 1970 = A. Adriani, "Ritratti dell'Egitto greco-romano," *RM* 77:72–109.

Agnoli 2002 = N. Agnoli. *Museo Archeologico Nazionale di Palestrina: Le sculture*. Rome: L'Erma di Bretschneider.

Ajootian 1997 = A. Ajootian, "The Only Happy Couple: Hermaphrodites and Gender," in A. O. Koloski-Ostrow and C. L. Lyons, eds. *Naked Truths: Women, Sexuality, and Gender in Classical Art and Archaeology*, pp. 220–42. London: Routledge.

Albertson 2000 = F. C. Albertson, "Three Palmyrene Reliefs in the Colket Collection, University of Wyoming," *Syria* 77:159–68.

Albertson 1983 = K. K. Albertson, "The Return of the University Museum Demeter," *Expedition* 25, 3:21–31.

Alföldi 1960 = A. Alföldi, "Diana Nemorensis," *AJA* 64:137–44.

Alföldi 1965 = A. Alföldi. *Early Rome and the Latins*. Ann Arbor: University of Michigan Press.

Amelung and Arndt 1913 = W. Amelung and P. Arndt. *Photographische einzelaufnahmen antiker sculpturen*, series VII. Munich: Bruckmann.

Ancient Greek World 1995 = K. DeVries, D. G. Romano, I. B. Romano, Y. Stolyarik, and D. White, *The Ancient Greek World, The Rodney S. Young Gallery*. Philadelphia: University of Pennsylvania Museum of Archaeology and Anthropology.

Anderson 1989 = M. Anderson, *Roman Portraits in Context*. Atlanta: Emory University.

Andreae 1965 = B. Andreae, Review of H. Jucker, *Das Bildniss im Blätterkelch*, *Gnomon* 37:507–13.

Andrén 1965 = A. Andrén, "Classical Antiquities of the Villa San Michele," *OpRom* 5:119–41.

Androgyny in Art 1982 = *Androgyny in Art*, Exhibition Catalogue. Hempstead, NY: Hofstra University, Emily Lowe Gallery.

Arnold 1969 = D. Arnold, *Die Polykletnachfolge, Untersuchungen zur Kunst von Argos und Sikyon zwischen Polyklet und Lysipp (JdI-EH 25)*. Berlin: De Gruyter.

Art of the Late Antique 1968 = *Art of the Late Antique from American Collections*. Waltham, MA: Poses Institute of Fine Arts, Brandeis University.

Aspects of Ancient Greece 1979 = G. F. Pinney and B. S. Ridgway, eds., *Aspects of Ancient Greece*, Exhibition Catalogue. Allentown, PA: Allentown Art Museum.

Aurigemma 1941 = S. Aurigemma, "Sculture del Foro Vecchio di Leptis Magna Raffiguranti la Dea Roma e Principi della Casa dei Giulio-Claudi," *AfrIt* 8:1–92.

Aurigemma and de Santis 1964 = S. Aurigemma and A. de Santis, Gaeta, Formia, Minturno (*Itinerari dei Musei, Gallerie e Monumenti d'Italia* 92). 2nd ed. Rome: Istituto poligrafico dello Stato.

Balty 1977 = J. Ch. Balty, "Notes d'Iconographie Julio-Claudienne, IV. M. Claudius Marcellus et le "Type B" de l'Iconographie d'Auguste Jeune," *AntK* 20:102–18.

Bartman 1988 = E. Bartman, "*Décor et Duplicatio*: Pendants in Roman Sculptural Display," *AJA* 92:211–25.

Bartman 1992 = E. Bartman, *Ancient Sculptural Copies in Miniature*. Leiden: E. J. Brill.

Bartman 1999 = E. Bartman, *Portraits of Livia: Imaging the Imperial Woman in Augustan Rome*. Cambridge: Cambridge University Press.

Bartman 2002 = E. Bartman, "Eros's Flame: Images of Sexy Boys in Roman Ideal Sculpture," in E. Gazda, ed., *The Ancient Art of Emulation: Studies in Artistic Originality and Tradition from the Present to Classical Antiquity*, MAAR Supp. Vol. I, pp. 249–71. Ann Arbor: University of Michigan Press.

Bates 1910a = W. N. Bates, "Archaeological News," *AJA* 14:95–139.

Bates 1910b = W. N. Bates, "Archaeological News, 1910," *AJA* 14:361–99.

Bates 1910c = W. N. Bates, "Mediterranean Section—Sculptures from Lake Nemi," *MusJ* I, 2:30–33.

Bates 1911 = W. N. Bates, "Archaeological Discussions, 1910," *AJA* 15:219–66.

Bates 1912 = W. N. Bates, "General Meeting of the Archaeological Institute of America, 1911 (Greek and Roman Sculptures in Philadelphia)," *AJA* 16:101–110.

Bates 1914a = W. N. Bates, "Archaeological News, 1914," *AJA* 18:381–423.

Bates 1914b = W. N. Bates, "Archaeological Discussions, 1914," *AJA* 18:499–550.

Bates 1917a = W. N. Bates, "Archaeological News, 1916," *AJA* 21:91–114.

Bates 1917b = W. N. Bates, "Archaeological News, 1917," *AJA* 21:339–63.

Bauer and Rostovtzeff 1931 = P. V. C. Bauer and M. I. Rostevtzeff, *Excavations at Dura-Europos*, Vol. 2. New Haven: Yale University Press.

Beck and Bol 1983 = H. Beck and P. C. Bol, *Spätantike und frühes Christentum*. Frankfurt am Main: Das Liebieghaus, Museum alter Plastik.

Benndorf 1876 = O. Benndorf, "Bermerkungen zur griechischen Kunstgeschichte," *AM* 1:45–66.

Bentz 1998/99 = M. Bentz, "Eine Weihung von Reliefgefässen im Diana-Heiligtum am Nemi-See," *Boreas* 21/22:185–96.

Bergemann 1997 = J. Bergemann, *Demos und Thanatos: Untersuchungen zum Wertsystem der Polis im Spiegel der Attischen Grabreliefs des 4.*

Jahrhunderts v. Chr. und zur Funktion der Gleichzeitigen Grabbauten. Munich: Biering & Brinkmann.

Bernabò Brea and Cavalier 2002 = L. Bernabò Brea and M. Cavalier, *Terracotte Teatrali e Buffonesche della Sicilia Orientale Centrale.* Palermo: Mario Grispo Editore.

Bernoulli 1901 = J. J. Bernoulli, *Griechische Ikonographie,* Vol. II. Munich: F. Bruckmann.

Bianchi 1982 = R. S. Bianchi, "The Egg-Heads: One Type of Generic Portrait from the Egyptian Late Period," in *Römisches Porträt: Wege zur Erforschung eines gesellschaftlichen Phänomens, Wissenschaftliche Zeitschrift der Humboldt-Universität zu Berlin* 2/3, pp. 149–51. Berlin: Humboldt-Universität.

Bianchi 1988 = R. S. Bianchi, "The Pharaonic Art of Ptolemaic Egypt," in *Cleopatra's Egypt: Age of the Ptolemies,* pp. 55–80. Brooklyn: Brooklyn Museum with P. von Zabern.

Bieber 1961a = M. Bieber, *The Sculpture of the Hellenistic Age,* 2nd ed. New York: Columbia University Press.

Bieber 1961b = M. Bieber, *The History of the Greek and Roman Theater,* 2nd ed. Princeton: Princeton University Press.

Blagg 2000 = T. F. C. Blagg, "The Votive Model. Etrusco-Italic Temples from Nemi," in *Nemi—Status Quo,* pp. 83–90. Rome: L'Erma di Bretschneider.

Blümel 1933 = C. Blümel, *Katalog der Sammlung Antiken Skulpturen, Römische Bildnisse, Staatliche Museen* VI. Berlin: Verlag für Kunstwissenschaft.

Bober and Rubinstein 1986 = P. P. Bober and R. Rubinstein, *Renaissance Artists and Antique Sculpture: A Handbook of Sources.* London: Harvey Miller/Oxford University Press.

Bol 1972 = P. C. Bol, *Die Skulpturen des Schiffsfundes von Antikythera, AM-BH* 2. Berlin: Gebr. Mann Verlag.

Bol 1984 = R. Bol, *Des Statuenprogramm des Herodes-Atticus-Nymphäums in Olympia (OlForsch* 15). Berlin: W. de Gruyter.

Bol 1990 = P. C. Bol, ed., *Forschungen zur Villa Albani: Katalog der antiken Bildwerke* II. Berlin: Gebr. Mann Verlag.

Bol 1996 = P. Bol, *Der Antretende Diskobol.* Mainz: P. von Zabern.

Borbein 1996 = A. H. Borbein, in O. Palagia and J. J. Pollitt, eds., *Personal Styles in Greek Sculpture. Yale Classical Studies* Vol. 30, pp. 66–90. Cambridge: Cambridge University Press.

Born 2004 = H. Born, "…Auch Die Bronzen Waren Bunt…," in V. Brinkmann and R. Wünsche, eds., *Bunte Götter: Die Farbigkeit Antiker Skulptur,* pp. 127–31. Munich: Staatliche Antikensammlungen.

Borsari 1888 = L. Borsari, "Scavi in contrada S. Maria," *NSc:*194–96.

Borsari 1895 = L. Borsari, "Nemi – Nuove scoperte nell'area del tempio di Diana," *NSc* 1895:424–31.

Boschung 1989 = D. Boschung, *Die Bildnisse des Caligula. Das römische Herrscherbild* I, 4. Berlin: Gebr. Mann.

Braun 1966 = K. Braun, Untersuchungen zur Stilgeschichte bärtiger Köpfe auf attischen Grabreliefs und ihre Folgerungen für einige Bildnisköpfe. Diss.: Basel. Munich: C. Schön.

BrBr 1932 = P. Arndt and G. Lippold, eds., *Brunn-Bruckmann's Denkmäler Griechischer und Römischer Sculptur.* Munich: Bruckmann.

Brendel 1930 = O. Brendel, "Weiblicher torso in Oslo," *Die Antike* 6:41–64.

Brinkerhoff 1978 = D. Brinkerhoff, *Hellenistic Statues of Aphrodite.* New York: Garland Publishers.

Buchholz 1989 = H. G. Buchholz, *Max Ohnefalsch-Richter als Archäologe auf Zypern. Centre d'Études Chypriotes* cahier 11–12:3–27.

Buitron and Soren 1981 = D. Buitron and D. Soren, "Excavations in the Sanctuary of Apollo Hylates at Kourion," in J. C. Biers and D. Soren, eds., *Studies in Cypriot Archaeology,* pp. 99–116. Los Angeles: Institute of Archaeology, University of California.

Buitron-Oliver 1996 = D. Buitron-Oliver, *The Sanctuary of Apollo Hylates at Kourion: Excavations in the Archaic Precinct. (Studies in Mediterranean Archaeology* Vol. CIX). Jonsered: P. Åstroms.

Burrell 2004 = B. Burrell, *Neokoroi: Greek Cities and Roman Emperors.* Leiden: E. J. Brill.

Butterfield and Butterfield 1993 = *European and American Furniture and Decorative Arts in Los Angeles.* San Francisco: Butterfield and Butterfield Auctioneers Corp.

Caffarelli and Caputo 1964 = E. V. Caffarelli and G. Caputo, eds., *Leptis Magna: Presentazione di Ranuccio Bianchi Bandinelli.* Milano: Mondadori.

Cagiano de Azevedo 1939 = M. Cagiano de Azevedo, "Una dedica abrasa e i rilievi puteolani dei musei di Filadelfia e di Berlino," *BullCom* 67:45–56.

Cain 1985 = H.-U. Cain. *Römische Marmorkandelaber.* Mainz: P. von Zabern.

Cain 1988 = H.-U. Cain, "Chronologie, Ikonographie und Bedeutung der römischen Maskenreliefs," *BJb* 188:107–221.

Cain and Dräger 1994a = H.-U. Cain and O. Dräger, "Die Marmorkandelaber." in *Das Wrack:*239–83.

Cain and Dräger 1994b = H.-U. Cain and O. Dräger, "Die sogenannten neuattischen Werkstätten," in *Das Wrack:*809–29.

Calder 1996a = W. Calder III, "Paul Arndt," in N. deGrummond, ed., *Encyclopedia of the History of Classical Archaeology,* p. 83. Westport, CT: Greenwood Press.

Calder 1996b = W. Calder III, "Edward Perry Warren," in N. deGrummond, ed., *Encyclopedia of the History of Classical Archaeology,* p. 1186. Westport, CT: Greenwood Press.

Calza 1913 = A. Calza, in *Giornale d'Italia* January 31: page numbers not located.

Calza 1964 = R. Calza. *Scavi di Ostia.* Vol. 5: *I Ritratti* I. Rome: Istituto poligrafico dello Stato, Libreria dello Stato.

Calza 1972 = R. Calza, *Iconografia romana imperiale da Carausio a Giuliano (287–363 d.C.)* Rome: L'Erma di Bretschneider.

Calza 1978 = R. Calza, *Scavi di Ostia.* Vol. 9: *I Ritratti* II. Rome: Istituto poligrafico dello Stato, Libreria dello Stato.

Carpenter 1951 = R. Carpenter, "A Contribution to the Vergil-Menander Controversy," *Hesperia* 20:34–44.

Carra 1980 = R. M. Bonacasa Carra, "Ritratto di un dignitario libio nel Museo di Sabratha," *Quaderni di Archeologia della Libia* 11:101–112.

Carter 1970 = T. H. Carter, "The Stone Spirits," *Expedition* 12, 3:22–40.

Castiglione 1967 = L. Castiglione, "Kunst und Gesellschaft in römischen Ägypten," *Acta Antiqua* XV:107–52.

Charles-Gaffiot, Lavagne, and Hofman 2001 = J. Charles-Gaffiot, H. Lavagne, and J.-M. Hofman, eds., *Moi, Zénobia, Reine de Palmyre.* Paris: Skira.

Chase 1924 = G. H. Chase, *Greek and Roman Sculpture in American Collections.* Cambridge: Harvard University Press.

Chernow and Vallasi 1993 = B. A. Chernow and G. A. Vallasi, eds., *The Columbia Encyclopedia,* 5th ed. New York: Columbia University Press.

Clairmont 1970 = C. W. Clairmont, *Gravestone and Epigram: Greek Memorials from the Archaic and Classical Period*. Mainz: P. von Zabern.

Clairmont 1993 = C. Clairmont, *Classical Attic Tombstones*. Kilchberg: Akanthus.

Cleopatra's Egypt 1988 = *Cleopatra's Egypt: Age of the Ptolemies*. Brooklyn: The Brooklyn Museum with P. von Zabern.

Closterman 1999 = W. Closterman, *The Self-Presentation of the Family: The Function of Classical Attic Peribolos Tombs*. Ph.D. Diss.: Johns Hopkins University. Baltimore.

Coarelli 1987 = F. Coarelli, *I Santuari del Lazio in età repubblicana*. Rome: La Nuova Italia Scientifica.

Coarelli 1989 = F. Coarelli, ed., *Minturnae*. Rome: NER.

Coarelli *et al.* 1981 = F. Coarelli, I. Kajanto, U. Nyberg, M. Steinby, *L'area sacra di Largo Argentina 1*. Rome: Poliglotta Vaticana.

Cohon 1984 = R. H. Cohon, *Greek and Roman Stone Table Supports with Decorative Reliefs*. Diss.: New York University. New York.

Cohon 1993 = R.Cohon, "The Typology, History, and Authenticity of Roman Marble Craters," *JRA* 6:312–30.

Colledge 1967 = M. A. R. Colledge, *The Parthians*. London: Thames and Hudson.

Colledge 1976 = M. A. R. Colledge, *The Art of Palmyra*. London: Westview Press.

Colledge 1977 = M. A. R. Colledge, *Parthian Art*. Ithaca: Cornell University Press.

Collins-Clinton 1993 = J. Collins-Clinton, "A Hellenistic Torso from Cosa," *Studies in the History of Art* 43:257–78.

Comstock and Vermeule 1976 = M. Comstock and C. Vermeule, *Sculpture in Stone: The Greek, Roman and Etruscan Collections of the Museum of Fine Arts Boston*. Boston: Museum of Fine Arts, Boston.

Connelly 1988 = J. B. Connelly, *Votive Sculpture of Hellenistic Cyprus*. Nicosia: Dept. of Antiquities of Cyprus/New York University Press.

Cooper 1993 = W. A. Cooper, *Classical Taste in America: 1800–1840*. Baltimore: Baltimore Museum of Art.

Counts 1998 = D. B. Counts, *Contributions to the Study of Cypriote Sculpture: Limestone Votives from Athienou-Malloura*. Ph.D. diss.: Brown University.

Crema 1933 = L. Crema, "Marmi di Minturno nel Museo Archeologico di Zagabria," *BStM* 4:25–44.

Crome 1935 = J. F. Crome, *Das Bildnis Vergils*. Reale Acc. Virgiliana di Mantova, Atti e Memorie XIV.

Crome 1952 = J. F. Crome, *Il Volto di Virgilio*. Reale Acc. Virgiliana di Mantova, Atti e Memorie XXVIII.

Cultrera 1911 = G. Cultrera, *Dionisio e il leone*. Rome.

Curtius 1925 = L. Curtius, "Die Aphrodite von Kyrene," *Die Antike* I:36–60.

Curtius 1935 = L. Curtius, "Ikonographische Beiträge zur Porträt der römischen Republik und der julisch-claudischen Familie," *RM* 50:260–320.

Curtius 1938–39 = L. Curtius, "Ikonographische Beiträge zum Porträt der römischen Republik und der julisch-claudischen Familie," *RM* 53–54:112–29.

D'Ambra 2000 = E. D'Ambra, "Nudity and Adornment in Female Portrait Sculpture of the Second Century AD," in D. E. E. Kleiner and S. B Matheson, *I Claudia II*, pp. 101–14. Austin: University of Texas Press.

Danti 2001 = M. Danti, "Palmyrene Funerary Sculptures at Penn," *Expedition* 43:33–40.

Das Wrack 1994 = H. Hellenkemper Sallies, H. -H. von Prittwitz, and G. and G. Bauchhenss, *Das Wrack: Der antike Schiffsfunde von Mahdia*. Köln: Rheinland Verlag.

DeGrassi 1939 = N. DeGrassi, "Un rilievo storico del Foro di Cesare," *BullCom* 67:61–80.

de Grazia 2000 = C. de Grazia Vanderpool, "Serial Twins: Riace B and Some Roman Relatives," in *From the Parts to the Whole, Acta of 13th International Bronze Conference*, Cambridge, MA, May 28–June 1, 1996, *JRA Supplementary Series* 39, pp. 106–16. Portsmouth, RI.

de Kersauson 1986 = K. de Kersauson, *Catalogue des portraits romains, Museé du Louvre*. Paris: Éditions de la Réunion des museés nationaux.

De Luca 1976 = G. De Luca, *I Monumenti Antichi di Palazzo Corsini in Roma*. Rome: Accademia Nazionale dei Lincei.

De Maria 1988 = S. De Maria, *Gli archi onorari di Roma e dell'Italia romana*. Rome: l'Erma di Bretschneider.

De Mot 1913 = J. De Mot, "La Vénus de Courtrai," *MonPiot* 21:145–62.

Dentzer-Feydy and Teixidor 1993 = J. Dentzer-Feydy and J. Teixidor, eds., *Les antiquités de Palmyre au musée du Louvre*. Paris: Réunion des Musées Nationaux.

Dennison 1905 = W. Dennison, "A New Head of the "Scipio" Type," *AJA* 9:11–43.

Denti 1992 = M. Denti, *La statuaria in marmo del santuario di Rossano di Vaglio*. Galatina: Congedo Editore.

Dentzer 1982 = J.-M. Dentzer, *Le motif du banquet couché dans le Proche-Orient et le monde grec du VIIe au IVe Siècle Avant J.-C.* Rome: École Française de Rome.

Deonna 1938 = W. Deonna, *Délos 18: Le mobilier délien*. Paris: E. de Boccard.

De Puma 1988 = R. D. De Puma, *Roman Portraits*. Davenport, IA: University of Iowa Museum of Art.

De' Spagnolis 1981 = M. De' Spagnolis, *Minturno*. Itri: Odisseo.

Devoti 1987 = L. Devoti, *Campagna romana viva. Speculum Dianae. Il Lago della Selva Aricina oggi di Nemi*. Frascati: Gruppo Archeologico Latino.

Döhl 1968 = H. Döhl, *Der Eros des Lysipp*. Diss.: Göttingen.

Dörig 1973 = J. Dörig, "Le Dionysos de l'Helicon oeuvre de Lysippe," *AntP* 12:125–30.

Dörtlük *et al.* 1988 = K. Dörtlük, S. Kor, M. Gürdal, G. Kural, M. Kirmizi, İ. A. Atila, C. Tibet, S. Aydal, N. Aydin, E. Özgür, A. Özgür, O. Atvur, Ü. Atvur, S. B. İzgiz, N. Karagöz, *Antalya Museum*. Istanbul: Turkish Republic Ministry of Culture and Tourism.

Dohan 1928 = E. H. Dohan, "Three Greek Grave Monuments," *MusJ* 19, 3:249–60.

Dohan 1931 = E. H. Dohan, "Two Greek Sculptures," *UPMB* 2, 5:150–3.

Dohan 1936 = E. H. Dohan, "Two Syrian Sculptured Portraits," *UPMB* 6, 5:20–22.

Dono Hartwig 1994 = R. Paris, ed., *Dono Hartwig: Originali ricongiunti e copie tra Ann Arbor e Rome. Ipotesi per il Templum Gentis Flaviae*. Rome: Ministero per i Beni Culturali e Ambientali, Soprintendenza di Roma.

Downey 1977 = S. Downey, *The Excavations at Dura-Europos: The Stone and Plaster Sculpture*, Final Report III, Part I, fascicle 2. *Monumenta Archaeologica* 5. Los Angeles: Institute of Archaeology, University of California.

Drerup 1950 = H. Drerup, *Ägyptische Bildnisköpfe griechischer und römischer Zeit* (*Orbis Antiquus* Heft 3). Munster: Aschendorffsche Verlagsbuchhandlung.

Dwyer 1981 = E. J. Dwyer, "Pompeian oscilla collections," *RM*

88:247–306.

Dyggve, *et al.* 1934 = E. Dyggve, F. Poulsen, K. Rhomaios, *Das Heroon von Kalydon*. Copenhagen: Levin & Munksgaard.

Edwards 1996 = C. M. Edwards, "Lysippos," in O. Palagia and J. J. Pollitt, eds. *Personal Styles in Greek Sculpture. Yale Classical Studies* Vol 30, pp. 130–153. Cambridge/New York: Cambridge University Press.

Edwards 1957 = G. R. Edwards, "Panathenaics of Hellenistic and Roman Times," *Hesperia* 26:320–49.

Edwards 1958 = G. R. Edwards, "Italy and Rome," *UPMB* 22, 2:1–11.

Elliott 2004 = T. Elliott, *Europe, North Africa and West Asia: Physical Geography*. Chapel Hill, NC: Ancient World Mapping Center, University of North Carolina.

Emerson 1905 = A. Emerson, "Torso of a Hermes," *U. of Pa Transactions of the Dept. of Archaeology* I, 3:169–75.

Fabricius 1999 = J. Fabricius, *Die hellenistischen Totenmahlreliefs: Grabrepräsentation und Wertvorstellungen in ostgriechischen Städten*. Munich: Verlag Dr. Friedrich Pfeil.

Farrar 1998 = L. Farrar, *Ancient Roman Gardens*. Phoenix Mill: Sutton Publishing.

Fay 1959 = T. Fay, "*The Head*: A Neurosurgeon's Analysis of a Great Stone Portrait," *Expedition* 1, 4:12–18.

Felletti Maj *Ritratti* 1953 = B. M. Felletti Maj. *I Ritratti, Museo Nazionale Romano*. Rome: De Luca Editore.

Fink 1972 = J. Fink, "Germanicus-Porträt," *Antike und Universal Geschichte: Festschrift H. E. Stier*, pp.280–8. Munster: Aschendorff.

Fischer 1990 = M. L. Fischer. *Das korinthische Kapitell im Alten Israel in der hellenistischen und römischen Periode*. Mainz: Verlag Phillip von Zabern.

Fischer 1991 = M. L. Fischer, "Figured Capitals in Roman Palestine. Marble Imports and Local Stones: Some Aspects of 'Imperial' and 'Provincial' Art," *AA* 1991:119-144.

Fisher 1923 = C. Fisher, "Beth Shean: Excavations of the University Museum Expedition, 1921–1923," *MusJ* 14:227–48.

Fittschen 1970 = K. Fittschen, "Zum Kleobis- und Biton-Relief in Venedig," *JdI* 85:171–93.

Fittschen 1977 = K. Fitttschen, *Katalog der Antiken Skulpturen in Schloss Erbach*. Berlin: Gebr. Mann Verlag.

Fittschen 1984 = K. Fittschen, Review of J. Inan and E. Alföldi-Rosenbaum, *Römische und frühbyzantinische Porträtplastik aus der Türkei. Neue Funde*, in GGA 236:188–210.

Fittschen 1997 = K. Fittschen, "Privatporträts hadrianischer Zeit," in J. Bouzek and I Ondřejová, eds., *Roman Portraits: Artistic and Literary Acts of the Third International Conference on Roman Portraits* (Prague 1989), pp. 32–6. Mainz: P. von Zabern.

Fittschen 1999 = K. Fittschen, *Prinzenbildnisse Antoninischer Zeit*. Mainz: P. von Zabern.

Fittschen and Zanker *Katalog* = K. Fittschen and P. Zanker, *Katalog der römischen Porträts in den Capitolinischen Museen und den anderen kommunalen Sammlungen der Stadt Rom* I, 1985; III, 1983. Mainz: P. von Zabern.

FitzGerald 1931 = G. M. FitzGerald, *Beth Shan Excavations 1921–23: The Arab and Byzantine Levels*. Philadelphia: University Press for the University of Pennsylvania Museum.

Flinders Petrie 1896 = W. Flinders Petrie, *Koptos*. London: B. Quaritch.

Flower 2001 = H. I. Flower, "A Tale of Two Monuments: Domitian, Trajan, and Some Praetorians at Puteoli," *AJA* 105:625–48.

Foerster and Tsafrir 1992 = G. Foerster and Y. Tsafrir, "Nysa-Scythopolis in the Roman period: 'A Greek city of Coele Syria' —Evidence from the Excavations at Bet-Shean," *ARAM* 4:117-139.

Fourrier 2001 = S. Fourrier, "Naucratis, Chypre et la Grèce de l'Est: le commerce des sculptures 'chypro-ioniennes'," in U. Höckmann and D. Kreikenbom, eds., *Naukratis: Die Beziehungen zu Ostgriechenland, Ägypten und Zypern in archaischer Zeit*, pp. 39–54. Möhnesee: Bibliopolis.

Fowler 1905 = H. N. Fowler, "Archaeological News, 1905," *AJA* 9:335–88.

Francis 1998 = J. E. Francis, "Re-writing Attributions: Alkamenes and the Hermes Propylaios," in K. J. Hartswick and M. C. Sturgeon, eds., ΣΤΕΦΑΝΟΣ: *Studies in Honor of Brunilde Sismondo Ridgway*, pp. 61–8. Philadelphia: University of Pennlvania Museum.

Frel 1969 = J. Frel, *Les sculpteurs attiques anonymes: 430–300*. Prague: Universita Karlova.

Frel 1981 = J. Frel, *Roman Portraits in the Getty Museum*. Tulsa/Malibu: Philbrook Art Center and J. Paul Getty Museum.

Friis Johansen 1951 = K. Friis Johansen, *The Attic Grave-Reliefs of the Classical Period*. Copenhagen: E. Munksgaard.

Fuchs 1959 = W. Fuchs, *Die Vorbilder neuattischen Reliefs. JdI EH* 20. Berlin: W. de Gruyter.

Fuchs 1987 = M. Fuchs, *Untersuchungen zur Ausstattung Römischer Theater*. Mainz: P. von Zabern.

Fuchs 1999 = M. Fuchs, *In Hoc Etiam Genere Graeciae Nihil Cedamus: Studien zur Romanisierung der späthellenistischen Kunst im 1. Jh. v. Chr*. Mainz: P. von Zabern.

Fuhrmann 1940 = H. Fuhrmann, "Archäologische Grabungen und Funde in Italien und Libyen (Tripolis und Kyrene) Oktober 1938–Oktober 1939," *AA* 55:362–554.

Fuks 1976 = G. Fuks, *Scythopolis—A Study of a Greek City in the Near East*. D.Phil. Thesis: University of Oxford.

Fullerton 1990 = M. D. Fullerton, *The Archaistic Style in Roman Statuary. Mnemosyne Suppl.* 110. Leiden: E. J. Brill.

Furnée-van Zwet 1956 = L. Furnée-van Zwet, "Fashion in Women's Hair-Dress in the First Century of the Roman Empire," *BABesch* 31:1–22.

Furtwängler 1901 = A. Furtwängler, "Ancient Sculptures at Chatsworth House," *JHS* 21:209–28.

Furtwängler 1905 = A. Furtwängler, "Neue Denkmäler antiker Kunst III: Antiken in den Museen von Amerika," *SBMünch*: 241–80.

Furtwängler 1964 = A. Furtwängler, *Masterpieces of Greek Sculpture*, reprint. Chicago: Argonaut Publishers.

Gaber-Saletan 1986 = P. Gaber-Saletan, *Regional Styles in Cypriote Sculpture: The Sculpture from Idalion*. New York: Garland Publishers.

Gabrici 1908 = E. Gabrici, "Campania – Teano," *NSc*:399–416.

Gabrici 1909 = E. Gabrici, "Pozzuoli," *NSc*:212–15.

Gazda and Haeckl 1996 = E. K. Gazda and A. E. Haeckl, *Images of Empire: Flavian Fragments in Rome and Ann Arbor Rejoined*. Ann Arbor: University of Michigan Press.

Gercke 1968 = W. B. V. Gercke, *Untersuchungen zum römischen Kinderporträt*. Diss.: Hamburg U.

Getty Handbook 1991 = *The J. Paul Getty Museum Handbook of the Collections*. Malibu: J. Paul Getty Museum.

Ghini 1997a = G. Ghini, "Dedica a Iside e Bubastis del santuario di Diana Nemorense," in *Iside* 1997:335–7.

Ghini 1997b = G. Ghini, "The New Excavations in the Sanctuary of Diana," in *In the Sacred Grove of Diana*, pp. 79–182. Copenhagen: Ny

Carlsberg Glyptotek.

Ghini 2000 = G. Ghini, "Ricerche al santuario di Diana: risultati e progetti," in *Nemi—Status Quo*, pp. 53–64. Rome: L'Erma di Bretschneider.

Ghislanzoni 1915 = E. Ghislanzoni, "Notizie archeologiche sulla Cirenaica," *NotArch* I:65–239.

Ghislanzoni 1927a = E. Ghislanzoni, "Il Santuario delle Divinità Alessandrine," *NotArch* IV:147–206.

Ghislanzoni 1927b = E. Ghislanzoni, "Rilievo policromo di Bengasi," *AfrIt* 1:101–15.

Gjerstad *et al.* 1935 = E. Gjerstad, J. Lindros, E. Sjöqvist, and A. Westholm, *The Swedish Cyprus Expedition: Finds and Results of the Excavations in Cyprus 1927–1931.* Vol II. Stockholm: The Swedish Cyprus Expedition.

Giuliano 1957 = A. Giuliano, *Catalogo dei ritratti romani del Museo Profano Lateranense.* Vatican City: Tipografia poliglotta vaticana.

Giuliano 1979 = A. Giuliano, ed., *Museo Nazionale Romano—Le sculture*, I, 1. Rome: De Luca Editore.

Giuliano 1983 = A Giuliano, ed., *Museo Nazionale Romano—Le sculture*, I, 6. Rome: De Luca Editore.

Giuliano 1985 = A. Giuliano, ed., *Museo Nazionale Romano—Le sculture*, I, 8, part 1. Rome: De Luca Editore.

Giumlia 1983 = A. Giumlia, *Die neuattischen Doppelhermen.* Vienna: VWG.

Giustozzi 2001 = N. Giustozzi, "Gli dèi 'a pezzi': L'Hercules Πολυκλέους e la tecnica acrolitha nel II secolo a.C.," *BullComm* 102:7–82.

Gizzi 2000 = S. Gizzi, "Il restauro del santuario di Diana a Nemi: problemi e prospettive," in *Nemi—Status Quo*, pp. 65–82.

Goette 1984 = H. R. Goette, "Das Bildnis des Marcus Vilonius Varro in Kopenhagen: Zu den Basen von Portraitbüsten und zum Realismus flavisch-traianischer Bildnisse," *Boreas* 7:89–104.

Goodlet 1991 = V. C. Goodlett, "Rhodian Sculpture Workshops," *AJA* 95:669–81.

Gradel 1997 = I. Gradel, "Diana on Coinage," in *In the Sacred Grove of Diana*, pp. 200–3. Copenhagen: Ny Carlsberg Glyptotek.

Graindor 1939 = P. Graindor, *Bustes et Statues-Portraits d'Égypte Romaine.* Cairo: P. Barbey.

Grassinger 1991 = D. Grassinger, *Römische Marmorkratere.* Mainz: P. von Zabern.

Grassinger 1994 = D. Grassinger, "Die Marmorkratere." in *Das Wrack*: 259–83.

Grimm 1976 = G. Grimm, "Ein neues Bildnis Vespasians aus Ägypten," *Festschrift für Gerhard Kleiner*, pp. 101–3. Tübingen: E. Wasmuth.

Grove Dictionary of Art 1996 = J. Turner, ed., *Dictionary of Art.* London: MacMillan Publishers/New York: Grove Dictionaries.

Gualandi 1969 = G. Gualandi, "Artemis-Hekate. Un problema di tipologia nella scultura ellenistica," *RA* fasc. 2:233–72.

Gualandi 1976 = G. Gualandi, "Sculture di Rodi," *ASAtene* 54:7–259.

Guide to the Collections 1965 = *Guide to the Collections, The University Museum*, Philadelphia ("The Mediterranean World"), pp. 45–67. Philadelphia: The University Museum.

Guide to the Etruscan and Roman Worlds 2002 = D. White, A. B. Brownlee, I. B. Romano, and J. M. Turfa, *Guide to the Etruscan and Roman Worlds at the University of Pennsylvania Museum of Archaeology and Anthropology.* Philadelphia: University of Pennsylvania Museum of Archaeology and Anthropology.

Gulaki 1981 = A. Gulaki, *Klassische und Klassizistische Nikedarstellungen.* Diss.: Bonn.

Guldager Bilde 2005 = P. Guldager Bilde, "The Roman Villa by Lake Nemi: From Nature to Culture–between Private and Public," in A Klymne and B. Santilla Frizell, eds., *Roman Villas around the Urbs. Interaction with Landscape and Environment.* Proceedings of a conference at Swedish Institute in Rome, Sept. 17–18, 2004, pp. 1–10. Rome: Swedish Institute in Rome.

Guldager Bilde 1995 = P. Guldager Bilde, "The Sanctuary of Diana Nemorensis: The Late Republican Acrolithic Cult Statues," *ActaArch* 66:191–217.

Guldager Bilde 1997a = P. Guldager Bilde, "Chio d(onum) d(edit): Eight Marble Vases from the Sanctuary of Diana Nemorensis," *AnalRom* XXIV:53–81.

Guldager Bilde 1997b = P. Guldager Bilde, "The Cult-statues of the Sanctuary," in *In the Sacred Grove of Diana*, pp. 199–200. Copenhagen: Ny Carlsberg Glyptotek.

Guldager Bilde 1998 = P. Guldager Bilde, "'Those Nemi Sculptures…' Marbles from a Roman Sanctuary in the University of Pennsylvania Museum," *Expedition* 40:36–47.

Guldager Bilde 2000 = P. Guldager Bilde, "The Sculptures from the Sanctuary of Diana Nemorensis, Types and Contextualisation: An Overview," in *Nemi—Status Quo*, pp. 93–109. Rome: L'Erma di Bretschneider.

Guldager Bilde 2005 = P. Guldager Bilde, "The Roman Villa by Lake Nemi: From Nature to Culture—Between Private and Public," A. Klynne and B. Santillo Frizell, eds. *Roman Villas Around the Urbs. Interaction with Landscape and Environment.* Proceedings of conference held at Swedish Institute in Rome, Sept. 17–18, 2004, pp. 1–10.

Guldager Bilde and Moltesen 2002 = P. Guldager Bilde and M. Moltesen, *A Catalogue of Sculptures from the Sanctuary of Diana Nemorensis in the University of Pennsylvania Museum, Philadelphia.* Rome: G. Bretschneider.

Hackländer 1996 = N. Hackländer, *Der archaistische Dionysos: eine archäologische Untersuchung zur Bedeutung archaistischer Kunst in hellenistischer und römischer Zeit.* Frankfurt: Peter Lang.

Hänninen 2000 = M.-L. Hänninen, "Traces of Women's Devotion in the Sanctuary of Diana at Nemi," in *Nemi—Status Quo*, pp. 45–50. Rome: L'Erma di Bretschneider.

Hafner 1954 = G. Hafner, *Späthellenistische Bildplastik.* Berlin: Gebr. Mann Verlag.

Hall 1913a = E. H. Hall, "A Roman Relief from Pozzuoli," *MusJ* 4, 4:142–6.

Hall 1913b = E. H. Hall, "A Seated Dionysos," *MusJ* 4, 4:164–7.

Hall 1914a = E. H. Hall, "A Neo-Attic Relief and a Roman Portrait Head," *MusJ* 5, 1:26–30.

Hall 1914b = E. H. Hall, "A Colored Marble Statuette," *MusJ* 5, 2:115–16.

Hall 1914c = E. H. Hall, "A Roman Portrait Head," *MusJ* 5, 2:122–4.

Hall 1914d = E. H. Hall, "Two Marbles from Lake Nemi," *MusJ* 5, 2:118–121.

Hall 1921 = E. H. Hall, "An Archaic Head from Cyprus," *MusJ* 12, 3:201–3.

Harnett 1986 = Erika B. Harnett, *The Sculpture of Roman Minturnae.* Diss.: Bryn Mawr College. Bryn Mawr.

Harnett 1998 = E. B. Harnett, "Some Lost Sculptures from Minturnae," in K. J. Hartswick and M. C. Sturgeon, eds., ΣΤΕΦΑΝΟΣ: *Studies in*

Honor of Brunilde Sismondo Ridgway, pp. 101–4. Philadelphia: University Museum.

Harrison 1961 = E. B. Harrison, *The Athenian Agora*. Vol. I: *Portrait Sculpture*. Princeton: American School of Classical Studies at Athens.

Harrison 1965 = E. B. Harrison, *The Athenian Agora*. Vol. XI: *Archaic and Archaistic Sculpture*. Princeton: American School of Classical Studies at Athens.

Hartswick 2004 = K. J. Hartswick, *The Gardens of Sallust: A Changing Landscape*. Austin: University of Texas Press.

Haselberger and Romano 2002 = L. Haselberger and D. G. Romano, *Mapping Augustan Rome*. JRA Supplementary Series 50. Portsmouth, RI.

Haskell and Penny 1981 = F. Haskell and N. Penny, *Taste and the Antique. The Lure of Classical Sculpture 1500–1900*. New Haven: Yale University Press.

Hauser 1889 = F. Hauser, *Die neu-attischen Reliefs*. Stuttgart: K. Wittwer.

Herbert and Berlin 2003 = S. C. Herbert and A. Berlin, *Excavations at Coptos (Qift) in Upper Egypt, 1987–1992. JRA Supplementary Series* 53. Portsmouth, RI.

Hermary 1981 = A. Hermary, *Amathonte II: Testimonia*. Paris: Études Chypriotes.

Hermary 1989 = A. Hermary, *Musée du Louvre. Catalogue des antiquités de Chypre: Sculptures*. Paris: Éditions de la Réunion des musées nationaux.

Hermary 1991= A. Hermary, "Sculptures "Chrypro-ioniennes" du Musée de l'Ermitage à Leningrad," *RDAC*:173–8.

Hermary 1996 = A. Hermary, "Les Sculptures en Pierre," in D. Buitron-Oliver, *The Sanctuary of Apollo Hylates at Kourion: Excavations in the Archaic Precinct*, pp. 139–49. Jonsered: Paul Åströms Förlag.

Hermary 2000 = A. Hermary, *Amathonte V: Les Figurines en Terre Cuite Archaïques et Classiques, Les Sculptures en Pierre*. Paris: École Française d'Athènes.

Hermary 2001 = A. Hermary, "Naucratis et la sculpture égyptisante à Chypre," in U. Höckmann and D. Kreikenbom, eds., *Naukratis: Die Beziehungen zu Ostgriechenland, Ägypten und Zypern in archaischer Zeit*, pp. 27–38. Möhnesee: Bibliopolis.

Herrmann 1993 = A. Herrmann, "The Boy with the Jumping Weight," *BullClevMus* 80:299–323.

Higgins 1980 = R. Higgins, *Greek and Roman Jewellery*, 2nd ed. Berkeley: University of California Press.

Hill 1981 = D. K. Hill, "Some Sculpture from Roman Domestic Gardens," *Seventh Dumbarton Oaks Colloquium on the History of Landscape Architecture. Ancient Roman Gardens*, pp. 83–94. Washington, DC: Dumbarton Oaks.

Hillers and Cussini 1996 = D. R. Hillers and E. Cussini, *Palmyrene Aramaic Texts*. Baltimore: Johns Hopkins University Press.

Himmelmann-Wildschütz 1956 = N. Himmelmann-Wildschütz, *Studien zum Ilissos-Relief*. Munich: Prestel.

Hinks 1976 = R. P. Hinks, *Greek and Roman Portrait Sculpture*, 2nd ed. London: British Museum.

Hollinshead 2002 = M. Hollinshead, "Extending the Reach of Marble: Struts in Greek and Roman Sculpture," in E. Gazda, *The Ancient Art of Emulation: Studies in Artistic Originality and Tradition from the Present to Classical Antiquity*, pp. 117–52. Ann Arbor: University of Michigan Press.

Holtzmann 1980 = B. Holtzmann, "Sculptures Argienne (IV)," *BCH Supp*. VI: *Études Argiennes*, pp.185–94. Paris.

Homès-Fredericq 1963 = D. Homès-Fredericq, *Hatra et Ses Sculptures Parthes: Étude Stylistique et Iconographique*. Istanbul: Nederlands Historisch-Archaeologisch Instituut.

Hornbostel 1978 = W. Hornbostel, "Serapiaca I," in M. B. de Boer and T. A. Eldridge, eds., *Hommages à Maarten J. Vermaseren*, pp. 510–518. Leiden: E. J. Brill.

Howarth 1969 = J. L. Howarth, "A Palmyrene Head at Bryn Mawr College," *AJA* 73:441–6.

Hundsalz 1987 = B. Hundsalz, *Das dionysische Schmuckrelief*. Munich: Tuduv.

Hvidberg-Hansen 1998 = F. O. Hvidberg-Hansen, *The Palmyrene Inscriptions. Ny Carlsberg Glyptotek*. Copenhgen: Ny Carlsberg Glyptotek.

IG = *Inscriptiones Graecae*.

Inan and Rosenbaum 1966 = J. Inan and E. Rosenbaum, *Roman and Early Byzantine Portrait Sculpture in Asia Minor*. London: Oxford University Press for British Academy.

Inan and Alföldi-Rosenbaum 1979 = J. Inan and E. Alföldi-Rosenbaum, *Römische und frühbyzantinische Porträtplastik aus der Türkei. Neue Funde*. Mainz: P. von Zabern.

Ingholt 1928 = H. Ingholt, *Studier over Palmyrensk Skulptur*. Copenhagen: C. A. Reitzels Forlag.

Ingholt 1935 = H. Ingholt, "Five Dated Tombs from Palmyra," *Berytus* 2:57–120.

Ingholt 1954 = H. Ingholt, *Palmyrene and Gandharan Sculpture*. New Haven: Yale University.

In the Sacred Grove of Diana 1997 = P. Guldager Bilde and M. Moltesen, *In the Sacred Grove of Diana: Finds from a Sanctuary at Nemi*. Copenhagen: Ny Carlsberg Glyptotek.

Introduction to the Collections 1985 = L. Horne, ed., *Introduction to the Collections of the University Museum*. Philadelphia: University Museum.

James 1961 = F. W. James, "Beth Shan," *Expedition* 3, 2:31–36.

James, Kempinski, and Tzori 1975 = F. James, A. Kempinski, and N. Tzori, "Beth-Shean," in M. Avi-Yonah, ed., *Encyclopedia of Archaeological Excavation in the Holy Land*. Vol. I (English ed.), pp. 207–29. London: Oxford University Press.

Jensen 1984 = R. C. Jensen, "The Kourion Ballplayer," *Report of the Department of Antiquities, Cyprus, Nicosia*: 281–4.

Jockey 1995 = P. Jockey, "Unfinished Sculpture and Its Workshops on Delos in the Hellenistic Period," in Y. Maniatis, N. Herz, and Y. Basiakos, eds., *The Study of Marble and Other Stones Used in Antiquity*, ASMOSIA III, pp. 87–93. London: Archetype Publications.

Jockey 1998 = P. Jockey, "Neither School nor *Koine*: The Local Workshops of Delos and Their Unfinished Sculpture," in O. Palagia and W. Coulson, eds., *Regional Schools in Hellenistic Sculpture*, pp. 177–84. Oxford: Oxbow Books.

Jockey 1999 = P. Jockey, "La technique composite à Delos à l'époque hellénistique," in M. Schvoerer, ed., *Archéomatériaux: Marbres et autres roches. Actes de la IV Conference internationale*, ASMOSIA IV, pp. 305–16. Bordeaux: Presses Universitaires de Bordeaux.

Jockey 2000 = P. Jockey, ""Aphrodite Express:" À Propos d'une École(?) Délienne de Sculpture," in F. Blondé and A. Muller, *L'Artisanat en Grèce ancienne: les productions, les diffusions*, pp. 75–90. Lille: Université Charles-de-Gaulle.

Johannowsky 1952 = W. Johannowsky, "Contributi alla topografia della Campania antica. I: La via Puteolis-Neapolim," *RendNap* 27:83–146.

Johannowsky 1963 = W. Johannowsky, "Relazione Preliminare sugli scavi de Teano," *BdA* 48:131–165.

Johannowsky 1976 = W. Johannowsky, "Teanum Sidicinum (Teano)," in R. Stillwell, ed., *Princeton Encyclopedia of Classical Sites*, p. 888. Princeton: Princeton University Press.

Johansen 1994 = F. Johansen, *Catalogue Roman Portraits* I. Copenhagen: Ny Carlsberg Glyptotek.

Johnson 1931 = F. P. Johnson, *Corinth IX: Sculpture*. Cambridge, MA: Harvard University Press.

Johnson 1932a = J. Johnson, "Two Sculptures from Minturnae," *UPMB* 4, 1:9–12.

Johnson 1932b = J. Johnson, "The Excavation of Minturnae," *Art and Archaeology* 33:283–93.

Johnson 1933a = J. Johnson, "A Marble Head from Minturnae," *UPMB* 4, 2:49–53.

Johnson 1933b = J. Johnson, "A Marble Head from Minturnae," *UPMB*, 4, 3:67–70.

Johnson 1933c = J. Johnson, "Minturnae: A Résumé of the Initial Campaign," *BStM* 4:6–16.

Johnson 1936 = J. Johnson, "The Road to Empire—I," *Scientific American* 154:301–3.

Johnson 1940 = J. Johnson, *Minturnae, RE* Suppl. Vol. VII:458–93.

Johnson, Baldwin, and Strutt 2003 = P. Johnson, E. Baldwin, and K. Strutt, *Teanum Sidicinum: Geophysical Report—January 2003*. Rome: BSR/APSS.

Jones 1979 = B. W. Jones. *Domitian and the Senatorial Order. A Prosopographical Study of Domitian's Relationship with the Senate, AD 81–96*. Philadelphia: American Philosophical Society.

Jucker 1959 = H. Jucker, "Verkannte Köpfe," *MusHel* 16:275–91.

Jucker 1961 = H. Jucker, *Das Bildnis im Blätterkelch*. Lausanne: Urs Graf Verlag.

Jucker 1962 = H. Jucker, "Aegyptiaca. Betrachtungen zur kaiserzeitlichen Munz- und Porträtkunst Aegyptens," *Jdb. Bern Hist. Mus.* 41–42:289–331.

Jucker 1977 = H. Jucker, "Die Prinzen des Statuenzyklus aus Veleia," *JdI* 92:204–40.

Jucker 1981 = H. Jucker, "Römische Herrscherbildnisse aus Ägypten," *ANRW* II, 12, 2:667–725.

Kabus-Jahn 1963 = R. Kabus-Jahn, *Studien zur Frauenfiguren des vierten Jahrhunderts vor Christus*. Diss.: Freiburg im Breisgau/Darmstadt.

Kähler 1951 = H. Kähler, "Der Trajansbogen in Puteoli," *Studies Presented to D. M. Robinson* I, pp. 430–9. St. Louis: Washington University.

Känel 2000 = R. Känel, "Das Dianaheiligtum in Nemi: Die Baudekoration aus Terrakotta," in *Nemi—Status Quo*, pp. 131–9. Rome: L'Erma di Bretschneider.

Kahil and Augé 1981 = L. Kahil and C. Augé, *Mythologie Gréco-Romaine, Mythologies Périphériques*. Paris: Éditions du Centre National de la Recherche Scientifique.

Kansteiner 2000 = S. Kansteiner. *Herakles: Die Darstellungen in der Grossplastik der Antike*. Cologne: Böhlau Verlag.

Karageorghis 1993 = V. Karageorghis, *The Coroplastic Art of Ancient Cyprus Vol III: The Cypro-Archaic Period Large and Medium Size Sculpture*. Nicosia: A. G. Leventis Foundation.

Karageorghis 1994 = V. Karageorghis, *The Coroplastic Art of Ancient Cyprus Vol. IV: The Cypro-Archaic Period Small Figurines*. Nicosia: A. G. Leventis Foundation.

Karageorghis 2000 = V. Karageorghis, *Ancient Art from Cyprus: The Cesnola Collection*. New York: Metropolitan Museum of Art.

Karageorghis and Brennan 1999 = V. Karageorghis and T. P. Brennan, *Ayia Paraskevi Figurines in the University of Pennsylvania Museum*. Philadelphia: University Museum, University of Pennsylvania.

Keil 1855 = H. Keil, *Grammatici Latini*. Leipzig: B. G. Tevbneri.

Keppie 1991 = L. Keppie, *Understanding Roman Inscriptions*. Baltimore: Johns Hopkins University Press.

Kinney 1997 = D. Kinney, "Spolia. *Damnatio* and *Renovatio Memoriae*," *MAARome* XLII:117–48.

Kirkbride 1969 = D. Kirkbride, "Ancient Arabian Ancestor Idols," *Archaeology* 22:116–21, 188–95.

Kiss 1975a = Z. Kiss, *L'iconographie des princes julio-claudiens au temps d'Auguste et de Tibère*. Warsaw: Éditions scientifiques de Pologne.

Kiss 1975b = Z. Kiss, "Notes sur le portrait impérial romain en Egypte," *MDAIK* 31:293–302.

Kiss 1979 = Z. Kiss, "Une étape mal connue de l'art égyptien d'époque romaine: Les portraits de Caracalla," in W. F. Reineke, ed., *Actes du Ier Congrès International d'Egyptologie*, pp. 377–81. Berlin: Akademie Verlag.

Kiss 1984 = Z. Kiss, *Études sur le Portrait Impérial Romain en Egypte*. Warsaw: Éditions scientifiques de Pologne.

Kleiner 1983 = D. E. E. Kleiner, *The Monument of Philopappos in Athens*. Rome: G. Bretschneider.

Kleiner 1992 = D. E. E. Kleiner, *Roman Sculpture*. New Haven: Yale University Press.

Knittlmayer and Heilmeyer 1998 = B. Knittlmayer and W.-D. Heilmeyer, eds., *Staatliche Museen zu Berlin, Die Antikensammlung. Altes Museum—Pergamonmuseum*. Mainz: P. von Zabern.

Koch and Sichtermann 1982 = G. Koch and H. Sichtermann. *Römische Sarkophage*. Munich: C. H. Beck.

Koch-Brinkmann and Posamentir 2004a = U. Koch-Brinkmann and R. Posamentir, "Die Grabstele der Paramythion," in V. Brinkmann and R. Wünsche, eds., *Bunte Götter: Die Farbigkeit Antiker Skulptur*, pp. 149–55. Munich: Staatliche Antikensammlungen.

Koch-Brinkmann and Posamentir 2004b = U. Koch-Brinkmann and R. Posamentir, "Ornament und Malerei Einer Attischen Grablekythos," in V. Brinkmann and R. Wünsche, eds., *Bunte Götter: Die Farbigkeit Antiker Skulptur*, pp. 157–65. Munich: Staatliche Antikensammlungen.

Koeppel 1980 = G. M. Koeppel, "Fragments of a Domitianic Monument in Ann Arbor and Rome," *Bulletin of the Museum of Art and Archaeology, The University of Michigan* 3:14–29.

Koeppel, *Historischen Reliefs II*, 1984= G. Koeppel, "Die historischen Reliefs der römischen Kaiserzeit II: Stadtrömische Denkmäler unbekannter Bauzugehörigkeit aus flavischer Zeit," *BJb* 184:1–65.

Koeppel, *Historischen Reliefs III*, 1985= G. Koeppel, "Die historischen Reliefs der römischen Kaiserzeit III: Stadtrömische Denkmäler unbekannter Bauzugehörigkeit aus trajanischer Zeit," *BJb* 185:143–213.

Kokula 1984 = G. Kokula, *Marmorlutrophoren, AM-BH* 10. Berlin: Gebr. Mann Verlag.

Kondoleon 2000 = C. Kondoleon, *Antioch: The Lost Ancient City*. Princeton: Princeton University Press.

Koortbojian 2002 = M. Koortbojian, "Forms of Attention: Four Notes on Replication and Variation," in E. Gazda, ed., *The Ancient Art of Emulation: Studies in Artistic Originality and Tradition from the Present*

to *Classical Antiquity*, *MAAR* Supp. Vol. I, pp. 173–204. Ann Arbor: University of Michigan Press.

Kosmopoulou 2002 = A. Kosmopoulou, *The Iconography of Sculptured Statue Bases in the Archaic and Classical Periods*. Madison: University of Wisconsin Press.

Kourou *et al.* 2002 = N. Kourou, V. Karageorghis, Y. Maniatis, K. Polikreti, Y Bassiakos, and C. Xenophontos, *Statuettes of Cypriote Type Found in the Aegean: Provenience Studies*. Nicosia: Leventis Foundation.

Kraus 1954 = T. Kraus, "Bemerkungen zum Sessel des Dionysospriesters im Athener Dionysostheater," *JdI* 69:32–48.

Kreikenbom 1990 = D. Kreikenbom, *Bildwerke nach Polyklet: kopienkritische Untersuchungen zu den männlichen statuaruschen Typen nach polykletischen Vorbildern*. Berlin: Gebr. Mann Verlag.

Kron 1989 = U. Kron, "Götterkronen und Priesterdiademe: Zu den griechischen Ursprüngen der sog. Büstenkronen," in N. Başgelen and M. Lugal, *Festschrift für Jale İnan*, pp. 373–90. Istanbul: Arkeoloji ve Sanat Yayinlari.

Kruse 1975 = H.-J. Kruse, *Römische weibliche Gewandstatuen des zweiten Jahrhunderts n. Ch.* Göttingen: Deutschen Archäologisches Instituts.

Kyrieleis 1989 = H. Kyrieleis, "New Cypriot Finds from the Heraion of Samos," in V. Tatton-Brown, ed., *Cyprus and the East Mediterranean in the Iron Age, Proceedings of the Seventh British Museum Classical Colloquium*, April 1988, pp. 52–67. London: British Museum Publications.

Landwehr 1990 = C. Landwehr, "Die Sitzstatue eines bärtigen Gottes in Cherchel: Zur Originalität römischer Vatergottdarstellungen," in B. Andreae, ed., *Phyromachos-Probleme*, pp. 101–22. Mainz: P. von Zabern.

Landwehr 1992 = C. Landwehr, "Juba II. Als Diomedes?," *JdI* 107:103–24.

La Regina 1998 = A. La Regina, ed., *Museo Nazionale Romano, Palazzo Massimo alle Terme*. Rome: Electa.

Lawrence 1927 = A. W. Lawrence, *Later Greek Sculpture and Its Influence on East and West*. New York: Harcourt, Brace.

Lazzarini 2002 = L. Lazzarini, "La determinazione della provenienza delle pietre decorative usate dai romani," in M. DeNuccio and L. Ungaro, eds., *I Marmi Colorati della Roma Imperiale*, pp. 223–65. Venice: Marsilio.

Leander Touati 1987 = A. M. Leander Touati, *The Great Trajanic Frieze: The Study of a Monument and the Mechanism of Message Transmission in Roman Art*. *Acta Instituti Romani Regni Sueciae* XLV. Rome/Stockholm: Svenska Institutet.

LeBohec 1989 = Y. LeBohec, *L'armée romaine sous le haut-empire*. Paris: Éditions du Centre national de la recherche scientifique.

Legrain 1927 = L. Legrain, "Tomb Sculptures from Palmyra," *MusJ* 18, 4:325–50.

Legrain 1928 = L. Legrain, "Small Sculptures from Babylonian Tombs," *MusJ* 19, 2:195–212.

LIMC = *Lexicon Iconographicum Mythologiae Classicae*, Vol. I (1981); Vol. II (1984); Vol. III (1986); Vol. IV (1988); Vol V (1990); Vol VI (1992); Vol. VII (1994); Vol. VIII (1997). Zurich/Munich: Artemis Verlag.

Lippold 1923 = G. Lippold, *Kopien und Umbildungen Griechischer Statuen*. Munich: O. Beck.

Lippold 1950 = G. Lippold, *Handbuch der Archäologie*, III, 1. Munich: C. H. Beck.

Lippold 1956 = G. Lippold, *Die Skulpturen des Vaticanischen Museums* vol. III:2. Berlin: W. De Gruyter.

Livi 2002 = V. Livi, "A Story Told in Pieces: Architectural Terracottas from Minturnae," *Expedition* 44:24–35.

L'Orange 1984 = H. P. L'Orange, *Das spätantike Herrscherbild von Diokletian bis zu den Konstantin-Söhnen: 284–361 n. Chr.* in M. Wegner, series ed., *Das Römische Herrscherbild*, pp. 3–140. Berlin: Verlag Gebr. Mann.

Luce 1916 = S. B. Luce, "A Greek Torso," *MusJ* 7, 2:87–8.

Luce 1917 = S. B. Luce, "An Attic Grave Stele," *MusJ* 8, 1:10–14.

Luce 1921 = S. B. Luce, *Catalogue of the Mediterranean Section, The University Museum*. Philadelphia: University Museum.

Luce 1930 = S. B. Luce, "Studies of the Exploits of Herakles on Vases," *AJA* 34:313–33.

MacCormick 1983 = A. G. MacCormick, ed., *Mysteries of Diana: The Antiquities from Nemi in Nottingham Museums*. Nottingham: Castle Museum Nottingham.

Mackay 1949 = D. Mackay, "The Jewellery of Palmyra and Its Significance," *Iraq* 11:160–87.

Madeira 1964 = P. Madeira, *Men in Search of Man*. Philadelphia: University of Pennsylvania Press.

Maderna 1988 = C. Maderna, *Iuppiter, Diomedes, und Merkur als Vorbilder für Römische Bildnisstatuen*. Heidelberg: Verlag Archäologie und Geschichte.

Magi 1945 = F. Magi, *I Rilievi Flavi del Palazzo della Cancelleria*. Rome: Presso la Pontificia accademia romana di archeologia.

Manderscheid 1981 = H. Manderscheid, *Die Skulpturen Ausstattung der Kaiserzeitlichen Thermenanlagen*. Berlin: Gebr. Mann Verlag.

Mansuelli 1958 = G. A. Mansuelli, *Galleria degli Uffizi: Le Sculture* I. Rome: Istituto poligrafico dello Stato.

Marble in Antiquity 1992 = H. Dodge and B. Ward-Perkins, eds., *Marble in Antiquity: Collected Papers of J. B. Ward-Perkins*. Rome: British School at Rome.

Marcadé 1957 = J. Marcadé, *Recueil des signatures de sculpteurs grecs* II. Paris: E. de Boccard.

Marcadé 1969 = J. Marcadé, *Au Musée de Délos: Étude sur la sculpture en ronde bosse découverte dans l'ile*. Paris: E. de Boccard.

Mariani 1897 = L. Mariani, "Regione I (Latium et Campania)," *NSc* 5:148–50.

Mariani 1913–1914 = L. Mariani, "La Venere di Cirene," *Annuario dell'Accademia di S. Luca*: 14–18.

Mariani 1914 = L. Mariani, "L'Afrodite di Cirene," *BdA* VIII:177–84.

Marmi Colorati 2002 = M. DeNuccio and L. Ungaro, eds., *I Marmi Colorati della Roma Imperiale*. Venice: Marsilio.

Martin 1987 = H. G. Martin, *Römische Tempelkultbilder. Eine archäologische Untersuchungen zur späten Republik*. Rome: L'Erma di Bretschneider.

Marvin 1997 = M. Marvin, "Roman Sculptural Reproductions or Polykleitos: The Sequel," in A. Hughes and E. Ranfft, *Sculpture and Its Reproductions*, pp. 7–28. London: Reaktion Books.

Massner 1982 = K. Massner, *Bildnisangleichung: Untersuchungen zur Entstehungs- und Wirkungsgeschichte der Augustusporträts (43 v. Chr.–68 n. Chr.)*. Berlin: Gebr. Mann Verlag.

Masson 1998 = O. Masson, "Les ex-voto trouvés par L. Palma di Cesnola à Golgoi en 1870," in M. Amandry, H. Cassimatis, A. Coubet, and A. Hermary, eds., *Mélanges Olivier Masson*, Cahier 27, pp. 25–9. Paris: Centre d'Études Chypriotes.

Mastrokostas 1966 = E. I. Mastrokostas, "ΕΠΙΣΤΗΜΑΤΑ ΕΚ ΜΥΡΡΙΝΟΥΝΤΟΣ," in ΧΑΡΙΣΤΗΡΙΟΝ ΕΙΣ Α. Κ. ΟΡΛΑΝΔΟΝ Vol. III, pp. 281–99. Athens: Bibliotheki tis Athenais Archeologikis Hetaireias.

Matheson 1996 = S. B. Matheson, "The Divine Claudia: Women as Goddesses in Roman Art," in D. E. E. Kleiner and S. B. Matheson, eds., *I Claudia: Women in Ancient Rome*, pp. 182–93. New Haven: Yale University Art Gallery.

Matthews 1958–59 = K. D. Matthews, "Portrait of a Hero," *Expedition* 1:36–37.

Matthews 1966 = K. D. Matthews, "Domitian: The Lost Divinity," *Expedition* 8:30–36.

Matthews 1970 = K. D. Matthews, "The Imperial Wardrobe of Ancient Rome," *Expedition* 12:2–13.

Mattusch 1994 = C. C. Mattusch, "Bronze Herm of Dionysos," in *Das Wrack*, pp. 431–50.

Mattusch 1998 = C. C. Mattusch, "Rhodian Sculpture: A School, a Style, or Many Workshops," in O. Palagia and W. Coulson, eds., *Regional Schools in Hellenistic Sculpture*, pp. 149–56. Oxford: Oxbow Books.

Mattusch 2004 = C. C. Mattusch, *The Villa dei Papiri at Herculaneum. Life and Afterlife of a Sculpture Collection*. Los Angeles: J. Paul Getty Museum.

Matz 1969 = F. Matz, *Die dionysischen Sarkophage*, Vol. II. Berlin: Gebr. Mann Verlag.

Matz and von Duhm 1881 = F. Matz and F. von Duhm, *Antike Bildwerke in Rom mit Ausschluss der grösseren Sammlungen*. I. Leipzig: Verlag Karl W. Hiersemann.

Μαχαίρα 1998 = β. Μαχαίρα, "Παρατηρήσεις σχετικά με τη Θεματική παραγωγή της 'Σχολής' της Ρόδου," in O. Palagia and W. Coulson, eds., *Regional Schools in Hellenistic Sculpture*, pp. 137–48. Oxford: Oxbow Books.

Mazar, Foerster, and Tzori 1993 = A. Mazar, G. Foerster, and N. Tzori, "Beth-Shean," in E. Stern, ed., *The New Encyclopedia of Archaeological Excavations in the Holy Land*, pp. 214–35. Jerusalem: Israel Exploration Society and Carta.

McFadden 1951 = G. McFadden, "Archaeological News—Cyprus," *AJA* 55:167–70.

McFadden 1952a = G. McFadden, "Archaeological News—Cyprus," *AJA* 56:128–31.

McFadden, 1952b = G. McFadden, "Eleven Hundred Years of the Worship of Apollo of the Woodlands," *Illustrated London News* 5 April: 588–90.

Merker 1973 = G. Merker, *The Hellenistic Sculpture of Rhodes*. Göteborg: P. Åströms.

Meyer 1989 = M. Meyer, "Alte Männer auf attischen Grabdenkmälern," *AM* 104:49–82.

Michon 1913 = E. Michon, "Nouvelles statuettes d'Aphrodite provenant d'Egypt," *MonPiot* 21:163–171.

Milne 1898 = J. G. Milne, *A History of Egypt under Roman Rule*, Vol. V. London: Methuen and Co.

Mingazzini 1958 = P. Mingazzini, "Apelles," *Enciclopedia Universale dell'Arte*, Vol. I, p. 472. Venice.

Minturnae I 1935 = J. Johnson, *Excavations at Minturnae* I. Philadelphia: University of Pennsylvania Press.

Minturnae II = J. Johnson, *Excavations at Minturnae* II. Philadelphia: University of Pennsylvania Press, 1933.

Moltesen 1995 = M. Moltesen, *Greece in the Classical Period: Ny Carlsberg Glyptotek*. Copenhagen: Ny Carlsberg Glyptotek.

Moltesen 1997 = M. Moltesen, "Up the Nile at Nemi," in B. Magnusson, S. Renzetti, P. Vian, S. J. Voicu, eds., *Ultra Terminum Vagari: Scritti in onore di Carl Nylander*, pp. 211–17. Rome: Edizioni Quasar.

Moltesen 2000 = M. Moltesen, "The Marbles from Nemi in Exile: Sculpture in Copenhagen, Nottingham, and Philadelphia," *Nemi—Status Quo*, pp. 111–19. Rome: L'Erma di Bretschneider.

Moltesen, Romano, and Herz 2002 = M. Moltesen, I. Bald Romano, and N. Herz, "Stable Isotopic Analysis of Sculpture from the Sanctuary of Diana at Nemi, Italy," in L. Lazzarini, ed., *Interdisciplinary Studies on Ancient Stone, ASMOSIA VI: Proceedings of the Sixth International Conference*, pp. 101–6. Padova: Bottega d'Erasmo, Aldo Ausilio Editore.

Montemartini 1999 = M. Bertoletti, M. Cima, and E. Talamo, eds., *Sculptures of Ancient Rome: The Collections of the Capitoline Museum of the Montemartini Power Plant*. Rome: Electa.

Moreno 1984 = P. Moreno, "Argomenti lisippei," *Xenia* 8:21–26.

Moreno 1995 = P. Moreno, *Lisippo: L'arte e la fortuna*. Milan: Fabbri Editore.

Morpurgo 1931 = L. Morpurgo, "Nemi – Teatro e altri edifici in contrada 'La Valle'," *NSc* 6, ser. 7:237–309.

Morrow 1985 = K. M. Morrow, *Greek Footwear and the Dating of Sculpture*. Madison: University of Wisconsin Press.

Moss 1988 = C. F. Moss, *Roman Marble Tables*. Diss.: Princeton University.

Masson 1998 = O. Masson, "Les ex-voto trouvés par L. Palma di Cesnola à Golgoi en 1870," in M. Amandry, H. Cassimatis, A. Coubet, and A. Hermary, eds., *Mélanges Olivier Masson*. Centre d'Études Chypriotes, cahier 27, pp. 25–29. Paris: E. de Boccard.

Mostra d'arte antica 1932 = Exhibition Catalogue, *Mostra d'arte antica*. Rome: Soprintendenza di Roma.

Müller 1927 = V. Müller, "Zwei Syrische Bildnisse römischer Zeit," *BerlWPr* 86:1–33.

Müller 1932 = V. Müller, "A Portrait of the Late Roman Empire," *MusJ* 23:45–54.

Musche 1988 = B. Musche, *Vorderasiatischer Schmuck zur Zeit der Arsakiden und der Sasaniden*. Leiden: E. J. Brill.

Negev 1976 = A. Negev, "Scythopolis," *Princeton Encyclopedia of Classical Sites*, pp. 815–6. Princeton: Princeton University Press.

Nemi—Status Quo 2000 = J. R. Brandt, A.-M. Leander Touati, and J. Jahle, eds., *Nemi—Status Quo: Recent Research at Nemi and the Sanctuary of Diana*. Rome: L'Erma di Bretschneider.

Neudecker 1988 = R. Neudecker, *Die Skulpturen-Ausstattung Römischer Villen in Italien*. Mainz: P. von Zabern.

Neugebauer 1921 = K. A. Neugebauer, *Asklepios*. *BerlWPr* 78:3–53.

Nick 2001 = G. Nick, "Typologie der Plastik des zyprischen und des 'Mischstils' aus Naukratis," in U. Höckmann and D. Kreikenbom, eds., *Naukratis: Die Beziehungen zu Ostgriechenland, Ägypten und Zypern in archaischer Zeit*, pp. 55–67. Möhnesee: Bibliopolis.

Nielsen and Østergaard 1997 = A. M. Nielsen and J. Stubbe Østergaard, *Catalogue: The Eastern Mediterranean in the Hellenistic Period*. Copenhagen: Ny Carlsberg Glyptotek.

Nieto Ibáñez 1999 = J.-M. Nieto Ibáñez, "The Sacred Grove of Scythopolis (Flavius Josephus, *Jewish War* II 466–471)," *IEJ* 49:260–8.

Nodelman 1964 = S. A. Nodelman, *Severan Imperial Portraiture AD 193–217*. Diss.: Yale University.

*OCD*² 1970 = N. G. L Hammond and H. H. Scullard, eds., *Oxford Classical Dictionary*, 3rd ed. Oxford: Oxford University Press.

Of Time and the Image 1965 = Exhibition Catalogue, *Of Time and the Image: Three Periods of Change*. Philadelphia: Philadelphia College of Art.

Ohnefalsch-Richter 1893 = M Ohnefalsch-Richter, *Kypros, the Bible*

Bibliography

and Homer. London: Asher and Co.

Oren 1973 = E. Oren, The Northern Cemetery of Beth Shan. Leiden: E. J. Brill.

Østergaard 1996 = J. Stubbe Østergaard, *Imperial Rome*. Copenhagen: Ny Carlsberg Glyptotek.

Ovadiah and Turnheim 1994 = A. Ovadiah and Y. Turnheim, *"Peopled" Scrolls in Roman Architectural Decoration in Israel: The Roman Theatre at Beth Shean/Scythopolis*. Rome: G. Bretschneider.

Packer 1997 = J. E. Packer, *The Forum of Trajan in Rome: A Study of the Monuments*. Berkeley: University of California Press.

Padgett 2001 = M. Padgett, ed., *Roman Sculpture in the Art Museum, Princeton University*. Princeton: Princeton University Press.

Paribeni 1959 = E. Paribeni. *Catalogo delle sculture di Cirene: statue e rilievi di carattere religioso*. Rome: L'Erma di Bretschneider.

Parlasca 1966 = K. Parlasca, *Mumienporträts und verwandte Denkmäler*. Wiesbaden: Steiner.

Parlasca 1982 = K. Parlasca, *Syrische Grabreliefs hellenistischer und römischer Zeit*. Mainz: P. von Zabern.

Parlasca 1994 = K. Parlasca, "Eine Palmyrenische Tierkopffibel in Privatbesitz," *ArchKorres* 24:299–309.

Parlasca 1995 = K. Parlasca, "Some Problems of Palmyrene Plastic Art," in S. AbouZayd, ed., *Palmyra and the Aramaeans*. ARAM (Society for Syro-Mesopotamian Studies) Vol. 7:59–71.

Parlasca 1999 = K. Parlasca, "Palmyra und die Arabische Kultur. Tradition und Rezeption," in K. Parlasca, ed., *Palmyra und die Arabische Kultur. Tradition und Rezeption*, pp. 269–80. Beirut/Stuttgart: Franz Steiner Verlag.

Parlasca 2001 = K. Parlasca, catalogue entries in J. Charles-Gaffiot, H. Lavagne, and J.-M. Hofmann, eds., *Moi, Zénobia, Reine de Palmyre*. Paris: Skira.

Pedley 1998 = J. Pedley, "Problems in Provenance and Patronage: A Group of Late Hellenistic Statuettes from Paestum," in O. Palagia and W. Coulson, eds., *Regional Schools in Hellenistic Sculpture*, pp. 199–208. Oxford: Oxbow Books.

Perkins 1973 = A. Perkins, *The Art of Dura-Europos*. Oxford: Clarendon Press.

Perrot 1906 = G. Perrot, "Une Statuette de la Cyrénaïque et l'Aphrodite Anadyomène d'Apelle," *MonPiot* 13:117–35.

Peters 1904 = J. P. Peters, *Nippur or Explorations and Adventures on the Euphrates*, Vol. 2. New York: G. P. Putnam's Sons.

Petriaggi 2003 = R. Petriaggi, ed., *Il Satiro Danzante*. Milan: Leonardo International.

Pfisterer-Haas 1990 = S. Pfisterer-Haas, "Ältere Frauen auf attischen Grabdenkmälern," *AM* 105:170–96.

Pfuhl and Möbius 1977 = E. Pfuhl and H. Möbius, *Die Ostgriechischen Grabreliefs* I. Mainz: P. von Zabern.

Pfulh and Möbius 1979 = E. Pfuhl and H. Möbius, *Die Ostgriechischen Grabreliefs* II. Mainz: P. von Zabern.

Picard 1948 = C. Picard, *Manuel d'archéologie grecque* III. Paris: A. Picard.

Pietrangeli 1949 = C. Pietrangeli, *Principali Gruppi di ritratti giulio-claudi rinvenuti nel Mondo Romano*. Agrigento.

Ploug 1995 = G. Ploug, *Catalogue of the Palmyrene Sculptures—Ny Carlsberg Glyptotek*. Copenhagen: Ny Carlsberg Glyptotek.

Pochmarski 1974 = E. Pochmarski, *Das Bild des Dionysos in der Rundplastik der klassischen Zeit Griechenlands*. Ph.D. Diss.: Graz.

Pochmarski 1990 = E. Pochmarski, *Dionysische Gruppen: eine typolo-*

gische Untersuchung zur Geschichte des Stützmotivs. Vienna: Österreichischen Archäologischen Instituts.

Polaschek 1971 = K. Polaschek, "Zur Zeitstellung einiger römischer Bildnisse im Landesmuseum Trier," *TriererZeit* 34:119–42.

Polaschek 1973 = K. Polaschek, *Studien zur Ikonographie der Antonia Minor*. Rome: "L'Erma" di Bretschneider.

Pollini 1996 = J. Pollini, "The 'Dart Aphrodite': A New Replica of the 'Arles Aphrodite Type', the Cult Image of Venus Victrix in Pompey's Theater at Rome, and Venusian Ideology and Politics in the Late Republic-Early Principate," *Latomus* 55:757–83.

Pollini 1987 = J. Pollini, *The Portraiture of Gaius and Lucius Caesar*. New York: Fordham University Press.

Pollini 1995 = J. Pollini, "The Augustus from Prima Porta and the Transformation of the Polykleitan Heroic Ideal: The Rhetoric of Art," in W. G. Moon, *Polykleitos, the Doryphoros, and Tradition*, pp. 262–82. Madison: University of Wisconsin Press.

Pollitt 1986 = J. J. Pollitt, *Art in the Hellenistic Age*. Cambridge: Cambridge University Press.

Porter and Moss 1937 = B. Porter and R. Moss, *Topographical Bibliography of Ancient Egyptian Hieroglyphic Texts, Reliefs and Paintings* Vol. V: Upper Egypt: Sites. Oxford: Clarendon Press.

Portraits and Propaganda 1989 = R. Winkes, ed., *Portraits and Propaganda: Faces of Rome*. Providence, RI: Brown University.

Posamentir 2001 = R. Posamentir, "Zur Wiedergewinnung und Bedeutung Bemalter Grabstelen im Klassischen Athen," in G. Hoffmann and A. Lezzi-Hafter, eds., *Les Pierres de l'offrande: Autour de l'oeuvre de Christoph W. Clairmont*, pp. 52–64. Kilchberg: Akanthus.

Poulsen 1921 = F. Poulsen, *Ikonographische Miscellen*. Copenhagen: A. F. Host.

Poulsen 1933 = F. Poulsen, *Sculptures antiques des musées de Province espanols*. Copenhagen: Levin and Munksgaard.

Poulsen 1951 = F. Poulsen, *Catalogue of Ancient Sculpture in the Ny Carlsberg Glyptotek*. Copenhagen: Ny Carlsberg Glyptotek.

Poulsen 1960 = V. Poulsen, *Claudische Prinzen*. Baden Baden: B. Grimm Verlag.

Pressouyre 1984 = S. Pressouyre, *Nicolas Cordier: recherches sur la sculpture à Rome autour de 1600*. Rome: École française de Rome.

Quick 2004 = J. Quick, ed., *Magnificent Objects from the University of Pennsylvania Museum of Archaeology and Anthropology*. Philadelphia: University of Pennsylvania Museum.

Raehs 1990 = A. Raehs, *Zur Ikonographie des Hermaphroditen*. Frankfurt: Peter Lang Verlag.

Raftopoulou 2000 = E. G. Raftopoulou, *Figures Enfantines du Musée National d'Athènes*. Athens: Deutsches Archäologisches Institut Athen.

Raggio forthcoming 2005 = O. Raggio, "A Giustiniani Bacchus and François Duquesnoy," *MMAJ* 40.

Rambo 1919 = E. F. Rambo, "A Group of Funerary Stelae," *MusJ* 10, 3:149–55.

Rambo 1920 = E. E. Rambo, "Greek and Roman Sculpture," *MusJ* 11, 2:36–7.

Ranke 1950 = H. Ranke, "The Egyptian Collection of the University Museum," *UPMB* 15, 2–3:5–109.

Reinach 1897 = S. Reinach, *Répertoire de la statuaire grecque et romaine* II, pt. II. Paris: E. Leroux.

Reinach 1910 = S. Reinach, *Répertoire de la statuaire grecque et romaine* IV. Paris: E. Leroux.

321

Reinach 1912a = S. Reinach, "Courrier de l'art antique," *Gazette des Beaux Arts*:59–73.

Reinach 1912b = S. Reinach, *Repertoire de reliefs grecs et romaines* II. Paris: E. Leroux.

Reinach 1924 = S. Reinach, *Répertoire de la statuaire grecque et romaine* V. Paris: E. Leroux.

Richter 1948 = G. M. A. Richter, *Roman Portraits*. New York: Metropolitan Museum of Art.

Richter 1954a = G. M. A. Richter, *Catalogue of Greek Sculptures, Metropolitan Museum of Art*. Cambridge, MA: Harvard University Press.

Richter 1954b = G. M. A. Richter, "Family Groups on Attic Grave Monuments," in *Neue Beiträge zum klass. Altertumswissenschaft (Festschrift Schweitzer)*, pp. 256–9. Stuttgart: W. Kohlhammer.

Richter 1965 = G. M. A. Richter, *The Portraits of the Greeks* Vol. II. London: Phaidon Press.

Richter 1966 = G. M. A. Richter, *The Furniture of the Greeks, Etruscans, and Romans*. London: Phaidon Press.

Ridgway 1972 = B. S. Ridgway, *Museum of Art Rhode Island School of Design: Classical Sculpture*. Providence, RI: RISD.

Ridgway *Fifth Century Styles* 1981 = B. S. Ridgway, *Fifth Century Styles in Greek Sculpture*. Princeton: Princeton University Press.

Ridgway *Fourth Century Styles* 1997 = B.S. Ridgway, *Fourth-Century Styles in Greek Sculpture*. Madison: University of Wisconsin Press.

Ridgway *Hellenistic Sculpture I* 1990 = B. S. Ridgway, *Hellenistic Sculpture I: The Styles of ca. 331–200 BC*. Madison: University of Wisconsin Press.

Ridgway *Hellenistic Sculpture II* 2000 = B. S. Ridgway, *Hellenistic Sculpture II: The Styles of ca. 200–100 BC*. Madison: University of Wisconsin Press.

Ridgway *Hellenistic Sculpture III* 2002 = B. S. Ridgway, *Hellenistic Sculpture III: The Styles of ca. 100–31 BC*. Madison: University of Wisconsin Press.

Ridgway *Roman Copies* 1984 = B. S. Ridgway, *Roman Copies of Greek Sculpture: The Problem of the Originals*. Ann Arbor: University of Michigan Press.

Ridgway 1976 = B. S. Ridgway, "The Aphrodite of Arles," *AJA* 80:147–54.

Ridgway 1995 = B. S. Ridgway, "*Paene ad exemplum*: Polykleitos' Other Works," in W. G. Moon, ed., *Polykleitos, the Doryphoros, and Tradition*, pp. 177–99. Madison: University of Wisconsin Press.

Ridgway 1996 = B. S. Ridgway, "Is the Hope Head an Italian Goddess? A Case of Circumstantial Evidence," *Expedition* 38, 3:55–62.

Ridgway 1997 = B. S. Ridgway, "A Goddess in Philadelphia," in *VLTRA TERMINVM VAGARI: Scritti in onore di Carl Nylander*, pp. 271–9. Rome: Editori Quasar.

Riemann 1940 = H. Riemann, *Kerameikos, Ergebnisse der Ausgrabungen 2: Die Skulpturen vom 5. Jahrhundert bis in römische Zeit*. Berlin: W. de Gruyter.

Robertson 1975 = M. Robertson, *A History of Greek Art*. London: Cambridge University Press.

Robinson 1940 = D. M. Robinson, "A New Marble Bust of Menander, Wrongly Called Vergil," *PAPS* 83:465–77.

Robl 1970 = C. Robl, *Ancient Portraits*. Chapel Hill, NC: Ackland Art Center.

Röwer 1980 = R. Röwer, *Studien zur Kopienkritik frühhellenistischer Porträts*. Diss: Munich.

Roller 1999 = L. E. Roller, *In Search of God the Mother: The Cult of Anatolian Cybele*. Berkeley: University of California Press.

Romano 1980 = I. Bald Romano, *Early Greek Cult Images*. Diss.: University of Pennsylvania.

Romano and Romano 1999 = D. G. Romano and I. B. Romano, *Catalogue of the Classical Collections of the Glencairn Museum*. Bryn Athyn: Glencairn Museum.

Romans and Barbarians 1976 = *Roman and Barbarians*. Exhibition Catalogue. Boston: Museum of Fine Arts.

Rose 1997 = C. B. Rose, *Dynastic Commemoration and Imperial Portraiture in the Julio-Claudian Period*. Cambridge: Cambridge University Press.

Rosenbaum 1960 = E. Rosenbaum, *A Catalogue of Cyrenaican Portrait Sculpture*. London: Oxford University Press.

Rotili 1972 = M. Rotili, *L'arco di Traiano a Benevento*. Rome: Istituto poligrafico dello Stato.

Roullet 1972 = A. Roullet, *The Egyptian and Egyptianizing Monuments of Imperial Rome*. Leiden: E. J. Brill.

Rowe 1927 = A. Rowe, "The Discoveries at Beth-Shan during the 1926 Season," *MusJ* 18:9–45.

Rowe 1930 = A. Rowe, *The Topography and History of Beth-Shan*. Philadelphia: University Press for University of Pennsylvania Museum.

Ruegg 1995 = S. D. Ruegg, *Underwater Investigations at Roman Minturnae* II. Jonsered: P. Åströms.

Rumscheid 2000 = J. Rumscheid, *Kranz und Krone: Zu Insignien, Siegespreisen und Ehrenzeichen der römischen Kaiserzeit*. InstForsch 43. Tübingen: E. Wasmuth.

Sadurska and Bounni 1994 = A. Sadurska and A. Bounni, *Les sculptures funéraires de Palmyre*. Rivista di archeologia suppl. 13. Rome: G. Bretschneider.

Säflund 1973 = G. Säflund, "Il Germanico del Museo del Louvre. Proposta di Identificazione e di Interpretazione," *OpRom* 9:1–18.

Sauter 2002 = E. Sauter, "Das Relief aus Epidauros, Athen, National Museum Inv. 1425 und 1425β," *Antike Plastik* 28:125–162.

Schlumberger 1951 = D. Schlumberger, *La Palmyrène du nord-ouest*. Paris: Librairie Orientaliste Paul Geuthner.

Schmaltz 1970 = B. Schmaltz, *Untersuchungen zu den attischen Marmorlekythen*. Berlin: Gebr. Mann Verlag.

Schmidt 1968 = G. Schmidt, *Samos Bd VII: Kyprische Bildwerke aus dem Heraion von Samos*. Bonn: R. Habelt.

Schmidt-Colinet 1992 = A. Schmidt-Colinet, *Das Tempelgrab Nr. 36 in Palmyra: Studien zur Palmyrenischen Grabarchitektur und Ihrer Ausstattung*. Mainz: P. von Zabern.

Schneider 1986 = R. M. Schneider. *Bunte Barbaren*. Worms: Wernersche Verlagsgesellschaft Worms.

Schneider 1999 = C. Schneider, *Die Musengruppe von Milet*. Milesische Forschungen Band I. Mainz: P. von Zabern.

Schneider 2002 = R. M. Schneider, "Nuove Immagini del Potere Romano. Sculture in Marmo Colorato nell'Impero Romano," in *I Marmi Colorati*, pp. 83–105. Venice: Marsilio.

Scholz 1992 = B. I. Scholz, *Untersuchungen zur Tracht der römischen matrona*. Köln: Böhlau Verlag.

Schrader 1932 = H. Schrader, "Nachrichten und Vorlagen," *Gnomon* 8:505–12.

Schröder 1989 = S. F. Schröder, *Römische Bacchusbilder in der Tradition des Apollon Lykeios*. Rome: G. Bretschneider.

Schürmann 1984 = W. Schürmann, *Corpus of Cypriote Antiquities 9: Katalog der Kyprischen Antiken im Badischen Landesmuseum Karlsruhe*

(*SIMA* XX: 9). Gothenburg: P. Åströms.

Schultz 2003 = P. Schultz, "Kephisodotus the Younger," in O. Palagia and S. V. Tracy, eds., *The Macedonians in Athens, 322–229 B.C.*, pp. 186–93. Oxford.

Schweitzer 1954 = B. Schweitzer, "Altrömische Traditionselemente in der Bildniskunst des dritten nachchristlichen Jahrhunderts," *Nederlands Kunsthistorisch Jaarboek* 5:173–190.

Scranton 1967 = R. Scranton, *The Achitecture of the Sanctuary of Apollo Hylates at Kourion.* TAPS 57, part 5. Philadelphia: American Philosophical Society.

Segall 1939 = B. Segall, "A Rock-Crystal Statuette of Heracles,"*JWalt* II:113–17.

Seiler 1969 = S. Seiler, *Beobachtungen am Doppelhermen.* Diss.: Universität Hamburg.

Seipel 1999 = W. Seipel, ed., *Die Sammlung Zyprischer Antiken im Kunsthistorischen Museum.* Vienna: Kunsthistorisches Museum.

Sichtermann 1962 = H. Sichtermann, "Archäologische Funde und Forschungen in Libyen," *AA*:417–536.

Sieveking 1919 = J. Sieveking, "Römisches Soldatenreliefs," in *SBMünch*:3–9.

Skupinska-Løvset 1983 = I. Skupinska-Løvset, *Funerary Portraiture of Roman Palestine: An Analysis of the Production in its Culture-Historical Context.* Gothenburg: Paul Åströms Förlag.

Smith 1991 = R. R. R. Smith, *Hellenistic Sculpture: A Handbook.* London: Thames and Hudson.

Smith 1998 = R. R. R. Smith, "Cultural Choice and Political Identity in Honorific Portrait Statues in the Greek East in the Second Century A.D.," *JRS* 88:56–93.

Sobel 1990 = H. Sobel, *Hygieia: Die Göttin der Gesundheit.* Darmstadt: Wissenschaftliche Buchgesellschaft.

Soren 1987 = D. Soren, ed., *The Sanctuary of Apollo Hylates at Kourion, Cyprus.* Tucson: University of Arizona Press.

Sørensen 1978 = L. W. Sørensen, "Early Archaic Limestone Statuettes in Cypriote Style: A Review of their Chronology and Place of Manufacture," *RDAC*: 111–21.

Sørensen 1994 = L. W. Sørensen, "The Divine Image?," in F. Vandenabeele and R. Laffineur, eds., *Cypriote Stone Sculpture: Proceedings of the Second International Conference of Cypriote Studies.* Brussels-Liège, 17–19 May, 1993, pp. 79–89. Brussels-Liège: A. G. Leventis Foundation/Universiteit Brussel.

Sox 1991 = D. Sox, *Bachelors of Art: Edward Perry Warren and the Lewes House Brotherhood.* London: Fourth Estate.

Springer 1907 = A. Springer, *Handbuch der Kunstgeschichte I: Das Altertum.* Leipzig: E. A. Seemann.

Stark 1971 = J. K. Stark, *Personal Names in Palmyrene Inscriptions.* Oxford: Clarendon Press.

Stephanidou-Tiveriou 1979 = T. Stephanidou-Tiveriou, *Neoattika.* Athens: Athenais Archaiologiki Hetaireia.

Stephanidou-Tiveriou 1985 = T. Stephanidou-Tiveriou, *Trapezophora tou Mouseiou Thessalonikis.* Thessalonike: Aristoteleio Panepistimio.

Stephanidou-Tiveriou 1993 = T. Stephanidou-Tiveriou, *Trapezophora me Plastiki Diakosmisi: I Attiki Omada.* Athens: Ekdosi tou Tameiou Archeologikon Poron kai Apallotrioseon.

Stevenson 1985 = S. Y. Stevenson, "Some Sculpture from Koptos in Philadelphia," *AJA* 10:347–51.

Strong 1932 = E. Strong, "Exhibition of Ancient Art in Rome," *BStM*

3:8–11.

Strutt and Johnson 2002 = K. Strutt and P. Johnson, *Teanum Sidicinum: Geophysical Survey Report—May 2002.* Rome: BSR/APSS.

Studniczka 1918 = F. Studniczka, "Das Bildnis Menanders," *NJbb* 41:1–31.

Stupperich 1977 = R. Stupperich, Staatsbegräbnis und Privatgrabmal im Klassischen Athen. Diss.: Münster.

Tatton-Brown 1986 = V. Tatton-Brown, "Gravestones of the Archaic and Classical Periods: Local Production and Foreign Influences," in V. Karageorghis, ed., *Acts of the International Archaeological Symposium: Cyprus between the Orient and Occident*, pp. 439–52. Nicosia: Dept. of Antiquities, Cyprus.

Technau 1932 = W. Technau, "Archäologische Funde in Italien, Tripolitanien und der Kyrenaika von Oktober 1931 bis Oktober 1932," *AA* 47:447–539.

The Classic World 1986 = *The Classic World*, Exhibition Catalogue. Bryn Athyn, PA: The Glencairn Museum.

Thiersch 1932 = H. Thiersch, *Nachrichten von der Gesellschaft der Wissenschaften zu Göttingen Philologisch-historische Klasse* I/9:52–76.

Thönges-Stringaris 1965 = R. N. Thönges-Stringaris, "Das Griechische Totenmahl," *AthMitt* 80:1–99.

Thompson 1982 = D. B. Thompson, "A Dove for Dione," *Hesperia* Supplement XX:155–62.

Thorpe 1904 = F. N. Thorpe, *William Pepper, M.D., LL.D. (1843–1898) Provost of the University of Pennsylvania.* Philadelphia: J. P. Lippincott Co.

Todisco 1993 = L. Todisco, *Scultura Greca del IV Secolo.* Milan: Longanesi.

Torelli 1987 = M. Torelli, "Culto Imperiale e spazi urbani in età Flavia. Dai rilievi Hartwig all'Arco di Tito," in *L'Urbs. Espace urbain et histoire (1er siècle av. J-C–III siècle ap. J-C)*, pp. 563–82. Rome: École Française de Rome.

Traversari 1986 = G. Traversari, *La Statuaria Ellenistica del Museo Archeologico di Venezia.* Rome: G. Bretschneider.

Trimble 1999 = J. F. Trimble, *The Aesthetics of Sameness: A Contextual Analysis of the Large and Small Herculaneum Woman Statue Types in the Roman Empire.* Diss.: University of Michigan.

Trimble 2000 = J. F. Trimble, "Replicating the Body Politic: The Herculaneum Women Statue Types in Early Imperial Italy," *JRA* 13:41–68.

Tsafrir and Foerster 1990 = Y. Tsafrir and G. Foerster, "Beth Shean excavations – 1988-1989," *Hadashot Arkhyologyot* 95:30-38 (in Hebrew).

Uhlenbrock 1986 = J. P. Uhlenbrock, *Herakles, Passage of the Hero through 1000 Years of Classical Art.* Annandale-on-Hudson: Bard College.

Van Ingen 1939 = W. Van Ingen, *Figurines from Seleucia on the Tigris.* Ann Arbor: University of Michigan Press.

Vermaseren 1977 = M. J. Vermaseren, *Cybele and Attis: the Myth and the Cult.* London: Thames and Hudson.

Vermeule 1964 = C. C. Vermeule, "Greek and Roman Portraits in North American Collections Open to the Public," *ProcPhilAss* 108:99–134.

Vermeule 1968 = C. C. Vermeule, *Roman Imperial Art in Greece and Asia Minor.* Cambridge, MA: Belknap Press of Harvard University Press.

Vermeule 1981 = C. C. Vermeule, *Greek and Roman Sculpture in America.* Malibu, CA: J. P. Getty Museum.

Vermeule 2000 = C. Vermeule, "The Sculpture of Roman Syria," in C. Kondoleon, ed., *Antioch: The Lost Ancient City*, pp. 91–102. Princeton: Princeton University Press.

Vermeule and Brauer 1990 = C. C. Vermeule and A. Brauer, *Stone Sculp-*

ture—*Greek, Roman, and Etruscan Collection of the Harvard University Art Museums*. Cambridge, MA: Harvard University Museums.

Versluys 2002 = M. J. Versluys, *Aegyptiaca Romana: Nilotic Scenes and the Roman Views of Egypt* (*Religions of the Graeco-Roman World* Vol. 144). Leiden: E. J. Brill.

Vessberg 1941 = O. Vessberg, *Studien zur Kunstgeschichte der römischen Republik*. Lund: C. W. K. Gleerup.

Vierneisel-Schlörb 1988 = B. Vierneisel-Schlörb, *Klassische Grabdenkmäler und Votivreliefs*. Munich: Glyptothek München.

von Heintze 1966–67 = H. von Heintze, "Doppelherme mit Hermes und Herakles," *RM* 73–74:251–5.

von Mook 1998 = D. W. von Mook, *Die figürlichen Grabstelen Attikas in der Kaiserzeit*. Mainz: P. von Zabern.

von Oppenheim 1925a = M. von Oppenheim, "A Marble Head of a Syrian Prince," *Antiquarian Quarterly* 3:75.

von Oppenheim 1925b = M. von Oppenheim, "A Bust of Julia Maesa," *Antiquarian Quarterly* 3:91–2.

Vorster 1998 = C. Vorster, *Die Skulpturen von Fianello Sabino: Zum Beginn der Skulpturenausstattung in römischen Villen*. Wiesbaden: Reichert.

Wakeley and Ridgway 1965 = E. T. Wakeley and B. S. Ridgway, "A Head of Herakles in the Philadelphia University Museum," *AJA* 69:156–60.

Walters Catalogue 1947 = *Early Christian and Byzantine Art*. Baltimore: Walters Art Gallery.

Warden and Romano 1994 = P. G. Warden and D. G. Romano, "The Course of Glory: Greek Art in a Roman Context at the Villa of the Papyri at Herculaneum," *Art History* 17, 2:228–54.

Ward-Perkins and Claridge 1978 = J. Ward-Perkins and A. Claridge, *Pompeii AD 79*. New York: Alfred A. Knopf.

Waywell 1986 = G. B. Waywell, *The Lever and Hope Collections. Ancient Sculptures in the Lady Lever Art Gallery, Port Sunlight and a Catalogue of the Ancient Sculptures formerly in the Hope Collection*. Berlin: Gebr. Mann Verlag.

Webb 1996 = P. A. Webb, *Hellenistic Architectural Sculpture: Figural Motifs in Western Anatolia and the Aegean Islands*. Madison: University of Wisconsin Press.

Webster 1998 = G. Webster, *The Roman Imperial Army of the First and Second Centuries AD*, 3rd ed. Norman, OK: University of Oklahoma Press.

Wegner 1971 = M. Wegner, *Macrinus bis Balbinus*, in M. Wegner, series ed., *Das Römische Herrscherbild*, pp. 131–249. Berlin: Verlag Gebr. Mann.

White forthcoming = D. White, "A Noteworthy Libyan Emigrée in Philadelphia: The Benghazi Venus," forthcoming in *Proceedings of the Conference on "Cirene e La Cirenaica nell'Antichità,"* Rome-Frascati, December, 1996.

Wiggers 1971 = H. Wiggers, *Caracalla, Geta, Plautilla*, in M. Wegner, series ed., *Das Römische Herrscherbild*, pp. 9–129. Berlin: Verlag Gebr. Mann.

Wilber 1976 = D. N. Wilber, "Seleucia," *The Princeton Encyclopedia of Classical Sites*, p. 822. Princeton: Princeton University Press.

Williams 1999 = C. Williams, *Roman Homosexuality: Ideologies of Masculinity in Classical Antiquity*. Oxford/New York: Oxford University Press.

Winckelmann 1755 = J. J. Winckelmann, *Gedanken über die Nachahmung der griechischen Wercke in der Malerey und Bildhauerkunst*. in A. W. Schlegels, ed., *Vorlesunger über Schöne Litteratur und Kunst*. Heilbrunn: Verlag Gebr. Henninger, 1884.

Winkes 2000 = R. Winkes, "Livia: Portrait and Propaganda," in D. E. E. Kleiner and S. B. Matheson, *I Claudia: Women in Roman Art and Society*, pp. 29–42. Austin: University of Texas Press.

Winter 1970 = N. A. Winter, Aphrodite Anadyomene: A Statuette from Benghazi in the University Museum, unpublished M.A. Thesis: Bryn Mawr College.

Witecka 1994 = A. Witecka, "A Catalogue of Jewellery Found in the Tower-tomb of Atenatan in Palmyra," *Studia palmyrenskie* 9:71–91.

Wörrle 1988 = M. Wörrle, *Stadt und Fest in Kaiserzeitlichen Kleinasien*. Munich: C. H. Beck Verlag.

Wood 1995 = S. Wood, "Diva Drusilla Panthea and the Sisters of Caligula," *AJA* 99:457–82.

Wood 1986 = S. Wood, *Roman Portrait Sculpture: 217–260 AD*. Leiden: E. J. Brill.

Wood 1987 = S. Wood, "Isis, Eggheads, and Roman Portraiture," *JARCE* 24:123–41.

Wrede 1972 = H. Wrede, *Die spätantike Hermengalerie von Welschbillig: Untersuchung zur Kunsttradition im 4. Jahrhundert n. Chr. und zur allgemeinen Bedeutung des antiken Hermenmals*. Berlin: W. de Gruyter.

Wrede 1981 = H. Wrede. *Consecratio in formam deorum. Vergöttlichte Privatpersonen in der römischen Kaiserzeit*. Mainz: P. von Zabern.

J. Young and S. Young 1955 = J. and S. Young, *Terracotta Figurines from Kourion*. Philadelphia: University Museum, University of Pennsylvania.

Zagdoun 1989 = M.-A. Zagdoun, *La sculpture archaïsante dans l'art hellenistique et dans l'art romain du Haut-Empire*. Athens: École française d'Athènes.

Zanker 1983 = P. Zanker, *Provinzielle Kaiserporträts: zur Rezeption der Selbstdarstellung des Princeps*, Heft 90. Munich: Verlag der Bayerische Akademie der Wissenschaften.

Zevi 1993 = F. Zevi, ed., *Puteoli* Vols. 1 and 2. Naples: Banco di Napoli.

Concordance

UPM Accession Nos.	Cat. Nos.	UPM Accession Nos.	Cat. Nos.	UPM Accession Nos.	Cat. Nos.
B 318	150	MS 3455	56	MS 5671	91
B 319	152	MS 3456	66	MS 5674	15
B 3988	151	MS 3457 (+ MS 3462)	60	MS 5675	19
B 8902	141	MS 3458	50	MS 5681	125
B 8903	142	MS 3459	73	MS 5700	37
B 8904	132	MS 3460	74	MS 5702	106
B 8905	131	MS 3461	82	MS 5709	18
B 8906	136	MS 3463	58	MS 5710	17
B 8907	147	MS 3465 (+ MS 6012 +		MS 5840	14
B 8908	143	MS 3464)	62	MS 5970	34
B 8909	134	MS 3466	59	MS 6027	128
B 8910	135	MS 3467	53	MS 6028	69
B 8911	133	MS 3468	57	29-100-18	12
B 8912	130	MS 3469	71	29-107-917	101
B 9186	146	MS 3470	70	29-107-918	95
B 9187	137	MS 3473	67	29-107-919	94
B 9188	144	MS 3474	51	29-107-920	98
B 9189	145	MS 3475	72	29-107-921	96
B 9365	148	MS 3476	68	29-107-922	99
B 9368	149	MS 3477	55	29-107-923	97
CG 2004-6-1	39	MS 3478	54	29-107-924	93
CG 2004-6-2	129	MS 3479	46	29-107-980	100
E 976	110	MS 3480	49	30-7-1	27
L-29-160	120	MS 3481	61	30-51-1	42
L-51-1	112	MS 3482	63	32-36-62	90
L-51-2	104	MS 3483	44	32-36-63	84
L-64-531	36	MS 3484	45	32-36-64	83
L-123-24	127	MS 4017	124	32-36-65	87
L-123-25	38	MS 4018	116	32-36-66	85
MS 149	1	MS 4019	20	32-36-67	86
MS 151	2	MS 4020	21	32-36-68	88
MS 154	7	MS 4023	25	38-19-1	24
MS 155	4	MS 4025	30	38-19-2	26
MS 159	6	MS 4026	28	39-42-1	89
MS 160	5	MS 4027	118	50-1-110	41
MS 161	3	MS 4028	43	54-3-1	122
MS 213	103	MS 4029	114	54-28-19	11
MS 214	113	MS 4030	105	54-28-20	9
MS 215	108	MS 4031	31	54-28-21	8
MS 216	109	MS 4032	126	54-28-22	10
MS 250	111	MS 4033	115	63-6-1	23
MS 292	16	MS 4034	48	64-28-69	13
MS 1120	107	MS 4036	64	65-26-2	35
MS 3446	75	MS 4037	81	69-14-1	29
MS 3447	76	MS 4916	123	77-2-1	32
MS 3448	77	MS 4917	92	81-22-3	119
MS 3449	78	MS 4918	121	89-22-1	154
MS 3450	79	MS 4919	102	89-22-2	153
MS 3451	80	MS 5439	40	89-22-3	140
MS 3452	65	MS 5461	33	89-22-4	139
MS 3453	47	MS 5470	22	89-22-5	138
MS 3454	52	MS 5483	117		

Index

About the Author

Irene Bald Romano is currently the Administrative Director of the American School of Classical Studies at Athens and holds research appointments in the Mediterranean Section of the University of Pennsylvania Museum of Archaeology and Anthropology and in the Department of Classical and Near Eastern Archaeology at Bryn Mawr College. Dr. Romano earned a Ph.D. in Classical Archaeology from the University of Pennsylvania (1980) and has taught at the University of Pennsylvania and at Franklin and Marshall College. She has participated in archaeological field projects in Spain, Italy, Greece, and Turkey. Dr. Romano is the author of two other major catalogues (*The Terracotta Figurines and Related Vessels*. Gordion Special Studies Vol. II. Philadelphia, 1995; and jointly with David Gilman Romano, *Catalogue of the Classical Collections of the Glencairn Museum*. Bryn Athyn, 1999), as well as numerous articles on Classical sculpture, Greek cult practices, and Hellenistic terracottas and pottery. She has been affiliated with the University of Pennsylvania Museum of Archaeology and Anthropology in various capacities since 1980 and was, recently, the coordinator and co-curator of the reinstallation of the Museum's Classical galleries, "Worlds Intertwined: Etruscans, Greeks, and Romans."